# THEORIES OF

# MODERN ART

# THEORIES OF
# MODERN ART

## A Source Book
## by Artists and
## Critics

### HERSCHEL B. CHIPP

*contributions by*
PETER SELZ *and* JOSHUA C. TAYLOR

UNIVERSITY OF CALIFORNIA PRESS
Berkeley, Los Angeles and London

University of California Press, Berkeley and Los Angeles, California
University of California Press, Ltd., London, England
Theories of Modern Art is a volume in the
CALIFORNIA STUDIES IN THE HISTORY OF ART
sponsored in part by the Samuel H. Kress Foundation
ISBN 0-520-05256-0
Library of Congress Catalog Card Number 68-12038

Printed in the United States of America

08   07   06   05   04   03
26   25   24

The paper used in this publication meets the minimum requirements of
ANSI/NISO Z39.48-1992 (R 1997) (*Permanence of Paper*). ∞

# PREFACE

This book came into being in response to a need, voiced by art historians and students, for access to the fundamental theoretical documents of twentieth-century art. Most of the significant texts originally were published in now obscure publications: ephemeral little magazines, newspapers, or small editions of books. They are thus often extremely difficult and sometimes impossible to find. Although many fragments have been translated with varying degress of fidelity, only a very few have received extensive and accurate translations into English.

Of the texts that are available few have been thoroughly studied, and consequently they have not been utilized to the full extent of their value as significant theoretical documents. It is too easy for an author to use quotations from an artist's writings in order to expand upon his own meaning without having made a careful analysis and evaluation of the deeper meanings intended in the original text. In contrast to the frequent expedient use of quotations from valuable texts, a careful and rigorous methodology is available to and generally used by historians of modern art in treating other materials. It is hoped that the method suggested in the following pages will indicate the possibilities of a more careful analysis and interpretation of these documents.

The texts in this book have been selected on the basis of their value in explaining the basic theories and concepts of modern art. They may deal with an artist's individual struggle with a specific problem or they may deal with the broad ideology of a group manifesto. They are concerned with both form and subject matter, with social and cultural ideas, with the act of painting, and with many other sorts of ideas. Many of them are basic to the development of the concepts of abstract art. For these reasons, a history of theories is not identical with the history of painting, even though the ultimate purpose of studying theory is naturally to illuminate the art. For example, much more space is given to the extensive writings of Maurice Denis than would normally be given to his paintings in a history of art, while two brief sections comprise the best of the rare statements by Georges Braque.

There are several important omissions here which should be treated in separate volumes. The whole of architectural theory is essentially different

from that of painting and sculpture. American art before the Armory Show is basically anti-theoretical and should be studied from a broader viewpoint that would include the social, political, and cultural environment. Contemporary art since 1945 in America and in Europe deserves a separate volume organized differently from the present work, where only a certain few clear directions are indicated. Other omissions may be noted, but the main areas covered by the texts conform closely to the advice of a large number of American art historians on what would be the most useful scope for this book.

The texts begin with the masters of Postimpressionism, Cézanne, Van Gogh, and Gauguin, whose ideas are important foundations for later movements. Impressionism and Neoimpressionism are consigned to an earlier stage of development which the publisher expects to cover in another volume devoted to the nineteenth century. For the sake of clarity the texts are grouped by movements, but the reader is warned to be wary of forcing group ideologies on individual artists. With a very few exceptions (for example, part of Kandinsky's writings appear under German Expressionism and part under Abstract Art), an artist's writings are placed with the movement corresponding to his most creative period. His thoughts at this period are assumed to be of the greatest value as documents, even though his later writings may be more comprehensive in their judgments. In focusing on the period of an artist's greatest artistic and ideological innovations, we quite obviously cannot suggest the subtle influence of other styles and ideologies which may appear throughout a long career. A history of art is the proper place for considering the various periods of a particular artist's career, and the present book should be supplemented by a detailed study of such a history.

The texts in general are arranged in chronological order, but this system is occasionally modified, as with Gauguin's writings, where certain themes seem important enough to be grouped together. Contemporary artists are listed separately as individuals, in accordance with the nature of their ideas. In all cases the date of writing is considered of primary importance and hence it is always cited when known.

It is my hope that by making available these theoretical documents and by outlining a method for approaching them, the study of modern art may be put on a sounder ideological basis than heretofore. It is believed that the careful study of theories and ideologies will clarify the sources and traditions of modern art, and will show how these are rooted in the culture in a way similar to earlier artistic traditions. It may help to dispel the all-too-common popular beliefs that modern art is overly individualistic, capricious,

and irresponsible, or that it is only experimental and problematic, by demonstrating that the freedom, diversity, and ambiguities of art are also the characteristics of the more viable elements of modern life as a whole. The first step in any such study is in the deepest possible understanding of the concepts underlying the art.

For valuable advice and criticism I am especially indebted to the kind interest of Meyer Schapiro. Bernard Karpel and Lucy Lippard rendered invaluable assistance in locating original source material. Also for their interest and assistance I wish to thank: James S. Ackerman, Klaus Berger, Charles Chassé, Mme. Sonia Delaunay, Robert J. Goldwater, William I. Homer, H. W. Janson, D.-H. Kahnweiler, Thomas Munro, Alfred Neumeyer, Stephen C. Pepper, H. R. Rookmaaker, and Vincent W. Van Gogh.

George Wittenborn kindly made available certain English translations of documents first published by him in his valuable *Documents of Modern Art* series.

The idea of this book first was suggested in 1958 by Peter H. Selz, and early plans involved four scholars, Selz, Joshua H. Taylor, Joseph C. Sloane, and myself. Each of us was to prepare the material in his own field. All the other men deserve credit for formulating the basic policies, which were developed and applied by the author. Editing is by the author. All translations not otherwise credited are by the author.

Valuable advice in the preparation of the book was rendered by Walter W. Horn, Editor of the California Studies in the History of Art, and both advice and expert assistance by the staff of the University of California Press.

Substantial financial support for the research on this project was generously provided by the Committee on Research, University of California, Berkeley, and I wish to thank them for their invaluable aid.

Especially valuable assistance in the selection and preparation of the manuscript was rendered by the intelligent and devoted participation of Anita Ventura (Anita Ventura Mozley).

<div style="text-align: right">Herschel B. Chipp</div>

*Paris*
*May* 1968

# CONTENTS

397      Surrealism

445      Introduction: *Scuola Metafisica* by Joshua C. Taylor

## VIII. ART AND POLITICS: The Artist and the Social Order

456      Introduction by Peter Selz

## IX. CONTEMPORARY ART: The Autonomy of the Work of Art

589    Introduction: The Europeans

# GENERAL INTRODUCTION

This book is based on the belief that the writings and statements of painters and sculptors as well as of critics and poets, are valid source materials for a study of the ideas and doctrines of modern art. Artists are considered to be legitimate commentators upon their own art, immersed as they are in the ideas and attitudes of their environment and being the sole participants in and witnesses to the act by which the work of art is created. Indeed, the primary purpose of this book is to supplement existing historical and critical studies by going beyond them in time and by taking as its province the actual ideological milieu of the particular works of art. Problems in the definition and development of art styles are left to other authors; we attempt here to present and study the ideas and conditions current when the work of art was produced. But we can in this one book only suggest the complexity of the several levels upon which these ideas and conditions may influence the inception and development of the particular work of art.

The method proposed, which may seem to some as unduly searching, is, of course, more a guide than a system of investigation. It should be applied, naturally, with the aim of understanding to the fullest the intentions of the writer, both said and unsaid. It should also be applied in a spirit which is sympathetic to the problem of a painter or sculptor who may be expressing himself in a medium in which he may not have had much experience. Even if the study of theoretical documents in terms of their contexts, as proposed here, results in only partial success, still the frequent misuse of quotations out of context might be corrected.

The central problem arises immediately in taking up the study of documents of another age and from a different environment: how should we begin to evaluate these ideas, considering that they have emerged from a cultural context different from our own, that they have been conditioned by complex personal attitudes, and that they have been inflected by the precise situation and the medium through which they are expressed?[1]

[1] A useful guide to the student in analyzing texts such as those discussed here has been developed by Thomas Munro, *College Art Journal* (New York), XVII, Winter 1958, 197–198. His outline poses matter-of-fact questions which, although intended to apply to criticism, are also relevant to theoretical texts such as these. When answered, they can aid in a re-creation of the ideological environment that may add greatly to an understanding of the meaning of the text (see Appendix).

General factors bearing upon theoretical documents of this kind may be summarized under four headings.

(1) The general cultural context of the age and in particular those ideas and theories of greatest interest to the artist, whether they come from science, history, literature, political or social theory, or from other periods of art.

As an example, Henry Van de Velde's theories of the new art, which were basic to the Art Nouveau movement, were deeply influenced by the earlier social theories of William Morris. And Mondrian's adherence to Theosophy while he was painting in a style indebted to Art Nouveau and prior to the development of his characteristic abstract art based on an equilibrium of opposites, is a circumstance of undeniable significance. Also, André Breton's interpretations of Freud and his interest in automatism as manifested in art are fundamental to an understanding of Surrealist theory. None of these examples of the influence of the cultural context upon a particular ideology has been studied sufficiently.

(2) The specific ideological milieu in which the writer formulated and tested his own ideas and thoughts, such as his circle of friends and acquaintances and his contacts with critics, poets, and writers.

For example, Guillaume Apollinaire was a close friend of many artists, including Robert Delaunay; he wrote a poem about Delaunay's paintings and engaged in discussions with him on the subject of the possibilities of expression solely by means of color. Some of his writings on Orphism are indebted to these conversations, and Delaunay's statements were influenced as well.

(3) The medium through which the ideas were transmitted, insofar as it conditioned the intellectual and emotional attitude the writer assumed in addressing a specific audience: his choice of language, his logicality or absence of it, and perhaps even the kind of ideas chosen.

For example, a thought would inevitably be expressed with quite different emotional overtones and intellectual formulations if an artist were engaged in the free-for-all of a spirited argument with other artists at a café than if he were collaborating with an art historian for a monograph on his work. If the former situation occurred when he was unknown except to a few other artists and the latter when he had become an international figure, then the ideas themselves might well have been inflected by the different audience and his different relation to it. In addition, the situation precipitating a particular statement may have been an important factor in determining how and what was said. It may have been a response to an attack, or it may have

been a desire to explain something to the public. In recent years many artists have readily taken up the pen at the request of museum and gallery directors and many have appeared before the public in panel discussions and in film, radio, and television interviews. These and other media act as agents for transforming ideas as they appear in the mind into other forms with different possibilities and limitations. These factors should be considered when one seeks the meaning of the ideas.

(4) The writer's personal qualifications as a theoretician, as they may be conditioned by both his education and past experience with ideas, and his present attitude toward the written or spoken word as a means of conveying intentions.

An academic training may provide either a viable foundation for individual development, as with Henri Matisse, or it may impose rigid shackles that can be broken only by an act of force. Written and spoken ideas may be a fertile source of plastic images, as with Odilon Redon, or they may seem to the artist to pose the threat of "literary ideas" that should be resisted at all costs.

In opposition to our belief in the validity of artists' statements as source material for a study of the meaning of their art, some critics and even some artists are unwilling to consider them in this light. C. J. Ducasse believes that "the artist's business is to practice art, and not to talk about it," and that aesthetic ideas are the proper realm only of philosophers.[2] He even mistrusts what critics say, advising the art-lover to ignore both artist and critic as distractions from what he considers the proper attitude of the viewer, which is simply "listening for feeling impact." Some artists, for different reasons, share Ducasse's suspicion of the artist in the role of theoretician. Cézanne admonished Emile Bernard, even while the young man was completing an article on his painting: "do not be an art critic, but paint, therein lies salvation."

Some contemporary artists (although their numbers are becoming fewer) believe that the sources of their art lie in such a personal area of feeling that no words can touch it, or else they feel that what they do is so different from anything that has been done in the past that no thought can express it. Some are like Houdon, who modestly denied any knowledge of what he called the "Art Terms" used by critics, and who explained that he did not "use the new Dictionary and understand very little these brand new words,

[2] C. J. Ducasse, *The Philosophy of Art* (New York: Dial, 1929), p. 2. Cited with a rejoinder in Charles E. Gauss, *The Aesthetic Theories of French Artists* (Baltimore: Johns Hopkins, 1949), pp. 5–6.

3

ingenious though they be." [3] Hence, he continued, "I leave that matter to the Learned, striving only to do well without aspiring to speak well."

Let us also note that the most common objection raised by some artists to discussing ideas on art is that they "paint them, not talk about them." But it is remarkable how rarely artists' statements deal with so-called purely "painterly ideas" (if, indeed, strictly speaking, there are any such ideas), and how frequently they deal with beliefs, attitudes, and intentions, just as do those of other informed and thoughtful persons who speak of their life interests.

Charles E. Gauss demonstrated his great faith in artists' writings by basing a book upon them, and he firmly answered Ducasse's mistrust by reminding us that an artist is concerned primarily with the creative process and not with aesthetics.[4] He pointed out the chief fallacy of Ducasse's objections: "We do not go to the theories of the artists to find the answer to aesthetic problems but turn to them as materials for philosophic study."

Probably the greatest statement of faith in the value of artists' ideas was expressed by Charles Baudelaire. When defending Richard Wagner as a critic, he wrote these impassioned words:

> I have heard many persons even attack the great extent of his faculties and his high critical intelligence as a reason for a mistrust of his musical genius, and I think that this is the proper occasion to refute a very common error, the principal root of which is perhaps the most miserable of human sentiments, envy. "A man who reasons so much about his art is not capable of naturally producing beautiful works," say those who would thus strip the genius of his reasonableness, and would assign to him a function purely instinctive, and in short, vegetal.... I pity those poets whom only instinct guides; I believe them incomplete. In the spiritual life of the initiators a crisis inevitably arises, when they desire to rationalize their art, to discover those obscure laws by virtue of which they have produced, and to draw from this study a series of precepts of which the divine end is infallibility in poetic production ... it is impossible that a poet does not harbor a critic. The reader will not, therefore, be astonished that I consider the poet as the best of all critics.[5]

The willingness of most modern artists to express their ideas (and the relevance and quality of many of these) bear out Baudelaire's

---

[3] Cited in *Letters of the Great Artists*, Vol. I, *Ghiberti to Gainsborough*, ed. Richard Friedenthal (London: Thames and Hudson, 1963), p. 240.

[4] Gauss, *The Aesthetic Theories of French Artists*, pp. 5–6. For another defense of artists as theoreticians, based principally upon the writings of Delacroix, Gauguin, and Van Gogh, see Alfred Werner, "Artists Who Write," *Art Journal* (New York), XXIV, Summer 1965, 342–347.

[5] Charles Baudelaire, "Fragments sur le Beau, la Poésie et la Morale," *Variétés Critiques*, II (Paris: Crès, 1924), pp. 189–190.

judgment of Wagner, so that while we may not treat their statements as an aesthetic system, we can look to them for invaluable ideas which bear upon their thinking and ultimately upon their art.

The most conclusive evidence, however, of the value of this type of source material is in the usefulness to art historians of several collections of documents, all of which have appeared since 1945. Chief among these is *Artists on Art* by Robert J. Goldwater and Marco Treves.[6] Although covering the broad period since the Early Renaissance and limited to rather brief passages, the authors' discriminating selections of significant material useful to the art historian and student has made this book a standard reference. Professor Goldwater clearly expressed his high valuation of artists' statements in the Introduction:

> When such opinions have been presented, not as objective, professional criticism, but in relation to the artists' own creation they have been included here; often they are more revealing than the abstract words and conventional phrases of a generalized aesthetic.[7]

Elizabeth G. Holt's *Literary Sources of Art History*[8] includes fewer but longer selections, and is concerned not only with art theory but also with other literary and documentary material as well. The first edition includes material through the eighteenth century; it has been reprinted in two paperback volumes, and a third volume, which includes the nineteenth century, has been added. The material in the third volume is more theoretical than that in the first two, and since most of it is by artists, it is more relevant to the present discussion. Gauss's *Aesthetic Theories of French Artists* is an analysis from the point of view of aesthetics of selected passages by artists of the chief art movements from Courbet to Surrealism. In this book the ideas of the artists are considered in relation to contemporary aesthetic theories. Other books take as their field a broad range of thought embracing literature and social theory during certain ages. Eugen Weber's *Paths to the Present*[9] consists of selected documents dealing with European thought as well as with art from Romanticism to Existentialism. There are several other useful

---

[6] *Artists on Art*, eds. Robert J. Goldwater and Marco Treves (New York: Pantheon, 1945).

[7] *Artists on Art*, eds. Goldwater and Treves, p. 11.

[8] *Literary Sources of Art History*, ed. Elizabeth G. Holt (Princeton, N.J.: Princeton University, 1947). Expanded and revised as *A Documentary History of Art*, 3 vols. (New York: Doubleday Anchor, 1957, 1966).

[9] *Paths to the Present: Aspects of European Thought from Romanticism to Existentialism*, ed. Eugen Weber (New York: Dodd, Mead, 1960).

compilations, the earliest and the most extensive of which were published in Germany.

Thus, there are available in these and other collections many theoretical documents that are potentially of real value. Unfortunately, in general only brief excerpts of most of the documents have been published, and hence their potential richness of ideas has not fully been realized.[10] And only in a few cases have the documents been selected, studied, and compared with the view of providing a deeper understanding of the ideology of an entire movement.[11]

The points of study outlined above would attempt to define an ideological context for the documents, thus extending their meanings, and hopefully would eventually lead to deeper understanding of the art. According to this method, a document is seen not only as a theoretical view of an artistic problem but also as the product of broad environmental conditions.

This approach—a contextualist one, in which the object of study has been viewed in relation to its ideological environment—has been anticipated in both art history and aesthetics. It follows the method developed by the Viennese school of art history, which evolved toward the end of the nineteenth century within the Austrian Institute of Historical Research at the University of Vienna. These art historians—chiefly Alois Riegl, Franz Wickhoff, and Max Dvorak—considered art and theories of art to be part of the larger whole of cultural history, and they thought that both might often be influenced and even determined by wholly nonartistic events. Their work and that of their students projected art upon a broader plane than had previously been thought relevant, and it enriched and vitalized its study by viewing it in relation to a social and cultural context.[12] Their work, further-

---

[10] A notable exception is the excellent series of documents published in their entirety by George Wittenborn, Inc., New York, under the general title *The Documents of Modern Art*, ed. Robert Motherwell. Also, *Modern Artists on Art*, ed. Robert L. Herbert (New York: Prentice-Hall, 1964), includes ten selected documents in their entirety.

[11] Guillaume Apollinaire's writings on art have been collected, edited and annotated in a valuable work, *Chroniques d'Art*, ed. L.-C. Breunig (Paris: Gallimard, 1960). "Miroirs de l'Art," directed by Pierre Berès and André Chastel, and published by Hermann, Paris, is a series of documents annotated according to the point of view discussed in this article. At this date the following works on modern art have appeared: Apollinaire, *Les peintres cubistes;* Denis, *Du symbolisme au classicisme: Théories;* and Signac, *D'Eugène Delacroix au Néoimpressionisme.*

[12] For a recent clear and brief outline of the method, see Friedrich Antal; "Remarks on the Method of Art History, I," *Burlington Magazine* (London), XCI, February 1949, 49–52.

Hippolyte Taine also formulated about the same time as the Viennese a philosophy of art on the basis of his belief in the class interaction of art and culture. He wrote: "The work of art is determined by an ensemble which is the general state of spirit and customs surrounding it." *Philosophie de l'art* (Paris: Hachette, 1903), p. 101.

more, opened the way for the study of non-Western and exotic arts, such as African, Oceanic, folk, child, and even the decorative arts, which by direct or indirect means have enriched and inflected the concepts of the mainstream of modern art.

This attitude and these specific influences have been considered within the larger field of a study of style by Meyer Schapiro, who profoundly illuminated all of these and other related problems.[13] Schapiro views art styles as possessing the power of formulating in the deepest sense the group emotion and thoughts of the culture. He believes that the characteristics of style are determined on several different levels: by the emotions and thoughts of the individual, and by the views of the group, of the nation, and even of the world. With this view he opens up the possibility of a complex interaction between the culture and the work of art whereby the art gains in viability by reason of its source in the living culture.

Contextualism is the term employed by Stephen C. Pepper for one of the major hypotheses of aesthetic theory.[14] He sees it as a synthetic rather than an analytic process, with its origins in the historic event. This process attempts to re-create the historic event in the living present, thus perceiving it in its full reality as an experienced as well as an intellectually conceived phenomenon.

Erwin Panofsky has in his search for the deeper meanings in works of art so expanded the boundaries of art history that it can no longer be satisfied with history as only a factual discipline. His article on iconology describes a method for revealing the deepest possible meanings of historical facts. He outlines three principal levels of meaning in the subject matter of a work of art.[15] His aim is to penetrate from apparent meanings—the lowest level—to intrinsic or symbolic meanings—the highest level—which in the deepest and most profound sense constitute the "content" of the work of art.

The first or lowest level, "primary or natural subject matter," may be transposed for use in studying a written text as the primary or the apparent, literal meaning of the ideas presented. It is comprised of the facts as stated and their inter-relationships.

---

[13] Meyer Schapiro, "Style," *Anthropology Today*, ed. Sol Tax (Chicago: University of Chicago, 1952), pp. 287–312. In this article Professor Schapiro investigates so deeply many other fundamental aspects of the problem of methodology that it has become a basis study unmatched in theoretical art-historical literature.

[14] Stephen C. Pepper, *World Hypotheses* (Berkeley: University of California, 1942), Ch. X.

[15] Erwin Panofsky, "Iconography and Iconology: An Introduction to the Study of Renaissance Art," *Studies in Iconology* (New York and London: Oxford University Press, 1939). Reprinted in *Meaning in the Visual Arts* (New York, Doubleday Anchor, 1955).

The second level of meaning consists of "secondary or conventional subject matter," where the apparent, literal meanings in the simple form of the first level, are connected to larger themes and concepts which are part of our general cultural and historical knowledge. In the case of a written text we might paraphrase Panofsky to say that on this level we relate the specific ideas under discussion to broad "secondary or conventional ideas."

The third level of meaning involves a synthesis composed of the apparent ideas of the first level, the general cultural and ideological context of the second level together with relevant ideas from other humanistic disciplines. On this high level the knowledge and wisdom of scholars and of evidence from other related fields is brought to bear on the ideas concerned. On this level we are permitted an insight into the intrinsic meaning or "the content" of the subject matter.

The method that prevailed on the two lower levels, called *iconography*, or the description of images, is transformed on the third level into *iconology*, or the science of the study of the meaning of images. Similarly, in the study of ideas we may, through a close study of the contexts and by reference to the study of related ideas in other disciplines, be able to penetrate from the apparent or literal meanings of ideas to their intrinsic meanings, or, in the deepest sense, their "content."

Some penetrating thoughts on the value of a study of the context of a work of art for an understanding of it have been stated by James S. Ackerman.[16] First of all, he condemns art historians' excessive concern with historical developments, which he believes tends to engulf both the artist and the work of art in an evolutionary "trend." He believes that it is only by studying the art in terms of its context that it may be freed sufficiently from arbitrary classifications to permit its intrinsic qualities to be revealed. Professor Ackerman considers creative activity itself to a primary value, outweighing conventional abstract constructs, such as the myth of "development," and the dogma of an "*avant-garde*" in art. He writes:

Starting with the premise of the autonomy of the individual work, we would seek out the intention and the experiences of the artist as he produced it. By autonomy I do not mean isolation, because the experiences of the artist inevitably bring him into contact with his environment and traditions; he cannot work in a historical vacuum. So we would need to know what the artist had seen and done before, what he sees and does now for the first time, what he or his patron wishes to accomplish, how his intentions and solutions mature in the course

---

[16] James S. Ackerman, "Art History and the Problem of Criticism," *Daedalus* (Cambridge, Mass.), LXXXIX, Winter 1960 253–263.

of production. Every tool of history must be at hand to understand all this, and some new ones, too, such as those of psychology and other social sciences. In short, we would formulate the history of art primarily in terms of contexts rather than developments.[17]

When the attitudes and methods suggested here are consistently and relevantly applied, the statements of artists and other similar documents of modern art may become more meaningful and hence more useful to the art historian. By re-creating the conditions, facts, and ideas contributing to the appearance of the document he may proceed from the merely factual statement, with its apparent meaning, to the deeper intrinsic meaning, with all its richness of association and implication. Such an understanding of documents may help to avoid the common fault, the expedient use of texts out of context for ends other than those intended by the original author. But more importantly, by providing an ideological context for a theoretical document, then analyzing the ideas according to a relevant method, one may gain valuable additional information on the conceptions underlying the art and, eventually, a deeper insight into the art itself.

[17] *Ibid.*, p. 261.

POSTIMPRESSIONISM:
Individual Paths to
Construction and Expression

INTRODUCTION: The Letters of Cézanne

Cézanne's views on art come to us almost exclusively through a relatively small number of letters to personal friends. He was a prodigious letter writer, and many of his letters have been preserved, but generally he spoke less of art than of family affairs, friends, and general problems. Even in his voluminous correspondence with his boyhood friend, Emile Zola, who was active in intellectual and artistic circles in Paris, he speaks mainly of personal matters, of Zola's novels, and of almost everything but his own painting. In writing to his close friend and mentor, Camille Pissarro, he dwells at length upon the numerous family problems of the older man and even upon his own, but seldom on theoretical matters of art.

His few writings on art occur under special circumstances and for reasons that seem rather clear. The majority of them come from the last three years of his life, when he was in his late sixties, and they are addressed to three young men, all of whom had exerted the considerable effort necessary to seek out the solitary painter. The three had become, although at different times, close personal friends of Cézanne and had gained an intimate knowledge of his opinions, his many doubts and fears, and his resentment of critics and the officialdom of the Paris art world. Joachim Gasquet (1873–1921) was a poet, twenty-three years old in 1896 when he approached Cézanne filled with admiration for his paintings, which he had seen at Père Tanguy's in Paris. Although the young man was the son of one of Cézanne's boyhood friends, such an unexpected confrontation threw the old man into confusion and drove him to rebuke Gasquet for mocking him. Finally, however, the gentle earnestness and tact of young Gasquet permitted the development of a warm relationship. Charles Camoin was an art student, twenty-two years old in 1901 when, while serving his military duty at Aix, he sought out Cézanne for advice and companionship. Again a close personal friendship developed which was continued later in the correspondence containing some of Cézanne's observations on art. Emile Bernard (1868–1941) was

known to Cézanne as early as 1890 when the young man, then twenty-two years old, published a eulogistic article on Cézanne's paintings, which he had seen in Paris, in the series *Les Hommes d'Aujourd'hui*. However they did not meet until 1904, when Bernard sought out Cézanne in Aix. Again, the younger man was taken into the confidence of the older, and he probably came closer to being what we could call a pupil of the master than any other artist. Bernard was an unusually active young man, extremely curious intellectually, and with a theoretical turn of mind. He had turned away from Gauguin and from the Nabis to seek an art of greater formal strength which he hoped would have religious implications. His sincere and searching questions undoubtedly stimulated Cézanne to formulate his own ideas on art, many of which were meant to correct the very intellectuality that Bernard manifested in posing the questions. The month which the two artists spent together in conversation and on painting expeditions later resulted in a series of letters in which Cézanne expressed his ideas most clearly. The meeting and the ensuing correspondence formed the basis for several articles by Bernard in which these ideas were reported.

In "Une Conversation avec Cézanne" published in *Mercure de France* in 1921, Bernard writes:

In 1904 in the course of one of our walks in the surroundings of Aix, I said to Cézanne:

What do you think of the Masters?

They are good. I went to the Louvre every morning when I was in Paris; but I ended up by attaching myself to nature more than they did. One must make a vision for oneself.

What do you mean by that?

One must make an optic, one must see nature as no one has seen it before you . . . .

Will that not result in a vision that is too personal, incomprehensible to other men? After all, is not painting like speaking? When I speak I use the same language as you; would you understand me if I had made a new, unknown one? It is with the common language that one must express new ideas. Perhaps this is the only means to make them valid and to make them acceptable.

I mean by optic a logical vision, that is, with nothing of the absurd.

But upon what do you base your optic, Master?

Upon nature.

What do you mean by that word? Is it a case of our nature or nature itself?

It is a case of both.

Therefore, you conceive of art as a union of the universe and the individual?

I conceive it as a personal apperception. I situate this apperception in sensation, and I ask that the intelligence organize it into a work.

But of what sensations do you speak? Of those of your feelings, or of those of your retina?

I think that there cannot be a separation between them; besides, being a painter I attach myself first of all to visual sensation.[1]

Although Cézanne had always deeply resented the teaching of art along with all other aspects of its institutionalization, the reasons why he took such a personal interest in instructing the young men seem clear. They approached him as pupils who, deeply moved by the work of the master, sought to understand the man and as a result to perfect their own art. He became a sage, solitary and grand, whose every work and gesture was precious. This unique position is in contrast to his discomfort and even suffering in the presence of the sophisticated repartee of the Café Guerbois crowd (the Impressionists), and of his furious resentment of the hostile critical remarks that were frequently aimed at his work. He complained in his old age that his own generation was against him, a conviction fortified by a long series of obstacles that since his youth had resisted his desire to become an artist at almost every turn. It even began in his home, where only his own extreme stubbornness had finally prevailed over parental objections, and it continued in Paris, where he was consistently rejected at the salons and by the dealers and collectors. At the same time his friends among the Impressionists had been recognized, one by one, so that by about 1880 all of them except Cézanne had been accepted in the official salon.

The scantness of his theoretical remarks on art is not surprising. Although he reiterated his favorite maxim—to work and to avoid theorization—he was not anti-intellectual. He had done well in school, consistently winning prizes, especially in Latin and mathematics, and he had, while a young man, written poetry for Zola. He had read the great novelists and playwrights and was able to comment intelligently upon the novels sent to

[1] *Mercure de France* (Paris), CXLVIII, 551 (1 June 1921), 372–397.

him as gifts by his friend. But he could not participate in nor tolerate the gay and witty conversation of his friends among the Impressionists and the writers who began to meet at the Café Guerbois about 1866. He was usually glum and silent when he joined them; when he did speak out, he usually ended by becoming argumentative and vehement and then rushing away in anger. He seemed to be able to discuss serious subjects only with a single person and then only when he was perfectly at ease in that person's presence. His most influential artistic friendship was with the gentle and learned Camille Pissarro, probably beginning in 1861 but becoming more intimate in 1872 when Cézanne moved to Auvers. Pissarro taught him by example to put foremost the study of the object in nature and to allow ideas and theories to follow if necessary only after that.

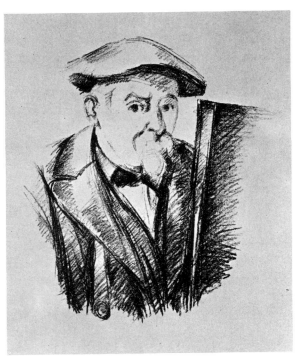

*Paul Cézanne, Self-Portrait, ca. 1898, transfer lithograph.*

Cézanne's writing style is awkward, cryptic, and often ungrammatical, and he expresses himself often only with great effort. In that regard his writing is similar to his earliest paintings.

Cézanne's kindness and his willingness to discuss art with the young artists who had befriended him—a quality that belies the common myth of the master as an impossible misanthrope—can be readily summarized. He

was pleased by the genuine admiration which these young artists held toward his work. Maurice Denis's painting, *Hommage à Cézanne* (1900), which attracted a great deal of attention when exhibited at *La Libre Esthétique* in Brussels in 1901, showed an array of the important younger artists (Redon, Vuillard, Denis, Sérusier, Ranson, Roussel, Bonnard) gathered in Vollard's gallery in respectful admiration of a still life by Cézanne. It was only in 1895, when he was fifty-six, that his work had finally been shown at Vollard's Gallery in Paris, followed by exhibitions in 1900 at the Paris Centennial and in 1905 at the Salon d'Automne. Only in the isolation of his last years, taking advantage of what was probably his only intellectual stimulus as well as his closest contact with the current world of art, was he finally able to speak to these young men of his artistic attitudes.

# PAUL CÉZANNE:
## Excerpts from the Letters

## PAINTING FROM NATURE

*To Emile Zola, Aix, n.d. [ca. 19 October 1866] (#21, pp. 74–75)*★

But you know all pictures painted inside, in the studio, will never be as good as the things done outside. When out-of-door scenes are represented, the contrasts between the figures and the ground are astounding and the landscape is magnificent. I see some superb things and I shall have to make up my mind only to do things out-of-doors.[1]

I have already spoken to you about a picture I want to attempt; it will represent Marion and Valabregue setting out to look for a motif (the landscape motif of course). The sketch which Guillemet considers good and which I did after nature makes everything else seem bad.[2] I feel sure that all the pictures by the old masters representing things out-of-doors have only been done hesitatingly, for they do not seem to me to have the true and above all the original aspect lent by nature.

★ The references following the letter citation are to *Paul Cézanne: Letters*, ed. John Rewald (London: Cassirer, 1941). The translations were made from the French by Marguerite Kay. In a few cases, words or phrases were translated by the present editor somewhat differently than by the translator, although the meaning is essentially the same. These changes appear in brackets. American spelling of such words as color and honor is used in this text. All the letters cited appear in excerpt. Headings to the selections are by the editor.

[1] Zola (1840–1902) and Cézanne had been close friends since their boyhood together in Aix-en-Provence, and they had maintained what Zola called "secret affinities" into their professional lives. Zola had gone to Paris in 1858 and his entreaties to Cézanne to join him were the major reason for Cézanne's trip there in 1861. They shared many artistic tastes and although later were to fall apart, this letter reveals the warmth and intimacy of their relations as young men. Earlier that year Zola had dedicated a collection of his art reviews, *Mes salons*, to Cézanne, although he had not mentioned his friend's paintings in the text. (For an English translation of the dedication see John Rewald, *Paul Cézanne* [New York: Simon and Schuster, 1948 translated by Margaret H. Liebman], pp. 56–57.) Cézanne, only twenty-six years of age when he wrote this letter, apparently was then only thinking of painting out-of-doors, for his paintings show little evidence that he had actually done so.

[2] Only the sketch of this picture is known (Venturi Catalogue no. 96). According to the letters written by Marion to Morstatt, Cézanne at this period seems to have been preparing other portraits of his friends. [Rewald's footnote.]

# WORK BEFORE THEORY

*To Octave Maus, Paris, 27 November 1889 (#115, p. 190)*[1]

I must tell you with regard to this matter that the many studies I made having given only negative results, and dreading the critics who are only too justified, I had resolved to work in silence until the day when I should feel myself able to defend in theory the results of my attempts.

# THE ARTIST'S ROLE

*To Joachin Gasquet, Aix, 30 April 1896 (#124, pp. 198–199)*[2]

Could you but see inside me, the man within, you would be so [angry] no longer. Do you not see to what a sad state I am reduced[?] Not master of myself, a man who does not exist, and it is you, who claim to be a philosopher, who would cause my final downfall? But I curse the X . . . s and the few rascals who, for the sake of writing an article for 50 francs, drew the attention of the public to me. All my life I have worked to be able to earn my living, but I thought that one could do good painting without attracting attention to one's private life. To be sure, an artist wishes to raise his standard intellectually as much as possible, but the man must remain in obscurity. Pleasure must be found in study. If it had been given me to succeed, I should have remained in my corner with my few studio companions with whom we used to go out for a pint. I still have a good friend from those days. Well, he has not been successful, which does not prevent him from being far more of a painter than all the daubers in spite of their medallions and decorations, which make me sick, and you want me at my age to believe in anything? Moreover, I am as good as dead.

# "LET US WORK . . ."

*To Joachin Gasquet and to a young friend, n.d. (#129 bis, p. 203)*

For my part, I am getting old. I shall not have time to express myself . . . . Let us work . . . .

. . . The study of the model and its realization is sometimes very slow in coming.

[1] Madeleine-Octave Maus was the leader of *Les Vingt* of Brussels, a group of the most advanced artists of Belgium and Holland. Under the direction of Maus the artists arranged an annual exhibition of their own work to which was added that of other new artists. Maus's taste was for the most adventurous art, and his judgment was usually very good: he showed the work of the Impressionists in 1886, Seurat in 1887, Ensor in 1888, and Gauguin in 1889. Cézanne's letter is a reply to Maus's invitation to exhibit three paintings in the next exhibition to be held in the spring of 1890.

[2] This letter was written later on the same evening in which Cézanne had met young Gasquet strolling in the *Cours Mirabeau*, Aix's broad central boulevard. Cézanne had imagined

## DISCUSSING PAINTING

*To Charles Camoin, Aix, 28 January 1902 (#148, p. 218)*[1]

I have little to tell you; indeed one says more and perhaps better things about painting when facing the motif than when discussing purely speculative theories—in which, as often as not, one loses oneself.

## CONTACT WITH NATURE

*To Charles Camoin, Aix, 22 February 1903 (#160, p. 228)*

But I must work.—All things, particularly in art, are theory developed and applied in contact with nature.

*To Charles Camoin, Aix, 13 September 1903 (#163, p. 230)*

Couture used to say to his pupils: "Keep good company, that is: Go to the Louvre. But after having seen the great masters who respose there, we must hasten out and by contact with nature revive in us the instincts and sensations of art that dwell within us."

## ON CONCEPTION AND TECHNIQUE

*To Louis Aurenche, Aix, 25 January 1904 (#165, p. 232)*

In your letter you speak of my realization in art. I think that every day I am attaining it more, although with some difficulty. For if the strong experience of nature—and assuredly I have it—is the necessary basis for all conception of art on which rests the grandeur and beauty of all future work, the knowledge of the means of expressing our emotion is no less essential, and is only to be acquired through very long experience.

The approbation of others is a stimulus of which, however, one must sometimes be wary. The feeling of one's own strength renders one modest.

## "THE CYLINDER, THE SPHERE, THE CONE..."

*To Emile Bernard, Aix, 15 April 1904 (#167, p. 234)*

---

that Gasquet was angry at him and he hastened to write this letter wherein he revealed his frustrations and timidity.

Gasquet, aged 23, a writer and poet, was the son of one of Cézanne's school-day friends. Despite this awkward beginning they were later to become close friends.

[1] Camoin (b. 1879) had sought out Cézanne while he was fulfilling his military service in Aix, and the two had become close friends. He had been a student of Gustave Moreau together with Matisse and Marquet at the *Ecole des Beaux-Arts*, and even during his army service he exhibited in Paris with the young painters who were to become the Fauves. He conveyed to Cézanne the admiration which Matisse and the other young painters held for him.

May I repeat what I told you here: treat nature by the cylinder, the sphere, the cone, everything in proper perspective so that each side of an object or a plane is directed towards a central point. Lines parallel to the horizon give breadth, that is a section of nature or, if you prefer, of the spectacle that the *Pater Omnipotens Aeterne Deus* spreads out before our eyes. Lines perpendicular to this horizon give depth. But nature for us men is more depth than surface, whence the need of introducing into our light vibrations, represented by reds and yellows, a sufficient amount of blue to give the impression of air.

I must tell you that I had another look at the study you made in the lower floor of the studio, it is good. You should, I think, only continue in this way. You have the understanding of what must be done and you will soon turn your back on the Gauguins and the Van Goghs!

## THE STUDY OF NATURE

*To Emile Bernard, Aix, 12 May 1904 (#168, p. 235–236)*

My absorption in my work and my advanced age will explain sufficiently my delay in answering your letter.

Moreover, in your last letter you discourse on such widely divergent topics, though all are connected with art, that I cannot follow you in all your phases . . . .

I am progressing very slowly, for nature reveals herself to me in very complex forms; and the progress needed is incessant. One must see one's model correctly and experience it in the right way; and furthermore express oneself forcibly and with distinction.

Taste is the best judge. It is rare. Art only addresses itself to an excessively small number of individuals.

The artist must scorn all judgment that is not based on an intelligent observation of character. He must beware of the literary spirit which so often causes painting to deviate from its true path—the concrete study of nature—to lose itself all too long in intangible speculations.

The Louvre is a good book to consult but it must only be an intermediary. The real and immense study that must be taken up is the manifold picture of nature.

*To Emile Bernard, Aix, 26 May 1904 (#169, pp. 236–237)*

On the whole I approve of the ideas you are going to expound in your next article for the *Occident*. But I must always come back to this: the painter must devote himself entirely to the study of nature and try to produce pictures which are an instruction. Talks on art are almost useless. The work which goes to bring progress in one's own subject is sufficient compensation for the incomprehension of imbeciles.

Literature expresses itself by abstractions, whereas painting by means of drawing and color gives concrete shape to sensations and perceptions. One is neither too scrupulous nor too sincere nor too submissive to nature; but one is more or less master of one's model, and above all, of the means of expression. Get to the heart of what is before you and continue to express yourself as logically as possible.

*To Emile Bernard, Aix, 25 July 1904 (#171, p. 239)*

I received the "Revue Occidentale" and can only thank you for what you wrote about me.[1] I am sorry that we cannot be together now, for I do not want to be right in theory but in nature. Ingres, in spite of his "estyle" [Aixian pronunciation— John Rewald] and his admirers, is only a very little painter. You know the greatest painters better than I do; the Venetians and the Spaniards.

To achieve progress nature alone counts, and the eye is trained through contact with her. It becomes concentric by looking and working. I mean to say that in an orange, an apple, a bowl, a head, there is a culminating point; and this point is always—in spite of the tremendous effect of light and shade and colorful sensations—the closest to our eye; the edges of the objects recede to a center on our horizon. With a small temperament one can be very much a painter. One can do good things without being very much of a harmonist or a colorist. It is sufficient to have a sense of art—and this sense is doubtless the horror of the bourgeois. Therefore institutions, pensions, honors can only be made for cretins, rogues and rascals. Do not be an art critic, but paint, therein lies salvation.

## ON SELF-CONFIDENCE

*To Charles Camoin, Aix, 9 December 1904 (#174, pp. 241–242)*

Studying the model and realizing it is sometimes very slow in coming for the artist.

Whoever the master is whom you prefer, this must only be a directive for you. Otherwise you will never be anything but an imitator. With any feeling for nature whatever, and some fortunate gifts—and you have some—you should be able to dissociate yourself; advice, the methods of another must not make you change your own manner of feeling. Should you at the moment be under the influence of one who is older than you, believe me as soon as you begin to feel yourself, your own emotions will finally emerge and conquer their place in the sun—*get the upper hand*, confidence—what you must strive to attain is a good method of *construction*.

[1] Bernard's article (*L'Occident* [Paris], July 1904), wherein he described his first visit to Cézanne in Aix. Theodore Reff believes that this article, which was approved by Cézanne,

# THE OLD MASTERS

*To Emile Bernard, Aix, 23 December 1904 (#175, pp. 242–243)*

I shall not dwell here on aesthetic problems. Yes, I approve of your admiration for the strongest of all the Venetians; we are celebrating Tintoretto. Your desire to find a moral, an intellectual point of support in the works, which assuredly we shall never surpass, makes you continually on the *qui vive*, searching incessantly for the way, [which] you dimly apprehend, [that] will lead you surely to the recognition in front of nature of what your means of expression are; and the day you will have found them, be convinced that you will find also without effort and in front of nature the means employed by the four or five great ones of Venice.

This is true without possible doubt—I am very positive:—an optical impression is produced on our organs of sight which makes us classify as *light*, half-tone or quarter-tone the surfaces represented by color sensations. (So that light does not exist for the painter). As long as we are forced to proceed from black to white, the first of these abstractions being like a point of support for the eye as much as for the mind, we are confused, we do not succeed in mastering ourselves in *possessing ourselves*. During this period (I am necessarily repeating myself a little) we turn towards the admirable works that have been handed down to us throughout the ages, where we find comfort, a support such as a plank is for the bather.— Everything you tell me in your letter is very true.

*To Emile Bernard, Aix n.d. [1905] (#183, p. 250)*

The Louvre is the book in which we learn to read. We must not, however, be satisfied with retaining the beautiful formulas of our illustrious predecessors. Let us go forth to study beautiful nature, let us try to free our minds from them, let us strive to express ourselves according to our personal temperaments. Time and reflection, moreover, modify little by little our vision, and at last comprehension comes to us.

# ABSTRACTION

*To Emile Bernard, Aix, 23 October 1905 (#184, pp. 251–252)*

Your letters are valuable to me for a double reason—the first purely selfish—because their arrival lifts me out of the monotony which is caused by the incessant

---

is more reliable than the others as an expression of Cézanne's ideas: "Cezanne and Poussin," *Journal of the Warburg and Courtauld Institutes* (London), XXIII (January–June 1960), 150–174. Reff also evaluates the reliability of Bernard and other first-hand commentators on Cézanne's ideas.

and constant search for the sole and unique aim, and this produces, in moments of physical fatigue, a kind of intellectual exhaustion; secondly, I am able to describe to you again, rather too much I am afraid, the obstinacy with which I pursue the realization of that part of nature, which, coming into our line of vision, gives the picture. Now the theme to develop is that—whatever our temperament or power in the presence of nature may be—we must render the image of what we see, forgetting everything that existed before us. Which, I believe, must permit the artist to give his entire personality whether great or small.

Now, being old, nearly 70 years, the sensations of color, which give light, are the reason for the abstractions which prevent me from either covering my canvas or continuing the delimitation of the objects when their points of contact are fine and delicate; from which it results that my image or picture is incomplete. On the other hand, the planes are placed one on top of the other from whence Neoimpressionism emerged, which outlines the contours with a black stroke, a failing that must be fought at all costs. Well, nature when consulted gives us the means of attaining this end.

## INTENSITY OF NATURE

*To his son Paul, Aix, 8 September 1906 (#193, p. 262)*

—Finally I must tell you that as a painter I am becoming more clear-sighted in front of nature, but that with me the realization of my sensations is always very difficult. I cannot attain the intensity that is unfolded before my senses. I have not the magnificent richness of coloring that animates nature. Here on the edge of the river, the motifs are very plentiful, the same subject seen from a different angle gives a subject for study of the highest interest and so varied that I think I could be occupied for months without changing my place, simply bending a little more to the right or left.

## ON TECHNICAL QUESTIONS

*To Emile Bernard, Aix, 21 September 1906 (#195, p. 266)*

You must forgive me for continually coming back to the same thing; but I believe in the logical development of everything we see and feel through the study of nature and turn my attention to technical questions later; for technical questions are for us only the means of making the public feel what we feel ourselves, and of making ourselves understood. The great masters whom we admire can have done nothing else.

## MUSEUMS

*To his son Paul, Aix, 26 September 1906 (#197, p. 268)*

He [Charles Camoin] showed me a photograph of a figure by the unfortunate Emile Bernard; we are agreed on this point, namely that he is an intellectual engorged by the memory of the museums, but who does not look at nature enough, and that is the great thing, to make oneself free of the school and indeed of all schools. —So that Pissarro was not mistaken, though he went a little too far, when he said that all the necropoles of art should be burned.

## NATURE THE BASIS OF HIS ART

*To Paul, Aix, 13 October 1906 (#200, p. 271)*

I must carry on. I simply must produce after nature.—Sketches, pictures, if I were to do any, would be merely constructions after [nature], based on method, sensations, and developments suggested by the model, but I always say the same thing.

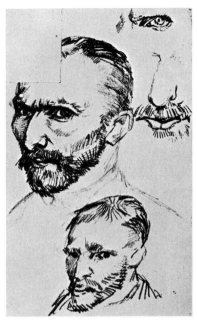

*Vincent van Gogh, self-portraits from a
letter of March 1886.*

# INTRODUCTION: The Letters of Van Gogh

The statements by Van Gogh specifically concerned with his ideas and
theories on art are not numerous, and are most often very simple and direct.
They occur almost exclusively during a very brief period, the first few
fruitful and idyllic months when, having just left Paris at the age of thirty-
five, he settled in Arles for a stay that lasted from February 1888 until May
1889. There are several reasons why these ideas and theories should have
appeared in his letters at this particular time and for so brief a period.

He enjoyed at Arles, for the first time in two years, a solitude which
he sorely needed, and which he had been unable to achieve in Paris, where
he had lived with his brother Theo and had associated with artists in the
studios and cafés of Montmartre. His high moral conception of what it
meant to be an artist, rooted as it was in a profoundly religious spirit, did not
allow him to tolerate for long the gay bohemianism of most of his colleagues.
When he finally did set up his studio in the Yellow House in Arles he was
independent of the many personalities and artistic forces of Paris that had so
intoxicated him, and he was able at last to consider himself an independent
artist. Now he had the time and the leisure to speculate upon the many ideas

and theories of art to which he had listened, and which he himself had discussed in Paris. And in his own house, he could make plans for the organization of the artists' brotherhood about which he had dreamed for so long.

In Paris he had become a close friend of the young Emile Bernard who, even at the age of eighteen, had an extraordinarily active intellect, one that was devoted to theorization. Bernard seemed always to know what was new in the way of ideas, especially the theories of the Pont-Aven artists, and he discussed them with his many friends. Van Gogh was also a friend and painting companion of Paul Signac, theoretician of Neoimpressionism, and while in Paris he had often spoken with great vehemence on this, the most controversial of the *avant-garde* movements. Because he lived in Paris in close personal contact with his brother and his artist friends, there was little necessity to write down the many ideas on art that were racing through his mind. So, in Arles he discovered a natural setting perfectly suited to meditation on the theories discussed in Paris. To the Dutchman accustomed to the cool, pale tones of the north, the brilliant sun, the blue sky, and the warm, rich colors of the flora and earth of Provence recalled the color of Japanese prints, and they offered as well a chance to put into practice some of the lessons he had learned from the Impressionists and the Neoimpressionists.

For all of these reasons, the letters written during the first few months at Arles, while he was assimilating the influences of the Paris art movements into his own individual and forceful style, were filled with thoughts of his friends and meditations on art. With the arrival of Gauguin in October, he was at first stimulated anew, but the violence of their many differences and conflicts soon created an emotional crisis for Van Gogh that put an end to this idyllic period.

Most of the statements on art are addressed, as were the letters, to Vincent's younger brother Theo, who had succeeded him in the employ of the art dealers, Goupil and Company in Paris. The devotion of Theo to his brother and his understanding of his problems is well known to readers of the letters. When Vincent left the art gallery in 1875, Theo had at once urged him to become an artist. This was five years before Vincent himself fully realized the possibility. Theo faithfully supported him out of his own modest income throughout the entire struggle, and was an unfailing source of the encouragement which Vincent so desperately needed. Since Theo achieved, by 1888, an influential position in the gallery, he was also for Vincent an important contact with the Parisian art world.

In his early decision to become an art dealer, Vincent entered a profession already well-established in his family. Of his father's five brothers,

*Vincent van Gogh, signature on a letter,
undated (ca. September 1888).*

three were art dealers, all of them successful, and one had become the prin-
cipal partner in Goupil and Company, one of the leading houses in Europe.
This one, his uncle Vincent, took a special interest in his young namesake,
and in 1869, when Vincent was 16, engaged him at the Hague branch of the
firm. Young Vincent was highly successful and well-liked during his three
years there. He was promoted to the London office, where he stayed for two
years, and then, in 1874, to the principal office in Paris. During these six
years as an art dealer, Vincent had become acquainted with the works of the
masters of the past who were later to become important for him as an artist.
He admired particularly those who, like the Barbizon painters Rousseau,
Millet, Diaz, and Breton, were sympathetic to simple peasant people. In
1874, shortly after his arrival in Paris, he became deeply and emotionally
preoccupied with a study of the Bible. This led to increasing dissatisfaction
with the business and, in the next year, to his resignation from Goupil.

The next five years, from 1875 to 1880, were spent in a desperate
struggle to establish himself as a minister, a period which not only inflicted
the utmost hardships upon him, but ultimately resulted in failure in his
every attempt to become a man of God. In this endeavor, too, he had a
precedent in his family, since both his father and his grandfather (also named
Vincent) were ministers, the latter having achieved considerable eminence
because of his brilliance as a scholar and his nobility of character. Although
Vincent strove mightily to master the difficult requirements necessary to
prepare himself for entrance into a school of the ministry, he soon discovered
that his own calling was worlds apart from the academic approach of the
schools. Two attempts to fulfill his powerful emotional need to preach the
Gospel, first as a lay preacher and then as a volunteer missionary in a mining
village in the Borinage in southern Belgium, resulted in failure.

When Van Gogh finally came to art, he was 27 years old, and al-
though he bore a family name distinguished by eminence and success, he had
rejected the profession of his uncles and he had totally failed, despite great

personal sacrifices, in the profession of his father and grandfather. The resolve to become an artist was finally made in 1880, after a long period of painful self-examination while in seclusion in the Borinage. His intense desire to become an artist, fortified by his early experience with art and permeated with religious feeling, preceded even a knowledge of how to paint. As Meyer Schapiro has observed, he threw himself into art with all the intensity of a religious convert. In a long letter to Theo[1]—a manifesto of his new consecration—he tells of his struggles:

> I am a man of passions, capable of and subject to doing more or less foolish things, which I happen to repent, more or less, afterward . . . must I consider myself a dangerous man, incapable of anything?
> . . . my only anxiety is, how can I be of use in the world? Can't I serve some purpose and be of any good?
> And then one feels an emptiness where there might be friendship and strong and serious affections, and one feels a terrible discouragement gnawing at one's very moral energy, and fate seems to put a barrier to the instincts of affection, and a choking flood of disgust envelopes one. And one exclaims, "How long, my God!"

He writes of his loneliness for pictures, for which he had such a passion during his years in the art gallery, and exclaims:

> I am good for something, my life has a purpose after all, I know that I could be quite a different man! How can I be useful, of what service can I be? There is something inside of me, what can it be?

He now writes about art as he had formerly written about his religion, seeing art as one means of worshipping God.

> To try to understand the real significance of what the great artists, the serious masters, tell us in their masterpieces, *that* leads to God . . . .

Thus, becoming an artist not only fulfilled his craving for art itself, but also consummated his powerful religious desires, whose frustration had so shaken him during the previous five years. He had found a purpose in life that absorbed his violent passions and directed them into a profession which he believed to be a socially useful one. It is for these reasons that we may speak of Van Gogh as a convert to art. He was as much concerned with its social purpose as with its theories, and these concerns both are reflected in

---

[1] Letter No. 133, July 1880, Vol. I, *The Complete Letters of Vincent van Gogh.* (See next section for full citation.)

the statements about art found in his letters. Throughout his entire adult life he poured into them his noblest ideas as well as his doubts and fears about himself; they were the chief means by which he achieved and maintained intimate contact with others, a contact which he rarely enjoyed for long in personal relations. So much do they reveal about him that they portray in detail both the finding of a self and the making of an artist.

# VINCENT VAN GOGH:
## Excerpts from the Letters

### THE POTATO EATERS, 1885[1]

*To his brother Theo, Neunen, 30 April 1885 (404, Vol. II, 369–370)* ★

As to the potato eaters, it is a picture that will show well in gold, I am sure of that, but it would show as well on a wall, papered in the deep color of ripe corn.

*It simply cannot be seen* without such a setting.

It does not show up well against a dark background, and not at all against a dull background. That's because it gives a glimpse of a very gray interior. In reality too it stands in a gold frame, as it were, because the hearth and the glow of the fire on the white wall would be nearer to the spectator, now they are outside the picture, but in reality they throw the whole thing into perspective.

I repeat, it must be shut off by framing it in something of a deep gold or brass color.

If you yourself want to see it as it must be seen, don't forget this, please. This putting it next to a gold tone gives, at the same time, a brightness to *spots where you would not expect it*, and takes away the marbled aspect it gets when unfortunately placed against a dull or black background. The shadows are painted in blue, and a gold color puts life into this . . . .

I have tried to emphasize that those people, eating their potatoes in the lamplight, have dug the earth with those very hands they put in the dish, and so it speaks of *manual labor*, and how they have honestly earned their food.

I have wanted to give the impression of a way of life quite different from that of us civilized people. Therefore I am not at all anxious for everyone to like it or to admire it at once.

[1] Collection V. W. Van Gogh, Laren, The Netherlands.
    In 1883, at thirty years of age, Van Gogh abandoned his two-year struggle as a student of painting in the academies of Brussels and The Hague and returned to his father's house in Neunen. There he devoted himself completely to painting, and wandered about the countryside painting the peasants for whom he had a very deep sympathy. This painting is the largest he had ever done, another indication of the importance he gave it (size 50, or about 32″ × 45″).
    ★ The references in parentheses following the letter citation indicate, unless stated otherwise, the letters in Volume III. *The Complete Letters of Vincent van Gogh*, 3 Vols. (Greenwich, Connecticut, published by the New York Graphic Society, 1958), from which these selections are excerpted. Headings to the selections are by the editor.

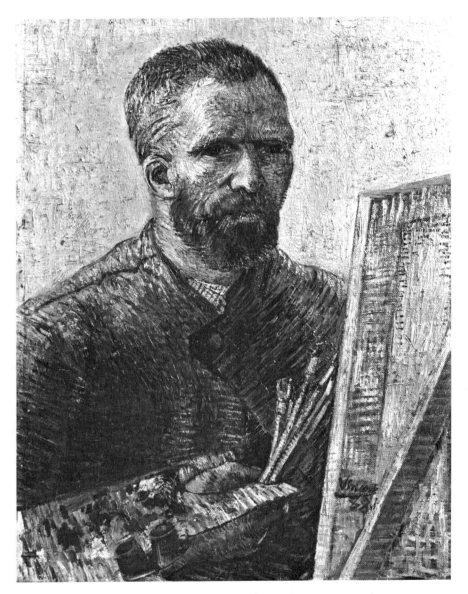

*Vincent van Gogh, Self-Portrait Before the Easel,*
*1888, oil on canvas.*

All winter long I have had the threads of this tissue in my hands, and have searched for the ultimate pattern; and though it has become a tissue of rough, coarse aspect, nevertheless the threads have been chosen carefully and according to certain rules. And it might prove to be a real *peasant picture. I know it is.* But he who prefers to see the peasants in their Sunday-best may do as he likes. I personally am convinced I get better results by painting them in their roughness than by giving them a conventional charm.

I think a peasant girl is more beautiful than a lady, in her dusty, patched blue skirt and bodice, which get the most delicate hues from weather, wind, and sun. But if she puts on a lady's dress, she loses her peculiar charm. A peasant is more real in his fustian clothes in the fields than when he goes to church on Sunday in a kind of dress coat.

In the same way it would be wrong, I think, to give a peasant picture a certain conventional smoothness. If a peasant picture smells of bacon, smoke, potato steam—all right, that's not unhealthy; if a stable smells of dung—all right, that belongs to a stable; if the field has an odor of ripe corn or potatoes or of guano or manure—that's healthy, especially for city people.

## TROPICAL COLOR[1]

*To his sister Wilhelmina, Arles, 30 March 1888 (W3, p. 431)*

But by intensifying *all* the colors one arrives once again at quietude and harmony. There occurs in nature something similar to what happens in Wagner's music, which, though played by a big orchestra, is nonetheless intimate. Only when making a choice one prefers sunny and colorful effects, and there is nothing that prevents me from thinking that in the future many painters will go and work in tropical countries. You will be able to get an idea of the revolution in painting when you think, for instance, of the brightly colored Japanese pictures that one sees everywhere, landscapes and figures. Theo and I have hundreds of Japanese prints in our possession.

## IMAGINATION

*To Emile Bernard, Arles, April 1888 (B3, p. 478)*

The imagination is certainly a faculty which we must develop, one which alone can lead us to the creation of a more exalting and consoling nature than the single brief glance at reality—which in our sight is ever changing, passing like a flash of lightning—can let us perceive.

A starry sky, for instance—look, that is something I should like to try

[1] Vincent's trip to Aries, where he arrived on 20 February 1888, was motivated largely by a search for the rich color he had seen in Japanese prints.

to do, just as in the daytime I am going to try to paint a green meadow spangled with dandelions. So much in criticism of myself and in praise of you.

## MY BRUSH STROKE HAS NO SYSTEM

*To Emile Bernard, Arles, April 1888 (B3, p. 478)*

At the moment I am absorbed in the blooming fruit trees, pink peach trees, yellow-white pear trees. My brush stroke has no system at all. I hit the canvas with irregular touches of the brush, which I leave as they are. Patches of thickly laid-on color, spots of canvas left uncovered, here and there portions that are left absolutely unfinished, repetitions, savageries; in short, I am inclined to think that the result is so disquieting and irritating as to be a godsend to those people who have fixed preconceived ideas about technique. For that matter here is a sketch, the entrance to a Provençal orchard with its yellow fences, its enclosure of black cypresses (against the mistral), its characteristic vegetables of varying greens: yellow lettuces, onions, garlic, emerald leeks.

Working directly on the spot all the time, I try to grasp what is essential in the drawing—later I fill in the spaces which are bounded by contours—either expressed or not, but in any case *felt*—with tones which are also simplified, by which I mean that all that is going to be soil will share the same violet-like tone, that the whole sky will have a blue tint, that the green vegetation will be either green-blue or green-yellow, purposely exaggerating the yellows and blues in this case.

In short, my dear comrade, in no case an eye-deceiving job.

## BLACK AND WHITE ARE COLORS

*To Emile Bernard, Arles, second half of June 1888 (B6, p. 490)*

A technical question. Just give me your opinion on it in your next letter. I am going to put the *black* and the *white*, just as the color merchant sells them to us, boldly on my palette and use them just as they are. When—and observe that I am speaking of the simplification of color in the Japanese manner—when in a green park with pink paths I see a gentleman dressed in black and a justice of the peace by trade (the Arab Jew in Daudet's *Tartarin* calls this honorable functionary *zouge de paix*) who is reading *L'Intransigeant* . . . .

Over him and the park a sky of a simple cobalt . . . . Then why not paint the said *zouge de paix* with ordinary bone black and the *Intransigeant* with simple, quite raw white? For the Japanese artist ignores reflected colors, and puts the flat tones side by side, with characteristic lines marking off the movements and the forms.

In another category of ideas—when for instance one composes a motif of colors representing a yellow evening sky, then the fierce hard white of a white wall against this sky may be expressed if necessary—and this in a strange way—by raw white, softened by a neutral tone, for the sky itself colors it with a delicate

lilac hue. Furthermore imagine in that landscape which is so naïve, and a good thing too, a cottage whitewashed all over (the roof too) standing in an orange field—certainly orange, for the southern sky and blue Mediterranean provoke an orange tint that gets more intense as the scale of blue colors gets a more vigorous tone—then the black note of the door, the windows and the little cross on the ridge of the roof produce a simultaneous contrast of black and white just as pleasing to the eye as that of blue and orange.

Or let us take a more amusing motif: imagine a woman in a black-and-white-checked dress in the same primitive landscape with a blue sky and an orange soil—that would be a rather funny sight, I think. In Arles they often do wear black and white checks.

Suffice it to say that black and white are also colors, for in many cases they can be looked upon as colors, for their simultaneous contrast is as striking as that of green and red, for instance.

The Japanese make use of it for that matter. They express the mat and pale complexion of a young girl and the piquant contrast of the black hair marvelously well by means of white paper and four strokes of the pen. Not to mention their black thornbushes starred all over with a thousand white flowers.

## COMPLEMENTARY COLOR

*To Emile Bernard, Arles, second half of June 1888 (B6, pp. 491)*

What I should like to find out is the effect of an intenser blue in the sky. Fromentin and Gérôme see the soil of the South as colorless, and a lot of people see it like that. My God, yes, if you take some sand in your hand, if you look at it closely, and also water, and also air, they are all colorless, looked at in this way. *There is no blue without yellow and without orange*, and if you put in blue, then you must put in yellow, and orange too, mustn't you? Oh well, you will tell me that what I write to you are only banalities.

*To Emile Bernard, Arles, second half of June 1888 (B7, p. 492)*

There are many hints of yellow in the soil, neutral tones resulting from mixing violet with yellow; but I have played hell somewhat with the truthfulness of the colors.

## THE STARRY NIGHT, 1888[1]

*To Emile Bernard, Arles, second half of June 1888 (B7, p. 492)*

But when shall I paint my *starry sky*, that picture which preoccupies me continuously? Alas! Alas! it is just as our excellent colleague Cyprien says in J. K. Huysmans' *En Ménage:* "The most beautiful pictures are those one dreams about when smoking pipes in bed, but which one will never paint."

[1] Museum of Modern Art, New York.

One must attack them nonetheless, however incompetent one may feel before the unspeakable perfection, the glorious splendors of nature.

## SIMULTANEOUS CONTRAST OF COLORS

*To Emile Bernard, Arles, second half of June, 1888 (B7, p. 493)*

This is what I wanted to say about black and white. Take the Sower. The picture is divided in half; one half, the upper part, is yellow; the lower part is violet. Well, the white trousers allow the eye to rest and distract it at the moment when the excessive simultaneous contrast of yellow and violet would irritate it.

## SIMULTANEOUS CONTRASTS OF LINES AND FORMS

*To Emile Bernard, Arles, beginning of August 1888 (B14, p. 508)*

When are you going to show us studies of such vigorous soundness again? I urgently invite you to do it, although I most certainly do not despise your researches relating to the property of lines in opposite motion—as I am not at all indifferent, I hope, to the simultaneous contrasts of lines, forms. The trouble is— you see, my dear comrade Bernard—that Giotto and Cimabue, as well as Holbein and Van Dyck, lived in an obeliscal—excuse the word—solidly framed society, architecturally constructed, in which each individual was a stone, and all the stones clung together, forming a momumental society. When the socialists construct their logical social edifice—which they are still pretty far from doing— I am sure mankind will see a reincarnation of this society. But, you know, we are in the midst of downright *laisser-aller* and anarchy. We artists, who love order and symmetry, isolate ourselves and are working to define *only one thing*.

## EXPRESSIVE COLOR

*To Theo, Arles, n.d. [ca. August, 1888] (520, p. 6)*

What a mistake Parisians make in not having a palate for crude things, for Monticellis, for common earthenware. But there, one must not lose heart because Utopia is not coming true. It is only that what I learned in Paris is leaving me, and I am returning to the ideas I had in the country before I knew the impressionists. And I should not be surprised if the impressionists soon find fault with my way of working, for it has been fertilized by Delacroix's ideas rather than by theirs. Because instead of trying to reproduce exactly what I see before my eyes, I use color more arbitrarily, in order to express myself forcibly. Well, let that be, as far as theory goes, but I'm going to give you an example of what I mean.

I should like to paint the portrait of an artist friend, a man who dreams great dreams, who works as the nightingale sings, because it is his nature. He'll be a blond man. I want to put my appreciation, the love I have for him, into the picture. So I paint him as he is, as faithfully as I can, to begin with.

But the picture is not yet finished. To finish it I am now going to be the arbitrary colorist. I exaggerate the fairness of the hair, I even get to orange tones, chromes and pale citron-yellow.

Behind the head, instead of painting the ordinary wall of the mean room, I paint infinity, a plain background of the richest, intensest blue that I can contrive, and by this simple combination of the bright head against the rich blue background, I get a mysterious effect, like a star in the depths of an azure sky.

Again, in the portrait of the peasant I worked this way, but in this case without wishing to produce the mysterious brightness of a pale star in the infinite. Instead, I imagine the man I have to paint, terrible in the furnace of the height of harvest time, as surrounded by the whole Midi. Hence the orange colors flashing like lightning, vivid as red-hot iron, and hence the luminous tones of old gold in the shadows.

## NATURE AND ART

*To Theo, Arles, n.d. [ca. August 1888] (522, p. 10)*

At all events, law and justice apart, a pretty woman is a living marvel, whereas the picture by da Vinci and Correggio only exist for other reasons. Why am I so little an artist that I always regret that the statue and the picture are not alive? Why do I understand the musician better, why do I see the *raison d'être* of his abstractions better?

## PORTRAITURE OF THE SOUL

*To Theo, Arles, n.d. [August 1888] (531, p. 25)*

Oh, my dear brother, sometimes I know so well what I want. I can very well do without God both in my life and in my painting, but I cannot, ill as I am, do without something which is greater than I, which is my life—the power to create.

And if, frustrated in the physical power, a man tries to create thoughts instead of children, he is still part of humanity.

And in a picture I want to say something comforting, as music is comforting. I want to paint men and women with that something of the eternal which the halo used to symbolize, and which we seek to convey by the actual radiance and vibration of our coloring.

Portraiture so understood does not become like an Ary Scheffer just because there is a blue sky in the background, as in "St. Augustine." For Ary Scheffer is so little of a colorist.

But it would be more in harmony with what Eug. Delacroix attempted and brought off in his "Tasso in Prison," and many other pictures, representing a *real* man. Ah! portraiture, portraiture with the thoughts, the soul of the model in it, that is what I think must come.

35

## THE NIGHT CAFE, 1888[1]

*To Theo, Arles, 8 September 1888 (533, pp. 28–29)*

Then to the great joy of the landlord, of the postman whom I had already painted, of the visiting night prowlers and of myself, for three nights running I sat up to paint and went to bed during the day. I often think that the night is more alive and more richly colored than the day.

Now, as for getting back the money I have paid to the landlord by means of my painting, I do not dwell on that, for the picture is one of the ugliest I have done. It is the equivalent, though different, of the "Potato Eaters."

I have tried to express the terrible passions of humanity by means of red and green.

The room is blood red and dark yellow with a green billiard table in the middle; there are four citron-yellow lamps with a glow of orange and green. Everywhere there is a clash and contrast of the most disparate reds and greens in the figures of little sleeping hooligans, in the empty, dreary room, in violet and blue. The blood-red and the yellow-green of the billiard table, for instance, contrast with the soft tender Louis XV green of the counter, on which there is a

*Vincent van Gogh, The Night Café, 1888, oil on canvas.*

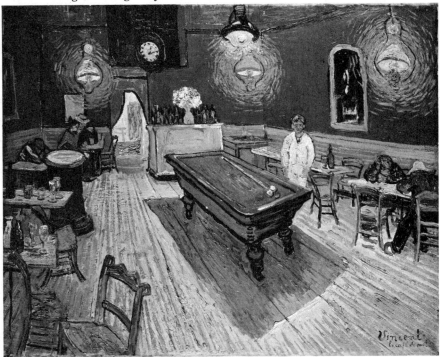

[1] Yale University Art Gallery, New Haven.

pink nosegay. The white coat of the landlord, awake in a corner of that furnace, turns citron-yellow, or pale luminous green.

*To Theo, Arles, n.d. [ca. September 1888] (534, p. 31)*

In my picture of the "Night Café" I have tried to express the idea that the café is a place where one can ruin oneself, go mad or commit a crime. So I have tried to express, as it were, the powers of darkness in a low public house, by soft Louis XV green and malachite, contrasting with yellow-green and harsh blue-greens, and all this in an atmosphere like a devil's furnace, of pale sulphur.

And all with an appearance of Japanese gaiety, and the good nature of Tartarin.

## COLOR OF THE SOUTH

*To Theo, Arles, n.d. [ca. September 1888] (538, p. 39)*

But for my part I foresee that other artists will want to see color under a stronger sun, and in a more Japanese clarity of light.

Now if I set up a studio and refuge at the gates of the South, it's not such a crazy scheme. And it means that we can work on serenely. And if other people say that it is too far from Paris, etc., let them, so much the worse for them. Why did the greatest colorist of all, Eugène Delacroix, think it essential to go South and right to Africa? Obviously, because not only in Africa but from Arles onward you are bound to find beautiful contrasts of red and green, of blue and orange, of sulphur and lilac.

And all true colorists must come to this, must admit that there is another kind of color than that of the North. I am sure if Gauguin came, he would love this country; if he doesn't it's because he has already experienced more brightly colored countries, and he will always be a friend, and one with us in principle.

And someone else will come in his place.

If what one is doing looks out upon the infinite, and if one sees that one's work has its *raison d'être* and continuance in the future, then one works with more serenity.

*To Theo, Arles, n.d. [ca. September 1888] (539, p. 42)*

Because I have never had such a chance, nature here being so *extraordinarily* beautiful. Everywhere and all over the vault of heaven is a marvelous blue, and the sun sheds a radiance of pale sulphur, and it is soft and as lovely as the combination of heavenly blues and yellows in a Van der Meer of Delft. I cannot paint it as beautifully as that, but it absorbs me so much that I let myself go, never thinking of a single rule.

That makes three pictures of the gardens opposite the house. Then the two cafés, and then the sunflowers. Then the portrait of Bock and of myself. Then the red sun over the factory, and the men unloading sand, and the old mill. Not to

mention the other studies, you see that I have got some work behind me. But my paints, my canvas and my purse are all completely exhausted today. The last picture, done with the last tubes of paint on the last canvas, of a garden, green of course, is painted with pure green, nothing but Prussian blue and chrome yellow.

## SUGGESTIVE COLOR

*To Theo, Arles, n.d. [ca. September 1888] (539, pp. 44–45)*

I often think of his [Seurat's] method, though I do not follow it at all; but he is an original colorist, and Signac too, though to a different degree, their stippling is a new discovery, and at all events I like them very much. But I myself—I tell you frankly—am returning more to what I was looking for before I came to Paris. I do not know if anyone before me has talked about suggestive color, but Delacroix and Monticelli, without talking about it, did it.

But I have got back to where I was in Nuenen, when I made a vain attempt to learn music, so much did I already feel the relation between our color and Wagner's music.

## PAINT FROM THE MODEL

*To Theo, Arles, n.d. [ca. September 1888] (541, p. 48)*

And to get at that character, the fundamental truth of it: that's three times now that I've painted the same spot.

It happens to be the garden just in front of my house. But this corner of the garden is a good example of what I was telling you, that to get at the real character of things here, you must look at them and paint them for a long time.

*To Theo, Arles, n.d. [ca. September 1888] (542, p. 52)*

This winter I intend to draw a great deal. If only I could manage to draw figures from memory, I should always have something to do. But if you take the cleverest figure done by all the artists who sketch on the spur of the moment, Hokusai, Daumier, in my opinion that figure will never come up to the figure painted from the model by those same masters, or other portrait painters.

And in the end, if models, especially intelligent models, are doomed to fail us too often, we must not despair for this reason or grow weary in the struggle.

## JAPANESE ARTISTS LIVE IN NATURE

*To Theo, Arles, n.d. [ca. September 1888] (542, p. 55)*

If we study Japanese art, we see a man who is undoubtedly wise, philosophic and intelligent, who spends his time doing what? In studying the distance between the earth and the moon? No. In studying Bismarck's policy? No. He studies a single blade of grass.

But this blade of grass leads him to draw every plant and then the seasons, the wide aspects of the countryside, then animals, then the human figure. So he passes his life, and life is too short to do the whole.

Come now, isn't it almost a true religion which these simple Japanese teach us, who live in nature as though they themselves were flowers?

And you cannot study Japanese art, it seems to me, without becoming much gayer and happier, and we must return to nature in spite of our education and our work in a world of convention.

Isn't it sad that the Monticellis have never yet been reproduced in good lithographs or in etchings which vibrate with life? I should very much like to know what artists would say if an engraver like the man who engraved the Velásquez made a fine etching of them. Never mind, I think it is more our job to try to admire and know things for ourselves than to teach them to other people. But the two can go together.

I envy the Japanese the extreme clearness which everything has in their work. It is never tedious, and never seems to be done too hurriedly. Their work is as simple as breathing, and they do a figure in a few sure strokes with the same ease as if it were as simple as buttoning your coat.

## THE YELLOW HOUSE, 1888[1]

*To Theo, Arles, n.d. [September 1888] (543, p. 56)*

Also a sketch of a size 30 canvas[2] representing the house and its surroundings in sulphur-colored sunshine, under a sky of pure cobalt. The subject is frightfully difficult; but that is just why I want to conquer it. It's terrific, these houses, yellow in the sun, and the incomparable freshness of the blue. And everywhere the ground is yellow too. I shall send you a better drawing than this rough improvised sketch out of my head later on.

The house on the left is pink with green shutters, I mean the one in the shadow of the tree. That is the restaurant where I go for dinner every day. My friend the postman lives at the end of the street on the left, between the two railway bridges. The night café I painted is not in the picture, it is to the left of the restaurant.

# I CANNOT WORK WITHOUT A MODEL

*To Emile Bernard, Arles, first half of October 1888 (B19, pp. 517–18)*

I won't sign this study, for I never work from memory. There is some color in it which will please you, but once again, I have painted a study for you which I should have preferred not to paint.

I have mercilessly destroyed one important canvas—a "Christ with the

[1] Collection V. W. van Gogh, Laren, The Netherlands.
[2] See table of sizes of canvases, p. 40.

| Nº | Figure | Paysage | Marine | |
|---|---|---|---|---|
| 1 | 22x16 | 22x14 | 22x12 | |
| 2 | 24x19 | 24x16 | 24x14 | |
| 3 | 27x22 | 27x19 | 27x16 | |
| 4 | 33x24 | 33x22 | 33x19 | |
| 5 | 35x27 | 35x24 | 35x22 | |
| 6 | 41x33 | 41x27 | 41x24 | |
| 8 | 46x38 | 46x33 | 46x27 | |
| 10 | 55x46 | 55x38 | 55x33 | |
| 12 | 61x50 | 61x46 | 61x38 | |
| 15 | 65x54 | 65x50 | 65x46 | |
| 20 | 73x60 | 73x54 | 73x50 | |
| 25 | 81x65 | 81x60 | 81x54 | |
| 30 | 92x73 | 92x65 | 92x60 | |
| 40 | 100x81 | 100x73 | 100x65 | |
| 50 | 116x89 | 116x81 | 116x73 | |
| 60 | 130x97 | 130x89 | 130x81 | |
| 80 | 146x114 | 146x97 | 146x89 | |
| 100 | 162x130 | 162x114 | 162x97 | |
| 120 | 195x130 | 195x114 | 195x97 | |

*Table of sizes of canvases (in centimeters).*

Angel in Gethsemane"—and another one representing the "Poet against a Starry Sky"—in spite of the fact that the color was right—because the form had not been studied beforehand from the model, which is necessary in such cases.

. . . And I cannot work without a model. I won't say that I don't turn my back on nature ruthlessly in order to turn a study into a picture, arranging the colors, enlarging and simplifying; but in the matter of form I am too afraid of departing from the possible and the true.

I don't mean I won't do it after another ten years of painting studies, but, to tell the honest truth, my attention is so fixed on what is possible and really exists that I hardly have the desire or the courage to strive for the ideal as it might result from my abstract studies.

Others may have more lucidity than I do in the matter of abstract studies, and it is certainly possible that you are one of their number, Gauguin too . . . and perhaps I myself when I am old.

But in the meantime I am getting well acquainted with nature. I exaggerate, sometimes I make changes in a motif; but for all that, I do not invent the whole picture; on the contrary, I find it all ready in nature, only it must be disentangled.

## THE BEDROOM, 1888[1]

*To Theo, Arles, second half of October 1888 (554, p. 86)*

This time it's just simply my bedroom, only here color is to do everything, and giving by its simplification a grander style to things, is to be suggestive here of *rest*

[1] Collection V. W. van Gogh, Laren, The Netherlands.

or of sleep in general. In a word, looking at the picture ought to rest the brain, or rather the imagination.

The walls are pale violet. The floor is of red tiles.

The wood of the bed and chairs is the yellow of fresh butter, the sheets and pillows very light greenish-citron.

The coverlet scarlet. The window green.

The toilet table orange, the basin blue.

The doors lilac.

And that is all—there is nothing in this room with its closed shutters.

The broad lines of the furniture again must express inviolable rest. Portraits on the walls, and a mirror and a towel and some clothes.

The frame—as there is no white in the picture—will be white.

This by way of revenge for the enforced rest I was obliged to take.

I shall work on it again all day, but you see how simple the conception is. The shadows and the cast shadows are suppressed; it is painted in free flat tints like the Japanese prints. It is going to be a contrast to, for instance, the Tarascon diligence and the night café.

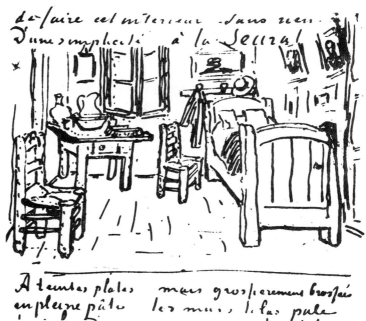

Vincent van Gogh, sketch for The Bedroom at Arles in a letter to Gauguin, undated (ca. October 1888). Vincent writes that it was "of a Seurat-like simplicity; with flat tints, but brushed on roughly with a thick impasto . . ."

*To Paul Gauguin, Arles, n.d. [ca. October 1888] (B22, p. 527)*

I have done, still for my decoration, a size 30 canvas of my bedroom with the white deal furniture that you know. Well, I enormously enjoyed doing this interior of nothing at all, of a Seurat-like simplicity; with flat tints, but brushed on roughly, with a thick impasto, the walls pale lilac, the ground a faded broken red, the chairs and the bed chrome yellow, the pillows and the sheet a very pale green-citron, the counterpane blood red, the washstand orange, the washbasin blue, the window green. By means of all these very diverse tones I have wanted to express an *absolute restfulness*, you see, and there is no white in it at all except the little note produced by the mirror with its black frame (in order to get the fourth pair of complementaries into it).

Well, you will see it along with the other things, and we will talk about it, for I often don't know what I am doing when I am working almost like a sleepwalker.

## STRONG SOUTHERN COLOR

*To Theo, Arles, October 1888 (555, p. 88)*

So write me some details about the new friends' painting soon, and if they are really painters trying to make progress in virgin fields, boldly recommend the South to them. I believe that a new school of *colorists* will take root in the South, as I see more and more that those in the North rely on their ability with the brush, and the so-called "picturesque," rather than on the desire to express something by color itself. Your news gave me great pleasure, but it so astonishes me not to know what there was inside that frame.

Here, under a stronger sun, I have found what Pissarro said confirmed, and also what Gauguin wrote to me, the simplicity, the fading of the colors, the gravity of great sunlight effects.

## WORKING FROM MEMORY[1]

*To Theo, Arles, n.d. [ca. 23 October 1888] (561, p. 103)*

I am going to set myself to work from memory often, and the canvases from memory are always less awkward, and have a more artistic look than studies from nature, especially when one works in mistral weather.

---

[1] These two letters written during Gauguin's short stay with Vincent in Arles clearly show his influence on Vincent's thought. Compare them with Vincent's ideas on memory before this event (B 19, to Emile Bernard, first half of October, 1888) and a year after it (B 21, to Bernard, beginning of December, 1889). Gauguin's own thoughts on the role of memory are well expressed in his essay "Diverse Choses" (*see passages below*).

*To Theo, Arles, December 1888 (563, p. 106)*

Gauguin, in spite of himself and in spite of me, has more or less proved to me that it is time I was varying my work a little. I am beginning to compose from memory, and all my studies will still be useful for that sort of work, recalling to me things I have seen.

## TREATMENT OF THE SUBJECT

*To Theo, St. Rémy, 9 June 1889 (594, p. 179)*

When the thing represented is, in point of character, absolutely in agreement and one with manner of representing it, isn't it just that which gives a work of art its quality?

## BIBLICAL SUBJECTS

*To Theo, St. Rémy, November 1889 (614, pp. 228–229)*

If I continue, I certainly agree with you that it is perhaps better to attack things with simplicity than to seek after abstractions.

And I am not an admirer of Gauguin's "Christ in the Garden of Olives," for example, which he sent me a sketch of. And then as for Bernard's picture, he promises me a photograph of it. I don't know, but I fear that his biblical compositions will make me want something different. Lately I have seen the women picking and gathering the olives, but as I had no chance of getting a model, I have done nothing with it. However, now is not the moment to ask me to admire our friend Gauguin's composition, and our friend Bernard has probably never seen an olive tree. Now he is avoiding getting the least idea of the possible, or of the reality of things, and that is not the way to synthetize—no, I have never taken any stock in their biblical interpretations.

*To Theo, St. Rémy, n.d. [ca. November 1889] (615, p. 233)*

The thing is that this month I have been working in the olive groves, because their Christs in the Garden, with nothing really observed, have gotten on my nerves. Of course with me there is no question of doing anything from the Bible—and I have written to Bernard and Gauguin too that I considered that our duty is thinking, not dreaming, so that when looking at their work I was astonished at their letting themselves go like that. For Bernard has sent me photos of his canvases. The trouble with them is that they are a sort of dream or nightmare—that they are erudite enough—you can see that it is someone who is gone on the primitives—but frankly the English Pre-Raphaelites did it much better, and then again Puvis and Delacroix, much more healthily than the Pre-Raphaelites.

It is not that it leaves me cold, but it gives me a painful feeling of collapse instead of progress. Well, to shake that off, morning and evening these bright cold

days, but with a very fine, clear sun, I have been knocking about in the orchards, and the result is five size 30 canvases, which along with the three studies of olives that you have, at least constitute an attack on the problem. The olive is as variable as our willow or pollard willow in the North, you know the willows are very striking, in spite of their seeming monotonous, they are the trees characteristic of the country. Now the olive and the cypress have exactly the significance here as the willow has at home. What I have done is a rather hard and coarse reality beside their abstractions, but it will have a rustic quality, and will smell of the earth. I should so like to see Gauguin's and Bernard's studies from nature, the latter talks to me of portraits—which doubtless would please me better.

## PAINT YOUR GARDEN AS IT IS

*To Emile Bernard, St. Rémy, beginning of December 1889 (B21, pp. 522–525)*

As you know, once or twice, while Gauguin was in Arles, I gave myself free rein with abstractions, for instance in the "Woman Rocking," in the "Woman Reading a Novel," black in a yellow library; and at the time abstraction seemed to me a charming path. But it is enchanted ground, old man, and one soon finds oneself up against a stone wall.

I won't say that one might not venture on it after a virile lifetime of research, of a hand-to-hand struggle with nature, but I personally don't want to bother my head with such things. I have been slaving away on nature the whole year, hardly thinking of Impressionism or of this, that and the other. And yet, once again I let myself go reaching for stars that are too big—a new failure—and I have had enough of it.

So I am working at present among the olive trees, seeking after the various effects of a gray sky against a yellow soil, with a green-black note in the foliage; another time the soil and the foliage all of a violet hue against a yellow sky; then again a red-ocher soil and a pinkish green sky. Yes, certainly, this interests me far more than the above-mentioned abstractions.

If I have not written you for a long while, it is because, as I had to struggle against my illness, I hardly felt inclined to enter into discussions—and I found danger in these abstractions. If I work on very quietly, the beautiful subjects will come of their own accord; really, above all, the great thing is to gather new vigor in reality, without any preconceived plan or Parisian prejudice. . . .

I am telling you about these two canvases, especially about the first one, to remind you that one can try to give an impression of anguish without aiming straight at the historic Garden of Gethsemane; that it is not necessary to portray the characters of the Sermon on the Mount in order to produce a consoling and gentle motif.

Oh! undoubtedly it is wise and proper to be moved by the Bible, but modern reality has got such a hold on us that, even when we attempt to reconstruct

the ancient days in our thoughts abstractly, the minor events of our lives tear us away from our meditations, and our own adventures thrust us back into our personal sensations—joy, boredom, suffering, anger, or a smile. . . .

Sometimes by erring one finds the right road. Go make up for it by painting your garden just as it is, or whatever you like. In any case it is a good thing to seek for distinction, nobility in the figures; and studies represent a real effort, and consequently something quite different from a waste of time. Being able to divide a canvas into great planes which intermingle, to find lines, forms which make contrasts, that is technique, tricks if you like, cuisine, but it is a sign all the same that you are studying your handicraft more deeply, and that is a good thing.

However hateful painting may be, and however cumbersome in the times we are living in, if anyone who has chosen this handicraft pursues it zealously, he is a man of duty, sound and faithful. Society makes our existence wretchedly difficult at times, hence our impotence and the imperfection of our work. I believe that even Gauguin himself suffers greatly under it too, and cannot develop his powers, although it is in him to do it. I myself am suffering under an absolute lack of models. But on the other hand there are beautiful spots here. I have just done five size 30 canvases, olive trees. And the reason I am staying on here is that my health is improving a great deal. What I am doing is hard, dry, but that is because I am trying to gather new strength by doing some rough work, and I'm afraid abstractions would make me soft.

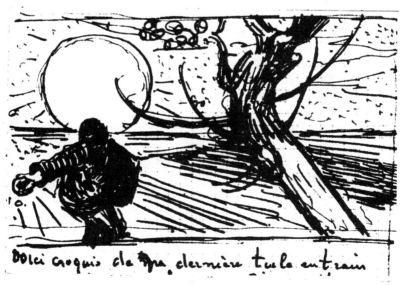

*Vincent van Gogh, sketch for The Sower in a letter to Theo, end of October 1888.*

45

## ON MONTICELLI, GAUGUIN

*To G.- Albert Aurier, Saint-Rémy, 12 February 1890 (626a, pp. 256–257)*

Many thanks for your article in the *Mercure de France*,[1] which greatly surprised me. I like it very much as a work of art in itself; in my opinion your words produce color; in short, I rediscover my canvases in your article, but better than they are, richer, more full of meaning. However, I feel uneasy in my mind when I reflect that what you say is due to others rather than to myself. For example, Monticelli[2] in particular. Saying as you do: "As far as I know, he is the only painter to perceive the chromatism of things with such intensity, with such a metallic, gem-like luster," be so kind as to go and see a certain bouquet by Monticelli at my brother's—a bouquet in white, forget-me-not blue and orange—then you will feel what I want to say. But the best, the most amazing Monticellis have long been in Scotland and England. In a museum in the North—the one in Lisle, I believe—there is said to be a very marvel, rich in another way and certainly no less French than Watteau's "Départ pour Cythère." At the moment Mr. Lauzet is engaged in reproducing some thirty works of Monticelli's.

Here you are; as far as I know, there is no colorist who is descended so straightly and directly from Delacroix, and yet I am of the opinion that Monticelli probably had Delacroix's color theories only at second hand; that is to say, that he got them more particularly from Diaz and Ziem. It seems to me that Monticelli's personal artistic temperament is exactly the same as that of the author of the *Decameron*—Boccaccio—a melancholic, somewhat resigned, unhappy man, who saw the wedding party of the world pass by, painting and analyzing the lovers of his time—he, the one who had been left out of things. Oh! he no more imitated Boccaccio than Henri Leys[3] imitated the primitives. You see, what I mean to say is that it seems there are things which have found their way to my name, which you could better say of Monticelli, to whom I owe so much. And further, I owe much to Paul Gauguin, with whom I worked in Arles for some months, and whom I already knew in Paris, for that matter.

Gauguin, that curious artist, that alien whose mien and the look in whose eyes vaguely remind one of Rembrandt's "Portrait of a Man" in the Galerie Lacaze—this friend of mine likes to make one feel that a good picture is equivalent to a good deed; not that he says so, but it is difficult to be on intimate terms with him without being aware of a certain moral responsibility. A few days before

---

[1] G.-Albert Aurier, "Les Isolés: Vincent van Gogh," *Mercure de France* I, 1 (January 1890), 24–29.

[2] Adolphe Monticelli (1824–1886) was a late Romantic painter of vaguely-defined park scenes. His rich color was inherited from Delacroix, but it was quite dark with glittering bright colors playing over the surface. His somewhat theatrical brushwork and thick impasto had also impressed Van Gogh.

[3] Henri Leys (1815–1869), Belgian academic history painter.

parting company, when my disease forced me to go into a lunatic asylum, I tried to paint "his empty seat." [4]

It is a study of his armchair of somber reddish-brown wood, the seat of greenish straw, and in the absent one's place a lighted torch and modern novels.

If an opportunity presents itself, be so kind as to have a look at this study, by way of a memento of him; it is done entirely in broken tones of green and red. Then you will perceive that your article would have been fairer, and consequently more powerful, I think, if, when discussing the question of the future of "tropical painting" and of colors, you had done justice to Gauguin and Monticelli before speaking of me. *For the part which is allotted to me, or will be allotted to me, will remain, I assure you, very secondary.*

[4] *Gauguin's Chair* (December 1888), Collection V. W. van Gogh, Laren, The Netherlands.

SYMBOLISM AND OTHER
SUBJECTIVIST TENDENCIES:
Form and the Evocation of Feeling

## INTRODUCTION

The artists participating in the subjectivist movements of about 1885–1900 may be grouped together only because they all rejected the realist conceptions of art that had prevailed for the preceding generation. It is on this basis only that they may be discussed together; stylistically, they varied widely. Following the lead of the advanced poets, they turned away from the exterior world and inward to their own feelings for their subject matter. Although they often employed traditional religious or literary subjects in their painting, they declared that its feeling qualities were derived more from colors and forms than from the subject chosen. The movement, therefore, was a result of new freedoms made possible by throwing off the obligation to "represent" the tangible world, and of new stimuli gained from an exploration of the subjective world. The new freedom and stimuli also allowed the range of ideas on what constituted proper subject matter for painting to be greatly expanded. They stimulated some of the more vigorous painters to create new formal characteristics, or even a new style, to convey better the more intangible qualities of the new subjectivist themes of painting.

The movement was first heralded for the poets in the Symbolist Manifesto (1886) by Jean Moréas (1856–1910). Moréas, rejecting the naturalism of Emile Zola and the writers of the previous generation, proclaimed that "opposed to 'teaching, declamation, false sensibility, objective description,' symbolic poetry seeks to clothe the Idea in a perceptible form . . . ." The Symbolist poets, grouped about Stéphane Mallarmé (1842–1898), developed theories of art which were to provide an ideological background for the thoughts of many of the artists. Their theories centered in a rejection of the world of the commonplace middle-class people meticulously described in Zola's "scientifically" probing novels.

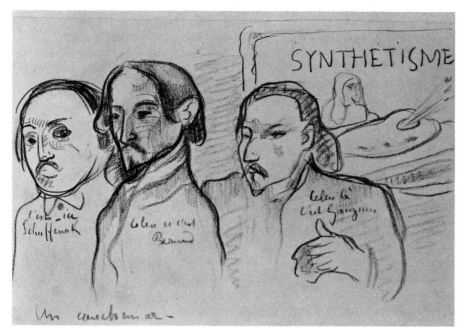

*Paul Gauguin or Emile Bernard, A Nightmare*
(*portraits of Emile Schuffenecker, Bernard and*
*Gauguin*), *ca. 1888, crayon.*

They believed that the greatest reality lay in the realm of the imagination
and fantasy. These attitudes of the new subjective movement had been
expressed a little earlier by Paul Verlaine (1844–1896) in his *Art poétique*
(1882) and by J.-K. Huysmans (1848–1907) in *A Rebours* (1884). Taking their
inspiration from Romanticism and in particular from the poet Charles
Baudelaire, these writers found life tolerable only in the cultivation of their
own feelings and sensations. Baudelaire's *Culte de moi* was revived; his
concern with individuality of expression was transformed into an obsessive
concern with the intimate, private world of the self that led to a rejection of
the exterior world. The poets took inspiration in this attitude from
Baudelaire's conviction that "the whole of the visible universe is only a
storehouse of images and signs to which the imagination assigns a place and
a relative value; it is a kind of nourishment that the imagination must digest
and transform." Baudelaire's theory of "correspondence," stated in the
poem "Correspondence" of 1857, was also deeply influential on the poets
and painters. It was, briefly, that a work of art was to be so expressive of
basic feelings and so evocative of ideas and emotion that it would rise to a

49

level on which all the arts were interrelated; sounds would suggest colors, colors sounds, and even ideas would be evoked by sounds or colors.

The Symbolist poet Gustave Kahn, in defining their aims, went further, reversing the conventional relation of artist and his subject. Rather than begin with the tangible world and then subjectivize it according to feeling, he took feeling or idea as the starting point of a work of art, which was then objectified in the actual form of the poem of the painting. He wrote in *L'Evénement*, 1886, that "the essential aim of our art is to objectify the subjective (the externalization of the Idea) instead of subjectifying the objective (nature seen through the eyes of a temperament). Thus we carry the analysis of the Self to the extreme, we let the multiplicity and intertwining of rhythm harmonize with the measure of the Idea . . . ."

By thus reversing the traditional order Kahn elevates the self to a level superior to that of nature, in the sense understood by the preceding generation. Whereas Baudelaire praised Delacroix because his colors and forms expressed so well the mood of the subject of his paintings, Kahn saw the subjective, expressive qualities of colors and forms as equivalent or even superior to the subject depicted. The fact that the poets praised the power of the colors and forms of a work of art, and that they expressed them in the terminology of vision, was naturally highly stimulating to the painters. This is but one stage short of the twentieth-century theory that the colors and forms of painting may convey the mood and the idea of a subject without ever actually representing or even suggesting that subject. But while the painters could conceive of the evocative powers of forms and colors existing independent of the subject, they were by no means prepared to carry out in their work the full implications of these theories. It was not until the second decade of the twentieth century, and by artists of quite different convictions, that the first truly abstract paintings could be realized.

The artists of this movement also wrote essays on their art, sometimes with great perception. Even more remarkable is that their theories were not just *a posteriori* contemplations on or explanations of what they had already done, as is frequently the case with artists' statements, but rather their writings often anticipated formal ideas which later appeared in their art. We can assume from this that the theories were probably first stated by the poets and were developed internally by the artists as they struggled with their own problems. The painters were, almost without exception, associated to varying degrees with the principal advanced poets of the time and some of them were also poets or even playwrights, critics, or essayists. Several of them were art critics. Most of them were prolific letter-writers, and they poured out their artistic struggles in the form of lengthy correspondence

with their friends. Seldom since that time and perhaps never before had painter and poet come so close together both in their personal associations and in their struggle with common artistic problems. This kind of association had already been advocated by Richard Wagner in his concept of the "total art," whereby the arts, chiefly music, poetry, and painting would be merged into a sacred union. Wagner, while in Paris, had been drawn into the circle of Mallarmé, where he was highly revered by the French poets. That artists such as Gauguin, Maurice Denis, and Odilon Redon were highly receptive to the literary ideas of the poets is proven by the presence of Symbolist concepts in their writings and also in their paintings. Some of these ideas, such as Synthetism, appeared in the writings of Gauguin before corresponding formal features appeared in his paintings.

Paul Gauguin (1848–1903) grew up in a family environment that was dominated by writers; his father was a journalist, and his maternal grandmother had been a feminist lecturer and writer. He carried on a regular correspondence with his friends, especially Van Gogh and Emile Bernard, that contains prolonged discussions of the major ideas and issues confronting both the poets and painters. Gauguin was convinced that what he was attempting in painting was unprecedented and that it, therefore, had to be worked out in ideas as well as in the work itself. The fact that he considered himself to be a "savage" beyond the taint of civilization did not inhibit such sophisticated theorizing, nor did it even restrain him from disputes with critics who had discussed his work. He also wrote, when he first became associated with the poet's group, articles of art criticism for Albert Aurier's *avant-garde* journal *Le Moderniste*, and in Oceania he wrote several long essays concerning his ideas on art and on social and religious problems. He had read the classic authors, and so it is not surprising that even when he "escaped" from European civilization and fled to Polynesia he received regularly and preserved until his death the leading literary journal, *Mercure de France*. And while ill and in a hospital in Tahiti, he read J. A. Moerenhout's extensive study of life and customs in the South Pacific, *Voyages aux iles du Grand Ocean* (1835), from which he took most of the native lore included in his *Noa-Noa* as tales told to him by Tehura. He even

51

edited and published in mimeographed form his own little newspaper of criticism and comment, chiefly on the local colonial administration.

Gauguin, then, could have been expected to be interested in and even involved in the vital new ideas of the poets. But writing often was difficult for him, and his conversation was so dominated by his own passionate egotism that he usually soon quarrelled with his companions. He found in Emile Bernard (1868–1941) and Paul Sérusier (1863–1927), both much younger than himself, a necessary intellectual stimulus. Both of them were of superior intellect and background. Bernard was especially important for Gauguin, as he had a remarkable talent for discovering, understanding, and transmitting new ideas. Furthermore, he knew and corresponded with many of the major artists, and wrote articles on them, including Van Gogh and Cézanne. He was a friend of Albert Aurier, brilliant Symbolist writer and art critic of about his own age, and Bernard encouraged the critic to write articles on Gauguin and the Symbolist movement. Aurier introduced Gauguin into Mallarmé's circle, where, called the "Symbolist painter," Gauguin often expounded his ideas with great force. Indeed, Gauguin was so well regarded that the poets tendered him a farewell banquet before his first departure for Tahiti in 1891. He had already included both the words "Symbolism" and "Synthetism" in portraits (one of them of Jean Moréas); he had used Symbolist inscriptions on his ceramic sculptures and in his woodcuts; and when in 1896–1897 he wrote the essay, "Diverses Choses," strongly influenced by Edgar Allan Poe, he gave it the Symbolist subtitle:

Notes éparses sans suit comme les Rêves
comme la vie tout faite de morceau.

Although he was later to deny any influence from the literary men, it is quite evident both in his writings and in the subject matter of some of his paintings, such as *Whence Do We Come?*, *What Are We?*, *Where Are We Going?* (1898), that he was deeply immersed in the body of Symbolist ideas which he shared with the poets.

G.-Albert Aurier (1865–1892) was the most knowledgeable and sympathetic of the Symbolist critics; he had studied painting and was a close friend of many of the artists, and he took up the cause of their art with zest. His youthful friendship with Bernard, which began when he was twenty-three, led him to follow Bernard's suggestions and write several highly perceptive articles on the young painters. Chief among these is the first article ever written on Van Gogh (1890), which appeared in the first issue of *Mercure de France*. He had already published articles by Bernard and Gauguin in his own critical review, *Le Moderniste* (1889), and he had pub-

licized as well as reviewed the Café Volpini exhibition of 1889, where Gauguin and his followers showed their work. In his comprehensive article on Gauguin (1891) he praised him as the leader of the Symbolist artists, a term which he preferred to Synthetism, and in a long article on Symbolism (1892) he defined the aesthetics of the movement, distinguishing between it and Synthetism. Since he considered the movement closely akin to Symbolism in literature, he founded an aesthetics of Symbolist art based on the theories already developed for the literary movement. His early death at the age of twenty-seven ended what surely would have been a highly influential career as an art critic, especially in the pages of the *Mercure de France*. The art section of this journal was taken over by Camille Mauclair, the arch-enemy of the Symbolists as well as of Cézanne, Lautrec, and other new artists, and thus much of the impetus created by Aurier was lost.

Gauguin's own ideas, expressed so forcefully but sometimes so awkwardly, were elaborated upon and given widespread dissemination by a group of young painters who revered him as their master. Soon the essential conditions of a "school" were provided: a powerful and colorful personality as the master, several intellectually alert and devoted disciples, an organized group to formulate the theory, and an art school where the ideas and the style were propagated in the instruction.

The chief disciples were Paul Sérusier and Maurice Denis (1870–1943). The first group was composed in 1888 of the students at the Académie Julian. Sérusier, the acknowledged leader of the Académie Julian group, had launched the movement when he had brought back from Pont-Aven in 1888 the revered pronouncement of Gauguin that had given the young students the key to the new art:

How do you see this tree?

Is it really green? Use green, then, the most beautiful green on your palette. And that shadow, rather blue? Don't be afraid to paint it as blue as possible.

Several of the artists organized in 1891 the group called the Nabis, which also included Paul Ranson, Edouard Vuillard, Pierre Bonnard and K.-X. Roussel. The school was the Académie Ranson, founded in 1908, where most of them taught.

It was only many years later that Sérusier developed his own theory, but Maurice Denis, beginning at the age of nineteen with his important essay, "Définition du Néo-traditionisme" (1890), was active in elaborating upon the ideas of Gauguin as transmitted to him by Sérusier. For a few years, until he turned ultraconservative like others of the Nabis and began to apply doctrinaire religious interpretations to the idealist principles of

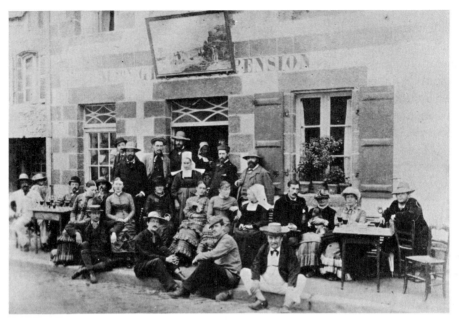

*Residents of the Pension Gloanec, Pont-Aven Brittany, ca. 1888, including Gauguin, Emile
Bernard, Charles Laval, Meyer de Haan and Charles Filiger. The man wearing a cap and
seated on the curbstone may be Gauguin.*

Symbolism, he wrote some of the most perceptive articles on the ideology,
history, and formal characteristics of the subjectivist movement. Denis's
eminence during his long life as the most influential mural painter since
Puvis de Chavannes, and his activity with artists' organizations including his
own Studio of Sacred Art, gave him an authority that tended further to
propagate among another generation the ideas and theories derived from
Gauguin and the poets.

Some of the other painters drew their ideas and imagery directly
from the writings of the poets and novelists. Such men as Gustave Moreau
and Rodolphe Bresdin in one generation, and Edvard Munch and Odilon
Redon in another, painted highly imaginative and unreal scenes which
were frequently drawn from literary sources. According to the views of
H. R. Rookmaaker, they are the counterpart in the plastic realm of the
Symbolist poets in the literary, hence they may be called Symbolist painters.

Even though Redon (1840–1916), in particular, greatly enriched his
art far beyond the basic necessity of representing the subject, both he and the
other artists of his generation employed formal means that were for the most
part conventional. Redon was inclined toward fantastic literature, having

studied especially Baudelaire and Poe, and he had studied botany, all of which became important for his work. He once remarked that he admired human beauty "with the prestige of thought." He had been for a time an art critic in Bordeaux, and soon became a member of the Symbolist poet's group in Paris, where he became friends with Mallarmé, Gide, and Valéry. His many letters and his journal are substantial literary documents, well written, and rich in ideas and imagery.

Although James Ensor, Edvard Munch, and Ferdinand Hodler developed in environments quite different from that of Paris of the *fin-de-siècle*, they were also closely associated with literary men, and each of them had at one time entered into the milieu of French Symbolism in Paris. Ensor (1860–1949) also had studied the writers of fantasy, and was himself a prolific writer of letters, essays, art criticism, and speeches, many of which appeared in the leading *avant-garde* literary magazines. Later critics have praised his colorful and extremely expressive prose, which has the deformation and antisyntactical characteristics of Expressionist writing. Ensor provided himself with material for his often caustic essays by engaging in the bitter artistic battles between the factions of progress and conservatism in Belgium, battles that were kept raging by new statements emanating from the advanced artistic movements of Paris. His articles appeared in the Symbolist journal, *La Plume*, which in 1899 had arranged for his first exhibition in Paris and had at the same time published a special number of the magazine devoted to his painting. Like his painting, Ensor's writing is strongly flavored by his personal situation and tastes: he was a somewhat misanthropic bachelor living with his mother above their curio shop in the small Flemish resort city of Ostende, and he was much interested in peasant folklore, especially as seen in the regional carnivals.

Munch (1863–1944) was obsessed with subjects of emotional crises in his paintings; this was in part the result of childhood tragedies in Norway. He witnessed very early the death of his mother and his sister from tuberculosis and the anxiety and severe nervous attacks suffered by his father. In 1886 at the age of twenty-three he was, along with the novelist Hans Jaeger, one of the literary and artistic bohemians who attacked the conservative and rigid social habits of his countrymen. Shortly thereafter he went to Paris to study, but although he saw the most advanced painting of the time, little influence of it can be seen in his work. He found Berlin to be more congenial; the intellectual climate was more psychologically oriented, and there were more artists and poets from Central Europe and Scandinavia, chiefly Stanislas Przybyszewsky and August Strindberg. Munch's first Berlin exhibition in 1892 was forcibly closed by the authorities; as a result of

this he achieved a sudden fame and was asked to send a traveling exhibition throughout the country. A later stay in Paris, when Munch came into contact with the Symbolist poets, resulted in 1896 in his designing the sets for Ibsen's *Peer Gynt* at the *Théâtre de l'Oeuvre*, where other painters and playwrights had often collaborated. The remainder of Munch's life after this time was spent in Northern Europe, partly in Germany, but mostly on the lonely coast of Norway. Significantly, his letters and writings have to do chiefly with his personal life and not with art theory, except for a few brief aphorisms.

Hodler (1853–1918) was by nature inclined toward art theory. He had made a deep study of the writings of Dürer and Leonardo during his youth in Switzerland. He was also a student of religion and of natural science, and later gave lectures of a somewhat mystical and idealistic tone on the subject of "The Mission of the Artist." His theory of parallelism shows the influence of these earlier interests tinged with an individual symbolism based on a metaphysical view of the unity of nature. When Hodler exhibited in Paris in 1892, he was sponsored by the Rose Croix, an artistic group even more idealist and anti-nature in its beliefs than the Symbolists.

Henry van de Velde (1863–1957) was the most influential mind in the formulation of the ideology of *Art Nouveau*, the counterpart in the applied arts of Symbolism in painting. Basing his thought on the idealism of William Morris, he nevertheless, in contrast to Morris, completely accepted the fact of industrialism and machine production and their aesthetic implications. He saw the new movement (although avoiding the term *Art Nouveau*) as a necessary revolution against traditional concepts, and he saw the foundation of the future in its desire totally to design a harmonious environment that would in turn render life also more harmonious. He had been associated with the French Symbolist poets while a student in Paris; he had studied Morris's theories; and he had been a member of *Les XX*, the *avant-garde* artist's group in Brussels.

His activities embraced every avenue for the dissemination of ideas; he was a prolific author and a persuasive lecturer, and in 1901 he formulated a curriculum and a method of teaching at the Dessau Kunstgewerbeschule that became the foundation for the Bauhaus after van de Velde was forced to leave Germany during World War I. The range of his activities as a designer was equally wide: in 1895 he designed his own home in every detail, including the dresses worn by his wife; he designed museums, houses, interiors, furniture, posters, embroidery, decorative drawings, as well as continuing to produce drawings and lithographs.

*Paul Gauguin, cover design of Cahier pour Aline, Tahiti, 1893.*

*Paul Gauguin, Self-Portrait 1891–
1892 drawing.*

# PAUL GAUGUIN:
## Synthetist Theories

### FEELING AND THOUGHT

*From a letter to Emile Schuffenecker, Copenhagen, 14 January 1885\**

As for me, it seems to me at times that I'm mad, and yet the more I reflect at night in my bed, the more I think I'm right. For a long time the philosophers have considered the phenomena which seem to us supernatural and yet of which we have the *sensation*. Everything is in.that word. Raphael and the others were men in

---

\* From *Lettres de Gauguin à sa femme et à ses amis*, ed. Maurice Malingue (Paris: Grasset, 1949), #11, pp. 44–47.

Schuffenecker (1851–1934) was Gauguin's closest friend and at this time the only person who discussed art with him. He had worked at the same bank until first he and then Gauguin resigned in order to devote themselves to painting, after which time he often assisted Gauguin by offering him lodging or money.

The winter of 1884–1885 was an extremely difficult time for Gauguin. His wife's relatives, with whom he was living, exerted constant pressure on him to abandon his career as an artist and return to business, and he had failed in his several attempts to serve as a representative for Paris business firms. This letter is one of his few contacts with his friends in Paris and with the world of art.

The ideas expressed are in accord with the most advanced ideas of the times. The valuation of the mind as well as of the senses, and the admiration for the ordering effect of science and mathematics had been stated by David Sutter in his essays "Phenomena of Vision" in 1880, although they had been known to earlier painters and to academic theoreticians. Seurat was also in the process of formulating his theories, which were to be developed further three years later on the basis of the scientific aesthetics of Charles Henry, Ogdon N. Rood, and Michel E. Chevreul.

whom the sensation was formulated before thought, which allowed them, when studying, never to destroy the sensation and to remain artists. For me, the great artist is the formulary of the greatest intelligence; he receives the most delicate perceptions, and thus the most invisible translations of the brain.

Look at the immense creation of nature and see whether there are not laws to create, with very different aspects which are yet similar in their effect, all the human sentiments. See a huge spider, a tree trunk in a forest; both unaccountably give you a sensation of terror. Why does it disgust you to touch a rat and many other such things: it is not reason behind these feelings. All our five senses arrive *directly at the brain*, conditioned by an infinity of things which no education can destroy. I conclude that there are lines which are noble, false, etc. The straight line indicates the infinite, the curve limits creation, without taking into account the fatality of numbers. Have the numbers 3 and 7 been sufficiently studied? Colors are still more explicative, though less varied, than lines because of their power over the eye. There are noble tones, ordinary ones, tranquil harmonies, consoling ones, others which excite by their vigor. In short, you see in graphology the features of honest men and of liars; why is it that the lines and colors of the amateur also do not give us more or less the grandiose character of the artist. . . .

The further I go the more I am overwhelmed by this sense that the translations of thought are something completely different from literature; we will see who is right. If I am wrong why is it that all your Academy, who know the means employed by the old masters, cannot produce the pictures of a master? Because they don't create one nature, one intelligence, and one heart; because the youthful Raphael had intuition, and in his pictures there are relations of lines which can't be accounted for, since it's the most intimate part of a man that finds itself again completely hidden. Look even in the accessories and in the landscape of a Raphael, you will find the same feeling as in a head. It is pure everywhere. A landscape of Carolus Durand is as vulgar as a portrait. (I can't explain it but I have this feeling.)

Work *freely and passionately*, you will make progress and sooner or later if you have any worth they will recognize it. Above all don't sweat over a canvas; a great emotion can be translated instantly, dream about it and seek for it the simplest form.

The equilateral triangle is the most solid and perfect form of a triangle. An elongated triangle is more elegant. In pure truth, sides don't exist; according to our feelings, lines to the right advance and those to the left recede. The right hand strikes, the left is in defense. A long neck is graceful but heads sunk on the shoulders are more pensive. A duck with its eye turned upward listens; I know, I tell you a bunch of idiotic things; your friend Courtois is more sensible but his painting is so stupid. Why are the willows with hanging branches called "weeping"? Is it because descending lines are sad? Is the sycamore sad because it is put in cemeteries; no, it is the color that is sad.

59

## ABSTRACTION

*From a letter to Emile Schuffenecker, Pont Aven, 14 August 1888**

Some advice: do not paint too much after nature. Art is an abstraction; derive this abstraction from nature while dreaming before it, and think more of the creation which will result than of nature. Creating like our Divine Master is the only way of rising toward God.

## SHADOWS

*From a letter to Emile Bernard, Arles, November 1888†*

You discuss shadows with Laval and ask me if I care about them. . . . In so far as an explanation of light, yes! Look at the Japanese, who certainly draw admirably, and you will see life in the outdoors and sunlight without shadows, using color only as a combination of tones . . . giving the impression of warmth, etc. Besides I consider Impressionism as a completely new quest which must necessarily separate itself from everything mechanical like photography, etc. That is why I will get as far away as possible from that which gives the illusion of a thing, and since shadows are the *trompe l'œil* of the sun, I am inclined to do away with them.

If in your composition, shadow enters as a necessary form, it's a completely different thing. Thus if instead of a figure you put the shadow only of a person, you have found an original starting point, the strangeness of which you have calculated. Such is the raven on the head of Pallas, who is there rather than a parrot through the choice of the artist, a calculated choice. And so, therefore, my dear Bernard, put in shadows if you consider them useful, or don't put them in. It's all the same thing, if you consider yourself not a slave to shadow; it is, as it were, the shadow which is at your service. I am expressing my thought to you very *grosso modo*, it is up to you to read between the lines.

## "NOTES SYNTHETIQUES"

*From the manuscript, ca. 1888‡*

* Malingue, *Lettres de Gauguin,* #67, p. 134.
† Malingue, *Lettres de Gauguin,* #75, pp. 149–150.
  Gauguin had met Bernard in Pont-Aven in 1886. Although Bernard was only eighteen years of age at the time and twenty years younger than Gauguin, a lively exchange of ideas soon developed. The two had been together during the summer of 1888, preceding Gauguin's visit to Van Gogh in Arles, and this letter represents Gauguin's need for the rational intellectual discussion that was becoming increasingly difficult between himself and Van Gogh. The subject of the letter—avoidance of shadows—is one in which both Gauguin and Bernard shared a deep interest, as it was becoming the basis of their "cloisonnist" styles, and later was to be one of the points on which they quarrelled.
  ‡ Originally published in *Vers et Prose* (Paris), XXII (July–August–September, 1910) 51–55. This English translation from *Paul Gauguin, A Sketchbook,* text by Raymond Cogniat

*Paul Gauguin, 1888.*

Painting is the most beautiful of all arts. In it, all sensations are condensed; contemplating it, everyone can create a story at the will of his imagination and—with a single glance—have his soul invaded by the most profound recollections; no effort of memory, everything is summed up in one instant. —A complete art which sums up all the others and completes them. —Like music, it acts on the soul through the intermediary of the senses: harmonious colors correspond to the harmonies of sounds. But in painting a unity is obtained which is not possible in music, where the accords follow one another, so that the judgment experiences a continuous fatigue if it wants to reunite the end with the beginning. The ear is actually a sense inferior to the eye. The hearing can only grasp a single sound at a time, whereas the sight takes in everything and simultaneously simplifies it at will.

foreword by John Rewald, 3 vols. (New York: Hammer Galleries, 1962), I, 57–64. Rewald dates this manuscript at about 1888, in which case it most probably was written in Pont-Aven. It reflects Symbolist ideas, such as the relations between painting, music, and literature, although Gauguin seems especially hostile toward the literary art critic.

Like literature, the art of painting tells whatever it wishes, with the advantage that the reader immediately knows the prelude, the setting, and the ending. Literature and music require an effort of memory for the appreciation of the whole; the last named is the most incomplete and the least powerful of arts.

You can dream freely when you listen to music as well as when looking at a painting. When you read a book, you are a slave of the author's thought. The author is obliged to address himself to the mind before he can impress the heart, and God knows how little power a reasoned sensation has. Sight alone produced an instantaneous impulse. But then, the men of letters alone are art-critics; they alone defend themselves before the public. Their introductions are always a justification of their work, as if really good work does not defend itself on its own.

These gentlemen flutter about the world like bats which flap their wings in the twilight and whose dark mass appears to you in every direction; animals disquieted by their fate, their too heavy bodies preventing them from rising. Throw them a handkerchief full of sand and they will stupidly make a rush at it.

One must listen to them judging all human works. God has created man after his own image which, obviously, is flattering for man. "This work pleases me and is done exactly the way I should have conceived it." All art criticism is like that: to agree with the public, to seek a work after one's own image. Yes, gentlemen of letters, you are incapable of criticizing a work of art, be it even a book. Because you are already corrupt judges; you have beforehand a ready-made idea— that of the man of letters—and have too high an opinion of your own thoughts to examine those of others. You do not like blue, therefore you condemn all blue paintings. If you are a sensitive and melancholy poet, you want all compositions to be in a minor key. —Such a one likes graciousness and must have everything that way. Another one likes gaiety and does not understand a sonata.

It takes intelligence and knowledge in order to judge a book. To judge painting and music requires special sensations of nature besides intelligence and artistic science; in a word, one has to be a born artist, and few are chosen among all those who are called. Any idea can be formulated, but not so the sensation of the heart. What efforts are not needed to master fear or a moment of enthusiasm! Is not love often instantaneous and nearly always blind? And to say that thought is called spirit, whereas the instincts, the nerves, and the heart are part of matter. What irony!

The vaguest, the most undefinable, the most varied is precisely matter. Thought is a slave of sensations. I have always wondered why one speaks of "noble instincts." . . .

Above man is nature.

Literature is human thought described by words.

Whatever talent you may have in telling me how Othello appears, his heart devoured by jealousy, to kill Desdemona, my soul will never be as much

impressed as when I have seen Othello with my own eyes entering the room, his forehead presaging the storm. That is why you need the stage to complement your work.

You may describe a tempest with talent—you will never succeed in conveying to me the sensation of it.

Instrumental music as well as numbers are based on a unit. The entire musical system derives from this principle, and the ear has become used to all these divisions. The unit is established through the means of an instrument, yet you may choose some other basis and the tones, half-tones, and quarter-tones will follow each other. Outside of these you will have dissonance. The eye is used less than the ear to perceive these dissonances, but then divisions [of color] are more numerous, and for further complication there are several units.

On an instrument, you start from one tone. In painting you start from several. Thus, you begin with black and divide up to white—the first unit, the easiest and the most frequently used one, hence the best understood. But take as many units as there are colors in the rainbow, add those made up by composite colors, and you will reach a rather respectable number of units. What an accumulation of numbers, truly a Chinese puzzle! No wonder then that the colorist's science has been so little investigated by the painters and is so little understood by the public. Yet what richness of means to attain an intimate relationship with nature!

They reprove our colors which we put [unmixed] side by side. In this domain we are perforce victorious, since we are powerfully helped by nature which does not proceed otherwise. A green next to a red does not produce a reddish brown, like the mixture [of pigments], but two vibrating tones. If you put chrome yellow next to this red, you have three tones complementing each other and augmenting the intensity of the first tone: the green. Replace the yellow by a blue, you will find three different tones, though still vibrating through one another. If instead of the blue you apply a violet, the result will be a single tone, but a composite one, belonging to the reds.

The combinations are unlimited. The mixture of colors produces a dirty tone. Any color alone is a crudity and does not exist in nature. Colors exist only in an apparent rainbow, but how well rich nature took care to show them to you side by side in an established and unalterable order, as if each color was born out of another!

Yet you have fewer means than nature, and you condemn yourself to renounce all those which it puts at your disposal. Will you ever have as much light as nature, as much heat as the sun? And you speak of exaggeration—but how can you exaggerate since you remain below nature?

Ah! If you mean by exaggerated any badly balanced work, then you are right in that respect. But I must draw your attention to the fact that, although your work may be timid and pale, it will be considered exaggerated if there is a mistake of harmony in it. Is there then a science of harmony? Yes.

63

In that respect the feeling of the colorist is exactly the natural harmony. Like singers, painters sometimes are out of tune, their eye has no harmony. Later there will be, through study, an entire method of harmony, unless people neglect it, as is done in the academies and most of the time also in studios. Indeed, the study of painting has been divided into two categories. One learns to draw first and then to paint, which means that one applies color within a pre-established contour, not unlike a statue that is painted after it is finished. I must admit that until now I have understood only one thing about this practice, namely that color is nothing but an accessory. "Sir, you must draw properly before painting"—this is said in a pedantic manner; but then, all great stupidities are said that way.

Does one wear shoes instead of gloves? Can you really make me believe that drawing does not derive from color, and vice-versa? To prove this, I commit myself to reduce or enlarge one and the same drawing, according to the color with which I fill it up. Try to draw a head by Rembrandt in his exact proportions and then put on the colors of Rubens—you will see what misshapen product you derive, while at the same time the colors will have become unharmonious.

During the last hundred years large amounts have been spent for the propagation of drawing and the number of painters is increasing, yet no real progress has been made. Who are the painters we admire at the present? All those who reproved the schools, all those who drew their science from the personal observation of nature. Not one . . . [manuscript not completed].

## DECORATION

*From a letter to Daniel de Monfried, Tahiti, August 1892*★

It can only do you good to be forced to decorate. But beware of *modeling*. The simple stained-glass window, attracting the eye by its divisions of colors and forms, that is still the best. A kind of music. To think that I was born to do decorative art and that I have not been able to achieve it. Neither windows, nor furniture, nor ceramics, nor whatever. . . . There lie my real aptitudes much more than in painting strictly speaking.[1]

★ Malingue, *Lettres de Gauguin*, #132, p. 232.

De Monfried (1856–1929) was the closest friend and best correspondent of Gauguin during the last twelve years of his life in Tahiti and the Marquesas. He was a painter of modest talents who was constant in his admiration for Gauguin. He was in comfortable financial circumstances, and so was able to lend Gauguin his studio in Paris and to buy several of his paintings at the auction that was to make possible the first trip to Tahiti. He also looked after Gauguin's affairs, both business and personal, during his long absence. Thus, many of the letters to De Monfried are concerned with both theoretical and personal problems.

[1] Only a few months earlier Albert Aurier had called Gauguin the only great decorator of the century, adding the name of Puvis de Chavannes as a possible second (*Révue Encyclopédique*, April 1892. See the quotation in Maurice Denis' essay of 1903 in hommage to Gauguin, "The Influence of Paul Gauguin" reprinted below). Since Gauguin had worked

## THE IMPRESSIONISTS

*Three selections from the manuscript "Diverses Choses, 1896–1897," Tahiti★*

The Impressionists study color exclusively insofar as the decorative effect, but without freedom, retaining the shackles of verisimilitude. For them the dream landscape, created from many different entities, does not exist. They look and perceive harmoniously, but without any aim. Their edifice rests upon no solid base which is founded upon the nature of the sensation perceived by means of color.

They heed only the eye and neglect the mysterious centers of thought, so falling into merely scientific reasoning. . . . They are the officials of tomorrow, as bad as the officials of yesterday. . . . The art of yesterday has plumbed the depths, it has produced masterpieces and will continue to do so. Meanwhile, the officials of today are aboard a boat that is vacillating, badly constructed and incomplete. . . . When they speak of their art, what is it? A purely superficial art, full of affectations and purely material. There is no thought there.

. . . "But you have a technique?" they will demand.

No, I have not. Or rather I do have one, but it is very fugitive, very flexible, according to my disposition when I arise in the morning; a technique which I apply in my own manner to express my own thought without any concern for the truth of the common, exterior aspects of Nature.

## MEMORY

*From "Diverses Choses"*

The task of whoever paints is not at all like that of a mason's who, compass in hand, builds a house after a plan furnished by an architect. It is well for young people to have a model so long as they draw a curtain over it while they paint.

It is better to paint from memory. Thus your work will be your own; your sensation, your intelligence and your soul will then survive the scrutiny of the amateur. He goes to his stable if he wishes to count the hairs of his donkey and to determine the place of each of them.

---

extensively in ceramics before leaving for Tahiti and had already realized a "decorative" style in such paintings as *The Vision After the Sermon* (1888), the despair expressed in his letter probably is the result of poverty. He complains to De Montfried that not only have his paintings not found buyers in Paris, but friends and dealers who owe him money have not paid him. Finally, his hope that he would receive commissions to paint the portraits of officials in Tahiti had not been realized, and not being able to purchase canvas, he had turned to wood sculpture.

★ From "Diverses Choses, 1896–1897," an unpublished manuscript, part of which appears in Jean de Rotonchamp, *Paul Gauguin, 1848–1903* (Paris: Crès, 1925); these selections from pp. 210, 216, 211.

## COLOR

*From "Diverses Choses"*

Color, being itself enigmatic in the sensations which it gives us, can logically be employed only enigmatically. One does not use color to draw but always to give the musical sensations which flow from itself, from its own nature, from its mysterious and enigmatic interior force.

## PUVIS DE CHAVANNES

*From a letter to Charles Morice, Tahiti, July 1901*★

Puvis explains his idea, yes, but he does not paint it. He is a Greek while I am a savage, a wolf in the woods without a collar. Puvis would call a painting "Purity," and to explain it he would paint a young virgin holding a lily in her hand—a familiar symbol; consequently one understands it. Gauguin, for the title "Purity," would paint a landscape with limpid waters; no stain of the civilized human being, perhaps a figure.

Without entering into details there is a wide world between Puvis and myself. As a painter Puvis is a lettered man but he is not a man of letters, while I am not a lettered man but perhaps a man of letters.

Why is it that before a work the critic wants to make points of comparison with former ideas and with other authors. And not finding what he believes should be there, he comprehends no more and he is not moved. Emotion first! understanding later.

★ Malingue, *Lettres de Gauguin*, #174, pp. 300–301.
Charles Morice was an important Symbolist poet, critic, and editor of literary journals who had become a friend of Gauguin's during the time that the painter frequented the meetings of the poets and writers. He wrote several sympathetic articles on Gauguin, beginning about the time of his departure for Tahiti in 1891, and later he wrote articles for *Mercure de France* and an important biography. Gauguin's remarks in this letter seem to be a reply to Morice's statement in his first article on Gauguin in 1891 that "Puvis de Chavannes, Carrière, Renoir, Redon, Degas, Gustave Moreau, and Gauguin are, in painting, guiding the young artists."

# GAUGUIN:  On His Paintings

## SELF-PORTRAIT, LES MISERABLES, 1888[1]
*From a letter to Emile Schuffenecker, Quimperlé, 8 October 1888*[*]

I have this year sacrificed everything—execution, color—for style, wishing to impose upon myself nothing except what I can do. It is, I think, a transformation which has not yet borne fruit but which will. I have done the self-portrait which Vincent asked for. I believe it is one of my best things: absolutely incomprehensible (for example) it is so abstract. Head of a bandit in the foreground, a Jean Valjean (*Les Misérables*) personifying also a disreputable Impressionist painter, shackled always to this world. The design is absolutely special, a complete abstraction. The eyes, mouth, and nose are like the flowers of a Persian carpet, thus personifying the symbolic aspect. The color is far from nature; imagine a vague suggestion of pottery contorted by a great fire! All the reds, violets, striped by flashes of fire like a furnace radiating from the eyes, seat of the struggles of the painter's thought. The whole on a chrome background strewn with childish bouquets. Chamber of a pure young girl. The Impressionist is pure, still unsullied by the putrid kiss of the Ecole des Beaux Arts.

## MANAO TUPAPAU (THE SPIRIT OF THE DEAD WATCHING) 1892[2]
*From the manuscript "Cahier pour Aline," Tahiti, 1893*[†]

A young Tahitian girl is lying on her stomach, showing part of her frightened face. She rests on a bed covered by a blue *pareu* and a light chrome yellow sheet. A violet purple background, sown with flowers glowing like electric sparks; a strange figure sits beside the bed.

Captured by a form, a movement, I paint them with no other preoccupation than to execute a nude figure. As it is, it is a slightly indecent study of a

---

[1] Collection V. W. van Gogh, Laren, The Netherlands.

[*] Malingue, *Lettres de Gauguin*, #71, pp. 140–141.

This painting was the result of a request from Van Gogh that both Gauguin and Bernard, who were at Pont-Aven, should paint the other's portrait and send both portraits to Arles. Neither painter being able, for different reasons, to paint the other's face, they resolved to make self-portraits which would include a sketch of the other in the background. Gauguin made an additional observation in a letter to Van Gogh that "by painting him [Jean Valjean] in my own likeness, you have an image of myself as well as a portrait of all of us, poor victims of society, who retaliate only by doing good." (From an unpublished letter in the possession of Ir. V. W. van Gogh.)

[2] Collection A. Conger Goodyear, New York.

[†] From Gauguin's manuscript, "Cahier pour Aline" (his daughter), Tahiti, 1893. This selection appears in De Rotonchamp, *Paul Gauguin*, pp. 218–220. Excerpts of it appear in

*Paul Gauguin, page from Cahier pour Aline, Tahiti, 1893, with a sketch of The Spirit of the Dead Watching (Manao Tupapau).*

nude, and yet I wish to make of it a chaste picture and imbue it with the spirit of the native, its character and tradition.

The *pareu* being intimately connected with the life of a Tahitian, I use it as a bedspread. The bark cloth sheet must be yellow, because in this color it arouses something unexpected for the spectator, and because it suggests lamplight. This, however, prevents me from making an actual effect of a lamp. I need a background of terror; purple is clearly indicated. And now the musical part of the picture is laid out.

What can a young native girl be doing completely nude on a bed, and in this somewhat difficult position? Preparing herself for making love? That is

English translation in Robert J. Goldwater, *Paul Gauguin* (New York: Abrams, 1957), p. 140. Malingue, *Lettres de Gauguin*, includes the letter to his wife of 8 December 1892 (#134, pp. 235–238), in which the explanation in slightly different language first appeared. It was written frankly with the hope of stimulating interest and sales in his work—for instance, he priced *Manao Tupapau* at 1500 francs, or double the price of any of his other paintings, and he told his wife that he wanted the price of these paintings to be much higher than those he had made in France. He prefaces the explanation with: "So that you can understand [the meaning of the paintings] and can as they say be malicious, I will give you the strictest explanation and, besides, there is one that I hope to keep or else to sell high. The *Manao pupapau* [sic]." This comment follows the explanation: "This is a little text that will prepare you for the critics when they bombard you with their malicious questions. . . . What I have just written is very boring, but I think it is necessary for back there."

certainly in character, but it is indecent, and I do not wish it to be so. Sleeping? The amorous activity would then be over, and that is still indecent. I see here only fear. What kind of fear? Certainly not the fear of Susanna surprised by the elders. That kind of fear does not exist in Oceania.

The *tupapau* (Spirit of the Dead) is clearly indicated. For the natives it is a constant dread. A lamp is always lighted at night. No one ever goes out on the paths on a moonless night without a lantern, and even then they travel in groups.

Once I have found my *tupapau* I devote my attention completely to it and make it the motif of my picture. The nude sinks to a secondary level.

What can a spirit mean to a Tahitian? She knows neither the theatre nor the reading of novels, and when she thinks of a dead person she thinks necessarily of someone she has already seen. My spirit can only be an ordinary little woman. Her hand is outstretched as if to seize a prey.

My decorative sense leads me to strew the background with flowers. These flowers are the phosphorescent flowers of the *tupapau*; they are the sign that the spirit nears you. Tahitian beliefs.

The title *Manao tupapau* has two meanings, either the girl thinks of the spirit, or the spirit thinks of her.

To sum up: The musical part: undulating horizontal lines; harmonies of orange and blue, united by the yellows and purples (their derivatives) lit by greenish sparks. The literary part: the spirit of a living person linked to the spirit of the dead. Night and Day.

This genesis is written for those who must always know the *why* and the *wherefore*.

Otherwise it is simply a study of an Oceanian nude.

## WHENCE DO WE COME? WHAT ARE WE? WHERE ARE WE GOING? 1898[1]

*From a letter to Daniel de Monfried, Tahiti, February 1898*[*]

I did not write to you last month; I had nothing more to say to you except to repeat that I no longer had any courage. Having received nothing from Chaudet by the last post, and suddenly almost recovering my health, so that there was no longer any chance of dying naturally, I wanted to kill myself. I left to conceal myself in the mountains where my dead body would have been devoured by the ants. I did not have a revolver, but I had some arsenic which I had saved during my eczema.

[1] Museum of Fine Arts, Boston.

[*] The letter is included in *Lettres de Gauguin à Daniel de Monfried*, ed. Mme. Annie Joly-Ségalen (Paris: Falaize, 1950), #40, pp. 118–119. Courtesy of Editions Georges Fall, 15 rue de Montsouris, Paris. The English translation of the first part is from John Rewald, *Gauguin* (London, Paris, New York: Heinemann, with Hyperion, 1949), p. 29.
The meaning of this, the major Symbolist painting by Gauguin, has been the subject of considerable speculation. His attempt at suicide following its completion suggests that it was meant as a kind of last testament for himself as well as a summarization of his ideas. H. R.

Paul Gauguin, letter to Daniel de Monfried describing *Whence Do We Come? What Are We? Where Are We Going?*, February 1898.

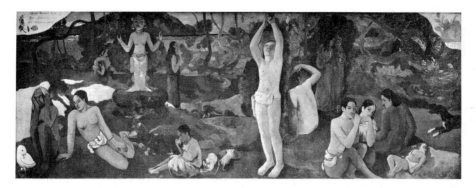

*Paul Gauguin, Whence Do We Come? What Are We? Where Are We Going? 1898, oil on canvas.*

I do not know whether the dose was too strong or whether the vomitings nullified the action of the poison by rejecting it. Finally, after a night of terrible suffering, I went back home. During this whole month, I have been afflicted with pressures at the temples and spells of dizziness and nausea when I was having my meager meals. This month I receive 700 francs from Chaudet and 150 francs from Maufra: with that I pay the most furious creditors. Then I begin again to live as before, in misery and shame. In May the bank will seize and sell at a miserable price all I possess; among other things my paintings. Then we shall see how to start again in another way. I must tell you that in December my mind was indeed made up. So, before dying, I wanted to paint a big canvas which I had in mind, and during that whole month I worked day and night in an incredible fever. By God, it is not made like a Puvis de Chavannes, studies from nature, preparatory cartoon, etc. It is all done in a bold style, directly with the brush, on sackcloth full of knots and wrinkles, so it looks terribly rough.

They will say that it is careless . . . not finished. It is true that one is not a good judge of one's own work; however, I believe that this canvas not only surpasses all the preceding ones, but also that I will never do anything better or even similar to it. Before dying I put into it all my energy, such a painful passion under terrible circumstances, and a vision so clear without corrections, that the haste

---

Rookmaaker, *Synthetist Art Theories*, (Amsterdam: Svets and Zeitlinger, 1959), pp. 230–237, thinks that the concept was derived from Balzac's *Séraphita*, who speculates on the destiny of humanity: "Whence does it come, where is it going?" He cites also Carlyle's *Sartor Resartus*, a copy of which was included by Gauguin in his portrait of Meyer de Haan of 1889. In writing of himself Carlyle asks the question "Whence? How? Whereto?" Rookmaaker cites also a similar question which Hippolyte Taine asked in a study of Carlyle: "Mais d'où venons-nous? O Dieu, où allons-nous?"

See the excellent interpretation of the meaning of the painting by Robert T. Goldwater, "The Genesis of a Picture: Theme and Form in Modern Painting," *Critique* (New York), October 1946. Also Georges Wildenstein, "L'idéologie et l'esthétique dans deux tableaux-clés de Gauguin," *Gazette des Beaux-Arts* (Paris) 6th Period, XLVII (January–April, 1956), 127–159.

disappears and the life surges up. It does not smell of the model, of professional techniques and of so-called rules—from all of which I always did free myself, although sometimes with trepidation.

It is a canvas about five feet [high] by twelve [wide].* The two upper corners are chrome yellow, with an inscription on the left, and my name on the right, like a fresco on a golden wall with its corners damaged.

To the right, below, a sleeping baby and three seated women. Two figures dressed in purple confide their thoughts to each other. An enormous crouching figure which intentionally violates the perspective, raises its arm in the air and looks in astonishment at these two people who dare to think of their destiny. A figure in the center is picking fruit. Two cats near a child. A white goat. An idol, both arms mysteriously and rhythmically raised, seems to indicate the Beyond. A crouching girl seems to listen to the idol. Lastly, an old woman approaching death appears reconciled and resigned to her thoughts. She completes the story. At her feet a strange white bird, holding a lizard in its claw, represents a futility of words.

The setting is the bank of a stream in the woods. In the background the ocean, and beyond the mountains of a neighboring island. In spite of changes of tone, the landscape is blue and Veronese green from one end to another. The naked figures stand out against it in bold orange.

If anyone said to the students competing for the Rome Prize [*Prix de Rome*] at the Ecole des Beaux Arts, the picture you must paint is to represent *Whence Do We Come? What Are We? Where Are We Going?* what would they do? I have finished a philosophical work on this theme, comparable to the Gospels.[1] I think it is good; [if I have the strength to copy it I will send it to you].

*André Fontainas, Review of Gauguin's Exhibition and Whence Do We Come . . . ?†*

Everyone is at liberty to choose either a commonplace or an unusual setting, as he pleases. That in itself is of no importance. The essential—since I cannot see in these pictures an exact representation of scenes in Tahiti or in the Marquesas—is that the art of the painter must convey to us an image, true or false (that does not matter), of a tropic land, luxuriant and primitive, covered with gigantic dense jungle growth, a land of deep waters and violent contrasts of light and air, peopled by a dignified race, modest and unspoiled. That M. Gauguin should have abandoned the too artificial simplicity of Brittany for his Oceanic mirages is yet another proof of

---

* The English translation from this point on is from Goldwater, *Paul Gauguin*, p. 140. The material in brackets is in the original text and has been added by myself.

[1] Probably the manuscript, "L'esprit modern et la catholisme," *ca.* 1897–1898, unpublished except in fragments by H. S. Leonard in *Bulletin of the City Art Museum of St. Louis*, Summer 1949.

† Originally published in *Mercure de France*, XXIX, 109 (January–March 1899), 235–238. This English translation from Paul Gauguin, *Letters to Ambroise Vollard and André Fontainas*, ed. John Rewald (San Francisco: Grabhorn, 1943), pp. 19–21.

his complete sincerity. Out there on his enchanted island he is no longer concerned with the absurd mania for playing at the restoration of the great archaic romance of Brittany, so tedious after all. He no longer needs to worry about his reputation among the literary aesthetes; he is alive in the midst of distant seas, and the pictures he sends to his friends from time to time continue to prove to us that he is working.

What impresses the beholder at once is the careful study of arrangement in his canvases, which are primarily decorative. The landscapes that compose their profound, subdued harmony are organized not so much for crude picturesque effect as for the purpose, almost always achieved, of creating warm, brooding wellsprings for the surging emotions. If the violent oppositions of such full and vibrant tones, which do not blend and never merge into one another through intermediate values, first distract and then rivet the attention, it must also be admitted that while they are often glowing, bold, and exultant they sometimes lose their effect by monotonous repetition; by the juxtaposition, irritating in the long run, of a startling red and a vibrant green, identical in value and intensity. And yet it is undoubtedly the landscape that satisfies and ever exalts one in M. Gauguin's painting. He has invented a new and broad method of painting landscapes by synthesis and, in the words that he himself wrote in Mercure de France [XIII, February 1895, p. 223], by "seeking to express the harmony between human life and that of animals and plants in compositions in which I allowed the deep voice of the earth to play an important part."

At Vollard's, hanging not far from an extremely delicate landscape painted some years ago, in which figures at the water's edge are watching the reflection of the sun sparkling on the waves, there is a purely decorative picture conceived in this manner and, I believe, very characteristic of the artist's personality. In the midst of the sombre blues and greens, noble animal and vegetable forms intermingle, composing a pure pattern. Nothing more; a perfect harmony of form and color.

There is also a landscape of varied yellows spread out like a delicate curtain of thin golden rain. Here and there the green of some strange leaf, the repeated detail of bright red berries. A man in a sarong reaches towards the low branches of a tree. All this—the light, the graceful effort of the gesture, the grouping of objects and colors—compose a simple and exquisite picture.

If only M. Gauguin were always like that! Or if he would paint as he does when he shows us ceremonial dancers lingering under the trees amidst thick undergrowth, or nude women bathing surrounded by gorgeous, strangely illuminated vegetation. But too often the people of his dreams, dry, colorless, and rigid, vaguely represent forms poorly conceived by an imagination untrained in metaphysics, of which the meaning is doubtful and the expression is arbitrary. Such canvases leave no impression but that of deplorable error, for abstractions are not communicated through concrete images unless, in the artist's own mind, they have already taken shape in some natural allegory which gives them life.

73

That is the lesson taught by the noble example Puvis de Chavannes gives us through his art. To represent a philosophical ideal he creates harmonious groups of figures whose attitudes convey to us a dream analogous to his own. In the large picture exhibited by M. Gauguin, nothing—not even the two graceful and pensive figures standing so tranquilly and beautifully, or the masterful evocation of a mysterious idol—would reveal to us the meaning of the allegory, if he had not taken the trouble to write high up in a corner of the canvas: "Whence do we come? What are we? Where are we going?"

However, in spite of the outlandishness of these near-savages, to which one becomes accustomed, the interest is diverted from the naked woman crouched in the foreground and again becomes fixed wholly upon the charm of the setting in which the action takes place.

But if I point out the grace of a woman half-reclining on a sort of couch, magnificent and curious, in the open air, I prefer not to dwell on other paintings which show the persistent efforts of an obstinate innovator in all the willfulness, slightly brutal, of his struggle.

In other respects M. Gauguin is without doubt an unusually gifted painter from whom the opportunity of displaying the vigorous energy of his temperament by the execution of an important decorative composition on the walls of a public edifice has been too long withheld. There we could see exactly what he is capable of doing, and if he would guard against a tendency towards abstraction, I am sure we should see powerful and truly harmonious creations produced by his hand.

*Gauguin's letter in response to Fontainas's article, Tahiti, March 1899*★

> Un grand sommeil noir
> Tombe sur ma vie
> Dormez, tout espoir
> Dormez, toute envie.
>                    Verlaine

Monsieur Fontainas,

In the January number of the *Mercure de France*, you have two interesting articles, "Rembrandt" and "The Vollard Gallery." In the latter you mention me. In spite of your dislike you have tried to make an honest study of the art or rather the work of a painter who has no emotional effect upon you. A rare phenomenon among critics.

I have always [thought] that it was the duty of a painter never to answer criticisms, even hostile ones—especially hostile ones; nor flattering ones, either, because those are often dictated by friendship.

This time, without departing from my habitual reserve, I have an irresistible desire to write to you, a caprice if you will, and—like all emotional

★ The letter is included in Malingue, *Lettres de Gauguin*, #170, pp. 286–290. This English translation from Rewald, *Paul Gauguin*, pp. 21–24.

people—I am not good at resisting. Since this is merely a personal letter it is not a real answer but simply a chat on art; your article prompts and evokes it.

We painters, we who are condemned to penury, accept the material difficulties of life without complaining, but we suffer from them insofar as they constitute a hindrance to work. How much time we lose in seeking our daily bread! The most menial tasks, dilapidated studios, and a thousand other obstacles. All these create despondency, followed by impotence, rage, violence. Such things do not concern you at all, I mention them only to convince both of us that you have good reason to point out numerous defects, violence, monotony of tone, clashing colors, etc. Yes, all these probably exist, do exist. Sometimes however they are intentional. Are not these repetitions of tones, these monotonous color harmonies (in the musical sense) analogous to oriental chants sung in a shrill voice, to the accompaniment of pulsating notes which intensify them by contrast? Beethoven uses them frequently (as I understand it) in the "Sonata Pathétique," for example. Delacroix too with his repeated harmonies of brown and dull violet, a sombre cloak suggesting tragedy. You often go to the Louvre; with what I have said in mind, look closely at Cimabue.

Think also of the musical role color will henceforth play in modern painting. Color, which is vibration just as music is, is able to attain what is most universal yet at the same time most elusive in nature: its inner force.

Here near my cabin, in complete silence, amid the intoxicating perfumes of nature, I dream of violent harmonies. A delight enhanced by I know not what sacred horror I divine in the infinite. An aroma of long-vanished joy that I breathe in the present. Animal figures rigid as statues, with something indescribably solemn and religious in the rhythm of their pose, in their strange immobility. In eyes that dream, the troubled surface of an unfathomable enigma.

Night is here. All is at rest. My eyes close in order to see without actually understanding the dream that flees before me in infinite space; and I experience the languorous sensation produced by the mournful procession of my hopes.

In praise of certain pictures that I considered unimportant you exclaim: "If only Gauguin were always like that!" But I don't want to be always like that.

"In the large panel that Gauguin exhibits there is nothing that explains the meaning of the allegory." Yes, there is: my dream is intangible, it comprises no allegory; as Mallarmé said, "It is a musical poem, it needs no libretto." Consequently the essence of a work, unsubstantial and out of reach, consists precisely of "that which is not expressed; it flows by implication from the lines without color or words; it is not a material structure."

Standing before one of my pictures of Tahiti, Mallarmé also remarked: "It is amazing that one can put so much mystery in so much brilliance."

To go back to the panel: the idol is there not as a literary symbol but as a statue, yet perhaps less of a statue than the animal figures, less animal also, combining my dream before my cabin with all nature, dominating our primitive soul,

the unearthly consolation of our sufferings to the extent that they are vague and incomprehensible before the mystery of our origin and of our future.

And all this sings with sadness in my soul and in my design while I paint and dream at the same time with no tangible allegory within my reach—due perhaps to a lack of literary education.

Awakening with my work finished, I ask myself: "Whence do we come? What are we? Where are we going?" A thought which has no longer anything to do with the canvas, expressed in words quite apart on the wall which surrounds it. Not a title but a signature.

You see, although I understand very well the value of words—abstract and concrete—in the dictionary, I no longer grasp them in painting. I have tried to interpret my vision in an appropriate décor without recourse to literary means and with all the simplicity the medium permits: a difficult job. You may say that I have failed, but do not reproach me for having tried, nor should you advise me to change my goal, to dally with other ideas already accepted, consecrated. Puvis de Chavannes is the perfect example. Of course Puvis overwhelms me with his talent and experience, which I lack; I admire him as much as you do and more, but for entirely different reasons (and—don't be annoyed—with more understanding). Each of us belongs to his own period.

The government is right not to give me an order for a decoration for a public building which might clash with the ideas of the majority, and it would be even more reprehensible for me to accept it, since I should have no alternative but to cheat or lie to myself.

At my exhibition at Durand Ruel's [1893] a young man who didn't understand my pictures asked Degas to explain them to him. Smiling, he recited a fable by La Fontaine. "You see," he said, "Gauguin is the thin wolf without the collar." [that is, he prefers liberty with starvation to servitude with abundance— John Rewald].

After fifteen years of struggle we are beginning to free ourselves from the influence of the Academy, from all this confusion of formulas apart from which there has been no hope of salvation, honor, or money: drawing, color composition, sincerity in the presence of nature, and so on. Only yesterday some mathematician [Charles Henry] tried to prove to us that we should use unchangeable light and color.

Now the danger is past. Yes, we are free, and yet I still see another danger flickering on the horizon; I want to discuss it with you. This long and boring letter has been written with only that in view. Criticism of today, when it is serious, intelligent, full of good intentions, tends to impose on us a method of thinking and dreaming which might become another bondage. Preoccupied with what concerns it particularly, its own field, literature, it will lose sight of what concerns us, painting. If that is true, I shall be impertinent enough to quote Mallarmé: "A critic is someone who meddles with something that is none of his business."

In his memory will you permit me to offer you this sketch of him, hastily dashed off, a vague recollection of a beautiful and beloved face, radiant, even in the shadows. Not a gift but an appeal for the indulgence I need for my foolishness and violence.

*Paul Gauguin, sketch of a Marquesan sculpture, 1891–93.*

# GAUGUIN:  On Primitivism

## BUFFALO BILL AT THE WORLD'S FAIR

*From a letter to Emile Bernard, Paris, n.d. [February 1889]*★

I have been to Buffalo's. You must make all efforts to come to see it. It is of enormous interest.

## JAVANESE VILLAGE AT THE WORLD'S FAIR

*From a letter to Emile Bernard, Paris, n.d. [March 1889]*†

You were wrong not to come the other day. There are Hindu dancers in the Javanese village. All the art of India is there, and my photographs of Cambodia literally are found there, too. I will go there again Tuesday, as I have a rendezvous with a mulatto girl.

★ Malingue, *Lettres de Gauguin*, #80, p. 157.
† Malingue, *Lettres de Gauguin*, #81, p. 157.
  Entire native villages were built on the fairgrounds and inhabited by native families brought to represent the various French colonies throughout the world. Accompanied by restaurants serving native food and vendors selling curios and photographs, these displays were among the most popular of the fair.
  The "Cambodian photographs" referred to by Gauguin are probably those of the temple of Boro-Budur, a replica of which was built on the fairgrounds. Gauguin's own photographs are illustrated and their influence on his painting discussed in Bernard Dorival, "Sources of the Art of Gauguin from Java, Egypt and Ancient Greece," *Burlington Magazine* (London) XCIII, (April 1951) 118–122.

## LONGING FOR THE TROPICS

*From a letter to his wife Mette, Paris, n.d. [February 1890]**

May the day come, perhaps very soon, when I'll bury myself in the woods of an ocean island to live on ecstasy, calmness and art. With a new family, and far from that European struggle for money. There in the silence of the beautiful tropical nights of Tahiti, I shall be able to listen to the sweet murmuring music of my heart's beating, in amorous harmony with the mysterious beings of my environment. Free at last, without money trouble, I'll be able to love, to sing and to die.

*From a letter to Emile Bernard, Le Pouldu, n.d. [June 1890]†*

What I am going to make is a studio of the tropics. With the money I have I can buy a house in the country like those we have seen at the International Exposition.

*From a letter to J. F. Willumsen, Pont-Aven, autumn, 1890‡*

As for me, my mind is made up. I am going soon to Tahiti, a small island in Oceania, where the material necessities of life can be had without money. I want to forget all the misfortunes of the past, I want to be free to paint without any glory whatsoever in the eyes of the others and I want to die there and to be forgotten here. And if my children are able and wish to come and join me, I would feel completely isolated. A terrible epoch is brewing in Europe for the coming generation: the kingdom of gold. Everything is putrefied, even men, even the arts. There, at least, under an eternally summer sky, on a marvellously fertile soil, the Tahitian has only to lift his hands to gather his food; and in addition he never works. When in Europe men and women survive only after unceasing labor during which they struggle in convulsions of cold and hunger, a prey to misery, the Tahitians, on the contrary, happy inhabitants of the unknown paradise of Oceania, know only sweetness of life. To live, for them, is to sing and to love—(a lecture on Tahiti, Van der Veere)—. Once my material life is well organized, I can there devote myself to great works of art, freed from all artistic jealousies and with no need whatsoever of lowly trade.

In art one is concerned with the condition of the spirit for three quarters of the time; one must therefore care for oneself if he wishes to make something great and lasting.

* Malingue, *Lettres de Gauguin*, #100, p. 184.
† Malingue, *Lettres de Gauguin*, #105, p. 191.
‡ Originally published in *Les Marges* (Paris), 15 March 1918. The letter also appears in French in Sven Lövgren, *The Genesis of Modernism* (Stockholm: Almquist & Wiksell, 1959), pp. 164–165. Willumsen (1863–1958) was a Danish painter who for a time was a member of the Pont-Aven group.

*An exchange of letters between August Strindberg and Gauguin*

*Strindberg's reply to a request from Gauguin, Paris n.d. [1 February, 1895]**

You have set your heart on having the preface to your catalogue written by me, in memory of the winter of 1894–95 when we lived here behind the Institute, not far from the Pantheon and quite close to the cemetery of Montparnasse.

I should gladly have given you this souvenir to take away with you to that island in Oceania, where you are going to seek for space and a scenery in harmony with your powerful stature, but from the very beginning I feel myself in an equivocal position and I am replying at once to your request with an "I cannot" or, more brutally still, with an "I do not wish to."

At the same time I owe you an explanation of my refusal, which does not spring from a lack of friendly feeling, or from a lazy pen, although it would have been easy for me to place the blame on the trouble in my hands which, as a matter of fact, has not given the skin time to grow in the palms.

Here it is: I cannot understand your art and I cannot like it. I have no grasp of your art, which is now exclusively Tahitian. But I know that this confession will neither astonish nor wound you, for you always seem to me fortified especially by the hatred of others: your personality delights in the antipathy it arouses, anxious as it is to keep its own integrity. And perhaps this is a good thing, for the moment you were approved and admired and had supporters, they would classify you, put you in your place and give your art a name which, five years later, the younger generation would be using as a tag for designating a superannuated art, an art they would do everything to render still more out of date.

I myself have made many serious attempts to classify you, to introduce you like a link into the chain, so that I might understand the history of your development, but in vain.

I remember my first stay in Paris, in 1876. The city was a sad one, for the nation was mourning over the events that had occurred and was anxious about the future; something was fermenting.

In the circle of Swedish artists we had not yet heard the name of Zola, for *L'Assommoir* was still to be published. I was present at a performance at the Théâtre Français of *Rome Vaincue*, in which Mme. Sarah Bernhardt, the new star,

* This English translation fron *Paul Gauguin's Intimate Journals*, trans. Van Wyck Brooks (Bloomfield: Indiana University Press, 1958), pp. 42–49. Originally published by Liveright, New York.

Strindberg (1845–1912), the Swedish dramatist and novelist, was at that time an influential figure in the circles of *Mercure de France*, the *Théâtre de l'Oeuvre*, and the *Nabis*. He was also a painter of considerable talent, and worked steadily during these years. His subjects were limited to almost a single theme, seascapes with dramatically tempestuous skies, akin in spirit to the highly charged emotionality of his plays. His brushstrokes are more activated than those of any of the contemporary movements, anticipating the expressionism of the *Brücke* group of about ten years later.

was crowned as a second Rachel, and my young artists had dragged me over to Durand-Ruel's to see something quite new in painting. A young painter who was then unknown was my guide and we saw some marvelous canvases, most of them signed Monet and Manet. But as I had other things to do in Paris than to look at pictures (as the secretary of the Library of Stockholm it was my task to hunt up an old Swedish missal in the library of Sainte-Geneviève), I looked at this new painting with calm indifference. But the next day I returned, I did not know just why, and I discovered that there was "something" in these bizarre manifestations. I saw the swarming of a crowd over a pier, but I did not see the crowd itself; I saw the rapid passage of a train across a Normandy landscape, the movement of wheels in the street, frightful portraits of excessively ugly persons who had not known how to pose calmly. Very much struck by these canvases, I sent to a paper in my own country a letter in which I tried to explain the sensation I thought the Impressionists had tried to render, and my article had a certain success as a piece of incomprehensibility.

When, in 1883, I returned to Paris a second time, Manet was dead, but his spirit lived in a whole school that struggled for hegemony with Bastien-Lepage.[1] During my third stay in Paris, in 1885, I saw the Manet exhibition. This movement had now forced itself to the front; it had produced its effect and it was now classified. At the triennial exposition, which occurred that very year, there was an utter anarchy—all styles, all colors, all subjects, historical, mythological and naturalistic. People no longer wished to hear of schools or tendencies. Liberty was now the rallying-cry. Taine had said that the beautiful was not the pretty, and Zola that art was a fragment of nature seen through a temperament.

Nevertheless, in the midst of the last spasms of naturalism, one name was pronounced by all with admiration, that of Puvis de Chavannes. He stood quite alone, like a contradiction, painting with a believing soul, even while he took a passing notice of the taste of his contemporaries for allusion. (We did not yet possess the term symbolism, a very unfortunate name for so old a thing as allegory.)

It was toward Puvis de Chavannes that my thoughts turned yesterday evening when, to the tropical sounds of the mandolin and the guitar, I saw on the walls of your studio that confused mass of pictures, flooded with sunshine, which pursued me last night in my dreams. I saw trees such as no botanist could ever discover, animals the existence of which had never been suspected by Cuvier, and men whom you alone could have created, a sea that might have flowed out of a volcano, a sky which no God could inhabit.

"Monsieur," I said in my dream, "you have created a new heaven and a

---

[1] Jules Bastien-Lepage (1848–1884) was an academic painter of realistic subjects from the lives of the common people. He was enormously popular at the official salons and hence he and those like him seemed to stand in the way of the younger artists of Manet's circle. The Manet memorial exhibition of 1884 was held at the Ecole des Beaux-Arts; the setting signified his victory over his academic detractors.

new earth, but I do not enjoy myself in the midst of your creation. It is too sun-drenched for me, who enjoy the play of light and shade. And in your paradise there dwells an Eve who is not my ideal—for I, myself, really have an ideal of a woman or two!" This morning I went to the Luxembourg to have a look at Chavannes, who kept coming to my mind. I contemplated with profound sympathy the poor fisherman, so attentively occupied with watching for the catch that will bring him the faithful love of his wife, who is gathering flowers, and his idle child. That is beautiful! But now I am striking against the crown of thorns, Monsieur, which I hate, as you must know! I will have none of this pitiful God who accepts blows. My God is rather that *Vitsliputsli*[1] who in the sun devours the hearts of men.

No, Gauguin is not formed from the side of Chavannes, any more than from Manet's or Bastien-Lepage's!

What is he then? He is Gauguin, the savage, who hates a whimpering civilization, a sort of Titan who, jealous of the Creator, makes in his leisure hours his own little creation, the child who takes his toys to pieces so as to make others from them, who abjures and defies, preferring to see the heavens red rather than blue with the crowd.

Really, it seems to me that since I have warmed up as I write I am beginning to have a certain understanding of the art of Gauguin.

A modern author has been reproached for not depicting real beings, but for quite simply creating his personages himself. Quite simply!

Bon voyage, Master; but come back to us and come and see me. By then, perhaps, I shall have learned to understand your art better, which will enable me to write a real preface for a new catalogue in the Hôtel Drouot. For I, too, am beginning to feel an immense need to become a savage and create a new world.

*Reply to Strindberg from Gauguin, Paris, n.d. [5 February 1895]*★

Dear Strindberg,

I received your letter today; your letter which is a preface for my catalogue. I had the idea to ask you for this preface the other day when I saw you in my studio playing the guitar and singing; your blue northern eye attentively studying the paintings on the walls. I had then the premonition of a revolt: the conflict between your civilization and my barbarism.

Civilization from which you suffer; barbarism which is for me a rejuvenation.

Compared with the Eve of my choice, whom I have painted in the forms

---

[1] Aztec war god. Human sacrifice was part of the ritual, and the priest donned the flayed skin of the victim in order to impersonate and placate the god.

★ Although Strindberg had refused Gauguin's request that he write a preface to the exhibition catalogue, Gauguin actually published both letters in it (Hôtel Drouot, Paris, 18 February 1895). This letter is included in Malingue, *Lettres de Gauguin*, #154, pp. 262–264.

and harmonies of another world, your chosen memories have perhaps evoked a painful past. The Eve of your civilized conception makes misogynists of you and almost all of us; but the ancient Eve, which frightened you in my studio, might well some day smile upon you less bitterly. This world, to which a Cuvier or a botanist would be unknown, would be a paradise which I alone would have portrayed. And from the portrayal to the realization of the dream is a long way. But no matter! Is not a glimpse of happiness a foretaste of *Nirvana*?

The Eve which I have painted (she alone) can logically remain nude before our gaze. In such a simple state yours could not move without being indecent, and, being too pretty (perhaps), would be the evocation of evil and pain.

To make you understand my thought completely, I will no longer directly compare the two women, but the Maori or Turkestanian language, which my Eve speaks, and language spoken by your chosen woman, the European language of inflections.

In the languages of Oceania, composed of essential elements preserving their ruggedness, with no taste for polish whether isolated or joined, everything is naked and primordial.

While the roots of the languages of inflections, with which, as with all languages, they have commenced, disappear in the daily commerce which has worn threadbare their projections and their contours. It is a perfected mosaic, where one ceases to see the rough joinings of the stones in order to admire only a pretty painting like jewelry. An expert eye alone is able to detect the process of construction.

Excuse this long philological digression; I believe it necessary to explain the savage pattern which I had to use in order to decorate an exotic country and people.

It remains for me to thank you, dear Strindberg.

When will we see you again?

Then, as today, all my best to you.

## PRIMITIVISM

*From the manuscript "Diverses Choses, 1896–1897," Tahiti**

I think that man has certain moments of playfulness, and infantile things, far from being injurious to his serious work, endow it with grace, gaiety and naïveté.... When machines have come, art has fled, and I could never believe that photography has been beneficial to us. A fancier of horses claims that "since the instantaneous photograph,[1] the painter has come to understand this animal, and Meissonier, the

---

* De Rotonchamp, *Paul Gauguin*, p. 212.

[1] Gauguin is probably referring to the photographs of Eadweard Muybridge (1830–1904), photographer and student of animal locomotion who captured the motion of animals

glory of France, has been enabled to render all the attitudes of this noble animal."
But as for me, I go back very far, even farther than the horses of the Parthenon, . . .
as far as the toys of my infancy, the good wooden hobby-horse.

## MARQUESAN ART

*From the manuscript "Avant et Après," Marquesas Islands, 1903*\*

We do not seem to suspect in Europe that there exists, both among the Maoris of
New Zealand and the Marquesans, a very advanced decorative art. Our fine critics
are mistaken when they take all this for Papuan art!

In the Marquesan especially there is an unparalleled sense of decoration.
Give him a subject even of the most ungainly geometrical forms and he will succeed
in keeping the whole harmonious and in leaving no displeasing or incongruous
empty spaces. The basis is the human body or the face, especially the face. One is
astonished to find the face where one thought there was nothing but a strange
geometric figure. Always the same thing, and yet never the same thing.

Today, even for gold, you can no longer find any of those beautiful objects
in bone, shell, iron-wood which they used to make. The police have *stolen* it all and
sold it to amateur collectors; yet the Administration has never for an instant
dreamed of establishing a museum in Tahiti, as it could so easily do, for all this
Oceanic art.

None of these people who consider themselves learned have ever for an
instant suspected the value of the Marquesan artists. There is not the pettiest offi-
cial's wife who would not exclaim at the sight of it, "It's horrible! It's savagery!"
Savagery! Their mouths are full of it.

## LIFE OF A SAVAGE

*Last letter to Charles Morice, Atuana, Marquesas Islands, April 1903*†

I am striken to the ground, but not yet vanquished. Is the Indian who smiles during
his torture vanquished? The savage is decidedly better than us. You were mistaken
once in saying that I was wrong to say I am a savage. It is true, nevertheless; I am
a savage. And the civilized foresee it, for there is nothing surprising or confusing in

---

and human beings by .means of a series of rapid-sequence photographs. His first book of
photographs of horses, *The Horse in Motion*, appeared in 1878, and in 1881 he invented a
zoo-proxiscope which projected animated pictures on a screen.

  \* Published in facsimile (Leipzig: Kurt Wolff, 1918); text only (Paris: Crès, 1923).
English translation from Brooks, *Paul Gauguin's Intimate Journals*, pp. 92–95.

  † Malingue, *Lettres de Gauguin*, #181, pp. 318–319.

  Gauguin wrote what was to be his last letter to De Monfried about the same time as
this one, and then devoted many days to writing letters to the court of appeals in Papeete
protesting his conviction to three months imprisonment by a local court for libellous remarks
about the police. Although exhausted and ill, he undertook a lengthy letter to the chief of the

Paul Gauguin, cover design *Avant et Après, 1903*
Marquesas.

my work except this savage-in-spite-of-myself. For that reason it is inimitable. The work of a man is the explanation of that man. Hence two kinds of beauty: one that results from instinct and another which would come from studying. The combination of the two, with its necessary modifications, produces certainly a great and very complicated richness, which the art critic must devote himself to discover . . . . Art has just gone through a long period of aberration caused by physics, chemistry, mechanics, and the study of nature. Artists, having lost all of their savagery, having no more instincts, one could even say imagination, went astray on every path, looking for productive elements which they did not have enough strength to create. Consequently, they act only as a disorderly crowd, they feel frightened like lost ones when they are alone. That is why solitude must not be advised for everyone, since one must have strength to be able to bear it and to act alone.

---

*gendarmerie* in Papeete in which he most eloquently defended his own actions and at the same time continued his attacks upon the local police. (For quotations from the letter, as well as much additional new documentary material, see Bengt Danielsson, *Gauguin in the South Seas* [London: George Allen and Unwin, 1965], Ch. X.) After several days during which he would see no one he was found dead on May 8, 1903.

# SYMBOLIST THEORIES

*G.-Albert Aurier, from "Essay on a New Method of Criticism," 1890-1893*★

Apart from the criticism in the newspapers, which is in fact not so much criticism as reporting, the criticism of this century has had the pretension to be scientific.

It has been peculiar to the nineteenth century to try to introduce science everywhere, even where it is least concerned;—and when I say science, one must not think of mathematics, the only real science, but of those obtuse bastards of science, the natural sciences.

But these natural sciences, being inexact, in contradistinction to the rational or exact sciences, are by definition not able to come to absolute solutions, and lead therefore inevitably to skepticism and to the *fear to think*.

They must, therefore, be accused of having made this society lose faith, become earthbound, incapable of thousands of those intellectual or emotional human utterances which can be characterized by the term devotion.

They are therefore responsible—as Schiller has already said—for the poorness of our art, which they have assigned exclusively to the domain of imitation, the only quality that can be established by experimental methods. In giving art this end, which is contradictory to art itself, have they not simply suppressed it completely? This is what has happened, with the exception of those rare artists who have had the strength to isolate themselves far from this environment with its destructive ideas.

If we have understood this, is it not time to react, to chase away science, as Verlaine said, "the intruder of the house," the "murderer of oratory," and to enclose, if that is still possible, the invading scientists in their laboratories?

A work of art is a new being that not only has a soul but it has a double soul (soul of the artist and soul of nature, father and mother).

To love is the only way to penetrate into a thing. To understand God, one must love Him; to understand a woman, one must love her; understanding is in proportion to love. The only means, thus, to understand a work of art is to become the lover of it. This is possible, as the work is a being that has a soul and manifests this by a language that one can learn.

It is even easier to have true love for a work of art than for a woman, as

★ "Essai sur une nouvelle méthode de critique," incomplete first draft of a manuscript published posthumously in G.-Albert Aurier, *Oeuvres posthumes de G.-Albert Aurier*, (Paris: Mercure de France, 1893), pp. 175-176. This English translation is by H. R. Rookmaaker and myself. (The initials H.R.R. in footnotes in the next two sections indicate notes by H. R. Rookmaaker.)

in the work of art materiality barely exists and almost never lets love degenerate into sensualism.[1] Perhaps this method will be ridiculed. Then I shall not answer. Perhaps it will be considered mystical. Then I shall say: yes, without a doubt, this is mysticism, and it is mysticism that we need today, and it is mysticism alone that can save our society from brutalization, sensualism and utilitarianism. The most noble faculties of our soul are in the process of atrophying. In a hundred years we shall be brutes whose only ideal will be the easy appeasement of bodily functions; by means of positive science we shall have returned to animality, pure and simple. We must react. We must recultivate in ourselves the superior qualities of the soul. We must become mystics again. We must relearn to love, the source of all understanding.

*G.-Albert Aurier, ca. 1892.*

But, alas, it is too late to recapture love in all its original wholeness. The sensualism of this century has denied us the ability to see in a woman something else than flesh suitable for the appeasement of our physical desires. The love of a woman is no longer permitted us. The skepticism of this century has denied us the ability to see in God anything else than a nominal abstraction, perhaps nonexistent. The love of God is no longer permitted us.

[1] Aurier's ideas are developed in a neo-platonic framework, from which we can understand this argumentation. H.R.R.

One love alone is still allowed us, that of works of art. Let us, therefore, fling ourselves upon this last plank of salvation. Let us become mystics of art.

And if we do not succeed in this, let us return to our troughs wailing the definitive *Finis Galliae* [end of France].

### G.-Albert Aurier, from "Symbolism in Painting: Paul Gauguin," 1891*

It is evident—it is almost trite to state it—, that there exists in the history of art two great contradictory tendencies, of which, unquestionably, the one depends on blindness and the other on the clairvoyance of that inner eye of man on which Swedenborg speaks. They are the realist trend and the ideistic trend. (I do not say idealistic; we'll see why.)[1]

Without a doubt, realistic art—that is, art of which the one and only aim is the representation of material externals, the sensory appearances—constitutes an interesting aesthetic manifestation. It shows the worker's soul in a certain way, as in a reflection, as it shows us the deformations that the object has undergone in going through it. Indeed, no one challenges the fact that realism, even if it has been a pretext for numerous abominations, as impersonal and banal as photographs, has often produced incontestable masterpieces, resplendent in the museum of our memories. But yet, it is not less unchallengable for anyone willing to reflect truthfully, that ideistic art appears to be more pure and more elevated—more pure and more elevated through the complete purity and the complete elevatedness that separates matter from idea. We can even affirm that the supreme art cannot but be ideistic, art by definition (as we know intuitively) being the representative materialization of what is the highest and the most truly divine in the world, of what is, in the last analysis, the only thing existent—the Idea. Therefore, those who do not know about the Idea, nor are able to see it, nor believe in it, merit our compassion, just as those poor stupid prisoners of the allegorical cavern of Plato did for free men.

And yet, if we except most of the Primitives[2] and some of the great masters of the Renaissance, the general tendency of painting has been up until now, as everyone knows, almost exclusively realist. Many even confess to be unable to understand that painting, that art which is *representational* par excellence, and capable of imitating all the visible attributes of matter to the point of illusionism, could be anything else but a faithful and exact reproduction of objectivity,

---

* "Le Symbolisme en peinture; Paul Gauguin," *Mercure de France* (Paris), II (1891), 159–164. Reprinted in Aurier, *Oeuvres posthumes*, pp. 211–218. This English translation is by H. R. Rookmaaker and myself.

[1] Aurier does not say idealistic, as he wants to use this term only for the contemporary classicist, whom he believed was only a specific type of realist. H.R.R.

[2] Aurier does not think here of primitive art in our sense of tribal art, but rather of the art of the late Middle Ages and before Raphael. He may also have included pre-classical Greek, Egyptian, and Mesopotamian art. H.R.R.

an ingenious facsimile of the so-called real world. Even the idealists themselves (who, I repeat, one should be careful not to confuse with those artists whom I wish to call ideist), were almost always, whatever they themselves pretended to be, nothing but realists; the goal of their art was nothing but the direct representation of material forms; they were content *to arrange* objectivity, following certain conventional and prejudiced notions of quality; they prided themselves upon presenting us *beautiful* objects—that means *beautiful as objects*—the interest in their works always residing in qualities of form, that is to say, of reality. What they have called ideal was never anything but the cunning dressing up of ugly tangible things. In one word, they have painted a conventional objectivity, which is yet objectivity, and, to paraphrase the famous saying of one of them, Gustave Boulanger,[1] there is after all little difference between the idealists and the realists of today but a choice "between the helmet and the cap."[2]

They are also poor stupid prisoners of the allegorical cavern. Let us leave them to fool themselves in contemplating the shadows that they take for reality, and let us go back to those men who, their chains broken and far from the cruel native dungeon, ecstatically contemplate the radiant heavens of Ideas. The normal and final end of painting, as well as of the other arts, can never be the direct representation of objects. Its aim is to express Ideas, by translating them into a special language.

Indeed, in the eyes of the artist—that is, the one who must be the *Expresser of Absolute Beings*—objects are only relative beings, which are nothing but a translation proportionate to the relativity of our intellects, of Ideas, of absolute and essential beings. Objects cannot have value more than objects as such. They can appear to him only as *signs*. They are the letters of an enormous alphabet which only the man of genius knows how to spell.[3]

To write his thought, his poem, with these signs, realizing that the sign, even if it is indispensable, is nothing in itself and that the idea alone is everything, seems to be the task of the artist whose eye is able to distinguish essences from tangible objects. The first consequence of this principle, too evident to justify pause, is a necessary *simplification in the vocabulary of the sign*. If this were not true, would not the painter then in fact resemble the naïve writer who believed he was adding something to his work by refining and ornamenting his handwriting with useless curls?

But, if it is true that, in this world, the only real beings cannot but be Ideas, and if it is true that objects are nothing but the revealers of the appearances of these ideas and, by consequence, have importance only as signs of Ideas, it is not

[1] Gustave Rodolphe Boulanger (1824–1888), a pupil of Delaroche, achieved fame in the salons with his genre paintings depicting everyday life in Greek and Roman antiquity. H.R.R.

[2] Boulanger probably meant the helmet to refer to classical antiquity and the warrior, and the cap to refer to contemporary life and the common man. H.R.R.

[3] These ideas are borrowed from Delacroix and Baudelaire. See Rookmaaker, *Synthetist Art Theories*, p. 24. H.R.R.

less true that to our human eyes, our eyes of proud *shadows of pure beings*, shadows living unconscious of their illusory state and the animated deceit of the spectacle of fallacious tangible things, I say, it is not less true that to our near-sighted eyes objects most often appear to be nothing but objects, nothing else but objects, independent of their symbolic meaning—to the point that often we are not able even by sincere efforts to imagine them to be signs.

This fatal inclination to consider in practical life the object as nothing but an object is evident and, one can say, almost general. Only the superior man, illuminated by that supreme quality that the Alexandrians rightly called ecstasy, is able to persuade himself that he himself is nothing but a sign thrown, by a mysterious preordination, in the midst of an uncountable crowd of signs; only he, the conqueror of the monster illusion, can walk as master in the fantastic temple

> whose living pillars
> sometimes give forth indistinct words

while the imbecile human flock, duped by the appearances that lead them to the denial of essential ideas, will pass forever blind

> through forests of symbols
> which watch him with familiar glances.[1]

The work of art should never lend itself to such a deception, not even for the eyes of the popular herd. The art-lover, in fact (who is not an artist at all and consequently in no way has insight into the symbolic correspondences), would find himself before the work of art in a situation analogous to the crowd before the objects of nature. He would perceive the objects represented only as objects—that which must be avoided. It is necessary, therefore, that the ideistic work does not produce this confusion; it is necessary, therefore, that we should attain such a position that we cannot doubt that the objects in the painting have no meaning at all as objects, but are only signs, words, having in themselves no other importance whatsoever.

In consequence certain appropriate laws will have to rule pictorial imitation. The artist will have, necessarily, the task to avoid carefully this antimony of all art: concrete truth, illusionism, *trompe l'oeil*, in order not to give in any way by his painting that deceitful impression of nature that acts on the onlooker as nature itself, that is, without possible suggestion, that is (if I may be pardoned for the barbarous neologism), not ideistically.

It is logical to imagine the artist fleeing from the analysis of the object in order to guard himself against these perils of concrete truth. Every detail is, in fact, really nothing but a partial symbol, most often unnecessary for the total significance of the object. The strict duty for the ideistic painter is, therefore, to realize a

---

[1] From Baudelaire, "Correspondances." H.R.R.

rational selection among the multiple elements combined in objectivity, and to use in his work only the lines, forms, the general and distinctive colors serving to describe precisely the ideistic meaning of the object, adding to it those partial symbols which corroborate the general symbol.

Yet, it is easy to deduce, the artist always has the right to exaggerate those directly significant qualities (forms, lines, colors, etc.) or to attenuate them, to deform them, not only according to his individual vision, not according to the configuration of his own personal subjectivity (as happens even in realistic art), but more to exaggerate them, to attenuate them, to deform them according to the needs of the Idea to be expressed.[1]

Thus, to summarize and to come to conclusions, the work of art, as I have logically evoked it, will be:

1. *Ideist*, for its unique ideal will be the expression of the Idea.

2. *Symbolist*, for it will express this Idea by means of forms.

3. *Synthetist*, for it will present these forms, these signs, according to a method which is generally understandable.

4. *Subjective*, for the object will never be considered as an object but as the sign of an idea perceived by the subject.

5. (It is consequently) *Decorative*—for decorative painting in its proper sense, as the Egyptians and, very probably, the Greeks and the Primitives understood it, is nothing other than a manifestation of art at once subjective, synthetic, symbolic and ideist.

Now, we must reflect well upon this: decorative painting is, strictly speaking, the true art of painting. Painting can be created only *to decorate* with thoughts, dreams and ideas the banal walls of human edifices. The easel-picture is nothing but an illogical refinement invented to satisfy the fantasy or the commercial spirit in decadent civilizations. In primitive societies, the first pictorial efforts could be only decorative.

This art, that we have tried to legitimatize and to characterize by all the deductions above, this art that possibly seemed complicated and that some journalists like to treat as overrefined, has thus, in the last analysis, returned to the formula of art that is simple, spontaneous and primordial. This is the criterium of the rightness of the esthetic reasoning employed. Ideistic art, that we had to justify by abstract and complicated arguments, as it seems so paradoxical to our decadent civilizations that have forgotten all primeval revelations, is thus, without any doubt, the true and absolute art. As it is legitimate from a theoretical point of view, it finds itself, moreover, fundamentally identical with primitive art, to art as it was divined by the instinctive geniuses of the first ages of humanity. But is this all? Is there not still some element missing that makes art, understood in this way, true art?

Is it in the man who, thanks to his innate talents, thanks also to the good

---

[1] Compare with Maurice Denis's "subjective deformation" and "objective deformation" in the essay "Synthetism," below.

qualities he has acquired, finds himself confronted with nature knowing how to read in every object its abstract significance, the primordial idea that goes beyond it, the man who, by his intelligence and his approach, knows how to use objects as a sublime alphabet to express the Ideas in which he has the insight? Is he truly, because of this, a complete artist? Would he be the Artist?

Is not this man rather an ingenious scholar, a supreme formulator who knows how to write down Ideas like a mathematician? Is not he in some ways an algebraicist of Ideas, and is not his work a miraculous equation, or rather a page of ideographic writing reminding us of the hieroglyphic texts of the obelisks of ancient Egypt?

Yes, without a doubt; the artist, even if he has no other psychic gifts, will not be only that, as he will then be only a *comprehensive expresser*, and if comprehension completed by the power to express is enough to constitute the scholar, it is not enough to constitute the artist.

He needs, to be really worthy of this fine title of nobility—so stained in our industrialized world of today—, to add another gift even more sublime to this ability of comprehension. I mean the gift of *emotivity*. This is certainly not the emotivity that every man has in relation to illusory sentimental combinations of beings and objects, nor is it the sentimentality of the popular café singers or the makers of popular prints—but it is the transcendental emotivity, so grand and precious, that makes the soul tremble before the pulsing drama of the abstractions. Oh, how rare are those who move body and soul to the sublime spectacle of Being and pure Ideas! But this is the gift that means the *sine qua non*, this is the sparkle that Pygmalion wanted for his Galatea, this is the illumination, the golden key, the Daimon, the Muse . . . .

Thanks to this gift, symbols—that is, Ideas—arise from the darkness, become animated, begin to live with a life that is no longer our life of contingencies and relativities, but a splendid life which is the essential life, the life of Art, the being of Being.

Thanks to this gift, art which is complete, perfect, absolute, exists at last.

*G.-Albert Aurier, from "The Symbolist Painters," 1892* ★

After having proclaimed the omnipotence of scientific observation and deduction for eighty years with childlike enthusiasm, and after asserting that for its lenses and scalpels there did not exist a single mystery, the nineteenth century at last seems to perceive that its efforts have been in vain, and its boast puerile. Man is still walking about in the midst of the same enigmas, in the same formidable unknown, which has become even more obscure and disconcerting since its habitual neglect. A

★ "Les peintres symbolistes," *Révue Encyclopédique* (Paris), April 1892. Reprinted in Aurier, *Oeuvres posthumes*, pp. 293–309. This selection, translated by H. R. Rookmaaker, appears in his *Synthetist Art Theories*, p. 1.

great many scientists and scholars today have come to a halt discouraged. They realize that this experimental science, of which they were so proud, is a thousand times less certain than the most bizarre theogony, the maddest metaphysical reverie, the least acceptable poet's dream, and they have a presentiment that this haughty science which they proudly used to call "positive" may perhaps be only a science of what is relative, of appearances, of "shadows" as Plato said, and that they themselves have nothing to put on old Olympus, from which they have removed the deities and unhinged the constellations.

## Maurice Denis, from "Definition of Neotraditionism," 1890*

### I

It is well to remember that a picture—before being a battle horse, a nude woman, or some anecdote—is essentially a plane surface covered with colors assembled in a certain order.[1]

### II

I am seeking a *painter's* definition of that simple word "nature," the word which is both the label and the definition of the theory of art most generally accepted by our dying century.

Is it perhaps: the totality of our optical sensations? But, not to mention the disturbance natural to the modern eye, who is not aware of the power mental habits have over our vision? I have known young men who gave themselves over to fatiguing gymnastics of the optic nerves in order to see the *trompe l'oeil* in the *Poor Fisherman* [by Puvis de Chavannes]; and they found it, I am sure. With irreproachable scientific method, M. Signac can prove to you the absolute necessity

---

* Originally published in *Art et critique* (Paris), 23 and 30 August 1890; included in Maurice Denis, *Théories; 1890–1910*, 4th ed. (Paris: Rouart et Watelin, 1920), pp. 1–13. An annotated abridgment of *Théories* appears in the series "Miroirs de l'Art": Maurice Denis, *Du Symbolisme au Classicisme: Théories*, ed. Oliver Revault d'Allonnes (Paris: Hermann, 1964). Portions of this essay also appear in English translation in *Artists on Art*, eds. Robert Goldwater and Marco Treves (New York: Pantheon, 1945), pp. 380–381.

The following footnote by Denis appear in *Théories, op. cit.*, p. 1: "*Art et Critique*, 23 and 30 August 1890. I was only twenty years of age. [Denis was born November 25, 1870, and so was only nineteen at that time.—Ed.] I had been a student at the Ecole des Beaux-Arts since July 1888. This article was signed Pierre-Louis, a pseudonym which I abandoned at the request of Pierre Louys, the future author of *Aphrodite*."

[1] The formalist point of view expressed here by Denis had already existed, although as a minor current, in academic art theory. Charles Blanc, professor at the Ecole des Beaux-Arts and founder of the *Gazette des Beaux-Arts*, wrote in an influential handbook of art theory: "Painting is the art of expressing all the conceptions of the soul by means of all of the realities of nature, represented on a single surface in their forms and in their colors." (*Grammaire des arts du dessin* [Paris: Renouard, 1867], p. 509.)

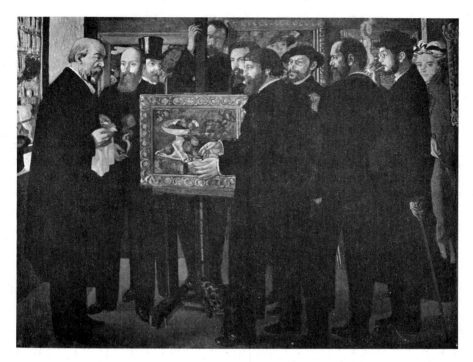

*Maurice Denis, Hommage à Cézanne, 1900, oil on canvas. (L to R: Odilon Redon, Edouard Vuillard, André Mellerio, Ambroise Vollard, Maurice Denis, Paul Sérusier, Paul Ranson, Ker-Xavier Roussel, Pierre Bonnard, Mme. Denis.)*

of his chromatic perceptions. While M. Bouguereau,[1] if his classroom corrections are sincere, is totally convinced that he is copying "nature."

### III

Go to the museum and consider each canvas apart, isolated from the others: each one will give you even if not a complete illusion at least an aspect of nature that pretends to be true. You will see in each picture what you want to see.

However, if it should happen that by an effort of the will one should see "nature" in the pictures, the reverse is true. Painters have an ineluctable tendency to merge those aspects perceived in reality with aspects of painting already seen.

---

[1] Adolph-William Bouguereau (1825–1905) was a popular academic salon painter, a member of the academy, and a favorite of the court. He preferred familiar Neoclassical subjects, which he rendered in a meticulous and hyper-refined style. His most popular subjects were his nudes, which were erotic both in the smooth, soft surfaces and in their concept. Thus he represented an outdated and devitalized tradition, as well as entrenched special privilege, to the younger and more original artists.

It is impossible to determine all that can modify the modern vision, but there is no doubt but that the torment of intellectuality, through which most of the young artists pass, results in the creation of very real optical deviations. One sees very readily grey violets when one has for a long time sought whether or not they are violet.

The irrational admiration of old pictures because they must be admired, in which one seeks conscious renditions of nature has certainly deformed the eye of the masters of the schools.

From the admiration of modern pictures, which one studies in the same spirit, comes an infatuation that leads to other difficulties. Has it been observed that this indefinable "nature" perpetually modifies itself, that it is not the same in the salon of 1890 as in the salons of thirty years ago, and that there is a fashion in "nature"—a changing fantasy as with clothing and hats?

## IV

Thus the modern artist forms, by choice and synthesis, a certain eclectic and exclusive habit of interpreting optical sensations—which becomes the naturalist criterion, the ideosyncratic character of the painter, what *littérateurs* later called temperament. It is a kind of hallucination about which aesthetics has nothing to say, since reason itself depends upon it and exerts no control.

## V

When one says that nature is beautiful, more beautiful than all of painting—assuming that we remain within the limitations of aesthetic judgment—he means to say that one person's impressions of nature in himself are better than those of others. That we must readily admit. But does one want to compare the hypothetical and imagined plenitude of the original effect with the mere notation of that effect by such and such a consciousness? Here the great question of temperament presents itself: "Art is nature seen through a temperament."[1]

A very just definition because it is very vague, and which leaves uncertain the important point, the criterion of temperaments. The painting of M. Bougereau is nature seen through a temperament. M. Raffaëlli is an extraordinary observer, but do you think he is sensitive to beautiful forms and colors? Where does the "painter" temperament begin and end?

There is a science which is concerned with these things: aesthetics (is it not known?) which, thanks to the research of Charles Henry, defines and bases itself on the psychology of Spencer and Bain.

Before exteriorizing sensations such as those, it would be necessary to determine their value from the point of view of beauty.

[1] Although Denis quotes Emile Zola's famous aphorism, his own belief is almost diametrically opposite, since he wished to transcend the individual temperament and base his art upon universals.

## VI

I do not know why painters have so misunderstood the word "naturalist'"when applied in a uniquely philosophic sense to the Renaissance.

I maintain that the predellas of Angelico which are in the Louvre, *The Man in Red* of Ghirlandaio, and many other works of the Primitives, recall for me more precisely "nature" than Giorgione, Raphael, Da Vinci. They are another manner of seeing—they are different fantasies.

## VII

And then in our sensations everything changes, both object and subject. One must be very well trained to perceive the same model on the table on two successive days. There is life, the intensity of coloration, light, mobility, air, a host of things which one does not render. I am now on familiar themes that are, however, very true and quite obvious.

## VIII

Finally, I recognize that there is a strong possibility that general assent, in this as in other insoluble questions, has some value, namely, that the photograph conveys to a greater or less degree the reality of a form, and that a facsimile of nature is "as much nature as possible."

Therefore, I will say of these sorts of works and of those that tend toward them that they are "nature." I will call "nature" the *trompe l'oeil* of the crowds, like the grapes of the antique painter pecked by the birds, and the panoramas of M. Detaille, where one is uncertain (O, aesthetic emotion) if a certain caisson in the foreground is real or on the canvas.

## IX

"Be sincere: it is sufficient to be sincere to paint well. Be naïve. Make crudely that which one sees."

This is the proper and infallible apparatus of the rigorous exactitude that they want to fabricate in the academies!

## X

Those who have frequented the atelier of Bourgereau have received no instruction the equal of that when one day the master proclaimed: "Drawing, it is the connective tissue."

The anatomical complexity of connective tissue was fixed in his mixed-up brain as something extraordinary and desirable! Drawing, it is the connective tissue! Of all the good people who think that this is like Ingres! I would not be astonished at this afterthought if it were an improvement upon Ingres. With naturalism, certainly yes! The naturalist photographs.

They are all here, the meager talents who are the masters of today. They have inaccurate memories of the romantic effervescence, of pilgrimages to Italian

museums, of the obligatory admiration of the masters. These events are ever incomprehensible for the deformation of their aesthetic—they have retained only some motifs from the masters. Delacroix said that he would gladly spend his time giving away the stations of the cross sold in the bazaar (Alas, how numerous they are in our churches!). The gentlemen of the Institute concern themselves with making the canvases of the Renaissance discordant. And there still remains enough of the splendor which they disparage to excite the unintelligent admiration of the masses, who turn instinctively toward this beauty.

## XI

Factors in the reputation of Meissonier:[1]

(a) Deformation of intimate Dutch compositions.

(b) The abundant literary spirit (the faces of Napoleon, which is grotesque to us, approaches the sublime for the crowd). The expression of the heads: very spirited; the naïve gamester, the crafty one, the impudent and the ironic ones.

(c) Above all, the mastery of execution, which makes one exclaim without reserve, "That's powerful."

Oh, this grievous vulgarization of art, this facile dilettantism! They enjoy utilizing technical terms, they persuade themselves in the end that they are judging!

## XV

"Art, it is when things appear rounded," another definition by a lost soul.

Did not this ingenious and unknown history of modeling come from Paul Gauguin?

In the beginning was a pure arabesque, as little *trompe l'oeil* as possible; the wall is empty: fill it with symmetrical spots of form, harmonious with colors (stained-glass, Egyptian paintings, Byzantine mosaics, Japanese kakemonos).

Then comes the painted bas-relief (metopes of Greek temples, the church of the Middle Ages).

Then the trial of antiquity in ornamental *trompe l'oeil* is taken up again by the fifteenth century, replacing painted bas-relief by painting modeled like bas-relief, which, moreover, retains the initial idea of decoration (the Primitives; remember the conditions in which Michelangelo, a sculptor, decorated the vault of the Sistine).

Perfection of this modeling: modeling in full relief, that leads from the first academies of the Carrachi to our decadence. Art is when things appear rounded.

[1] Ernest Meissonier (1815–1891) specialized in large history paintings, in particular of the armies of Napoleon in the field. His style, however, was an unselective and unimaginative naturalism that rendered his dramatic or heroic subjects banal to the eyes of the young followers of Gauguin.

## XX

All the feeling of a work of art comes unconsciously, or nearly so, from the state of the artist's soul. "He who wishes to paint Christ's story must live with Christ," said Fra Angelico. This is a truism.

Let us analyze the hemicycle of Chavannes at the Sorbonne that necessitates a written explanation for the vulgar. Is it literary? Certainly not, for that explanation is false: the examiners of the baccalaureat should know that the beautiful form of Ephebus that droops down toward a semblance of water symbolizes studious youth. It is a beautiful form, is it not, aesthetes? And the depth of our emotion comes from the ability of these lines and of these colors to explain themselves as uniquely beautiful and divine with beauty.

With the *Ménages sans enfants:* the legend alone interests me (they will give you 25 fr. 50 to begin)[1] because the ridiculousness of a minute rendering of dirty heads and of grotesque furnishings repulses me; it is the same malady, I assure you, as the little guns of M. Detaille or the bracelets of M. Toulmouche.

It is effort with Raffaëlli; limpid and normal play of faculties with Chavannes.

And to continue. Would not the trickery of *trompe l'oeil,* sought for or attained, contribute to the disagreeable effect that I have called "literary"?

Imagine Paul Gauguin's *Calvaire* if executed by M. Friant.[2] That idea should come from F. Coppée. It is that our overwhelming impression of a moral order in front of the Calvary or of the bas-relief *Soyez Amoureuse* does not emerge from the motif or the objects of nature represented, but from the representation itself, from forms and coloration.

The emotion—bitter or sweet, "literary" as the painters say—emerges from the canvas itself, a plane surface covered with colors. There is no need to interpose the memory of any former sensation (as that of a motif derived from nature).

A Byzantine Christ is a symbol; the Jesus of the modern painter, even in the most correctly drawn headdress, is merely literary. In the one, the form is expressive; in the other, an imitation of nature which tries to be nature.

And as I said that all representation can be derived from nature, every beautiful work can arouse the highest and most complete emotions, the ecstasy of the Alexandrians.

Even a simple research in lines, as the *Femme en rouge* by Anquetin (at the Champ de Mars) has a feeling value.

---

[1] This is a rather facetious remark arising from the fact that Denis finds himself in a position of agreement with the "vulgar public" mentioned above, that is, both are interested in the story. Hence, the mention of the payment to begin, which probably means that, lacking atristic interest, the painting has only the legend—its beginning point—to redeem itself.

[2] At Boussod and Valadon [Paris] (1890). M.D.

Also the frieze of the Parthenon, also, above all, a great sonata of Beethoven!

## XXII

Here is the only form of art, the true. When unjustifiable partisanships and illogical prejudices are eliminated, the field is cleared for the imaginations of the painters, for the aesthetes of beautiful appearances.

Neotraditionism cannot be slowed down by learned and feverish psychologies, with literary sentimentalities; it calls myth all those things which are not of its emotional domain.

It attains definitive syntheses. Everything is contained within the beauty of the work itself.

## XXIV

Art is the sanctification of nature, of that common nature which is content just to exist. Great art, what we call decorative, is the art of the Hindus, Assyrians, Egyptians, Greeks, the art of the Middle Ages and the Renaissance, and the works decidedly superior to modern art. What is great art if not the disguise of natural objects with their vulgar sensations by icons that are sacred, magical and commanding?

Is it hieratic simplicity of the Buddhas; or of monks transformed by the aesthetic sense of a religious race? Compare again a lion in nature to the lions of Khorsabad; which of them forces one to his knees? The Doryphorus, Diadumenos, Achilles, Venus di Milo and the Samothrace are truly the redemption of the human form. Do we need to speak of the saints of the Middle Ages? Do we need to cite the prophets of Michelangelo and the women of Da Vinci?

I have studied the Italian Pignatelli from whom Rodin took his *John the Baptist*; it is, instead of a banal model, an apparition of a voice on the march; a venerable bronze. And do we know who was the man whom Puvis exalted in the eternally melancholy *Poor Fisherman?*

Universal triumph of the imagination of the aesthetes over crude imitation; triumph of the emotion of the Beautiful over the naturalist deceit.

*Maurice Denis, from "The Influence of Paul Gauguin," 1903*\*

Gauguin is dead, and now that Séguin's well-documented study has been published in *L'Occident*,[1] it is more appropriate to examine his influence on the artists of his time than his own work, which we hope will soon be brought together in a complete exhibition.

---

\* *L'Occident* (Paris), October 1903. Included in Denis, *Théories*, 1920, pp. 166–171.
[1] *L'Occident*, March, April, and May 1903.

The most daring young artists among us who around 1888 attended the *Académie Julian* were almost completely ignorant of the great movement in art which under the name of Impressionism had just revolutionized the art of painting. They had gotten to Roll, to Dagnan; they admired Bastien-Lepage; they spoke of Puvis with a respectful indifference, although secretly doubting that he knew how to draw. Thanks to Paul Sérusier, then *massier* [monitor] for the little studios of the Faubourg Saint-Denis and executing his duties with brilliant imaginativeness, the milieu was, without a doubt, much more cultivated than those of most of the academies. It was customary there to speak of Péladan and of Wagner, of the Lamoureux concerts, and of decadent literature, about which, by the way, we knew little enough. One of Ledrain's students introduced us to Semitic literature, and Sérusier held forth on the doctrines of Plotinus and the School of Alexandria to young Maurice Denis, who was studying there for his examination in philosophy for the *Baccalauréat ès lettres*.

It was at the beginning of 1888 that the name of Gauguin was revealed to us by Sérusier, back from Pont-Aven, who showed us, not without a certain mystery, a cigar box cover on which could be seen a landscape [later called the "Talisman."] It seemed crude because of its synthetic formulation in purple, vermilion, Veronese green and other pure colors—just as they came out of the tube—with almost no white mixed in. "How do you see this tree," Gauguin had said, standing in one of the corners of the *Bois d'Amour*. "Is it really green? Use green then, the most beautiful green on your palette. And that shadow, rather blue? Don't be afraid to paint it as blue as possible."

Thus was introduced to us for the first time, in a paradoxical and unforgettable form, the fertile concept of the "plane surface covered with colors assembled in a certain order." Thus we learned that every work of art was a transposition, a caricature, the passionate equivalent of a sensation received. This was the origin of an evolution in which H. G. Ibels, P. Bonnard, Ranson, M. Denis participated without delay.[1] We began to frequent some places completely unknown to our patron, Jules Lefebvre: the mezzanine of the Maison Goupil on the boulevard Montmartre, where Van Gogh, the painter's brother, showed us, along with the Gauguins from Martinique, the Vincents, the Monets and the Degas'; Père Tanguy's shop in the rue Clauzel where, with such emotion, we discovered Paul Cézanne.

---

[1] We will not attempt to name here all of Gauguin's "students." Some, like Armand Séguin, were frequent and attentive visitors to him in Brittany. Others were subjected to his influence only through Sérusier. Such was Jan Verkade, who evolved from Synthetism to Divine Proportions and became one of the most remarkable artists of the School of Beuron. For Edouard Vuillard, the crisis brought on by Gauguin's ideas was of short duration. He does owe to Gauguin, however, the solidity of the system of dabs upon which he sustains the intense and delicate charm of his compositions. As for Aristide Maillol, I doubt if he had ever met Gauguin; and yet what a lesson the *xoana* of the Master of Pont-Aven would have been for this Greek of the *belle époque*! M.D.

The extremely philosophical intellect of Sérusier very quickly transformed the least words of Gauguin into a scientific doctrine, which made a decisive impression on us. For Gauguin was no professor. Nevertheless some people accused him of being one—Lautrec took malicious pleasure in giving him this appellation. On the contrary, Gauguin's was an intuitive gift. In his conversation, as in his writing, there were striking aphorisms and profound insights—affirmations, in a word, of a logic which astounded us. I imagine that he realized this only later, after leaving Brittany where his initiates[1] were gathered, for Paris, where at the time of the great manifestations of literary symbolism he found that his ideas had been given systematic and polished form, by such writers, for example, as Albert Aurier.

It was perhaps not he who invented Synthetism, which became Symbolism through contact with the literary men. Emile Bernard is very positive on this controversial question. All the same Gauguin was the Master, and the undisputed one. His paradoxes were welcomed and quoted by everyone. He was admired not only for his talent and inexhaustible imagination, but for every trait in his romantic behavior—his gesticulation and fluency, his physical strength, his capacity for alcohol, and his pugnacity. The mystery of his ascendancy was to furnish us with one or two very simple and essential verities at a time when we were completely lacking in instruction. Thus, without ever having sought beauty in the classic sense, he soon had us engrossed in it. He wanted above all to convey character, to express the "inner thought," even in ugliness. He was still an Impressionist, but he claimed to read the book "wherein are written the eternal laws of Beauty."[2] He was fiercely individualistic and yet he clung to the most collective and most anonymous of the popular traditions. And we extracted a law, instructive principles, and a method from his contradictions.

But the Impressionist ideal was far from being outmoded, even at that late date—a living was to be had from the acquisition and sale of a Renoir or a Degas. Gauguin passed this ideal on to us, adding to it the borrowings he himself had made from the classic tradition and from Cézanne. He revealed Cézanne's work to us not as that of an independent genius, or of an irregular from the school of Manet, but as what it actually is, the outcome of a long effort and the necessary result of a great crisis.

As it had always been explained by its proponents' works and by their paradoxes, Impressionism meant a return to the sun, to diffused light and freedom of composition. It meant the sense of values seen in Corot's work, an iridescent technique, a taste for fresh color, and finally the Japanese influence, that leaven which little by little permeated the whole mixture. It was all that, yes, but much

---

[1] There were also his friends Emile Bernard, Filiger, De Haan, Maufra, as well as Chamaillard, who had some influence on the evolution of his ideas. Not to forget that he saw a great deal of Van Gogh. M.D.

[2] Preface to Armand Séguin's Catalogue, 1895 M.D. [The preface was reprinted in *Mercure de France*, XIII (February 1895), 223–224. H.B.C.]

else besides. Along with this bequest, Gauguin announced to us a second, presenting both at the same time.

Gauguin freed us from all the hindrances imposed upon our painters' instincts by the idea of copying. In our studio the grossest realism had followed the colorless academicism of the last students of Ingres; there one of our professors, Doucet, recommended that we use photographs of Jerusalem to heighten the interest of a sketch whose subject was borrowed from the Passion of Jesus Christ. We were, however, aspiring to the joy of "self-expression," an idea which was then dominating the young writers just as insistently as it is now. The theory of equivalents, which we had extracted from Gauguin's expressive imagery, furnished us with the means toward this goal. Gauguin gave us a claim to lyricism; for instance, if we could paint in vermilion that tree which appeared to us very reddish at a certain moment, why, then, not translate these impressions plastically by exaggeration, which is justifiable in the metaphors of poets? Why not stress even to the point of distortion the curve of a lovely shoulder, overdo the pearly whiteness of a flesh tint, stylize the symmetry of a branch not moved by any wind?

That explained to us everything in the Louvre and the Primitives, and Rubens and Veronese. But we completed the rudimentary teaching of Gauguin by substituting for his over-simplified idea of pure color the idea of beautiful harmonies, infinitely varied as in nature. We adapted all the resources of the palette to all the conditions of our sensibilities, and the sights motivating them became just so many symbols of our own subjectivity. We sought equivalents, but equivalents in beauty! Meanwhile, in contrast to us, some exaggeratedly conscientious Americans were displaying a stupid skill in copying the banal shapes of some insignificant model under dingy light.[1] Our eyes were filled with the splendors that Gauguin had brought back from Martinique and from Pont-Aven. Magnificent dreams compared with the miserable realities of official instruction! It was a salutary intoxication, an unforgettable wave of enthusiasm! Moreover, Sérusier proved to us by Hegel that logically and philosophically, it was Gauguin who was right, and the weighty articles of Albert Aurier emphasized the fact.

At that time we hardly felt Gauguin's exotic savor, the quasi-barbaric refinements of his Impressionism. We saw him only as the decisive example of Expression through Décor.

[1] Many foreign students attended the *Académie Julian,* because many important salon painters and professors at the *Académie des Beaux-Arts* taught there and because there were no entrance examinations. The American Robert Henri was a student during the same years that Denis and his companions were there. Henri was indignant at the lack of seriousness of most of the students. He wrote: "Julian's Academy, as I knew it, was a great cabaret with singing and huge practical jokes and, as such, was a wonder . . . . It was a factory, too, where thousands of drawings were turned out.

"It is true, too, that among the great numbers of students there were those who searched each other out and formed little groups which met independently of the school, and with art as a central interest, talked and developed ideas about everything under the sun." *The Art Spirit* (Philadelphia: Lippincott, 1923), p. 101.

The word "decorative" had not yet become the *tarte à la crème* of discussions among artists and even among laymen. Gauguin, with an unusual incognizance, denied to his most perspicacious admirers that he was a decorator. The fact that he admitted being an artisan, that he made furniture, pottery, that he embellished even his wooden shoes, makes us sympathize very keenly with the apostrophe of Aurier: "Well, what about it! We have in our agonized century only one great decorator, two perhaps, counting Puvis de Chavannes, and our imbecilic society, made up of bankers and engineers, refuses to give to this unique artist the smallest palace, the meanest national hovel, in which to hang the sumptuous cloaks of his dreams!" (*Révue encyclopédique*, April 1892.)

His honest treatment, homogeneous, flexible, and broad, which he evidentally got from Cézanne, was as far from scientific Pointillism as the glossy trickeries of the first students of Moreau. He executed a canvas of 6[1] with the breadth of an immense fresco. And from that we drew the wise maxim that all painting has as its aim to decorate and to be ornamental.

Art Nouveau and its snobbery did not yet exist. The Exhibition of 1889 had not yet revealed the researches in foreign countries, especially of the English.

Thus at the perfect moment it had been Gauguin's role to project into the spirit of several young men the dazzling revelation that art is above all a means of expression. He had taught them, perhaps without wanting to, that all objects of art must be decorative. And finally, by the example of his work, he had proven that all grandeur, all beauty is worth nothing without simplification and clarity, or without a homogeneity of *matière*.

He was not the sort of "gentleman artist" that had become so distasteful to us for the past fifteen years—indeed, his sensuality was uncommon—but his works were rugged and sound. He fully justified Carlyle's etymological play on words with *genius* and *ingenuity*. Something of the essential, of the profoundly true, emanated from his savage art, from his rough common sense, and from his vigorous naïveté. The paradoxes which he brought out in conversation, undoubtedly in order to seem just as pretentious as the others, and because he was a Parisian, concealed basic teachings, deep truths, eternal ideas, which no art in any era has been able to do without. With them he invigorated painting again. He was for our corrupt time a kind of Poussin without classical culture, who, instead of serenely going to Rome to study the antiquities, became inflamed by a passion to discover a tradition beneath the coarse archaism of Breton calvaries and of Maori idols, or in the crude coloring of the *Images d'Epinal*.[2] Yes, but like the great

---

[1] Canvases and stretcher bars come in standard sizes designated by numbers. Each number refers to the longer dimension of a rectangle; and each number is subdivided into three proportions: a long rectangle called "seascape," a shorter one called "landscape," and one approaching a square called "figure."

All size 6 canvases are approximately $16\frac{1}{2}$ inches long, while the width varies approximately as follows: seascape, 10 inches; landscape, 11 inches; and figure, 13 inches. See complete table of sizes in chap. i, *Postimpressionism*.

[2] Popular prints, usually woodcuts, in a crude style and color and with moralistic

Poussin, he passionately loved simplicity and clarity, which he incited us to desire unreservedly. For him too, *synthesis* and *style* were almost synonymous.

## Maurice Denis, Synthetism, 1907★

To synthesize is not necessarily to simplify in the sense of suppressing certain parts of the object: it is to simplify in the sense of *rendering intelligible*. It is, in short, to put in hierarchic order: to set each picture to a single rhythm, to a dominant; it is sacrifice, to subordinate—to generalize. It does not suffice to *stylize* an object, as they say at the school of Grasset; that is to make a nondescript copy of something, and then heavily to emphasize the outside contour. Simplification thus achieved is not synthesis.

"Synthesis," said Sérusier, "consists in containing all possible forms within the small number of forms which we are capable of conceiving: straight lines, the several angles, arcs of circles, and ellipses. Outside of these we become lost in an ocean of varieties." Here is doubtlessly a mathematical conception of art, not lacking in grandeur.

## Maurice Denis, Subjective and Objective Deformation, 1909†

We have substituted for the idea of "nature seen through a temperament," the theory of equivalence or of the symbol; we asserted that the emotions or spiritual states caused by any spectacle bring to the imagination of the artist symbols or plastic equivalents. These are capable of reproducing emotions or states of the spirit without it being necessary to provide the *copy* of the initial spectacle; thus for each

---

overtones. They usually depicted familiar historical events, such as the exploits of Napoleon, or fables from folklore. The chief producer was in Epinal (Vosges).

★ Excerpt from "Cézanne," *L'Occident* (Paris), September 1907. Included in Denis, *Théories*, 1920, pp. 245–261, excerpt p. 260.

Denis uses both the terms Symbolism and Synthesism (Synthetism) in the two following essays. A clear distinction is not easy, but Rookmaaker makes a useful one (*Synthetist Art Theories*, Chs. III, V, VI): *Symbolism* means the ideas developed by the poets from Baudelaire to the Symbolist movement itself, and their counterparts among the painters, especially Gustav Moreau, Rodolphe Bresdin and Odilon Redon. They accept the traditional device of the allegory, the idea of the "literary" subject and in general the appearances and characteristics of the physical world. *Synthetism*, on the other hand, as applied to the artists of Gauguin's circle, accepts the Symbolists' equivalence of reality and the symbol, but believes that it is not necessary to represent objects in order to transmit emotion but that the work of art itself had that possibility.

† Excerpts from "De Gauguin et de Van Gogh au Classicisme," *L'Occident* (Paris), May 1909. Included in Denis, *Théories*, 1920, pp. 262–278, excerpts pp. 267–268, 275.

state of our sensibility there must be a corresponding objective harmony capable of expressing it.[1]

Art is no longer only a visual sensation which we record, only a photograph, however refined it may be, of nature. No, it is a creation of our spirit of which nature is only the occasion. Instead of "working with the eye, we search in the mysterious center of thought," as Gauguin said. Thus imagination again became, as Baudelaire wished, the queen of the faculties. Thus we set free our sensibility, and art, instead of being a *copy*, became the *subjective deformation* of nature.

From the objective viewpoint, the decorative composition, aesthetic and rational, which was not conceived by the Impressionists because it was contrary to their taste for improvisation, became the counterpart, the necessary corrective, to the theory of equivalents. It sanctioned for the sake of expression all transformations, even to the point of being caricatural, and also all excesses of character. The *objective deformation* in turn obliged the artist to transpose everything into Beauty. In summary, the expressive synthesis, the symbol, of a feeling, must be an eloquent transcription of it and at the same time be an object composed for the pleasure of the eyes.

Intimately bound together in Cézanne, these two tendencies are found again in various states in Van Gogh, in Gauguin, in Bernard, in all the old synthetists. It is in correspondence to their thought; it is a proper summation of the essence of their theory to reduce it to the two deformations. But while decorative deformation is Gauguin's usual preoccupation, it is on the contrary subjective deformation which gives Van Gogh's painting its character and its lyricism. With the former, under crude or exotic appearances, one finds again, along with a rigorous logic, artifices of composition in which, I venture to say, a little Italian rhetoric survives. The other, who comes to us from Rembrandt's country, is, on the contrary, an exasperated romantic; the picturesque and the pathetic touch him much more than plastic beauty and order. Thus they represent an exceptional example of the double classic and romantic movement. Let us find in these two masters of our youth some concrete images to illustrate a statement too abstract and perhaps obscure . . . .

In the same way, having accepted Symbolism or the theory of equivalents, we can define the role of imitation in the plastic arts. It is this knowledge which is the central problem of painting. The School of Overbeck,[2] the School of Ingres,

[1] I have already given this definition of Symbolism many a time. It is less metaphysical than Aurier's in his already cited manifesto of 1892, but his has never been understood by painters. Let us meditate upon this word from Cézanne: "I wanted to copy nature . . . I wasn't able to. I was satisfied with myself when I discovered that the sun, for example (sunny objects), could not be reproduced but had to be represented by something else than that which I was seeing—by color . . . ." Emotion which a beautiful object evokes is in every way similar to the religious emotion which overcomes us when we enter a Gothic nave; such is the power of the proportions, of the colors, and of the forms brought together by genius, so that they inevitably impose on any spectator the spiritual state which has created them. M.D.

[2] Johann Friedrich Overbeck (1789–1869) was a member of the Nazarenes, the German Romantic group who took their subject matter from Christianity and who aspired to live

all of the academic schools held to the cult of objective, canonical beauty, —and thus the question was badly put. But the great error of the nineteenth-century academies was to have taught a paradox between style and nature. The Masters never distinguished between reality, as an element in art at least, and the interpretation of reality. Their drawings and their studies from nature have just as much style as their paintings. The word ideal is misleading; it dates from an era of materialistic art. One does not stylize artificially, after the event, a stupid copy of nature. "Do what you like, so long as it is intelligent," Gauguin said. Even when he imitates, the genuine artist is a poet. The technique, the content, the aim of his art warn him well enough not to confuse the *object* that he creates with the spectacle of nature which is the subject of it. The Symbolist viewpoint asks us to consider the work of art as an equivalent of a sensation received; thus nature can be, for the artist, only a state of his own subjectivity. And what we call subjective distortion is virtually style.

### Ferdinand Hodler, "Parallelism" ★

I call parallelism any kind of repetition.

When I feel most strongly the charm of things in nature, there is always an impression of unity.

If my way leads into a pine wood where the trees reach high into heaven, I see the trunks that stand to the right and to the left of me as countless columns. One and the same vertical line, repeated many times, surrounds me. Now, if these trunks should be clearly outlined on an unbroken dark background, if they should stand out against the deep blue of the sky, the reason for this impression of unity is parallelism. The many upright lines have the effect of a single grand vertical or of a plane surface . . . .

A tree always produces the same form of leaf and fruit. When Tolstoy, in *What is Art?*, says that two leaves of the same tree are never exactly alike, one might more correctly answer that nothing looks more like a maple leaf than the leaf of the maple . . . .

I must also point out that in nearly all the examples I have just given, the repetition of color enhances that of form. The petals of a flower, as well as the leaves of a tree, are generally of the same color.

Now we also recognize the same principle of order in the structure of animal and human bodies in the symmetry of the right and left halves . . . .

---

as "monks in a monastery of art." Despite their high idealism their styles were eclectric, deriving mainly from various Italian fifteenth-century masters. Hence, they soon lapsed into an academic style.

★ Originally published in Ewald Bender, *Die Kurst Ferdinand Hodlers*, I, *Das Früwerk Bis 1895* (Zurich: Rascher, 1923), pp. 215–228. This English translation from *Artists on Art*, edited by Robert Goldwater and Marco Treves, pp. 392–394. Reprinted by permission of Pantheon Books, Inc., a Division of Random House, Inc.

*Ferdinand Hodler, poster for his exhibition at the Vienna Secession, 1904.*

Let us then sum up: Parallelism can be pointed out in the different parts of a single object, looked at alone; it is even more obvious when one puts several objects of the same kind next to each other.

Now if we compare our own lives and customs with these appearances in nature, we shall be astonished to find the same principle repeated . . . .

When an important event is being celebrated, the people face and move in the same direction. These are parallels following each other . . . .

If a few people who have come together for the same purpose sit around a table, we can understand them as parallels making up a unity, like the petals of a flower.

When we are happy we do not like to hear a discordant voice that disturbs our joy.

Proverbially, it is said: Birds of a feather flock together.

In all these examples parallelism, or the principle of repetition, can be pointed out. And this parallelism of experience is, in expression, translated into the formal parallelism which we have already discussed . . . .

If an object is pleasant, repetition will increase its charm; if it expresses sorrow or pain, then repetition will intensify its melancholy. On the contrary, any subject that is peculiar or unpleasant will be made unbearable by repetition. So repetition always acts to increase intensity . . . .

Since the time that this principle of harmony was employed by the primitives, it has been visually lost, and so forgotten. One strove for the charm of variety, and so achieved the destruction of unity . . . .

Variety is just as much an element of beauty as parallelism, provided that one does not exaggerate it. For the structure of our eye itself demands that we introduce some variety into any absolutely unified object . . . .

To be simple is not always as easy as it seems . . . .

The work of art will bring to light a new order inherent in things, and this will be: the idea of unity.

### James Ensor, *The Beach at Ostende, 1896*★

The beach is extraordinarily animated. It is a mixture of all of the elegant Brussellois and the less elegant public of Ghent—a disparate, mottled world. Slick young men in flannels rampant on the field of sand. Mussels heaped upon more mussels. Little cuties teasing soft, crablike creatures. Slender Englishwomen stride briskly past, etc., etc.

*Picture postcard of the beach at Ostende with*
*a drawing by Ensor.*

★ Excerpt from "A Ostende," *La Ligue Artistique* (August 1896). Included in James Ensor, *Les Ecrits de James Ensor* (Brussels: Luminère, 1944), p. 69.

Ensor lived his entire life, except for brief visits to Brussels and Paris, just off the beach front in the seaside resort city of Ostende. During the summer season the beach was crowded with peasants from the neighboring rural regions and visitors from Brussels and Dover just across the channel. Since Ostende was the nearest foreign resort to London, other than French ones, many English visitors preferred its lower prices and generally greater sympathy with their own habits and preferences in food.

This swarming of ants increases on Sundays at bathing time: bathers maneuvering their pachydermic shapes on broad, flat feet. Toadlike female peasants, broad bottoms, screeching. Rustics soaping their grimy feet. Grotesque horseplay. Indescribable tumbles, etc., etc.

Some shadows on this happy scene: we cite the hardhearted donkey drivers, tattered dirt-eaters. A rapacious tribe that sickens all sensitive hearts and litters the beautiful, delicately tinted beach. The English people now and then distractedly slapping their insensible brats. Let us comfort the martyred donkeys and lash the ferocious sneaks.

Another distressing picture: a nondescript aquarium, mysterious fish swimming there between two glass plates. Some sorrowful shellfish sprawling inert in stagnant water. A fish expectorating a kind of acid in the faces of the good Ostendais, themselves spitters of subsidies. Chameleon-like whitefish, pustulated lobsters, ill-tempered crabs, shabby wood lice, etc., etc.

## James Ensor, from the Preface to his Collected Writings, 1921 *

Let us present our claims fully and philosophically, and if they seem to have the dangerous odor of pride, so much the better.

Definite and proven results:

My unceasing investigations, today crowned with glory, aroused the enmity of my snail-like followers, continually passed on the road. [How can one explain the appreciations of a Semmonier, Mauclair, etc., since] thirty years ago, long before Vuillard, Bonnard, Van Gogh and the luminists, I pointed the way to all the modern discoveries, all the influence of light and freeing of vision[?]

A vision that was sensitive and clear, not understood by the French Impressionists, who remained superficial daubers suffused with traditional recipes. Manet and Monet certainly reveal some sensations—and how obtuse! But their uniform effort hardly foreshadows decisive discoveries.

Let us condemn the dry and repugnant attempts of the Pointillists, already lost both to light and to art. They apply their Pointillism coldly, methodically, and without feeling; and in their correct and frigid lines they achieve only one of the aspects of light, that of vibration, without arriving at its form. Their too-limited method prohibits further investigation. An art of cold calculation and narrow observation, already far surpassed in vibration.

* The preface from which this is an excerpt appears in the 1921 edition of *Les Ecrits* (Brussels: Sélection), pp. 22–24, but not in the 1944 edition cited above. This English translation is from Goldwater and Treves, *Artists on Art*, p. 387. Passages enclosed by brackets were omitted there and are translated by the editor.

In later years Ensor was honored by many art and literature societies. He continued to write essays bitterly critical of the foibles of Belgian society and he gave banquet speeches in which he assumed the role of a wise old sage. In 1930 he was given the title of Baron by the King of Belgium.

O Victory! the field of observation grows infinite, and sight, freed and sensitive to beauty, always changes; and perceives with the same acuity the effects or lines dominated by form or light.

[Extensive researches will seem contrary.] Narrow minds demand old beginnings, identical continuations. The painter must repeat his little works, and all else is condemned. [That is the advice of certain classifying censors, who segregate our artists like oysters in an oyster bed. O, the odious meannesses that favor the conformists of art! For the shabby in spirit, the outdoor painter may not attempt a decorative composition; the portraitist must remain one for life!] These poor creatures demand that adorable fantasy, roseate flower of heaven, the inspirer of the creative painter, be severely banished from the artistic program . . . .

Yes, before me the painter did not heed his vision.

*James Ensor, from a speech delivered at a banquet given for him by La Flandre Littéraire, Ostende, 22 December 1923**

Ever since 1882 I've known what I am talking about. Observation modifies vision. The first vulgar vision is simple line, dry and without attempt at color. The second phase is when the more practiced eye discerns the values and delicacy of tones. This vision is already less commonplace.

The last phase of vision is when the artist sees the subtlety and the shifting play of light, its planes and its attractions. These progressive discoveries modify the primitive vision; line weakens and becomes secondary. This vision will be poorly understood; it requires long observation and attentive study. The vulgar will see in it only disorder and error. Thus has art evolved from the line of the Gothic through the color and movement of the Renaissance, finally to culminate in the light of modern times. Again I'll say it: Reason is the enemy of art. Artists dominated by reason lose all feeling, powerful instinct is enfeebled, inspiration becomes impoverished and the heart lacks its rapture. At the end of the chain of reason is suspended the greatest folly, or the nose of a pawn.

All the rules, all the canons of art vomit death exactly like their bronze-mouthed brothers of the battlefield. The learned and reasoned investigations of the Pointillists, researches pointed out and extolled by scientists and eminent professors, are dead, stone dead.

Impressionism is dead, luminism is dead—all meaningless labels. I have seen born, pass and die many schools and promoters of ephemera. Cubists, Futurists [etc., etc.] . . . .

And so, I have cried with all my lungs: the louder these bullfrogs croak the closer they are to bursting.

My friends, works of a personal vision alone will live. One must create a

* Ensor, *Les Ecrits*, 1944, pp. 123–124. Translation by Nancy McCauley and myself.

*James Ensor, Myself Surrounded by Demons, 1898, color lithograph.*

personal pictorial science, and be excited before beauty as before a woman one loves. Let us work with love and without fear of our faults, those inevitable and habitual companions of the great qualities. Yes, faults are qualities; and fault is superior to quality. Quality stands for uniformity in the effort to achieve certain common perfections accessible to anyone. Fault eludes conventional and banal perfections. Therefore fault is multiple, it is life, it reflects the personality of the artist and his character; it is human, it is everything, it will redeem the work.

*James Ensor, from a speech delivered at his exhibition at the Jeu du Paume, Paris, 1932*★

The Flemish sea gives me all its nacreous fires, and I embrace it every morning, noon, and night. Ah, the wonderful kisses of my beloved sea, sublimated kisses, sandy, perfumed with foam, refreshingly pungent.

★ This English translation from Paul Haesaerts, *James Ensor* (New York: Abrams, 1959), pp. 357–358.

I salute you, Paris, and all your hills where people work and have fun. Paris, powerful magnet, all the big stars of Belgium cling to your sides. Paris, fetish, I have brought you my own little star, show me your best profile.

Dear friends, I recall 1929, the year of my most retrospective show at the Palais des Beaux-Arts in Brussels. Your generous critics vied with each other showering me with praise, and now your great men are interested in my labors.

Dear brothers-in-law of France, you will see close-up some of my interiors, my kitchen with curly cabbages, my barbate and striped fishes, my modern animalized goddesses, my lady friends with pursed lips rouged with adorable affectation, my rebellious angels glimpsed in the clouds, and I will be well represented.

All my paintings have come I don't know where from, mostly from the sea.

And my suffering, scandalized, insolent, cruel, malicious masks, and a long time ago I could say and write, "trailed by followers I have joyfully shut myself in the solitary milieu ruled by the mask with a face of violence and brilliance."

And the mask cried to me: Freshness of tone, sharp expression, sumptuous decor, great unexpected gestures, unplanned movements, exquisite turbulence.

O the animal masks of the Ostend Carnival: bloated vicuna faces, misshapen birds with the tails of birds of paradise, cranes with sky-blue bills gabbling nonsense, clay-footed architects, obtuse sciolists, with moldy skulls, heartless vivisectionists, odd insects, hard shells giving shelter to soft beasts. Witness *The Entry of Christ into Brussels*, which teems with all the hard and soft creatures spewed out by the sea. Won over by irony, touched by splendors, my vision becomes more refined, I purify my colors, they are whole and personal.

I see no heavy ochers in our country. Sterile ochers come from the earth, they shall return to the earth without drums or trumpets. Ah, the tender flowers of painting were submerged by a wave of mud.

Tarnished, rancid, crackled under the smoky varnishes, or excessively washed and scrubbed, embellished and retouched, the masterpieces of the great old painters have nothing valuable to say.

Iris is no longer there. Restorers, varnishers, listen to my ever-young motto:

Frogs that croak the loudest come closest to bursting. Let us brighten our colors that they may sing, laugh, shout all their joys.

From the heights of the sacred hills of Paris, all lighthouses lit up, shine, green lights of youth, golds and silvers of maturity, pinks of maidenhood.

Roar Fauves, wild beasts, Dodos, Dadas, dance Expressionists, Futurists, Cubists, Surrealists, Orphists. Yours is a great art. Paris is great.

Let us encourage the painter's art and its diverse canons. Fire salvos upon salvos, cannoneers of art, for the salvation of color.

Color, color, life of things living and inanimate, enchantment of painting. Colors of our dreams, colors of our loved ones . . . .

Cannoneers, to your guns, and you too, lady-cannoneers. Fire your salvos to glorify the genius of your artists, fire blanks at painters too fond of comforts.

Painters and lady painters, my friends, your holy cannons do not spew death but light and life.

*Edvard Munch, Art and Nature*\*

## Warnemünde, 1907–1908

Art is the opposite of nature.

A work of art can come only from the interior of man.

Art is the form of the image formed from the nerves, heart, brain and eye of man.

Art is the compulsion of man towards crystallization.

Nature is the unique great realm upon which art feeds.

Nature is not only what is visible to the eye—it also shows the inner images of the soul—the images on the back side of the eyes.

\* From Johan H. Langaard and Reidar Revold, *Edvard Munch* (Oslo: Belser, 1963), p. 62.

Although Munch was always very close to literary men, he wrote little on his art. His letters are concerned principally with personal and family affairs, and his seclusion late in life kept him away from those who might have inquired into his ideas.

Although frequently staying in sanitariums for treatment of mental illness and alcoholism, Munch continued to be productive. His stay at Warnemünde on the Baltic coast of Germany was a pleasant and creative period preceding a prolonged stay in a hospital in Copenhagen. He lived the last decades of his life at Ekely outside Oslo where he constructed a studio and a simple dwelling for himself.

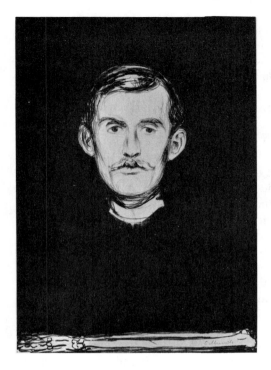

*Edvard Munch, Self-Portrait, 1896, lithograph.*

## Ekely, 1929

A work of art is like a crystal—like the crystal it must also possess a soul and the power to shine forth.

It is not enough for a work of art to have ordered planes and lines.

If a stone is tossed at a group of children, they hasten to scatter.

A regrouping, an action, has been accomplished. This is composition. This regrouping, presented by means of color, lines and planes is an artistic and painterly motif.

It [painting] doesn't have to be "literary"—an invective which many people use in regard to paintings that do not depict apples on a tablecloth or a broken violin.

## Ekely, 1928

One good picture with ten holes in it is better than ten bad pictures with no holes. A charcoal mark on the wall can be greater art than ten pictures on a solid background and in costly gold frames.

Leonardo da Vinci's best pictures are destroyed. But they do not die. An ingenious thought lives forever.

## Odilon Redon, *Suggestive Art, 1909**

What was it that at the beginning made my work difficult and at the same time slowed it down so? Was it a way of seeing that was not in accord with my particular talents? A kind of struggle between the heart and the mind?—I do not know.

The fact remains that at the very beginning I always aimed at perfection and (could you believe it) at the perfection of form. But let me tell you now that no plastic form—and I mean form observed objectively, exactly for what it is, according to the laws of light and shadow and by the rather conventional means of modeling—could be found in any of my works. At the very most, I often tried in the beginning to reproduce (for one must insofar as possible know everything) objects of the exterior world according to the rules of an art which was based on the old way of seeing. I simply did it as an exercise. But now in my maturity, I declare, indeed I insist, that all my work is limited exclusively to the resources of chiaroscuro. It also owes a great deal to the effects produced by the abstract character of line—that agent from a profound source acting directly upon the spirit. Suggestive art can fulfill nothing without going back uniquely to the mysterious play of shadows and the rhythm of imaginatively conceived lines. Ah, they were never more successfully realized than in the work of da Vinci. The mystery of his art and the boundless fascination which it exerts on our spirits would be impossible without them. They are the very roots of the words which constitute his language. And it is through a sense of perfection, excellence and reason, and through a quiet submission to the laws of nature that this admirable and supreme genius has mastered the entire art of form; he dominates it in its very essence. "Nature is overflowing with an infinite number of principles which are not a part of experience," he writes. Nature was for him, as it must be for all masters, both an absolute necessity and a basic axiom. What painter would ever think otherwise?

It is nature then that decrees that we obey the needs of the gifts which she has bestowed upon us. My own talents have directed me into the realm of dreams. I gave myself over to the torments of the imagination and to the various surprises that nature provided for me by means of my pencil, but I channeled and trained these surprises according to the basic laws of the organism of art that I know and feel. My sole aim: to instill in the spectator, by means of quite unexpected allurements, all the evocations and fascinations of the unknown on the boundaries of thought.

I said nothing, moreover, that was not already nobly stated by Albrecht Dürer in his print *Melancholia*. It was thought to be incoherent. No, it is clearly defined, it is defined solely in terms of line and according to its great powers. His is a grave and profound spirit that lulls us like the dense and complicated accents of

* From Odilon Redon, *A soi-même: Journal (1867–1915)*, (Paris: Corti, 1961); pp. 25–29. First published 1922 (Paris; Floury).

a rigorous fugue. Compared to him, we can only chant abbreviated motifs of a few measures.

Suggestive art is like an illumination of things for dreams, toward which thought also is directed. Decadence or not, it is so. Let us say rather that it is growth, the evolution of art for the supreme elevation and expansion of our personal life through a necessary exaltation—our highest point of strength or moral support.

This suggestive art lies completely within the exciting realm of the art of music, and more freely and radiantly. It is also my own art through a combination of various elements brought together, of forms that are transposed and transformed without any relation to the contingencies at hand, but which nevertheless possess a logic all their own. All the errors made by critics concerning my first works were the result of their inability to see that it was not at all necessary to define, to understand, to limit, to be precise, because everything that is sincerely and humbly new— such as the beautiful from elsewhere—carries its meaning within itself.

The designation of my drawings by titles is often redundant, so to speak. A title is justified only when it is vague, indeterminate and when it aims even confusedly at the equivocal. My drawings *inspire* and do not offer explanations. They resolve nothing. They place us, just as music does, in the ambiguous world of the indeterminate.

They are a sort of *metaphor*, explained Remy de Gourmont[1] in setting them apart, far from any sort of geometric art. He sees in them an imaginative logic. I believe that this writer has said more in a few lines than anything else formerly written about my first works.

Imagine arabesques or various types of linear involutions unwinding themselves not on a flat surface but in space, with all that which the deep and indeterminate limits of the sky can offer the spirit; imagine the play of their lines projecting upon and combining with the most diverse elements imaginable, including that of the human face. If this face possesses the particularities of him whom we encounter daily in the street, along with its very real, immediate but unexpected truth, you will have then the usual combinations that appear in many of my drawings.

Further explanation could hardly make the fact any clearer that they are the reverberations of a human expression, that, by means of the license of fantasy, they have been embodied in a play of arabesques. I believe that this action will originate in the mind of the beholder and will arouse in his imagination any number of fantasies whose meaning will be broad or limited according to his sensitivity and imaginative aptitude to enlarge or diminish.

Moreover, everything derives from universal life; a painter who neglects to draw a wall vertically draws poorly because he diverts the spirit from the idea

---

[1] De Gourmont (1858–1915) was a critic and novelist and a leading apologist for the Symbolist poets and writers. Redon's art had a special appeal for him as it had for many Symbolist writers.

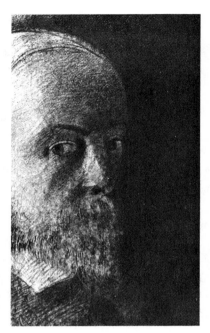

*Odilon Redon, Self-Portrait, ca. 1895, crayon.*

of stability. The same is true of the painter who fails to render his water with consideration for the horizontal (to cite only the very simplest of phenomena). But in the vegetal world, for example, there are certain secret and inherent life tendencies that a sensitive landscape painter could not possibly misinterpret: the trunk of a tree forcefully thrusts out its branches according to the laws of growth and the flow of sap. A true artist must feel this and must represent it accordingly.

The same is true with animal or human life. We cannot move a hand without our entire body being displaced in obedience to the laws of gravity. A draftsman knows that. In creating certain fantastic creatures I believe that I have complied with these intuitive suggestions of the instincts. Contrary to the insinuations of Huysmans,[1] they do not owe their conception to that terrifying world of the infinitely minute as revealed by the microscope. Not at all. While creating them I took the greatest care to organize their structure.

There is a method of drawing which the imagination has liberated from those bothersome worries presented by the details of the exterior world in order to represent only imaginary objects. I have created various fantasies based on the stem of a flower, the human face, or even on certain skeletal elements, which, I believe,

[1] Joris-Karl Huysmans (1848–1907), novelist and critic, first wrote in the naturalistic vein of Zola, but with the autobiographical novel *A Rebours* (1884) turned to Symbolist ideas of which he had a rich store. His essays of art criticism (collected in 1883 as *L'Art moderne*) expressed the ideals of the imaginative and fantastic world of the writers and poets. He wrote several articles on Redon and referred to his work in *A Rebours*.

were drawn, constructed and formed as they had to be. They are thus formed because they possess an organism. Any time a human figure cannot give the illusion that it is about to leave the picture frame, so to speak, to walk, act or think, the drawing is not truly modern. They cannot take away from me the merit of giving the illusion of life to my most fantastic creations. All my originality consists, therefore, in endowing completely improbable beings with human life, according to the laws of the probable and in placing, as much as possible, the logic of the visible at the service of the invisible.

This method proceeds naturally and easily from the vision of the mysterious world of shadows for which Rembrandt, in revealing it to us, supplied the key.

But, on the other hand, as I have often said, the method that has been the most fruitful and the most necessary to my development is the copying of real things, carefully reproducing the objects of the exterior world in their most minute, individual and accidental details. After attempting to copy minutely a pebble, a sprout of a plant, a hand, a human profile or any other example of living or inorganic life, I experience the onset of a mental excitement; at that point I need to create, to give myself over to representations of the imaginary. Thus blended and infused, nature becomes my source, my yeast and my leaven. I believe that this is the origin of my true inventions. I believe that this is true of my drawings; and it is likely that, even with the weakness, unevenness, and imperfection inherent in all that man recreates, one could not for an instant stand the sight of them (because they are humanly expressive), if they were not, as I have just said, created, formed, and built according to the law of life and the moral transmission necessary to all existence.

*Odilon Redon, "Introduction to a Catalogue"* ★

I will direct my words here neither to those with metaphysical inclinations nor to pedagogues, for they do not gaze steadfastly on the beauties of nature. The conventions peculiar to their mentality keep them too far from those intermediary ideas that link sensations with thoughts. Their spirit is too much preoccupied with abstractions to enable them fully to partake of and savor the joys of art, which always involve the rapports of the soul with the objects of the exterior world.

I speak to those who surrender themselves gently to the secret and mysterious laws of the emotions and the heart, without assistance from sterile explanations.

The artist submits day after day to the fatal rhythm of the impulses of the universe surrounding him. His eyes—those ever-sensitive, ever-active centers of sensation—are hypnotized by the marvels of a nature which he loves, which he

★ *A soi même*, pp. 115–116.

scrutinizes. Like his soul, they are in constant communion with even the most chance phenomena, and this communion is a pleasure for him when he is a true painter; he even shows a certain inclination toward it. How could he possibly abandon such a gratifying and complete world for the world of generalization inhabited by the scholar or the aesthetician? He cannot do it; such a venture outside of himself is an impossibility. Do not ask him to be a prophet; he bears only his own fruit—such is his function.

If the artist compares himself with others in order to judge them, it is only by a very awkward and difficult operation—the more difficult because he must remove his own eyeglasses in order to see clearly the work of others, and yet does not have the benefit of theirs. He can speak well only of himself, his own adventure, of his unique situation, joyous or tragic, in which destiny has placed him.

For myself, I believe that I have produced an expressive, suggestive, and indeterminate art. Suggestive art is the irradiation of sublime plastic elements, drawn together and combined with the purpose of evoking visions which it illuminates and exalts, meanwhile inciting thought.

If the public of my own rationalist generation—at a time when the rather low-vaulted edifice of Impressionism was erected—failed to respond immediately to my art, the present generation understands it better. Natural evolution brings that about. Besides, youth with its quite different mentality is affected more than ever before by the mighty tides of music, and consequently opens itself also to the fictions and dreams of the idealist forms of this art.

*Henry Van de Velde, "Memoirs: 1891–1901"**

The work we[1] did during these early years of the closing decade of the nineteenth century was of such fundamental importance that it should have provided serious critics and historians of art with enough material to enlighten the curiosity of those it has intrigued or nonplussed into formulating what are often either extravagant

---

* From "Henry Van de Velde, Extracts From His Memoirs, 1891–1901," *Architectural Review* (London), CXII, 669 (September 1952), 143–155.

These particular passages were selected by Van de Velde for this publication from among the several versions of his *Memoirs* and his many fragmentary writings, and he worked in close collaboration with the translator in editing and translating them. A voluminous correspondence between the two attests to the great care given to the task. Although these passages do not appear in the same form in Van de Velde's autobiography, *Memoirs* (not yet published), they are considered an accurate reflection of his thoughts. A letter from M. C. Lemaire, Secretary of the *Association Henry Van de Velde*, who is in charge of the extensive *Archives Henry Van de Velde* in the *Bibliotèque Royale de Belgique*, Brussels, to the present author states that "Author and translator have given the greatest care to the text, which I believe reflects very well the often moving thoughts of Henry Van de Velde."

[1] The pioneers of 1893–1895, Serrurier-Bovy and Van de Velde in furniture and decoration, and Hankar and Horta in architecture. [Van de Velde's footnote.]

or entirely fallacious conclusions. On one point, notwithstanding, there is general agreement. No writers on the subject deny that the first symptoms of revolt appeared in Belgium, or that it spread from Brussels to Paris, and thence to Germany and Holland. But few have attempted to unravel the moral scruples which drove these Belgian precursors into proclaiming their rebellion by the creation of forms deliberately divorced from allegiance to the past. Yet in the very disparate motives which severally animated them lies the explanation of why this movement subsequently began to evolve in two radically different directions—a divergence that did not, however, become immediately apparent.

Although there was at bottom little similarity in our aims, the work of all four of us was lumped together, judged and described by the one quality obviously common to the whole of it: its newness. This was how the term *"Art Nouveau"* originated. The ambition which had prompted Serrurier-Bovy, Hankar and Horta to affranchise themselves from tradition by launching out into new forms was in reality the desire to enjoy all the excitement and prestige of inaugurating a renascence. My hopes of what liberation from tutelage to the past and the

*Ernst Ludwig Kirchner, Henry Van de Velde, 1917,
woodcut.*

*Henri van de Velde, poster for the journal*
*Dekorative Kunst, 1897.*

dawning of a new era in design might bring about were just as high as theirs, but such an illusory prospect failed to satisfy me. I knew we had to delve far deeper, that the goal to be striven for was a much more vital one than mere newness, which by its very nature can only be ephemeral. If we were to attain it we must begin by clearing away all those obstructions the centuries had accumulated in our path, stemming the inroads of ugliness, and challenging every agency that corrupts natural taste. There were two essential principles which confirmed my faith and guided me in the quest I had set myself: one aesthetic, the other ethical. Here I must explain that, apart from a little ordinary schooling, I was fortunate in having escaped the sort of mental deformation education usually inflicts. Being self-taught I had the same unsophisticated resources at my command as cave-dwelling primitive man when the first glimmerings of human intelligence spurred him into approximating form to function. Hence I was an artist of a different stamp, scanning an altogether different horizon, to those who let themselves be led away by the lure of novelty.

I firmly believed I could achieve my ends, of which the attainment of beauty was not least, by virtue of an aesthetic founded on reason and therefore immune to caprice. And as one who was fully aware how falsehood can sully inanimate objects in precisely the same way as it degrades the character of men and women I felt confident my probity would be proof against the manifold insinuations of imposture.

These were the simple but transcendent truths I had stumbled upon in the course of my long meditations. I remained steadfast in the conviction that they were destined to inform the whole of my life's work.

Could these immemorial precepts be adapted to the material requirements of such an advanced civilization, and would their validity persist in an age with a mentality as corrupt and complex as our own? There were moments when my faith was within an ace of faltering.

My friend Fernand Brouer, the editor of *La Société Nouvelle*, who had published *"Déblaiement d'Art,"* [The Clearing Away of Art] my first essay on the

liberation of the arts from the stranglehold of academic perversion, urged me to develop the points it left somewhat in abeyance. This I proceeded to do in "*Aperçus en Vue d'une Synthèse*" [Notes to Serve as the Basis for a Tentative Synthesis] by expanding what I had previously written under the headings of "The Worn-Out Fruit-Tree," "The Supremacy of the Beaux Arts," and "The Regeneration of Painting and Sculpture" (i.e., from the degrading level of easel pictures and drawing room statuettes to which they had sunk). Once again I reiterated my conviction that the élite of mankind would soon cast off its craven subservience to the conventions of the herd, and reaffirmed that those who constitute this élite must begin by impressing the aesthetic morality which is personal to every one of us on what being nearest should be dearest to all mankind:

"In assuring you that we can make our homes the direct reflection of our own wishes, our own tastes, if we will but choose, I know the answer you are going to give me is that it is impossible. It is only impossible so long as we go on resigning ourselves to the repression of our own personalities and accept the human environment imposed on us with the same mute submissiveness as dogs do their kennels and horses their stables. And this simply because of the unreasoning belief that very few people were born with the gift of self-expression—which is not true, and could only be true if civilization had deprived us of a capacity even our primeval ancestors possessed. Will no one stand up to assert the consciousness of having an aesthetic conscience of his own and bring some spontaneous echo of his inner being, some genuinely individual contribution, to the furnishing of his own home?"

# III     FAUVISM AND EXPRESSIONISM:
## The Creative Intuition

INTRODUCTION : by Peter Selz

The Symbolist's attitude of evoking sensations by means of forms and colors established the basis for the trend toward abstraction which is central to the art of the twentieth century. But the next generation of artists, born about 1880, was no longer subject to the romantic malaise of the *fin de siècle*. Retaining the involvement with the artist's private world, they expressed their subjective individuality with a much more emphatic—often vehement— affirmation. The temper of the new dynamic century called for a "transvaluation of values" by means of a dramatic, bold, and often urgent statement.

During the first decade of the twentieth century these new forces made themselves powerfully felt on both sides of the Rhine: in Dresden and Munich as well as in Paris. Paris, the cultural capital of the world, however, remained the greatest magnet and focal point of the new movement. Artists from all over the world continued to flow there and banded together in groups of a newly self-conscious *avant-garde*, which joyously celebrated its own activity.

An incomparable figure of these "banquet years" was the retired customs inspector Henri Rousseau (1844–1910), who, in 1886, began showing his Sunday paintings in the exhibitions of the *Société des Artistes Indépendents*, and whose simple soirees were attended by the leading writers and poets, painters and sculptors, musicians and critics of the next generation. They all admired the magical simplicity of his vision, in which dream and reality are articulated by precise statement. His letter to André Dupont and his poetic inscription for his last painting, *The Dream*, testify to his unique conception of reality.

Rousseau's *Hungry Lion* was shown in the same room with paintings by Matisse, Derain, Vlaminck, Marquet, and Rouault in the 1905 exhibition of the *Salon d'Automne*. It was possibly Rousseau's subject matter, but certainly the wild colors and apparent distortions practiced by these men, that caused the critic Louis Vauxcelles to refer to them as *les fauves* (wild beasts).

The Fauves never developed any consistent art theory or artistic

program, yet they asserted themselves with a distinctive style. Their mentor, without doubt, was Henri Matisse (1869–1954), who was also the oldest of the group and had experimented with a number of modes before arriving at the highly original, free "fauve" style, with its intense assertion of the painter's own vision. Maurice Denis realized at once that Matisse's work was essentially "painting in itself, the act of pure painting . . . a search for the absolute." But when Matisse a few years later noted down some of his thoughts on art, he sounds calm and moderate: he believes in capturing the essentials of nature, he commends the idealism of Greek sculpture, asserts his principal interest in the human figure, and strives for serenity. But he also stresses the importance of expression. This, in fact, is his paramount goal. To Gauguin, too, the expression of feeling was essential, but Matisse clearly states that expression to him consists of the total composition of the picture, the relationship of all its various elements, which, in turn rests on the artist's sensations, while "rules have no existence outside of individuals." The emphasis on "artistic intuition" which underlies Matisse's theory, reveals him as a contemporary of Bergson and Croce. To Benedetto Croce, whose aesthetic theory is so important in twentieth-century thought, the artist gains knowledge of a pre-perceptual nature by means of intuition. And as the true intuition of the artist objectifies itself in his expressive form, intuition and expression are actually identical. Matisse would have agreed with this postulation. In his old age he reiterated this position when he said that "each work is a combination of symbols invented during the execution as they are needed in the particular spot."

If Matisse stressed both tradition and discipline, the younger Maurice de Vlaminck (1876–1958) had no use for either. A powerful young professional bicycle racer who was self-taught as a painter, he was inspired largely by Van Gogh's vehement expression and relied in his early work primarily on his own instincts. Even as late as 1923 he exclaimed: "I try to paint with my heart and my loins, not bothering about style."

Vlaminck's rather intemperate attitude is related to that of a group of young German painters who banded together in Dresden in 1905 to unify their forces in a surge toward a vital and revolutionary art form. The *Brücke* (Bridge) parallels the contemporaneous Fauves in many respects. But if the young French artists used distortion primarily for the sake of a new pictorial harmony, the more agitated distortions of the northern painters were precipitated by their subjective need to find equivalents for their own conflicts and isolation. The artists, as Ernst Ludwig Kirchner (1880–1938) points out in the *Chronik der Brücke*, found inspiration in the medieval German woodcut, African, and Oceanic sculpture, Etruscan art, and other

primitive manifestations—all forms which seemed anticlassical, barbaric, and "expressionist." During the eight years of the group's existence, the *Brücke* artists shared their workshops, held a number of exhibitions, issued manifestos, and published portfolios. After it had served its purpose, and the artists (who had moved to Berlin in the meantime) grew apart, the *Brücke* gave way. Kirchner's *Chronik*, not authorized by the other artists and never checked with them, was the immediate cause of the collapse.

Emil Nolde (1867–1956), himself a member of the *Brücke* from 1906 to 1907, was the oldest of the German Expressionists. Like his younger friends he felt a close affinity to primitive art, and in 1913 he traveled to German New Guinea to experience it at close hand; he even contemplated a book on the art of the aborigines, which he felt to be strong and uncorrupted like "healthy German art." Nolde's painting reflects the very rhythms of life on the marshland of the North Sea and the uniquely mystical piety of the people in that region. During his entire life Nolde showed a deeply personal, almost visionary concern with religion, regarding himself as a kind of mystic evangelist. In the summer of 1909 he became severely ill and experienced a sudden need for religious self-expression by means of painting. The recall of this almost ecstatic episode in his autobiography gives insight into his fervent, tempestuous personality.

In great contrast to the isolation of the North Germans, the *Blaue Reiter* (Blue Rider) artists in Munich were in the mainstream of European culture. In their exhibitions they united the *avant-garde* artists from Germany, Russia, and France and postulated no specific formal language or style, because to them art was the embodiment of the spirit, no matter what form it might assume. Wassily Kandinsky (1866–1944), the spiritual leader of the group, was a man of broad culture and great intellectual power. Familiar with the various currents of European thought, he was extremely interested in philosophy and religion, poetry and music. His universal genius attempted to unify the rational with the irrational. Kandinsky and his friends continued to search for the common spiritual basis of all the arts and experimented with the equivalents of sounds and colors, hoping to achieve a total synaesthetic form, which would have physical as well as psychological effects. Here they followed the tradition proposed by Wagner and explored by Scriabin and Schönberg. Together with his book, *Concerning the Spiritual in Art*, Kandinsky's essay "On the Problem of Form" has become a pivotal document of abstract art. In this, his most mature contribution to the theory of art, Kandinsky sees two main roads, the "great realism" (as exemplified by the simplicity of Henri Rousseau) and the "great abstraction" (embodied by his own work) leading to one goal, which is the expression of the artist's

inner meaning. Form itself is meaningless unless it is the expression of an artist's inner necessity and everything is permitted to serve this end.

Franz Marc (1880–1916), Kandinsky's associate in the *Blaue Reiter*, also saw art as a means to penetrate reality and to reach the true essence of it. Old traditions were of no use in this endeavor; new ones would have to be created. In his attempt to identify with nature he uses Cubist and Futurist forms and gives them a more descriptive function, or rather transforms them poetically, to incorporate the animal into a total cosmic nature-rhythm. With his Franciscan love for animals he asks "how it nature reflected in the eyes of the animal . . . how does a horse see the world?" Finally, just before he was killed in World War I, in his constant search for purity and ever greater dematerialization in art, Marc followed his friend Kandinsky into the realm of Abstract Expressionism.

Paul Klee (1879–1940) shares with his friends of the *Blaue Reiter* the desire to "reveal the reality that is visible behind things." It is art which makes visible, as he explains, and it is the lines of the draftsman, which are going for a walk, which can lead to the land of deeper insight. Fully aware of the interrelationship of space and time, Klee sees art as nothing less than the "simile of Creation." His "Creative Credo" was written in 1918 while Klee was still in the army. It is the kernel of his theoretic writings and is followed by his more extensive *Pedagogical Sketchbook*, *On Modern Art* and *The Thinking Eye* (first German editions: 1925, 1945, and 1956). The last, based on his Bauhaus lectures, is called by Sir Herbert Read "the most complete presentation of the principles of design ever made by a modern artist."

Paul Klee invented symbols for the unconscious experience of man and for the formative process of nature, and achieved thereby a most penetrating artistic expression. As a teacher at the Bauhaus in Weimar and Dessau and then at the Academy at Düsseldorf, and as a theoretician of poetic propensity, he was able to provide additional insights into the meaning of art.

Max Beckmann's (1884–1950) emphasis on the importance of the visible object, in contrast to the more subjective emotionalism of the Expressionists, brought him in close contact with the artists of the *Neue Sachlichkeit* (New Objectivity) movement between the wars. By endowing the dream with precise structure and meticulous detail, he belongs to that mainstream of modernism which has some parallel in the writings of Kafka and Joyce, in the paintings of De Chirico and Bacon, and the films of Antonioni and Bergman. In all their work the feeling of human estrangement is enhanced by the use of hard physical reality. In a series of great

triptychs he delved into the mystery of space, preoccupied with what he termed the magic of transforming three dimensions into two, while at the same time glimpsing "that fourth dimension which my whole being is seeking."

Beckmann felt himself to be part of a great Western tradition which includes Greek mythology and European philosophy, the painting of Grünewald, Rembrandt, and Blake, as well as Henri Rousseau, "that Homer of the porter's lodge whose prehistoric dreams have sometimes brought me near the gods." What Kandinsky, Expressionism's chief theorist, had termed the Great Realism continues in Beckmann in altered form, following the dictates of *his* inner necessity.

# FAUVISM

*Henri Rousseau, letter to the Art Critic André Dupont explaining The Dream, 1910* ★

I am answering your kind letter immediately in order to explain to you the reason why the sofa in question is included [in my picture *The Dream*]. The woman sleeping on the sofa dreams that she is transported into the forest, hearing the music of the snake charmer's instrument. This explains why the sofa is in the picture . . . I thank you for your kind appreciation; if I have kept my naïveté, it is because M. Gérome, who was professor at the *École des Beaux-Arts*, and M. Clément, director of the *École des Beaux-Arts* at Lyon, always told me to keep it. So in the future you will no longer find it astonishing. And I was also told that I did not belong to this century. You must realize that I cannot now change the manner that I have acquired with such stubborn labor. I end this note by thanking you in advance for the article you will write about me. Please accept my best wishes, and a hearty and cordial handshake.

*Henri Rousseau, Inscription for The Dream, 1910* †

> In a beautiful dream
> Yadwigha gently sleeping
> Heard the sounds of a pipe
> Played by a sympathetic charmer
> While the moon reflects
> On the rivers and the verdant trees
> The serpents attend
> The gay tunes of the instrument.

★ Originally published in *Soirées de Paris* (Rousseau issue), 15 January 1914 [misprinted 1913], p. 57. This English translation is from *Artists on Art*, eds. Robert Goldwater and Marco Treves, p. 403. Copyright 1945 by Pantheon Books, Inc. Reprinted by permission of Pantheon Books, Inc., a Division of Random House, Inc.

† *Soirées de Paris*, 15 January 1914, p. 65. *The Dream* (The Museum of Modern Art, New York).

In contrast to the poetic tone of the interpretation for M. Dupont and of the inscription, Rousseau in a confidential mood explained to his friend André Salmon that the sofa was there only because of its red color.

Rousseau's statements on art are extremely rare, although he wrote three plays (never produced), an autobiography, and several letters to Apollinaire (published in the Rousseau number of *Les Soirées de Paris*, 15 January 1914).

*Henri Rousseau, The Dream, 1910, oil on canvas.*

## Henri Matisse, *"Notes of a Painter," 1908*★

A painter who addresses the public not in order to present his works but to reveal some of his ideas on the art of painting exposes himself to several dangers. In the first place, I know that some people like to think of painting as dependent upon literature and therefore like to see in it not general ideas suited to pictorial art, but rather specifically literary ideas. I fear, therefore, that the painter who risks himself in the field of the literary man may be regarded with disapproval; in any case, I

★ Originally published as "Notes d'un peintre" in *La Grande Revue* (Paris), 25 December 1908, pp. 731–745. This English translation is from *Matisse: His Art and His Public* by Alfred H. Barr, Jr., copyright 1951 by The Museum of Modern Art, New York, and reprinted with its permission. The first complete English translation by Margaret Scolari Barr was published in *Henri-Matisse*, The Museum of Modern Art, 1931, and then again in *Matisse: His Art and His Public*. Within one year the essay was translated into Russian and German: *Toison d'Or* (*Zolotoye Runo*), No. 6, 1909; *Kunst und Künstler*, Vol. VII, 1909, pp. 335–347.

An interesting account of Matisse's remarks and criticism to his students during the early days of the *Académie Matisse* was written in 1908 by Sarah Stein, one of his students. It has been reprinted in Barr, *Matisse, His Art and His Public*, pp. 550–552.

*Henri Matisse, Self-Portrait, ca. 1900, brush and ink.*

myself am fully convinced that the best explanation an artist can give of his aims and ability is afforded by his work.

However, such painters as Signac, Desvallières, Denis, Blanche, Guérin, Bernard, etc., have written on such matters in various periodicals. In my turn I shall endeavor to make clear my pictorial intentions and aspirations without worrying about the writing.

One of the dangers which appears to me immediately is that of contradicting myself. I feel very strongly the bond between my old works and my recent ones. But I do not think the way I thought yesterday. My fundamental thoughts have not changed but have evolved and my modes of expression have followed my thoughts. I do not repudiate any of my paintings, but I would not paint one of them in the same way had I to do it again. My destination is always the same but I work out a different route to get there.

If I mention the name of this or that artist it will be to point out how our manners differ so that it may seem that I do not appreciate his work. Thus I may be accused of injustice towards painters whose efforts and aims I best understand, or whose accomplishments I most appreciate. I shall use them as examples not to establish my superiority over them but to show clearly through what they have done, what I am attempting to do.

What I am after, above all, is expression. Sometimes it has been conceded that I have a certain technical ability but that, my ambition being limited, I am

unable to proceed beyond a purely visual satisfaction such as can be procured from the mere sight of a picture. But the purpose of a painter must not be conceived as separate from his pictorial means, and these pictorial means must be the more complete (I do not mean complicated) the deeper is his thought. I am unable to distinguish between the feeling I have for life and my way of expressing it.

Expression to my way of thinking does not consist of the passion mirrored upon a human face or betrayed by a violent gesture. The whole arrangement of my picture is expressive. The place occupied by figures or objects, the empty spaces around them, the proportions, everything plays a part. Composition is the art of arranging in a decorative manner the various elements at the painter's disposal for the expression of his feelings. In a picture every part will be visible and will play the role conferred upon it, be it principal or secondary. All that is not useful in the picture is detrimental. A work of art must be harmonious in its entirety; for superfluous details would, in the mind of the beholder, encroach upon the essential elements.

Composition, the aim of which is expression, alters itself according to the surface to be covered. If I take a sheet of paper of given dimensions I will jot down a drawing which will have a necessary relation to its format—I would not repeat this drawing on another sheet of different dimensions, for instance on a rectangular sheet if the first one happened to be square. And if I had to repeat it on a sheet of the same shape but ten times larger I would not limit myself to enlarging it: a drawing must have a power of expansion which can bring to life the space which surrounds it. An artist who wants to transpose a composition onto a larger canvas must conceive it over again in order to preserve its expression; he must alter its character and not just fill in the squares into which he has divided his canvas.

Both harmonies and dissonances of color can produce very pleasurable effects. Often when I settle down to work I begin by noting my immediate and superficial color sensations. Some years ago this first result was often enough for me—but today if I were satisfied with this, my picture would remain incomplete. I would have put down the passing sensations of a moment; they would not completely define my feelings and the next day I might not recognize what they meant. I want to reach that state of condensation of sensations which constitutes a picture. Perhaps I might be satisfied momentarily with a work finished at one sitting but I would soon get bored looking at it; therefore, I prefer to continue working on it so that later I may recognize it as a work of my mind. There was a time when I never left my paintings hanging on the wall because they reminded me of moments of nervous excitement and I did not like to see them again when I was quiet. Nowadays I try to put serenity into my pictures and work at them until I feel that I have succeeded.

Supposing I want to paint the body of a woman: first of all I endow it with grace and charm but I know that something more than that is necessary. I try to condense the meaning of this body by drawing its essential lines. The charm will then become less apparent at first glance but in the long run it will begin to emanate

from the new image. This image at the same time will be enriched by a wider meaning, a more comprehensively human one, while the charm, being less apparent, will not be its only characteristic. It will be merely one element in the general conception of the figure.

Charm, lightness, crispness—all these are passing sensations. I have a canvas on which the colors are still fresh and I begin work on it again. The colors will probably grow heavier—the freshness of the original tones will give away to greater solidity, an improvement to my mind, but less seductive to the eye.

The impressionist painters, Monet, Sisley especially, had delicate, vibrating sensations; as a result their canvases are all alike. The word "impressionism" perfectly characterizes their intentions, for they register fleeting impressions. This term, however, cannot be used with reference to more recent painters who avoid the first impression and consider it deceptive. A rapid rendering of a landscape represents only one moment of its appearance. I prefer, by insisting upon its essentials, to discover its more enduring character and content, even at the risk of sacrificing some of its pleasing qualities.

Underneath this succession of moments which constitutes the superficial existence of things animate and inanimate and which is continually obscuring and transforming them, it is yet possible to search for a truer, more essential character which the artist will seize so that he may give to reality a more lasting interpretation. When we go into the seventeenth- and eighteenth-century sculpture rooms in the Louvre and look for instance at a Puget, we realize that the expression is forced and exaggerated in a very disquieting way. Then again if we go to the Luxembourg, the attitude in which the painters seize their models is always the one in which the muscular development will be shown to greatest advantage. But movement thus interpreted corresponds to nothing in nature and if we catch a motion of this kind by a snapshot, the image thus captured will remind us of nothing that we have seen. Indication of motion has meaning for us only if we do not isolate any one sensation of movement from the preceding and from the following one.

There are two ways of expressing things; one is to show them crudely, the other is to evoke them artistically. In abandoning the literal representation of movement it is possible to reach toward a higher ideal of beauty. Look at an Egyptian statue: it looks rigid to us; however, we feel in it the image of a body capable of movement and which despite its stiffness is animated. The Greeks too are calm; a man hurling a discus will be shown in the moment in which he gathers his strength before the effort or else, if he is shown in the most violent and precarious position implied by his action, the sculptor will have abridged and condensed it so that balance is re-established, thereby suggesting a feeling of duration. Movement in itself is unstable and is not stuited to something durable like a statue unless the artist has consciously realized the entire action of which he represents only a moment.

It is necessary for me to define the character of the object or of the body that I wish to paint. In order to do this I study certain salient points very carefully:

if I put a black dot on a sheet of white paper the dot will be visible no matter how far I stand away from it—it is a clear notation; but beside this dot I place another one, and then a third. Already there is confusion. In order that the first dot may maintain its value I must enlarge it as I proceed putting other marks on the paper.

If upon a white canvas I jot down some sensations of blue, of green, of red—every new brush stroke diminishes the importance of the preceding ones. Suppose I set out to paint an interior: I have before me a cupboard; it gives me a sensation of bright red—and I put down a red which satisfies me; immediately a relation is established between this red and the white of the canvas. If I put a green near the red, if I paint in a yellow floor, there must still be between this green, this yellow and the white of the canvas a relation that will be satisfactory to me. But these several tones mutually weaken one another. It is necessary, therefore, that the various elements that I use be so balanced that they do not destroy one another. To do this I must organize my ideas; the relation between tones must be so established that they will sustain one another. A new combination of colors will succeed the first one and will give more completely my interpretation. I am forced to transpose until finally my picture may seem completely changed when, after successive modifications, the red has succeeded the green as the dominant color. I cannot copy nature in a servile way; I must interpret nature and submit it to the spirit of the picture. When I have found the relationship of all the tones the result must be a living harmony of tones, a harmony not unlike that of a musical composition.

For me all is in the conception—I must have a clear vision of the whole composition from the very beginning. I could mention the name of a great sculptor who produces some admirable pieces but for him a composition is nothing but the grouping of fragments and the result is a confusion of expression. Look instead at one of Cézanne's pictures: all is so well arranged in them that no matter how many figures are represented and no matter at what distance you stand, you will be able always to distinguish each figure clearly and you will always know which limb belongs to which body. If in the picture there is order and clarity it means that this same order and clarity existed in the mind of the painter and that the painter was conscious of their necessity. Limbs may cross, may mingle, but still in the eyes of the beholder they will remain attached to the right body. All confusion will have disappeared.

The chief aim of color should be to serve expression as well as possible. I put down my colors without a preconceived plan. If at the first step and perhaps without my being conscious of it one tone has particularly pleased me, more often than not when the picture is finished I will notice that I have respected this tone while I have progressively altered and transformed the others. I discover the quality of colors in a purely instinctive way. To paint an autumn landscape I will not try to remember what colors suit this season, I will be inspired only by the sensation that the season gives me; the icy clearness of the sour blue sky will express the

season just as well as the tonalities of the leaves. My sensation itself may vary, the autumn may be soft and warm like a protracted summer or quite cool with a cold sky and lemon yellow trees that give a chilly impression and announce winter.

My choice of colors does not rest on any scientific theory; it is based on observation, on feeling, on the very nature of each experience. Inspired by certain pages of Delacroix, Signac is preoccupied by complementary colors and the theoretical knowledge of them will lead him to use a certain tone in a certain place. I, on the other hand, merely try to find a color that will fit my sensation. There is an impelling proportion of tones that can induce me to change the shape of a figure or to transform my composition. Until I have achieved this proportion in all the parts of the composition I strive towards it and keep on working. Then a moment comes when every part has found its definite relationship and from then on it would be impossible for me to add a stroke to my picture without having to paint it all over again. As a matter of fact, I think that the theory of complementary colors is not absolute. In studying the paintings of artists whose knowledge of colors depends only upon instinct and sensibility and on a consistency of their sensations, it would be possible to define certain laws of color and so repudiate the limitations of the accepted color theory.

What interests me most is neither still life nor landscape but the human figure. It is through it that I best succeed in expressing the nearly religious feeling that I have towards life. I do not insist upon the details of the face. I do not care to repeat them with anatomical exactness. Though I happen to have an Italian model whose appearance at first suggests nothing but a purely animal existence, yet I succeed in picking out among the lines of his face those which suggest that deep gravity which persists in every human being. A work of art must carry in itself its complete significance and impose it upon the beholder even before he can identify the subject matter. When I see the Giotto frescoes at Padua I do not trouble to recognize which scene of the life of Christ I have before me but I perceive instantly the sentiment which radiates from it and which is instinct in the composition in every line and color. The title will only serve to confirm my impression.

What I dream of is an art of balance, of purity and serenity devoid of troubling or depressing subject matter, an art which might be for every mental worker, be he businessman or writer, like an appeasing influence, like a mental soother, something like a good armchair in which to rest from physical fatigue.

Often a discussion arises upon the value of different processes, and their relation to different temperaments. A distinction is made between artists who work directly from nature and those who work purely from their imagination. I think neither of these methods should be preferred to the exclusion of the other. Often both are used in turn by the same man; sometimes he needs contact with reality before he can organize them into a picture. However, I think that one can judge of the vitality and power of an artist when after having received impressions from nature he is able to organize his sensations to return in the same mood on different

days, voluntarily to continue receiving these impressions (whether nature appears the same or not); this power proves he is sufficiently master of himself to subject himself to discipline.

The simplest means are those which enable an artist to express himself best. If he fears the obvious he cannot avoid it by strange representations, bizarre drawing, eccentric color. His expression must derive inevitably from his temperament. He must sincerely believe that he has painted only what he has seen. I like Chardin's way of expressing: "I put on color until it resembles (is a good likeness)," or Cézanne: "I want to secure a likeness," or Rodin: "Copy nature!" or Leonardo: "He who can copy can do (create)." Those who work in an affected style, deliberately turning their backs on nature, are in error—an artist must recognize that when he uses his reason, his picture is an artifice and that when he paints, he must feel that he is copying nature—and even when he consciously departs from nature, he must do it with the conviction that it is only the better to interpret her.

Some will object perhaps that a painter should have some other outlook upon painting and that I have uttered only platitudes. To this I shall answer that there are no new truths. The role of the artist, like that of the scholar, consists in penetrating truths as well known to him as to others but which will take on for him a new aspect and so enable him to master them in their deepest significance. Thus if the aviators were to explain to us the researches which led to their leaving earth and rising in the air they would be merely confirming very elementary principles of physics neglected by less successful inventors.

An artist has always something to learn when he is given information about himself—and I am glad to have learned which is my weak point. M. Peladan in the *Revue Hébdomadaire* reproaches a certain number of painters, amongst whom I think I should place myself, for calling themselves *"fauves"* and yet dressing like everyone else so that they are no more noticeable than the floorwalkers in a department store. Does genius count for so little? In the same article this excellent writer pretends that I do not paint honestly and I feel that I should perhaps be annoyed though I admit that he restricts his statement by adding, "I mean honestly with respect to the Ideal and the Rules." The trouble is that he does not mention where these rules are—I am willing to admit that they exist but were it possible to learn them what sublime artists we would have!

Rules have no existence outside of individuals: otherwise Racine would be no greater genius than a good professor. Any of us can repeat a fine sentence but few can also penetrate the meaning. I have no doubt that from a study of the works of Raphael or Titian a more complete set of rules can be drawn than from the works of Manet or Renoir, but the rules followed by Manet and Renoir were suited to their artistic temperaments and I happen to prefer the smallest of their paintings to all the work of those who have merely imitated the *Venus of Urbino* or the *Madonna of the Goldfinch*. Such painters are of no value to anyone because, whether we want to or not, we belong to our time and we share in its opinions, preferences, and delusions. All artists bear the imprint of their time but the great artists are those in

which this stamp is most deeply impressed. Our epoch for instance is better represented by Courbet than by Flandrin, by Rodin better than by Frémiet. Whether we want to or not between our period and ourselves an indissoluble bond is established and M. Peladan himself cannot escape it. The aestheticians of the future may perhaps use his books as evidence if they get it in their heads to prove that no one of our time understood a thing about the art of Leonardo da Vinci.

## Henri Matisse, "Exactitude is Not Truth," 1947*

Among these drawings, which I have chosen with the greatest of care for this exhibition, there are four—portraits perhaps—done from my face as seen in a mirror. I should particularly like to call them to the visitors' attention.

These drawings seem to me to sum up observations that I have been making for many years on the characteristics of a drawing, characteristics that do not depend on the exact copying of natural forms, nor on the patient assembling of exact details, but on the profound feeling of the artist before the objects which he has chosen, on which his attention is focused, and the spirit of which he has penetrated.

My convictions on these matters crystallized after I had verified the fact that, for example, in the leaves of a tree—of a fig tree particularly—the great difference of form that exists among them does not keep them from being united by a common quality. Fig leaves, whatever fantastic shapes they assume, are always unmistakably fig leaves. I have made the same observation about other growing things: fruit, vegetables, etc.

Thus there is an inherent truth which must be disengaged from the outward appearance of the object to be represented. This is the only truth that matters.

The four drawings in question are of the same subject, yet the calligraphy of each one of them shows a seeming liberty of line, of contour, and of the volume expressed.

Indeed, no one of these drawings can be superimposed on another, for all have completely different outlines.

In these drawings the upper part of the face is the same, but the lower is completely different. In no. 158, it is square and massive; in no. 159, it is elongated in comparison with the upper portion; in no. 160, it terminates in a point; and in no. 161, it bears no resemblance to any of the others. [See illustration.]

Nevertheless the different elements which go to make up these four drawings give in the same measure the organic makeup of the subject. These

---

* From *Henri Matisse, Retrospective Exhibition of Paintings, Drawings and Sculpture Organized in Collaboration with the Artist*, Philadelphia Museum of Art exhibition catalogue, 3 April–9 May 1948, pp. 33–34. This essay was written in 1947 at the time Matisse selected for the exhibition at the Philadelphia Museum of Art the four drawings of his own face made in 1939. This English translation is by Esther Rowland Clifford.

elements, if they are not always indicated in the same way, are still always wedded in each drawing with the same feeling—the way in which the nose is rooted in the face—the ear screwed into the skull—the lower jaw hung—the way in which the glasses are placed on the nose and ears—the tension of the gaze and its uniform density in all the drawings, —even though the shade of expression varies in each one.

It is quite clear that this sum total of elements describes the same man, as to his character and his personality, his way of looking at things and his reaction to life, and as to the reserve with which he faces it and which keeps him from an uncontrolled surrender to it. It is indeed the same man, one who always remains an attentive spectator of life and of himself.

It is thus evident that the anatomical, organic inexactitude in these drawings, has not harmed the expression of the intimate character and inherent truth of the personality, but on the contrary has helped to clarify it.

Are these drawings portraits or not?

What is a portrait?

Is it not an interpretation of the human sensibility of the person represented?

. . .

*Henri Matisse, four Self-Portraits, October 1939, crayon drawings.*

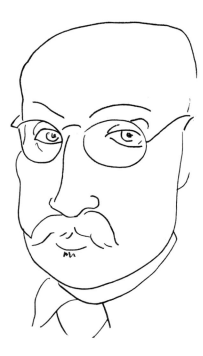

The only saying of Rembrandt's that we know is this: "I have never painted anything but portraits."

Is the portrait in the Louvre, painted by Raphael and showing Joan of Aragon in a red velvet dress, really what is meant by a portrait?

. . .

These drawings are so little the result of chance, that in each one it can be seen how, as the truth of the character is expressed, the same light bathes them all, and that the plastic quality of their different parts—face, background, transparent quality of the spectacles, as well as the feeling of material weight—all impossible to put into words, but easy to do by dividing a piece of paper into spaces by a simple line of almost even breadth—all these things remain the same.

Each of these drawings, as I see it, has its own individual invention which comes from the artist's penetration of his subject, going so far that he identifies himself with it, so that its essential truth makes the drawing. It is not changed by the different conditions under which the drawing is made; on the contrary, the expression of this truth by the elasticity of its line and by its freedom lends itself to the demands of the composition; it takes on light and shade and even life, by the turn of spirit of the artist whose expression it is.

*L'exactitude n'est pas la vérité.*

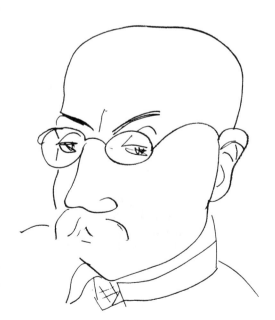 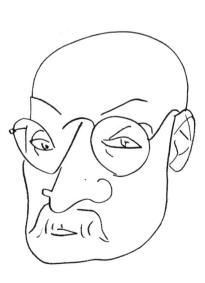

*Henri Matisse, Facility in Painting*
*Letter to Henry Clifford, Vence, 14 February 1948\**

I hope that my exhibition may be worthy of all the work it is making for you, which touches me deeply.

However, in view of the great repercussions it may have, seeing how much preparation has gone into it, I wonder whether its scope will not have a more or less unfortunate influence on young painters. How are they going to interpret the impression of apparent facility that they will get from a rapid, or even a superficial, over-all view of my paintings and drawings?

I have always tried to hide my own efforts and wished my works to have the lightness and joyousness of a springtime which never lets anyone suspect the labors it has cost. So I am afraid that the young, seeing in my work only the apparent facility and negligence in the drawing, will use this as an excuse for dispension with certain efforts which I believe necessary.

The few exhibitions that I have had the opportunity of seeing during these last years make me fear that the young painters are avoiding the slow and painful preparation which is necessary for the education of any contemporary painter who claims to construct by color alone.

This slow and painful work is indispensable. Indeed, if gardens were not dug over at the proper time, they would soon be good for nothing. Do we not first have to clear, and then cultivate, the ground at each season of the year?

When an artist has not known how to prepare his flowering period, by work which bears little resemblance to the final result, he has a short future before him: or when an artist who has "arrived" no longer feels the necessity of getting back to earth from time to time, he begins to go round in circles repeating himself, until by this very repetition, his curiosity is extinguished.

An artist must possess Nature. He must identify himself with her rhythm, by efforts that will prepare the mastery which will later enable him to express himself in his own language.

The future painter must feel what is useful for his development—drawing or even sculpture—everything that will let him become one with Nature, identify himself with her, by entering into the things—which is what I call Nature—that arouse his feelings. I believe study by means of drawing is most essential. If drawing is of the Spirit and color of the Senses, you must draw first, to cultivate the spirit and to be able to lead color into spiritual paths. That is what I want to cry aloud, when I see the work of the young men for whom painting is no longer an adventure, and whose only goal is the impending first one-man show which will first start them on the road to fame.

***

\* "Letter to Mr. Henry Clifford [Director] of Philadelphia Museum of Art previous to the opening there of a major Matisse exhibition," Philadelphia Museum of Art exhibition catalogue, pp. 15–16. This English translation is by Esther Rowland Clifford.

It is only after years of preparation that the young artist should touch color—not as description, that is, but as a means of intimate expression. Then he can hope that all the images, even all the symbols, which he uses, will be the reflection of his love for things, a reflection in which he can have confidence if he has been able to carry out his education, with purity, and without lying to himself. Then he will employ color with discernment. He will place it in accordance with a natural design, unformulated and completely concealed, that will spring directly from his feelings: this is what allowed Toulouse-Lautrec, at the end of his life, to exclaim, "At last, I do not know how to draw anymore."

The painter who is just beginning thinks that he paints from his heart. The artist who has completed his development also thinks that he paints from his heart. Only the latter is right, because his training and discipline allow him to accept impulses that he can, at least partially, conceal.

I do not claim to teach: I only want my exhibition not to suggest false interpretations to those who have their own way to make. I should like people to know that they cannot approach color as if coming into a barn door [*entrer au moulin*]: that one must go through a severe preparation to be worthy of it. But first of all, it is clear that one must have a gift for color as a singer must have a voice. Without this gift one can get nowhere, and not everyone can declare like Correggio, "*Anch'io son pittore.*" A colorist makes his presence known even in a simple charcoal drawing.

My dear Mr. Clifford, here is the end of my letter. I started it to let you know that I realize the trouble you are taking over me at the moment. I see that, obeying an interior necessity, I have made it an expression of what I feel about drawing, color, and the importance of discipline in the education of an artist. If you think that all these reflections of mine can be of any use to anyone, do whatever you think best with this letter . . . .

*Henri Matisse, "Testimonial," 1952*★

I could not say anything about my feeling about space beyond what has already been expressed in my pictures. Nothing would be clearer than what you can see on this wall: this girl I painted twenty years ago; this *Bouquet of Flowers* and this *Sleeping Woman*, which date from these last years; and, behind you, that final design for a stained-glass window made of cut-up pieces of colored paper.

As for *La joie de vivre*—I was thirty-five at the time of this *découpage*,[1]

★ From "Témoignages" (observations assembled by Maria Luz and approved by Henri Matisse), *XXᵉ Siecle* (Paris), January 1952, pp. 66–80.

[1] Literally, the cutting out of shapes, but probably used here to refer to the definite, simple contours of the figures in this painting, which are as if they were cut out of paper. He refers to *Joie de Vivre*, completed early in 1906 (Barnes Collection, Merion, Pennsylvania), in which the contours are indeed *découpés*. But studies for the painting are in the loosely brushed Fauvist technique of the previous summer. H.B.C.

and I am now eighty-two—I have stayed the same as when I created it. I do not mean this in the way my friends would mean it, wanting to compliment me upon my appearance, but I say it because all this time I have sought for the same ends, which perhaps I have achieved in different ways.

I had no other purpose when I made the chapel.[1] In a very restricted space—the size is five meters—I wanted to inscribe a spiritual space, one whose dimensions are not limited by the objects represented. That is exactly what I have done up to now in pictures of fifty centimeters or a meter.

You must not tell me that in "discovering" this, I have recreated the space separately from the object—I have never abandoned the object. The object is not of such interest by itself; it is the environment which creates it. It is with this approach that I have worked all my life before the same objects. They imparted to me the power of reality, drawing my thoughts into everything these objects have undergone for and with me. A glass of water with a flower is a different thing from one with a lemon. The object is an actor: a good actor can play a different role in ten plays, as an object can do in ten different pictures. It is not perceived alone by itself, but evokes a group of elements. But you remind me of that little table which I painted isolated in a garden? Well, it represented the whole fresh-air ambience in which I had lived.

The object must act powerfully on the imagination, and the artist's feeling, expressing itself through the object, must render it worthy of interest. It only says what one makes it say.

On a painted surface I render space in an interpretation of what I see. I make of it a color limited by drawing. When I use painting, I have the feeling of quantity—a surface of color which I need, and whose contour I modify in order to define my feeling exactly. Let us call the first action "painting" and the second "drawing." (As far as I am concerned, painting and drawing are one.) I choose my amount of colored surface and make it conformable to my feeling of design, just as the sculptor molds the clay, modifying the lump he made at first by extending it according to his feelings.

Look again at this stained-glass window: here is a dugong (a very recognizable fish—it is in *Larousse*), and over it a sea animal of an algae-like shape. All around are begonias.

This Chinese soldier on the mantelpiece is expressed by a color, and its outline determines the amount of activity.

This one [the artist rolled the figure between his fingers] is in turquoise and eggplant colors such as no soldier ever wore, and would be ruined if he were dressed in colors taken from material reality. To such invented colors whose contours are determined by "drawing" there becomes added the feeling of the artist, to complete the meaning of the object. Everything here is necessary. This

---

[1] The Chapel of the Rosary of the Dominican Nuns of Vence (Alpes-Maritimes), consecrated 23 June 1951. H.B.C.

brown spot, representing the ground on which one imagines the person to be standing, gives the turquoise and eggplant colors an airy existence which, because of their intensity, otherwise could be lost.

The painter chooses his color with the profound concentration suitable to him, just as the musician chooses the tone and intensity of his instruments. The color does not govern the design, but harmonizes with it.

"Vermilion cannot do everything," Othon F. [Friesz] used to say with asperity. Neither is it merely necessary that the color simply clothe the forms, for they must be constituted by it.

You ask me whether my *découpages* are an end of my studies? My searchings do not yet seem to me to have a limit. *Découpage* is what I have found simplest these days, most direct for my self-expression. One must study an object for a long time to learn what its symbolic meaning is. And once again, in a composition the object becomes a new symbol taking part in the whole through restraining its own power. In short, each work is a combination of symbols invented during the execution as they are needed in the particular spot. Removed from the composition for which they were created, these symbols have no more function.

This is the reason why I have never tried to play chess, although friends who think they understand me well have recommended it to me. I answered them, "I cannot play with symbols which never change. These bishops, kings, queens, castles, tell me nothing. But if you used figurines like this, that, and the other person whose lives we know about, then I could play." But during the course of each game I would invent a symbol for each pawn.

The symbol, then, for which I invent an image has no worth unless it speaks with other symbols, which I must choose in the course of my invention, and which are entirely peculiar to that invention. The symbol is determined during the moment I use it—and use it for the object in which it will take part. That is why I cannot make symbols beforehand which could never change, as if they were symbols in literature. The freedom of my invention would then be paralyzed.

My *découpages* do not break away from my former pictures. It is only that I have achieved more completely and abstractly a form reduced to the essential, and have retained the object, no longer in the complexity of its space, but as the symbol which is both sufficient and necessary to make the object exist in its own right, as well as for the composition in which I have conceived it.

I have always sought to be understood, and when my words were garbled by critics or colleagues, I considered it no fault of theirs but my own, because I had not been clear enough to be comprehended. This attitude has enabled me to work all my life without feeling hatred, or even bitterness toward criticism, from whatever source it came, as I relied solely upon clarity of expression in my works to achieve my end. Hatred, rancor, and a vengeful disposition are burdens which the artist cannot load upon himself. His path is so difficult that he must rid his spirit of all that could weigh upon it.

143

*Maurice Vlaminck, "Prefatory Letter"* ★

Dear Friend,

You ask me what I think of the movement taking place in "young French painting" and what I am working on? I shall do my best to satisfy you.

I never go to museums. I avoid their odor, their monotony and severity. In them I rediscover my grandfather's rages when I played hookey. I try to paint with my heart and my loins, not bothering with style.

I never ask a friend how he makes love to his wife in order to love mine, nor what woman I ought to love, and I never worry about how women were loved in 1802. I love like a man and not like a schoolboy or a professor.

*Maurice Vlaminck, Self-Portrait, ca. 1908, etching.*

★ Maurice de Vlaminck, "Lettre-Préface." This English translation is by Lucy R. Lippard from *Lettres, poèmes et 16 réproductions des oeuvres du peintre* (Paris: Librarie Stock, 1923), pp. 7–9.

I have no one but myself to please.

Style *a priori* like Cubism, roundism, etc., etc., leaves me cold. I am not a modiste, nor a doctor nor a man of science.

Science gives me a toothache. I am ignorant of mathematics, the forth dimension, the golden section.

For me "the Cubist uniform" is very militarist, and you know how little I am "the soldier type." Barracks make me neurasthenic and Cubist discipline reminds me of my father's words: "The army will do you good! It will give you character!"

I detest the word "classic" in the sense in which the public uses it.

Madmen scare me. The reasoned, mathematical, Cubist and scientific madness of August 4th, 1914,[1] has cruelly demonstrated to us the falsity of the result.

"Painting," my friend, is a good deal more difficult and a good deal more foolish than all that. If this interests you, a few supplementary details.

I never go to funerals, I do not dance on the 14th of July, I do not play the horses or demonstrate in the streets. I adore children.

VLAMINCK

P.S.—Don't confuse kitchen and pharmacy.

[1] The date of the British declaration of war on Germany following the invasion of Belgium and the beginning of full-scale military operations. Its critics had often charged that Cubism was a discipline and therefore militaristic.

Vlaminck was 38 years of age in 1914 and so was permitted to work in a munitions factory rather than to serve in the army. He had fulfilled his compulsory military service in 1896. H.B.C.

# EXPRESSIONISM

*Emil Nolde, from Jahre der Kämpfe* *

1909 . . . I was no longer satisfied with the way I drew and painted during the last few years, imitating nature and creating form all done preferably with the first stroke, the first brushful of paint. I rubbed and scratched the paper until I tore holes in it, trying to reach something else, something more profound, to grasp the very essence of things. The techniques of Impressionism suggested to me only a means, but no satisfactory end.

Conscientious and exact imitation of nature does not create a work of art. A wax figure confoundingly lifelike causes nothing but disgust. A work becomes a work of art when one re-evaluates the values of nature and adds one's own spirituality. I tried to pursue notions such as these, and often I stood contemplating the landscape, so grey, so simple, yet so splendidly rich with the animation of sun and wind and clouds.

I was happy when I could make something concentrated and simple out of all this complexity.

I tried landscapes. I painted black-spotted cattle, children singing and dancing rounds hand in hand. The technique was loose and flickering. I began to feel a need for greater cohesion. In the midst of these most serious efforts I came down with food poisoning. Some polluted water I drank made me deathly sick. Ada [Nolde's wife] returned from England as fast as trains and boats allowed.

Lying quiet and exhausted, resting for a few minutes free of pain, I heard a neighbor say on the other side of the drawn window curtains: "Is he dead?" It was strange to hear these words, because I felt the whole great time of creativity should still lie ahead of me.

The worst of the crisis had passed when Ada arrived in the middle of the night. She was unendingly good and kind during the weeks of convalescence, but then she recognized with subtle comprehension my inner burden. Only half of me had been at her side, and again she left the painter alone.

I drew thirteen people on a canvas, with a hard pencil and a sharp point. The Saviour and his twelve apostles, sitting around a table in the balmy spring night, the night before Christ's great passion. These were the hours when Christ revealed to his beloved disciples His grand thought of redemption. From the innermost depth He spoke the words preserved for us in His sacraments. John leaned his head on the shoulder of his divine friend.—

Without much intention, knowledge, or thought I had followed an irresistible desire to represent profound spirituality, religion, and tenderness. A

* This English translation is by Ernest Mundt from Emil Nolde, *Jahre der Kämpfe*, second volume of an autobiography, 1902–1914 (Berlin: Rembrandt, 1934), pp. 102–108, 172–175. A second and enlarged edition was published by Christian Wolff (Flensburg, 1958), and is authorized by Ada and Emil Nolde.

few of the heads of apostles and a head of Christ I had sketched before. Near shock I stood before the drawing. No image of nature was near me, and now I was to paint the most mysterious, the profoundest, most inward event of all Christian religion! Christ, His face transfigured, sanctified and withdrawn, encircled by His disciples who are profoundly moved.

I painted and painted, hardly knowing whether it was night or day, whether I was a human being or only a painter.

I saw the painting when I went to bed, it confronted me during the night, it faced me when I woke up.

I painted happily. The painting was finished. *The Last Supper.*

The painting of *The Derision of Christ* saved me from drowning in religion and compassion. Here the soldiers yell and hit and taunt and spit.

Then again I went down to the mystical depth of human divine existence. The painting of the Pentecost was sketched out. Five of the fishermen apostles were painted in ecstatic supersensory reception of the Holy Ghost. My Ada arrived that evening. I was distracted. She saw it, and the very next morning she departed for somewhere, on her own initiative. The painting could have remained a fragment—but now I kept on painting happily—red-lilac flames above the heads of the disciples, in the holy hour pregnant with joy when they became blessed apostles called upon to bear witness to divine revelation.

"Go you therefore, and teach all nations, baptizing them in the name of the Father, and the Son, and of the Holy Ghost." This is what their divine friend called to them, and how beautiful is all they report Christ is saying to them. How infinitely beautiful it must have been to be present when He said these words.

The apostles went forth into the world. The message of redemption kindled magnificent fires. "Believe and you will be saved!" Altars, crowns, and empires tottered and tumbled.—

Engrossed with feelings such as these I painted my religious pictures. Light and dark and the cold and warm of hues occupied the painter. So did the representation of people moved by the spirit of religion, and also deep groping religious thoughts so despairing that they almost drove him insane. The Bible contains contradictions and various scientific mistakes. To remain uncritical demands the very best of intentions and an almost superhuman respect.

Why did the message of redemption have to settle out in cold dogma and vain form, only rarely kindling a small flame which quickly dies? The number of Christians is small. Barely a third of humanity! The number of "live" Christians is infinitesimal. Why did happiness and enthusiasm end so soon? Why was Buddhism able to resist, how could the teachings of Mohammed destroy large parts of humanity, my God, why?

Who is conceited enough to assume that our earth is distinguished among the planets? What is so significant about the earth, this little things, in the universe of millions of far greater bodies where, measured by earthly standards, the chances for life and development are incomparatively better?

The insect crawling on the ground does not recognize man. Do we recognize in its dimensions the all-encompassing God?

Is not God infinitely more powerful and majestic than people once reported, than they could imagine Him to be in their little delusions of superiority?

Aren't we all afflicted with megalomania?

The wise ones, the stupid ones, the saintly and the pious ones, they all know nothing. We all know nothing.

Knowledge and science are inadequate when it comes to the simplest questions about time and eternity, about God, about heaven and Satan.

Faith alone has no limitations.

Faith is easy for the simple-minded. His convictions are built on a rock unshaken by doubt.

In the absence of knowledge, dedicated piety has all the room.

Thus ended my burrowing thoughts. They are just an example of my many stirrings and inner battles.

And life went on.

Hans, my departed brother, must have fought in his youth many desperate battles with his soul, because he most pleadingly prayed to God, asking Him to give his children but little brains.

Nearly despairing in dark hours I too have wished at times that as an artist I had received a lighter gift.

Only the superficial have it easy.

I produced this summer one other painting, a Crucifixion with many small figures. I could not go on. Had I lost my feeling for religion? Was I spiritually tired? I think it was both. I had had enough.

*Emil Nolde, Self-Portrait with Pipe, 1908, lithograph.*

*Ernst Ludwig Kirchner, program for Die Brücke, 1905, woodcut.*

I doubt that I could have painted with so much power the Last Supper and the Pentecost, both so deeply fraught with feeling, had I been bound by a rigid dogma and the letter of the Bible. I had to be artistically free, not confronted by a God hard as steel like an Assyrian king, but with God inside of me, glowing and holy like the love of Christ. *The Last Supper* and *The Pentecost* marked the change from optical, external stimuli to values of inner conviction. They became milestones—in all likelihood not only for my own work.

Relatives of my father's visited me one evening. Pious as in a church, shyly and reluctantly they sat in front of *The Last Supper* and *The Pentecost*. The paintings moved them with their sacredness. "There is Christ, in the middle, and there is John, and this is probably Peter?" they asked, pointing to *The Last Supper*. "And who is sitting in the middle here?" they asked, looking to *The Pentecost*. When I said it was Peter, they became very quiet. If Peter looked like that during the Last Supper, he could not have another face in the Pentecost. One of these could not be true.—Such were their orientation and criticism.

The effect of my paintings on unsophisticated people always gratified me. Even the most intricate and profound works became meaningful to them in a short while. Difficulties arose only with people spoiled by the surface glitter of city life. Their orientation was different.[1] It was not long before I overheard comments such as "derision and blasphemy" lightly tossed off in front of my paintings.

These people, used to the pleasantly innocuous and often saccharine oils of the Italian and German Renaissance, resented the glowing intensity of my work.

I was working on a book on the artistic expressions of primitive peoples (*Kunstaeusserungen der Naturvoelker*).[2] I jotted down some sentences intended to be used as introduction. 1912.

1. The most perfect art is found in classic Greece. Raphael is the greatest of all painters. This is what every art teacher told us twenty or thirty years ago.

2. Many things have changed since that time. We do not care for Raphael, and the sculptures of the so-called classic periods leave us cool. The ideals of our predecessors are no longer ours. We are less fond of works which for centuries have been identified with the names of great masters. Artists wise in the ways of their times created sculptures and paintings for palaces and Popes. Today, we admire and love the simple, monumental sculptures in the cathedrals of Naumburg, Magdeburg, or Bamberg, carved by self-sufficient people working in their own stone yards, people of whose lives we know little, whose very names have not survived.

3. Our museums are becoming larger and fuller, and they are growing fast. I am no friend of these vast agglomerations, which suffocate us with their size. I expect soon to see a reaction against such excessive collections.

4. Not too long ago, the art of only a few periods was deemed worthy of representation in museums. Then others were added. Coptic and Early Christian art, Greek terra cotta and vases, Persian and Islamic art swelled the ranks. Why then are Indian, Chinese, and Javanese art still considered the province of science and ethnology? And why does the art of primitive peoples as such receive no appreciation at all?

5. Why is it that we artists love to see the unsophisticated artifacts of the primitives?

6. It is a sign of our times that every piece of pottery or dress or jewelry, every tool for living has to start with a blueprint.—Primitive people begin making things with their fingers, with material in their hands. Their work expresses the pleasure

---

[1] The theme of the superiority of the simple or the primitive way of life over the civilized way was common in both Nolde's writings and in the subject matter of his art. It was, in fact, a basic belief of the age everywhere among the leading movements and artists, even the Constructionists. H.B.C.

[2] The book was never completed, and apparently this text comprises all that was ever actually written. H.B.C.

of making. What we enjoy, probably, is the intense and often grotesque expression of energy, of life.

These sentences reach into the present, and perhaps even beyond it.

The fundamental sense of identity, the plastic—colorful—ornamental pleasure shown by "primitives" for their weapons and their objects of sacred or daily uses are surely often more beautiful than the saccharinely tasteful decorations on the objects displayed in the show cases of our salons and in the museums of arts and crafts.

There is enough art around that is over-bred, pale, and decadent. This may be why young artists have taken their cues from the aborigines.

We "educated" people have not moved so wondrously far ahead, as is often said. Our actions cut two ways. For centuries, we Europeans have treated the primitive peoples with irresponsible voraciousness. We have annihilated people and races—and always under the hypocritical pretext of the best of intentions.

Animals of prey know little pity. We whites often show even less.

The first introductory sentences concerning Greek art and the art of Raphael may appear to be tossed off with a lack of responsibility. This is not the case. The painter openly states his opinions. The Assyrians, the Egyptians had a powerful plastic sense, and so did the Archaic Greeks. But then followed a period of pleasing poses, of many limbs, of males and females needing the signs of sex to show whether they were men or women. These were times of frightening decay. Even if all the aesthetes down to this day have maintained the opposite.

Glory be to our strong, healthy German art.

And this painter much preferred the holy German madonnas, invested with the souls of Grünewald and others, over the Latin, superficially presentable paintings of Raphael, which fit so well into the milieu of doges and Popes.

All the arts of all the Mediterranean people share certain qualities which are their property. Our German art has glorious qualities of its own.

We respect the art of the Latins; German art has our love.

The southern sun, tempting us, the Nordic people since time immemorial, stealing what is most our own, our strength, our reticence, our inmost tenderness.

A little weakness, a little sweetness, a little superficiality—and the whole world curries the artist's favor.

Only when a painting is altogether weak, sweet, and superficial will every one recognize it as bad.

Who among us knows the Edda, the Isenheim Altar, Goethe's Faust, Nietzsche's Zarathustra, all these runes hewn in stone, these proud, sublime works of Nordic Germanic peoples! There are eternal truths, and not the intoxications of the day.

A young artist once prayed: "I want my art so much to become strong, and unsentimental, and fervent."

*Wassily Kandinsky, "The Effect of Color," 1911\**

If you let your eye stray over a palette of colors, you experience two things. In the first place you receive *a purely physical effect*, namely the eye itself is enchanted by the beauty and other qualities of color. You experience satisfaction and delight, like a gourmet savoring a delicacy. Or the eye is stimulated as the tongue is titillated by a spicy dish. But then it grows calm and cool, like a finger after touching ice. These are physical sensations, limited in duration. They are superficial, too, and leave no lasting impression behind if the soul remains closed. Just as we feel at the touch of ice a sensation of cold, forgotten as soon as the finger becomes warm again, so the physical action of color is forgotten as soon as the eye turns

*Wassily Kandinsky, ca. 1903.*

\* Chapter 5, *Uber das Geistige in der Kunst* (Munich: R. Piper, 1912), pp. 37–42 (actually published in December, 1911). English translation by Francis Golffing, Michael Harrison, and Ferdinand Ostertag from *Concerning the Spiritual in Art* (New York: Wittenborn, Schultz, 1947), pp. 43–45.

away. On the other hand, as the physical coldness of ice, upon penetrating more deeply, arouses more complex feelings, and indeed a whole chain of psychological experiences, so may also the superficial impression of color develop into an experience.

On the average man, only impressions caused by familiar objects will be superficial. A first encounter with any new phenomenon exercises immediately an impression on the soul. This is the experience of the child discovering the world; every object is new to him. He sees light, wishes to hold it, burns his finger and feels henceforth a proper respect for flame. But later he learns that light has a friendly side as well, that it drives away the darkness, makes the day longer, is essential to warmth and cooking, and affords a cheerful spectacle. From the accumulation of these experiences comes a knowledge of light, indelibly fixed in his mind. The strong, intensive interest disappears, and the visual attraction of flame is balanced against indifference to it. In this way the whole world becomes gradually disenchanted. The human being realizes that trees give shade, that horses run fast and automobiles still faster, that dogs bite, that the moon is distant, that the figure seen in a mirror is not real.

Only with higher development does the circle of experience of different beings and objects grow wider. Only in the highest development do they acquire an internal meaning and an inner resonance. It is the same with color, which makes a momentary and superficial impression on a soul whose sensibility is slightly developed. But even this simplest effect varies in quality. The eye is strongly attracted by light, clear colors, and still more strongly by colors that are warm as well as clear; vermilion stimulates like flame, which has always fascinated human beings. Keen lemon-yellow hurts the eye as does a prolonged and shrill bugle note the ear, and one turns away for relief to blue or green.

But to a more sensitive soul the effect of colors is deeper and intensely moving. And so we come to the second result of looking at colors: *their psychological effect*. They produce a correspondent spiritual vibration, and it is only as a step towards this spiritual vibration that the physical impression is of importance.

Whether the psychological effect of color is direct, as these last few lines imply, or whether it is the outcome of association, is open to question. The soul being one with the body, it may well be possible that a psychological tremor generates a corresponding one through *association*. For example, red may cause a sensation analogous to that caused by flame, because red is the color of flame. A warm red will prove exciting, another shade of red will cause pain or disgust through association with running blood. In these cases color awakens a corresponding physical sensation, which undoubtedly works poignantly upon the soul.

If this were always the case, it would be easy to define by association the physical effects of color, not only upon the eye but the other senses. One might say that bright yellow looks sour, because it recalls the taste of a lemon.

But such definitions are not universal. There are several correlations

between taste and color which refuse to be classified. A Dresden doctor reported that one of his patients, whom he designated as an "exceptionally sensitive person," could not eat a certain sauce without tasting "blue," i.e., without "seeing blue."[1] It would be possible to suggest, by way of explanation, that in highly sensitive people the approach to the soul is so direct, the soul itself so impressionable, that any impression of taste communicates itself immediately to the soul, and thence to the other organs of sense (in this case, the eyes). This would imply an echo or reverberation, such as occurs sometimes in musical instruments which, without being touched, sound in harmony with an instrument that is being played. Men of sensitivity are like good, much-played violins which vibrate at each touch of the bow.

But sight has been known to harmonize not only with the sense of taste but with the other senses. Many colors have been described as rough or prickly, others as smooth and velvety, so that one feels inclined to stroke them (e.g., dark ultramarine, chrome-oxide green, and madder-lake). Even the distinction between warm and cool colors is based upon this discrimination. Some colors appear soft (madder-lake), others hard (cobalt green, blue-green oxide), so that fresh from the tube they seem to be "dry."

The expression "perfumed colors" is frequently met with.

The sound of colors is so definite that it would be hard to find anyone who would express bright yellow with base notes, or dark lake with the treble.[2] The explanation in terms of association will not satisfy us, in many important cases. Those who have heard of chromotherapy know that colored light can influence the whole body. Attempts have been made with different colors to treat various nervous ailments. Red light stimulates and excites the heart, while blue light can cause temporary paralysis. If the effect of such action can be observed in animals and plants, as it has, then the association theory proves inadequate. In any event one must admit that the subject is at present unexplored, but that it is unquestionable that color can exercise enormous influence upon the body as a physical organism.

The theory of association is no more satisfactory in the psychological sphere. Generally speaking, color directly influences the soul. Color is the key-

---

[1] Freudenberg, "Spaltung der Persönlichkeit" (*Übersinnliche Welt*, 1908, No. 2, pp. 64–65). The author also discusses hearing color, and says that no rules can be laid down. But see L. Sbanejeff in *Musik*, No. 9, Moscow, 1911, where the imminent possibility of laying down a law is clear. W.K.

[2] Much theory and practice have been devoted to this question. People have thought to paint in counterpoint. Also, unmusical children have been successfully helped to play the piano by quoting a parallel in color (e.g. of flowers). Mme. A. Sacharjin-Unkowsky has worked along these lines for several years and has evolved a method of "so describing sounds by natural colors, and colors by natural sounds, that color could be heard and sound seen." The system has proved successful for several years both in the inventor's own school and the Conservatory at St. Petersburg. Finally Scriabin, on more spiritual lines, has paralleled sounds and colors in a chart not unlike that of Mme. Unkowsky. In *Prometheus* he has given convincing proof of his theories. (His chart appeared in *Musik*, No. 9, Moscow, 1911.) W.K.

board, the eyes are the hammers, the soul is the piano with many strings. The artist is the hand that plays, touching one key or another purposively, to cause vibrations in the soul.

*It is evident therefore that color harmony must rest ultimately on purposive playing upon the human soul: this is one of the guiding principles of internal necessity.*

### Wassily Kandinsky, "On the Problem of Form," 1912*

At the appointed time, necessities become ripe. That is, the creative *spirit* (which one can designate as the abstract spirit) finds an avenue to the soul, later to other souls, and causes a yearning, an inner urge.

When the conditions necessary for the ripening of a precise form are fulfilled, the yearning, the inner urge acquires the power to create in the human spirit a new value which, consciously or unconsciously, begins to live in the human being. From this moment on, consciously or unconsciously, the human being seeks to find a material form for the new value which lives in him in spiritual form.

That is the searching of the spiritual value for materialization. Matter is here a storeroom and from it the spirit chooses what is specifically *necessary* for it—just as the cook would.

That is the positive, the creative. That is the good. *The white, fertilizing ray.*

This white ray leads to evolution, to elevation. Thus behind matter the creative spirit is concealed within matter. The veiling of the spirit in the material is often so dense that there are generally few people who can see through to the spirit. Thus, especially today, many do not see the spirit in religion and in art. There are whole epochs which disavow the spirit, since the eyes of people, generally at such times, cannot see the spirit. It was so in the nineteenth century and is, on the whole, still so today.

People are blinded.

A black hand is laid over their eyes. The black hand belongs to him who hates. He who hates endeavors, with all means, to hold back the evolution, the elevation.

That is the negative, the destructive. That is the evil. *The black, death-bringing hand.*

The evolution, the movement forward and upward, is only possible if the path is clear, that is if no barriers stand in the way. That is the *external condition*.

The force which moves the human spirit forward and upward on the clear path is the abstract spirit, one which must naturally ring out and be able to be heard; a summoning must be possible. That is the *internal condition*.

To destroy both of these conditions is the means of the black hand against evolution.

---

* This English translation is by Kenneth Lindsay from Wassily Kandinsky, "Über die Formfrage," *Der Blaue Reiter* (Munich: R. Piper, 1912), pp. 74-100.

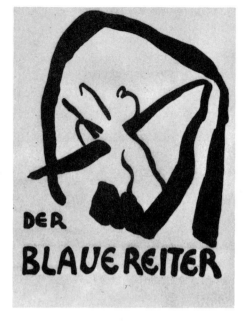

*Wassily Kandinsky, Der Blaue Reiter, title page of the first exhibition catalogue, Munich, 1911, woodcut.*

The tools for it are: fear of the clear path; fear of freedom (which is philistinism); and deafness to the spirit (which is dull materialism).

Therefore, people regard each new value with hostility; indeed, they seek to fight it with ridicule and slander. The human being who carries the value is pictured as ridiculous and dishonest. The new value is laughed at and abused. That is the misery of life.

The joy of life is the irresistible, constant victory of the new value.

This victory proceeds slowly. The new value conquers the people quite gradually. And when it becomes undoubtable in many eyes, this value, which was absolutely necessary today, will be turned into a wall—a wall which is erected against tomorrow.

The changing of the new value (of the fruit of freedom) into a petrified form (a wall against freedom) is the work of the black hand.

The whole evolution, that is to say, the inner development and the outer culture, is then a shifting of the barriers.

The barriers are constantly created from new values which have overthrown the old barriers.

Thus, one sees that basically the new value is not the most important, but rather the spirit which has revealed itself in this value. And further, the freedom necessary for the revelations.

Thus, one sees that the absolute is not to be sought in the form (materialism).

The form is always bound to its time, is relative, since it is nothing more

than the means necessary today in which today's revelation manifests itself, resounds.

The resonance is then the soul of the form which can only become alive through the resonance and which *works* from within to without.

*The form is the outer expression of the inner content.*

Therefore one should not make a deity of form. And one should fight for the form only insofar as it can serve as means of expression of the inner resonance. Therefore one should not seek salvation in *one* form.

This statement must be understood correctly. Every creative artist's own means of expression (that is, form) is the best since it most appropriately embodies that which he feels compelled to proclaim. From that, however, the conclusion is often falsely drawn that this means of expression is, or ought to be, the best for other artists also.

Since the form is only an expression of the content and the content is different with different artists, it is then clear that there can be *many different forms at the same time* which are *equally good*. *Necessity creates the form*. Fish which live at great depths have no eyes. The elephant has a trunk. The chameleon changes its color, and so forth.

Thus, the spirit of the individual artist is mirrored in the form. The form bears the stamp of the *personality*.

The personality, however, can naturally not be conceived as something which stands outside of time and space. Rather, it is subject, to a certain extent, to time (epoch), to space (people).

Just as each individual artist has to make his word known, so does each people, and consequently, also that people to which this artist belongs. This connection is mirrored in the form and is characterized by the *national element* in the work.

And finally also, each age has its especially assigned task, the revelation possible at a specific age. The reflection of this temporal element is recognized in the work as *style*.

All these three elements inevitably leave their stamp on a work of art. It is not only superfluous to worry about their presence, but also harmful since forcing, here too, can achieve nothing but a delusion, a temporal betrayal.

And, on the other hand, it becomes self-evident that it is superfluous and harmful to want to lay particular stress upon only one of the three elements. Just as today many concern themselves with the national element and still others with style, recently homage has been paid especially to the cult of the personality (of the individual element).

As has been said in the beginning, the abstract spirit takes possession first of a single human spirit; later it governs an ever-increasing number of people. At this moment, individual artists are subjected to the spirit of the time which forces them to use particular forms which are related to each other and, therefore, also possess an external similarity.

This factor is called a *movement*. It is completely justified and indispensable to a group of artists (just as the individual form is indispensable for one artist).

And as no salvation is to be sought in the form of a single artist, it is not to be sought in this group-form. For each group its own form is the best since it most effectively embodies that which the group feels duty-bound to make known. One should not thereby conclude, however, that this form is or ought to be the best for all. Here also, full freedom shall prevail: one shall consider valid every form, deem correct (= artistic) every form, which represents an inner content. If one acts otherwise, one is no longer serving the free spirit (white ray) but the petrified barrier (black hand).

Here also, one arrives at the same result which was established above: the form (material substance) in general is not the most important, but rather the content (spirit).

Consequently, the form can have a pleasant or unpleasant effect, can appear beautiful, ugly, harmonious, disharmonious, skillful, unskillful, fine, coarse, and so forth, and yet it must not be accepted or rejected either for the qualities which are held to be positive or for the qualities which are felt to be negative. All of these notions are completely relative, as one observes at first glance in the endless, changing series of forms which have already existed.

The form itself is just as relative. This is the way the form is to be appreciated and understood. One must approach a work in such a way that the form has an effect on the soul. And through the form, the content (spirit, inner resonance). Otherwise one elevates the relative to the absolute.

In practical life one will hardly find a person who, if he wants to go to Berlin, gets off the train in Regensburg. In spiritual life, getting off the train in Regensburg is a rather usual thing. Sometimes even the engineer does not want to go any further, and all of the passengers get off in Regensburg. How many, who sought God, finally remained standing before a carved figure! How many, who sought art, became caught on a form which an artist had used for his own purposes, be it Giotto, Raphael, Dürer, or Van Gogh!

And so, as a last conclusion it must be established that it is not most important whether the form is personal, national, or has style; whether or not it is in accordance with the major contemporary movements; whether or not it is related to many or few other forms; whether or not it stands completely by itself: but rather *the most important thing in the question of form is whether or not the form has grown out of the inner necessity.*[1]

The existence of forms in time and in space can likewise be explained by the inner necessity of time and of space. Therefore, it will finally become possible to pick out and schematically present the characteristics of the time and of a people.

---

[1] That is, one may not make a uniform out of a form. Works of art are not soldiers. With a given artist, a given form can be the best at one time and the worst at another. In the first case, it has grown in the soil of inner necessity; in the second—in the soil of outer necessity: out of ambition and greed. W. K.

And the greater the epoch is—that is, the greater (quantitatively and qualitatively) the strivings toward the spiritual are—the richer in number the forms become; and greater collective currents (group movements) are to be observed . . . which is self-evident.

These characteristics of a great spiritual epoch (which was prophesied and which makes itself known today in one of the first of the beginning stages) can be seen in contemporary art. Namely:

1. a great freedom which appears unlimited to some and which
2. makes the *spirit* audible; which *spirit*
3. we observe revealing itself in things with a particularly strong force; which *spirit*
4. will gradually—and already does—take for itself as tools all spiritual domains; from which
5. it also creates in every spiritual domain—consequently in plastic art too (especially in painting)—many isolated and group-embracing *means of expression* (forms); and
6. today the whole storeroom is at the *spirit's* disposal; that is, *every material substance* from the most "solid" to the simply two-dimensionally living (abstract), is used as an element of form.

Concerning No. 1. As far as freedom is concerned, it expresses itself in the striving for liberation from the forms which have already embodied freedom's aim, that is from the old forms; and in the striving for creation of new and infinitely manifold forms.

Concerning No. 2. The instinctive searching for the extreme limits of contemporary expressional means—means of personality, of people, of time—is: a subordinating—determined by the spirit of the time—of the seemingly unrestrained freedom; and an act of making more precise the direction in which the searching must take place. The little bug, which runs in all directions under a glass, believes to see before it an unrestricted freedom. At a certain point, however, it encounters the glass: it can see further but not go any further. And moving the glass forward gives the bug the possibility of running through more space. And the bug's main movement is determined by the controlling hand. In like fashion our epoch, esteeming itself to be completely free, will encounter certain limits: these limits, however, will be shifted "tomorrow."

Concerning No. 3. This seemingly unrestrained freedom and the involvement of the spirit arises from the fact that we are beginning to feel the spirit, the *inner resonance*, in everything. And at the same time, this beginning ability turns into a riper fruit of the seemingly unrestrained freedom and of the entering spirit.

Concerning No. 4. Regarding all other spiritual domains, we cannot try to make more precise the indicated effects. Nevertheless it must become clear to

159

everyone of his own accord that the cooperating of freedom and the spirit will be reflected everywhere, sooner or later.[1]

Concerning No. 5. In the fine arts (especially in painting) we encounter today a striking abundance of forms. In part they appear as forms of individual, great personalities; and in part they sweep along whole groups of artists in one large and quite precisely flowing current.

And the great diversity of the forms still allows the common striving to be easily recognized. And particularly in the mass movement the all-embracing spirit of form can be recognized today. And so it is sufficient to say: *everything is permitted.* That which is permitted today certainly cannot be overstepped. That which is forbidden today remains imperturbably standing.

And one should not set himself any limits, since they are set anyway. That is valid not only for the sender (artist) but also for the receiver (observer). He can and must follow the artist, and he should have no fear of being led astray. Physically the human being cannot even move in a straight line (the field and meadow paths!) and even less so spiritually. And especially among spiritual paths the straight road is often the long one, since it is wrong, and the one which appears wrong is often the most correct.

Whenever "feeling" asserts itself, it will sooner or later correctly lead the artist as well as the observer. The fearful clinging to *one* form leads finally and inevitably into a dead end. The open feeling leads toward freedom. The former is to restrict oneself to the material substance. The latter is to follow the spirit: the spirit creates one form and goes on to others.

Concerning No. 6. The eye which is directed at one point (be it form or content) cannot possibly survey a large plane. The inattentive eye, roaming over the surface, surveys this large plane or one part of it, but is caught by the external dissimilarities and loses itself in contradictions. The reason for these contradictions lies in the diversity of means which the spirit of today extracts, apparently without plan, from the storeroom of material substances. Many call the present state of painting "anarchy." The same word is also used, here and there, in characterizing the present state of music. By it one falsely understands a planless overthrowing and disorder. Anarchy is planfulness and order which are not produced by an external and ultimately failing force, but are created by *the feeling of the good.* Here, too, limits are set. However, they must be designated as *inner* and they must replace the outer limits. And these limits also are always extended, whereby arises the ever-increasing freedom which, on its part, creates a clear path for further revelations. Contemporary art, which in this sense is to be correctly designated as anarchistic, reflects not only the spiritual standpoint which has already been won, but it embodies the spiritual which is ripe for disclosure as a materializing force.

The forms for embodiment, which are extracted from the storeroom of

---

[1] I have discussed this question somewhat more deeply in my publication, *On the Spiritual in Art.* w. k.

matter by the spirit, can easily be arranged between two poles. These two poles are:

1. the great abstraction,
2. the great realism.

These two poles open *two roads* which lead finally *to one goal*.

Between these two poles lie many combinations of different harmonies of the abstract with the real.

Both of these elements were always present in art, where they were to be designated as the "purely artistic" and the "objective." The first expressed itself in the second, whereby the second served the first. It was a varied balancing which apparently sought to achieve the acme of the ideal in absolute equilibrium.

And it seems today that one no longer finds a goal in this ideal, that the lever which holds the balance pans of the scale has disappeared and that both balance pans intend to lead their existences separately, as self-contained units independent of each other. And also in this shattering of the ideal scale, one sees "anarchistic elements." Art has apparently put an end to the pleasant supplementing of the abstract with the objective—and conversely.

On the one hand, the diverting support in the objective is taken away from the abstract, and the observer feels himself floating in the air. One says: art is losing its footing. On the other hand, the diverting idealization in the abstract (the "artistic" element) is taken away from the objective, and the observer feels nailed to the floor. One says: art is losing its ideal. These reproaches grow from inadequately developed feeling. The practice of giving the most attention to form, and the behavior of the observer which springs from that—that is, the clinging to the usual form of equilibrium—are the blinding forces which leave no clear path to free feeling.

The aforementioned great realism—just now budding for the first time— is an endeavor to drive the outwardly artistic out of the picture and to embody the content of the work by simple ("inartistic") reproduction of the simple solid object.

The outer shell of the object, which is understood and fixed in the picture in this way, and the simultaneous striking out of the usual obtrusive beauty, expose most surely the inner resonance of the thing. Especially through this shell and by this reducing of the "artistic" to the minimum, the soul of the object stands out most strongly, since the outer palatable beauty can no longer divert.[1]

And that is only possible because we are increasingly able to hear the whole world just as it is, that is, with no beautifying interpretation.

---

[1] The spirit has already absorbed the content of accustomed beauty and finds no new nourishment in it. The form of this accustomed beauty gives the usual delights to the lazy physical eye. The effect of the work gets stuck in the realm of the physical. The spiritual experience becomes impossible. Thus, this beauty often creates a force which does not lead to the spirit but away from the spirit. W. K.

*The "artistic," brought to the minimum, must be recognized here as the most strongly working abstract.*[1]

The great contrast to this realism is the great abstraction which consists of the endeavor to eliminate, apparently fully, the objective (the real), and which seeks to embody the content of the work in "unmaterial" forms. The abstract life of the objective forms is reduced to the minimum, and consequently, the striking predominance of the abstract units expose the inner resonance of the picture most certainly. And just as in realism the inner resonance is strengthened by the removal of the abstract, this resonance is also strengthened in the abstraction by the removal of the real. There it was the accustomed outward palatable beauty which formed the damper. Here it is the accustomed outward supporting object.

For the "understanding" of such pictures, the same liberation is necessary as in realism, that is, it must become possible, here too, to be able to hear the whole world just as it is without objective interpretation. And here these abstracted or abstract forms (lines, planes, spots, and so forth) are not important as such, but only their inner resonance, their life. Just as in realism, not the object itself or its outer shell are important, but its inner resonance, its life.

*The "objective," brought to the minimum, must be recognized in the abstraction as the most strongly working reality.*[2]

Thus we finally see: if in the great realism reality appears strikingly large and the abstract strikingly small and if in the great abstraction this relation seems to be reversed, in the last analysis (= aim) these two poles equal each other. Between these two antipodes the sign of equality can be placed:

Realism = Abstraction

Abstraction = Realism.

*The greatest external difference turns into the greatest internal equality.*

Some examples will transfer us from the realm of reflection into the realm

---

[1] *The quantitative diminution of the abstract is consequently equal to the qualitative magnification of the abstract.* Here we have touched one of the most essential laws: the *external* magnifying of a means of expression leads, in certain circumstances, to the diminishing of the *internal* power of the same. Here, $2 + 1$ is less than $2 - 1$. This law naturally manifests itself also in the smallest form of expression: a spot of color often loses intensity and must lose effect—through external magnification and through the external increase of strength. An especially good movement of colors often results from a hemming-in of them; a sad resonance can be achieved by direct sweetness of color, and so forth. These are all manifestations of the law of contrast in its broader consequences. Briefly stated: *the true form arises from the combination of feeling and science.* Here again I must call to mind the cook! Good, physical food also results from the combination of a good recipe (where everything is exactly specified in pounds and grams) and of the guiding feeling. A great characteristic of our time is the rise of knowledge: *Kunstwissenschaft* is gradually taking its proper place. That is the coming "thoroughbass," for which an infinite path of change and development is naturally in store. W. K.

[2] Thus, at the other pole we encounter the same law as was just mentioned, according to which the *quantitative diminution is equal to the qualitative magnification.* W. K.

of the tangible. If the reader looks at any letter of these lines naïvely, that is: as an object instead of as a familiar symbol of a part of a word; as something other than the practical-purposeful abstract form which man has created as a fixed symbol for a definite sound; then he will see in this letter a physical form which makes a definite external and inner impression. This impression is independent of the abstract form just mentioned. In this sense the letter consists of:

1. the main form (the whole appearance) which, quite roughly termed, appears "gay," "sad," "striving," "receding," "defiant," "ostentatious," and so forth;

2. and consists of individual lines curved this way or that, which always make a certain inner impression, that is, they are just as "gay," "sad," and so forth.

When the reader has felt these two elements of the letter, there arises in him immediately the feeling which is caused by this letter as a *being* with *inner life*.

Here, one should not come up with the retort that this letter affects someone in this way and another in a different way. That is secondary and understandable. Generally speaking, every being affects different people one way or another. We see only that the letter consists of two elements which, in the end, do express *one* resonance. The individual lines of the second element can be "gay" and yet the whole impression (element 1) can have a "sad" effect, and so forth. The individual movements of the second element are organic parts of the first. We observe in every song, every piano piece, in every symphony, the same kind of construction and the same kind of subordination of the individual elements to *one* resonance. And a drawing, sketch, or picture is formed by exactly the same procedure. Here the laws of construction reveal themselves. At the moment, only one thing is important for us: the letter has an effect. And, as has been said, this is a double effect:

1. The letter acts as a purposeful symbol;

2. it acts as a form first and later as inner resonance of this form, self-supporting and completely independent.

It is important to us that these two effects are not reciprocal, that the first effect is external and the second one has an inner import.

From this we draw the conclusion that the *external effect can be a different one from the inner effect*: the inner effect is caused by the *inner resonance*; and this is *one of the most powerful* and deepest *means of expression* in every composition.[1]

Let us take another example. We see in this same book a dash. This dash, if it is applied in the right place—as I am doing here—is a line with a practical-purposeful significance. Let us lengthen this short line and yet leave it in the right place: the import of the line remains, as does its significance. There arises, however, an indefinable characteristic through the unusualness of this extension, at which

---

[1] Here I touch such great problems only in passing. The reader need only become further absorbed in these questions and then, for example, the powerful, mysterious, irresistibly enticing element of this last conclusion will appear of its own accord. W. K.

point the reader asks himself why the line is so long and whether this length does not have a practical-purposeful purpose. Let us put this same line in an incorrect place (just as—I am doing here). The correct practical-purposeful element is lost and can no longer be found. The ramifications of the inquiry have greatly increased. The thought of a misprint remains, that is, of the distortion of the practical-purposeful element—which sounds negative here. Let us place the same line on an empty page. Let it be, for example, long and curved. This case is very similar to the supposed misprint, only one thinks (as long as hope for explanation exists) of the correct practical-purposeful element. And later (if no explanation can be found), of the negative element. However, as long as this or that line remains in the book, the practical-purposeful element cannot be definitely eliminated.

Then let us apply a similar line to a background on which it is possible to avoid the practical-purposeful element completely. For example to a canvas. As long as the observer (he is no longer a reader) regards the line on the canvas as a means of outlining an object, he remains subject to the impression of the practical-purposeful element. However, the minute he says to himself that the practical object in the picture played mostly an incidental role and not a purely pictorial one, and that the line sometimes had an exclusively, purely painterly significance,[1] at this moment the soul of the observer is ready to experience the *pure inner resonance* of this line.

But has the object, the thing, been removed thereby from the picture? No. The line is, as we have seen above, a thing which has just as much practical-purposeful import as a chair, a fountain, a knife, a book, and so forth. And this thing was used in the last example as a purely pictorial means, without the other qualities which it can also possess—that is, in its pure inner resonance.

So, if in the picture a line is freed from the aim of designating a thing and functions as a thing itself, its inner resonance is not weakened by any subordinate roles and acquires its full inner strength.

Thus we arrive at the result that pure abstraction also makes use of things which lead their material existence, just as pure realism does. The greatest negation of the objective and its greatest affirmation again receive the sign of equality. And this sign is again justified by the mutually held aim: by the embodying of the same inner resonance.

Here we see that as a matter of principle it has *no significance at all whether a real or abstract form is used by the artist.*

*Since both forms are internally equal* the choice must be left to the artist, who must know best himself by which means he can materialize most clearly the content of his art. Abstractly put: *In principle, there is no question of form.*

And in fact: if there were a question of form involving principle, an answer would also be possible. And everyone who knows the answer would be

---

[1] Van Gogh used the line, as such, with particular strength and without wanting, in so doing, to indicate the objective in any way. w. k.

able to create works of art. That means that from then on art would no longer exist. Practically stated, the question of form changes into the question: Which form shall I use in this case in order to arrive at the necessary expression of my inner experience? The answer is in this case always scientifically precise, absolute, and for other cases relative, i.e., a form which is the best in one case can be the worst in another case: everything here depends upon the inner necessity which alone can make a form correct. And only then can a form have a meaning for several when the inner necessity, under the pressure of time and space, chooses individual forms which are related to each other. However, this changes nothing at all in the relative meaning of form since the form which is correct in this case can be wrong in many other cases.

All of the rules which have already been discovered in former art and which are still to be discovered—rules upon which the art historians place an excessively large value—are not general rules: they do not lead to art. If I know the rules of the cabinetmaker, I will always be able to make a table. But he who knows what are presumably the rules of the painter may not be certain that he can create a work of art.

These presumed rules, which in painting will soon lead to a "thorough bass" [Generalbass: the old practice that the bass line in a musical composition determines, in the hands of a knowing practitioner, the harmony. K. L.], are nothing but recognition of the inner effect of the individual means and their combination. But there will never be rules by which an employment of the form-effect and combination of the individual means, necessary just in one particular case, could be achieved.

The practical result: *one may never believe a theoretician (art historian, critic, and so forth) when he asserts that he has discovered some objective mistake in the work.*

And: *the only thing* which the theoretician can justifiably assert is that he has, until now, not yet become familiar with this or that use of the means. And: the theoreticians who find fault with a work or praise it, starting with the analysis of the forms which have already existed, are the most harmful misleaders. They form a wall between the work and the naïve observer.

From this standpoint (which, unfortunately, is mostly the only one possible), the *art critic is the worst enemy of art.*

*The ideal art critic,* then, would not be the critic who would seek to discover the "mistake,"[1] "abberations," "ignorance," "plagiarisms," and so forth, but the one who would seek *to feel* how this or that form has an inner effect, and would then impart expressively his whole experience to the public.

Here, of course, the critic would need the soul of a poet, since the poet must feel objectively in order to embody his feeling subjectively. That is, the critic would have to possess a creative power. In reality, however, critics are very

---

[1] For example, "anatomical mistakes," "poor drawing," and the like, or later, offenses against the coming "thoroughbass." W. K.

often unsuccessful artists who are frustrated by the lack of their own creative power and therefore feel called upon to direct the creative power of others.

Moreover, the question of form is often harmful to the artists for the reason that untalented persons (that is, persons who have no *inner* urge for art), using the forms of others, counterfeit works and thereby cause confusion.

Here I must be precise. To criticism, to the public, and often to artists, the using of someone else's form means a crime or a fraud. But in reality that is only true if the "artist" uses someone else's forms without inner necessity and thereby creates a lifeless, dead, sham work. If, however, the artist, for the expression of his inner impulses and experiences, makes use, according to inner truth, of one or another form which is "not his own," he is then using his right to make use of every form which is to him an *inner necessity*—whether it be a useful article, a heavenly body, or a form which has already been artistically materialized by another artist.

This whole question of "imitation"[1] has not nearly the significance which is again attributed to it by the critics.[2] What is living remains. What is dead disappears.

And in fact: the farther into the past we look, the fewer deceptions and sham works we find. They have mysteriously disappeared. Only the genuine artistic beings remain, that is, those which possess a soul (content) in their bodies (form).

Further, if the reader looks at any given object on his table (be it only a cigar butt), he will notice immediately the same two effects. It does not matter where or when (in the street, church, in the sky, water, in the stable, or forest), everywhere the two effects will expose themselves and everywhere the inner resonance will be independent from the outer sense.

*The world resounds. It is a cosmos of spiritually acting beings. So dead matter is living spirit.*

If we draw the conclusion—which is necessary to us here—from the independent effect of the inner resonance, we see that this inner resonance will gain in intensity if the outer, practical-purposeful import which suppresses it is removed. Here lies the one explanation for the marked effect of a child's drawing upon the impartial, the untraditional observer. The practical-purposeful element is foreign to the child since he looks at each thing with unaccustomed eyes and still possesses the unclouded ability to register the thing as such. Only later does he slowly become familiar with the practical-purposeful element through many and often sad experiences. Thus the inner resonance of the object reveals itself of its own

---

[1] Every artist knows how fantastic criticism in this field is. The critic knows that the wildest assertions can be made, especially here, with complete impunity. For example, the *Negress* by Eugen Kahler, a good naturalistic atelier-study, was compared to . . . Gauguin. The only reason for this comparison could have been the brown skin of the model (see *Münchner Neueste Nachrichten*, Oct. 12, 1911), and so forth. w. к.

[2] And thanks to the prevailing overestimation of this question, the artist is discredited with impunity. w. к.

accord and without exception in every child's drawing. The adults, especially the teachers, endeavor to force the practical-purposeful element on the child and criticize the child for his drawing, even from this shallow standpoint: "Your man cannot walk because he has only one leg," "One cannot sit on your chair, since it is crooked," and so forth.[1] The child laughs at himself. But he ought to cry. Now the talented child also has, aside from the ability to do away with the external, the power to clothe the remaining internal into a form in which it appears most strongly and effectively (so to say, it "speaks"!).

Every form is many-sided. One discovers in it more and more other happy qualities. However, I only want to emphasize a side of good child-drawing which is important to us at the moment: the compositional. Here we can easily see the unconscious use of the two above-mentioned parts of the letter (the use being developed as if of its own accord): that is (1) the *whole appearance* which is very often precise and here and there goes to the point of being schematic; and (2) the *individual forms* which compose the great form; each of these individual forms leads its own existence. (Thus, for example, the *Arabs* by Lydia Wieber.)[2] There is an unconscious and enormous force in the child which manifests itself here and which puts the work of the child on an equally high (and often much higher!) level as the work of the adult.[3]

For every glowing, there is a cooling-off. For every early bud—the threatening frost. For every young talent—an academy. These are not tragic words but a sad fact. The academy is the surest means of ruining the above-mentioned force of the child. Even the very great strong talent is more or less held back in this respect by the academy. The weaker talents go to ruin by the hundreds. An academically educated person of average talent distinguishes himself by having learned the practical-purposeful and by having lost the ability to hear the inner resonance. Such a person will deliver a "correct" drawing which is dead.

If a person who has not acquired any artistic schooling—and is thus free of objective artistic knowledge—paints something, the result will never be an empty pretense. Here we see an example of the working of the inner force which is influenced only by the *general* knowledge of the practical-purposeful.

Since, however, the use of even this general knowledge can only be made to a limited extent, the external is also done away with (only less than with the child, but to a great extent) and the inner resonance gains in force: not a dead thing comes into being, but a living one. Christ said: "Suffer the children to come unto me, for theirs is the kingdom of Heaven."

---

[1] As it is so often the case: one teaches those who ought to teach. And later on, one is surprised that nothing becomes of the talented children. w. k.

[2] Kandinsky reproduced several drawings by children in *Der Blaue Reiter*, one of them of Arabs. In the Piper edition (Munich 1965) it appears on p. 59. H. B. C.

[3] "Folk art" also possesses this startling quality of compositional form. (See for example the plague votive picture from the church in Murnau.) w. k.

The artist, who is similar in many ways to the child throughout his life, can often arrive at the inner resonance of things more easily than someone else. With regard to this, it is exceptionally interesting how the composer Arnold Schönberg uses pictorial means, simply and surely. As a rule, only this inner resonance interests him. He gives no attention to any embellishments or epicurisms and the "poorest" form becomes, in his hands, the richest. (See his self-portrait.)

Here lies the root of the new great realism. The outer shell of the thing, presented with complete and exclusive simplicity, is already a separation of the thing from the practical-purposeful and is the ringing forth of the sound of the internal. Henri Rousseau, who can be designated the father of this realism, has shown the way with a simple and convincing gesture.

Henri Rousseau has opened the way for the new possibilities of simplicity. This value of his versatile talent is, at the moment, the most important to us.

There must be some relationship between objects, or between an object and its parts. This relationship can be strikingly harmonious or strikingly disharmonious. A schematized rhythm can be used here, or a concealed one.

The irresistible urge of today to reveal the purely compositional—to unveil the future laws of our great epoch—is the power which forces artists to strive toward one goal in different ways.

It is natural that the human being turns, in such a case, to the most regular and, at the same time, the most abstract. Thus, we see that throughout different periods of art the triangle was used as the basis for construction. This triangle was often used as an equilateral one. Thus the number received its significance—that is, the completely abstract element of the triangle. In today's search for abstract relationships, the number plays a particularly great part. Every numerical formula is cool, like an icy mountain peak, and as greatest regularity, firm, like a block of marble. The formula is cold and firm, like every necessity. The searching to express the compositional in a formula is the cause for the rise of so-called Cubism. This "mathematical" construction is a form which must sometimes lead—and with consistent use does lead—to the $n$th degree of destruction of the material cohesion of the parts of the thing. (For instance, Picasso.)

The final goal also in this direction is to create a picture which is brought to life—becomes a being—through its own schematically constructed organs. If this course can in general be reproached, it is for *no other reason* than that the use of the number here is too limited. Everything can be represented as a mathematical formula or simply as a number. But there are different numbers: 1 and 0.333 . . . have equal rights. They are equally living, internally resounding beings. Why should one be satisfied with 1? Why should one exclude 0.333? Connected with this, the question arises: Why should one diminish artistic expression by *exclusive* use of triangles and similar geometrical forms and bodies? It shall be repeated, however, that the compositional endeavors of the Cubists stand in a direct connection with the necessity to create purely pictorial beings

which, on the one hand, speak in the objective and through the objective and, on the other hand, finally turn into pure abstraction by different combinations with the more or less resounding object.

Between the purely abstract and the purely realistic composition lie the possibilities of combination of the abstract and real elements in one picture. These possibilities of combination are great and manifold. In all cases, the life of the work can pulsate strongly and can thus act freely with regard to the question of form.

The combinations of the abstract with the objective, the choice between the infinite abstract forms or the choice within the objective material, that is, the choice of the individual means in both areas, is and remains left to the inner desire of the artist. The form which is tabooed or condemned today and which apparently lies apart from the main current, is only waiting for its master. This form is not dead, it is merely immersed in a kind of lethargy. When the content (spirit)— which can reveal itself only through this seemingly dead form—becomes ripe; when the hour of its materialization has struck; then it steps into this form and will speak through it.

And especially the layman should not approach the work with the question: "What has the artist *not* done?" or put differently: "Where has the artist allowed himself to neglect *my* desires?"; but he should ask himself: "What has the artist done?" or: "Which of *his* inner desires has the artist expressed here?" I also believe that the time will still come when criticism too will find its task not in the search for the negative, the deficient, but in the search and conveyance of the positive, the correct. One of the "important" concerns of today's criticism of abstract art is the question of how to distinguish the incorrect from the correct in this art. Primarily this means, how is one to discover the negative here? The attitude toward the work of art should be different from the attitude toward a horse which one wants to buy: with the horse, one important negative quality covers up all the positive ones and makes it worthless; with the work of art, the proportion is reversed: one important positive quality covers up all the negative ones and makes it valuable.

When this simple thought is considered, the questions of form—which are based on principle and are thus absolute—fall away of their own accord. The question of form will then receive its relative value. And among other things the choice of the form which is necessary to the artist and to his work will finally be left to the artist himself . . . .

Later, the reader together with the artist, can go on to objective considerations and to scientific analysis. Here he will then find that all of the possible examples obey one inner call—composition, and that they all stand on one inner basis—construction. The inner content of the work can be affiliated with either one or the other of two procedures which today (is it only today? or is it only particularly evident today?) dissolve in themselves all secondary movements. These two procedures are:

169

1. The breaking up of the soulless-material life of the nineteenth century; that is, the falling down of the material supports which were thought to be the only firm ones, the decay and dissolution of the individual parts.

2. The building up of the psychic-spiritual life of the twentieth century which we are experiencing and which manifests and embodies itself even now in strong, expressive, and definite forms.

These two procedures are the two sides of "today's movement." To qualify the works which have already been produced, or even to state the final goal of this movement, would be a presumption which would immediately be cruelly punished with lost freedom.

As has often been said before, we shall not strive for restriction but for liberation. One shall not reject without *intense* attempts to discover something which is alive.

It is better to regard death as life than life as death. Even if only one single time. And only in a place which has become free can something *grow* again. He who is free seeks to enrich himself through everything and to let the life of every being affect him—even if it is only a burned match.

Only through freedom can *that which is coming* be received.

And one does not stand off to the side like the withered tree under which Christ saw the sword that was lying ready.

*Oskar Kokoschka, "On the Nature of Visions," 1912*★

The state of awareness of visions is not one in which we are either remembering or perceiving. It is rather a level of consciousness at which we experience visions within ourselves.

This experience cannot be fixed; for the vision is moving, an impression growing and becoming visual, imparting a power to the mind. It can be evoked but never defined.

★ "On the Nature of Visions," translated by Hedi Medlinger and John Thwaites in Edith Hoffmann, *Kokoschka: Life and Work* (London: Faber & Faber, 1947), pp. 285–287. Published in the original German ("Von der Natur des Gesichte"), in *Oscar Kokoschka Schriften 1907–1955*, ed. Hans Maria Wingler (Munich: Langen-Müller, 1956).
While still a young man, Kokoschka (b. 1886), showed exceptional talent in both painting and poetic drama. His earliest oil paintings were shown, and his first drama, *Mörder, Hoffnung der Frauen*, was produced at the Vienna Kunstschau of 1908. The scandal caused by the latter resulted in Kokoschka's forced departure from Vienna, to which he returned in later years only as a visitor.
This essay was written during the time when he was an important contributor to the Expressionist journal *Der Sturm* in Berlin and was becoming known throughout Germany. Although his theories in their concern with inner feelings and images are related to those of Kandinsky, his art showed no tendency toward complete abstraction. In fact, he scorned it, always basing his own painting upon the objects and appearances of the physical world. Since 1953 he has conducted a summer school at Salzburg called *Schule des Sehens*.

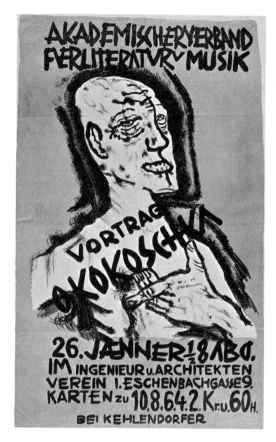

Oskar Kokoschka, self-portrait on poster for his lecture at the Academic Society for Literature and Music, 1912, color lithograph.

Yet the awareness of such imagery is a part of living. It is life selecting from the forms which flow towards it or refraining, at will.

A life which derives its power from within itself will focus the perception of such images. And yet this free visualising in itself—whether it is complete or hardly yet perceptible, or undefined in either space or time—this has its own power running through. The effect is such that the visions seem actually to modify one's consciousness, at least in respect of everything which their own form proposes as their pattern and significance. This change in oneself, which follows on the vision's penetration of one's very soul, produces the state of awareness, of expectancy. At the same time there is an outpouring of feeling into the image which becomes, as it were, the soul's plastic embodiment. This state of alertness of the mind or consciousness has, then, a waiting, receptive quality. It is like an unborn child, as yet unfelt even by the mother, to whom nothing of the outside world slips through. And yet whatever affects his mother, all that impresses her down to the slightest birthmark on the skin, all is implanted in him. As though he could use

her eyes, the unborn receives through her his visual impressions, even while he is himself unseen.

The life of the consciousness is boundless. It interpenetrates the world and is woven through all its imagery. Thus it shares those characteristics of living which our human existence can show. One tree left living in an arid land would carry in its seed the potency from whose roots all the forests of the earth might spring. So with ourselves; when we no longer inhabit our perceptions they do not go out of existence; they continue as though with a power of their own, awaiting the focus of another consciousness. There is no more room for death; for though the vision disintegrates and scatters, it does so only to reform in another mode.

Therefore we must harken closely to our inner voice. We must strive through the penumbra of words to the core within. "The Word became flesh and dwelt among us." And then the inner core breaks free—now feebly and now violently—from the words within which it dwells like a charm. "It happened to me according to the Word."

If we will surrender our closed personalities, so full of tension, we are in a position to accept this magical principle of living, whether in thought, intuition, or in our relationships. For in fact we see every day beings who are absorbed in one another, whether in living or in teaching, aimless or with direction. So it is with every created thing, everything we can communicate, every constant in the flux of living; each one has its own principle which shapes it, keeps life in it, and maintains it in our consciousness. Thus it is preserved, like a rare species, from extinction. We may identify it with "me" or "you" according to our estimate of its scale or its infinity. For we set aside the self and personal existence as being fused into a larger experience. All that is required of us is to RELEASE CONTROL. Some part of ourselves will bring us into the unison. The inquiring spirit rises from stage to stage, until it encompasses the whole of Nature. All laws are left behind. One's soul is a reverberation of the universe. Then too, as I believe, one's perception reaches out towards the Word, towards awareness of the vision.

As I said at first, this awareness of visions can never fully be described, its history can never be delimited, for it is a part of life itself. Its essence is a flowing and a taking form. It is love, delighting to lodge itself in the mind. This adding of something to ourselves—we may accept it or let it pass; but as soon as we are ready it will come to us by impulse, from the very breathing of our life. An image will take shape for us suddenly, at the first look, as the first cry of a newborn child emerging from its mother's womb.

Whatever the orientation of a life, its significance will depend on this ability to conceive the vision. Whether the image has a material or an immaterial character depends simply on the angle from which the flow of psychic energy is viewed, whether at ebb or flood.

It is true that the consciousness is not exhaustively defined by these images moving, these impressions which grow and become visual, imparting a

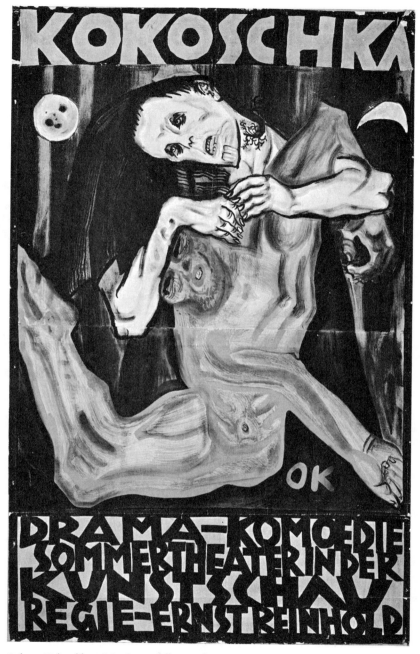

Oskar Kokoschka, Mörder, Hoffnung der Frauen, 1909.
Poster for his own somewhat autobiographical play.

173

power to the mind which we can evoke at will. For of the forms which come into the consciousness some are chosen while others are excluded arbitrarily.

But this awareness of visions which I endeavor to describe is the viewpoint of all life as though it were seen from some high place; it is like a ship which was plunged into the seas and flashes again as a winged thing in the air.

Consciousness is the source of all things and of all conceptions. It is a sea ringed about with visions.

My mind is the tomb of all those things which have ceased to be the true Hereafter into which they enter. So that at last nothing remains; all that is essential of them is their image within myself. The life goes out of them into that image as in the lamp the oil is drawn up through the wick for nourishing the flame.

So each thing, as it communicates itself to me, loses its substance and passes into the HEREAFTER WHICH IS MY MIND. I incorporate its image which I can evoke without the intermediacy of dreams. "Whenever two or three are gathered together in My name, I am in their midst" [Matt. 18:20]. And, as though it could go out to men, my vision is maintained, fed, as the lamp is by its oil, from the abundance of their living. If I am asked to make all this plain and natural the things themselves must answer for me, as it were, bearing their own witness. For I have represented them, I have taken their place and put on their semblance through my visions. It is the psyche which speaks.

I search, inquire, and guess. And with what sudden eagerness must the lamp wick seek its nourishment, for the flame leaps before my eyes as the oil feeds it. It is all my imagination, certainly, what I see there in the blaze. But if I have drawn something from the fire and you have missed it, well, I should like to hear from those whose eyes are still untouched. For is this not my vision? Without intent I draw from the outside world the semblance of things; but in this way I myself become part of the world's imaginings. Thus in everything imagination is simply that which is natural. It is nature, vision, life.

### Ernst Ludwig Kirchner, "Chronik der Brücke," 1916*

In the year 1902 the painters Bleyl and Kirchner met in Dresden. Heckel came to them through his brother, a friend of Kirchner. Heckel brought Schmidt-Rottluff along, whom he knew from Chemnitz. They came together in Kirchner's studio to work there. Here they found the opportunity to study the nude—the basis of all visual art—in its natural freedom. From drawing on this basis resulted the desire, common to all, to derive inspiration for work from life itself, and to submit to direct experience. In a book, *Odi profanum*, each individual drew and wrote down

* A few copies of this were privately printed in Berlin in 1916. This English translation is by Peter Selz from *College Art Journal* (Autumn 1950), pp. 50–51. It appears also in his *German Expressionist Painting* (Berkeley and Los Angeles: University of California Press, 1957), Appendix A, pp. 320–321.

his ideas, and in this way they made it possible to compare their distinctive features. So they grew, very naturally, into a group which came to be called *Brücke*. One inspired the other. From southern Germany Kirchner brought the woodcut, which he had revived under the inspiration of the old prints in Nuremberg. Heckel carved wooden figures. Kirchner enriched this technique with polychromy and sought the rhythm of closed form in pewter casting and in stone. Schmidt-Rottluff made the first lithographs on stone. The first exhibition of the group took place on its own premises in Dresden; it was given no recognition. Dresden, however, yielded much inspiration through its scenic charm and old culture. Here *Brücke* also found its first art-historical corroboration in Cranach, Beham, and other medieval German masters. During an exhibit of Amiet in Dresden he was appointed to membership in the group. In 1905 Nolde followed, his fantastic style bringing a new feature to *Brücke*. He enriched our exhibitions with his interesting etching technique and learned how we worked with the woodcut. On his invitation Schmidt-Rottluff went with him to Alsen, and later Schmidt-Rottluff and Heckel went to Dangast. The brisk air of the North Sea brought forth a monumental Impressionism, especially in Schmidt-Rottluff. During this time, in Dresden, Kirchner continued to work in closed composition and in the ethnographic museum found a parallel to his own creation in African negro sculpture and in Oceanic beam carvings. The desire to free himself from

*Ernst Ludwig Kirchner, Self-Portrait with a Pipe, 1908, drypoint.*

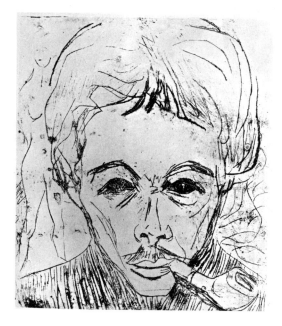

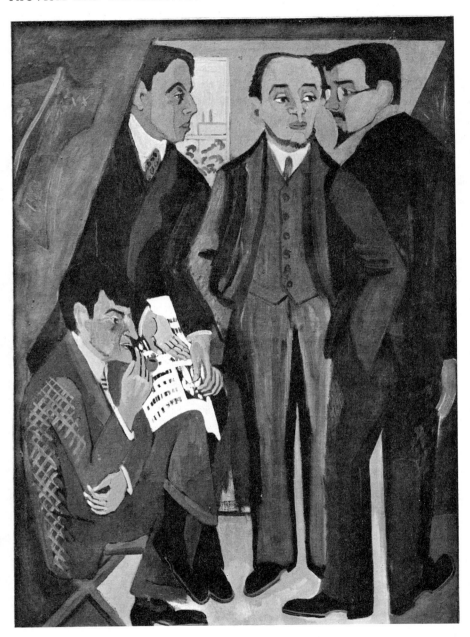

*Ernst Ludwig Kirchner, The Painters of Die Brücke, 1925, oil on canvas. (L to R: Otto Müller, Kirchner, Erich Heckel, Karl Schmidt-Rottluff)*

academic sterility led Pechstein to join *Brücke*. Kirchner and Pechstein went to Gollverode, to work there together. An exhibition of *Brücke*, including its new members, took place in the Salon Richter in Dresden and made a great impression on the young artists of Dresden. Heckel and Kirchner attempted to bring the new painting and its exhibition space into harmony. Kirchner furnished the rooms with murals and batiks, on which Heckel had worked with him. In 1907 Nolde resigned from *Brücke*; Heckel and Kirchner went to the Moritzburg lakes, in order to study the nude in the open air; Schmidt-Rottluff worked in Dangast on the completion of his color rhythm; Heckel traveled to Italy and brought back with him the inspiration of Etruscan art; Pechstein went to Berlin to work on a commission for decorations. He attempted to bring the new painting into the *Sezession*. In Dresden Kirchner studied the hand printing of lithography. Bleyl, who had gone into teaching, left *Brücke* in 1909. Pechstein went to Dangast to join Heckel. During

*Ernst Ludwig Kirchner, Chronik der Brücke, title page, 1913, woodcut.*

the same year both of them came to Kirchner at Moritzburg in order to do studies of the nude in the lake environment. In 1910 the *Neue Sezession* was organized after the rejection of younger German painters by the old *Sezession*. In order to support Pechstein's position in the *Neue Sezession* Heckel, Kirchner, and Schmidt-Rottluff also became members. In the first exhibition of the *Neue Sezession* they met Mueller. In his studio they saw Cranach's *Venus*, which they themselves had always esteemed very highly. The sensuous harmony of his life with his work made Mueller a natural member of *Brücke*. He introduced us to the fascination of distemper technique.[1] In order to keep their endeavors pure the members of *Brücke* resigned from membership in the *Neue Sezession*. They exchanged promises to exhibit only jointly in the *Sezession*. Then followed an exhibit of *Brücke* in the entire gallery of the art salon, Gurlitt. Pechstein broke the confidence of the group by becoming a member of the *Sezession*, and was expelled from *Brücke*. The *Sonderbund* invited *Brücke* to join its Cologne exhibitions of 1912, and commissioned Heckel and Kirchner to decorate and paint the chapel of the exhibition rooms. The majority of the members of *Brücke* is now in Berlin. *Brücke* has retained here its intrinsic character. From its internal coherence it radiates the new values of artistic creation to the modern artistic production throughout Germany. Uninfluenced by contemporary movements of Cubism, Futurism, etc., it fights for a human culture, the soil of all real art. *Brücke* owes its present position in the art world to these goals.

*Franz Marc, How Does a Horse See the World?*★

Is there a more mysterious idea for an artist than to imagine how nature is reflected in the eyes of an animal? How does a horse see the world, how does an eagle, a doe, or a dog? It is a poverty-stricken convention to place animals into landscapes as seen by men; instead, we should contemplate the soul of the animal to divine its way of sight.

Many other thoughts hide behind this one. Let me try to test its synthesizing force.

It makes us disdain the rigid and all-too-narrow focus of the painter's consciousness. Does it make sense to paint an apple and with it the window sill on which it lies? If you say it is a problem of "sphere and plane," the concept "apple" really falls by the wayside. We get off on an interesting tangent recently discovered for us by some marvellous painters. But what if we want to paint the apple, the beautiful apple? Or the doe in the forest? or the oak tree? What does the doe have in common with the view of the world as it appears to people? Does it make any

---

[1] A water medium with glue as the cohesive agent. H. B. C.

★ The English translations from this book are by Ernest Mundt and Peter Selz from Franz Marc, *Briefe, Aufzeichnungen und Aphorismen*, 2 vols. (Berlin: Cassirer, 1920), I, 121–122.

*Franz Marc, Deer Resting, woodcut.*

reasonable or artistic sense to paint the doe as it appears on our retina—or in the manner of the Cubists because we feel the world to be cubistic?

Who says the does feels the world to be cubistic? It's the doe that feels, therefore the landscape must be "doe-like." That is its predicate. The artistic logic of Picasso, Kandinsky, Delaunay, Burljick, etc., is perfect. They don't "see" the doe and they don't care. They project *their* inner world—which is the noun of the sentence. Naturalism contributes the object. The predicate, the most difficult and basically the most important part is rendered but rarely. The predicate is the most important part of a thoughtful sentence. The noun is the premise. The object is a negligible echo: it makes the thought specific, and banal. I could paint a picture called *The Doe.* Pisanello has painted them. I also may want to paint a picture, *The Doe Feels.* How infinitely more subtle must the painter's sensitivity be in order to paint that! The Egyptians have done it. *The Rose:* Manet painted it. *The Rose Is in Bloom:* who has painted the blooming of the rose? The Indians did it. They gave the predicate.

If I wanted to represent a cube, I could present it in the manner in which I was taught to draw a cigar box or something of that sort. I'd give its outward shape as I optically see it—the object, no more, no less—and I might do that poorly or well. But I also could present the cube not as I see it but how it exists, as its predicate.

The Cubists were the first to paint space not as a subject: they "said something about" space, they rendered the predicate of the subject.

It is typical of our best painters that they avoid living subject matter. They render the predicate of the still-life. To render the predicate of living things remains an unsolved problem. Kandinsky passionately loves all that is alive, but in order to find its artistic form, he turns it into a schema.

Who is able to paint the existence of a dog as Picasso paints the existence of a cubic shape? (In the thematic style of musicians).

Without being challenged I must protest against the thought that the reader, knowing that I often paint animals, will draw from this fact the unjustified conclusions that I am speaking in this discussion of my own paintings. The opposite is true: dissatisfaction with my work forces me to think. That's what makes me write these lines.

*Franz Marc, Aphorisms, 1914–1915*★

<div align="center">1</div>

Everything has appearance and essence, shell and kernel, mask and truth. What does it say against the inward determination of things that we finger the shell without reaching the kernel, that we live with appearance instead of perceiving the essence, that the mask of things so blinds us that we cannot find the truth?

<div align="center">31</div>

Traditions are lovely things—to create traditions, that is, not to live off them.

<div align="center">32</div>

Every builder and shaper of form and life looks for the solid foundation, the rock upon which to build. Only very rarely has he found it in the traditions; they have proven usually to be treacherous, and never solid. The great shapers do not search for their form in the fogs of the past. They plumb for the innermost, true center of gravity of their own times. It is the only guide that can help them in their work.

The mysterious word "truth" always makes me think of this physical idea of a center of gravity. Truth is always on the move. It is always somewhere, but never in the foreground, never on the surface.

<div align="center">35</div>

The day cannot be far away when the Europeans—the true Europeans yet to be born—will feel greatly distressed by formlessness. Then they will reach out in pain and search for form. They will not be looking for this new form in the past, nor will they want to find it on the outside of nature, in her stylized façade. They will build the new form from within, according to their new knowledge. This knowledge will have changed the old fables of the world into a general principle of form, and transform the old philosophy, which looks at the outside of the world, into another one that looks into it and beyond.

The art to come will be giving form to our scientific convictions. This art is our religion, our center of gravity, our truth. It will be profound enough and substantial enough to generate the greatest form, the greatest transformation the world has ever seen.

<div align="center">78</div>

Natural law has been the vehicle of art. Today we are replacing this law with the problem of religiosity. The art of our epoch will undoubtedly show profound analogies with the arts of long past, primitive times—but without the formalistic approximations now attempted by some anarchists who have no sense.

★ *Briefe, Aufzeichnungen und Aphorismen,* I, 126–132.

*Franz Marc.*

It is equally certain that our time will be followed by a period of detached maturity. Then formal laws of art—or traditions—will again be established. According to the parallelism of events, this will happen in the very distant times of a ripe, late Europeanism.

<div align="center">87</div>

I caught a strange thought—it had settled on my open hand like a butterfly—the thought that people once before, a long time ago, like alter egos, loved abstractions as we do now. Many an object hidden away in our museums of anthropology looks at us with strangely disturbing eyes. What made them possible, these productions of a sheer will to abstraction? How can one think such abstract thoughts without our modern methods of abstract thinking? Our European desire for abstract form is nothing other than the highly conscious, action-hungry determination to overcome sentimentality. But those early people loved abstractions before they had encountered sentimentality.

*Franz Marc, letter, 12 April 1915*★

Dear L:

As I read your last letters with greater care, their inner artistic logic becomes more and more convincing. In the aphorisms I have touched upon "the truth" from many sides without ever getting to the essential point. The essence lies in total renunciation, as in the parable of the rich youth. Only after this has been accomplished is it possible to see whether the feelings that remain are worthwhile to have meaning for others. For most of us this would not be the case: our paintings would be utterly unattractive—or, better, we would stop painting them. Contemplation, proper restraint, conscience itself would keep us away from impure

★ *Briefe, Aufzeichnungen und Aphorismen*, I, 49–51.

production. When measured against this exalted scale, extremely little remains of all European art. The progress-hungry spirit of modern centuries was all-too-set against the kind of art we are dreaming about. My instincts so far have not guided me too badly on the whole, even though my paintings are not pure. I especially mean the instinct that led me away from people to a feeling for animality, for the "pure beasts." People with their lack of piety, especially men, never touched my true feelings. But animals with their virginal sense of life awakened all that is good in me. Another instinct led me from animals to abstractions, which roused me even more. It brought me to that second sight, timeless in the Indian sense, in which the living feelings shine in their purity.

Very early I found people to be "ugly": animals seemed more beautiful, more pure. But then I discovered in them, too, so much that was ugly and un-feeling—and instinctively, by an inner compulsion, my presentation became more schematic or more abstract. Trees, flowers, the earth all showed me every year more and more of their deformity and repulsiveness—until now, suddenly, I have become fully conscious of nature's ugliness and impurity. Perhaps it is our European point of view that makes the world look poisoned and distorted. This is why I dream of a new Europe.

Kandinsky hotly pursues this truth, and I love him for it. You may be quite right when you say that as a person he is not pure and strong enough, and that his feelings, therefore, lack general validity and concern only the sentimental hypersensitive romantic. But his efforts remain wonderful; they express a solitary greatness.

Reading all this you must not assume that I have fallen back into my old fault of just *thinking* all the time about the possibilities of abstract form. On the contrary, I am trying to live very much by my feelings. My outward interest in the world is very restrained and cool, very perspicacious. My real interest is not caught up in it, and I am leading a negative sort of life. This gives breathing space to the pure feelings and to the artistic unfolding. I place great trust in my instincts, in producing by instinct. But this I can do only in Ried.[1] Back there it will happen. I often have the feeling that I hold in my pocket something secret, something very happy at which I must not look. I just put my hand on it once in a while and touch it from the outside.

## Paul Klee, "Creative Credo," 1920[*]

I. Art does not reproduce the visible; rather, it makes visible. A tendency toward the abstract is inherent in linear expression: graphic imagery being confined to

[1] Marc's home in Upper Austria, where he had settled shortly before he entered the German army in 1914. H. B. C.

[*] Originally published in *Schöpferische Konfession*, ed. Kasimir Edschmid (Berlin: Erich Reiss, 1920) (*Tribune der Kunst und Zeit*, No. 13). This English translation by Norbert Guterman from *The Inward Vision: Watercolors, Drawings and Writings by Paul Klee* (New York: Abrams, 1959), pp. 5–10.

*Paul Klee, An Artist (self-portrait), 1919, pen and wash.*

outlines has a fairy-like quality and at the same time can achieve great precision. The purer the graphic work—that is, the more the formal elements underlying linear expression are emphasized—the less adequate it is for the realistic representation of visible things.

The formal elements of graphic art are dot, line, plane, and space—the last three charged with energy of various kinds. A simple plane, for instance—that is, a plane not made up for more elementary units—would result if I were to draw a blunt crayon across the paper, thus transferring an energy-charge with or without modulations. An example of a spatial element would be a cloudlike vaporous spot, usually of varying intensity, made with a full brush.

II. Let us develop this idea, let us take a little trip into the land of deeper insight, following a topographic plan. The dead center being the point, our first dynamic act will be the line. After a short time, we shall stop to catch our breath (the broken line, or the line articulated by several stops). I look back to see how far we have come (counter-movement). Ponder the distance thus far traveled (sheaf of lines). A river may obstruct our progress: we use a boat (wavy line). Further on there might be a bridge (series of curves). On the other bank we encounter someone who, like us, wishes to deepen his insight. At first we joyfully travel together (convergence), but gradually differences arise (two lines drawn independently of each other). Each party shows some excitement (expression, dynamism, emotional quality of the line).

We cross an unplowed field (a plane traversed by lines), then thick woods. One of us loses his way, explores, and on one occasion even goes through the motions of a hound following a scent. Nor am I entirely sure of myself: there is another river, and fog rises above it (spatial element). But then the view is clear again. Basket-weavers return home with their cart (the wheel). Among them is a child with bright curls (corkscrew movement). Later it becomes sultry and dark

183

(spatial element). There is a flash of lightning on the horizon (zigzag line), though we can still see stars overhead (scattered dots). Soon we reach our first quarters. Before falling asleep, we recall a number of things, for even so little a trip has left many impressions—lines of the most various kinds, spots, dabs, smooth planes, dotted planes, lined planes, wavy lines, obstructed and articulated movement, counter-movement, plaitings, weavings, bricklike elements, scalelike elements, simple and polyphonic motifs, lines that fade and lines that gain strength (dynamism), the joyful harmony of the first stretch, followed by inhibitions, nervousness! Repressed anxieties, alternating with moments of optimism caused by a breath of air. Before the storm, sudden assault by horseflies! The fury, the killing. The happy ending serves as a guiding thread even in the dark woods. The flashes of lightning made us think of a fever chart, of a sick child long ago.

III. I have mentioned the elements of linear expression which are among the visual components of the picture. This does not mean that a given work must consist of nothing but such elements. Rather, the elements must produce forms, but without being sacrificed in the process. They should be preserved. In most cases, a combination of several elements will be required to produce forms or objects or other compounds—planes related to each other (for instance, the view of a moving stream of water) or spatial structures arising from energy-charges involving the three dimensions (fish swimming in all directions).

Through such enrichment of the formal symphony the possibilities of variation, and by the same token, the possibilities for expressing ideas, are endlessly multiplied.

It may be true that "in the beginning there was the deed," yet the idea comes first. Since infinity has no definite beginning, but like a circle may start anywhere, the idea may be regarded as primary. "In the beginning was the word."

IV. Movement is the source of all change. In Lessing's *Laocoön*, on which we squandered study time when we were young, much fuss is made about the difference between temporal and spatial art. Yet looking into the matter more closely, we find that all this is but a scholastic delusion. For space, too, is a temporal concept.

When a dot begins to move and becomes a line, this requires time. Likewise, when a moving line produces a plane, and when moving planes produces spaces.

Does a pictorial work come into being at one stroke? No, it is constructed bit by bit, just like a house.

And the beholder, is he through with the work at one glance? (Unfortunately he often is.) Does not Feuerbach[1] say somewhere that in order to understand a picture one must have a chair? Why the chair? So that your tired

---

[1] Anselm Feuerbach (1829–1880) was one of the *Deutsch-Römer* group of German artists who opposed the prevailing realism of this period and sought the corrective for it in Rome. Feuerbach's art expressed, in his own words, a "majestic, forbidding tranquility."

H. B. C.

legs won't distract your mind. Legs tire after prolonged standing. Hence, time is is needed. Character, too, is movement. Only the dead point as such is timeless. In the universe, too, movement is the basic datum. (What causes movement? This is an idle question, rooted in error.) On this earth, repose is caused by an accidental obstruction in the movement of matter. It is an error to regard such a stoppage as primary.

The Biblical story of the creation is an excellent parable of movement. The work of art, too, is above all a process of creation, it is never experienced as a mere product.

A certain fire, an impulse to create, is kindled, is transmitted through the hand, leaps to the canvas, and in the form of a spark leaps back to its starting place, completing the circle—back to the eye and further (back to the source of the movement, the will, the idea). The beholder's activity, too, is essentially temporal. The eye is made in such a way that it focuses on each part of the picture in turn; and to view a new section, it must leave the one just seen. Occasionally the beholder stops looking and goes away—the artist often does the same thing. If he thinks it worth while, he comes back—again like the artist.

The beholder's eye, which moves about like an animal grazing, follows paths prepared for it in the picture (in music, as everyone knows, there are conduits leading to the ear; the drama has both visual and auditive trails). The pictorial work was born of movement, is itself recorded movement, and is assimilated through movement (eye muscles).

A man asleep, the circulation of his blood, the regular breathing of his lungs, the intricate functioning of his kidneys, and in his head a world of dreams, in contact with the powers of fate. An organization of functions, which taken together produce rest.

V. Formerly we used to represent things visible on earth, things we either liked to look at or would have liked to see. Today we reveal the reality that is behind visible things, thus expressing the belief that the visible world is merely an isolated case in relation to the universe and that there are many more other, latent realities. Things appear to assume a broader and more diversified meaning, often seemingly contradicting the rational experience of yesterday. There is a striving to emphasize the essential character of the accidental.

By including the concepts of good and evil a moral sphere is created. Evil is not conceived as the enemy whose victories disgrace us, but as a force within the whole, a force that contributes to creation and evolution. The simultaneous existence of the masculine principle (evil, stimulating, passionate) and the feminine principle (good, growing, calm) result in a condition of ethical stability.

To this corresponds the simultaneous unification of forms, movement and counter-movement, or, to put is more naïvely, the unification of visual oppositions (in terms of colorism: use of contrasts of divided color, as in Delaunay). Each energy calls for its complementary energy to achieve self-contained stability based

on the play of energies. Out of abstract elements a formal cosmos is ultimately created independent of their groupings as concrete objects or abstract things such as numbers of letters, which we discover to be so closely similar to the Creation that a breath is sufficient to turn an expression of religious feelings, or religion, into reality.

VI. A few examples: A sailor of antiquity in his boat, enjoying himself and appreciating the comfortable accommodations. Ancient art represents the subject accordingly. And now: the experiences of a modern man, walking across the deck of a steamer: 1. His own movement, 2. the movement of the ship which could be in the opposite direction, 3. the direction and the speed of the current, 4. the rotation of the earth, 5. its orbit, and 6. the orbits of the stars and satellites around it.

The result: an organization of movements within the cosmos centered on the man on the steamer.

An apple tree in bloom, its roots and rising saps, its trunk, the cross section with the annual rings, the blossom, its structure, its sexual functions, the fruit, the core with its seeds. -

An organization of states of growth.

VII. Art is a simile of the Creation. Each work of art is an example, just as the terrestrial is an example of the cosmic.

The release of the elements, their grouping into complex subdivisions, the dismemberment of the object and its reconstruction into a whole, the pictorial polyphony, the achievement of stability through an equilibrium of movement, all these are difficult questions of form, crucial for formal wisdom, but not yet art in the highest circle. In the highest circle an ultimate mystery lurks behind the mystery, and the wretched light of the intellect is of no avail. One may still speak reasonably of the salutary effects of art. We may say that fantasy, inspired by instinctual stimuli creates illusory states which somehow encourage or stimulate us more than the familiar natural or known supernatural states, that its symbols bring comfort to the mind, by making it realize that it is not confined to earthly potentialities, however great they may become in the future; that ethical gravity holds sway side by side with impish laughter at doctors and parsons.

But, in the long run, even enhanced reality proves inadequate.

Art plays an *unknowing* game with ultimate things, and yet achieves them!

Cheer up! Value such country outings, which let you have a new point of view for once as well as a change of air, and transport you to a world which, by diverting you, strengthens you for the inevitable return to the greyness of the working day. More than that, they help you to slough off your earthly skin, to fancy for a moment that you are God; to look forward to new holidays, when the soul goes to a banquet in order to nourish its starved nerves, and to fill its languishing blood vessels with new sap.

Let yourself be carried on the invigorating sea, on a broad river or an enchanting brook, such as that of the richly diversified, aphoristic graphic art.

*Max Beckmann, "On My Painting," 1938*\*

Before I begin to give you an explanation, an explanation which it is nearly impossible to give, I would like to emphasize that I have never been politically active in any way. I have only tried to realize my conception of the world as intensely as possible.

Painting is a very difficult thing. It absorbs the whole man, body and soul—thus I have passed blindly many things which belong to real and political life.

I assume, though, that there are two worlds: the world of spiritual life and the world of political reality. Both are manifestations of life which may sometimes coincide but are very different in principle. I must leave it to you to decide which is the more important.

What I want to show in my work is the idea which hides itself behind so-called reality. I am seeking for the bridge which leads from the visible to the invisible, like the famous cabalist who once said: "If you wish to get hold of the invisible you must penetrate as deeply as possible into the visible."

My aim is always to get hold of the magic of reality and to transfer this

*Max Beckmann, Self-Portrait, 1922, woodcut.*

\* Originally a lecture entitled "Meine Theorie in der Malerei," given at the New Burlington Gallery, London, 21 July 1938. The lecture was published in this English translation by Buchholz Gallery, Curt Valentin, New York, 1941.

reality into painting—to make the invisible visible through reality. It may sound paradoxical, but it is, in fact, reality which forms the mystery of our existence.

What helps me most in this task is the penetration of space. Height, width, and depth are the three phenomena which I must transfer into one plane to form the abstract surface of the picture, and thus to protect myself from the infinity of space. My figures come and go, suggested by fortune or misfortune. I try to fix them divested of their apparent accidental quality.

One of my problems is to find the self, which has only one form and is immortal—to find it in animals and men, in the heaven and in the hell which together form the world in which we live.

Space, and space again, is the infinite deity which surrounds us and in which we are ourselves contained.

That is what I try to express through painting, a function different from poetry and music but, for me, predestined necessity.

When spiritual, metaphysical, material, or immaterial events come into my life, I can only fix them by way of painting. It is not the subject which matters but the translation of the subject into the abstraction of the surface by means of painting. Therefore I hardly need to abstract things, for each object is unreal enough already, so unreal that I can only make it real by means of painting.

Often, very often, I am alone. My studio in Amsterdam, an enormous old tobacco storeroom, is again filled in my imagination with figures from the old days and from the new, like an ocean moved by storm and sun and always present in my thoughts.

Then shapes become beings and seem comprehensible to me in the great void and uncertainty of the space which I call God.

Sometimes I am helped by the constructive rhythm of the cabala, when my thoughts wander over Oannes Dagon to the last days of drowned continents. Of the same substance are the streets with their men, women and children; great ladies and whores; servant girls and duchesses. I seem to meet them, like doubly significant dreams, in Samothrace and Piccadilly and Wall Street. They are Eros and the longing for oblivion.

All these things come to me in black and white like virtue and crime. Yes, black and white are the two elements which concern me. It is my fortune, or misfortune, that I can see neither all in black nor all in white. One vision alone would be much simpler and clearer, but then it would not exist. It is the dream of many to see only the white and truly beautiful, or the black, ugly and destructive. But I cannot help realizing both, for only in the two, only in black and in white, can I see God as a unity creating again and again a great and eternally changing terrestrial drama.

Thus without wanting it, I have advanced from principle to form, to transcendental ideas, a field which is not at all mine, but in spite of this I am not ashamed.

In my opinion all important things in art since Ur of the Chaldees, since Tel Halaf and Crete, have always originated from the deepest feeling about the mystery of Being. Self-realization is the urge of all objective spirits. It is this self which I am searching in my life and in my art.

Art is creative for the sake of realization, not for amusement; for transfiguration, not for the sake of play. It is the quest of our self that drives us along the eternal and never-ending journey we must all make.

My form of expression is painting; there are, of course, other means to this end, such as literature, philosophy or music; but as a painter, cursed or blessed with a terrible and vital sensuousness, I must look for wisdom with my eyes. I repeat, with my eyes, for nothing could be more ridiculous or irrelevant than a "philosophical conception" painted purely intellectually without the terrible fury of the senses grasping each visible form of beauty and ugliness. If from those forms which I have found in the visible, literary subjects result—such as portraits, landscapes, or recognizable compositions—they have all originated from the senses, in this case from the eyes, and each intellectual subject has been transformed again into form, color, and space.

Everything intellectual and transcendent is joined together in painting by the uninterrupted labor of the eyes. Each shade of a flower, a face, a tree, a fruit, a sea, a mountain, is noted eagerly by the intensity of the senses to which is added, in a way of which we are not conscious, the work of the mind, and in the end the strength or weakness of the soul. It is this genuine, eternally unchanging center of strength which makes mind and senses capable of expressing personal things. It is the strength of the soul which forces the mind to constant exercise to widen its conception of space.

Something of this is perhaps contained in my pictures.

Life is difficult, as perhaps everyone knows by now. It is to escape from these difficulties that I practice the pleasant profession of a painter. I admit that there are more lucrative ways of escaping the so-called difficulties of life, but I allow myself my own particular luxury, painting.

It is, of course, a luxury to create art and, on top of this, to insist on expressing one's own artistic opinion. Nothing is more luxurious than this. It is a game and a good game, at least for me; one of the few games which make life, difficult and depressing as it is sometimes, a little more interesting.

Love in an animal sense is an illness, but a necessity which one has to overcome. Politics is an odd game, not without danger I have been told, but certainly sometimes amusing. To eat and to drink are habits not to be despised but often connected with unfortunate consequences. To sail around the earth in 91 hours must be very strenuous, like racing in cars or splitting the atoms. But the most exhausting thing of all—is boredom.

So let me take part in your boredom and in your dreams while you take part in mine which may be yours as well.

To begin with, there has been enough talk about art. After all, it must always be unsatisfactory to try to express one's deeds in words. Still we shall go on and on, talking and painting and making music, boring ourselves, exciting ourselves, making war and peace as long as our strength of imagination lasts. Imagination is perhaps the most decisive characteristic of mankind. My dream is the imagination of space—to change the optical impression of the world of objects by a transcendental arithmetic progression of the inner being. That is the precept. In principal any alteration of the object is allowed which has a sufficiently strong creative power behind it. Whether such alteration causes excitement or boredom in the spectator is for you to decide.

The uniform application of a principle of form is what rules me in the imaginative alteration of an object. One thing is sure—we have to transform the three-dimensional world of objects into the two-dimensional world of the canvas.

If the canvas is only filled with two-dimensional conception of space, we shall have applied art, or ornament. Certainly this may give us pleasure, though I myself find it boring as it does not give me enough visual sensation. To transform three into two dimensions is for me an experience full of magic in which I glimpse for a moment that fourth dimension which my whole being is seeking.

I have always on principle been against the artist speaking about himself or his work. Today neither vanity nor ambition causes me to talk about matters which generally are not to be expressed even to oneself. But the world is in such a catastrophic state, and art is so bewildered that I, who have lived the last thirty years almost as a hermit, am forced to leave my snail's shell to express these few ideas which, with much labor, I have come to understand in the course of the years.

The greatest danger which threatens mankind is collectivism. Everywhere attempts are being made to lower the happiness and the way of living of mankind to the level of termites. I am against these attempts with all the strength of my being.

The individual representation of the object, treated sympathetically or antipathetically, is highly necessary and is an enrichment to the world of form. The elimination of the human relationship in artistic representation causes the vacuum which makes all of us suffer in various degrees—an individual alteration of the details of the object represented is necessary in order to display on the canvas the whole physical reality.

Human sympathy and understanding must be reinstated. There are many ways and means to achieve this. Light serves me to a considerable extent on the one hand to divide the surface of the canvas, on the other to penetrate the object deeply.

As we still do not know what this self really is, this self in which you and I in our various ways are expressed, we must peer deeper and deeper into its discovery. For the self is the great veiled mystery of the world. Hume[1] and Herbert

---

[1] Hume considered that what we call the *self* is actually only a collection of perceptions, and it is only these particular perceptions that we encounter when we attempt to understand it. H. B. C.

Spencer studied its various conceptions but were not able in the end to discover the truth. I believe in it and in its eternal, immutable form. Its path is, in some strange and peculiar manner, our path. And for this reason I am immersed in the phenomenon of the Individual, the so-called whole Individual, and I try in every way to explain and present it. What are you? What am I? Those are the questions that constantly persecute and torment me and perhaps also play some part in my art.

Color, as the strange and magnificent expression of the inscrutable spectrum of Eternity, is beautiful and important to me as a painter; I use it to enrich the canvas and to probe more deeply into the object. Color also decided, to a certain extent, my spiritual outlook, but it is subordinated to light and, above all, to the treatment of form. Too much emphasis on color at the expense of form and space would make a double manifestation of itself on the canvas, and this would verge on craft work. Pure colors and broken tones must be used together, because they are the compliments of each other.

These, however, are all theories, and words are too insignificant to define the problems of art. My first unformed impression, and what I would like to achieve, I can perhaps only realize when I am impelled as in a vision.

One of my figures, perhaps one from the *Temptation*, sang this strange song to me one night—

Fill up your mugs again with alcohol, and hand up the largest of them to me . . . in ecstasy I'll light the great candles for you now in the night, in the deep black night. We are playing hide-and-seek, we are playing hide-and-seek across a thousand seas, we gods . . . when the skies are red in the middle of the day, when the skies are red at night.

You cannot see us, no you cannot see us but you are ourselves . . . that is what makes us laugh so gaily when the skies are red in the middle of the night, red in the blackest night.

Stars are our eyes and the nebulae our beards . . . we have people's souls for our hearts. We hide ourselves and you cannot see us, which is just what we want when the skies are red at midday, red in the blackest night.

Our torches stretch away without end . . . silver, glowing red, purple, violet, green-blue, and black. We bear them in our dance over the seas and the mountains, across the boredom of life.

We sleep and our brains circle in dull dreams . . . we wake and the planets assemble for the dance across bankers and fools, whores and duchesses.

Thus the figure from my *Temptation* sang to me for a long time, trying to escape from the square on the hypotenuse in order to achieve a particular constellation of the Hebrides, to the Red Giants and the Central Sun.

And then I awoke and yet continued to dream . . . painting constantly appeared to me as the one and only possible achievement. I thought of my grand old friend Henri Rousseau, that Homer in the porter's lodge whose prehistoric

dreams have sometimes brought me near the gods. I saluted him in my dream. Near him I saw William Blake, noble emanation of English genius. He waved friendly greetings to me like a super-terrestrial patriarch. "Have confidence in objects," he said, "do not let yourself be intimidated by the horror of the world. Everything is ordered and correct and must fulfill its destiny in order to attain perfection. Seek this path and you will attain from your own self ever deeper perception of the eternal beauty of creation; you will attain increasing release from all that which now seems to you sad or terrible."

I awoke and found myself in Holland in the midst of a boundless world turmoil. But my belief in the final release and absolution of all things, whether they please or torment, was newly strengthened. Peacefully I laid my head among the pillows . . . to sleep, and dream, again.

# IV  CUBISM:
## Form as Expression

## INTRODUCTION

The Cubist movement was a revolution in the visual arts so sweeping that the means by which images could be formalized in a painting changed more during the years from 1907 to 1914 than they had since the Renaissance. Its inventions responded so directly to the critical artistic problems of the beginning of the twentieth century that Cubism itself had barely appeared when its formal devices began to influence other of the arts, particularly architecture and the applied arts, but also poetry, literature, and music. The full implications of this revolution, however, were realized only later, when the influence of its ideas upon ensuing movements in painting and sculpture, some of them quite different in character from Cubism, was seen. Cubism is, in fact, the immediate source of the formalist stream of abstract and nonfigurative painting that has dominated the art of the twentieth century. The movements of this stream—Constructivism, Neoplasticism, De Stijl, and Orphism—arose very soon after the development of Cubism itself, owing part of their impetus to the prevailing sentiment for formalism, but receiving a vital fertilization from Cubist formal devices and Cubist ideas. The movement, therefore, represents that point in the development of ideas crucial to twentieth-century art when those ideas were being formed.

There are several reasons why the movement stimulated so much contemporary writing from varied points of view and on different levels of meaning. First of all, the critic-poets and the artists who attempted to defend and explain Cubism realized that it questioned basic assumptions underlying the tradition of Western art, assumptions that had prevailed for many centuries. Their interest in non-Western art, such as African and other primitive sculpture, and their admiration for the naïveté of Henri Rousseau and the aggressiveness of Alfred Jarry, were, like Cubism itself, implicit rejections of traditional standards. With the exception of Picasso and Braque the activities of the Cubist artists were very much the subject of public controversy: they exhibited as a group in the *Salon des Indépendants* of 1911 and several times thereafter; they gave lectures and entered into arguments on their work; they regularly met together with critics and writers in order

to discuss the relation of Cubism to poetry, science, geometry, the fourth dimension, and so on; and, finally, they wrote articles and letters. This group of painters soon became identifiable as "the Cubists," and they accepted the term when Apollinaire first used it in print in 1911 to describe them. The two critic-poets most intimate with the movement, Guillaume Apollinaire (1880–1918) and André Salmon (b. 1881), were both art critics on important newspapers—*L'Intransigeant*, *Le Temps*, *Le Journal*—and journals—*Les Soirées de Paris*, *Montjoie!*—reviewing the salon exhibitions in which the Cubists appeared.

The writers fully supported the revolutionary character of the painting. They proclaimed the autonomy of the formal elements of the picture, and they attacked the academic dictum that the subject of a painting must deal with an important or noble event, or in any case a narrative or "literary" one that could be comprehended by the mind. Cubist art was conceptual, not only perceptual, they proclaimed; that is, it drew upon memory as well as upon objects actually viewed by the eyes.

The artists and writers who gathered from about 1905 onward at Picasso's studio, the *Bateau Lavoir*, on the slope of Montmartre, were intellectually well-equipped to formulate explanations and theories on Cubism. The active defenders among them were of two kinds: the critic-poets, Apollinaire and Salmon; and the artists, in particular Jean Metzinger, Albert Gleizes, Fernand Léger, and Juan Gris. The leaders of the movement, Picasso and Braque, were almost the only artists who did not attempt at that time to explain the movement.

Apollinaire and Salmon shared many factors in their background which prepared them for their roles as theoreticians and historians of Cubism: they were both well-educated and were well-known in the circles of the advanced Symbolist poets, in particular the *Vers et Prose* group; they were themselves editors of a magazine, *Le Festin d'Esope*; and they were both art critics of considerable influence during the crucial years, 1908 to 1914. Apollinaire had, in fact, introduced Picasso into the circle of Alfred Jarry, who, until his death in 1907, was the dominant figure among the young poets, and Picasso accompanied the two poets on their frequent visits to Henri Rousseau's soirees. Apollinaire's first article on Picasso in *La Plume* in 1905 dealt poetically with the blue-period paintings, and a later one in 1908 with the "plastic virtues." Although both articles relied upon Symbolist ideas of mysticism and purity, they were included in his book on Cubism. However, his newspaper reviews after 1911 showed an increasing understanding of the new movement, and when he founded and became

*Marie Laurencin, Group of Artists, 1908, oil
on canvas. (L to R: Picasso, Fernande Olivier,
Guillaume Apollinaire, Marie Laurencin.)*

editor of *Les Soirées de Paris* in 1912, and joined *Montjoie!* the following year,
he published some of his best articles and reviews on Cubism.

Salmon's account of contemporary art, *La jeune peinture française* of
1912, includes a chapter on Cubism. Its chief interest lies in his eye-witness
account of the stages through which Picasso's *Demoiselles d'Avignon* passed
before reaching its final form. Since he lived nearby, on the other slope of
Montmartre from the *Bateau Lavoir*, he was a frequent visitor to the studio.

Apollinaire's book did not appear until the spring of 1913, having
undergone several revisions in which Cubism figured more and more
prominently. The original title, *Méditations esthétiques*, was superseded by a
new one, *Les peintres cubistes*, and the former title became the subtitle. It is,
in part, a collection of fragments of articles from the newspapers and
*Soirées de Paris*, and, in part, a newly written section on the individual

artists wherein he makes a distinction between four kinds of Cubism. Although Symbolist idealism lingers, particularly in his views of nature, he also takes up some of the advanced plastic techniques such as collage. And his *Calligrammes*, beginning in 1914, represent an attempt to construct poems and even to arrange them on the printed page after the formal devices of Cubism.

The most important early writing by artists was the book by Albert Gleizes (1881–1953) and Jean Metzinger (1883–1956), *Du Cubisme*, of 1912. Both artists were interested in a theoretical explanation of the new painting, and Metzinger had written in 1910 an article in *Pan* (Paris) on Picasso's perspective. In it he said that Picasso "invented a free and mobile perspective" and that "form, used for too many centuries as the inanimate support of color finally recovers its right to life and to instability."

Metzinger, as a painter working in the Neoimpressionist style, knew the theories of Signac. He had exhibited his work in the Salon d'Antomme and, because of this prestige, was able to influence the juries to admit paintings of Cubist tendency. Gliezes had been associated with the literary Symbolist "Closerie des Lilas" group from about 1907, and was one of the founders of the Abbaye de Créteil group who were concerned with neo-religious ideas. It is probable that the influence of the latter suggested to Gleizes that greater formal simplicity in his art would carry greater power, and hence when in 1910 he met Picasso and then the Cubists he was receptive to their ideas and their art. Later he became a prolific writer on Cubism and especially on its later tendencies toward a more pure and spiritual art, interests which were supported by his adherence to the church and his religious mural paintings.

Metzinger was largely responsible for the great impact the Cubist paintings made in the *Salon des Indépendants* of 1911, as he and his colleagues on the hanging committee resolved to arrange the exhibition according to styles and not alphabetically by artists, as had been the custom. Thus, for the first time, all the Cubists were together and could be readily singled out from the more than 6,000 paintings in the exhibition. Both Metzinger and Gleizes had exhibited regularly since about 1903 in the important salons, the *Indépendants* and the *Automne*, and they held various official positions in them. Since they were well-versed in poetry, philosophy, and mathematics and had participated in the discussions at the *Bateau Lavoir*, it was natural that they should come to the defense of the movement after the violent attacks of 1911. They had ample intellectual and moral support from a new grouping of artists who had been meeting at Jacques Villon's studio at Puteaux, where the discussions were of a much more intellectual

*Andre Lhote, sketch demonstrating how he combined various elements of a glass into a single Cubist image, 1952.*

and abstract character than at the *Bateau Lavoir*. Almost all the Cubist painters, again with the exception of Picasso and Braque, met here, where they were joined by the critics.

In *Du Cubisme* the two artists attempted to explain some of the conceptions underlying the movement. They discussed in clear and rational terms the idea of the new "conceptual" as opposed to the old "visual" reality, and how the transformation of natural objects into the plastic realm of the painting was effected.

Fernand Léger (1881 1955) shared their desire for logical explanation, and gave lectures at the *Section d'Or* exhibition in 1912. He was deeply concerned with the technological aspects of contemporary life, in particular with machinery, modern architecture, motion pictures, and the theatre and advertising art. His early experience as an architectural draftsman and his friendship with Le Corbusier and the artists and architects of De Stijl, as well as his later mosaic designs such as for the Church at Assy (Haute-Savoie), provided him with wide practical experience.

He had admired the massive machinery with which he came into contact as an artilleryman during the First World War, had made designs based upon them, and after the war expressed his belief that machinery was not only the most successful of man's creations aesthetically but also his most significant. In 1924 he made a film equating the mechanized movements of the actors with those of manufactured objects.

Léger's ideas and theories were expressed in lectures in 1912 and 1913, and later at the Collège de France and the Museum of Modern Art, New York. He also published articles in Apollinaire's journals *Montjoie!* and *Les Soirées de Paris*, in Leonce Rosenberg's *Bulletin de la Vie Artistique* and in many other foreign publications, including several in the United States.

Theoretical justifications for nonfigurative art appeared in the writings of Juan Gris (1887–1927). Although Gris had lived in the *Bateau Lavoir* since 1906 while Picasso was still there, he began to paint only in 1910, after Picasso had left, and he exhibited for the first time when his *Hommage à Picasso* was shown in the *Salon des Indépendants* of 1912. He came to Cubism, therefore, in the later "Synthetic" period, having made illustrations in the style of *Jugendstil* during the formative "Analytic" stage of Cubism, when he had been in Madrid. His writings of 1921 and 1925 reflect the later attitude.

Although the initiators of Cubism, Picasso (b. 1881) and Braque (1882–1963), were frequently mentioned from about 1908 on and even quoted by the critics, and even though the *Bateau Lavoir* was at one time the locale where discussion was most intense, the two leaders themselves made no recorded statements during the prewar years. Their paintings were shown in Paris only at Kahnweiler's gallery, and hence they were not exposed to public comment as were those of the artists known in the salons as the Cubists. Braque's first statement was written in 1917 while he was recuperating from a severe head wound suffered in the war, and before he had returned to painting. It is a series of aphorisms which he repeated again and again in later years, wherein he proclaimed his desire for order, control, and limitations and where, agreeing with the others, he expressed his high valuation of the plastic or formal properties of painting.

Although Picasso had been closely associated with poets and writers all his life and has written several poems and a play, he has written only a very few, very brief, statements about himself. None of them deals with his ideas on art. For these we must rely upon informal conversations with close friends or upon their reminiscences. The first recorded statement of Picasso's was made in 1923. By then, Cubism no longer existed as a movement, and Picasso had taken up, in addition to the Cubist style, another quite realistic mode. His statements to De Zayas, Zervos, and Kahnweiler are straightforward and deal with important general attitudes rather than theoretical explanations of his art. When confronted with direct or searching questions he has been evasive or has replied in a metaphorical vein. His statement, however, when viewed as reflecting a personal involvement with art and life, should be considered as part (but only one part) of the evidence for studying a style or a particular work. Like the paintings themselves, his statements should be taken as responses to particular ideological situations the exact conditions of which we can only partially know. They emerge as imaginative and sometimes poetic comments, rich in associations and

allusions on many levels. While they consistently avoid direct explanation, they are yet bits of evidence reflecting aspects of the artist's personal struggle.

*André Salmon, from the "Anecdotal History of Cubism," 1912*\*

I

Picasso was then leading an admirable kind of existence. Never had the flourishing of his untrammeled genius been so dazzling.

He had questioned those masters worthy of reigning over souls that were troubled and seized with fervor, from El Greco to Toulouse-Lautrec. Now, truly himself and certain of his powers, he let himself be led by a vibrant fantasy which was at the same time Shakespearean and Neoplatonic. The spirit along, during that period, was leading Picasso. An example will illuminate his methods of working.

After a handsome series of metaphysical acrobats, ballerinas like maids of Diana, enchanting clowns, and "Trismegistusian harlequins,"[1] Picasso had painted

*André Billy, Portrait of André Salmon, drawing.*

* From André Salmon, *La jeune peinture française* (Paris: Société des Trente, 1912), pp. 41–55. (Published in November.)

Salmon was not so vigorous a partisan of Cubism as was Apollinaire; he therefore devoted only one chapter in his book to it. His art criticism and his several monographs on artists are concerned with a wide range of styles and artists, and are in general more historical than the writings of the other poet. For his description of the ambience of the *Bateau-Lavoir* group see his novel *La Négresse du Sacré-Coeur* (Paris: N.R.F., 1920).

[1] "Arlequins Trismégistes" is probably from Hermes Trismegistus (Greek, "thrice great"), a Hellenistic-Egyptian diety whose triple talents were as priest, the giver of religion; as king, giver of the art of politics, the law, and the arts and industries; and as philosopher, giver of language, writing, and the secrets of nature including alchemy. The art or science of alchemy, "hermetic art," was named for him.

Apollinaire used the term "l'arlequin trismégiste" in the poem *Crépuscule* of February 1909. Francis Carmody believes that when this rare word is attached to the harlequin he becomes a kind of magician.

*Picasso in the Bateau Lavoir with New Caledonia (Melanesia) sculptures, 1908.*

without a model the very pure and simple image of a young Parisian worker, beardless and dressed in blue denim—just about the appearance of the artist himself during working hours.

One night Picasso deserted the company of friends passing the time in intellectual palaver. He returned to his studio and, taking up again the canvas which had been abandoned for a month, crowned the effigy of the little worker with roses. By a sublime caprice he had made of that work a masterpiece.

Picasso could live and work this way, happy and justifiably satisfied with himself. There was nothing to indicate that, by any different effort, he would gain more praise or a quicker success, for his paintings were beginning to be discussed.

Nevertheless, Picasso felt an uneasiness. He turned his canvases to the wall and threw down his brushes.

For long days and many nights he drew, concretizing the abstract and reducing the concrete to essentials. Never was labor less compensated by pleasure, and it was without his recent youthful enthusiasm that Picasso undertook a big canvas which was to be the first application of his findings.

Already the artist had a passion for the art of the Negroes, which he ranked

*André Salmon in Picasso's studio, the Bateau Lavoir, with Les Demoiselles d'Avignon (covered), 1908.*

far above that of the Egyptians. His enthusiasm was not based upon an empty taste for the picturesque. The Polynesian or Dahomeian images appeared "rational" to him. Renewing his work, Picasso inevitably had to give us a view of the world which did not conform to the vision we had learned.

The frequenters of the curious atelier of the rue Ravignan [the *Bateau Lavoir*], who used to give the young master confidence were generally disappointed when he allowed them to appraise the first state of his new work.

This painting has never been revealed to the public. It is composed of six large female nudes delineated with a severe accent. For the first time with Picasso the expression of the faces is neither tragic nor impassioned. They are masks almost completely devoid of all humanity. However, these personages are not gods, neither are they Titans or heroes; they are not even allegorical or symbolical figures. They are naked problems, white numerals on a black background.

Here the principle of the "painting-equation" was laid down. Picasso's new canvas was spontaneously baptized the "philosophical b———" by a friend of the artist. That was, I think, the last studio joke to enliven the world of the young innovator painters. Henceforth, painting was becoming a science and quite an austere one.

## II

The large canvas of the severe, unilluminated figures did not remain for long in its first state.

Soon Picasso assaulted the faces, placing most of their noses front view in the shape of isosceles triangles. The sorcerer's apprentice always consulted the Oceanian and African enchanters.

Soon afterward, these noses appeared white and yellow; touches of blue and yellow gave volume to some of the bodies. Picasso made up for himself a limited palette of brusque tones rigorously corresponding to the schematic design.

Finally, dissatisfied with his first researches, he assailed the other nudes (they had been set aside and spared until then by this Neronian), seeking a new equilibrium, and composing his palette of pinks, whites, and greys.

For a short time, Picasso appeared to be satisfied with this gain; the "philosophical b———" was turned to the wall, and it is at that moment that he painted those canvases of a beautiful harmony of tones, of such a supple design—of nudes, most often—which constituted the last exhibition of Picasso in 1910.

The painter who had been the first to understand how to restore some nobility to a discredited subject, returned to the idea of the "study," and to subjects in his first manner (*Femme à sa toilette, Femme se peignant*), seeming thereby for the moment to renounce any further gains from the researches which had caused him to sacrifice his original gifts of immediate seduction.

It is necessary to follow step by step the one whose tragic curiosity was to stimulate Cubism. A vacation interrupted the painful experiments. Upon his return

Picasso took up again the large canvas of experiments which, as I have said, lived only through its figures.

He created for it an atmosphere, by a dynamic decomposition of luminous forces; an effort leaving far behind the attempts of Neoimpressionism and Division-ism. Geometric figures—of a geometry at the same time infinitesimal and cine-matic—appeared as the principle element of a style of painting whose development nothing from that time onward could arrest any longer.

Struck by Fate, Picasso could never again become the fertile, ingenious and knowledgable creator of works of human poetry.

## III

Let those inclined to consider the Cubists as audacious pranksters or shrewd dealers condescend to take notice of all the true drama presiding over the birth of that art.

Picasso himself had also "meditated upon geometry," and in choosing the primitive artists as his leaders he was not at all unaware of their barbarism. It was only that he logically grasped that they had attempted the real figuration of being, and not at all the realization of the idea—most often a sentimental one— which we make of it.

Those who see in the work of Picasso the marks of the occult, of the symbol, or of the mystic are in great danger of never understanding it.

By these means he wished to give us a total representation of man and of things. Such is the accomplishment of the barbarian image-makers. But since his concern is with painting, an art of surface, Picasso must create, in his turn, by situating these equilibrated figures, irrespective of the laws of academicism and of an anatomical system, in a space rigorously conforming to the unexpected liberty of movements.

The volition of such a creation suffices to make the one who is animated by it the foremost artist of his age, even if he may know only the austere joys of research without gathering the harvest.

The results of the primitive researches were disconcerting—no care whatsoever for grace, and taste repudiated as too narrow a standard.

Nude figures came into being whose distortion was scarcely surprising, prepared for it as we were by Picasso himself, by Matisse, Derain, Braque, Van Dongen and before that Cézanne and Gauguin. It was the hideousness of the faces that froze those who were only half-converted with horror.

Deprived of Smile, we could recognize only Grimace.

The smile of *La Giaconda* was for too long, perhaps, the Sun of Art.

The adoration of her corresponds to some decadent Christianity— particularly depressing, supremely demoralizing. One could say, paraphrasing Arthur Rimbaud, that *La Giaconda*, the eternal *Giaconda*, was a thief of the energies.

If one places side by side one of the nudes and one of the still-lifes of that

moment of "Picassisme" (Cubism had not yet been invented), it is difficult not to reflect to the advantage of the innovator.

Then, while the human effigy appears to us so inhuman and inspires in us a sort of fright, we are more prepared to submit our sensibility to the conspicuous and entirely new beauties of the representation of this piece of bread, this violin, this cup, such beauties as painting had never given us before.

It is because the accepted appearance of these objects is less cherished by us than our own appearance, our reflection deformed in the mirror of intelligence.

Thus one will willingly let himself be persuaded to search, with a desperate trust, Picasso or some painter of his school.

Will there be much time lost? Here is a problem!

Who will demonstrate the necessity, the superior aesthetic reason to paint beings and things such as they are and not at all as our eye has recognized them in the past, perhaps not always, but since man has meditated upon his image?

Isn't that itself what art is?

Is not science the only director of these seekers, anxious to make us endure all the edges of the prism at one time, merging touch and sight which are the sources of such disparate joys?

No one has yet been able to answer that question conclusively.

Besides, the concern to make us feel an object in its total existence is not in itself absurd. The aspect of the world is changing—we no longer wear the mask of our fathers, and our sons will not resemble us. Nietzsche has written: " 'We have made the world very small,' say the last men on earth, blinking." Terrible prophesy! Is not the salvation of the soul on the earth to be found in a completely new art?

That question I do not intend to answer today, having only set out to prove that artists, unjustly burdened, were obeying inevitable laws for which anonymous genius is responsible.

This chapter is nothing more than an anecdotal history of Cubism.

And there is nothing imprudent about what I bring up here. Mr. Jean Metzinger, as early as 1910, disclosed to a reporter: "We never had the curiosity to touch the objects we were painting."

## IV

But Picasso returned to the painting drill-ground. He had to put to test the accent of a new palette. The artist found himself in a truly tragic position. He had no disciples yet (among the later disciples several were to become hostile disciples). Some painter friends drew away from him (another than myself could cite names without scruple), conscious of their weaknesses and fearing the example, hating the beautiful snares of Intelligence. The rue Ravignan studio was no longer "the rendezvous of poets." The new ideal set apart the men who were beginning to look at themselves "on every side at once" and thus learning to scorn themselves.

Forsaken, Picasso found himself in the society of the African augurs. He made up for himself a palette rich with all the tints beloved of the old academicians: ochre, bitumen, and sepia, and painted several formidable nudes, grimacing and perfectly deserving of being execrated.

But with what singular nobility Picasso recasts everything he touches.

The monsters of his mind drive us to despair; never will they rouse even the vulgarians to the democratic laughter which makes Sunday crowds invade the *Salon des Indépendants*.

Already the Alchemist-Prince, this Picasso who makes us think of Goethe, of Rimbaud, of Claudel, was no longer alone.

Jean Metzinger, Robert Delaunay, Georges Braque were taking an extraordinary interest in his works.

André Derain (let us acknowledge it at once) was to join him again by following his own personal channels, only to move away from him later without having surpassed him. Picasso taught him at least the necessity of abandoning the conversational *salon* around Henri Matisse's studio.

Vlaminck, that giant of loyal and categorical thoughts like the punches of a good boxer, was, to his own amazement, losing his conviction that he was the Fauve type. He had never thought that one could exceed in audacity the violence of the anguished Vincent Van Gogh. He returned to Chatou, thoughtful but not converted.

Jean Metzinger and Robert Delaunay painted landscapes planted with cottages reduced to the severe appearance of parallelepipeds.[1] Living less of an interior life than Picasso, remaining to all outward appearances more like painters than their precursor, these young artists were in a much greater hurry for results, though they be less complete.

It was their great haste which brought about the success of the undertaking.

Exhibited, their works passed almost unobserved by the public and by art critics, who—green hats or blue hats, Guelfs and Gibelines, Montagues and Capulets—recognized only the Fauves, whether it be to praise or curse to them.

Now, the king of the Fauves (was it imprudence or political adroitness?), Henri Matisse, who had just been crowned at Berlin, with one word cast out Jean Metzinger and Robert Delaunay from the family.

With that feminine sense of the appropriate, the basis of his taste, he baptized the cottages of the two painters, "Cubist." An ingenuous or ingenious art critic was with him. He ran to his newspaper and with style wrote the gospel article; the next day the public learned of the birth of Cubism.[2]

---

[1] A body with parallel surfaces. In geometry, a six-sided prism whose faces are parallel.

[2] Salmon is presumably referring to the incident said to have occurred about 1 October 1908 at the time of the judging for the *Salon d'Automne*. According to Apollinaire's version (mentioned in chapter VII of *Les Peintres Cubistes*), Matisse described Braque's paintings to the

Schools disappear for lack of convenient labels. This is annoying to the public, for it likes the schools because they enable it to understand clearly without effort. The public accepted Cubism very docilely, even going so far as to recognize Picasso as head of the school and holding tenaciously to this belief.

Since then, the misunderstanding has only become worse.

Georges Braque, who, some months before, was painting brutal landscapes like Vlaminck's, concerned also with Seurat's discoveries, contributed not a little to strengthening the double misunderstanding.

He rejoined Jean Metzinger and Robert Delaunay. But, preoccupied earlier than these two with the human figure, he borrowed directly from Picasso, although there was sometimes still room in his works for a modest expression of his sensibility.

Later, he was to follow him, respectfully, step by step, causing a usually discerning writer to make the following excessive statement: "It is said that the inspirer of the movement is Mr. Picasso; but as he does not exhibit at all, we must consider Mr. Georges Braque as the true representative of the new school."

Much more intellectual, Jean Metzinger, painter and poet, author of beautiful esoteric verse, wanted to justify this Cubism as created by Henri Matisse, who was not participating in the undertaking, and thought he was assembling the confused elements of the doctrine.

If Cubism, then, baptized by Henri Matisse, really came from Picasso who did not practice it at all, Jean Metzinger has grounds for calling himself its leader. However, he conceded very quickly: "Cubism is the means, not the end." Ergo: Cubism is admirable because it does not exist, although it had been invented by four people.

Today we are seeing the Cubists growing farther and farther apart; little by little they are abandoning the little cooperative tricks they had in common; what they called discipline was, in short, only a gymnastic, something like *la culture plastique*.

They think they have been in the Academy, but they come out of the Gymnasium.

---

critic, Louis Vauxcelles, as like "little cubes." Vauxcelles used the term for the first time in print, but it was not the next day, as Salmon indicated, but about six weeks later on 14 November. The occasion was Vauxcelles' review of Braque's exhibition at Kahnweiler's gallery when his Cubist paintings were exhibited for the first time. (See Kahnweiler's account, below.) He wrote in *Gil Blas* (14 November 1908): "The upsetting example of Picasso and Derain has hardened him. Perhaps, also, the style of Cézanne and the remembrances of the static art of the Egyptians have obsessed him excessively. He constructs deformed metallic men of a terrible simplification. He is contemptuous of form, reduces everything, sites and figures and houses to geometric schemas, to cubes."

Vauxcelles (b. 1870) was a distinguished and learned writer who for many years had been art critic for this influential newspaper. Although his own tastes were exceedingly conservative (he praised Paul Chabas' *September Morn* when it was exhibited in 1912), and although later he was to attack the Cubists severely, his criticism is based upon sharp observation and clearly-defined although outdated standards.

*Albert Gleizes and Jean Metzinger, from Cubism, 1912*★

The word "Cubism" is here employed merely to spare the reader any uncertainty as to the object of our inquiry; and we would hasten to declare that the idea which the term evokes—that of volume—cannot by itself define a movement which tends towards the integral realization of Painting.

But we will not attempt definitions. We wish merely to suggest that the joy of confining unlimited art within the limits of the picture is worth the effort which it requires; and to incite to this effort whosoever is worthy of accomplishing it.

If we do not succeed, what matter! We are actuated and impelled by the pleasure which a man takes in speaking of the work to which his daily life is dedicated, and we honestly believe that we have said nothing which is not calculated to confirm the true painter in his personal predilection.

I

To estimate the significance of Cubism we must go back to Gustave Courbet.

This master, after David and Ingres had magnificently terminated a secular idealism, did not follow the example of the Delaroches and the Deverias, did not waste himself in servile repetition: he inaugurated a realistic impulse which runs through all modern efforts. Yet he remained the slave of the worst visual conventions. Unaware of the fact that in order to display a true relation we must be ready to sacrifice a thousand apparent truths, he accepted, without the slightest

★ Originally published in Albert Gleizes and Jean Metzinger, *Du Cubisme* (Paris: Figuière, 1912) (published in December). This English translation is from *Cubism* (London: Unwin, 1913). Parts III and V are omitted here. Reprinted with the kind permission of M. Jean Metzinger and M. Albert Gleizes, who approved of the selections from the book and also with the permission of Ernest Benn, Limited, successor to T. Fisher Unwin as owners of the copyright on the English translation.

The essay was written during 1912 at the time when Cubism had become the subject of the most vigorous controversy among the informed public and in the press. The Cubist painters had appeared for the first time as a group at the *Salon des Indépendants* of 1911, and a few weeks later Apollinaire publicly accepted the word "Cubists" for them. This group, which included almost all the Cubists with the exception of Braque and Picasso, was given to extensive discussion and theorization. While this book was being completed they were meeting at Jacques Villon's studio in Puteaux, where they were joined by the critics and poets.

Since this group was known as "the Cubists," many of them felt obliged to reply to the violent attacks directed at them. Because Gleizes and Metzinger were leaders in the group discussions and because they were deeply concerned with the public reaction to the movement, they took up the task of explaining it. Hence the pedagogical tone of the essay and their references to earlier masters.

They illustrated their book with reproductions of the work of most of the Cubists, as follows: Gleizes, Metzinger, and Léger, 5 each; Marie Laurencin, Duchamp, and Picabia, 2 each; Cézanne, Picasso, Derain, and Gris, 1 each; and Braque, none. Their selection emphasized their separateness from Picasso and Braque, who did not exhibit in the salons and who did not participate in the Cubists' meetings.

*Jean Metzinger, Self-Portrait, drawing.*

intellectual control, all that his retina presented to him. He did not suspect that the visible world can become the real world only by the operation of the intellect; and that the objects which most forcibly impress us are not always those whose existence is richest in plastic truths.

Reality is more profound than the academic formulas, and more complex also. Courbet was like one who observes the ocean for the first time, and who, diverted by the movements of the waves, has no thought of the depths; we cannot blame him, since it is to him that we owe our present joys, so subtle and so potent.

Edouard Manet marks a higher stage. But his realism is as yet inferior to the idealism of Ingres, and his *Olympia* is heavy beside the *Odalisque*. We should love him for transgressing the decrepit rules of composition, for diminishing the value of the anecdote to the extent of painting "no matter what." In him we recognize a forerunner; we for whom the beauty of a work resides essentially in the work, not in that which is only the pretext for the work. In spite of many failings we call Manet a realist less because he represented everyday episodes than because he knew how to endow the many potential qualities concealed in the most commonplace objects with a radiant reality.

After him there is a scission. The realistic impulse is divided into superficial realism and profound realism. The former claims the Impressionists—Monet, Sisley, etc.—and the latter Cézanne.

The art of the Impressionists involves an absurdity: by diversity of color it seeks to create life, and it promotes a feeble and ineffectual quality of drawing. The dress sparkles in a marvelous play of colors; but the figure disappears, is atrophied. Here, even more than in Courbet, the retina predominates over the brain; but the Impressionist is conscious of this, and to justify himself he speaks of the incompatibility of the intellectual faculties and the artistic sense!

But no energy can set itself in opposition to the general impulse on which it is based. We must not regard Impressionism as a false departure. The only possible error in art is imitation; it infringes the law of time, which is the Law. Merely by the liberty displayed by their technique, or shown in the constituent elements of a tint, Monet and his disciples helped to widen the field of effort. They never attempted to render painting decorative, symbolic, or moral. If they were not great painters they were painters, and for that reason we should respect them.

People have tried to present Cézanne as a sort of genius *manqué*; they say that his knowledge is admirable, but that he cannot sing or say his ideas; he only stutters. The truth is that he was unfortunate in his friends. Cézanne is one of the greatest of those artists who constitute the landmarks of history, and it ill becomes us to compare him to Van Gogh or Gauguin. He suggests Rembrandt. Like the painter of the *Pilgrims of Emmaus*, neglecting idle applause, he has plumbed reality with a resolute eye, and if he himself has not attained those regions in which the profounder realism is insensibly transformed into a luminous spiritualism, at least he has left, for those who desire steadily to attain it, a simple and wonderful method.

He teaches us to overcome the universal dynamism. He reveals the reciprocal and mutual modifications caused by supposedly inanimate objects. From him we have learned that to alter the coloration of a body is to corrupt its structure. He prophesies that the study of primordial volume will open unknown horizons to us. His work, a homogeneous mass, shifts under the glance, contracts, expands, fades or illumines itself, irrefragably proving that painting is not—or is no longer—the art of imitating an object by means of lines and colors, but the art of giving our instinct a plastic consciousness.

To understand Cézanne is to foresee Cubism. Henceforth we are justified in saying that between this school and the previous manifestations there is only a difference of intensity, and that in order to assure ourselves of the fact we need only attentively regard the methods of this realism, which, departing from the superficial reality of Courbet, plunges, with Cézanne, into the profoundest reality, growing luminous as it forces the unknowable to retreat.

Some maintain that such a tendency distorts the traditional curve. Whence do they derive their arguments? From the past or the future? The future does not belong to them, as far as we are aware, and one must needs be singularly ingenuous to seek to measure that which exists by that which exists no longer.

Under penalty of condemning all modern painting, we must regard Cubism as legitimate, for it continues modern methods, and we should see in it the only conception at present possible of the pictorial art. In other words, Cubism is at present painting itself.

Here we should like to demolish a very general misunderstanding, to which we have already made allusion. Many consider that decorative considerations should govern the spirit of the new painters. Undoubtedly they are ignorant of the most obvious signs which make decorative work the antithesis of

the picture. The decorative work of art exists only by virtue of its *destination*; it is animated only by the relations existing between it and determined objects. Essentially dependent, necessarily incomplete, it must in the first place satisfy the mind so as not to distract it from the spectacle which justifies and completes it. It is a medium, an instrument.

The picture bears its pretext, the reason for its existence, within it. You may carry a picture with impunity from a church to a drawingroom, from a museum to your study. Essentially independent, necessarily complete, it need not immediately satisfy the imagination: on the contrary, it should lead it, little by little, toward the fictitious depths in which the co-ordinative light resides. It does not harmonize with this or that environment; it harmonizes with things in general, with the universe: it is an organism.

Not that we wish to belittle decoration in order to benefit painting; it is enough for us to prove that although wisdom is the science of putting everything in its place, the majority of artists are far from possessing it. There is more than enough plastic and pictorial decoration, more than enough confusion and ambiguity.

Do not let us dispute as to the prime object of our art. Formerly the fresco incited the artist to represent distinct objects, evoking a simple rhythm, on which the light was spread at the limit of a synchronic vision, rendered necessary by the amplitude of the surfaces; today painting in oils allows us to express notions of depth, density, and duration supposed to be inexpressible, and incites us to represent, in terms of a complex rhythm, a veritable fusion of objects, within a limited space. As all preoccupation in art arises from the material employed, we ought to regard the decorative preoccupation, if we find it in a painter, as an anachronistic artifice, useful only to conceal impotence.

Does the difficulty which even a sensible and cultivated public experiences in reading modern works result from present conditions? We will admit that it does; but it may be transformed into a source of enjoyment. A man will enjoy today what exasperated him yesterday. The transformation is extremely slow, and the slowness is easily explained; for how should comprehension evolve as rapidly as the creative faculties? It follows in their wake.

## II

Dissociating, for convenience, things that we know to be indissolubly united, let us study, behind form and color, the integration of the plastic consciousness.

To discern a form implies, besides the visual function and the faculty of movement, a certain development of the imagination; to the eyes of most people the external world is amorphous.

To discern a form is to verify a pre-existing idea, an act that no one, save the man we call an artist, can accomplish without external assistance.

Before a natural spectacle the child, in order to coordinate his sensations

and to subject them to mental control, compares them with his picture book; the man, culture intervening, refers himself to works of art.

The artist, having discerned a form which presents a certain degree of analogy with his pre-existing idea, prefers it to other forms, and consequently—for we like to force our preferences on others—endeavors to enclose the quality of this form (the incommensurable sum of the affinities perceived between the visible manifestation and the tendency of his mind) in a symbol likely to impress others. When he succeeds he forces the crowd to assume, in respect of his integrated plastic consciousness, the attitude that he himself assumed in respect of Nature. But while the painter, eager to create, rejects the natural image directly he has made use of it, the crowd long remains the slave of the painted image, and persists in seeing the world only through the symbol adopted. This is why any new form seems monstrous, and why the most slavish imitations are admired.

Let the artist's function grow profounder rather than more extensive. Let the forms which he discerns and the symbols in which he incorporates their qualities be sufficiently remote from the imagination of the vulgar to prevent the truth which they convey from assuming a general character. Confusion results when the work is a species of unity indefinitely applicable to several categories, both natural and artistic. We concede nothing to the past: Why, then, should we favor the future by facilitating the task of the vulgarizer? Too great lucidity is unfitting: let us beware of masterpieces. Decorum demands a certain degree of dimness, and decorum is one of the attributes of art.

Above all, let no one be decoyed by the appearance of objectivity with which many imprudent artists endow their pictures. There are no direct means of valuing the processes by which the relations between the world and the thought of the artist are rendered perceptible to us. The fact commonly invoked, that we find in a painting the familiar characteristics which form its motive, proves nothing at all. Let us imagine a landscape. The width of the river, the thickness of the foliage, and height of the banks, the dimensions of each object and the relations of these dimensions—these are secure guarantees. Well, if we find these intact upon the canvas, we shall have learned nothing as to the talent or the genius of the painter. River, foliage, and banks, despite a conscientious representation to scale, no longer "tell" by virtue of their width, thickness, and height, or the relations between these dimensions. Torn from natural space, they have entered a different kind of space, which does not assimilate the proportion observed. This remains an external matter. It has just so much importance as a catalogue number, or a title at the bottom of a picture-frame. To contest this is to deny the space of painter; it is to deny painting.

The painter has the power of rendering as enormous things that we regard as infinitesimal, and as infinitesimal things that we know to be considerable; he changes quantity into quality.

To whom shall we impute the blunder? To the painters who disregard their rights. When from any spectacle they have separated the features which

summarize it, they believe themselves constrained to observe an accuracy which is truly superfluous. Let us remind them that we visit an exhibition to contemplate painting and to enjoy it: not to enlarge our knowledge of geography, anatomy, etc.

Let the picture imitate nothing; let it nakedly present its motive, and we should indeed be ungrateful were we to deplore the absence of all those things—flowers, or landscape, or faces—whose mere reflection it might have been. Nevertheless, let us admit that the reminiscence of natural forms cannot be absolutely banished—as yet, at all events. An art cannot be raised to the level of a pure effusion at the first step.

This is understood by the Cubist painters, who indefatigably study pictorial form and the space which it engenders.

This space we have negligently confounded with pure visual space or with Euclidian space.

Euclid, in one of his postulates, speaks of the indeformability of figures in movement, so we need not insist upon this point.

If we wished to refer the space of the painters to geometry, we should have to refer it to the non-Euclidian scientists; we should have to study, at some length, certain theorems of Rieman's.

As for visual space, we know that it results from the agreement of the sensations of convergence and accommodation.[1]

For the picture, a plane surface, the accommodation is negative. The convergence which perspective teaches us to represent cannot evoke the idea of depth. Moreover, we know that the most serious infractions of the rules of perspective will by no means compromise the spatiality of a painted work. The Chinese painters evoke space, although they exhibit a strong partiality for *divergence*.

To establish pictorial space, we must have recourse to tactile and motor sensations, indeed to all our faculties. It is our whole personality which, contracting or dilating, transforms the plane of the picture. As in reacting this plane reflects the personality upon the understanding of the spectator, pictorial space may be defined as a sensible passage between two subjective spaces.

The forms which are situated within this space spring from a dynamism which we profess to command. In order that our intelligence may possess it, let us first exercise our sensibility. There are only *nuances*; form appears endowed with

---

[1] This idea had been developed by Adolph von Hildebrand, who stated that an observer looking at an object in nature located close to him can focus upon only one point at a time and that he can grasp the totality of the object only after numerous fixations. On the contrary, when he looks at an object in a work of art he is looking into a homogeneous space which is under the control of the artist. This space "affords the only possible perception of form at a glance." In the case of the object in nature each fragment has its own "convergence" and "accommodation," while in art there is only one of each of these. *Das Problem der Form in der Bildenden Kunst* (Strassburg: Heitz, 1893) (English edition: New York: Stechert, 1907).

properties identical with those of color. It is tempered or augmented by contact with another form; it is destroyed or emphasized; it is multiplied or it disappears. An ellipse may change into a circle because it is inscribed in a polygon. A form more emphatic than those about it may govern the whole picture; may imprint its own effigy upon everything. Those picture-makers who minutely imitate one or two leaves in order that all the leaves of a tree may seem to be painted, show in a clumsy fashion that they suspect this truth. An illusion, perhaps, but we must take it into account. The eye quickly interests the mind in its errors. These analogies and contrasts are capable of all good and all evil; the masters felt them when they strove to compose in a pyramid, a cross, a circle, a semicircle, etc.

To compose, to construct, to design, reduces itself to this: to determine by our own activity the dynamism of form.

Some, and they are not the least intelligent, see the aim of our technique in the exclusive study of volumes. If they were to add that it suffices, surfaces being the limits of volumes and lines those of surfaces, to imitate a contour in order to represent a volume, we might agree with them; but they are thinking only of the *sensation of relief*, which we hold to be insufficient. We are neither geometers nor sculptors: for us lines, surfaces, and volumes are only modifications of the notion of plenitude. To imitate volumes only would be to deny these modifications for the benefit of a monotonous intensity. As well renounce at once our desire of variety.

Between reliefs indicated sculpturally we must contrive to hint at those lesser features which are suggested, but not defined. Certain forms should remain implicit, so that the mind of the spectator is the chosen place of their concrete birth.

We must also contrive to cut up by large restful surfaces all regions in which activity is exaggerated by excessive contiguity.

In short, the science of design consists in instituting relations between straight lines and curves. A picture which contained only straight lines or curves would not express life.

It would be the same with a picture in which curves and straight lines exactly compensated one another, for exact equivalence is equal to zero.

The diversity of the relations of line to line must be indefinite; on this condition it incorporates quality, the incommensurable sum of the affinities perceived between that which we discern and that which pre-exists within us: on this condition a work of art is able to move us.

What the curve is to the straight line the cold tone is to the warm tone in the domain of color.[1]

---

[1] Compare with Seurat's theory that colors could be considered on a scale of cool to warm, lines on a scale of passivity to activity, and tones from light to dark, and that these were evocative of moods from sad to gay. Metzinger had painted as a Neoimpressionist for several years before becoming a Cubist.

## IV

. . . . . . . . . . . . . . . . . . . . . . . . . . . . . . .

There is nothing real outside ourselves; there is nothing real except the coincidence of a sensation and an individual mental tendency. Be it far from us to throw any doubts upon the existence of the objects which impress our senses; but, rationally speaking, we can only experience certitude in respect of the images which they produce in the mind.

It therefore amazes us when well-meaning critics explain the remarkable difference between the forms attributed to nature and those of modern painting, by a desire to represent things not as they appear, but as they are. As they are! How are they, what are they? According to them, the object possesses an absolute form, an essential form, and we should suppress chiaroscuro and the traditional perspective in order to present it. What simplicity! An object has not one absolute form: it has many: it has as many as there are planes in the region of perception. That which these writers describe is marvelously applicable to geometrical form. Geometry is a science; painting is an art. The geometer measures; the painter tastes. The absolute of the one is necessarily the relative of the other; if logic is alarmed at this, so much the worse! Will it ever prevent a wine from being different in the retort of the chemist and in the glass of the drinker?

We are frankly amused to think that many a novice may perhaps pay for his too literal comprehension of the Cubist's theory, and his faith in the absolute truth, by painfully juxtaposing the six faces of a cube or the two ears of a model seen in profile.

Does it ensue from this that we should follow the example of the Impressionists and rely upon the senses alone? By no means. We seek the essential, but we seek it in our personality and not in a sort of eternity, laboriously divided by mathematicians and philosophers.

Moreover, as we have said, the only difference between the Impressionists and ourselves is a difference of intensity, and we do not wish it to be otherwise.

If so many eyes contemplate an object, there are so many images of that object; if so many minds comprehend it, there are so many essential images.

But we cannot enjoy in isolation; we wish to dazzle others with that which we daily snatch from the sensible world, and in return we wish others to show us their trophies. From a reciprocity of concessions arise those mixed images, which we hasten to confront with artistic creations in order to compute what they contain of the objective; that is, of the purely conventional.

If the artist has conceded nothing to common standards, his work will inevitably be unintelligible to those who cannot, as though by a stroke of the wings, plunge into unknown planes. If, on the contrary, by inability or lack of intellectual control, the painter remains the slave of the forms in customary use, his work will delight the crowd—his work? no, but the work of the crowd—and will depress the individual.

Among the so-called academic painters some may be well endowed; but how know it? Their painting is so truthful that it founders in the truth; in that negative truth, the mother of morals and all insipid things, which, true for all, are false for each.

Does this mean that a work of art must necessarily be unintelligible to the majority? No: here we have only a consequence, which is merely temporary, and by no means a necessity.

We should be the first to blame those who, to hide their incapacity, should attempt to fabricate puzzles. Systematic obscurity betrays itself by its persistence. Instead of a veil which the mind gradually draws aside as it adventures toward progressive wealth, it is merely a curtain hiding a void.

Moreover, let us remark that all plastic qualities guarantee a preliminary emotion, and every emotion certifies a concrete existence, so that it is enough for a picture to be well painted to assure us of the *veridicity* of its author, and that our intellectual effort will be rewarded.

It is not in the least surprising that people ignorant of painting should not spontaneously share our assurance; but nothing is more absurd than that they should be irritated thereby. Must the painter, to please them, turn back in his work, and restore to things the commonplace appearance from which it is his mission to deliver them?

From the fact that the object is truly transubstantiated, so that the most accustomed eye has some difficulty in discovering it, a great charm results. The picture which only surrenders itself slowly seems always to wait until we interrogate it, as though it reserved an infinity of replies to an infinity of questions. On this point let Leonardo da Vinci speak in defense of Cubism:

"We know well," says Leonardo, "that the sight, by rapid observations, discovers in one point an infinity of forms: nevertheless it comprehends only one thing at a time. Suppose, reader, that you were to see the whole of this written page at one glance, and were immediately to judge that it is full of different letters; you do not at the same moment know what letters they are, nor what they would say. You must go from one word to another and from line to line if you wish to attain a knowledge of these letters, as you must climb step by step to reach the top of a building, or you will never reach the top."

Not to discern at first contact the individuality of the objects which are the motives of a picture: the charm is considerable, but it is also dangerous. We disapprove not only of synchronic and primary images, but also of the facilities of a fantastic occultism; if we condemn the exclusive usage of customary symbols it is not because we wish to replace them by cabalistic signs. We will even willingly confess that it is impossible to write without employing ready-made phrases, or to paint if we totally neglect the familiar symbols. It is for each to decide whether he should scatter them all through his work, mix them intimately with personal symbols, or boldly exhibit them, magical discords, shreds of the great collective lie, at a single point of the plane of the higher reality which he appropriates to his

art. A true painter takes note of all the elements which experience reveals to him, even if these are neutral or vulgar. It is a matter of tact.

But the objective or conventional reality, that world which is intermediate between our consciousness and the consciousness of others, despite the fact that humanity has labored from immemorial ages to determine it, incessantly varies according to races, religions, scientific theories, etc. Thanks to an interval, we are able from time to time to insert our personal discoveries and vary the normal by surprising exceptions.

We have no doubt that those who measure with their pencils or brushes discover in a short time that roundness always does more than relative dimensions to represent a round object. We are certain that the least intelligent will quickly recognize that the pretense of representing the weight of bodies and the time spent in enumerating their various aspects is as legitimate as that of imitating daylight by the collision of an orange and a blue. Then the fact of moving around an object to seize several successive appearances, which, fused in a single image, reconstitute it in time, will no longer make thoughtful people indignant.

They will appreciate these diversities, those who confound plastic dynamism with the bustle of the streets. Finally, it will be recognized that there was never a Cubist technique, but merely a pictorial technique expounded with courage and variety by certain painters. They are reproached with exhibiting it to excess, and are advised to conceal their craft. Absurd! As though one were to tell a man to run, but not to move his legs!

Moreover, all painters exhibit their craft, even those whose industrious delicacy confounds the overseas barbarians. But there are painters' methods as there are writers' methods; by passing from hand to hand they grow colorless, insipid, and abstract.

The Cubist methods are far from being this, although they do not still emit the hard brilliancy of new coin, and an attentive study of Michelangelo authorizes us to say that they have won their patent of nobility.

*Guillaume Apollinaire, "The Beginnings of Cubism," 1912*\*

In the beginning of autumn of the year 1902[1] a young painter, De Vlaminck [1876–1958], seated on the Ile de la Grenouillère was painting the Chatou bridge. He painted rapidly, using pure colors, and his canvas was covered with brilliant

---

\* Originally published in *Le Temps* (Paris), 14 October 1912. Reprinted in *Guillaume Apollinaire: Chroniques d'Art (1902–1918)*, ed. L.-C. Breunig (Paris: Gallimard, 1960), pp. 263–266. A slightly different version, from a later manuscript in the possession of Madame Sonia Delaunay, appears in Pierre Francastel, *Du cubisme à l'Art abstrait* (Paris: S. E. V. P. E. N., 1957), pp. 151–154. The present translation has been made from the original text, but additions appearing in the later version have been included within brackets. This later manuscript was used by Apollinaire for his lecture at the Sturm Gallery, Berlin, in January 1913.

[1] Vlaminck stated that this meeting took place at the end of the year 1900, while he

*Pablo Picasso, Guillaume Apollinaire, 1916, drawing.*

hues. The work was nearly completed when he heard someone cough behind him. It was another painter, André Derain [1880–1954], who was scrutinizing his painting with a great deal of interest.

The ice was broken, and the two of them embarked upon a discussion of painting. Maurice de Vlaminck was acquainted with the works of the Impressionist painters Manet, Monet, Sisley, and Cézanne which Derain at that time knew nothing about. They discussed the work of Van Gogh and Gauguin as well. Night fell and, surrounded by the fog which arose from the Seine, the two young artists talked until midnight, at which time they both took their separate ways.

This first meeting was the beginning of a friendly and serious relationship. Vlaminck was always on the lookout for artistic curiosities. During his strolls through the towns along the Seine he bought from secondhand dealers some pieces of sculpture, masks, and fetishes carved in wood by the Negro artists of French West Africa which had been brought back by sailors or explorers.[1] He

---

was still in the army. See his *Portraits avant décès* (Paris: Flammarion, 1943), pp. 211–215. There are several letters from Derain to Vlaminck dated as early as 1901, thus verifying Vlaminck's date. See Derain, *Lettres à Vlaminck* (Paris: Flammarion, 1955).

[1] Vlaminck claims in his autobiography, *Tournant Dangereux* (Paris: Stock, 1929), that it was he who was the first among the artists to admire and collect African Negro sculpture (Goldwater places the date at 1904). According to him he saw two statues in a bistrot, was immediately interested and purchased them. He regarded them at that time as comparable to the provincial and folk art that he and his friends already knew about.

undoubtedly found in these grotesque and crudely mystical works, certain analogies with the paintings, graphic works, and sculptures which Gauguin had produced under the influence of Breton calvaries and savage Oceanic sculpture in his search for refuge and escape from European culture.

Whatever the case may be, these strange African images made a powerful impression upon André Derain who, while regarding them with a great deal of fondness, admired the talent with which the sculptors from Guinea and the Congo had reproduced the human figures without utilizing any element taken from direct vision. At a time when the Impressionists had delivered art from its academic chains, the taste of Maurice de Vlaminck for Negro sculpture and the musings of André Derain on these strange objects were destined to have a decisive influence on the future of French art.

At about the same time, there lived in Montmartre an adolescent with restless eyes and a face that was reminiscent of those of both Raphael and Forain. Pablo Picasso, who since he was sixteen years old had enjoyed a quasi-celebrity from his paintings which recalled the bitter canvases of Forain, had abruptly rejected his former style and devoted himself to creating mysterious paintings dominated by a deep blue. He lived in that strange wooden house on rue Ravignan [now 13, Place Emile Goudeau, XVIIIᵉ], which at one time or another was inhabited by so many artists who are today either famous or are becoming so. I knew him there in 1905. His fame at that time had not yet spread beyond the butte. He dressed in the blue smock worn by electricians; his words were often very bitter. The novelty of his art was well known throughout Montmartre. His studio, crowded with canvases representing mystical harlequins and with drawings over which we walked and which anyone could carry off, was the meeting place of all the young artists and all the young poets. [You could meet any number of people there: André Salmon, Harry Baur—the future Sherlock Holmes of the Théâtre Antoine—Max Jacob, Guillaume Janneau—future contributor to *Le Temps*—Alfred Jarry, Maurice Raynal, and many others.]

That same year André Derain met Henri Matisse, and from this meeting was born the famous Fauve movement that was composed of a great number of young artists who were later destined to become the Cubists [at this moment very much in the public eye].

I make special note of this meeting because it is valuable to emphasize the role that the artist André Derain who came from Picardy played in the evolution of French art.

The following year he became acquainted with Picasso, and the immediate result of their acquaintance was the birth of Cubism [in the beginning it involved, more than anything else, a somewhat Impressionistic handling of forms which had been anticipated in the late works of Cézanne. From the end of this year on, Cubism had ceased to be an exaggeration of Fauve painting which, in its violent coloring, was a sort of exasperated form of Impressionism. The new ideas of Picasso, Derain, and of another young painter, Georges Braque, resulted in the

true Cubism] which was the art of painting original arrangements composed of elements borrowed from conceived reality rather than from the reality of the vision. Everyone has a sense of this interior reality. One certainly does not have to be a cultivated person to realize that a chair, for example, never ceases to have four legs, a seat, and a back, no matter how we may look at it.

[In 1908 Georges Braque exhibited a Cubist painting at the *Salon des Indépendants*.] The Cubist canvases of Picasso, Braque, Metzinger, Gleizes, Léger, Jean (*sic*) Gris, etc., greatly aroused Henri Matisse, who was particularly struck by the geometrical aspect of the canvases, which revealed the great purity with which the artists represented essential reality. He uttered that ludicrous word "Cubism" which was so quickly to make its way in the world.[1] The young painters accepted it at once[2] because it permitted the artist to represent conceived reality with the appearance of the three dimensions [in short, it permitted him to *cubize*]. In merely representing a reality perceived by the eye they could produce little more than *trompe-l'oeil* effects, which with foreshortening and perspective deformed the basic qualities of the form as conceived by the mind.

[Meanwhile, the new school was enlarged by additional members, and from 1910 on it included Jean Metzinger—who was the first theorist of Cubism—Albert Gleizes, Marie Laurencin, Le Fauconnier, Robert Delaunay and Fernand Léger.]

[It was at this time that André Derain, appalled by the results of his ideas or perhaps in preparation for a new aesthetic revolution, broke away from Cubism and went into retirement.]

Soon new tendencies began to reveal themselves in the midst of Cubism. [Just as Robert Delaunay and Marcel Duchamps had done.] Picabia broke away from conceptionist formulas and gave himself over, at the same time as Marcel Duchamp, to an art which was unhampered by any rules. Delaunay, for his part, in silence invented an art of pure color.

They are thus driving themselves toward an entirely new art which will be to painting, as known up until now, what music is to poetry. [This art has as many rapports with music as is possible between two arts which are opposites.] This will be pure painting. Whatever one may think of this hazardous venture it cannot be denied that we are dealing with dedicated artists worthy of respect.

[A number of talented people such as Juan Gris, Roger de la Fresnaye, Louis Marcoussis, Pierre Dumont and even more, have recently joined the ranks of the Cubists.]

[1] In the original version, as first published, Apollinaire stated that Matisse's fateful word was evoked by the paintings of Picasso, Braque, and several other Cubists, an error that was corrected in later versions when he referred to Braque alone. Actually, according to the story, there were six paintings by Braque, and they were submitted to the jury of the *Salon d'Automne* in 1908. Apollinaire's mention of the *Indépendants* is in connection with the first salon exhibition of a Cubist painting by Braque.

[2] Apollinaire officially accepted the term for the Cubists in the introduction to an exhibition catalogue of *Les Indépendants* in Brussels, June 1911.

## Guillaume Apollinaire, from *The Cubist Painters*, *1913*

Originally published in Guillaume Apollinaire, *Les Peintres Cubistes: Méditations Esthétiques* (Paris: Figuière, 1913). This English translation by Lionel Abel is from *The Cubist Painters: Aesthetic Meditations* (New York: Wittenborn, 1944). Chap. I (written in June 1908) and sections on Marie Laurencin have been omitted.

This book has often been over-rated as a document of Cubism but under-rated for its insights into contemporary painting. It now appears, largely as a result of L.-C. Breunig's excellent study of the genesis of the manuscript (*Guillaume Apollinaire: Les Peintres Cubistes*, with J.-Cl. Chevalier [Paris: Hermann, 1965]), that Apollinaire originally intended the book to be a collection of his writings on art under the title *Méditations Esthétiques* and not specifically a book on Cubism. He had used that title for an article in *La Vie* as late as 8 February 1913, just a month before the book finally was published, wherein he used much of the first part of the book (which in turn had appeared under other titles in *Les Soirées de Paris* during the Spring of 1912, when the book was first planned). Although at first he used the title *Méditations Esthétiques* for the book, he later added beneath it the subtitle *Les Peintres Cubistes*. When in the fall of 1912 he revised the page proofs to include more material on the Cubists either he or the publisher greatly diminished the size of the title and enclosed it within brackets, at the same time making the subtitle so large that it dominated the page. Thus, while the original order of titles still prevailed, *Les Peintres Cubistes*, which was in the inferior position, was obviously the title by which the publisher wished the book to be known (see illus.). This title, however, appears only on the two title pages, while every page in the book bears the heading *Méditations Esthétiques*, thus indicating that the change was a late one, probably so late that only the two title pages could be changed. As late as two years after it was published Apollinaire still referred to the book in a reverse order as *Méditations Esthétiques, Les Peintres Cubistes* (See Breunig, *Chroniques d'Art* [Paris: Gallimard, 1960, p. 468.).

Apollinaire's intentions may be revealed also by a simple statistical survey of the occurence of the word "Cubism" in the text. He did not use "Cubism" even once in the first six chapters of the book where he discussed the aesthetics of the new painting. He did not even use it in the essays on Picasso or Braque, nor on five other of the painters. In the entire manuscript as it appeared in the first page proofs (about September 1912) Cubism is mentioned only four times—in connection with Metzinger, Gleizes, and Gris—and then only to describe their adherence to the school.

Only later (after September 1912) did Apollinaire insert two brief sections in which he discussed Cubism itself and in which he attempted to explain his famous four categories of the movement. These two sections are chap. VII of the first part which is a brief history of Cubism, followed by the four categories, and a brief note at the end of the book, where the four categories were expanded to include many additional artists and also most of the critics as well. In short, it appears evident that only after Apollinaire had completed the book did he seriously consider including a discussion of Cubism in it.

Nevertheless, Apollinaire made some exceedingly perceptive observations on the innovations of what he usually called only the "new painting." These innovations were precisely those Cubist devices created by Picasso and Braque: collage, the use of painted letters, the use of actual extraneous foreign objects in a painting, and the depiction of three-dimensional objects in terms of the two dimensional flat plane. But since he treated these devices in the essay on Picasso without mentioning the word Cubism, it appears that in his mind the word Cubism was more closely associated with the painters of the salon manifestations—the Cubist "school"— than with the two initiators. Hence one might conclude that Apollinaire's interests were attracted chiefly by innovations in painting, for which he had considerable insight, but that he was not an apologist for the Cubist movement.

The book is divided into two parts. The first, under the heading "Sur la peinture,"

# GUILLAUME APOLLINAIRE

## [Méditations Esthétiques]

# Les Peintres Cubistes

### PREMIÈRE SÉRIE

Pablo PICASSO — Georges BRAQUE — Jean METZINGER
Albert GLEIZES — Juan GRIS — Mlle Marie LAURENCIN
Fernand LÉGER — Francis PICABIA — Marcel DUCHAMP
Duchamp-VILLON, etc.

consists of seven chapters (22 pages) almost all of which Apollinaire reprinted or revised from articles written in the Spring of 1912 for *Les Soirées de Paris* (which at that time he edited in collaboration with André Billy, René Dalize, André Salmon and André Tudesq) (see footnotes for exact references).

The second and larger half of the book (53 pages) is under the heading "Peintres nouveaux," and consists of ten sections on ten artists, nearly half of which were reprinted from other sources and the remaining written either for the first draft or as additions to the page proofs. The artists are mentioned in the following order: Picasso, Braque, Metzinger, Gleizes, Marie Laurencin (omitted here), Gris, Léger, Picabia, Duchamp, and, in the Appendix, the sculptor, Raymond Duchamp-Villon. Henri Rousseau was included in the section devoted to Marie Laurencin.

Apollinaire was impartial in illustrating his book, selecting four reproductions of the work of each of the artists discussed (with the exception of Rousseau, whose work was not illustrated), and also adding photographs of Metzinger, Gleizes, Gris, Picabia, and Duchamp.

For a detailed and illuminating study of the genesis of the book see Breunig's two publications (cited above).

## II[1]

Many new painters limit themselves to pictures which have no real subjects. And the titles which we find in the catalogues are like proper names, which designate men without characterizing them.

There are men named Stout who are in fact quite thin, and others named White who are very dark; well now, I have seen pictures entitled *Solitude* containing many human figures.

[1] Part II adapted from "Du sujet dans la peinture moderne," *Les Soirées de Paris*, No. 1 (February 1912) pp. 1–4.

In the cases in question, the artists even condescend at times to use vaguely explanatory words such as "portrait," "landscape," "still life"; however, many young painters use as a title only the very general term "painting."

These painters, while they still look at nature, no longer imitate it, and carefully avoid any representation of natural scenes which they may have observed, and then reconstructed from preliminary studies.

Real resemblance no longer has any importance, since everything is sacrificed by the artist to truth, to the necessities of a higher nature whose existence he assumes, but does not lay bare. The subject has little or no importance any more.

Generally speaking, modern art repudiates most of the techniques of pleasing devised by the great artists of the past.

While the goal of painting is today, as always, the pleasure of the eye, the art-lover is henceforth asked to expect delights other than those which looking at natural objects can easily provide.

Thus we are moving towards an entirely new art which will stand, with respect to painting as envisaged heretofore, as music stands to literature.

It will be pure painting, just as music is pure literature.

The music-lover experiences, in listening to a concert, a joy of a different order from the joy given by natural sounds, such as the murmur of the brook, the uproar of a torrent, the whistling of the wind in a forest, or the harmonies of human speech based on reason rather than on aesthetics.

In the same way the new painters will provide their admirers with artistic sensations by concentrating exclusively on the problem of creating harmony with unequal lights . . . .

The secret aim of the young painters of the extremist schools is to produce pure painting. Theirs is an entirely new plastic art. It is still in its beginnings, and is not yet as abstract as it would like to be. Most of the new painters depend a good deal on mathematics, without knowing it; but they have not yet abandoned nature, which they still question patiently, hoping to learn the right answers to the questions raised by life.

A man like Picasso studies an object as a surgeon dissects a cadaver.

This art of pure painting, if it succeeds in freeing itself from the art of the past, will not necessarily cause the latter to disappear; the development of music has not brought in its train the abandonment of the various genres of literature, nor has the acridity of tobacco replaced the savoriness of food.

## III[1]

The new artists have been violently attacked for their preoccupation with geometry. Yet geometrical figures are the essence of drawing. Geometry, the science of space,

[1] Parts III, IV, and V adapted from "La peinture moderne," *Les Soirées de Paris*, No. 3 April 1912), pp. 89–92, and No. 4 (May 1912), pp. 113–115.

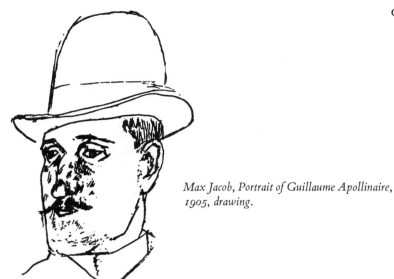

*Max Jacob, Portrait of Guillaume Apollinaire, 1905, drawing.*

its dimensions and relations, has always determined the norms and rules of painting.

Until now, the three dimensions of Euclid's geometry were sufficient to the restiveness felt by great artists yearning for the infinite.

The new painters do not propose, any more than did their predecessors, to be geometers. But it may be said that geometry is to the plastic arts what grammar is to the art of the writer. Today, scientists no longer limit themselves to the three dimensions of Euclid. The painters have been led quite naturally, one might say by intuition, to preoccupy themselves with the new possibilities of spatial measurement which, in the language of the modern studios, are designated by the term: *the fourth dimension.*[1]

[1] One of the frequent visitors to the *Bateau Lavoir* and to the meetings of the Puteaux group was Maurice Princet, a mathematician and an actuary for an insurance company. He was a cultivated amateur in painting, but he also contributed to the conversations by his speculations on the possible relations of Non-Euclidian geometry, and even of the Fourth Dimension, with the new concept of space in Cubist painting. At one time Metzinger and Gris undertook a study of geometry under the direction of Princet in order to explore these possibilities.

Some critics have speculated that the Cubist representation of objects were influenced by these new conceptions in geometry, and some of the artists' statements might support such a belief. But Metzinger made it quite clear that their interest in geometry was in no way a source of their innovations in painting. In 1910 he wrote that Picasso "defines a free, mobile perspective, from which that ingenious mathematician Maurice Princet has deduced a whole geometry." (*Pan* [Paris] October–November 1910, p. 650.) This attitude was verified in conversations with me in May, 1952, when Metzinger declared that their "ideas in painting necessitated more than the three dimensions, since these show only the visible aspects of a body at a given moment. Cubist painting . . . needed a dimension greater than the Third to express a synthesis of views and feelings toward the object. This is possible only in a 'poetic' dimension in which all the traditional dimensions are superseded."

223

Regarded from the plastic point of view, the fourth dimension appears to spring from the three known dimensions: it represents the immensity of space eternalizing itself in all directions at any given moment. It is space itself, the dimension of the infinite; the fourth dimension endows objects with plasticity. It gives the object its right proportions on the whole, whereas in Greek art, for instance, a somewhat mechanical rhythm constantly destroys the proportions.

Greek art had a purely human conception of beauty. It took man as the measure of perfection. But the art of the new painters takes the infinite universe as its ideal, and it is to this ideal that we owe a new norm of the perfect, one which permits the painter to proportion objects in accordance with the degree of plasticity he desires them to have.

Nietzsche divined the possibility of such an art:

"O divine Dionysius, why pull my ears?" Ariadne asks her philosophical lover in one of the celebrated dialogues on the *Isle of Naxos*. "I find something pleasant and delightful in your ears, Ariadne; why are they not even longer?"

Nietzsche, in relating this anecdote, puts in the mouth of Dionysius an implied condemnation of all Greek art.

Finally, I must point out that *the fourth dimension*—this utopian expression should be analyzed and explained, so that nothing more than historical interest may be attached to it—has come to stand for the aspirations and premonitions of the many young artists who contemplate Egyptian, Negro, and Oceanic sculptures, meditate on various scientific works, and live in the anticipation of a sublime art.[1]

## IV

Wishing to attain the proportions of the ideal, to be no longer limited to the human, the young painters offer us works which are more cerebral than sensual. They discard more and more the old art of optical illusion and local proportion, in order to express the grandeur of metaphysical forms. This is why contemporary art, even if it does not directly stem from specific religious beliefs, nonetheless possesses some of the characteristics of great, that is to say religious art.

## V

It is the social function of great poets and artists to continually renew the appearance nature has for the eyes of men.

Without poets, without artists, men would soon weary of nature's monotony. The sublime idea men have of the universe would collapse with dizzying speed. The order which we find in nature, and which is only an effect of art, would at once vanish. Everything would break up in chaos. There would be

---

[1] In this paragraph which Apollinaire wrote for the book and inserted in the earlier manuscript, he modified his view of the role of the Fourth Dimension as stated in the original article of April 1912 and in *La Vie* (Paris) No. 6, 8 February 1913.

no seasons, no civilization, no thought, no humanity; even life would give way, and the impotent void would reign everywhere.

Poets and artists plot the characteristics of their epoch, and the future docilely falls in with their desires.

The general form of an Egyptian mummy is in conformity with the figures drawn by Egyptian artists, and yet the ancient Egyptians were far from being all alike. They simply conformed to the art of their time.

To create the illusion of the typical is the social role and peculiar end of art. God knows how the pictures of Monet and Renoir were abused! Very well! But one has only to glance at some photographs of the period to see how closely people and things conformed to the pictures of them by these great painters.

Since of all the plastic products of an epoch, works of art have the most energy, this illusion seems to me quite natural. The energy of art imposes itself on men, and becomes for them the plastic standard of the period. Thus, those who mock the new painters are actually laughing at their own features, for people in the future will portray the men of today to be as they are represented in the most alive, which is to say, the newest, art of our time. And do not tell me there are today various other schools of painting in whose images humanity will be able to recognize itself. All the art works of an epoch end by resembling the more energetic, the most expressive, and the most typical works of the period. Dolls belong to popular art; yet they always seem to be inspired by the great art of the same epoch. This is a truth which can easily be verified. Yet who would dare to say that the dolls which were sold at bargain counters, around 1880, were shaped by a sentiment akin to what Renoir felt when he painted his portraits? No one perceived the relationship then. But this only means that Renoir's art was sufficiently energetic to take hold of our senses, even though to the general public of the epoch in which he made his debut, his conceptions seemed absurd and foolish.

## VI[1]

There has been a certain amount of suspicion, notably in the case of the most recent painters, of some collective hoax or error.

But in all the history of art there is not a single instance of such general collaboration in artistic fraud or error. There are, indeed, isolated cases of mystification and blundering. But the conventional elements of which works of art are to a great extent composed guarantee the impossibility of such instances becoming general.

If the new school of painting were indeed an exception to this rule, it would be so extraordinary as to verge on the miraculous. As readily imagine all the children of some country born without heads, legs, or arms, an obvious absurdity. There are no collective errors or hoaxes in art; there are only various epochs and dissimilar schools. Even if the aims pursued by these schools are not all

[1] Adapted and rewritten after material in *Les Soirées de Paris* (May 1912), pp. 113–115.

equally elevated or equally pure, all are equally respectable, and, according to the ideas one has of beauty, each artistic school is successively admired, despised, and admired once more.

## VII[1]

The new school of painting is known as Cubism,[2] a name first applied to it in the fall of 1908 in a spirit of derision by Henri Matisse, who had just seen a picture of some houses, whose cube-like appearance had greatly struck him.

The new aesthetics was first elaborated in the mind of André Derain, but the most important and audacious works the movement at once produced were those of a great artist, Pablo Picasso, who must also be considered one of the founders: his inventions, corroborated by the good sense of Georges Braque, who exhibited a Cubist picture at the *Salon des Indépendants* as early as 1908, were envisaged in the studies of Jean Metzinger, who exhibited the first Cubist portrait (a portrait of myself) at the *Salon des Indépendants* in 1910, and who in the same year managed to induce the jury of the *Salon d'Automne* to admit some cubist paintings. It was also in 1910 that pictures by Robert Delaunay, Marie Laurencin, and Le Fauconnier, who all belonged to the same school, were exhibited at the *Indépendants*.

The first group exhibition of the Cubists, who were becoming more numerous, took place in 1911 at the *Indépendants*; room 41, which was devoted to their works, made a deep impression. There were the knowing and seductive works of Jean Metzinger; some landscapes, *Male Nude* and *Woman with Phlox* by Albert Gleizes; *Portrait of Mme. Fernande X* and *Young Girls* by Marie Laurencin; *The Tower* by Robert Delaunay; *Abundance* by Le Fauconnier; and *Landscape with Nudes* by Fernand Léger.

That same year the Cubists made their first appearance outside of France, in Brussels; and, in the preface to the catalogue of this exhibition, I accepted on behalf of the exhibitors the appellations: *Cubism* and *Cubist*.

Towards the end of 1911 the exhibition of the Cubists at the *Salon d'Automne* made a considerable stir, and Gleizes (*The Hunt*, *Portrait of Jacques Nayral*), Metzinger (*Woman with Spoon*), and Fernand Léger were ridiculed without mercy. A new painter, Marcel Duchamp, had joined the group, as had the sculptor-architect, Duchamp-Villon.

Other group exhibitions were held in November, 1911 (at the *Galerie d'Art Contemporain*, rue Tronchet, Paris), and in 1912 (at the *Salon des Indépendants*; this show was marked by the debut of Juan Gris); in May of the same year another

---

[1] The brief history of Cubism with which this chapter begins was, according to Apolliniare's note, added to the page proofs in September 1912. It is based upon an article which, according to Breunig, was published on 10 October 1912 in *l'Intermédiaire des chercheurs et des curieux* (Paris).

[2] Apollinaire discussed the "new painting" at length (but did not mention any names) in the first part of the book, but this is the first mention of the word Cubism.

Cubist exhibition was held in Spain (Barcelona welcomed the young Frenchman with enthusiasm); finally in June, at Rouen an exhibition was organized by the *Société des Artistes Normands* (important for presenting Francis Picabia, who had just joined the new school). (*Note written in September*, 1912.—G.A.)

Cubism differs from the old schools of painting in that it aims, not at an art of imitation, but at an art of conception, which tends to rise to the height of creation.

In representing conceptualized reality or creative reality, the painter can give the effect of three dimensions. He can to a certain extent *cube*. But not by simply rendering reality as seen, unless he indulges in *trompe-l'oeil*, in foreshortening, or in perspective, thus distorting the quality of the forms conceived or created.

I can discriminate four trends in Cubism.[1] Of these, two are pure, and along parallel lines.

*Scientific Cubism* is one of the pure tendencies. It is the art of painting new structures out of elements borrowed not from the reality of sight, but from the reality of insight. All men have a sense of this interior reality. A man does not have to be cultivated in order to conceive, for example, of a round form.

The geometrical aspect, which made such an impression on those who saw the first canvases of the scientific Cubists, came from the fact that the essential

---

[1] Apollinaire's well-known but mystifying four categories of Cubism were vigorously condemned from the time they appeared in print. But they have also created a great deal of confusion in the minds of those who have taken them literally. It appears from later remarks of Apollinaire (see Breunig) that he did not mean them to be definitive, but, as in the case of his ambiguous references to the Fourth Dimension, was only attempting to evoke the spirit of the new directions in painting.

It should be noted that his classifications were first presented in a lecture entitled "The Quartering of Cubism" (*écartèlement*: literally, drawing and quartering) on 11 October 1912 at the first exhibition of the *Section d'Or*. This exhibition was organized by precisely those artists who were reacting against the Cubism of Picasso and Braque, and who were attempting to define new directions that in general were more intellectually motivated. They talked of geometry (as indicated by the name they chose for the group), of "pure" painting, and of color as the essential constituent of form. The scandal created by Cubism in the four salons it had dominated since the spring of 1911 had waned, and a few months later Apollinaire could write (but hastily retract) that "*Cubisme est mort, vive le Cubisme.*"

The *Section d'Or* exhibition cannot accurately be called a Cubist manifestation, but rather it represented the multiplicity of directions opened up by the innovations of the Cubism of 1909–1911 as seen in the works of such different artists as Duchamp, Villon, Picabia, and Fresnaye. The orthodox Cubists such as Metzinger, Gleizes, Leger, and Gris were, of course, also represented, but the character of the exhibition was established by a new ideology.

In his efforts to describe the diffusion of Cubism, however, Apollinaire forced almost every contemporary artist into one of his categories, even Matisse, Rouault, Boccioni, and Marie Laurencin. In a final note to the book he even aligned most of the critics according to his four categories. This entire new section, therefore, has more the spirit of an enthusiastic informal talk given before a strongly partisan audience than a careful attempt to discriminate between styles.

reality was rendered with great purity, while visual accidents and anecdotes had been eliminated. The painters who follow this tendency are: Picasso, whose luminous art also belongs to the other pure tendency of Cubism, Georges Braque, Albert Gleizes, Marie Laurencin, and Juan Gris.

*Physical Cubism* is the art of painting new structures with elements borrowed, for the most part, from visual reality. This art, however, belongs in the Cubist movement because of its constructive discipline. It has a great future as historical painting. Its social role is very clear, but it is not a pure art. It confuses what is properly the subject with images. The painter-physicist who created this trend is Le Fauconnier.

*Orphic Cubism* is the other important trend of the new art school. It is the art of painting new structures out of elements which have not been borrowed from the visual sphere, but have been created entirely by the artist himself, and been endowed by him with fullness of reality. The works of the Orphic artist must simultaneously give a pure aesthetic pleasure, a structure which is self-evident, and a sublime meaning, that is, the subject. This is pure art. The light in Picasso's paintings is based on this conception, to which Robert Delaunay's inventions have contributed much, and towards which Fernand Léger, Francis Picabia, and Marcel Duchamp are also addressing themselves.

*Instinctive Cubism*, the art of painting new structures of elements which are not borrowed from visual reality, but are suggested to the artist by instinct and intuition, has long tended towards Orphism. The instinctive artist lacks lucidity and an aesthetic doctrine; instinctive Cubism includes a large number of artists. Born of French Impressionism, this movement has now spread all over Europe.

Cezanne's last paintings and his water-colors belong to Cubism, but Courbet is the father of the new painters; and André Derain, whom I propose to discuss some other time, was the eldest of his beloved sons, for we find him at the beginning of the Fauvist movement, which was a kind of introduction to Cubism, and also at the beginnings of this great subjective movement; but it would be too difficult today to write discerningly of a man who so wilfully stands apart from everyone and everything.

The modern school of painting seems to me the most audacious that has ever appeared. It has posed the question of what is beautiful in itself.

It wants to visualize beauty disengaged from whatever charm man has for man, and until now, no European artist has dared attempt this. The new artists demand an ideal beauty, which will be, not merely the proud expression of the species, but the expression of the universe, to the degree that it has been humanized by light.

The new art clothes its creations with a grandiose and monumental appearance which surpasses anything else conceived by the artists of our time. Ardent in its search for beauty, it is noble and energetic, and the reality it brings us is marvelously clear. I love the art of today because above all else I love the light, for man loves light more than anything; it was he who invented fire.

# NEW PAINTERS

## Picasso[1]

If we were alert, all the gods would awaken. Born of the profound self-knowledge which humanity has kept of itself, the adored pantheisms resembling it have drowsed. But despite the eternal sleep, there are eyes reflecting humanities akin to these divine and joyous phantoms.

Such eyes are as attentive as the flowers whose desire it is always to behold the sun. O inventive joy, there are men who see with these eyes!

Picasso had been observing the human images which float in the azure of our memories, and partake of divinity, in order to damn the metaphysicians. How pious are his skies, alive with flights, and his heavy sombre lights, like those of grottoes!

There are children who have strayed off without having learned the catechism. They stop, and the rain stops falling. "Look, in those buildings there are people whose clothes are shabby." These children, whom one does not caress, know so much. "Mama, love me to death!" They can take things in their stride, and their successful dodges are mental evolutions.

The women one no longer loves come back to mind. By this time they have repeated their brittle ideas too often. They do not pray; they worship memories. Like an old church, they crouch in the twilight. These women renounce everything, and their fingers are itching to plait crowns of straw. At daybreak they disappear; they console themselves in silence. They cross many a threshold; mothers guard the cradles, so that the newborn may not inherit some taint; when they bend over the cradles, the little babes smile, sensing their goodness.

They often give thanks, and their forearms tremble like their eyelids.

Enveloped in frozen mist, old men wait unthinkingly, for it is only children who meditate. Inspired by far countries, animal struggles, locks of hardened hair, these old men beg without humility.

Other beggars have been used up by life. These are the infirm, the cripples, the bums. They are amazed to have come to the goal, which is still blue, but no longer the horizon. Old, they have become as foolish as kings who have too many troops of elephants bearing citadels. They are travelers who confound the flowers with the stars.

Grown old like oxen at twenty-five, the young have conducted nurslings to the moon.

On a clear day, certain women hold their peace; their bodies are angelic, and their glances tremble.

In the face of danger they smile an inner smile. They have to be frightened into confessing their little sins.

[1] The first part of this section is the following from "Les jeunes: Picasso peintre," *La Plume* (Paris), 14 May 1905, and was written shortly after the poet had met Picasso. Except for slight abridgment of the last three short paragraphs, it was reprinted as first written.

For a year, Picasso lived this type of damp painting, blue as the humid depth of an abyss, and full of pity.

Pity made Picasso harsher. The public squares held up one who had been hanged; he was stretched against the houses above the oblique passerby. The condemned awaited a savior. Miraculously the gallows hung athwart the roofs; the window panes flamed with flowers.

In rooms penniless painters drew fleecy nudes by lamplight. Women's shoes left by the bed were expressive of tender haste.

Calm followed this frenzy.

The harlequins go in splendid rags while the painting is gathering, warming or whitening its colors to express the strength and duration of the passions, while the lines delimited by the tights are bending, breaking off, or darting out.

In a square room, paternity transfigures the harlequin, whose wife bathes with cold water and admires her figure, as frail and slim as her husband, the puppet. Charming lilts mingle, and somewhere passing soldiers curse the day.

Love is good when one dresses it up, and the habit of spending one's time at home redoubles paternal feeling. The child brings the woman Picasso wanted glorious and immaculate closer to the father.

Primiparous mothers no longer expect the baby to arrive, because of certain ill-omened, raven-like chatterers. Christmas! They bring forth acrobats in the midst of pet monkeys, white horses, and dogs like bears.

The adolescent sisters, treading in perfect balance the heavy balls of the saltimbanques, impose on these spheres the radiant motion of worlds. These still adolescent youngsters have the anxieties of innocence; animals instruct them in the religious mystery. Some harlequins match the splendor of the women, whom they resemble, being neither male nor female.

The color has the flatness of frescoes; the lines are firm. But, placed at the frontiers of life, the animals are human, and the sexes are indistinct.

Hybrid beasts have the consciousness of Egyptian demigods; taciturn harlequins have their cheeks and foreheads paled by morbid sensuality.

These saltimbanques should not be confounded with actors. They should be observed with piety, for they celebrate mute rites with difficult dexterity. It is this which distinguishes Picasso from the Greek pottery painters whose designs he sometimes approaches. There, on the painted earthenware, bearded, garrulous priests offered in sacrifice animals, resigned and powerless. Here, virility is beardless, and shows itself in the sinews of thin arms; the flat part of the face and the animals are mysterious.

Picasso's taste for a running, changing, penetrating line has produced some probably unique examples of linear dry-point, in which he has not altered the general traits of things.

This Malagueño bruised us like a brief frost. His meditations bared themselves silently. He came from far away, from the rich composition and the brutal decoration of the seventeenth-century Spaniards.

And those who had known him before could recall swift insolences, which were already beyond the experimental stage.

His insistence on the pursuit of beauty has since changed everything in art.

Then he sharply questioned the universe.[1] He accustomed himself to the immense light of depths. And sometimes he did not scorn to make use of actual objects, a two-penny song, a real postage stamp, a piece of oil-cloth furrowed by the fluting of a chair. The painter would not try to add a single picturesque element to the truth of these objects.

Surprise laughs savagely in the purity of light, and it is perfectly legitimate to use numbers and printed letters as pictorial elements; new in art, they are already soaked with humanity.

It is impossible to envisage all the consequences and possibilities of an art so profound and so meticulous.

The object, real or illusory, is doubtless called upon to play a more and more important role. The object is the inner frame of the picture, and marks the limits of its profundity, just as the actual frame marks its external limits.

Representing planes to denote volumes, Picasso gives an enumeration so complete and so decisive of the various elements which make up the object, that these do not take the shape of the object, thanks to the effort of the spectator, who is forced to see all the elements simultaneously just because of the way they have been arranged.

Is this art profound rather than noble? It does not dispense with the observation of nature, and acts upon us as intimately as nature herself.

There is the poet to whom the muse dictates his chants, there is the artist whose hand is guided by an unknown being using him as an instrument. Such artists never feel fatigue, for they never labor, and can produce abundantly day in and day out, no matter what country they are in, no matter what the season: they are not men, but poetic or artistic machines. Their reason cannot impede them, they never struggle, and their works show no signs of strain. They are not divine and can do without their selves. They are like prolongations of nature, and their works do not pass through the intellect. They can move one without humanizing the harmonies they call forth. On the other hand, there are the poets and artists who exert themselves constantly, who turn to nature, but have no direct contact with her; they must draw everything from within themselves, for no demon, no muse inspires them. They live in solitude, and express nothing but what they have babbled and stammered time and again, making effort after effort, attempt after attempt just to formulate what they wish to express. Men created in the image of

---

[1] The remainder of the section on Picasso appeared in *Montjoie! I*, 3, 14 March, 1913, three days before the book was published.

God, a time comes when they are able to rest to admire their work. But what fatigue, what imperfections, what crudenesses!

Picasso was the first type of artist. Never has there been so fantastic a spectacle as the metamorphosis he underwent in becoming an artist of the second type.

The resolve to die came to Picasso as he watched the crooked eyebrows of his best friend anxiously riding his eyes. Another of his friends brought him one day to the border of a mystical country whose inhabitants were at once so simple and so grotesque that one could easily remake them.

And then after all, since anatomy, for instance, no longer existed in art, he had to reinvent it, and carry out his own assassination with the practiced and methodical hand of a great surgeon.

The great revolution of the arts, which he achieved almost unaided, was to make the world his new representation of it.

Enormous conflagration.

A new man, the world is his new representation. He enumerates the elements, the details, with a brutality which is also able to be gracious. Newborn, he orders the universe in accordance with his personal requirements, and so as to facilitate his relations with his fellows. The enumeration has epic grandeur, and, when ordered, will burst into drama. One may disagree about a system, an idea, a date, a resemblance, but I do not see how anyone could fail to accept the simple act of enumerating.

From the plastic point of view, it might be argued that we can do without so much truth, but, having once appeared, this truth became necessary. And then there are countries. A grotto in a forest where one cuts capers, a ride on a mule to the edge of a precipice, and the arrival in a village where everything smells of warm oil and spoiled wine. Or again, a walk to a cemetry, the purchase of a faience crown (the crown of immortals), the mention of the Mille Regrets, which is inimitable. I have also heard of clay candelabra, which were so applied to a canvas that they seemed to protrude from it. Pendants of crystal, and that famous return from Le Havre.

As for me, I am not afraid of art, and I have not one prejudice with regard to the painter's materials.

Mosaicists paint with marble or colored wood. There is mention of an Italian artist who painted with excrement; during the French revolution blood served somebody as paint. You may paint with whatever material you please, with pipes, postage stamps, postcards or playing cards, candelabra, pieces of oil cloth, collars, painted paper, newspapers.[1]

[1] The words "painted paper, newspapers" were added in long-hand by Apollinaire to the printed proofs of the book. Breunig and Chevalier have observed in their annotated edition of the book (p. 112) that this proves that Apollinaire had just learned about collage and hastened to include mention of it in his book.

comme une mandoline

car la RAI SON C'est ton Art Pomme

ô batailles la terre tremble B ... le comme une mandoline

COM
ME
LA
BAL
LE
A
TRA
VERS
LE

CORPS LE

té
rê
vé
la TRAVERSE SON LE

O res de la pipe les odeurs-centre
univers infiniment défiées qui

fourneaux forgent les chaînes
lient les antiraisons formelles

Que cet œillet te dise
la loi        des odeurs
qu'on n'a pas encore
promulguée et qui viendra
un        jour
régner        sur
nos        cerveaux
bien        +
précise & + subtile
que
les
sons
qui nous dirigent
Je préfère ton nez
à
tous
tes
organes ô mon amie
Il est le trône de
la
future
SA
GES
SE

*Guillaume Apollinaire, The Mandolin, The*
*Violet and the Bamboo, ca. 1913, calligram.*

233

For me it is enough to see the work; this has to be seen, for it is in terms of the quantity of an artist's production that one estimates the worth of a single work.

Delicate contrasts, parallel lines, a workman's craft, sometimes the object itself, sometimes an indication of it, sometimes an individualized enumeration, less sweetness than plainness. In modern art one does not choose, just as one accepts the fashion without discussion.

Painting . . . an astonishing art whose light is illimitable.

## GEORGES BRAQUE

Peaceful appearances in plastic generalization are joined once more in a temperate zone by the art of Georges Braque.

Georges Braque is the first of the new painters to have come in contact with the public after his aesthetic metamorphosis.

This important event took place in 1908, at the *Salon des Indépendants*.

Today the historic role of the *Salon des Indépendants* is becoming clear.

The art of the nineteenth century—in which the integrity of the French genius again was manifested—was simply one long revolt against the academic, to which the rebels opposed authentic traditions, long ignored by the masters of the degenerate painting which bastions the citadel of the rue Bonaparte.

Since its founding, the *Salon des Indépendants* has had a leading role in the evolution of modern art, and has successively revealed to us the trends and personalities which, for the last twenty-five years have made French painting today the only school which counts; it alone ransacks the universe for the logic of the great traditions, and it is always full of life.

It must be added that the *Salon des Indépendants* has shown no larger proportion of freakish works than have the official salons, for all their respectability.

Besides, the artistic culture of the present day is no longer based on a social discipline. And it is not the least merit of the work Braque showed in 1908, that it was in accord with the society in which the painter was evolving.

This feature, which had not appeared since the good period of Dutch painting, is the social element in the revolution of which Georges Braque was the spokesman.

It would have appeared two or three years earlier if Picasso had exhibited, but silence was necessary for him, and who knows—the abuse heaped on Georges Braque might have caused Picasso to turn aside from the difficult path he was the first to choose.

But in 1909, the revolution which had renewed the plastic arts was an accomplished fact. The pleasantries of the public and of the critics could not turn the tide.

Perhaps even more astonishing than the innovations introduced by Georges Braque's pictures, was the fact that one of the young painters had, without surrendering to the affectations of illustrators, restored to honor the order and craftsmanship without which there is no art.

Here, then, is Georges Braque.[1] His role was heroic. His art calm and splendid. He is a serious craftsman. He expresses a beauty full of tenderness, and the pearly lusters of his pictures play on our senses like a rainbow. This painter is angelic.

He has taught the aesthetic use of forms so hidden that only certain poets had intimations of them. These luminous signs flare around us, but only a handful of painters have grasped their plastic significance. The work, particularly in its plainest realizations, contains a multiplicity of aesthetic elements which, no matter how new, are always in accord with the sentiment of the sublime, that which enables man to put order in chaos: what looks new must not be scorned, nor what is dirty, nor what we use, not even the imitation wood or marble of house painters. These appearances seem trivial, but when action requires, a man must begin with them.

I detest artists who are not of their time, and, just as the language of the people was for Malherbe the proper language of his period, the means of the artisan, of the house painter, should be the most vigorous material expression of painting to the artist.

Georges Braque should be called "the verifier." He has verified all the innovations of modern art, and will verify still others.

## JEAN METZINGER

Not one of the other young contemporary painters has known as much injustice or displayed as great resolution as the exquisite artist Jean Metzinger, one of the purest artists of our time. He has never failed to learn from events. During his painful journey in search of a method, Jean Metzinger stopped for a while in every one of the well-policed towns through which he passed.

We first encountered him in the elegant and modern city of Neoimpressionism, whose founder and architect was Georges Seurat.

The true value of that great painter is still not understood.

In drawing, in composition, in the judiciousness of their contrasted lights, his works have a style which sets them apart from, and perhaps even above most of the works of his contemporaries.

[1] This paragraph includes a few scattered phrases from Apollinaire's essay on Braque that appeared in the catalogue for the exhibition at Kahnweiler's gallery (9–28 November 1908). Generally he adapted lengthy excerpts or entire texts for the book. The catalogue essay was the first substantial article on Braque's Cubist paintings.

No painter reminds me of Molière as does Seurat, of the Molière of the *Bourgeois Gentilhomme*, which is a ballet full of grace, lyricism, and common sense. And canvases like *The Circus* and *Le Chahut* are also ballets full of grace, lyricism, and good sense.

The Neoimpressionist painters are those who, to quote Paul Signac, "have since 1886 initiated the technique known as *divisionism*, employing as a means of expression the optical mixture of tints and tones."[1] This technique may be compared to the art of the Byzantine mosaicists; and I recollect that one day, in a letter to Charles Morice, Signac also referred to the library at Siena.

This luminous technique, which imposed order on the discoveries of the Impressionists, was first divined, and even applied by Delacroix, to whom it had been revealed while studying the pictures of Constable.

Seurat himself exhibited in 1896 the first divisionist painting—*A Sunday Afternoon on the Island of La Grande-Jatte*. It was he who carried furthest the contrast of complementary colors in the construction of pictures. His influence is felt today even at the Ecole des Beaux-Arts, and will be a seminal force in painting for some time to come.

Jean Metzinger played a role among the sophisticated and industrious Divisionists. But the fact is that the colored minutiae of the Neoimpressionists were used merely to indicate what elements formed the style of a period which, in nearly all its expressions, both industrial and artistic, seemed to the men of that period to be quite devoid of style. Seurat has drawn, with a precision that amounts to genius, certain pictures of the life of the period; in these works the firmness of style is rivaled by the almost scientific clarity of conception. (*Le Chahut* and *The Circus* almost belong to *Scientific Cubism*). He reorganized the whole art of his time, in order to be able to freeze the characteristic postures of that *fin de siècle*, that windup of the nineteenth century, in which everything was angular, enervated, childishly insolent, sentimentally comical [*Art Nouveau*].

So beautiful an intellectual vision could hardly prolong itself, and once the picturesque style implied by nineteenth-century art had been indicated, Neoimpressionism ceased to play an interesting role. It brought no innovation, besides the contrast of complementary colors; it did, however, make clear the aesthetic value of what preceding schools had discovered since the end of the eighteenth century. Too many new possibilities began to stimulate the young painters. They could not freeze themselves in a technique which, being the last and strictest expression of an artistic period, had given its full measure with the first stroke.

The technique became a tedious rule. The loud and colorful cries of the Fauves were going off in the distance. Jean Metzinger was drawn to them; and began to understand the symbolic significance of their colors and forms, for when

---

[1] The opening statement of Signac's *D'Eugène Delacroix au Néoimpressionisme*. These several paragraphs on Neoimpressionism are based upon Apollinaire's review of Signac's book in *L'Intransigéant*, 7 August, 1911, reprinted in Breunig, *Chroniques d'Art*, pp. 192–193.

that barbarous, but not savage city, given over to luxury and violent orgies, was deserted by the Barbarians, when the Fauves had ceased to roar, nobody remained except peaceful bureaucrats who, feature for feature, resembled the officials of the rue Bonaparte, in Paris. And the kingdom of the Fauves, whose civilization had seemed so powerful, so new, so astounding, suddenly took the aspect of a deserted village.

It was then that Jean Metzinger, joining Picasso and Braque, founded the Cubist city. There discipline is rigorous, but is in no danger of becoming a system; more freedom is enjoyed there than anywhere else.

From his experience with the Neoimpressionists, Jean Metzinger acquired a taste for minutiae, a taste by no means mediocre.

There is nothing unrealized in his work, nothing which is not the fruit of a rigorous logic, and if he ever fell into error (which I do not know or care to know), I am sure it was not by chance. His work will have the most authoritative documentary value for whoever will be interested in explaining our epoch. Thanks to Metzinger, we can distinguish between what has and what lacks aesthetic value in our art. A painting of Metzinger always contains its own explanation. This is perhaps a noble weakness, but it is certainly the result of great highmindedness, and is something unique, it seems to me, in the history of art.

The instant you catch sight of a painting by Metzinger, you feel the firm intent of the artist to be serious only about what is serious; and you feel that the occasion, in accordance with a method which I find excellent, furnishes him with the plastic elements of his art. But while he rejects nothing, he does not use anything haphazardly. His work is sound, more so, doubtless, than the work of most of his contemporaries. He will delight those who want to know the reasons for things; his reasons are such as to satisfy the mind.

The works of Jean Metzinger have purity. His meditations take beautiful forms whose harmony tends to approach sublimity. The new structures he is composing are stripped of everything that was known before him.

His art, always more and more abstract, but always charming, raises and attempts to solve the most difficult and unforeseen problems of aesthetics.

Each of his paintings contains a judgment of the universe, and his whole work is like the sky at night, when, cleared of clouds, it trembles with lovely lights.

There is nothing unrealized in his works; poetry enobles their slightest details.

## ALBERT GLEIZES

The powerful harmonies of Albert Gleizes should not be confused with the theoretical Cubism of the scientific painters. I remember his first experiments. In these his desire to simplify the elements of his art could already be felt. At his debut, Albert Gleizes was confronted by movements which had succeeded; the last of the

Impressionists, the Symbolists, some of whom had become Intimists, the Neo-impressionists, Divisionists, Fauves; his situation was not unlike that of the Douanier Rousseau, confronting the intellectualism and academicism of the official salons.

Then Gleizes came to understand the works of Cézanne, who had influenced the first Cubists.

He developed the harmonies which must be rated with the most serious and significant plastic art of the last ten years.

His portraits are ample proof that with him, as with most of the new painters, the individualization of the object is not left to the spectator.

The pictures of Albert Gleizes, and those of many of the young artists, are often regarded as bashful generalizations.

And yet, in most of the new pictures the individual characters are delineated with decisiveness, and even, at times, an abundance of details; it is hard to see how this could escape anyone who watched the new painters working, or even looked at their canvases with some degree of attentiveness.

Weak generalization is rather the characteristic of intellectual painters of decadent periods. What individual characters appear in the paintings of a Henry de Groux, who generalizes the decadent sentiments of the imitators of Baudelaire, or in the pictures of a Zuloaga, who generalizes the conventional Spain of the last romantics? True generalization permits a more profound type of individualization, determined by light, as in the pictures of the Impressionists—as with Claude Monet, Seurat, and even Picasso himself, artists who generalize sincerely, and refuse to specify the superficial traits of things. There is not a tree, a house, or a person whose individual characteristics the Impressionists have kept.

It was an important painter who remarked, as he set to work on a portrait, that it would not be a good likeness.

But there is a type of generalization at once vaster and more precise. Thus the portrait plays a most important role with the new painters. They can always guarantee the likeness, and I have never seen one of their portraits which did not resemble the person painted.

What regard for reality, for individual traits, could painters like Bouguereau or Henner have had?

With many of the new painters each plastic conception is individualized further by generalization, and this with a patience that is really extraordinary.

Because they are unconcerned with chronology, history, or geography, because they bring together elements heretofore kept separated, because a Gleizes attempts to dramatize objects, while concentrating on the artistic motions they elicit from him, it may be said that the goal of these new painters is a sublime precision.

All the figures in the pictures of Albert Gleizes are not the same figure, all trees are not the tree, all rivers, river; but the spectator, if he aspires to generality,

can readily generalize figure, tree, or river, because the work of the painter has raised these objects to a superior degree of plasticity in which all the elements making up individual characters are represented with the same dramatic majesty.

Majesty, this above all characterizes the art of Albert Gleizes. Thus he brings to contemporary art a startling innovation. Something which, before him, was found in but few of the modern painters.

This majesty arouses and provokes the imagination; considered from the plastic point of view, it is the immensity of things.

This is a powerful art. The pictures of Albert Gleizes were realized with a force comparable to that we feel in the pyramids, cathedrals, metal constructions, bridges, tunnels.

These works sometimes reveal awkwardness like those found in the great works humanity rates highest, because he who made them really aimed at the best possible work. The purest aim an artist can have in his work is to do his best; he is base indeed who is content to succeed without effort, without work, without giving all he has.

## HENRI ROUSSEAU[1]

The young artists have already made clear in what honor they hold the works of this poor angel that was Henri Rousseau the Douanier, who died towards the end of the summer of 1910. He might also be called the Inhabitant of Delight,[2] considering both the neighborhood he lived in, and the qualities which made his painting so charming to look at.

Few artists have been mocked during their lives as was the Douanier, and few men have faced with equal calm the hail of dirty digs and insults. This courteous old man always preserved his calm and good humor, and happily was able to find, in insults and mockeries, evidence that even the ill-intentioned could not disregard his work. This serenity, of course, was only pride. The Douanier was conscious of his power. He permitted himself to remark, once or twice, that he was the ablest painter of his time. And on more than one count this estimate is not so incorrect. He did indeed suffer from not having been educated in art when

[1] This essay appeared in the first of Apollinaire's several reviews of the *Salon des Indépendants* (*L'Intransigéant*, 20 April 1911). Rousseau had died on 4 September 1910, and a memorial exhibition of his paintings had been arranged in the Salon. They were assigned a significant location, room 42, located between the historic room 41, where the Cubists appeared together for the first time, and room 43, occupied by other young artists of advanced styles.

This essay was reprinted in a slightly different form in the memorial issue of *Les Soirées de Paris*, No. 20 (15 January 1914).

It was not given a separate heading in *Les Peintres Cubistes* but was placed under Marie Laurencin (not included here), with passages on Laurencin both before and after it. Although every other artist discussed in the book had his work illustrated, no paintings by Rousseau appeared.

[2] Rousseau lived in the Plaisance quarter south of the Gare Montparnasse.

a youth (you feel this), but later, when he wanted to paint, he studied the masters passionately, and he is almost the only modern to have divined their innermost secrets.

His sole defects derive from an occasional excess of sentiment, for he could not always rise above his broad good humor, and this was in sharp contrast to his artistic venturesomeness, and the attitude he took in contemporary art.

But what positive qualities he had! It is most significant that the young artists were sensitive to just these qualities. He is to be congratulated above all in that he aimed at realizing, and not merely paying homage to, these qualities.

The Douanier went to the very end in his work, something very rare today. His paintings were made without method, system, or mannerisms. From this comes the variety of his work. He did not distrust his imagination any more than he did his hand. From this came the grace and richness of his decorative compositions. He had taken part in the Mexican campaign, and his poetic and plastic recollections of tropical vegetation and fauna were most precise.[1]

The result has been that this Breton, this old man who lived mostly in the suburbs of Paris, is without doubt the most extraordinary, the boldest, the most charming painter of the exotic. His *Snake Charmer* is evidence enough of this. But Rousseau was more than a decorator; he was not just an image-maker; he was a painter. It is this which makes comprehension of his work so difficult for some people. He had a feeling for order, as is shown, not only in his pictures, but also in his drawings, which are as ordered as Persian miniatures. His art had purity, as is shown in his feminine figures, in the structure of his trees, and in the harmonious song of the different tones of a single color, a style which is found only in French painting, and marks pictures as belonging to the French school, no matter who the artist. I refer, of course, to paintings of masters.

This painter had the most powerful will. How doubt this, having seen his careful detail, certainly not due to weakness, how doubt this, when before you the song of the blues and the melody of the whites are intermingling in his *Wedding*, in which the face of an old peasant reminds one of certain Dutch men?

As a painter of portraits Rousseau is incomparable. A half-length portrait of a woman, in black and delicate greys, is carried even farther than a portrait by Cézanne. Twice I had the honor to sit for Rousseau in his small, light studio on the rue Perrel; I often watched him at work, and I know the care he gave to the tiniest details; he had the capacity to keep the original and definitive conception of his picture always before him until he had realized it; and he left nothing, above all, nothing essential, to chance.

---

[1] Rousseau was said to have served in Mexico during his military service. Some historians follow Apollinaire in attributing his scenes of the jungle to reminiscenes of the French occupation, but recently Charles Chassé has uncovered evidence in military records that Rousseau was never there and that the floral forms in his paintings are either so generalized that they cannot be localized or else they could be found in the Jardin des Plantes where Rousseau often drew.

Of all Rousseau's beautiful sketches, there is none so astonishing as the little canvas entitled *The Carmagnole*. It is the sketch for the *Centenaire de l'Indépendance*, under which Rousseau wrote:

*Auprès de ma blonde*
*qu'il fait bon, fait bon, fait bon ...*

Its nervous draftsmanship, variety, charm, and delicacy of tones make this work's excellence. His pictures of flowers show the resources of charm and emphasis in the soul and hand of the old Douanier.

## JUAN GRIS

Here is the man who has meditated on everything modern, here is the painter who wants to conceive only new structures, whose aim is to draw or paint nothing but materially pure forms.

His antics were of a sentimental sort. He wept romantically, instead of laughing as in drinking songs. He still ignores the fact that color is a form of the real. He is a man intent on discovering the most minute elements of thought. One by one he has found them, and his first canvases have the appearance of preparations for masterpieces. Bit by bit, the little genii of painting assemble. The pale hills are thronged. There are the bluish flames of gas-stoves, skies with forms falling back like weeping willows, and damp leaves. He gives his pictures the wet quality of newly painted façades. Painted wallpaper, a top hat, the disorder of advertisements on a high wall, —all these may very well serve to inspire a canvas by setting a limit to the painter's aims. Great forms thus acquire feeling. They are no longer tiresome. This art of ornamentation piously cherishes, and desperately tries to reanimate the last vestiges of classical art, such as the drawings of Ingres, and the portrait of David. Gris attains style, as Seurat did, but without the latter's originality as a theoretician.

Juan Gris has certainly taken this direction. His painting avoids the musical, that is, it seems to aim, above all, at scientific reality. Juan Gris has worked out in studies which relate him to Picasso, his only master, a type of drawing which at first seemed geometrical, but which was so individualized that it attained to style.

This art, if it perseveres in the direction it has taken, may end, not with scientific abstraction, but with that aesthetic arrangement which, after all, is the highest goal of scientific art. More forms may be suggested by the painter's ability, more colors, too, which are hints of forms. One could utilize objects whose capricious arrangement has undeniable aesthetic meaning. However, the impossibility of putting on canvas a man of flesh and blood, a mirror-wardrobe, or the Eiffel Tower, will force the painter to return (from collage) to the authentic method of painting, or to limit his talents to the minor art of shop windows—today many shop windows are admirably arranged—or even to that of the upholsterer, or the landscape gardener.

The latter two minor arts are not without influence on the painter; the shop window should have a similar influence. It could hardly be harmful to painting, since it could not replace it in the representation of perishable objects. Juan Gris is too much a painter to renounce painting.

Perhaps we shall see him attempt the great art of surprise; his intellectualism, and the attentive study of nature should supply him with unexpected elements from which a style might issue even as a style issues today from the metal constructions of engineers: the style of the department stores, garages, railroads, airplanes. Since art today has a very limited social role, it is only fitting that it should occupy itself with the disinterested and scientific study—even without aesthetic aims—of its immense domain.

As influenced by Picasso's scientific cubism, the art of Juan Gris is too rigorous and too impoverished; it is a profoundly intellectual art, according to color a merely symbolic significance. Picasso's painting are conceived in light (Impressionism). Juan Gris is content with purity, scientifically conceived.

The conceptions of Juan Gris are always pure, and from this purity parallels are sure to spring.

## FERNAND LEGER

Fernand Léger is one of the gifted artists of his generation. He did not tarry long with Postimpressionist painting—which was with us only yesterday, and already seems so remote. I have seen some of Léger's earliest experiments.

Night bathers, a horizontal sea, heads scattered, —as in the difficult compositions which, until then, Henri Matisse alone had attempted.

After having made some completely new drawings, Léger wanted to devote himself to pure painting.

Lumberjacks bore on their persons traces of the blows their axes left on the trees, and the general color partook of the greenish and deep light which falls across foliage.

After that Léger's work was a fairyland, in which persons drowning in perfumes smiled. There are indolent personages who voluptously transform the light of the city into a multiplicity of delicate and shadowy colors, memories of Norman shepherds. All the colors boil. Then a vapor forms, and when this is dissipated, the chosen colors remain; a kind of masterpiece was born of this ardor: it is entitled, *The Smoker*.

There is in Léger a desire to exact of a composition all the aesthetic emotion it can give. Right now he is lifting the landscape to the highest level of plasticity.

He discards whatever does not give his conception an agreeable and happy simplicity.

He was one of the first to resist the old instinct of the species "race," and to surrender happily to the instinct of civilization.

This instinct is resisted more widely than is supposed. This resistance,

with some, became a grotesque frenzy, the frenzy of ignorance. With others, it consisted of turning to account whatever came to them through the five senses.

When I look at a picture by Léger, I am content. It is not a stupid transposition achieved by the forger's craft. Nor is it a question of a work whose creator has done what everyone wants to do today. There are not a few who dream of refashioning souls or mediums of a kind found in the fourteenth or fifteenth centuries; there are others, still more skillful, who will make you a soul to fit the requirements of the Augustan age, or the time of Pericles, and all this in less time than it takes a child to learn to read. No, Léger is not one of those men who believe that humanity changes from century to century, and thus confound God with a customer, desirous as they are to identify their costumes with their souls. Here is an artist comparable to those of the fourteenth or fifteenth centuries, to those of the time of Augustus and Pericles, neither more nor less, and in the attainment of glory and mastery, heaven helps the painter who helps himself.

But Fernand Léger is not a mystic; he is a painter, a simple painter, and I rejoice as much in his simplicity as in the solidity of his judgment.

I love his art because it is not scornful, because it knows no servility, and because it does not reason. I love your light colors [couleurs légèrs], O Fernand Léger! Fantasy does not lift you to fairylands, but it grants you all your joys.

Here joy is expressed in the intention as well as in the execution. He will find other boiling points of form. The same orchards will bear even lighter colors. Other families will scatter themselves, like droplets from a waterfall, and the rainbow will come to dress in gorgeousness the tiny dancers of the ballet. The wedding guests hide one behind the other. Just another little effort to get rid of perspective, of that miserable tricky perspective, of that fourth dimension in reverse, of that infallible device for making all things shrink.

But this painting is liquid: the sea, blood, rivers, rain, a glass of water and our tears, the wet of kisses, with the sweat of great efforts and long fatigue.

## FRANCIS PICABIA

Coming from Impressionism, like most of the contemporary painters, Francis Picabia, like the Fauves, translated light into color. Thus he arrived at an entirely new art, for which color is no longer merely coloring, nor even a luminous transposition, for which color has no longer any symbolic significance, seeing that it is itself the form and light of whatever is represented.

Then he approached an art for which, as with Robert Delaunay, color is the ideal dimension. Consequently it has all the other dimensions. However, with Picabia the form is still symbolic, while the color is formal: a perfectly legitimate art, and surely a very subtle one. Color is saturated with energy, and its outmost points are prolonged in space. Here it is the medium which is the reality. Color no longer depends on the three known dimensions; it is color which creates them.

This art is as close to music as the opposite of music can be. One might well say that the art of Picabia would like to stand, with respect to past painting, as music stands to literature, but one cannot say that it is musical itself. The truth is, music proceeds by suggestion; here, on the other hand, we are presented with colors which are not supposed to affect us as symbols, but as concrete forms.[1] At the same time, without approaching new methods, an artist like Picabia here forgoes one of the principal elements of all painting: conception. In order for the artist to give the effect of having eliminated this element, color has to be formal (substance and dimension: the measure).

Let me add that the formulation of the title is, for Picabia, not separable, intellectually, from the work to which it refers. The title should play the part of an inner frame, as actual objects, and inscriptions exactly copied, do in the pictures of Picasso. It should ward off decadent intellectualism, and conjure away the danger artists always run of becoming literary. Analogous to Picabia's written titles, to the real objects, letters, and molded ciphers in the paintings of Picasso and Braque, are the pictorial arabesques in the backgrounds of Laurencin's pictures. With Albert Gleizes this function is taken by the right angles which retain light, with Fernand Léger by bubbles, with Metzinger by vertical lines, parallel to the sides of the frame cut by infrequent echelons. The equivalent will be found, in some form or other, in the works of all the great painters. It gives pictorial intensity to a painting, and this is enough to justify its legitimacy.

It is by such methods that one guards against becoming literary; Picabia, for example, tried to give himself entirely to color, without ever daring, when approaching his subject, to grant it a personal existence. (I must remark here that a title does not mean the artist has approached a subject.)

Pictures, like *Landscape*, *Spring*, *Dance at the Spring*, are real paintings: colors form unities or contrasts, are oriented in space, and increase or decrease in intensity so as to elicit an aesthetic emotion.

It is not a question of abstraction, for these works give direct pleasure. Here surprise plays an important role. Can the taste of a peach be called abstract? Each picture of Picabia has a definite existence, the limits of which are set by the title. These pictures are so far from *a priori* abstractions that the painter can tell you the history of each one of them; *Dance at the Spring* is simply the expression of a plastic emotion experienced spontaneously near Naples.

Once purified, this art would have an immense range of aesthetic emotion. It could take as its motto the remark of Poussin: "Painting has no other end than the delectation and joy of the eyes."

Picabia, who seems to be looking for a dynamic art, might abandon the

---

[1] Picabia's own theory was concerned with the "musical" character of his near-abstract painting, a subject which the two men had discussed. See his "Cubism by a Cubist," *For and Against, Views on the International Exhibition Held in New York and Chicago* [the Armory Show] (New York: American Association of Painters and Sculptors, Inc., 1913).

static picture for other means of expression (as Loie Fuller did).[1] But I urge him, as a painter of pictures, to address himself to the subject (poetry), which is the essence of plastic art.

## MARCEL DUCHAMP

Marcel Duchamp's pictures are still too few in number, and differ too much from one another, for one to generalize their qualities, or judge the real talents of their creator. Like most of the new painters, Marcel Duchamp has abandoned the cult of appearances. (It seems it was Gauguin who first renounced what has been for so long the religion of painters.)

In the beginning Marcel Duchamp was influenced by Braque (the pictures exhibited at the *Salon d'Automne*, 1911, and at the Gallery of the rue Tronchet, 1911), and by *The Tower* of Delaunay (*A Melancholy Young Man on a Train*).

To free his art from all perceptions which might become notions, Duchamp writes the title on the picture itself. Thus literature, which so few painters have been able to avoid, disappears from his art, but not poetry. He uses forms and colors, not to render appearances, but to penetrate the essential nature of forms and formal colors, which drive painters to such despair that they would like to dispense with them, and try to do so whenever possible.

To the concrete composition of his picture, Marcel Duchamp opposes an extremely intellectual title. He goes the limit, and is not afraid of being criticized as esoteric or unintelligible.

All men, all the beings that have passed near us, have left some imprints on our memory, and these imprints of lives have a reality, the details of which can be studied and copied. These traces all take on a character whose plastic traits can be indicated by a purely intellectual operation.

Traces of these beings appear in the pictures of Marcel Duchamp. Let me add—the fact is not without importance—that Duchamp is the only painter of the modern school who today (autumn, 1912) concerns himself with the nude: (*King and Queen Surrounded by Swift Nudes; King and Queen Swept by Swift Nudes; Nude Descending a Staircase*).

This art which strives to aestheticize such musical perceptions of nature, forbids itself the caprices and unexpressive arabesque of music.

An art directed to wresting from nature, not intellectual generalizations, but collective forms and colors, the perception of which has not yet become knowledge, is certainly conceivable, and a painter like Marcel Duchamp is very likely to realize such an art.

[1] American dancer (1862–1928) who abandoned the traditional technique for freely-flowing, serpentine movements which were enhanced by voluminous draperies and colored lights. She achieved great popularity in Paris in the nineties as the epitome of the *Art Nouveau* taste for sensuous and rhythmic movements which were so abstract as to be almost disembodied. Many artists, including Toulouse-Lautrec and Jules Chéret, painted her.

It is possible that these unknown, profound, and abruptly grandiose aspects of nature do not have to be aestheticized in order to move us; this would explain the flame-shaped colors, the compositions in the form of an N, the rumbling tones, now tender, now firmly accented. These conceptions are not determined by an aesthetic, but by the energy of a few lines (forms or colors).

This technique can produce works of a strength so far undreamed of. It may even play a social role.

Just as Cimabue's pictures were paraded through the streets, our century has seen the airplane of Blériot, laden with the efforts humanity made for the past thousand years, escorted in glory to the (Academy of) Arts and Sciences. Perhaps it will be the task of an artist as detached from aesthetic preoccupations, and as intent on the energetic as Marcel Duchamp, to reconcile art and the people.

# APPENDIX

## DUCHAMP-VILLON[1]

When sculpture departs from nature it becomes architecture. The study of nature is more necessary for sculptors than for painters, since it is easy to conceive of a painting free from nature. In fact, the new painters, while they study nature relentlessly, and even copy nature, refuse to accept the cult of natural appearances. It is actually only through conventions, amiably agreed to by the spectator, that it has been possible to correlate paintings with actual objects. The new painters have rejected such conventions, and some of them, opposing any return to the observation of these conventions, have chosen to introduce into their pictures, perfectly authentic elements, which, however, are alien to painting. For them, as for the writer, nature is a pure spring from which one may drink without fear of poisoning. Nature is their safeguard against the intellectualism of decadence, which is the greatest enemy of art.

Sculptors, on the other hand, can reproduce the appearances of nature (and not a few have done this). By the use of colors they can give us the illusion of livingness. However, they can exact of nature even more than the immediate appearance of life, and can even imagine, enlarge, or diminish, as did the Assyrian, Egyptian, Negro, and South Pacific sculptors, forms endowed with great aesthetic life, so long as these forms are ultimately based on nature. Attention to this basic limitation of sculpture justifies the work of Duchamp-Villon; when he wanted to escape this limitation, he turned directly to architecture.

A structure becomes architectural, and not sculptural, when its elements no longer have their justification in nature. Pure sculpture is subject to a singular necessity: it must have a practical purpose, whereas one can easily imagine an architectural work as disinterested as music, the art it most resembles. Think of the

---

[1] Duchamp-Villon had recently exhibited architectural models and sketches in the salon and Apollinaire reproduced two of them in his book.

Tower of Babel, the Colossus of Rhodes, the statue of Memmon, the Sphinx, the Pyramids, the mausoleums, the labyrinths, the sculptured blocks of Mexico, the obelisks, menhirs, etc.; also the triumphal or commemorative columns, l'Arc de Triomphe, and the Eiffel Tower. The whole world is covered with useless or almost useless monuments, which in any case are greater in their proportions than their purpose required. Indeed, the Mausoleum, the Pyramids are too large for tombs, and hence are quite useless; columns, even if, like the Trajan Column or the Vendôme Column, they are intended to commemorate events, are equally useless, since who is going to climb to the summits for the details of the historic scenes recorded there? What is more useless than a victory arch? The usefulness of the Eiffel Tower postdated its disinterested construction.

However the feeling for architecture has been lost, so much so that the uselessness of monuments today is shocking, and appears to people as almost monstrous.

In revenge, while nobody will insist that sculptures be of use, without a practical end they become ridiculous.

Sculpture has for its practical end the representation of heroes, gods, sacred animals, images; and this artistic necessity has always been understood; it is responsible for the anthropomorphic character of the gods, for the human form finds its natural aesthetic most easily, and gives the greatest freedom to the fancy of the artist.

When sculpture abandons the portrait, it becomes nothing more than a decorative technique, destined to impart intensity to architecture (street lamps, allegorical statues for gardens, balustrades, etc.).

The utilitarian end aimed at by most contemporary architects is responsible for the great backwardness of architecture as compared with the other arts. The architect, the engineer should have sublime aims: to build the highest tower, to prepare for time and ivy the most beautiful of ruins, to throw across a harbor or a river an arch more audacious than the rainbow, and finally to compose to a lasting harmony, the most powerful ever imagined by man.

Duchamp-Villon had this titanic conception of architecture. A sculptor and an architect, light is the only thing that counts for him; but in all the arts, also, it is only light, the incorruptible light, that counts.

## NOTE

Besides the artists of whom I have spoken in the preceding chapters, there are other living artists who in schools prior to Cubism, in the contemporary schools or as independent personalities, are attached, whether willingly or not, to the Cubist school.

Scientific Cubism defended by Canudo, Jacques Nayral, André Salmon, Granié, Maurice Raynal, Marc Brésil, Alexandre Mercereau, Reverdy, Tudesq, André Warnod, and the author of this work numbers among its new supporters Georges Deniker, Jacques Villon, and Louis Marcoussis.

Physical Cubism supported in the press by the writers listed above, as well as by Roger Allard and Olivier Hourcade, can claim the talents of Marchand, Herbin, and Véra.

Orphic Cubism, defended by Max Goth and the author of this work, seems to be the pure tendency Dumont and Valensi propose to follow.

Instinctive Cubism is an important movement; initiated some time ago, it is already a light outside of France. Louis Vauxcelles, René Blum, Adolphe Basler, Gustave Kahn, Marinetti, Michel Puy have supported certain individuals who base their work on this approach. The trend includes many artists including Henri Matisse, Rouault, André Derain, Raoul Dufy, Chabaud, Jean Puy, van Dongen, Severini, Boccioni, etc.

In addition to Duchamp-Villon, the following sculptors have announced their adherence to the Cubist school: Auguste Agéro, Archipenko, and Brancusi.

*Daniel-Henry Kahnweiler, from* The Rise of Cubism, *1915**

At the outset, a few prefatory words concerning the name of this school are necessary to avoid considering it as a program, and thus arrive at false conclusions. As the name "Impressionism" had been before, "Cubism" was a derogatory term applied by its enemies. Its inventor was Louis Vauxcelles, at that time art critic of the *Gil Blas*; sometime before, in the years 1904–1905, he had coined another meaningless name for the avant-garde of the *Indépendants* of that time—"*Les Fauves*," the wild beasts—a term which has since fortunately disappeared.

In September 1908 he met Matisse, who was a member of the *Salon d'Automne* jury for that year, and who told him that Braque had sent to the fall Salon paintings "*avec des petits cubes*." To describe them he drew on a piece of paper two ascending lines meeting in a peak, and between them some cubes.

He was referring to Braque's landscapes of L'Estaque painted that spring. With the sensitivity characteristic of such bodies, the jury rejected two of the six

* Originally published in *Der Weg zum Kubismus* (Munich: Delphin, 1920). This English translation by Henry Aronson from *The Rise of Cubism* (New York: Wittenborn, Schultz, 1949), pp. 5–16.

The original text was written in 1915 while Kahnweiler (b. 1884), a German citizen, was in Switzerland, having been forced to leave France after his vast art collection was sequestered by the French Government. He is a central figure in Cubism both through his activities as its most influential dealer and through his numerous writings. It is fortunate that he, the man closest to the artists and poets, should possess a sense both of history and of criticism,

He came from Germany as a young man and in 1907 opened a small gallery in the Rue Vignon near the Madeleine. He soon sought out Picasso, bought his paintings and, until 1914 when his possessions were seized by the French government, held exclusive control over his work. He showed Braque's paintings and also those of Derain and Gris in his gallery, but he also sent their work to many exhibitions abroad. The first exhibition of Braque's work in 1908 was also the last formal exhibition in the little gallery, as Kahnweiler preferred simply to have the work of his painters available for the few collectors, chiefly Germans, Russians, and Americans, whose tastes tended toward this art. Braque ceased to submit to the salons after 1908 and Picasso had never done so, and Kahnweiler recently stated that he had never spent a *sou* on any kind of publicity since the catalogue of the 1908 show.

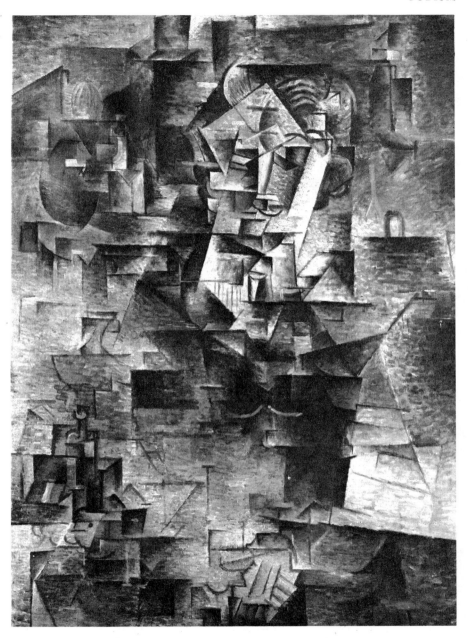

*Pablo Picasso, Daniel-Henry Kahnweiler,*
*1910, oil on canvas.*

paintings submitted. One was "fished out again," as someone put it, by Marquet, and another by Guérin, both of whom were members of the jury, but Braque nevertheless withdrew all six.

From Matisse's word "cube" Vauxcelles then invented the meaningless "Cubism" which he used for the first time in an article on the 1909 *Salon des Indépendants*, in connection with two other paintings by Braque, a still life and landscape. Strangely enough, he added to this term the adjective "Peruvian" and spoke of "Peruvian Cubism" and "Peruvian Cubists" which made the designation even more meaningless. This adjective soon disappeared, but the name "Cubism" endured and entered colloquial language, since Braque and Picasso, the painters originally so designated, cared very little whether they were called that or something else.

These two artists are the great founders of Cubism. In the evolution of the new art, the contributions of both are intimately related, often hardly distinguishable. Friendly conversations between the two afforded the new method of painting many advances which one or the other first put into practice. Both deserve credit; both are great and admirable artists, each in his own way. Braque's art is quieter, Picasso's is nervous and turbulent. The lucid Frenchman Braque and the fanatically searching Spaniard Picasso stand together.

In the year 1906, Braque, Derain, Matisse and many others were still striving for expression through color, using only pleasant arabesques, and completely dissolving the form of the object. Cézanne's great example was still not understood. Painting threatened to debase itself to the level of ornamentation; it sought to be "decorative," to "adorn" the wall.

Picasso had remained indifferent to the temptation of color. He had pursued another path, never abandoning his concern for the object. The literary "expression" which had existed in his earlier work now vanished. A lyricism of form retaining fidelity to nature began to take shape. He created large nudes roundly modeled in chiaroscuro. They appeared "classic" and his friends referred to a "Pompeiian Period." But Picasso's intention remained unfulfilled.

Here it should be made clear that I do not mean an established program when I speak of Picasso's or Braque's intentions, endeavors, and thoughts. I am attempting to describe in words the inner urge of these artists, the ideas no doubt clearly in their minds, yet rarely mentioned in their conversations, and then only casually.

Toward the end of 1906, then, the soft round contours in Picasso's paintings gave way to hard angular forms; instead of delicate rose, pale yellow, and light green, the massive forms were weighted with leaden white, gray, and black.

Early in 1907 Picasso began a strange large painting depicting women, fruit, and drapery, which he left unfinished [*Les Demoiselles d'Avignon*]. It cannot be called other than unfinished, even though it represents a long period of work. Begun in the spirit of the works of 1906, it contains in one section the endeavors of 1907 and thus never constitutes a unified whole.

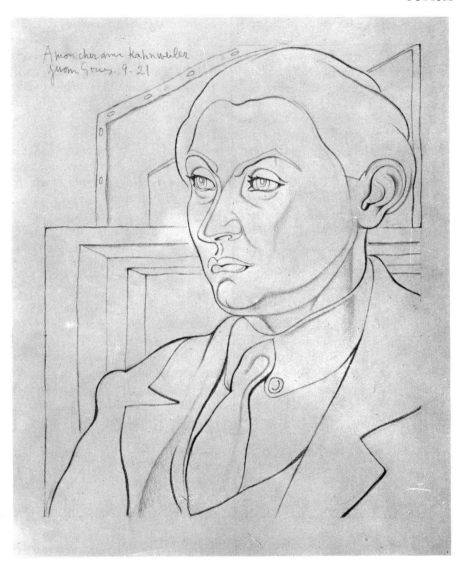

*Juan Gris, Portrait of D. H. Kahnweiler*
*1921, drawing.*

The nudes, with large, quiet eyes, stand rigid, like mannequins. Their stiff, round bodies are flesh-colored, black and white. That is the style of 1906.

In the foreground, however, alien to the style of the rest of the painting, appear a crouching figure and a bowl of fruit. These forms are drawn angularly, not roundly modeled in chiaroscuro. The colors are luscious blue, strident yellow, next to pure black and white. This is the beginning of Cubism, the first upsurge, a desperate titanic clash with all of the problems at once.

These problems were the basic tasks of painting: to represent three dimensions and color on a flat surface, and to comprehend them in the unity of that surface. "Representation," however, and "comprehension" in the strictest and highest sense. Not the simulation of form by chiaroscuro, but the depiction of the three dimensional through drawing on a flat surface. No pleasant "composition" but uncompromising, organically articulated structure. In addition, there was the problem of color, and finally, the most difficult of all, that of the amalgamation, the reconciliation of the whole.

Rashly, Picasso attacked all the problems at once. He placed sharp-edged images on the canvas, heads and nudes mostly, in the brightest colors: yellow, red, blue, and black. He applied the colors in threadlike fashion to serve as lines of direction, and to build up, in conjunction with the drawing, the plastic effect. But, after months of the most laborious searching, Picasso realized that complete solution of the problem did not lie in this direction.

At this point I must make it clear that these paintings are no less "beautiful" for not having attained their goal. An artist who is possessed of the divine gift, genius, always produces aesthetic creations, whatever their aspect, whatever their "appearance" may be. His innermost being creates the beauty; the external appearance of the work of art, however, is the product of the time in which it is created.

A short period of exhaustion followed; the artist's battered spirit turned to problems of pure structure. A series of pictures appeared in which he seems to have been occupied only with the articulation of the color planes. This withdrawal from the diversity of the physical world to the undisturbed peace of the work of art was of short duration. Soon Picasso perceived the danger of lowering his art to the level of ornament.

In the spring of 1908 he resumed his quest, this time solving one by one the problems that arose. He had to begin with the most important thing, and that seemed to be the explanation of form, the representation of the three-dimensional and its position in space on a two dimensional surface. As Picasso himself once said, "In a Raphael painting it is not possible to establish the distance from the tip of the nose to the mouth. I should like to paint pictures in which that would be possible." At the same time of course, the problem of comprehension—of structure—was always in the foreground. The question of color, on the other hand, was completely bypassed.

Thus Picasso painted figures resembling Congo sculptures, and still-lifes

of the simplest form. His perspective in these works is similar to that of Cézanne. Light is never more than a means to create form—through chiaroscuro, since he did not at this time repeat the unsuccessful attempt of 1907 to create form through drawing. Of these paintings one can no longer say, "The light comes from this or that side," because light has become completely a means. The pictures are almost monochromatic; brick red and red brown, often with a grey or grey green ground, since the color is meant only to be chiaroscuro.

While Picasso was painting in Paris, and in the summer, at La Rue-des-Bois (near Creil, Oise), Braque, at the other end of France, in l'Estaque (near Marseilles) was painting the series of landscapes we have already mentioned. No connection existed between the two artists. This venture was a completely new one, totally different from Picasso's work of 1907; by an entirely different route Braque arrived at the same point as Picasso. If, in the whole history of art, there were not already sufficient proof that the appearance of the aesthetic product is conditioned in its particularity by the spirit of the time, that even the most powerful artists unconsciously execute its will, then this would be proof. Separated by distance, and working independently, the two artists devoted their most intense effort to paintings which share an extraordinary resemblance. This relationship between their paintings continued but ceased to be astonishing because the friendship between the two artists, begun in the winter of that year, brought about a constant exchange of ideas.

Picasso and Braque had to begin with objects of the simplest sort: in landscape, with cylindrical tree trunks and rectangular houses; in still life, with plates, symmetrical vessels, round fruits, and one or two nude figures. They sought to make these objects as plastic as possible, and to define their position in space. Here we touch upon the indirect advantage of lyric painting. It has made us aware of the beauty of form in the simplest objects, where we had carelessly overlooked it before. These objects have now become eternally vivid in the reflected splendor of the beauty which the artist has abstracted from them.

Derain, too, had abandoned decorative light painting in 1907, preceding Braque by a few months. But from the outset, their roads were diverse. Derain's endeavor to retain fidelity to nature in his painting separated him forever from Cubism, no matter how closely his ideas may otherwise parallel those of Braque.

In the winter of 1908, the two friends began to work along common and parallel paths. The subjects of their still-life painting became more complex, the representation of nudes more detailed. The relation of objects to one another underwent further differentiation, and structure, heretofore relatively uncomplicated—as, for example, in a still life of the spring of 1907 whose structure forms a simple spiral—took on more intricacy and variety. Color, as the expression of light, or chiaroscuro, continued to be used as a means of shaping form. Distortion of form, the usual consequence of the conflict between representation and structure, was strongly evident.

Among the new subjects introduced at this time were musical instruments, which Braque was the first to paint, and which continued to play such an important role in Cubist still-life painting. Other new motifs were fruit bowls, bottles, and glasses.

During the summer of 1909 which Picasso spent at Horta (near Tolosa, Spain) and Braque at La Roche Guyon (on the Seine, near Mantes) the new language of form was further augmented and enriched, but left essentially unchanged.

Several times during the spring of 1910 Picasso attempted to endow the forms of his pictures with color. That is, he tried to use color not only as an expression of light, or chiaroscuro, for the creation of form, but rather as an equally important end in itself. Each time he was obliged to paint over the color he had thus introduced; the single exception is a small nude of the period (about 18 × 23 centimeters in size) in which a piece of fabric is colored in brilliant red.

At the same time Braque made an important discovery. In one of his pictures he painted a completely naturalistic nail casting its shadow on a wall. The usefulness of this innovation will be discussed later. The difficulty lay in the incorporation of this "real" object into the unity of the painting. From then on, both artists consistently limited the space in the background of the picture. In a landscape, for instance, instead of painting an illusionistic distant horizon in which the eye lost itself, the artists closed the three dimensional space with a mountain. In still-life or nude painting, the wall of a room served the same purpose. This method of limiting space had already been used frequently by Cézanne.

During the summer, again spent in L'Estaque, Braque took a further step in the introduction of "real objects," that is, of realistically painted things introduced, undistorted in form and color, into the picture. We find lettering for the first time in a *Guitar Player* of the period. Here again, lyrical painting uncovered a new world of beauty—this time in posters, display windows, and commercial signs which play so important a role in our visual impressions.

Much more important, however, was the decisive advance which set Cubism free from the language previously used by painting. This occurred in Cadaqués (in Spain, on the Mediterranean near the French border) where Picasso spent his summer. Little satisfied, even after weeks of arduous labor, he returned to Paris in the fall with his unfinished works. But he had taken the great step; he had pierced the closed form. A new tool had been forged for the achievement of the new purpose.

Years of research had proved that closed form did not permit an expression sufficient for the two artists' aims. Closed form accepts objects as contained by their own surfaces, viz., the skin; it then endeavors to represent this closed body, and, since no object is visible without light, to paint this "skin" as the contact point between the body and light where both merge into color. This chiaroscuro can provide only an illusion of the form of objects. In the actual three-dimensional world the object is there to be touched even after light is eliminated. Memory images of tactile perceptions can also be verified on visible bodies. The different

accommodations of the retina of the eye enable us, as it were, to "touch" three-dimensional objects from a distance. Two-dimensional painting is not concerned with all this. Thus the painters of the Renaissance, using the closed form method, endeavored to give the illusion of form by painting light as color on the surface of objects. It was never more than "illusion."

Since it was the mission of color to create the form as chiaroscuro, or light that had become perceivable, there was no possibility of rendering local color or color itself. It could only be painted as objectivated light.

In addition, Braque and Picasso were disturbed by the unavoidable distortion of form which worried many spectators initially. Picasso himself often repeated the ludicrous remark made by his friend, the sculptor Manolo, before one of his figure paintings: "What would you say if your parents were to call for you at the Barcelona station with such faces?" This is a drastic example of the relation between memory images and the figures represented in the painting. Comparison between the real object as articulated by the rhythm of forms in the painting and the same object as it exists in the spectator's memory inevitably results in "distortions" as long as even the slightest verisimilitude in the work of art creates this conflict in the spectator. Through the combined discoveries of Braque and Picasso during the summer of 1910 it became possible to avoid these difficulties by a new way of painting.

On the one hand, Picasso's new method made it possible to "represent" the form of objects and their position in space instead of attempting to imitate them through illusionistic means. With the representation of solid objects this could be effected by a process of representation that has a certain resemblance to geometrical drawing. This is a matter of course since the aim of both is to render the three-dimensional object on a two-dimensional plane. In addition, the painter no longer has to limit himself to depicting the object as it would appear from one given viewpoint, but wherever necessary for fuller comprehension, can show it from several sides, and from above and below.

Representation of the position of objects in space is done as follows: instead of beginning from a supposed foreground and going on from there to give an illusion of depth by means of perspective, the painter begins from a definite and clearly defined background. Starting from this background the painter now works toward the front by a sort of scheme of forms in which each object's position is clearly indicated, both in relation to the definite background and to other objects. Such an arrangement thus gives a clear and plastic view. But, if only this scheme of forms were to exist it would be impossible to see in the painting the "representation" of things from the outer world. One would only see an arrangement of planes, cylinders, quadrangles, etc.

At this point Braque's introduction of undistorted real objects into the painting takes on its full significance. When "real details" are thus introduced the result is a stimulus which carries with it memory images. Combining the "real" stimulus and the scheme of forms, these images construct the finished object in

the mind. Thus the desired physical representation comes into being in the spectator's mind.

Now the rhythmization necessary for the coordination of the individual parts into the unity of the work of art can take place without producing disturbing distortions, since the object in effect is no longer "present" in the painting, that is, since it does not yet have the least resemblance to actuality. Therefore, the stimulus cannot come into conflict with the product of the assimilation. In other words, there exist in the painting the scheme of forms and small real details as stimuli integrated into the unity of the work of art; there exists, as well, but only in the mind of the spectator, the finished product of the assimilation, the human head, for instance. There is no possibility of a conflict here, and yet the object once "recognized" in the painting is now "seen" with a perspicacity of which no illusionistic art is capable.

As to color, its utilization as chiaroscuro had been abolished. Thus, it could be freely employed, as color, within the unity of the work of art. For the representation of local color, its application on a small scale is sufficient to effect its incorporation into finished representation in the mind of the spectator.

In the words of Locke, these painters distinguish between primary and secondary qualities. They endeavor to represent the primary, or most important qualities, as exactly as possible. In painting these are: the object's form, and its position in space. They merely suggest the secondary characteristics such as color and tactile quality, leaving their incorporation into the object to the mind of the spectator.

This new language has given painting an unprecedented freedom. It is no longer bound to the more or less verisimilar optic image which describes the object from a single viewpoint. It can, in order to give a thorough representation of the object's primary characteristics, depict them as stereometric drawing on the plane, or, through several representations of the same object, can provide an analytical study of that object which the spectator then fuses into one again in his mind. The representation does not necessarily have to be in the closed manner of the stereometric drawing; colored planes, through their direction and relative position, can bring together the formal scheme without uniting in closed forms. This was the great advance made at Cadaques. Instead of an analytical description, the painter can, if he prefers, also create in this way a synthesis of the object, or in the words of Kant, "put together the various conceptions and comprehend their variety in one perception."

Naturally, with this, as with any new mode of expression in painting, the assimilation which leads to seeing the represented things objectively does not immediately take place when the spectator is unfamiliar with the new language. But for lyric painting to fulfill its purpose completely, it must be more than just a pleasure to the eye of the spectator. To be sure, assimilation always takes place finally, but in order to facilitate it, and impress its urgency upon the spectator, Cubist pictures should always be provided with descriptive titles, such as *Bottle and*

*Glass, Playing Cards and Dice* and so on. In this way, the condition will arise which H. G. Lewes referred to as "preperception" and memory images connected with the title will then focus much more easily on the stimuli in the painting.

Titling will also prevent sensory illusions of the kind which gave Cubism is name, and brought about its designation, so popular, particularly in France, as a geometric style. Here we must make a sharp distinction between the impression made upon the spectator and the lines of the painting itself. The name "Cubism" and the designation "Geometric Art" grew out of the impression of early spectators who "saw" geometric forms in the paintings. This impression is unjustified, since the visual conception desired by the painter by no means resides in the geometric forms, but rather in the representation of the reproduced objects.

How does such a sensory illusion come about? It occurs only with observers whom lack of habit has prevented from making the associations which lead to objective perception. Man is possessed by an urge to objectivate; he wants to "see something" in the work of art which should—and he is sure of this—represent something. His imagination forcefully calls up memory images, but the only ones which present themselves, the only ones which seem to fit the straight lines and uniform curves are geometric images. Experience has shown that this "geometric impression" disappears completely as soon as the spectator familiarizes himself with the new method of expression and gains in perception.

If we disregard representation, however, and limit ourselves to the "actual" individual lines in the painting, there is no disputing the fact that they are often straight lines and uniform curves. Furthermore, the forms which they serve to delineate are often similar to the circle and rectangle, or even to stereometric representations of cubes, spheres, and cylinders. But, such straight lines and uniform curves are present in all styles of the plastic arts which do not have as their goal the illusionistic imitation of nature. Architecture, which is a plastic art, but at the same time nonrepresentational, uses these lines extensively. The same is true of applied art. Man creates no building, no product which does not have regular lines. In architecture and applied art, cubes, spheres, and cylinders are the permanent basic forms. They do not exist in the natural world, nor do straight lines. But they are deeply rooted in man; they are the necessary condition for all objective perception.

Our remarks until now about visual perception have concerned its content alone, the two-dimensional "seen" and the three-dimensional "known" visual images. Now we are concerned with the form of these images, the form of our perception of the physical world. The geometric forms we have just mentioned provide us with the solid structure; on this structure we build the products of our imagination which are composed of stimuli on the retina and memory images. They are our categories of vision. When we direct our view on the outer world, we always demand those forms but they are never given to us in all their purity. The flat picture which we "see" bases itself mainly on the straight horizontal and vertical, and secondly on the circle. We test the "seen" lines of the physical world

for their greater or lesser relationship to these basic lines. Where no actual line exists, we supply the "basic" line ourselves. For example, a water horizon which is limited on both sides appears horizontal to us; one which is unlimited on both sides appears curved. Furthermore, only our knowledge of simple stereometric forms enables us to add the third dimension to the flat picture which our eye perceives. Without the cube, we would have no feeling of the three-dimensionality of objects, and without the sphere and cylinder, no feeling of the varieties of this three-dimensionality. Our *a priori* knowledge of these forms is the necessary condition, without which there would be no seeing, no world of objects. Architecture and applied art realize in space these basic forms which we always demand in vain of the natural world; the sculpture of periods which have turned away from nature approaches these forms insofar as its representational goal permits, and the two-dimensional painting of such periods gives expression to the same longing in its use of "basic lines." Humanity is possessed not only by the longing for these lines and forms, but also by the ability to create them. This ability shows itself clearly in those civilizations in which no "representational" plastic art has produced other lines and forms.

In its works Cubism, in accordance with its role as both constructive and representational art, brings the forms of the physical world as close as possible to their underlying basic forms. Through connection with these basic forms, upon which all visual and tactile perception is based, Cubism provides the clearest elucidation and foundation of all forms. The unconscious effort which we have to make with each object of the physical world before we can perceive its form is lessened by Cubist painting through its demonstration of the relation between these objects and basic forms. Like a skeletal frame these basic forms underlie the impression of the represented object in the final visual result of the painting; they are no longer "seen" but are the basis of the "seen" form.

It is not our intention to outline a complete history of Cubism here. We would exceed the limits of this work if we were to follow the development of the two artists any further, now that the definitive language of the new art has been created. Our mission was to fix the position of Cubism in the history of painting, and to demonstrate the motives which guided its founders.

This new style has taken ever-greater possession of the appearance of painting; an ever-growing number of painters has begun to paint "cubistically." This lyric painting is the expression of the intellectual spirit of our time. The necessary result of this will be that all true artists of the coming generation will espouse Cubism—in the wider sense.

Those who have already adopted Cubism include talented as well as untalented artists; in Cubism, too, they remain what they were. Those with talent create aesthetic products; those without it do not. For Cubism is only an "appearance," only the result of the purpose which the intellectual spirit of the time has imposed upon painting. Whether the picture with the Cubist appearance will be an aesthetic achievement, whether the aesthetically inclined spectator will be compelled to designate it as beautiful depends, as always, only on the painter's

genius. Yet every talented young artist will have to come to an understanding with Cubism. He will have little chance of getting along without it, just as a contemporary of Titian in Italy could never have reverted to the style of Giotto. The artist, as the executor of the unconscious plastic will of mankind, identifies himself with the style of the period, which is the expression of this will.

Just as the illusionistic art of the Renaissance created a tool for itself in oil painting, which alone could satisfy its striving for verisimilar representation of the smallest details, so Cubism had to invent new means for an entirely opposite purpose. For the planes of Cubist painting oil color is often unsuitable, ugly, and sometimes sticky. Cubism created for itself new media in the most varied materials: colored strips of paper, lacquer, newspaper, and in addition, for the real details, oilcloth, glass, sawdust, etc.

In the years 1913 and 1914 Braque and Picasso attempted to eliminate the use of color as chiaroscuro, which had still persisted to some extent in their painting, by amalgamating painting and sculpture. Instead of having to demonstrate through shadows how one plane stands above, or in front of a second plane, they could now superimpose the planes one on the other and illustrate the relationship directly. The first attempts to do this go far back. Picasso had already begun such an enterprise in 1909, but since he did it within the limits of closed form, it was destined to fail. It resulted in a kind of colored bas-relief. Only in open planal form could this union of painting and sculpture be realized. Despite current prejudice, this endeavor to increase plastic expression through the collaboration of the two arts must be warmly approved; an enrichment of the plastic arts is certain to result from it. A number of sculptors like Lipschitz, Laurens, and Archipenko has since taken up and developed this sculpto-painting.

Nor is this form entirely new in the history of the plastic arts. The Negroes of the Ivory Coast have made use of a very similar method of expression in their dance masks. These are constructed as follows: a completely flat plane forms the lower part of the face; to this is joined the high forehead, which is sometimes equally flat, sometimes bent slightly backward. While the nose is added as a simple strip of wood, two cylinders protrude about eight centimeters to form the eyes, and one slightly shorter hexahedron forms the mouth. The frontal surfaces of the cylinder and hexahedron are painted, and the hair is represented by raffia. It is true that the form is still closed here; however, it is not the "real" form, but rather a tight formal scheme of plastic primeval force. Here, too, we find a scheme of forms and "real details" (the painted eyes, mouth, and hair) as stimuli. The result in the mind of the spectator, the desired effect, is a human face.

*Georges Braque, Statement, 1908 or 1909*★

I couldn't portray a woman in all her natural loveliness. I haven't the skill. No one has. I must, therefore, create a new sort of beauty, the beauty that appears to

★ Quoted by Gelett Burgess, "The Wild Men of Paris," *Architectural Record* (New York), May 1910, p. 405.

me in terms of volume of line, of mass, of weight, and through that beauty interpret my subjective impression. Nature is a mere pretext for a decorative composition, plus sentiment. It suggests emotion, and I translate that emotion into art. I want to expose the Absolute, and not merely the factitious woman.

## Georges Braque, "Thoughts and Reflections on Art," 1917*

In art, progress does not consist in extension, but in the knowledge of limits.

Limitation of means determines style, engenders new form, and gives impulse to creation.

Limited means often constitute the charm and force of primitive painting. Extension, on the contrary, leads the arts to decadence.

New means, new subjects.

The subject is not the object, it is a new unity, a lyricism which grows completely from the means.

The painter thinks in terms of form and color.

The goal is not to be concerned with the *reconstitution* of an anecdotal fact, but with *constitution* of a pictorial fact.

Painting is a method of representation.

One must not imitate what one wants to create.

One does not imitate appearances; the appearance is the result.

To be pure imitation, painting must forget appearance.

To work from nature is to improvise.

One must beware of a formula *good for everything*, that will serve to interpret the other arts as well as reality, and that instead of creating will only produce a style, or rather a stylization.

The arts which achieve their effect through purity have never been arts that were good for everything. Greek sculpture (among others), with its decadence, teaches us this.

The senses deform, the mind forms. Work to perfect the mind. There is no certitude but in what the mind conceives.

The painter who wished to make a circle would only draw a curve. Its appearance might satisfy him, but he would doubt it. The compass would give him certitude. The pasted papers [*papiers collés*] in my drawings also gave me a certitude.

*Trompe l'oeil* is due to an *anecdotal chance* which succeeds because of the simplicity of the facts.

The pasted papers, the imitation woods—and other elements of a similar

* Originally published in *Nord-Sud* (Paris), Pierre Reverdy, ed., December 1917. English translation from *Artists on Art*, eds. Robert Goldwater and Marco Treves. Copyright 1945 by Pantheon Books, Inc. Reprinted by permission of Pantheon Books, Inc., a Division of Random House, Inc.

*Braque in his studio, ca. 1911.*

kind—which I used in some of my drawings, also succeed through the simplicity of the facts; this has caused them to be confused with *trompe l'oeil*, of which they are the exact opposite. They are also simple facts, but are *created by the mind*, and are one of the justifications for a new form in space.

Nobility grows out of contained emotion.

Emotion should not be rendered by an excited trembling; it can neither be added on nor be imitated. It is the seed, the work is the flower.

I like the rule that corrects the emotion.

*Georges Braque, Observations on his Method, 1954*\*

I had no more thought of becoming a painter than of breathing . . . . It pleased me to paint and I worked hard . . . as for me I never had a goal in mind. "A goal is a servitude," wrote Nietzsche, I believe, and it is true. It is very bad when one notices that one is a painter . . . if I had had any intention it was to accomplish myself day by day. In accomplishing myself I found that what I did resembled a painting. Making my way I continued. So . . . . But as one never lives outside of circumstances, when, in 1907, the ten canvases that I exhibited at the *Salon des Indépendents* were sold, I said to myself that I could do nothing else.

My habit of keeping a notebook of designs began in 1918. Before I drew on scraps of paper which I lost. Then I said to myself that it was necessary to keep a notebook. Since I always have a notebook within reach, and I draw no matter what, I preserve everything that passes through my head. And I was aware that all that served me well. There are times when one has the desire to paint, but knows not what to paint. I don't know what is the cause of this but there are moments when one feels empty. There is a great appetite to work, and then my sketchbook serves me as a cookbook when I am hungry. I open it and the least of the sketches can offer me material for work.

I make the background of my canvases with the greatest care because it is the ground that supports the rest; it is like the foundations of a house. I am always very occupied and preoccupied with the material because there is as much sensibility in the technique as in the rest of the painting. I prepare my own colors, I do the pulverizing . . . . I work with the material, not with ideas.

In my painting I always return to the center. I am the contrary, therefore, to one I should call a "*symphoniste*." In a symphony the theme approaches the infinite; there are painters (Bonnard is an example) who develop their themes to the infinite. There is in their canvases something like diffuse light, while with me, on the contrary, I attempt to reach the core of intensity; I concentrate.

\* Excerpts from Dora Vallier, "Braque, la Peinture et Nous," *Cahiers d'Art* (Paris), XXIX, 1 (October 1954), 13–24, *passim*. This English translation by Katherine Metcalf.

Braque's ideas on art are embodied almost exclusively in aphorisms which changed very little from the earliest to the latest. He once described them as serving the same purpose as a sketchbook—a reservoir of ideas to which he could turn for replenishment.

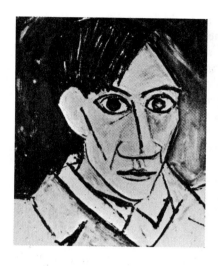

Pablo Picasso, *Self-Portrait, 1907, oil on canvas.*

Pablo Picasso, Statement, *1923*★

I can hardly understand the importance given to the word *research* in connection with modern painting. In my opinion to search means nothing in painting. To find, is the thing. Nobody is interested in following a man who, with his eyes fixed on the ground, spends his life looking for the pocketbook that fortune should put in his path. The one who finds something no matter what it might be, even if his intention were not to search for it, at least arouses our curiosity, if not our admiration.

Among the several sins that I have been accused of committing, none is more false than the one that I have, as the principal objective in my work, the spirit of research. When I paint my object is to show what I have found and not what I am looking for. In art intentions are not sufficient and, as we say in Spanish: love must be proved by facts and not by reasons. What one does is what counts and not what one had the intention of doing.

★ From an interview with Marius de Zayas. A translation approved by Picasso was published as "Picasso Speaks," *The Arts* (New York), May 1923, pp. 315–326.

Marius De Zayas was an American caricaturist and critic of Mexican descent who belonged to the circle of Alfred Stieglitz and the Photo-Secession Gallery (later "291"). He is the author of a brochure on Picasso published by the gallery in 1911 in connection with the first exhibition of Picasso in America, and later he was the director of the Modern Gallery which opened in 1915 with an exhibition of Picasso, Braque, and Picabia. His book explaining the new painting, *A Study of the Modern Evolution of Plastic Expression* (1913) mentioned Gleizes and Metzinger's *Du Cubisme*, and he also wrote *African Negro Art, its Influence on Modern Art* (1915), the first study of its kind in English. De Zayas was well-known to Apollinaire and his friends since he lived in Paris for most of the time between 1910 and 1914, and had several caricatures, including those of Apollinaire and Alfred Stieglitz, published in the last issue of *Les Soirées de Paris* (July–August 1914). He was thus extraordinarily well prepared to interview Picasso in 1923.

We all know that Art is not truth. Art is a lie that makes us realize truth, at least the truth that is given us to understand. The artist must know the manner whereby to convince others of the truthfulness of his lies. If he only shows in his work that he has searched, and re-searched, for the way to put over lies, he would never accomplish anything.

The idea of research has often made painting go astray, and made the artist lose himself in mental lucubrations. Perhaps this has been the principal fault of modern art. The spirit of research has poisoned those who have not fully understood all the positive and conclusive elements in modern art and has made them attempt to paint the invisible and, therefore, the unpaintable.

They speak of naturalism in opposition to modern painting. I would like to know if anyone has ever seen a natural work of art. Nature and art, being two different things, cannot be the same thing. Through art we express our conception of what nature is not.

Velasquez left us his idea of the people of his epoch. Undoubtedly they were different from what he painted them, but we cannot conceive a Philip IV in any other way than the one Velasquez painted. Rubens also made a portrait of the same king and in Rubens's portrait he seems to be quite another person. We believe in the one painted by Velasquez, for he convinces us by his right of might.

From the painters of the origins, the primitives, whose work is obviously different from nature, down to those artists who, like David, Ingres, and even Bouguereau, believed in painting nature as it is, art has always been art and not nature. And from the point of view of art there are no concrete or abstract forms, but only forms which are more or less convincing lies. That those lies are necessary to our mental selves is beyond any doubt, as it is through them that we form our aesthetic point of view of life.

Cubism is no different from any other school of painting. The same principles and the same elements are common to all. The fact that for a long time Cubism has not been understood and that even today there are people who cannot see anything in it, means nothing. I do not read English, an English book is a blank book to me. This does not mean that the English language does not exist, and why should I blame anybody else but myself if I cannot understand what I know nothing about?

I also often hear the word evolution. Repeatedly I am asked to explain how my painting evolved. To me there is no past or future in art. If a work of art cannot live always in the present it must not be considered at all. The art of the Greeks, of the Egyptians, of the great painters who lived in other times, is not an art of the past; perhaps it is more alive today than it ever was. Art does not evolve by itself, the ideas of people change and with them their mode of expression. When I hear people speak of the evolution of an artist, it seems to me that they are considering him standing between two mirrors that face each other and reproduce his image an infinite number of times, and that they contemplate the successive images of one mirror as his past, and the images of the other mirror as his future, while his

real image is taken as his present. They do not consider that they all are the same images in different planes.

Variation does not mean evolution. If an artist varies his mode of expression this only means that he has changed his manner of thinking, and in changing, it might be for the better or it might be for the worse.

The several manners I have used in my art must not be considered as an evolution, or as steps toward an unknown ideal of painting. All I have ever made was made for the present and with the hope that it will always remain in the present. I have never taken into consideration the spirit of research. When I have found something to express, I have done it without thinking of the past or of the future. I do not believe I have used radically different elements in the different manners I have used in painting. If the subjects I have wanted to express have suggested different ways of expression I have never hesitated to adopt them. I have never made trials nor experiments. Whenever I had something to say, I have said it in the manner in which I have felt it ought to be said. Different motives inevitably require different methods of expression. This does not imply either evolution or progress, but an adaptation of the idea one wants to express and the means to express that idea.

Arts of transition do not exist. In the chronological history of art there are periods which are more positive, more complete than others. This means that there are periods in which there are better artists than in others. If the history of art could be graphically represented, as in a chart used by a nurse to mark the changes of temperature of her patient, the same silhouettes of mountains would be shown, proving that in art there is no ascendant progress, but that it follows certain ups and downs that might occur at any time. The same occurs with the work of an individual artist.

Many think that Cubism is an art of transition, an experiment which is to bring ulterior results. Those who think that way have not understood it. Cubism is not either a seed or a foetus, but an art dealing primarily with forms, and when a form is realized it is there to live its own life. A mineral substance, having geometric formation, is not made so for transitory purposes, it is to remain what it is and will always have its own form. But if we are to apply the law of evolution and transformation to art, then we have to admit that all art is transitory. On the contrary, art does not enter into these philosophic absolutisms. If Cubism is an art of transition I am sure that the only thing that will come out of it is another form of Cubism.

Mathematics, trigonometry, chemistry, psychoanalysis, music, and whatnot, have been related to Cubism to give it an easier interpretation. All this has been pure literature, not to say nonsense, which brought bad results, blinding people with theories.

Cubism has kept itself within the limits and limitations of painting, never pretending to go beyond it. Drawing, design, and color are understood and practiced in Cubism in the spirit and manner that they are understood and practiced in

all other schools. Our subjects might be different, as we have introduced into painting objects and forms that were formerly ignored. We have kept our eyes open to our surroundings, and also our brains.

We give to form and color all their individual significance, as far as we can see it; in our subjects, we keep the joy of discovery, the pleasure of the unexpected; our subject itself must be a source of interest. But of what use is it to say what we do when everybody can see it if he wants to?

### *Pablo Picasso, On Les Demoiselles d'Avignon, 1933**

*"Les Demoiselles d'Avignon"* [1]—how that title can excite me! It was [André] Salmon who invented it. As you know very well, in the beginning it was called *The Brothel of Avignon.* Do you know why? "Avignon" has always been a familiar word to me, one woven into my life. I used to live a few steps away from the Calle d'Avignon [Barcelona], where I used to buy my paper and water colors. Then too, as you know, Max [Jacob's] grandmother was originally from Avignon. We used to make a lot of jokes about that painting. One of the women was Max's grandmother, Fernande was another one, Marie Laurencin another—all in a brothel in Avignon.

According to my first idea, there were also going to be men in the painting—you have seen the drawings for them, too. There was a student holding a skull, and a sailor. The women were eating—that explains the basket of fruit that is still in the painting. Then it changed and became what it is now.

### *Pablo Picasso, Conversation, 1935†*

We might adopt for the artist the joke about there being nothing more dangerous than implements of war in the hands of generals. In the same way, there is nothing more dangerous than justice in the hands of judges, and a paintbrush in the hands of a painter. Just think of the danger to society! But today we haven't the heart to expel the painters and poets from society because we refuse to admit to ourselves that there is any danger in keeping them in our midst.

---

* From an interview, 2 December 1933, with Daniel-Henry Kahnweiler published in *Le Point* (Souillac), XLII (October 1952), 24.

[1] Although *Les Demoiselles d'Avignon* (The Museum of Modern Art, New York), painted in 1907, marks the beginning of Cubism, this is the first direct mention of it by Picasso. It seems worthwhile to print his words, even though they were spoken much later. See also André Salmon's 1912 description of it while it was being painted (above).

† An interview with Christian Zervos published as "Conversation avec Picasso," in *Cahiers d'Art* (Paris), X, 7–10, 1935, 173–178. This English translation from *Picasso; Fifty Years of His Art* by Alfred H. Barr, Jr., copyright 1946 by The Museum of Modern Art, New York, and reprinted with its permission. Christian Zervos put down these remarks of Picasso immediately after a conversation with him at Boisgeloup in 1935. Picasso went over the notes and approved them informally. The above translation is based on one by Myfanwy Evans.

Zervos, a close friend of Picasso, was editor of *Cahiers d'Art*, established in 1926. It was the leading European journal concerned with contemporary art and in it Zervos published numerous articles by himself on Picasso as well as illustrations of his art.

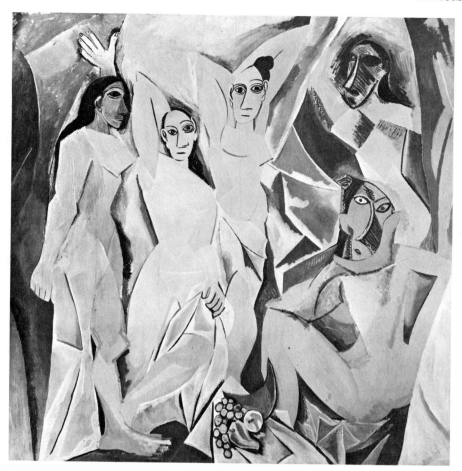

*Pablo Picasso, Les Demoiselles d'Avignon,*
*1907, oil on canvas.*

It is my misfortune—and probably my delight—to use things as my passions tell me. What a miserable fate for a painter who adores blondes to have to stop himself putting them into a picture because they don't go with the basket of fruit! How awful for a painter who loathes apples to have to use them all the time because they go so well with the cloth. I put all the things I like into my pictures. The things—so much the worse for them; they just have to put up with it.

In the old days pictures went forward toward completion by stages. Every day brought something new. A picture used to be a sum of additions. In my case a picture is a sum of destructions. I do a picture—then I destroy it. In the end, though, nothing is lost; the red I took away from one place turns up somewhere else.

267

*Fernande Olivier, Portrait of Picasso, drawing.*

It would be very interesting to preserve photographically, not the stages, but the metamorphoses of a picture. Possibly one might then discover the path followed by the brain in materializing a dream. But there is one very odd thing—to notice that basically a picture doesn't change, that the first "vision" remains almost intact, in spite of appearances. I often ponder on a light and a dark when I have put them into a picture; I try hard to break them up by interpolating a color that will create a different effect. When the work is photographed, I note that what I put in to correct my first vision has disappeared, and that, after all, the photographic image corresponds with my first vision before the transformation I insisted on.

A picture is not thought out and settled beforehand. While it is being done it changes as one's thoughts change. And when it is finished, it still goes on changing, according to the state of mind of whoever is looking at it. A picture lives a life like a living creature, undergoing the changes imposed on us by our life from day to day. This is natural enough, as the picture lives only through the man who is looking at it.

At the actual time that I am painting a picture I may think of white and put down white. But I can't go on working all the time thinking of white and painting it. Colors, like features, follow the changes of the emotions. You've seen the sketch I did for a picture with all the colors indicated on it. What is left of them? Certainly the white I thought of and the green I thought of are there in the picture, but not in the places I intended, nor in the same quantities. Of course, you can paint pictures by matching up different parts of them so that they go quite nicely together, but they'll lack any kind of drama.

I want to get to the stage where nobody can tell how a picture of mine is

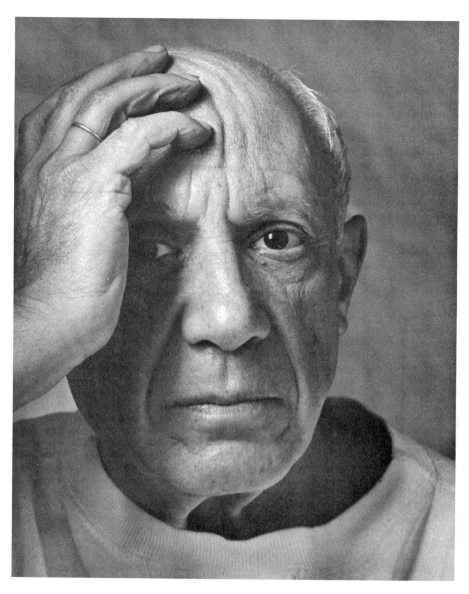

*Pablo Picasso.*
*Photograph by Arnold Newman.*

done. What's the point of that? Simply that I want nothing but emotion to be given off by it.

Work is a necessity for man.

A horse does not go between the shafts of its own accord.

Man invented the alarm clock.

When I begin a picture, there is somebody who works with me. Toward the end, I get the impression that I have been working alone—without a collaborator.

When you begin a picture, you often make some pretty discoveries. You must be on guard against these. Destroy the thing, do it over several times. In each destroying of a beautiful discovery, the artist does not really suppress it, but rather transforms it, condenses it, makes it more substantial. What comes out in the end is the result of discarded finds. Otherwise, you become your own connoisseur. I sell myself nothing.

Actually, you work with few colors. But they seem like a lot more when each one is in the right place.

Abstract art is only painting. What about drama?

There is no abstract art. You must always start with something. Afterward you can remove all traces of reality. There's no danger then, anyway, because the idea of the object will have left an indelible mark. It is what started the artist off, excited his ideas, and stirred up his emotions. Ideas and emotions will in the end be prisoners in his work. Whatever they do, they can't escape from the picture. They form an integral part of it, even when their presence is no longer discernible. Whether he likes it or not, man is the instrument of nature. It forces on him its character and appearance. In my Dinard pictures and in my Pourville pictures I expressed very much the same vision. However, you yourself have noticed how different the atmosphere of those painted in Brittany is from those painted in Normandy, because you recognized the light of the Dieppe cliffs. I didn't copy this light nor did I pay it any special attention. I was simply soaked in it. My eyes saw it and my subconscious registered what they saw: my hand fixed the impression. One cannot go against nature. It is stronger than the strongest man. It is pretty much to our interest to be on good terms with it! We may allow ourselves certain liberties, but only in details.

Nor is there any "figurative" and "nonfigurative" art. Everything appears to us in the guise of a "figure." Even in metaphysics ideas are expressed by means of symbolic "figures." See how ridiculous it is then to think of painting without "figuration." A person, an object, a circle are all "figures"; they react on us more or less intensely. Some are nearer our sensations and produce emotions that touch our affective faculties; others appeal more directly to the intellect. They all should be allowed a place because I find my spirit has quite as much need of emotion as my senses. Do you think it concerns me that a particular picture of mine represents two people? Though these two people once existed for me, they exist no longer. The "vision" of them gave me a preliminary emotion; then little by little their

actual presences became blurred; they developed into a fiction and then disappeared altogether, or rather they were transformed into all kinds of problems. They are no longer two people, you see, but forms and colors: forms and colors that have taken on, meanwhile, the idea of two people and preserve the vibration of their life.

I deal with painting as I deal with things, I paint a window just as I look out of a window. If an open window looks wrong in a picture, I draw the curtain and shut it, just as I would in my own room. In painting, as in life, you must act directly. Certainly, painting has its conventions, and it is essential to reckon with them. Indeed, you can't do anything else. And so you always ought to keep an eye on real life.

The artist is a receptacle for emotions that come from all over the place: from the sky, from the earth, from a scrap of paper, from a passing shape, from a spider's web. That is why we must not discriminate between things. Where things are concerned there are no class distinctions. We must pick out what is good for us where we can find it—except from our own works. I have a horror of copying myself. But when I am shown a portfolio of old drawings, for instance, I have no qualms about taking anything I want from them.

When we invented Cubism we had no intention whatever of inventing Cubism. We wanted simply to express what was in us. Not one of us drew up a plan of campaign, and our friends, the poets, followed our efforts attentively, but they never dictated to us. Young painters today often draw up a program to follow, and apply themselves like diligent students to performing their tasks.

The painter goes through states of fullness and evaluation. That is the whole secret of art, I go for a walk in the forest of Fontainebleau. I get "green" indigestion. I must get rid of this sensation into a picture. Green rules it. A painter paints to unload himself of feelings and visions. People seize on painting to cover up their nakedness. They get what they can wherever they can. In the end I can't believe they get anything at all. They've simply cut a coat to the measure of their own ignorance. They make everything, from God to a picture, in their own image. That is why the picture-hook is the ruination of a painting—a painting which has always a certain significance, at least as much as the man who did it. As soon as it is brought and hung on a wall, it takes on quite a different kind of significance, and the painting is done for.

Academic training in beauty is a sham. We have been deceived, but so well deceived that we can scarcely get back even a shadow of the truth. The beauties of the Parthenon, Venuses, Nymphs, Narcissuses are so many lies. Art is not the application of a canon of beauty but what the instinct and the brain can conceive beyond any canon. When we love a woman we don't start measuring her limbs. We love with our desires—although everything has been done to try and apply a canon even to love. The Parthenon is really only a farmyard over which someone put a roof; colonnades and sculptures were added because there were people in Athens who happened to be working, and wanted to express themselves. It's not

what the artist *does* that counts, but what he *is*. Cézanne would never have interested me a bit if he had lived and thought like Jacques Emile Blanche, even if the apple he painted had been ten times as beautiful. What forces our interest is Cézanne's anxiety—that's Cézanne's lesson; the torments of Van Gogh—that is the actual drama of the man. The rest is a sham.

Everyone wants to understand art. Why not try to understand the songs of a bird? Why does one love the night, flowers, everything around one, without trying to understand them? But in the case of a painting people have to *understand*. If only they would realize above all that an artist works of necessity, that he himself is only a trifling bit of the world, and that no more importance should be attached to him than to plenty of other things which please us in the world, though we can't explain them. People who try to explain pictures are usually barking up the wrong tree. Gertrude Stein joyfully announced to me the other day that she had at last understood what my picture of the three musicians was meant to be. It was a still life!

How can you expect an onlooker to live a picture of mine as I lived it? A picture comes to me from miles away: who is to say from how far away I sensed it, saw it, painted it; and yet the next day I can't see what I've done myself. How can anyone enter into my dreams, my instincts, my desires, my thoughts, which have taken a long time to mature and to come out into the daylight, and above all grasp from them what I have been about—perhaps against my own will?

With the exception of a few painters who are opening new horizons to painting, young painters today don't know which way to go. Instead of taking up our researches in order to react clearly against us, they are absorbed with bringing the past back to life—when truly the whole world is open before us, everything waiting to be done, not just redone. Why cling desperately to everything that has already fulfilled its promise? There are miles of painting "in the manner of"; but it is rare to find a young man working in his own way.

Does he wish to believe that man can't repeat himself? To repeat is to run counter to spiritual laws; essentially escapism.

I'm no pessimist, I don't loathe art, because I couldn't live without devoting all my time to it. I love it as the only end of my life. Everything I do connected with it gives me intense pleasure. But still, I don't see why the whole world should be taken up with art, demand its credentials, and on that subject give free rein to its own stupidity. Museums are just a lot of lies, and the people who make art their business are mostly imposters. I can't understand why revolutionary countries should have more prejudices about art than out-of-date countries! We have infected the pictures in museums with all our stupidities, all our mistakes, all our poverty of spirit. We have turned them into petty and ridiculous things. We have been tied up to a fiction, instead of trying to sense what inner life there was in the men who painted them. There ought to be an absolute dictatorship . . . a dictatorship of painters . . . a dictatorship of one painter . . . to suppress all those who have betrayed us, to suppress the cheaters, to suppress the tricks, to suppress

mannerisms, to suppress charms, to suppress history, to suppress a heap of other things. But common sense always gets away with it. Above all, let's have a revolution against that! The true dictator will always be conquered by the dictatorship of common sense . . . and maybe not!

## Pablo Picasso, *An idea is a beginning point and no more . . .*★

Do you know that when I painted my first guitars I had never had one in my hands? With the first money they gave me I bought one, and after that I never painted another. People think that bullfights in my pictures were copied from life, but they are mistaken. I used to paint them before I'd seen the bullfight so as to make money to buy my ticket. Have you really done what you planned to do? On leaving your house, do you not often change your route without thinking about it? Do you cease to be yourself on that account? And do you not get there anyhow? And even if you don't, does it matter? The reason is that you didn't have to go in the first place, and you would have been wrong to force destiny.

An idea is a beginning point and no more. If you contemplate it, it becomes something else. What I think about a great deal, I find I have always had complete in my mind. How can you then expect me to continue being interested in it? If I persist, it turns out differently because a different matter intervenes. As far as I am concerned, at any rate, my original idea has no further interest, because while I am realizing it I think about something else.

The important thing is to create. Nothing else matters; creation is all.

Have you ever seen a finished picture? A picture or anything else? Woe unto you the day it is said that you are finished! To finish a work? To finish a picture? What nonsense! To finish it means to be through with it, to kill, to rid it of its soul, to give it its final blow: the most unfortunate one for the painter as well as for the picture.

The value of a work resides precisely in what it is not.

## Pablo Picasso, *Found Objects, 1945*†

You remember that bull's head I exhibited recently? Out of the handle bars and bicycle seat I made a bull's head which everybody recognized as a bull's head. Thus

★ This English translation by Angel Flores from the London edition (pp. 145–147), *Picasso, An Intimate Portrait* (New York: Prentice-Hall, 1948; London: Allen, 1949). Original manuscript published later in Jaime Sabartes, *Retratos y recuerdos* (Madrid: 1953).

Sabartes had been a close friend of Picasso during his youth in Barcelona and Paris, and after a long separation had joined him again in Paris in 1935. This time they lived together, Sabartes assuming the position of secretary and constant companion. This biography of Picasso, undertaken at the suggestion of the artist, is one of the most detailed of all accounts of his life.

† Excerpt from an interview with André Warnod published as "En peinture tout n'est que signe, nous dit Picasso," *Arts* (Paris), 29 June 1945, pp. 1, 4. From *Picasso: Fifty Years of His Art* by Alfred H. Barr, Jr., copyright 1946 by The Museum of Modern Art, New York, and reprinted with its permission.

a metamorphosis was completed; and now I would like to see another metamorphosis take place in the opposite direction. Suppose my bull's head is thrown on the scrap heap. Perhaps some day a fellow will come along and say: "Why there's something that would come in very handy for the handle bars of my bicycle . . . ." And so a double metamorphosis would have been achieved.

### *Juan Gris, Response to a questionnaire on his art, 1921*★

I work with the elements of the intellect, with the imagination. I try to make concrete that which is abstract. I proceed from the general to the particular, by which I mean that I start with an abstraction in order to arrive at a true fact. Mine is an art of synthesis, of deduction, as Raynal has said.

I want to endow the elements I use with a new quality; starting from general types I want to construct particular individuals.

I consider that the architectural element in painting is mathematics, the abstract side; I want to humanize it. Cézanne turns a bottle into a cylinder, but I begin with a cylinder and create an individual of a special type: I make a bottle—a particular bottle—out of a cylinder. Cézanne tends towards architecture, I tend away from it. That is why I compose with abstractions (colors) and make my adjustments when these colors have assumed the form of objects. For example, I make a composition with a white and a black and make adjustments when the white has become a paper and the black a shadow: what I mean is that I adjust the white so that it becomes a paper and the black so that it becomes a shadow.

This painting is to the other what poetry is to prose.

Though in my *system* I may depart greatly from any form of idealistic or naturalistic art, in practice I cannot break away from the Louvre. Mine is the method of all times, the method used by the old masters: there are technical *means* and they remain constant.

### *Juan Gris, Response to a questionnaire on Cubism, 1925*†

Cubism? As I never consciously, and after mature reflection, became a Cubist but, by dint of working along certain lines, have been classed as such, I have never

★ Originally published in *L'Esprit Nouveau* (Paris), No. 5, February 1921, 533–534. This English translation by Douglas Cooper from the London edition (p. 138), Daniel-Henry Kahnweiler, *Juan Gris, His Life and Work* (London: Lund Humphries, 1947; New York; Valentin, 1947). Used by permission of Editions Gallimard, Paris.

Gris's theories reflect the fact that he entered into the Cubist movement and began painting only in 1911 in the later or "Synthetic" phase. After the war, when the movement had become widely recognized, the editors of *L'Esprit Nouveau* (Amédée Ozenfant and Charles-Edouard Jeanneret [Le Corbusier]) sought out explanations of Cubism from the artists.

† First published as a response to a questionnaire, "Chez les cubistes," in *Bulletin de la Vie Artistique*, eds. Félix Fénéon, Guillaume Janneau, and others (Paris), VI, 1 (1 January 1925), 15–17. English translation from Kahnweiler, *Juan Gris*, pp. 144–145. Janneau based his book *L'Art Cubiste* (Paris: Moreau, 1929) on this series of interviews.

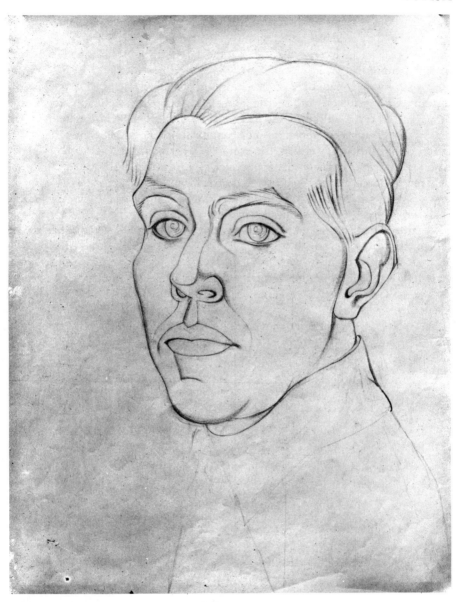

*Juan Gris, Self–Portrait, 1921, drawing.*

thought about its causes and its character like someone outside the movement who has meditated on it before adopting it.

Today I am clearly aware that, at the start, Cubism was simply a new way of representing the world.

By way of natural reaction against the fugitive elements employed by the Impressionists, painters felt the need to discover less unstable elements in the objects to be represented. And they chose that category of elements which remains in the mind through apprehension and is not continually changing. For the momentary effects of light they substituted, for example, what they believed to be the local colors of objects. For the visual appearance of a form they substituted what they believed to be the actual quality of this form.

But that led to a kind of representation which was purely descriptive and analytical, for the only relationship that existed was that between the intellect of the painter and the objects and practically never was there any relationship between the objects themselves.

Moreover, this is perfectly natural, for each new branch of intellectual activity always begins with description: that is to say, with analysis, classification. Before the existence of physics as a science, men described and classified physical phenomena.

Now I know perfectly well that when it began Cubism was a sort of analysis which was no more painting than the description of physical phenomena was physics.

*Juan Gris, Hommage à Pablo Picasso, 1911–1912, oil on canvas.*

But now that all the elements of the aesthetic known as "Cubist" can be measured by its pictorial technique, now that the analysis of yesterday has become a synthesis by the expression of the relationships between the objects themselves, this reproach is no longer valid. If what has been called "Cubism" is only an appearance, then Cubism has disappeared; if it is an aesthetic, then it has been absorbed into painting.

So how do you think that at this moment I can even consider the possibility of expressing myself "sometimes in the Cubist manner, sometimes in another artistic manner," since for me Cubism is not a manner?

Cubism is not a manner but an aesthetic, and even a state of mind; it is therefore inevitably connected with every manifestation of contemporary thought. It is possible to invent a technique or a manner independently, but one cannot invent the whole complexity of a state of mind.

But now I see that I have after all given you an approximate account of the development of my own painting, instead of strictly answering your questions.

*Fernand Léger, from "The Aesthetic of the Machine," 1924* ★

*Modern man lives more and more in a preponderantly geometric order.*

*All human creation mechanical or industrial is dependent upon geometric intentions.*

I wish especially to speak about the *prejudice* which blinds three-fourths of mankind and absolutely prevents them from ever attaining a free judgment of the ugly or beautiful phenomena by which they are surrounded. I believe that plastic beauty in general is totally independent of sentimental, descriptive, or imitative values. Every object, picture, piece of architecture, or ornamental organization has a value in itself; it is strictly absolute and independent of anything it may happen to represent.

Many individuals would be sensitive to the beauty of common objects, *without artistic intention*, if the preconceived notion of the *objet d'art* were not a bandage over their eyes. Bad visual education is the cause of this tendency, as is the modern mania for classification at all costs which categorizes individuals as well as tools. Men are *afraid of free consideration*, which, however, is the only possible spiritual state which permits reception of the beautiful. Victims of a critical, skeptical, and intellectual epoch, they strain themselves in the attempt to understand instead of relying upon their sensibility. "They have faith in the *fabricators of the arts*" because they are professionals. Titles and distinctions dazzle them and block their view. My aim here is to attempt to prove: that there is no such thing as Beauty that is catalogued, *hiérarchisée*; this is the worst possible error. Beauty is everywhere, in the arrangement of your pots and pans, on the white wall of your kitchen, more perhaps than in your eighteenth-century salon or in the official museum.

★ From *Bulletin de l'Effort Moderne* (Paris) I, 1 and 2 (January and February 1924), 5–9.

I would like therefore to speak about a new architectural order: *the architecture of the mechanical*. All of ancient and modern architecture, too, proceeds from geometric intentions.

In Greek art horizontal lines were made to dominate. It influenced the entire French seventeenth century. The Romanesque: vertical lines. The Gothic realized an equilibrium that was often perfect between the play of curves and of straight lines; it even arrived at that astonishing thing—a mobile architecture. There are Gothic façades that vibrate like a dynamic painting; this is the result of an interplay of complementary and contrasting lines.

One can assert this: a machine or a manufactured object may be beautiful when the relation of the lines which define its volume are balanced in an order corresponding to those of preceding architectures. We are not, then, in the presence of an intrinsically new phenomenon, but simply of an architectural manifestation like those of the past.

Where the question becomes more delicate is when we envisage all the consequences, that is, the *purposes* of mechanical creation. If the objectives of preceding architectural monuments were the predominance of the Beautiful over the useful, it is undeniable that, in the mechanical order, the dominant aim is *utility*, strictly utility. Everything is directed toward utility with the greatest possible severity. *The tendency toward utility does not, however, impede the accession to a state of beauty.*

The case of the evolution of the automobile form is a striking example of my point; it is even a curious fact that the more the machine perfects its utilitarian functions, the more beautiful it becomes.

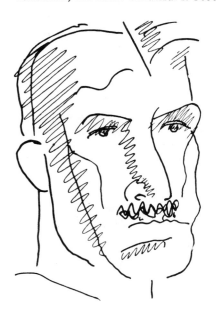

*Fernand Léger, Self-Portrait, 1922, drawing.*

That is to say, when vertical lines predominated in the beginning, contrary to its purpose, it was ugly—one looked for the horse. It was called a horseless carriage. But when, with the need for swiftness, it became lower and longer, when, in consequence, horizontal lines balanced by curves became dominant, it became a perfect whole logically organized for its end. It was beautiful.

But we must not conclude from this example of the relationship between beauty and utility in the auto that perfection of utility necessarily implies the perfection of beauty. I cannot deny that it may even be the contrary. I have laid eyes upon, but not remembered, frequent examples of the destruction of beauty by emphasis on the utilitarian.

Chance alone presides over the appearance of beauty in the manufactured object.

*Fernand Léger, from "A New Realism—the Object,"1926* ★

Every effort in the line of spectacle or moving-picture, should be concentrated on bringing out the values of the *object*—even at the expense of the subject and of every other so-called photographic element of interpretation, whatever it may be.

All current cinema is romantic, literary, historical expressionist, etc.

Let us forget all this and consider, if you please:

A pipe—a chair—a hand—an eye—a typewriter—a hat—a foot, etc., etc.

Let us consider these things for what they can contribute to the screen just as they are—*in isolation*—their value enhanced by every known means.

In this enumeration I have purposely included parts of the human body in order to emphasize the fact that in the new realism the human being, the personality, is very interesting only in these fragments and that these fragments should not be considered of any more importance than any of the other objects listed.

The technique emphasized is to isolate the object or the fragment of an object and to present it on the screen in close-ups of the largest possible scale. Enormous enlargement of an object or a fragment gives it a personality it never had before and in this way it can become a vehicle of entirely new lyric and plastic power.

I maintain that before the invention of the moving-picture no one knew the possibilities latent in a foot—a hand—a hat.

These objects were, of course, known to be useful—they were seen, but never looked at. On the screen they can be looked at—they can be discovered—and they are found to possess plastic and dramatic beauty when properly presented. We are in an epoch of specialization—of specialties. If manufactured objects are on the whole well realized, remarkably well finished—it is because they have been made and checked up by specialists.

★ From *The Little Review* (Paris) XI, 2 (Winter 1926), 7–8.

I propose to apply this formula to the screen and to study the plastic possibilities latent in the enlarged fragment, projected (as a close up) on the screen, specialized, seen and studied from every point of view both in movement and immobile . . . .

I repeat—for the whole point of this article is in this: the powerful—the spectacular effect of *the object* is entirely ignored at present.

# V  FUTURISM:
## Dynamism as the Expression
## of the Modern World

## INTRODUCTION: by Joshua C. Taylor*

On February 20, 1909, the energetic bilingual poet and editor, F. T. Marinetti, publisher of the controversial literary magazine *Poesia* (Milan), announced the movement of Futurism in a belligerent manifesto published on the front page of the Paris newspaper *Le Figaro*. The term Futurism caught the imagination of writers and artists throughout the world, as did Marinetti's insistence that the artist turn his back on past art and conventional procedures to concern himself with the vital, noisy life of the burgeoning industrial city. In Italy a group of painters gathered with the poets around Marinetti in 1909 to work out the implications of his manifesto for the visual arts. They published first a general manifesto, "The Manifestos of Futurist Painters," in February 1910, then, in March, the more specific "Futurist Painting: Technical Manifesto." It was not until much later in the year, however, that the painting of the three most notable of the first signers, Carlo Carrà (b. 1881), Umberto Boccioni (1882–1916), and Luigi Russolo (1885–1947), showed revolutionary formal changes consistent with the procedures set forth in the Technical Manifesto. Originally the manifestoes were subscribed to also by Aroldo Bonzagni and Romolo Romani, but they soon dropped out, and Gino Severini (b. 1883), working in Paris, and Giacomo Balla (1871–1958), in Rome, joined Boccioni, Carrà, and Russolo to form the closely knit group of Futurist painters.

In painting, the Futurist movement has often been erroneously considered an offshoot of Cubism. Actually, both its roots and its goals were very different, being more closely allied with those of the new movement in German painting which eventually was called Expressionism. A part of the confusion arose from the insistence of the Paris painters in reading the Technical Manifesto with the analytical procedures of Cubism in mind. The Italians, as insistent on maintaining their independence as the school of Paris was in maintaining its artistic dominance, repeatedly pointed out the differences in angry articles appearing in the journal *Lacerba*, published in Florence. The confusion has persisted, however, because several of the Futurist painters, Boccioni, Carrà, Soffici, and Severini (who, living in

---

* All translations in this chapter not otherwise credited are by Joshua C. Taylor.

*The Futurists in Paris, February 1912. (L to R: Luigi Russolo, Carlo Carrà F. T. Marinetti, Umberto Boccioni, Gino Severini.)*

Paris, was familiar with Cubism from the first), appropriated aspects of the formal language of Cubism, using them to serve their own ends. Boccioni and Carrà made contact with Cubist painting in 1911, first through publications, then on an autumn trip to Paris under the guidance of Severini. But the resemblance is superficial and, as Carrà points out in the following article, both the purpose and the effect of their painting were different.

The first major exhibition of Futurist painting was held in Milan, opening 30 April 1911. Beginning with an exhibition at the gallery of Bernheim-Jeune in Paris in February 1912, a group of Futurist works circulated through major European centers causing much comment and exerting considerable influence on public and artists alike. Exhibitions were held in England, Germany, and Holland, and illustrated reports of the exhibitions were widespread, appearing also in the American press. In 1913 Severini held a personal exhibition in London, and Boccioni, having published a revolutionary manifesto of Futurist sculpture in April 1912, showed his startling and original sculpture in Paris.

The poets kept pace with the painters and there was much cross-stimulation. In 1912 Marinetti published his theory of "free-word" poetry, in which evocative words printed in varying type faces and sizes, linked by

mathematical signs rather than grammatical connectives, were scattered dramatically over the page. The painters drew upon this idea and began to use words in their paintings, not, as in Cubism, for their forms, but as evocations of sounds and extra-pictorial associations.

Manifestoes were published also for music, first in July 1912 by Ballila Pratella, and Russolo devoted much of his time to experiments with music created by a battery of noise machines. He issued a manifesto, "The Art of Noises," in March 1913. A group experimented also with photography and moving pictures. Anton Giulio Bragaglia published a manifesto, "Fotodinamica Futurista," in Rome in 1912, and in September 1916 launched his "Manifesto of Futurist Cinema" and produced a full length Futurist film, *Perfido Incanto*. Theatrical performances also were staged which fore-shadowed in their shock and compulsive nonsense the later activity of the Dadaists.[1]

The young architect Antonio Sant'Elia joined forces with the Futurists in 1914 and republished his stirring proposals for a modern architecture, first used in an exhibition catalogue of that year, as a manifesto of Futurist architecture. His extraordinary designs, as well as his revolutionary manifesto, remained as inspiration for young architects. He himself was killed in the war in 1916.

The Futurist principle of "dynamism" as an expressive means, the painters' emphasis on process rather than on things (for which they cited the teachings of Henri Bergson as authority), and their emphasis upon the intuition and its power to synthesize the manifold experiences of sense and memory in a coherent "simultaneity," had profound effects on other movements: the Constructivists and their various branches, the English Vorticists, and subsequently on Dada and Surrealism.

By the end of 1914, the first phase of Futurism was drawing to a close; many of the original adherents were becoming critical of each other and of the constant pressure of Marinetti. With Italy's entry into the war in 1915, an event ardently promoted by Marinetti and his fellows, all effective artistic activity ceased. Both Boccioni and Sant'Elia were killed during the war, and Russolo was badly wounded. The group calling itself Futurist which formed around Marinetti after the war had little in common, either in artistic principles or in the quality of their achievement, with the original movement. Its vigorous tactics of propaganda, however, were esteemed by the new political leadership and the new Futurism became identified with Fascism.

[1] See *F. T. Marinetti Teatro*, ed. Giovanni Calendoli, 3 vols. (Rome, 1960).

## F. T. Martinetti, "The Foundation and Manifesto of Futurism," 1908*

We had been up all night, my friends and I, under the Oriental lamps with their pierced copper domes starred like our souls—for from them too burst the trapped lightning of an electric heart. We had tramped out at length on the luxurious carpets from the East our inherited sloth, disputing beyond the extremes of logic and blackening much paper with frenzied writing.

An immense pride swelled our chests because we felt ourselves alone at that hour, alert and upright like magnificent beacons and advance guard posts confronting the army of enemy stars staring down from their heavenly encampments. Alone with the stokers working before the infernal fires of the great ships; alone with the black phantoms that poke into the red-hot bellies of locomotives launched at mad speed; alone with the drunks reeling with their uncertain flapping of wings around the city walls.

Suddenly we started at the formidable sound of the enormous double-decked trams that jolted past, magnificent in multicolored lights like villages at holiday time that the flooded Po has suddenly rocked and wrenched from their foundations to carry over the cascades and through the whirlpools of a flood, down to the sea.

Then the silence became profound. But while we were listening to the interminable mumbled praying of the old canal and the creeking bones of the moribund palaces on their mossy, dank foundations, we suddenly heard automobiles roaring voraciously beneath our windows.

"Let's go!" I said, "Let's go, friends! Let's go out. Mythology and the Mystic Ideal are finally overcome. We are about to witness the birth of the centaur and soon we shall see the first angels fly!... The doors of life must be shaken to test the hinges and bolts!... Let's take off! Behold the very first dawn on earth! There is nothing to equal the splendor of the sun's rose-colored sword as it duels for the first time in our thousand-year darkness!..."

We went up to the three snorting beasts to pat lovingly their torrid breasts. I stretched out on my machine like a corpse on a bier; but I revived at once under the steering wheel, a guillotine blade that menaced my stomach.

The furious sweep of madness took us out of ourselves and hurled us through streets as rough and deep as stream beds. Here and there a sick lamp in a window taught us to mistrust the fallacious mathematics of our wasted eyes.

I cried, "The scent! The scent is enough for the beasts!..."

And we like young lions pursued Death with his black pelt spotted with pale crosses, streaking across the violet sky so alive and vibrant.

Yet we had no ideal lover reaching her sublime face to the clouds, nor a

* Originally published in *Le Figaro* (Paris) (20 February 1909). First English translation, made under Marinetti's direction, from *Poesia* (April–June 1909). Reprinted in the catalogue for the exhibition at Sackville Gallery, London, March 1912. First part, "Foundation," retranslated by Joshua C. Taylor.

*Alberto Grandi, Portrait of F. T. Marinetti, 1908, ink.*

cruel queen to whom to offer our bodies, twisted in the forms of Byzantine rings! Nothing to die for except the desire to free ourselves at last from our too exigent courage!

And we sped on, squashing the watchdogs on their doorsteps who curled up under our scorching tires like starched collars under a flat-iron. Death, domesticated, overtook me at every turn to graciously offer me her paw, and from time to time she would stretch out on the ground with the sound of grinding teeth to cast up soft caressing glances from every puddle.

"Let's break away from rationality as out of a horrible husk and throw ourselves like pride-spiced fruit into the immense distorted mouth of the wind! Let's give ourselves up to the unknown, not out of desperation but to plumb the deep pits of the absurd!"

I had hardly spoken these words when suddenly I spun around with a drunken lurch like a dog trying to bite his tail, and there all at once coming towards me were two cyclists, wavering in front of me like two equally persuasive but contradictory arguments. Their stupid dilemma was being disputed right in my way . . . . What a nuisance! Auff! . . . I stopped short and—disgusting—was hurled, wheels in the air, into a ditch . . . .

"Oh! maternal ditch, almost to the top with muddy water! Fair factory drainage ditch! I avidly savored your nourishing muck, remembering the holy black breast of my Sudanese nurse . . . . When I got out from under the upturned car—torn, filthy, and stinking—I felt the red hot iron of joy pass over my heart!

A crowd of fishermen armed with their poles, and some gouty naturalists were already crowding around the wonder. With patient and meticulous care they put up a high framework and enormous iron nets to fish out my automobile like a great beached shark. The machine emerged slowly, shedding at the bottom like scales its heavy body so sound, and its soft upholstery so comfortable.

They thought it was dead, my fine shark, but the stroke of my hand was enough to restore it to life, and there it was living again, speeding along once more on its powerful fins.

So, with face smeared in good waste from the factories—a plaster of metal slag, useless sweat, and celestial soot—bruised, arms bandaged, but undaunted, we declare our primary intentions to all *living* men of the earth:

1. We intend to glorify the love of danger, the custom of energy, the strength of daring.

2. The essential elements of our poetry will be courage, audacity, and revolt.

3. Literature having up to now glorified thoughtful immobility, ecstasy, and slumber, we wish to exalt the aggressive movement, the feverish insomnia, running, the perilous leap, the cuff, and the blow.

4. We declare that the splendor of the world has been enriched with a new form of beauty, the beauty of speed. A race-automobile adorned with great pipes like serpents with explosive breath ... a race-automobile which seems to rush over exploding powder is more beautiful than the *Victory of Samothrace*.

5. We will sing the praises of man holding the flywheel of which the ideal steering-post traverses the earth impelled itself around the circuit of its own orbit.

6. The poet must spend himself with warmth, brilliancy, and prodigality to augment the fervor of the primordial elements.

7. There is no more beauty except in struggle. No masterpiece without the stamp of aggressiveness. Poetry should be a violent assault against unknown forces to summon them to lie down at the feet of man.

8. We are on the extreme promontory of ages! Why look back since we must break down the mysterious doors of Impossibility? Time and Space died yesterday. We already live in the Absolute for we have already created the omnipresent eternal speed.

9. We will glorify war—the only true hygiene of the world—militarism, patriotism, the destructive gesture of anarchist, the beautiful Ideas which kill, and the scorn of woman.

10. We will destroy museums, libraries, and fight against moralism, feminism, and all utilitarian cowardice.

11. We will sing the great masses agitated by work, pleasure, or revolt; we will sing the multicolored and polyphonic surf of revolutions in modern capitals; the nocturnal vibration of arsenals and docks beneath their glaring electric moons; greedy stations devouring smoking serpents; factories hanging from the clouds by the threads of their smoke; bridges like giant gymnasts stepping over sunny rivers sparkling like diabolical cutlery; adventurous steamers scenting the horizon; large-breasted locomotives bridled with long tubes, and the slippery flight of airplanes whose propellers have flaglike flutterings and applauses of enthusiastic crowds.

*Umberto Boccioni, A Futurist Evening in Milan,
1911, drawing. (L to R: Boccioni, Pratella,
F. T. Marinetti, Carlo Carrà, and Luigi Russolo.)*

It is in Italy that we hurl this overthrowing and inflammatory declaration, with which today we found Futurism, for we will free Italy from her numberless museums which cover her with countless cemeteries.

Museums, cemeteries! . . . Identical truly, in the sinister promiscuousness of so many objects unknown to each other. Public dormitories, where one is forever slumbering beside hated or unknown beings. Reciprocal ferocity of painters and sculptors murdering each other with blows of form and color in the same museum.

That a yearly visit be paid there as one visits the grave of dead relatives, once a year! . . . We are ready to grant it! . . . That an annual offering of flowers be laid at the feet of the *Gioconda*, we conceive it! . . . But to take for a daily walk through the museums our spleen, lack of courage, and morbid restlessness, we will not grant it! . . . Why will you poison yourselves? Why will you decay?

What can one see in an old picture except the artist's laborious contortions, struggling to overcome the insuperable barriers ever resisting his desire to express his entire dream?

To admire an old picture is to pour our sentiment into a funeral urn instead of hurling it forth in violent gushes of action and productiveness. Will you thus consume your best strength in this useless admiration of the past from which you will forcibly come out exhausted, lessened, and trampled?

287

In truth, this daily frequenting of museums, libraries, and academies (those graveyards of vain efforts, those Mount Calvaries of crucified dreams, those registers of broken-down springs! . . .) is to the artist as the too-prolonged government of parents for intelligent young people, inebriated with their talent and ambitious will.

For the dying, invalids, and prisoners, let it pass. Perhaps the admirable past acts as a salve on their wounds, as they are forever debarred from the future . . . . But we will have none of it, we the young, the strong, the living futurists! . . .

Therefore welcome the kindly incendiarists with the carbon fingers! . . . Here they are! . . . Here! . . . Away and set fire to the bookshelves! . . . Turn the canals and flood the vaults of museums! . . . Oh! Let the glorious old pictures float adrift! Seize pickax and hammer! Sap the foundations of the venerable towns!

The oldest among us are thirty; we have thus at least ten years in which to accomplish our task. When we are forty, let others—younger and more daring men—throw us into the wastepaper basket like useless manuscripts! . . . They will come against us from far away, from everywhere, leaping on the cadence of their first poems, clawing the air with crooked fingers and scenting at the academy gates the good smell of our decaying minds already promised to the catacombs of libraries.

But we shall not be there. They will find us at least, on a winter's night, in the open country, in a sad, iron shed pitter-pattered by the monotonous rain, huddled round our trepidating airplanes, warming our hands at the miserable fire made with our present-day books flickering merrily in the sparkling flight of their images.

They will mutiny around us, panting with anguish and spite, exasperated one and all by our proud dauntless courage, they will rush to kill us, their hatred so much the stronger as their hearts will be overwhelmed with love and admiration for us! And powerful and healthsome Injustice will then burst radiantly in their eyes. For art can only be violence, cruelty, and injustice.

The oldest among us are thirty, yet we have already squandered treasures, treasures of strength, love, daring, and eager will, hastily, raving, without reckoning, never stopping, breathlessly. Look at us! We are not exhausted . . . . Our heart is not in the least weary! For it has been nourished on fire, hatred, and speed! . . . You are astonished? It is because you do not even remember living! . . .

Erect on the pinnacle of the world, we once more hurl forth our defiance to the stars.

Your objections? Enough! Enough! I know them! I quite understand what our splendid and mendacious intelligence asserts. We are, it says, but the result and continuation of our ancestors. —Perhaps! Be it so! . . . What of that? But we will not listen! Beware of repeating such infamous words! Rather hold your head up!

Erect on the pinnacle of the world we hurl forth once more our defiance to the stars! . . .

## "*Futurist Painting: Technical Manifesto,*" *11 April 1910*★

On the 8th of March, 1910, in the limelight of the Chiarella Theater of Turin, we launched our first Manifesto to a public of three thousand people—artists, men of letters, students and others; it was a violent and cynical cry which displayed our sense of rebellion, our deep-rooted disgust, our haughty contempt for vulgarity, for academic and pedantic mediocrity, for the fanatical worship of all that is old and worm-eaten.

We bound ourselves there and then to the movement of Futurist Poetry which was initiated a year earlier by F. T. Marinetti in the columns of the *Figaro.*

The battle of Turin has remained legendary. We exchanged almost as many knocks as we did ideas, in order to protect from certain death the genius of Italian Art.

And now during a temporary pause in this formidable struggle we come out of the crowd in order to expound with technical precision our program for the renovation of painting, of which our Futurist Salon at Milan was a dazzling manifestation.[1]

Our growing need of truth is no longer satisfied with Form and Color as they have been understood hitherto.

The gesture which we would reproduce on canvas shall no longer be a fixed *moment* in universal dynamism. It shall simply be the dynamic sensation itself (made eternal).

Indeed, all things move, all things run, all things are rapidly changing.

A profile is never motionless before our eyes, but it constantly appears and disappears. On account of the persistency of an image upon the retina, moving objects constantly multiply themselves; their form changes like rapid vibrations, in their mad career. Thus a running horse has not four legs, but twenty, and their movements are triangular.

All is conventional in art. Nothing is absolute in painting. What was truth for the painters of yesterday is but a falsehood today. We declare, for

---

★ Originally published as a pamphlet in Milan, 11 April 1910. This translation was made under Marinetti's guidance and published in the catalogue of the London exhibition. It differs in some minor points from the version published in the collected manifestoes of 1914 (*I Manifesti del Futurismo,* ed. F. T. Marinetti, [Florence: "Lacerba," 1914]).

[1] The "Salon" referred to is the "*Mostra d'arte libera,*" opened 30 April 1911. In most versions of the manifesto the following significant paragraph took the place of the above: "We were concerned then with the relation between ourselves and society. Today, instead, with this second manifesto, we resolutely shake off all relative considerations and ascend to the highest expressions of the pictorial absolute."

instance, that a portrait (to be a work of art) must not be like the sitter and that the painter carries in himself the landscapes which he would fix upon his canvas.

To paint a human figure you must not paint it; you must render the whole of its surrounding atmosphere.

Space no longer exists: the street pavement, soaked by rain beneath the glare of electric lamps, becomes immensely deep and gapes to the very center of the earth. Thousands of miles divide us from the sun; yet the house in front of us fits into the solar disk.

Who can still believe in the opacity of bodies, since our sharpened and multiplied sensitiveness has already penetrated the obscure manifestations of the medium? Why should we forget in our creations the doubled power of our sight capable of giving results analogous to those of the X-rays?

It will be sufficient to cite a few examples, chosen among thousands, to prove the truth of our arguments.

The sixteen people around you in a rolling motor bus are in turn and at the same time one, ten, four, three; they are motionless and they change places; they come and go, bound into the street, are suddenly swallowed up by the sunshine, then come back and sit before you, like persistent symbols of universal vibration.

How often have we not seen upon the cheek of the person with whom we were talking the horse which passes at the end of the street.

Our bodies penetrate the sofas upon which we sit, and the sofas penetrate our bodies. The motor bus rushes into the houses which it passes, and in their turn the houses throw themselves upon the motor bus and are blended with it.

The construction of pictures has hitherto been foolishly traditional. Painters have shown us the objects and the people placed before us. We shall henceforward put the spectator in the center of the picture.

As in every realm of the human mind, clear-sighted individual research has swept away the unchanging obscurities of dogma, so must the vivifying current of science soon deliver painting from academic tradition.

We would at any price re-enter into life. Victorious science has nowadays disowned its past in order the better to serve the material needs of our time; we would that art, disowning its past, were able to serve at last the intellectual needs which are within us.

Our renovated consciousness does not permit us to look upon man as the center of universal life. The suffering of a man is of the same interest to us as the suffering of electric lamp, which, with spasmodic starts, shrieks out the most heart-rending expressions of color.[1] The harmony of the lines and folds of modern dress works upon our sensitiveness with the same emotional and symbolical power as did the nude upon the sensitiveness of the old masters.

---

[1] In other publications this reads "expressions of grief."

F. T. Marinetti, *cover of Parole in libertà,*
*1919.*

In order to conceive and understand the novel beauties of a Futurist picture, the soul must be purified (become again pure); the eye must be freed from its veil of atavism and culture, so that it may at last look upon Nature and not upon the museum as the one and only standard.

As soon as ever this result has been obtained, it will be readily admitted that brown tints have never course beneath our skin; it will be discovered that yellow shines forth in our flesh, that red blazes, and that green, blue, and violet dance upon it with untold charms, voluptuous and caressing.

How is it possible still to see the human face pink, now that our life, redoubled by noctambulism, has mutliplied our perceptions as colorists? The human face is yellow, red, green, blue, violet. The pallor of a woman gazing in a jeweller's window is more intensely iridescent than the prismatic fires of the jewels that fascinate her like a lark.

The time has passed for our sensations in painting to be whispered. We wish them in future to sing and re-echo upon our canvases in deafening and triumphant flourishes.

Your eyes, accustomed to semidarkness, will soon open to more radiant visions of light. The shadows which we shall paint shall be more luminous than the highlights of our predecessors, and our pictures, next to those of the museums, will shine like blinding daylight compared with deepest night.

We conclude that painting cannot exist today without Divisionism. This is no process that can be learned and applied at will. Divisionism, for the modern painter, must be in INNATE COMPLEMENTARINESS, which we declare to be essential and necessary.

Our art will probably be accused of tormented and decadent cerebralism. But we shall merely answer that we are, on the contrary, the primitives of a new sensitiveness, multiplied hundredfold, and that our art is intoxicated with spontaneity and power.[1]

WE DECLARE:

1. THAT ALL FORMS OF IMITATION MUST BE DESPISED, ALL FORMS OF ORIGINALITY GLORIFIED.

2. THAT IT IS ESSENTIAL TO REBEL AGAINST THE TYRANNY OF THE TERMS "HARMONY" AND "GOOD TASTE" AS BEING TOO ELASTIC EXPRESSIONS, BY THE HELP OF WHICH IT IS EASY TO DEMOLISH THE WORKS OF REMBRANDT, OF GOYA AND OF RODIN.

3. THAT THE ART CRITICS ARE USELESS OR HARMFUL.

[1] In the publication of the collected manifestoes, in 1914, the following takes the place of this paragraph: "Finally, we reject the easy accusation of 'baroquism' with which some would like to confront us. The ideas we have presented here derive solely from our acute sensibility. While 'baroquism' signifies artificiality, irresponsible and devitalized virtuosity, the art we set forth is all spontaneity and power."

4. THAT ALL SUBJECTS PREVIOUSLY USED MUST BE SWEPT ASIDE IN ORDER TO EXPRESS OUR WHIRLING LIFE OF STEEL, OR PRIDE, OF FEVER AND OF SPEED.

5. THAT THE NAME OF "MADMAN" WITH WHICH IT IS ATTEMPTED TO GAG ALL INNOVATORS SHOULD BE LOOKED UPON AS A TITLE OF HONOR.

6. THAT INNATE COMPLEMENTARINESS IS AN ABSOLUTE NECESSITY IN PAINTING, JUST AS FREE METER IN POETRY OR POLYPHONY IN MUSIC.

7. THAT UNIVERSAL DYNAMISM MUST BE RENDERED IN PAINTING AS A DYNAMIC SENSATION.

8. THAT IN THE MANNER OF RENDERING NATURE THE FIRST ESSENTIAL IS IN SINCERITY AND PURITY.

9. THAT MOVEMENT AND LIGHT DESTROY THE MATERIALITY OF BODIES.

WE FIGHT:

1. AGAINST THE BITUMINOUS TINTS BY WHICH IT IS ATTEMPTED TO OBTAIN THE PATINA OF TIME UPON MODERN PICTURES.

2. AGAINST THE SUPERFICIAL AND ELEMENTARY ARCHAISM FOUNDED UPON FLAT TINTS, AND WHICH, BY IMITATING THE LINEAR TECHNIQUE OF THE EGYPTIANS, REDUCES PAINTING TO A POWERLESS SYNTHESIS, BOTH CHILDISH AND GROTESQUE.

3. AGAINST THE FALSE CLAIMS TO BELONG TO THE FUTURE PUT FORWARD BY THE SECESSIONISTS AND THE INDEPENDENTS, WHO HAVE INSTALLED NEW ACADEMIES NO LESS TRITE AND ATTACHED TO ROUTINE THAN THE PRECEDING ONES.

4. AGAINST THE NUDE IN PAINTING, AS NAUSEOUS AND AS TEDIOUS AS ADULTERY IN LITERATURE.

We wish to explain this last point. Nothing is *immoral* in our eyes; it is the monotony of the nude against which we fight. We are told that the subject is nothing and that everything lies in the manner of treating it. That is agreed; we, too, admit that. But this truism, unimpeachable and absolute fifty years ago, is no longer so today with regard to the nude, since artists obsessed with the desire to expose the bodies of their mistresses have transformed the Salons into arrays of unwholesome flesh!

*We demand, for ten years, the total suppression of the nude in painting.*[1]

UMBERTO BOCCIONI, *painter* (Milan)
CARLO D. CARRÀ, *painter* (Milan)
LUIGI RUSSOLO, *painter* (Milan)
GIACOMO BALLA, *painter* (Rome)
GINO SEVERINI, *painter* (Paris)

[1] In the publication of the collected manifestoes in 1914 these final two paragraphs were omitted. In their place was the following:

"You think us mad. We are, instead, the primitives of a new, completely transformed sensibility.

"Outside the atmosphere in which we live are only shadows. We Futurists ascend towards the highest and most radiant peak and proclaim ourselves Lords of Light, for already we drink from the live founts of the sun."

*"The Exhibitors to the Public," 1912* \*

We may declare, without boasting, that the first Exhibition of Italian Futurist Painting, recently held in Paris and now brought to London, is the most important exhibition of Italian painting which has hitherto been offered to the judgment of of Europe.

For we are young and our art is violently revolutionary.

What we have attempted and accomplished, while attracting around us a large number of skillful imitators and as many plagiarists without talent, has placed us at the head of the European movement in painting, by a road different from, yet, in a way, parallel with that followed by the Postimpressionists, Synthetists, and Cubists of France, led by their masters Picasso, Braque, Derain, Metzinger, Le Fauconnier, Gleizes, Léger, Lhote, etc.

While we admire the heroism of these painters of great worth, who have displayed a laudable contempt for artistic commercialism and a powerful hatred of academism, we feel ourselves and we declare ourselves to be absolutely opposed to their art.

They obstinately continue to paint objects motionless, frozen, and all the static aspects of Nature; they worship the traditionalism of Poussin, of Ingres, of Corot, aging and petrifying their art with an obstinate attachment to the past, which to our eyes remains totally incomprehensible.

We, on the contrary, with points of view pertaining essentially to the future, seek for a style of motion, a thing which has never been attempted before.

Far from resting upon the examples of the Greeks and the Old Masters, we constantly extol individual intuition; our object is to determine completely new laws which may deliver painting from the wavering uncertainty in which it lingers.

Our desire, to give as far as possible to our pictures a solid construction, can never bear us back to any tradition whatsoever. Of that we are firmly convinced.

All the truths learned in the schools or in the studios are abolished for us. Our hands are free enough and pure enough to start everything afresh.

It is indisputable that several of the aesthetic declarations of our French comrades display a sort of masked academism.

Is it not, indeed, a return to the Academy to declare that the subject, in painting, is of perfectly insignificant value?

We declare, on the contrary, that there can be no modern painting without

---

\* Catalogue introduction to the exhibition that opened at Bernheim-Jeune in Paris in February 1912 and then circulated to various European countries. The English translation is from the Sackville Gallery catalogue, London. It was published in the United States in the deluxe catalogue of the art exhibitions in the Panama-Pacific Exhibition in San Francisco, 1915, the first showing of Futurist painting in the United States.

the starting point of an absolutely modern sensation, and none can contradict us when we state that *painting* and *sensation* are two inseparable words.

If our pictures are Futurist, it is because they are the result of absolutely Futurist conceptions, ethical, aesthetic, political, and social.

To paint from the posing model is an absurdity, and an act of mental cowardice, even if the model be translated upon the picture in linear, spherical, or cubic forms.

To lend an allegorical significance to an ordinary nude figure, deriving the meaning of the picture from the objects held by the model or from those which are arranged about him, is to our mind the evidence of a traditional and academic mentality.

This method, very similar to that employed by the Greeks, by Raphael, by Titian, by Veronese, must necessarily displease us.

While we repudiate Impressionism, we emphatically condemn the present reaction which, in order to kill Impressionism, brings back painting to old academic forms.

It is only possible to react against Impressionism by surpassing it.

Nothing is more absurd than to fight it by adopting the pictural laws which preceded it.

The points of contact which the quest of style may have with the so-called *classic art* do not concern us.

Others will seek, and will, no doubt, discover, these analogies which in any case cannot be looked upon as a return to methods, conceptions, and values transmitted by classical painting.

A few examples will illustrate our theory.

We see no difference between one of those nude figures commonly called *artistic* and an anatomical plate. There is, on the other hand, an enormous difference between one of these nude figures and our Futurist conception of the human body.

Perspective, such as it is understood by the majority of painters, has for us the very same value which they give to an engineer's design.

The simultaneousness of states of mind in the work of art: that is the intoxicating aim of our art.

Let us explain again by examples. In painting a person on a balcony, seen from inside the room, we do not limit the scene to what the square frame of the window renders visible; but we try to render the sum total of visual sensations which the person on the balcony has experienced; the sun-bathed throng in the street, the double row of houses which stretch to right and left, the beflowered balconies, etc. This implies the simultaneousness of the ambient, and, therefore, the dislocation and dismemberment of objects, the scattering and fusion of details, freed from accepted logic, and independent from one another.[1]

[1] Boccioni, who was chiefly responsible for this preface, here describes his *The Noise of the Street Penetrates the House.*

In order to make the spectator live in the center of the picture, as we express it in our manifesto, the picture must be the synthesis of *what one remembers and of what one sees.*

You must render the invisible which stirs and lives beyond intervening obstacles, what we have on the right, on the left, and behind us, and not merely the small square of life artificially compressed, as it were, by the wings of a stage.

We have declared in our manifesto that what must be rendered is the *dynamic sensation*, that is to say, the particular rhythm of each object, its inclination, its movement, or, to put it more exactly, its interior force.

It is usual to consider the human being in its different aspects of motion or stillness, of joyous excitement or grave melancholy.

What is overlooked is that all inanimate objects display, by their lines, calmness or frenzy, sadness or gaiety. These various tendencies lend to the lines of which they are formed a sense and character of weighty stability or of aerial lightness.

Every object reveals by its lines how it would resolve itself were it to follow the tendencies of its forces.

This decomposition is not governed by fixed laws but it varies according to the characteristic personality of the object and the emotions of the onlooker.

Furthermore, every object influences its neighbor, not by reflections of light (the foundation of *impressionistic primitivism*), but by a real competition of lines and by real conflicts of planes, following the emotional law which governs the picture (the foundation of *Futurist primitivism*).

With the desire to intensify the aesthetic emotions by blending, so to speak, the painted canvas with the soul of the spectator, we have declared that the latter "*must in future be placed in the center of the picture.*"

He shall not be present at, but participate in, the action. If we paint the phases of a riot, the crowd bustling with uplifted fists, and the noisy onslaughts of cavalry are translated upon the canvas in sheaves of lines corresponding with all the conflicting forces, following the general law of violence of the picture.

These *force-lines* must encircle and involve the spectator so that he will in a manner be forced to struggle himself with the persons in the picture.

All objects, in accordance with what the painter Boccioni happily terms *physical transcendentalism*, tend to the infinite by their *force-lines*, the continuity of which is measured by our intuition.

It is these *force-lines* that we must draw in order to lead back the work of art to true painting. We interpret nature by rendering these objects upon the canvas as the beginnings or the prolongations of the rhythms impressed upon our sensibility by these very objects.

After having, for instance, reproduced in a picture the right shoulder or the right ear of a figure, we deem it totally vain and useless to reproduce the left shoulder or the left ear. We do not draw sounds, but their vibrating intervals. We do not paint diseases, but their symptoms and the consequences.

We may further explain our idea by a comparison drawn from the evolution of music.

Not only have we radically abandoned the motive fully developed according to its determined and, therefore, artificial equilibrium, but we suddenly and purposely intersect each motive with one or more other motives of which we never give the full development but merely the initial, central, or final notes.

As you see, there is with us not merely variety, but chaos and clashing of rhythms, totally opposed to one another, which we nevertheless assemble into a new harmony.

We thus arrive at what we call the *painting of states of mind*.

In the pictorial description of the various states of mind of a leave-taking, perpendicular lines, undulating and as it were worn out, clinging here and there to silhouettes of empty bodies, may well express languidness and discouragement.

Confused and trepidating lines, either straight or curved, mingled with the outlined hurried gestures of people calling one another, will express a sensation of chaotic excitement.

On the other hand, horizontal lines, fleeting, rapid, and jerky, brutally cutting into half-lost profiles of faces or crumbling and rebounding fragments of landscape, will give the tumultuous feelings of the persons going away.

It is practically impossible to express in words the essential values of painting.

The public must also be convinced that in order to understand aesthetic sensations to which one is not accustomed, it is necessary to forget entirely one's intellectual culture, not in order to *assimilate* the work of art, but to *deliver one's self up* to it heart and soul.

We are beginning a new epoch of painting.

We are sure henceforward of realizing conceptions of the highest importance and the most unquestionable originality. Others will follow who, with equal daring and determination will conquer those summits of which we can only catch a glimpse. That is why we have proclaimed ourselves to be *the primitives of a completely renovated sensitiveness.*

In several of the pictures which we are presenting to the public, vibration and motion endlessly multiply each object. We have thus justified our famous statement regarding the *"running horse which has not four legs, but twenty."*

One may remark, also, in our pictures spots, lines, zones of color which do not correspond to any reality, but which, in accordance with a law of our interior mathematics, musically prepare and enhance the emotion of the spectator.

We thus create a sort of emotive ambience, seeking by intuition the sympathies and the links which exist between the exterior (concrete) scene and the interior (abstract) emotion. Those lines, those spots, those zones of color, apparently illogical and meaningless, are the mysterious keys to our pictures.

We shall no doubt be taxed with an excessive desire to define and express in tangible form the subtle ties which unite our abstract interior with the concrete exterior.

Yet, could we leave an unfettered liberty of understanding to the public which always sees as it has been taught to see, through eyes warped by routine?

We go our way, destroying each day in ourselves and in our pictures the realistic forms and the obvious details which have served us to construct a bridge of understanding between ourselves and the public. In order that the crowd may enjoy our marvelous spiritual world, of which it is ignorant, we give it the material sensation of that world.

We thus reply to the coarse and simplistic curiosity which surrounds us by the brutally realistic aspects of our primitivism.

Conclusion: Our Futurist painting embodies three new conceptions of painting:

1. That which solves the question of volumes in a picture, as opposed to the liquefaction of objects favored by the vision of the Impressionists.

2. That which leads us to translate objects according to the *force-lines* which distinguish them, and by which is obtained an absolutely new power of objective poetry.

3. That (the natural consequence of the other two) which would give the emotional ambience of a picture, the synthesis of the various abstract rhythms of every object, from which there springs a fount of pictural lyricism hitherto unknown.

<div style="text-align: right">

Umberto Boccioni
Carlo D. Carra
Luigi Russolo
Giacomo Balla
Gino Severini

</div>

N.B. All the ideas contained in this preface were developed at length in the lecture on Futurist painting, delivered by the painter Boccioni at the Circolo Internazionale Artistico, at Rome on May 29, 1911.

*Umberto Boccioni, "Technical Manifesto of Futurist Sculpture," 1912**

In the monuments and exhibitions of every European city, sculpture offers a spectacle of such pitiable barbarism, clumsiness, and monotonous imitation, that my Futurist eye recoils from it with profound disgust!

The sculpture of every country is dominated by the blind and foolish imitation of formulas inherited from the past, an imitation encouraged by the

---

* Originally published on 11 April 1912. This translation was made from the volume of collected manifestoes, *I Manifesti del Futurismo*, edited by Marinetti, and is from *Futurism* by Joshua C. Taylor, 1961, The Museum of Modern Art, New York, and reprinted with its permission. The above translation is by Richard Chase. Boccioni republished the manifesto and the preface to the catalogue of his sculpture exhibition in Paris (Galerie La Boëtie, 20 June to 16 July 1913), in his *Pittura Scultura Futuriste* (Milan: Poesia, 1914), pp. 391–411, 413–421.

double cowardice of tradition and facility. In Latin countries we have the burdensome weight of Greece and Michelangelo, which is borne in France and Belgium with a certain seriousness of skill, and in Italy with grotesque imbecility. In German countries we have a foolish Greek-ized Gothicism, industrialized in Berlin, and in Munich sweetened with effeminate care by German pedantry. In Slavic countries, on the other hand, there is a confused clash between archaic Greek and Nordic and Oriental monstrosities, a shapeless mass of influences that range from the excess of abstruse details deriving from Asia, to the childish and grotesque ingenuity of the Lapps and Eskimos.

In all these manifestations of sculpture, as well as in those with a larger measure of innovating audacity, the same error is perpetuated: the artist copies the nude and studies classical statuary with the simple-minded conviction that he can find a style corresponding to modern sensibility without relinquishing the traditional concept of sculptural form. This concept, with its famous "ideal beauty" of which everyone speaks on bended knee, never breaks away from the Phidian period and its decadence.

And it is almost inexplicable why the thousands of sculptors who have continued from generation to generation to construct dummies have not as yet asked themselves why the galleries of sculpture, when not absolutely deserted, are visited with boredom and horror, and why the unveiling of monuments in squares all over the world meets with incomprehension and general hilarity. This does not happen with painting because of its continual renewal which, as slow as the process has been, is the clearest condemnation of the plagiarized and sterile works of all the sculptors of our epoch!

Sculptors must convince themselves of this absolute truth: to continue to construct and want to create with Egyptian, Greek, or Michelangelesque elements, is like wanting to draw water from a dry well with a bottomless bucket.

There can be no renewal in art whatever if the essence itself is not renewed, that is, the vision and concept of line and masses that form the arabesque. It is not simply by reproducing the exterior aspects of contemporary life that art becomes the expression of its own time; this is why sculpture as it has been understood to date by artists of the past century and the present is a monstrous anachronism!

Sculpture has failed to progress because of the limited field assigned to it by the academic concept of the nude. An art that has completely to strip a man or woman in order to begin its emotive function is a dead art! Painting has taken on new life, profundity, and breadth through a study of landscape and the environment, which are made to react simultaneously in relationship to the human figures or objects, reaching the point of our Futurist INTERPENETRATION OF PLANES (*Technical Manifesto of Futurist Painting*, 11 *April* 1910). In the same way sculpture will find a new source of emotion, hence of style, extending its plastic quality to what our barbarous crudity has made us think of until now as subdivided, impalpable, and thus plastically inexpressible.

We have to start from the central nucleus of the object that we want to create, in order to discover the new laws, that is, the new forms, that link it invisibly but mathematically to the APPARENT PLASTIC INFINITE and to the INTERNAL PLASTIC INFINITE. The new plastic art will, then, be a translation into plaster, bronze, glass, wood, and any other material, of those atmospheric planes that link and intersect things. This vision that I have called PHYSICAL TRANSCENDENTALISM (*Lecture on Futurist Painting at the Circolo Artistico*, Rome, May 1911) will be able to give plastic form to the mysterious sympathies and affinities that the reciprocal formal influences of the planes of objects create.

Sculpture must, therefore, give life to objects by making their extension in space palpable, systematic, and plastic, since no one can any longer believe that an object ends where another begins and that our body is surrounded by anything—bottle, automobile, house, tree, road—that does not cut through it and section it in an arabesque of directional curves.

There have been two attempts at renewal in modern sculpture: one decorative, concentrating on style; and the other strictly plastic, concentrating on material. The first, anonymous and disordered, lacked a coordinating technical genius and, since it was too closely tied to the economic requirements of building, only produced pieces of traditional sculpture more or less decoratively synthesized and confined within architectural or decorative motives or schemes. All the buildings and houses constructed in accordance with modern criteria include such efforts in marble, cement, or in metal plate.

The second attempt, more pleasing, disinterested, and poetic, but too isolated and fragmentary, lacked a synthetic idea to give it law. In working towards renewal it is not enough just to believe with fervor; one must formulate and work out a norm that points the way. I am referring to the genius of Medardo Rosso [1858–1928], to an Italian, and to the only great modern sculptor who has attempted to open up a larger field to sculpture, rendering plastically the influences of an ambience and the atmospheric ties that bind it to the subject.

Of the three other great contemporary sculptors, Constantin Meunier [1831–1905] has contributed nothing new to sculptural sensibility. His statues are almost always agreeable fusions of the Greek heroic with the athletic humility of the stevedore, sailor, or miner. His plastic and constructional concept of the statue and of bas-relief is still that of the Parthenon or the classical hero, although it was he who first attempted to create and deify subjects that had been previously despised or relegated to lower types of realistic reproduction.

[Antoine] Bourdelle [1861–1929] brings to the sculptural block an almost fanatic severity of abstract architectural masses. Of passionate temperament, highly strung, sincerely looking for the truth, he none the less does not know how to free himself from a certain archaic influence and from the general anonymity of the stonecutters of the Gothic cathedrals.

Rodin is of vaster spiritual agility, which has allowed him to go from the

Impressionism of the *Balzac* to the uncertainty of the *Burghers of Calais* and all the other Michelangelesque sins. He bears in his sculpture a restless inspiration and a sweeping lyrical drive, which would be truly modern if Michelangelo and Donatello had not already possessed these qualities in almost identical form four hundred or so years before, and if they were used to animate a completely re-created reality.

We thus have in the works of these three great sculptors influences coming from three different periods: Greek in Meunier, Gothic in Bourdelle, Italian Renaissance in Rodin.

The work of Medardo Rosso, on the other hand, is very modern and revolutionary, more profound and of necessity restricted. It involves neither heroes nor symbols, but the plane of a woman's brow, or of a child's, points towards a liberation of space, which will have a much greater importance in the history of the spirit than our times have given it. Unfortunately the impressionistic necessities of this attempt have limited Medardo Rosso's research to a kind of high or low relief, demonstrating that the human figure is still conceived of as a world in itself with traditional bases and an episodic goal.

The revolution of Medardo Rosso, although of the greatest importance, starts off from an external pictorial concept that overlooks the problem of a new construction of planes; while the sensual touch of the thumb, imitating the lightness of Impressionist brushstrokes, gives a sense of lively immediacy, it requires rapid execution from life and removes from the work of art its character of universal creation. It thus has the same strong points and defects as Impressionism in painting. Our aesthetic revolution also takes its start from these researches, but in continuing them it has gone on to reach an extreme opposite point.

In sculpture as in painting one cannot renovate without searching for THE STYLE OF THE MOVEMENT, that is, by making systematic and definitive in a synthesis what Impressionism has given us as fragmentary, accidental, and thus analytical. And this systematization of the vibrations of sculpture, whose foundation will be architectural, not only in the construction of the masses, but in such a way that the block of the sculpture will contain within itself the architectural elements of the SCULPTURAL ENVIRONMENT in which the subject lives.

Naturally we will bring forth a SCULPTURE OF ENVIRONMENT.

A Futurist composition in sculpture will embody the marvelous mathematical and geometrical elements that make up the objects of our time. And these objects will not be placed next to the statue as explanatory attributes or dislocated decorative elements but, following the laws of a new conception of harmony, will be imbedded in the muscular lines of the body. Thus from the shoulder of a mechanic may protrude the wheel of a machine, and the line of a table might cut into the head of a person reading; and a book with its fanlike leaves might intersect the stomach of the reader.

Traditionally a statue is carved out or delineated against the atmospheric

environment in which it is exhibited. Futurist painting has overcome this con-
ception of the rhythmic continuity of the lines in a human figure and of the figure's
isolation from its background and from its INVISIBLE INVOLVING SPACE. Futurist
poetry, according to the poet Marinetti, "after having destroyed the traditional
meter and created free verse, now destroys syntax and the Latin sentence. Futurist
poetry is an uninterrupted and spontaneous flow of analogies, each one of which is
intuitively related to the central subject. Thus, wireless imagination and free
words." The Futurist music of Balilla Pratella breaks through the chronometrical
tyranny of rhythm.

Why should sculpture remain behind, tied to laws that no one has the
right to impose on it? We therefore cast all aside and proclaim the ABSOLUTE
AND COMPLETE ABOLITION OF DEFINITE LINES AND CLOSED SCULPTURE. WE BREAK
OPEN THE FIGURE AND ENCLOSE IT IN ENVIRONMENT. We proclaim that the environ-
ment must be part of the plastic block which is a world in itself with its own
laws; that the sidewalk can jump up on your table and your head be transported
across the street, while your lamp spins a web of plaster rays between one house
and another.

We proclaim that the whole visible world must fall in upon us, merging
with us and creating a harmony measurable only by the creative imagination;
that a leg, an arm, or an object, having no importance except as elements of
plastic rhythm, can be abolished, not in order to imitate a Greek or Roman
fragment, but to conform to the harmony the artist wishes to create. A sculptural
entity, like a picture, can only resemble itself, for in art the human figure and
objects must exist apart from the logic of physiognomy.

Thus a human figure may have one arm clothed and the other bare, and
the different lines of a vase of flowers might freely intervene between the lines of
the hat and those of the neck.

Thus transparent planes, glass, sheets of metal, wires, outside or inside
electric lights, can indicate the planes, inclinations, tones, and half tones of a new
reality.

Thus a new intuitive coloring in white, in gray, in black, can increase the
emotive strength of planes, while the note of a colored plane will accentuate with
violence the abstract significance of the plastic reality!

What we have said about LINES/FORCES in painting (*Preface-Manifesto of
the Catalogue of the First Futurist Exhibition*, Paris, October 1911[1]) can be said
similarly of sculpture; the static muscular line can be made to live in the dynamic
line/force. The straight line will predominate in this muscular line, since only it
corresponds to the internal simplicity of the synthesis that we oppose to the external
baroquism deriving from analysis.

---

[1] The exhibition was held in February 1912, although Boccioni noted he had earlier
expounded on the ideas included in the preface to the catalogue. See the text of the preface
under the title, "The Exhibitors to the Public" (above).

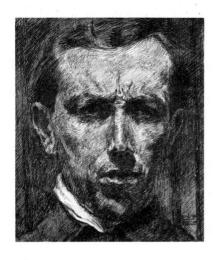

*Umberto Boccioni, Self-Portrait, 1910, etching.*

But the straight line will not lead us to imitate the Egyptians, the primitives, and the savages as some modern sculptors have desperately attempted to do in order to free themselves from the Greeks. Our straight line is alive and palpitating; it will lend itself to all that is necessary for the infinite expressions of the material; and its bare, fundamental severity will symbolize the severity of steel that determines the lines of modern machinery.

Finally we can affirm that in sculpture the artist must not shrink from using any means that will allow him to achieve REALITY. There is no fear more stupid than that which makes us afraid to go beyond the bounds of the art we are practicing. There is no such thing as painting, sculpture, music, or poetry; there is only creation! Therefore if a composition is in need of a special rhythmical movement to aid or contrast with the static rhythm of the SCULPTURAL ENTITY (a necessity in a work of art), one can superimpose any structure whatsoever that is capable of giving the required movements to the planes or lines.

We cannot forget that the tick-tock and the moving hands of a clock, the in-and-out of a piston in a cylinder, the opening and closing of two cogwheels with the continual appearance and disappearance of their square steel cogs, the fury of a flywheel or the turbine of a propeller, are all plastic and pictorial elements of which a Futurist work in sculpture must take account. The opening and closing of a valve creates a rhythm just as beautiful but infinitely newer than the blinking of an animal eyelid.

CONCLUSIONS

1. We proclaim that sculpture is based on the abstract reconstruction of the planes and volumes that determine the forms, not their figurative value.

2. ABOLISH IN SCULPTURE as in every other art THE TRADITIONAL SUBLIMITY OF THE SUBJECT.

3. Deny to sculpture as an aim any "true-to-life" episodic construction, but affirm the absolute necessity of using all reality in order to return to the essential elements of plastic sensibility. Thus, in perceiving bodies and their parts as PLASTIC ZONES, a Futurist composition in sculpture will use metal or wood planes for an object, static or moved mechanically, furry spherical forms for hair, semicircles of glass for a vase, wire and screen for an atmospheric plane, etc.

4. Destroy the wholly literary and traditional nobility of marble and of bronze. Deny the exclusiveness of one material for the entire construction of sculptural ensemble. Affirm that even twenty different materials can compete in a single work to effect plastic emotion. Let us enumerate some: glass, wood, cardboard, iron, cement, horsehair, leather, cloth, mirrors, electric lights, etc., etc.

5. Proclaim that in the intersection of the planes of a book with the angles of a table, in the lines of a match, in the frame of a window, there is more truth than in all the twisting of muscles, all the breasts and buttocks of the heroes and Venuses that inspire the modern idiocy in sculpture.

6. That only the most modern choice of subjects can lead to the discovery of new PLASTIC IDEAS.

7. That the straight line is the only means that can lead to the primitive virginity of a new architectural construction of sculptural masses or zones.

8. That there can be no renovation if not through a SCULPTURE OF ENVIRONMENT, for through this plasticity will be developed and, continuing, will be able to MODEL THE ATMOSPHERE that surrounds things.

9. The thing that one creates is nothing other than a bridge between the EXTERIOR PLASTIC INFINITE and the INTERIOR PLASTIC INFINITE; thus objects never end, and intersect with infinite combinations of sympathetic harmonies and clashing aversions.

## Carlo Carrà, *"From Cézanne to Us, the Futurists,"* 1913★

Cézanne is the last exponent of the old epoch. Those who proclaim him the initiator of a new school of painting are fooling themselves and others. His realism has the character of an architechtonic block. His works bring to mind Michelangelo. Although his compositions are erroneously considered dynamic, they are, instead, in their solidity and sobriety, absolutely static. The things Cézanne chooses to represent are locked in an old type of design, even though he tries to render nature in terms of cones, spheres, and cylinders. So far as the field of plastic deformation goes and its use in the study of motion, Paul Cézanne's works have on many counts the air of museum pieces. Renoir, for example, is in many instances more

★ Published as "Da Cézanne a noi Futuristi," *Lacerba* (Florence), 15 May 1913. A similar theme is treated in Boccioni's "Futurist Dynamism and French Painting," (*Il dinamismo futurista e la pittura francese*), *Lacerba*, 1 August 1913, republished in his *Pittura Scultura Futuriste*, pp. 423–435.

modern than he. Let the superficial critics be convinced that the neoclassic period was closed not by Poussin, nor David, nor Ingres, but by Cézanne.

In recent times, nostalgic traditionalists have been making a great fuss over the name of Ingres. So far as I am concerned, I must confess that I find the Italian Raphael too little satisfying to be able to admire the Frenchified Raphael of Ingres. If Raphael is the chief representative of "good sense," *the genius of universal mediocrity*, Ingres is his shadow, and fortunately in Italy shadows please no one— but Crocians.[1]

We admit that Cézanne has surpassed the older painters in that he has achieved greater strength in his construction through color.

Before Cézanne, painting was limited to drawing and tried, either because of impotence or immaturity or, more probably, complete lack of sensibility, to pass drawing off as a substitute for construction through color.

Cézanne does just the opposite, thus resolving the last part of the pictorial problem posed by the classical painters, that is, the study of the static and eternal aspect of nature.

He gives us the coloristic expression of forms from the same point of view as the earlier painters gave us the linear expression. In his coloristic sensibility, Cézanne surpassed the Egyptians, Persians, Chinese, and even the Byzantines, all limited to the concept of pure chromatic areas confined within geometric forms. He affirms tone as a colored mass and, because of the vitality he generates within the mass, he surpasses even Titian, Tintoretto, Rubens, etc., since he departs from the procedure of pure chiaroscuro upon which these artists depended. He remains, however, always exterior, limited to an apparent visual reality.

Longhi noted well in his article on the Futurist painters (*La Voce*, 10 April 1913) the eminently static quality of Cézanne's work, even in that which is most revolutionary. And his work, which has been able to generate Cubism, has no affinity at all with our study, which is essentially dynamic in character.

We Futurists combat the Cézannesque objectivism of color, just as we reject his classical objectivity of form. For us, painting must express color the way one senses music even though the means are very different, that is, analogously. We stand for a use of color free from the imitation of objects and things as colored images; we stand for an *aerial* vision in which the material of color is expressed in all of the manifold possibilities our subjectivity can create. For to us Futurists, form and color are related only in terms of subjective values.

Color that has objective correspondence (even if color tone) takes no part in and actually cancels out the abstract sense (which is the only concrete element in a work of art) and the expression as purely pictorial sensations.

---

[1] The Futurists' dislike of Benedetto Croce (1866–1952) was actually based more on his position as philosopher and historian than on his philosophy itself, aspects of which they shared. In this instant, Carrà probably refers to Croce's continual use of historial material in his philosophical formulations.

A painting that "charms the eye" in the usual sense of that phrase, always has exclusively visual origins. The observer's spirit remains passive, foreign to the work whose center is outside of him. Such a painting is the product of contemplative idealism, and one might call it a "sentimental miming of visible nature."

If our contemporaries still admire this inferior form of pictorial activity, it is owing to the writers who want to concern themselves with painting, even though they are totally ignorant of the art. These will call *divine*, in shameless ignorance, that which is nothing more than an external and mediocre decorative harmony.

We Futurists affirm that this thoroughly vulgar form of art is the antithesis of our own. It concerns two forms of pictorial mentality which negate each other when confronted, so profound is the ever increasing difference.

In Cézanne, two contradictory forces can be noted: one revolutionary, the other traditional.

All the works of this painter evince this oscillation between the museum and the sincerity of a genuine and primitive interpretation of life.

Obsessed with the religion of nature, Cézanne theoretically negated the lyrical necessity of deformation affirmed by the Impressionists. He thus reasoned very badly but, an unconscious and tormented genius, he worked very well, showing himself in his paintings to be the most audacious in the deformation and dispersal of lines and planes of all his contemporaries. This is why the myopes describe Cézanne as a genius *manqué*.

All of this demonstrates that the work of this artist is the most complex, the most difficult to define, of the whole nineteenth century. In a certain number of the works there is a feeling of El Greco, in others of Rembrandt.

We Futurists have surpassed the simple construction of Cézanne's colored masses because we have gone beyond the "melodic" type of construction in painting ("melody": that is another word, dear Soffici,[1] that we must discard and create a more pictorial term). Melodic construction is based, in its repetitions and its symmetrical equilibrium of rhythms and simple tones, on a pictorial feeling of calm. In this, Cézanne is not very far from Giotto.

Concluding we have demonstrated:

1. That the false classics, Poussin, David, and Ingres (without naming also that mediocre decorator, Puvis de Chevannes, who also for a moment seemed to be classical) brought nothing additional to the classical ideal. These artists, then, are not to be considered as contributors to any period of art.

[1] Ardengo Soffici (1879–1964), a painter and critic writing in *La Voce*, was early sensitive to the new trends in French painting. His 1911 essay on Cubism is one of the clearest early statements on that movement. Carrà refers to his article in *Lacerba*, "Cubism and Beyond," (15 January 1913) which Soffici considered a kind of ABC of terminology for the new art.

2. That Cézanne, with his color structure, only brings a pre-existing principle to its final conclusion (the static linear quality and the static color quality of the plastic world seen in external nature). For these, and other reasons, he does not open any new epoch of painting.

3. That only by taking off from a dynamic concept of the plastic world can painting be given a new orientation.

The rhythms and line forces give us the *abstract* weight of concrete plastic elements (machine, man, house, sea, etc.). If an object has its maximum emotive force in its formal construction, we shall give it in its architechtonic essential. If on the other hand, the object has such force in its harmony and disharmony of color, or in the refractions of light, we shall give it in terms of its tonal and luminous constructions. For our Futurist principles comprehend the three ways in which the plastic world is revealed to us: light, ambience, volume, and we intend to dramatize the coloristic formal and luminous masses in such a way as to assemble from these various entities a general pictorial dramatic unity.

If we accuse the Cubists of creating not works but only fragments, as did earlier the Impressionists, it is because one feels in their works the need for a further and broader development. Further, it is because their canvases lack a center essential to the organism of the work as a whole, and those surrounding forces that flow towards such a center and gravitate around it.

Finally, it is because one notes that the arabesque of their paintings is purely accidental, lacking the character of totality indispensable to the life of a work.

Our paintings are no longer accidental and transitory sensations, limited to an hour of the day, or to a day, or to a season. We Futurists, destroying the unity of time and place, bring to the painting an integration of sensations that is the synthesis of the plastic universal.

We continue to speak of technical matters since, for one who understands art, technique is at the same time cause and effect. What we have said is everything; what we are going to say is a closed book to those (and there are many of them) who pronounce on the facts and problems of painting with absolute cerebral incapacity and so many other incompetencies.

Color, in painting, is the first and last of emotions. Form is the intermediate emotion.

Related tones unify the mass and solidify it. Tones of complementary colors cut through the mass and divide it.

Shadow is concavity. Light is convexity.

Color-tone is the part most essential to the *I* of the painter and for this reason violently shocks the intimate feelings of others. Before a mysterious grouping of colors, an observer, even if an advanced and well-informed person, gives a scandalized shout. If the painting is constructed according to the laws of chiaroscuro, however, this does not occur. This is proved by the fact that the observer never feels so violent a revulsion before a work of sculpture, no matter how audacious.

307

Movement changes the forms.

In any movement, forms change their original relationships.

Guided hitherto by a static concept, painters have constructed dry and fixed forms and did not present the motion of any given movement, the currents and centers of the forces which constitute the individuality and synthesis of the movement itself. They artificially limited and stopped movement, because they lacked completely the power to identify themselves with things, being wholly preoccupied with all of the negative exterior aspects, far from the pictorial process of pure creation.

We are against the falsehood of the fixed law of the gravity of bodies: for Futurist painting, bodies will respond to the special center of gravity of the painting itself. Thus the centrifugal and centripetal will determine the weight, dimension, and gravity of bodies. In this way, objects will live in their plastic essence as part of the total life of the painting. If man were able to create a *plastic measure* capable of measuring the force that bodies express in lines, in the weight of their color-value, and in the direction of volumes, forces that our intuition leads us to apply in our works, all accusations of being arbitrary would be canceled, because one could describe them in terms of *plastic amperes, plastic hertzian waves,* etc.

And the public would no longer be scandalized and shout, because they would no longer be afraid that they were being tricked and would understand the new truth that we have agitated for in Italy and elsewhere for four years, a truth that has thrown the camp of painting into revolution.

# VI NEO-PLASTICISM AND CONSTRUCTIVISM: Abstract and Non-objective Art

## INTRODUCTION

One of the most sweeping of the several implications arising from the Cubist destruction of conventional modes of representation was the idea that painting should be an absolute entity with no relation to the objects of the visible world, and that it should be composed of completely abstract forms whose origins were in the mind. In these terms it became nearly the opposite of Analytic Cubism, which had derived its vocabulary by breaking down the forms of natural objects into abstract or semi-abstract shapes, and then reconstituting them into a dynamic arrangement which, however, still had ties to the original objects. This new painting referred to universals rather than to specifics, and it therefore appealed principally to the mind and only secondarily to the senses.

Some of the partisans of these principles believed that in the rarified realm of the universals, laws existed for art as well as for geometry, that supreme example of perfect relationships, and that therefore it might even be possible to construct works of art by means of the intellect. Art constructed according to this ideal, having avoided all taint of the material world, and being free of any personal influence of the individual artist, would be completely autonomous and obedient only to universal laws. Because of this belief art was often considered as a sort of idealist model for the harmonious relations which were believed ultimately possible for both individuals and for all of society.

Since this art referred to so much that was unseen, and since it implied that a new, ideal harmony between man and his environment could be attained, there was a great deal to be said in explanation. The sense of social destiny inherent in the new conception of art amounted to a messianic zeal among some of the artists; inevitably they were drawn together into groups. They wrote joint manifestoes, published magazines, wrote books, and gave lectures. No other twentieth-century artists were drawn so closely together or were so idealistically motivated to theoretical explanation.

Movements devoted to this ideal appeared all over Europe beginning just prior to the outbreak of war in 1914. The most revolutionary in conception and the most far-reaching in influence were, however, those that were formed in Holland and Russia. Theo van Doesburg (1883–1931) explains his own as the result of Dutch Protestant idealism, which had been influential in many aspects of Dutch culture ever since the Reformation. And we can observe that a strain of extremism has always existed in Russian thought, and that it came to an explosive climax just prior to the Revolution of 1917.

Even before the Dutch and Russian groups had formed, Robert Delaunay (1885–1941) in Paris had developed a nonobjective style which Apollinaire termed "Orphism." During 1912 and 1913 he painted pictures so completely dependent upon color contrasts and harmonies that they produced a dynamism of color that became for him his only subject matter. "Color alone is form and subject," he declared. In his efforts he had the support of earlier theories which considered the action of color contrasts as dynamic effects in themselves. Paul Signac (1861–1935) had been convinced that the effects of color could be controlled and directed toward desired results by the intellectual process of analyzing the separate aspects: the color of objects, the color of the light falling upon them, and the color of their reflections. The French physiologist Charles Henry had written several books, read by the artists, which attributed to the various colors certain degrees of dynamism and also movements in particular directions. The theories of both these men demolished the romantic and metaphysical associations that during the nineteenth century had been attributed to colors, and instead gave rational and scientific explanations of their actual characteristics. Thus, colors could be thought of in objective terms as "pure" elements, beyond the influence of physical objects and without associations of a sentimental nature. Delaunay's art and theory followed the strain of objective speculation of the Puteaux group[1] of artists, who were interested in analogies between art, mathematics, and music, and who were influenced by, but ideologically quite outside, the Cubism of Picasso and Braque. Delaunay was admired especially by the *Blaue Reiter* artists in Munich (see chap. iii), with whom he shared many ideas on "pure" color. After a visit to Paris in 1912, they invited him to join them in an exhibition of paintings

[1] Led by the brothers Jacques Villon, Marcel Duchamp, and Raymond Duchamp-Villon, the group met in Villon's studio at Puteaux. Other members included Fernand Léger, Albert Gleizes, Jean Metzinger, and the critics Guillaume Apollinaire, André Salmon, and Walter Pach. This group was the sponsor of the *Section d'Or* exhibition in October 1912 where new tendencies more abstract than Cubism were exhibited.

in Munich. An important correspondence on the problems of color ensued, and Delaunay also exhibited at the Sturm Gallery in Berlin in the winter of 1912–1913; Apollinaire accompanied him to give a lecture on his painting. This lecture, and an article on light and color by Delaunay translated into German by Paul Klee, were published by Herwath Walden in the journal *Der Sturm* in February, 1913.

Frantisek Kupka's (1871–1957) completely abstract painting had its origins in the colorful, decorative tradition of his native Bohemia and the art schools of Prague and Vienna, which gave it quite a different character from the aggressively analytical attitude of Cubism. In consequence, his ideas are more mystical and not so revolutionary as those of Delaunay, and they are not so much influenced by the long tradition of theories by earlier French artists and scientists.

Synchromism was similar in many of its aims to Orphism, but was closer to Futurism than to Cubism because of its interest in making colored forms become dynamic. Developed in 1912–1913 by the Americans S. MacDonald Wright (b. 1890) and Morgan Russel (1886–1953), it created a scandal at the first exhibition in 1913 in Paris. It also appeared during the same year in the *Salon des Indépendants*, soon after in Munich and in New York, after which Wright returned to America to work out a theory of color scales based upon the musical scale.

The most radical affirmation of the ideal of the absolute in art came, however, from Moscow; conditions in the world of art, as in the social and political realm, were ripe for revolution. In contrast to the almost hopeless backwardness of the country as a whole in cultural affairs, Moscow had a small group of earnestly *avant-garde* intellectuals and artists to whom were revealed intoxicating glimpses of the new, ideal world promised by the Bolsheviks. Russian artists had already quickly and fervently absorbed new movements from western Europe, and Picasso and Matisse were better known in advanced circles in Moscow than they were in Paris. Two collectors alone, Tschoukine and Morisov, had brought back from Paris before 1914 more than a hundred paintings by the two artists; the leading art magazines published numerous reproductions of Cubist paintings; and the Futurist Marinetti had made a highly successful lecture tour of Russia.

Kasimir Malevich (1878–1935), although he had never been outside of Russia, assimilated both the Fauvist and Cubist styles while they were still new and pressed onward toward the ideal of a purely abstract painting, which in 1913 he called Suprematism. In that year he painted the purest and most radical abstract picture yet seen, a black square on a white ground. He explains that "In 1913, trying desperately to liberate art from the ballast of

the representational world, I sought refuge in the form of the square." In the same year Vladimir Tatlin (1885–1956) made the first purely abstract relief construction of metal, glass, and wood, pushing to an extreme although logical consequence the idea of Cubist collage and construction. His movement, Constructivism, was motivated, like Suprematism, by a complete acceptance of the contemporary world of machinery and mass-produced objects—a significant taste in view of the technological backwardness of Czarist Russia. Indeed, the very fact that both these movements set up an ideal world based upon the absolute functionalism of machinery and the efficiency of the materials of industry earned them for a time the approval of Leon Trotsky and certain factions in the Bolshevik Party when they ruled Russia. Tatlin's great monument to the Third International—a third of a mile in height—conceived in 1919, but never built caused the Constructivist style to be for a time regarded as the true style of the proletarian revolution.[1] And the appointment of Malevich as a professor, first in the Moscow and then in the Leningrad Academy, gave official validation to the movement.

Naum Gabo (b. 1890) had been mainly a student of literature and a poet when he went to Munich in 1910 to study medicine. His older brother, Antoine Pevsner (b. 1884), had been studying painting in Kiev since 1909, and the family had carried on discussions on art at their home in Briansk. Although Gabo had gone to Munich to study medicine, his friendship in the German art center with Kandinsky and other artists turned his attention to painting and sculpture. Until the outbreak of the war in 1914, he made frequent visits to Russia and, under the influence of the art historian Heinrich Wölfflin, had visited Italy in 1913. He fled as a refugee to Norway in 1914 and was there joined by Pevsner, who had been living and painting in Paris since 1911. In Norway, Gabo produced his first sculptures influenced by the geometric forms of Synthetic Cubism—figurative models and heads made of joined planes of cardboard or plywood. After the outbreak of the Revolution in February 1917, Gabo and Pevsner returned to Russia. In Moscow they joined Tatlin, Malevich, and other expatriates like Kandinsky in the great experiment.

Unfortunately for the dreams of the artists, Trotsky began to lose favor, and Lenin's policies, always hostile to modern art, soon denied any freedom of expression to the artists. Perhaps associating Constructivism with the playful high jinks of the Dadaists of the Café Voltaire group, who were

---

[1] But see Trotsky's opinion in 1923 of Tatlin's monument in his *Literature and Revolution* (New York: Russell and Russell, 1957), excerpts of which appear in chap. viii, below.

his next-door neighbor in 1916 in Zürich when he was in exile, Lenin denied to them all commissions and official positions. By 1922 nearly all of the leaders of the new movements, finding themselves without a livelihood, were forced to leave Russia. Most of them went first to Berlin, where they were welcomed, and then they carried the radical gospel of Russian Constructivism to other of the groups of abstract artists: Kandinsky became a professor at the Bauhaus in Weimar, and El Lissitsky (1890–1947) joined for a short time the De Stijl group in Amsterdam. Malevich later went to the Bauhaus, where his manuscript, written in Russian, was translated into German and published as *Die Gegenstandslose Welt* in 1927. Gabo lived in Berlin until 1933 (although he was also active in the *Abstraction-Création* Group in Paris), when he moved to London. He was an editor with Ben Nicholson and others of the extraordinarily literate publication *Circle*, which was devoted to the theories of the radical abstract movements. In 1946 he moved to America, where he has continued to work and write. Pevsner, having lived in Paris in his youth, returned there to resume his residence.

Although purged in Russia, the purely abstract tradition became institutionalized in the Bauhaus and was forcefully propagated. The school was founded in 1919 at Weimar with the architect Walter Gropius as its head. The idea of the unity of the applied and fine arts had already been deeply imbedded there by the predecessor of the Bauhaus, the Weimar School of Applied Art, which had been founded in 1902 by Henry van de Velde in order to teach the ideals and applications of Jugendstil. Gropius's dedicatory speech at the Bauhaus rallied artists to the new ideal: "Let us create together the new building of the future, which will be everything in one—architecture and painting."

Although Gropius attracted to the school many leading artists, such as Kandinsky, Klee, Feininger, Oscar Schlemmer, and Gerhard Marcks, the ideology of the school centered more upon problems of design and construction than upon theoretical and idealistic principles of a new art and society. The basic courses were under the direction of Johannes Itten (b. 1888), pupil of the painter and theoretician Adolf Hoelzel (1853–1934), who proposed that the sources of creation lay in an intellectual and sensual understanding of the true physical nature of materials: wood, glass, metals, etc., and that contemporary technology with its host of new possibilities was the guiding inspiration. The painters provided, in Gropius's words, a "spiritual counterpoint" to the materialism of the designers. Many other artists and designers were inspired by the experiment to come to Weimar and later, when the school moved, to Dessau, and they contributed new

ideas. The theories of color harmony of Hoelzel were of primary importance as transmitted through two of his former students, Itten and Otto Schlemmer. Lazlo Moholy-Nagy's (1895–1946) imaginative investigation of the physical properties of color and light and of industrial materials aroused enormous enthusiasm among the students. Sibyl Moholy-Nagy later wrote that the spirit for rationalizing art was so strong that her husband developed a codified system whereby he could have a painting produced by a sign painter by means of telephoned instructions. Other talented men were attracted to the Bauhaus from Russia and Holland, the principal centers of similar experiments, among them Van Doesburg, Gabo, Malevich, and Lissitsky.

The sense of the social value of their program and the didactic strain in Bauhaus ideology led Gropius and Moholy to launch a series of fourteen publications on various aspects of art theory, among them Mondrian's *Die Neue Gestaltung* in 1925, Malevich's *Die Gegenstandslose Welt* in 1927, as well as books by Kandinsky, Klee, and Van Doesburg. But in the middle 'twenties internal conflicts developed, and both the teaching of painting and even the spirit of free experimentation were among the casualties, so that by the time the school was finally disbanded by the Nazis in 1933, it had become essentially a technical school for the training of designers. Most of the leaders of the Bauhaus—of both the early, experimental, and the late, practical phases—fled to America in the 'thirties. Here they built successful careers for themselves and became an important force in establishing the tradition in this country. Moholy established the Institute of Design in Chicago on the basis of Bauhaus principles; Gropius became chairman of the Department of Architecture at Harvard; Josef Albers held a corresponding position at Yale; and others, such as Ludwig Mies van der Rohe, Herbert Bayer, and Marcel Breuer, put into their practice of architecture and design the principles developed at the Bauhaus.

The purest of the abstract movements and the most idealistic in its ideology was the Dutch group, *De Stijl* (The Style), which was founded in Amsterdam in 1917. For the Dutch artists, chiefly Piet Mondrian (1872–1944) and Theo van Doesburg (1883–1931), and the architect J. J. P. Oud (b. 1890), *De Stijl* was a model for the perfect harmony they believed possible both for man as an individual and society as a whole. It thus had an ethical and even a spiritual mission, performing a function analogous to that of pure research in relation to practical applications of discovered principles. Far more than the German and Russian movements, it inspired an abstract strain, not only in architecture and design but also in painting and sculpture, that remains vigorous today and relevant to contemporary

art. Compared with it, the Bauhaus ideology seems rooted in materialism and directed mainly to practical applications. And Constructivism, unlike *De Stijl*, lacked a solid indigenous tradition of either technology or modern art to back it up. This lack, combined with the condemnation of the Communist party, caused its members to be quickly dispersed among the other movements.

The artistic conceptions of *De Stijl* were based upon a solid ideological foundation: the Dutch philosophy of idealism, an intellectual tradition of sobriety, clarity, and logic, and, as Oud expressed it, "Protestant iconoclasm." The artists believed in the existence of a universal harmony of which man could partake by subordinating himself to it. It lay in the realm of pure spirit which was freed from all conflict, from all objects of the physical world and freed even from all individuality. In terms of painting, the plastic means were reduced to the constituitive elements of line, space, and color, arranged in the most elemental compositions.

Piet Mondrian, back from Paris, was predominant in *De Stijl* and the artist who provided the purest strain of their beliefs. For him, Neoplasticism, his own theory of art, was far more than a style of painting; it was both a philosophy and a religion. Its ultimate aim was an art that, because it was so harmonious with universal principles, would cause all aspects of life to fall into accord with these principles. All of man's environment would become art. As Mondrian himself said, "In the future, the tangible embodiment of pictorial values will supplant art. Then we shall no longer need paintings, for we shall live in the midst of realized art."

The sources of his Platonic idealism lie deep within his background and early experience. Growing up in a strict Calvinist family, his need of a mystical element in religion turned him first to a study of and finally membership in the Theosophist movement. Although he lived in Paris almost continuously from 1910 to 1938, except for the war years, and although he was in the company of Picasso and the Cubists, whose influence turned his art and thought toward structural problems, idealism was the basis of his own artistic as well as his personal beliefs. His theories of art, therefore, partake of both his own idealistic and austere religion and the mystical purity of Theosophy.

Mondrian was already an adherent to Theosophy when he went to Paris in 1910. While there his instinctive sense for order drew him to Cubism, especially that of Picasso and Léger, and the style of his paintings rapidly evolved from a kind of Fauvism to a distinctive and highly disciplined structural style that soon became completely abstract. Caught in Holland by the war in 1914, he was forced to remain, and there he met Bart

van der Leck and Theo van Doesburg, both of whose work and beliefs were very much in accord with his own. Under the initiative of Van Doesburg, who became an ardent and brilliant propagandist for the movement, they founded *De Stijl* in 1917 and launched a magazine rich in ideas and theories on widely differing aspects of the new idealism. Van Doesburg, the editor, called upon artists everywhere to contribute their theories and explanations to the crusade. He proclaimed that "The quadrangle is the token of a new humanity. The square is to us what the cross was to the early Christians." [1]

The ideas of *De Stijl* were so vital and so universal in their relevance that they and the art resulting from them were called the International Style. Van Doesburg's lectures at the Bauhaus created an intensification of the idealist strain among the masters there and, in part, determined the direction of their thinking during the later 'twenties.

Mondrian remained in his painting and in his theory the most pure of all the members and when, in 1925, the movement showed signs of compromising its initial principles he resigned. His profound ideas and his almost saintly presence were instrumental to the growth of other abstract movements: *Abstraction-Creation*, which had been founded by Gabo and Pevsner in 1931 in Paris and which included Kandinsky, Arp, Auguste Herbin, Jean Helion, and many others, and the Circle Group which formed around Gabo and Ben Nicholson in 1938 in London. Even at the age of seventy, in New York during the Second World War, he implanted and stimulated the ideals and style in several leading American artists. He was a prolific and profound writer on his art and his beliefs, and he projected into his program for Neoplasticism the intensity of his own religious and moral feelings. Notwithstanding the austerity of his theory and his own habits, he readily adapted himself to life in New York, to which he had fled from London in 1940. He loved the tempo of the city, the sight of the skyscrapers, life in the streets, and, most of all, American jazz. As Werner Haftmann has observed, his tastes embraced the wide range from mysticism to technology, and from Theosophy to jazz. Perhaps this breadth of personality explains why Mondrian's last years, when he was in America and more than seventy years of age, was a period of renewed vigor and enrichment in his art.

Constantin Brancusi (1876–1957), born in Rumania, approached absolute forms from quite a different point of view than those who idealized the machine and architecture, or those who conceived of the structural principles of their art as an ideal model for society. His mysticism, a reflection

---

[1] Quoted by Hans Richter in "Dada Profiles," *Perspectives on the Arts*, Art Yearbook 5, ed. Hilton Kramer (New York: Art Digest, 1961).

of his eastern European background, led him to value forms in art that are related to the simplest and most elemental organic shapes, such as the egg and the fish. His abstraction is a search for these shapes; the clarity and logic of their relationships derive from this independent and subjective view, rather than from a rationale such as in Cubism. And his aphorisms on art are similarly concerned with elemental ideas.

*Robert Delaunay, letter to August Macke, 1912*＊

Direct observation of the luminous essence of nature is for me indispensable. I do not necessarily mean observation with palette in hand, although I am not opposed to notations taken from nature itself. I do much of my work from nature, "before the subject," as it is commonly called. But what is of great importance to me is observation of the movement of colors.

Only in this way have I found the laws of complementary and simultaneous contrasts of colors which sustain the very rhythm of my vision. In this movement of colors I find the essence, which does not arise from a system, or an *a priori* theory.

For me, every man distinguishes himself by his essence—his personal movement, as opposed to that which is universal. That is what I found in your works that I saw this winter at Cologne. You are not in direct communication with nature, the only source of inspiration directed toward beauty.[1] Such communication affects representation in its most vital and critical aspect. This communication alone, by the comparison of the antagonisms, rivalries, movements which give birth to decisive moments, permits the evolution of the soul, whereby a man realizes himself on earth. It is impossible to be concerned with anything else in art.

I say it is indispensable to look ahead of and behind oneself in the present. If there is such a thing as tradition, and I believe there is, it can only exist in the sense of the most profound movements of culture.

First of all, I always see the sun! The way I want to identify myself and others is with halos here and there—halos, movements of color. And that, I believe, is rhythm. Seeing is in itself a movement. Vision is the true creative rhythm. Discerning the quality of rhythms is a movement, and the essential quality of painting is representation—the movement of vision which functions in objectivizing itself toward reality. That is the essential of art, and its greatest profoundness.

＊ Robert Delaunay, *Du cubisme à l'art abstrait*, ed. Pierre Francastel (Paris: S.E.V.P.E.N., 1958), p. 186.
[1] Delaunay meant that Macke was right to avoid direct communication with nature, and to observe it but not serve it.

I am very much afraid of definitions, and yet one is almost forced to make them. One must take care, too, not to be inhibited by them. I have a horror of manifestoes made before the work is done.

*Robert Delaunay, letter to Wassily Kandinsky, 1912* ★

I find what you sent in this year useful. As for our work, I think that surely the public will have to get used to it. The effort it will have to make comes slowly, because it is drowned in habits. On the other hand, the artist has much to do in the realm of color construction, which is so little explored and so obscure, and hardly dates back any farther than to the beginning of Impressionism. Seurat sought for the primary laws. Cézanne demolished the whole of painting since its beginnings— that is to say, chiaroscuro adjusted to a linear construction, which predominated in all the known schools.

It is this research into pure painting that is the problem at the present moment. I do not know any painters in Paris who are really searching for this ideal world. The Cubist group of whom you speak experiments only in line, giving color a secondary place, and not a constructional one.

I have not yet tried to put into words my investigations in this new sphere, where all my efforts have been directed for a long time.

I am still waiting until I can find greater flexibility in the laws I discovered. These are based on studies in the transparency of color, whose similarity to musical notes drove me to discover the "movement of color." All this, which I believe is unknown to everyone, is for me still in my mind's eye. I am sending you a photograph of these endeavors, already outdated, which have so astonished my acquaintances, and which have met with suitable judgment totally free from "impressionism" only in rare connoisseurs. When I was doing this work—and I remember that you had asked me about it—I did not know anyone able to write about these things, but I had already made some experiments which were decisive. Even my friend Princet[1] was incapable of seeing them, and it has been but a short

---

★ Delaunay, *Du cubisme à l'art abstrait*, pp. 178–179.

[1] Maurice Princet, an actuary or statistician with an insurance company and an amateur painter, was a frequent visitor to the *Bateau Lavoir* and a friend of Delaunay. Metzinger, Gleizes and André Lhote all report that he led them in many speculative discussions on the possible relations between geometry, especially non-Euclidian, and the Cubists' new conception of space (see notes in chapter on Cubism). But in an introductory essay for an exhibition catalogue of Delaunay's painting (Galerie Barbazanges, Paris, 28 February–13 March 1912) Princet demonstrated his ability as a critic as well. Nothing he wrote there has to do with the rather playful mathematical speculations of the studios. While he believed, like Gleizes and Metzinger, in the necessity of "systematizing" sensations in the mind, and he stated that Delaunay applied a vigorous discipline to his means, he emphasized Delaunay's reliance upon taste and instinct. He declares that "his reflections lead him neither to mathematical formulae nor to Cabalistic mystical symbols," and that "if Delaunay discusses, argues, compares and deduces, it is always with pallette in hand."

318

time since they have begun to become apparent to him. I have confidence in the interpretation that could be produced by his sensitivity, and it seems to me that he has had a strong reaction which will lead to that result. I think, at the moment, that he will be able to reveal the meaning of these things as a result of the work he already began several years ago, which I brought to your attention.

## Robert Delaunay, *Light, 1912*[*]

Impressionism; it is the birth of Light in painting.

Light comes to us by the sensibility. Without visual sensibility there is no light, no movement.

Light in Nature creates the movement of colors.[1]

Movement is produced by the rapport of *odd elements*, of the contrasts of colors between themselves which constitutes *Reality*.

This reality is endowed with *Vastness* (we see as far as the stars), and it then becomes *Rhythmic Simultaneity*.

Simultaneity in light is *harmony, the rhythm of colors* which creates the *Vision of Man*. Human vision is endowed with the greatest *Reality*, since it comes to us directly from the contemplation of the Universe. The *eye* is the most refined of our senses, the one which communicates most directly with our mind, our consciousness.

The idea of the vital movement of the *world* and *its movement is simultaneity*.

Our understanding is *correlative* to our *perception*.

*Let us attempt to see.*

The auditory perception is not sufficient for our knowledge of the world; it does not have *vastness*.[2]

Its movement is *successive*, it is a sort of mechanism; its law is the *time of mechanical* clocks which, like them, has no relation with our perception of *visual movement in the Universe*.

---

[*] There are five versions of this article. This one was written in the summer of 1912, translated into German by Paul Klee and published in *Der Sturm* (Berlin), No. 144–145, January 1913. Klee's concern with this article is a clear indication of his interest in Delaunay and his color, an interest that soon had an influence on his painting. Printed in Delaunay, *Du cubisme à l'art abstrait*, pp. 146–147.

[1] Beginning in 1910 Delaunay painted a series of pictures all entitled *Window on the City*. The first ones were cityscapes flooded with light similar to his Eiffel Tower series, but others gradually became more abstract as they were formalized into grid-like patterns. In 1912 the title *Simultaneous Windows* was used for paintings that are almost wholly nonfigurative and are composed of brilliant contrasts of color. Of these paintings Apollinaire in 1913 wrote the poem *Les Fenêtres* concluding with:

> La fenêtre s'ouvre comme une orange,
> Le beau fruit de la lumière.

[2] In another version Delaunay adds, "because it does not exist in time."

It is comparable to the objects of geometry . . . .

Art in *Nature is rhythmic and has a horror of constraint*. If Art relates itself to an *Object*, it becomes descriptive, divisionist, literary.

It demeans itself by imperfect *means of expression*, it condemns itself, it is its own negation, *it does not avoid an Art of imitation*.

If all the same it represents the *visual relations* of objects or the *objects between them* without *light playing the organizing role* of the representation, it is conventional. It never reaches *plastic purity*. It is an infirmity; it is the negation of life and the sublimity of the art of painting.

In order that Art attain the limit of sublimity, it must draw upon our harmonic vision: *clarity*. Clarity will be color, proportion; these proportions are composed of diverse elements, simultaneously involved in an action. This action must be the representative harmony, the *synchronous movement* (simultaneity) *of light* which is the *only reality*.

This synchronous action then will be the Subject, which is the representative harmony.

*Stanton MacDonald Wright, statement on Synchromism, 1916*[*]

I strive to divest my art of all anecdote and illustration, and to purify it to the point where the emotions of the spectator will be wholly aesthetic, as when listening to good music.

Since plastic form is the basis of all enduring art, and since the creation of intense form is impossible without color, I first determined, by years of color experimentation, the relative spatial relation of the entire color gamut. By placing pure colors on recognizable forms (that is, by placing advancing colors on advancing objects, and retreating colors on retreating objects), I found that such colors destroyed the sense of reality, and were in turn destroyed by the illustrative contour. Thus, I came to the conclusion that color, in order to function significantly, must be used as an *abstract medium*. Otherwise the picture appeared to me merely as a slight, lyrical decoration.

Having always been more profoundly moved by pure rhythmic form (as in music) than by associative processes (such as poetry calls up), I cast aside as nugatory all natural representation in my art. However, I still adhered to the fundamental laws of composition (placements and displacements of mass as in the human body in movement), and created my pictures by means of color-form which, by its organization in three dimensions, resulted in rhythm.

[*] From the catalogue of the Forum Exhibition of Modern American Painters, New York, Anderson Galleries, 13–25 March 1916.

Wright later formalized some of his ideas on color by arranging colors on a scale similar to the musical octave and working out harmonious combinations. *A Treatise on Color* (Los Angeles: privately printed, 1924).

Later, recognizing that painting may extend itself into time, as well as be a simultaneous presentation, I saw the necessity for a formal climax which, though being ever in mind as the final point of consummation, would serve as a *point d'appui* from which the eye would make its excursions into the ordered complexities of the picture's rhythms. Simultaneously my inspiration to create came from a visualization of abstract forces interpreted, through color juxtapositions, into terms of the visual. In them was always a goal of finality which perfectly accorded with my felt need in picture construction.

By the above one can see that I strive to make my art bear the same relation to painting that polyphony bears to music. Illustrative music is a thing of the past: it has become abstract and purely aesthetic, dependent for its effect upon rhythm and form. Painting, certainly, need not lag behind music.

*Piet Mondrian, "Natural Reality and Abstract Reality," 1919*

The cultivated man of today is gradually turning away from natural things, and his life is becoming more and more abstract.

Natural (external) things become more and more automatic, and we observe that our vital attention fastens more and more on internal things.[1] The life of the truly modern man is neither purely materialistic nor purely emotional. It manifests itself rather as a more autonomous life of the human mind becoming conscious of itself.

Modern man—although a unity of body, mind, and soul—exhibits a changed consciousness: every expression of his life has today a different aspect, that is, an aspect more positively abstract.

It is the same with art. Art will become the product of another duality in man: the product of a cultivated externality and of an inwardness deepened and more conscious. As a pure representation of the human mind, art will express itself in an aesthetically purified, that is to say, abstract form.

The truly modern artist is aware of abstraction in an emotion of beauty; he is conscious of the fact that the emotion of beauty is cosmic, universal. This conscious recognition has for its corollary an abstract plasticism, for man adheres only to what is universal.

---

* Originally published as "de nieuwe beelding in de schilderkunst" in *De Stijl* (Amsterdam), I, 1919. This English translation from Michel Seuphor, *Piet Mondrian, Life and Work* (New York: Abrams, n.d.), pp. 142–144.
[1] Mondrian's high valuation of internal rather than external things, and of abstract rather than natural ones, is related to one of the principal tenets of Theosophy. It starts with the assumption of the essence of God, and then deduces from it the nature of the Universe. Because everything is seen through God, the natural world is essentially spiritual. Evil, which arises from a desire for material or finite things, may be overcome by absorption in God or the infinite.

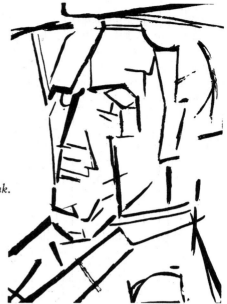

*Piet Mondrian, Self-Portrait, ca. 1942, ink.*

The new plastic idea cannot, therefore, take the form of a natural or concrete representation, although the latter does always indicate the universal to a degree, or at least conceals it within. This new plastic idea will ignore the particulars of appearance, that is to say, natural form and color. On the contrary, it should find its expression in the abstraction of form and color, that is to say, in the straight line and the clearly defined primary color.

These universal means of expression were discovered in modern painting by a logical and gradual progress toward ever more abstract form and color. Once the solution was discovered, there followed the exact representation of relations alone, that is to say, of the essential and fundamental element in any plastic emotion of the beautiful.

The new plastic idea thus correctly represents actual aesthetic relationships. To the modern artist, it is a natural consequence of all the plastic ideas of the past. This is particularly true of painting, which is the art least bound to contingencies. The picture can be a pure reflection of life in its deepest essence.

However, new plasticism is pure painting: the means of expression still are form and color, though these are completely interiorized; the straight line and flat color remain purely pictorial means of expression.

Although each art uses its own means of expression, all of them as a result of the progressive cultivation of the mind, tend to represent balanced relations with ever greater exactness. The balanced relation is the purest representation of universality, of the harmony and unity which are inherent characteristics of the mind.

If, then, we focus our attention on the balanced relation, we shall be able to see unity in natural things. However, there it appears under a veil. But even though we never find unity expressed exactly, we can unify every representation, in other words, the exact representation of unity can be expressed; it must be expressed, for it is not visible in concrete reality.

We find that in nature all relations are dominated by a single primordial relation, which is defined by the opposition of two extremes. Abstract plasticism represents this primordial relation in a precise manner by means of the two positions which form the right angle. This positional relation is the most balanced of all, since it expresses in a perfect harmony the relation between two extremes, and contains all other relations.

If we conceive these two extremes as manifestations of interiority and exteriority, we will find that in the new plasticism the tie uniting mind and life is not broken; thus, far from considering it a negation of truly living life we shall see a reconciliation of the matter-mind dualism.

If we realize through contemplation that the existence of anything is defined for us aesthetically by relations of equivalence, this is possible because the idea of this manifestation of unity is potential in our consciousness. For the latter is a particular instance of the universal consciousness, which is one.

If human consciousness is growing from the indeterminate towards the positive and the determinate, unity in man will also grow towards the positive and determinate.

If unity is contemplated in a precise and definite way, attention will be directed solely towards the universal, and as a consequence, the particular will disappear from art—as painting has already shown. For the universal cannot be expressed purely so long as the particular obstructs the path. Only when this is no longer the case can the universal consciousness (intuition, that is) which is at the origin of all art, be rendered directly, giving birth to a purified art expression.

This, however, cannot appear before its proper time. For it is the spirit of the times that determines artistic expression, which, in turn, reflects the spirit of the times. But at the present moment, that form of art alone is truly alive which expresses our present—or future—consciousness.

Composition allows the artist the greatest possible freedom, so that his subjectivity can express itself, to a certain degree, for as long as needed.

The rhythm of relations of color and size makes the absolute appear in the relativity of time and space.

In terms of composition the new plasticism is dualistic. Through the exact reconstruction of cosmic relations it is a direct expression of the universal; by its rhythm, by the material reality of its plastic form, it expresses the artist's individual subjectivity.

It thus unfolds before us a whole world of universal beauty without thereby renouncing the human element.

*Theo van Doesburg, introduction to Volume II of De Stijl, 1919*★

> The object of nature is man
> The object of man is style

That which is positively expressed in modern plasticity: well-balanced proportion between peculiarity and generalness, manifests itself more or less also in modern man and forms the original cause of social reconstruction, of which we are a witness.

In the same way as man has ripened to be able to oppose the domination of the individual, arbitrariness, the artist, too, has ripened so as to be able to resist the domination of individuality in plastic arts: natural form and color, emotions, etc. This resistance, which is based upon a ripened inwardness of man, on life in the strict sense of the word, on reasonable cognition, is reflected in the entire development of art, especially in that of the last fifty years.

It was therefore to be expected that this development of art, which took place by leaps and bounds, eventually had to result in quite a new plasticity, which only could appear in and by a period which was able to revolutionize completely the spiritual (inward) and material (outward) proportions.

*Cover of De Stijl, Amsterdam, November 1921.*

★ Originally published in *De Stijl* (Amsterdam), II, October 1919, p. 1. Translated in *De Stijl* (exhibition catalogue), Amsterdam, Stedelijk Museum, 7 June–9 September, 1951, pp. 7, 9.

324

This period is our period and today we are witnessing the birth of a new plasticity. There, where on the one hand the need for a new spiritual—in the widest sense of the word—as well as material foundation for art and culture makes itself conspicuous, and on the other hand tradition and convention—necessary companions of every new idea or action—try to keep their own ground in all fields by timidly opposing the new ideas, the task of all those who have to testify to the new cognition of the time—either plastically or graphically—becomes an important and difficult one. Their task demands an unabated energy and perseverance, which is strengthened and stimulated by preservative opposition.

In that manner they, who deliberately give a false interpretation of the new conceptions and contemplate modern plastic works of art in the same way as they contemplate the impressionistic works, i.e. not deeper than the surface, unwittingly cooperate in the foundation of a new conception of life and art. We can only be thankful to them for that.

If we look back upon the numbers [of *De Stijl*] of the past year, then it must fill us with admiration that productive artists succeeded in giving form to the ideas, which they acquired in the course of their work, thereby contributing much to the elucidation of the new cognition of art.

This is sufficiently confirmed by the increasing interest—also abroad—in the contents of this monthly magazine, which did not fail to influence the young, as well as the old generation. These contents therefore provide for the need of man, who has acquired a deeper aesthetical cognition. This may be a stimulus to continue with our aesthetical work for civilization, in spite of the difficulties which considerably impede the publication of periodicals.

*Naum Gabo, "The Realistic Manifesto," Moscow, 5 August 1920*<sup>★</sup>

> Above the tempests of our weekdays,
> Across the ashes and cindered homes of the past,
> Before the gates of the vacant future,

We proclaim today to you artists, painters, sculptors, musicians, actors, poets . . . to you people to whom Art is no mere ground for conversation but the source of real exaltation, our word and deed.

The impasse into which Art has come to in the last twenty years must be broken.

The growth of human knowledge with its powerful penetration into the mysterious laws of the world which started at the dawn of this century,

★ Written in Russian by Naum Gabo and signed by Gabo and his brother Antoine Pevsner, this manifesto was distributed as a handbill at an exhibition which included their work. This English translation from *Gabo*, introductory essays by Sir Herbert Read and Leslie Martin (London: Lund Humphries, 1957).

The blossoming of a new culture and a new civilization with their un-precedented-in-history surge of the masses towards the possession of the riches of Nature, a surge which binds the people into one union, and last, not least, the war and the revolution (those purifying torrents of the coming epoch), have made us face the fact of new forms of life, already born and active.

What does Art carry into this unfolding epoch of human history?

Does it possess the means necessary for the construction of the new Great Style?

Or does it suppose that the new epoch may not have a new style?

Or does it suppose that the new life can accept a new creation which is constructed on the foundations of the old?

In spite of the demand of the renascent spirit of our time, Art is still nourished by impression, external appearance, and wanders helplessly back and forth from Naturalism to Symbolism, from Romanticism to Mysticism.

The attempts of the Cubists and the Futurists to lift the visual arts from the bogs of the past have led only to new delusions.

Cubism, having started with simplification of the representative technique, ended with its analysis and stuck there.

The distracted world of the Cubists, broken in shreds by their logical anarchy, cannot satisfy us who have already accomplished the Revolution or who are already constructing and building up anew.

One could heed with interest the experiments of the Cubists, but one cannot follow them, being convinced that their experiments are being made on the surface of Art and do not touch on the bases of it, seeing plainly that the end result amounts to the same old graphic, to the same old volume, and to the same decora-tive surface as of old.

One could have hailed Futurism in its time for the refreshing sweep of its announced Revolution in Art, for its devastating criticism of the past, as in no other way could one have assailed those artistic barricades of "good taste" . . . powder was needed for that and a lot of it . . . but one cannot construct a system of art on one revolutionary phase alone.

One had to examine Futurism beneath its appearance to realize that one faced a very ordinary chatterer, a very agile and prevaricating guy, clad in the tatters of worn-out words like "patriotism," "militarism," "contempt for the female," and all the rest of such provincial tags.

In the domain of purely pictorial problems, Futurism has not gone further than the renovated effort to fix on the canvas a purely optical reflex which has already shown its bankruptcy with the Impressionists. It is obvious how to every one of us that by the simple graphic registration of a row of momentarily arrested movements, one cannot re-create movement itself. It makes one think of the pulse of a dead body.

The pompous slogan of "Speed" was played from the hands of the Futur-ists as a great trump. We concede the sonority of that slogan and we quite see how

*Naum Gabo, 1941.*

it can sweep the strongest of the provincials off their feet. But ask any Futurist how does he imagine "Speed" and there will emerge a whole arsenal of frenzied automobiles, rattling railway depots, snarled wires, the clank and the noise and the clang of carouseling streets . . . does one really need to convince them that all that is not necessary for speed and for its rhythms?

Look at a ray of sun . . . the stillest of the still forces, it speeds more than 300 kilometres in a second . . . behold our starry firmament . . . who hears it . . . and yet what are our depots to those depots of the Universe? What are our earthly trains to those hurrying trains of the galaxies?

Indeed, the whole Futurist noise about speed is too obvious an anecdote, and from the moment that Futurism proclaimed that "Space and Time are yesterday's dead," it sunk into the obscurity of abstractions.

Neither Futurism nor Cubism has brought us what our time has expected of them.

Besides those two artistic schools our recent past has had nothing of importance or deserving attention.

But Life does not wait and the growth of generations does not stop and

we who go to relieve those who have passed into history, having in our hands the results of their experiments, with their mistakes and their achievements, after years of experience equal to centuries . . . we say . . .

No new artistic system will withstand the pressure of a growing new culture until the very foundation of Art will be erected on the real laws of Life.

Until all artists will say with us . . .

All is a fiction . . . only life and its laws are authentic and in life only the active is beautiful and wise and strong and right, for life does not know beauty as an aesthetic measure . . . efficacious existence is the highest beauty.

Life knows neither good nor bad nor justice as a measure of morals . . . need is the highest and most just of all morals.

Life does not know rationally abstracted truths as a measure of cognizance, deed is the highest and surest of truths.

Those are the laws of life. Can art withstand those laws if it is built on abstraction, on mirage, and fiction?

We say . . .

Space and time are re-born to us today.

Space and time are the only forms on which life is built and hence art must be constructed.

States, political and economic systems perish, ideas crumble, under the strain of ages . . . but life is strong and grows and time goes on in its real continuity.

Who will show us forms more efficacious than this . . . who is the great one who will give us foundations stronger than this?

Who is the genius who will tell us a legend more ravishing than this prosaic tale which is called life?

*The realization of our perceptions of the world in the forms of space and time is the only aim of our pictorial and plastic art.*

*In them we do not measure our works with the yardstick of beauty, we do not weigh them with pounds of tenderness and sentiments.*

*The plumb-line in our hand, eyes as precise as a ruler, in a spirit as taut as a compass . . . we construct our work as the universe constructs its own, as the engineer constructs his bridges, as the mathematician his formula of the orbits.*

*We know that everything has its own essential image; chair, table, lamp, telephone, book, house, man . . . they are all entire worlds with their own rhythms, their own orbits.*

*That is why we in creating things take away from them the labels of their owners . . . all accidental and local, leaving only the reality of the constant rhythm of the forces in them.*

*1. Thence in painting we renounce color as a pictorial element, color is the idealized optical surface of objects; an exterior and superficial impression of them; color is accidental and it has nothing in common with the innermost essence of a thing.*

*We affirm that the tone of a substance, i.e. its light-absorbing material body is its only pictorial reality.*

2. We renounce *in a line, its descriptive value; in real life there are no descriptive lines, description is an accidental trace of a man on things, it is not bound up with the essential life and constant structure of the body. Descriptiveness is an element of graphic illustration and decoration.*

We affirm *the line only as a direction of the static forces and their rhythm in objects.*

3. We renounce *volume as a pictorial and plastic form of space; one cannot measure space in volumes as one cannot measure liquid in yards: look at our space . . . what is it if not one continuous depth?*

We affirm *depth as the only pictorial and plastic form of space.*

4. We renounce *in sculpture, the mass as a sculptural element.*

*It is known to every engineer that the static forces of a solid body and its material strength do not depend on the quantity of the mass . . . example—a rail, a T-beam, etc.*

*But you sculptors of all shades and directions, you still adhere to the age-old prejudice that you cannot free the volume of mass. Here (in this exhibition) we take four planes and we construct with them the same volume as of four tons of mass.*

*Thus we bring back to sculpture the line as a direction and in it we affirm depth as the one form of space.*

5. We renounce *the thousand-year-old delusion in art that held the static rhythms as the only elements of the plastic and pictorial arts.*

We affirm *in these arts a new element, the kinetic rhythms, as the basic forms of our perception of real time.*

These are the five fundamental principles of our work and our constructive technique.

Today we proclaim our words to you people. In the squares and on the streets we are placing our work convinced that art must not remain a sanctuary for the idle, a consolation for the weary, and a justification for the lazy. Art should attend us everywhere that life flows and acts . . . at the bench, at the table, at work, at rest, at play; on working days and holidays . . . at home and on the road . . . in order that the flame to live should not extinguish in mankind.

We do not look for justification, neither in the past nor in the future.

Nobody can tell us what the future is and what utensils does one eat it with.

Not to lie about the future is impossible and one can lie about it at will.

We assert that the shouts about the future are for us the same as the tears about the past: a renovated daydream of the romantics.

A monkish delirium of the heavenly kingdom of the old attired in contemporary clothes.

He who is busy today with the morrow is busy doing nothing.

And he who tomorrow will bring us nothing of what he has done today is of no use for the future.

Today is the deed.

We will account for it tomorrow.

The past we are leaving behind as carrion.
The future we leave to the fortune-tellers.
We take the present day.

*Naum Gabo, "Sculpture: Carving and construction in space," 1937\**

The growth of new ideas is the more difficult and lengthy the deeper they are rooted in life. Resistance to them is the more obstinate and exasperated the more persistent their growth is. Their destiny and their history are always the same. Whenever and wherever new ideas appeared they have always been victorious if they had in themselves enough life-giving energy. No idea has ever died a violent death. Every idea is born naturally and dies naturally. An organic or spiritual force which could exterminate the growth of any new idea by violence does not exist. This fact is not realized by those who are all too keen to fight against any new idea the moment it appears on the horizon of their interests. The method of their fight is always the same. At the beginning they try to prove that the new idea is nonsensical, impossible, or wicked. When this fails they try to prove that the new idea is not at all new or original and therefore of no interest. When this also does not work they have recourse to the last and most effective means: the method of isolation; that is to say, they start to assert that the new idea, even if it is new and original does not belong to the domain of ideas which it is trying to complete. So, for instance, if it belongs to science, they say it has nothing to do with science; if it belongs to art, they say it has nothing to do with art. This is exactly the method used by our adversaries, who have been saying ever since the beginning of the new art, and especially the Constructive Art, that our painting has nothing to do with painting and our sculpture has nothing to do with sculpture. At this point I leave it to my friends the painters to explain the principles of a constructive and absolute painting and will only try to clarify the problems in my own domain of sculpture.

According to the assertions of our adversaries, two symptoms deprive constructive sculpture of its sculptural character. First, that we are abstract in our carving as well as in our constructions, and second that we insert a new principle, the so-called construction in, space which kills the whole essential basis of sculpture as being the art of solid masses.

A detailed examination of this slander seems to be necessary.

What are the characteristics which make a work of art a sculpture? Is the Egyptian Sphinx a sculpture? Certainly, yes. Why? It cannot be only for the reason that it consists of stone or that it is an accumulation of solid masses, for if it were so, then why is not any house a sculpture, and why are the Himalayan Mountains not a sculpture? Thus there must be some other characteristics which distinguish a

\* From *Circle: International Survey of Constructive Art*, eds. J. L. Martin, Ben Nicholson, and Naum Gabo (London: Faber & Faber, 1937), pp. 103–11. Reprinted 1966 (New York: George Wittenborn).

sculpture from any other solid object. I think they could be easily established by considering that every sculpture has the following attributes:—

    I. It consists of concrete material bounded by forms.

    II. It is intentionally built up by mankind in three-dimensional space.

    III. It is created for this purpose only, to make visible the emotions which the artist wishes to communicate to others.

There are the main attributes which we find in every sculptural work since the art of sculpture began, and which distinguish a sculptural work from any other object. Any other attributes which appear are of a secondary and temporary nature and do not belong to the basic substance of sculpture. In so far as these main attributes are present in some of our surroundings we have always the right to speak about them as things with a sculptural character. I will carefully try to consider these three main attributes to see if a constructive sculpture lacks any of them.

    I. Materials and Forms.

Materials in sculpture play one of the fundamental roles. The genesis of a sculpture is determined by its material. Materials establish the emotional foundations of a sculpture, give it basic accent and determine the limits of its aesthetical action. The source of this fact lies hidden deep in the heart of human psychology. It has a utilitarian and aesthetical nature. Our attachment to materials is grounded in our organic similarity to them. On this akinness is based our whole connection with Nature. Materials and Mankind are both derivatives of Matter. Without this tight attachment to materials and without this interest in their existence the rise of our whole culture and civilization would have been impossible. We love materials because we love ourselves. By using materials sculptural art has always gone hand in hand with technique. Technics does not banish any material from being used in some way or for some constructive purpose. For technique as a whole, any material is good and useful. This utility is only limited by its own qualities and properties. The technician knows that one cannot impose on material those functions which are not proper to its substance. The appearance of a new material in the technique determines always a new method in the system of construction. It would be naïve and unreasonable to build a steel bridge with the same methods as those used in their stone bridges by the Romans. Similarly, technicians are now searching for new methods in construction for reinforced concrete since they know the properties of this material are different from the properties of steel. So much for technics.

In the art of sculpture every material has its own aesthetical properties. The emotions aroused by materials are caused by their intrinsic properties and are as universal as any other psychological reaction determined by nature. In sculpture as well as in technics every material is good and worthy and useful, because every single material has its own aesthetical value. In sculpture as well as in technics the method of working is set by the material itself.

There is no limit to the variety of materials suitable for sculpture. If a

sculptor sometimes prefers one material to another he does it only for the sake of its superior tractability. Our century has been enriched by the invention of many new materials. Technical knowledge has elaborated methods of working with many of the older ones which could never before be used without difficulty. There is no aesthetical prohibition against a sculptor using any kind of material for the purpose of his plastic theme depending on how much his work accords with the properties of the chosen one. The technical treatment of materials is a mechanical question and does not alter the basic attributes of a sculpture. Carved or cast, molded or constructed, a sculpture does not cease to be a sculpture as long as the aesthetical qualities remain in accord with the substantial properties of the material. (So, for instance, it would be a false use of glass if the sculptor neglected the essential property of this material, namely, its transparency.) That is the only thing our aesthetical emotions are looking for as far as the materials of a sculpture are concerned. The new Absolute or Constructive sculpture is intending to enrich its emotional language, and it could only be considered as an evidence of spiritual blindness or an act of deliberate malice to reproach an artistic discipline for enriching its scale of expression.

The character of the new materials which we employ certainly influences the sculptural technique, but the new constructive technique which we employ in addition to the carving does not determine the emotional content of our sculptures. This constructive technique is justified on the one hand by the technical development of building in space and on the other hand by the large increase in our contemplative knowledge.

The constructive technique is also justified by another reason which can be clarified when we examine the content of the "space problem in sculpture." As shown in the accompanying illustration, the two cubes illustrate the main distinction between the two kinds of representation of the same object, one corresponding to carving and the other to construction. The main points which distinguish them lie in the different methods of execution and in the different centers of interest. The first represents a volume of mass; the second represents the space in which the mass exists made visible. Volume of mass and volume of space are sculpturally not the same thing. Indeed, they are two different materials It must be emphasized that I do not use these two terms in their high philosophical sense. I mean two very concrete things with which we come in contact every day. Two such obvious things as mass and space, both concrete and measurable.

Up to now, the sculptors have preferred the mass and neglected or paid very little attention to such an important component of mass as space. Space interested them only in so far as it was a spot in which volumes could be placed or projected. It had to surround masses. We consider space from an entirely different point of view. We consider it as an absolute sculptural element, released from any closed volume, and we represent it from inside with its own specific properties.

*Naum Gabo, objects from "Sculpture: Carving
and Construction in Space."*

I do not hesitate to affirm that the perception of space is a primary natural sense which belongs to the basic senses of our psychology. The scientist will probably find in this affirmation of mine a large field for argument and will surely suspect me of ignorance. I do not grudge him this pleasure. But the artist, who is dealing with the domain of visual art, will understand me when I say we experience this sense as a reality, both internal and external. Our task is to penetrate deeper into its substance and bring it closer to our consciousness; so that the sensation of space will become for us a more elementary and everyday emotion the same as the sensation of light or the sensation of sound.

In our sculpture space has ceased to be for us a logical abstraction or a transcendental idea and has become a malleable material element. It has become a reality of the same sensuous value as velocity or tranquillity and is incorporated in the general family of sculptural emotions where up to date only the weight and the volume of mass have been predominant. It is clear that this new sculptural emotion demands a new method of expression different from those which have been used and should be used to express the emotions of mass, weight and solid volume. It demands also a new method of execution.

The stereometrical method in which Cube II is executed shows elementarily the constructive principle of a sculptural space expression. This principle goes through all sculptural constructions in space, manifesting all its varieties according to the demands of the sculptural work itself.

At this place I find it necessary to point to those too hasty conclusions which some followers of the constructive movements in art have arrived at in their anxiety not to be left in the rear. Snatching at the idea of space they hasten to

assume that this space-idea is the only one which characterizes a constructive work. This assumption is as wrong an interpretation of the constructive idea in sculpture as it is harmful for their own work. From my first affirmation of the space-idea in the *Realistic Manifesto*, 1920, I have not ceased to emphasize that in using the spatial element in sculpture I do not intend to deny the other sculptural elements; that by saying, "We cannot measure or define space with solid masses, we can only define space by space," I did not mean to say that massive volumes do not define anything at all, and are therefore useless for sculpture. On the contrary, I have left volume its own property to measure and define—masses. Thus volume still remains one of the fundamental attributes of sculpture, and we still use it in our sculptures as often as the theme demands an expression of solidity.

We are not at all intending to dematerialize a sculptural work, making it nonexistent; we are realists, bound to earthly matters, and we do not neglect any of those psychological emotions which belong to the basic group of our perceptions of the world. On the contrary, adding Space perception to the perception of Masses, emphasizing it and forming it, we enrich the expression of Mass, making it more essential through the contrast between them, whereby Mass retains its solidity and Space its extension.

Closely related to the space problem in sculpture is the problem of Time. There is an affinity between them although the satisfactory solution of the latter still remains unsolved, being complex and obstructed by many obstacles. The definite solution is still handicapped by its technical difficulties. Nevertheless, the idea and the way for its solution is already traced in its main outlines by the constructive art. I find it essential for the completion of the discussion of the whole problem of our sculpture to sketch here in general terms the question of Time.

My first definition, formulated in the *Realistic Manifesto*, was. "We deny the thousand-year-old Egyptian prejudice that static rhythms are the only possible bases for a sculpture. We proclaim the kinetic rhythms as a new and essential part of our sculptural work, because they are the only possible real expressions of Time emotions."[1] It follows from this definition that the problem of Time in sculpture is synonymous with the problem of motion. It would not be difficult to prove that the proclamation of this new element is not the product of the idle fancy of an efficient mind. The constructive artists are not the first and will, I hope, not be the last, to exert themselves in the effort to solve this problem. We can find traces of these efforts in almost too many examples of ancient sculpture. It was only presented in illusory forms which made it difficult for the observer to recognize it. For instance, who has not admired in the Victory of Samothrace, the so-called dynamic rythms, the imaginary forward movement incorporated in this sculpture? The expression of motion is the main purpose of the composition of the

---

[1] Various translations from the original Russian of the Realistic Manifesto quote this statement somewhat differently than Gabo's text here (see "Realistic Manifesto," above). Since this text was written in English by Gabo in 1937, it may be taken as an accurate expression of his meaning.

lines and masses of this work. But in this sculpture the feeling of motion is an illusion and exists only in our minds. The real Time does not participate in this emotion; in fact, it is timeless. To bring Time as a reality into our consciousness, to make it active and perceivable we need the real movement of substantial masses removable in space.

The existence of the arts of Music and Choreography proves that the human mind desires the sensation of real kinetic rhythms passing in space. Theoretically there is nothing to prevent the use of the Time element, that is to say, real motions, in painting or sculpture. For painting the film technique offers ample opportunity for this whenever a work of art wishes to express this kind of emotion. In sculpture there is no such opportunity and the problem is more difficult. Mechanics has not yet reached that stage of absolute perfection where it can produce real motion in a sculptural work without killing, through the mechanical parts, the pure sculptural content; because the motion is of importance and not the mechanism which produces it. Thus the solution of this problem becomes a task for future generations.

I have tried to demonstrate in the kinetic construction [see illustrations] in space photographed here the primary elements of a realization of kinetic rhythms in sculpture. But I hold it my artistic duty to repeat in this place what I said in 1920, that these constructions do not accomplish the task; they are to be considered as examples of primary kinetic elements for use in a completed kinetic

*Naum Gabo, drawing for "Sculpture: Carving and Construction in Space."*

composition. The design is more an explanation of the idea of a kinetic sculpture than a kinetic sculpture itself.

Returning to the definition of sculpture in general, it is always stated as a reproach that we form our materials in abstract shapes. The word "abstract" has no sense, since a materialized form is already concrete, so the reproach of abstraction is more a criticism of the whole trend of the constructive idea in art than a criticism of sculpture alone. It is time to say that the use of the weapon "abstract" against our art is indeed only the shadow of a weapon. It is time for the advocates of naturalistic art to realize that any work of art, even those representing natural forms, is, in itself, an act of abstraction, as no material form and no natural event can be re-realized. Any work of art in its real existence, being a sensation perceived by any of our five senses, is concrete. I think it will be a great help to our common understanding when this unhappy word "abstract" is cancelled from our theoretic lexicon.

The shapes we are creating are not abstract, they are absolute. They are released from any already existent thing in nature and their content lies in themselves. We do not know which Bible imposes on the art of sculpture only a certain number of permissible forms. Form is not an edict from heaven, form is a product of Mankind, a means of expression. They choose them deliberately and change them deliberately, depending on how far one form or another responds to their emotional impulses. Every single shape made "absolute" acquires a life of its own, speaks its own language and represents one single emotional impact attached only to itself. Shapes act, shapes influence our psyche, shapes are events and Beings. Our perception of shapes is tied up with our perception of existence itself. The emotional content of an absolute shape is unique and not replaceable by any other means at the command of our spiritual faculties. The emotional force of an absolute shape is immediate, irresistible, and universal. It is impossible to comprehend the content of an absolute shape by reason alone. Our emotions are the real manifestation of this content. By the influence of an absolute form the human psyche can be broken or molded. Shapes exult and shapes depress, they elate and make desperate; they order and confuse, they are able to harmonize our psychical forces or to disturb them. They possess a constructive faculty or a destructive danger. In short, absolute shapes manifest all the properties of·a real force having a positive and a negative direction.

The constructive mind which animates our creative impulses enables us to draw on this inexhaustible source of expression and to dedicate it to the service of sculpture, at the moment when sculpture was in a state of complete exhaustion. I dare to state, with complete confidence in the truth of my assertion, that only through the efforts of the Constructive Idea to make sculpture absolute did sculpture recover and acquire the new force necessary for it to undertake the task which the new epoch is going to impose on it.

The critical condition in which sculpture found itself at the end of the last century is obvious from the fact that even the rise of naturalism through the growth

of the impressionist movement was not able to awaken sculpture from its lethargy. The death of sculpture seemed to everybody inevitable. It is not so any more. Sculpture is entering on a period of renaissance. It again assumes the role which it formerly played in the family of the arts and in the culture of peoples. Let us not forget that all the great epochs at the moment of their spiritual apogee manifested their spiritual tension in sculpture. In all great epochs when a creative idea became dominant and inspired the masses it was sculpture which embodied the spirit of the idea. It was in sculpture that the demoniac cosmology of the primitive man was personified; it was sculpture which gave the masses of Egypt confidence and certainty in the truth and the omnipotence of their King of Kings, the Sun; it was in sculpture that the Hellenes manifested their idea of the manifold harmony of the world and their optimistic acceptance of all its contradictory laws. And do we not find completed in the impetuous verticals of the Gothic sculpture the image of the Christian idea?

Sculpture personifies and inspires the ideas of all great epochs. It manifests the spiritual rhythm and directs it. All these faculties were lost in the declining period of our culture of the last century. The Constructive idea has given back to sculpture its old forces and faculties, the most powerful of which is its capacity to act architectonically. This capacity was what enabled sculpture to keep pace with architecture and to guide it. In the new architecture of today we again see an evidence of this influence. This proves that the constructive sculpture has started a sound growth, because architecture is the queen of all the arts, architecture is the axis and the embodiment of human culture. By architecture I mean not only the building of houses but the whole edifice of our everyday existence.

Those who try to retard the growth of the constructive sculpture are making a mistake when they say that constructive sculpture is not sculpture at all. On the contrary, it is the old glorious and powerful art re-born in its absolute form ready to lead us into the future.

*Kasimir Malevich, "Introduction to the Theory of the Additional Element in Painting"* ★

The village, as center of the required environment, was no longer suited to the painting of Cézanne, but equally alien to it is the art of the big city, of the industrial worker (and the more so, in fact, the more intensive is the metallic culture proceeding out of industrial work). The art of the industrial environment has its first beginnings in Cubism and Futurism, that is, at the point where conventional painting leaves off. These two cultures (Cubism and Futurism) differ, incidentally, in their ideologies. Whereas Cubism during the first phase of its development still stands at the edge of the culture of Cézanne, Futurism, already pointing toward

★ Originally published in a German translation from the original Russian in Kasimir Malevich, *Die Gegenstandslose Welt*, Bauhaus Book 11 (Munich: Langen, 1927). This English translation from the German edition is by Howard Dearstyne from *The Non-Objective World* (Chicago: Theobald, 1959), pp. 61–65.

abstract art, generalizes all phenomena and thereby borders on a new culture—
*non-objective Suprematism.*

*I call the additional element of Suprematism "the suprematist straight line"*
*(dynamic in character). The environment corresponding to this new culture has been*
*produced by the latest achievements of technology, and especially of aviation, so that one*
*could also refer to Suprematism as "aeronautical." The culture of Suprematism can*
*manifest itself in two different ways, namely, as dynamic Suprematism of the plane (with*
*the additional element of the "suprematist straight line") or as static Suprematism in*
*space—abstract architecture (with the additional element of the "suprematist square").*

As has already been said, the art of Cubism and Suprematism is to be
looked upon as the art of the industrial, taut environment. Its existence depends
upon this environment, just as the existence of Cézanne's culture is dependent upon
a provincial environment. To increase the effectiveness of those engaged in art,
the state should assume the responsibility of making a suitable environment (a
beneficial "climate") available to artists of the most varied cultures and, indeed,
this could be accomplished by arranging for academies to be located not always
and of necessity in large cities but also in the provinces and the country.

Nature untouched, the nature of the farmer, the provinces, the city and
great industry . . . these constitute the different types of environment, for each of
which a particular artistic culture is most appropriate, most closely related intrin-
sically.

One can therefore speak, in connection with the additional elements of
various pictorial cultures, of favorable and unfavorable environments. If, for
example, a Futurist, Cubist, or Suprematist were to be transplanted to the prov-
inces and isolated from the city, he would gradually divest himself of the addi-
tional element for which he has an affinity and, under the influence of the new
environment, relapse into the primitive state of imitating nature.

The sickle form of Cubism and the straight line of Suprematism, both
familiar to him, would be suppressed by the external conditions of the new en-
vironment, in which nothing of metallic culture, of restless movement, of geometry
and tautness is in evidence. His creative drive would no longer be incited to in-
tensive work but would fall more and more under the influence of the new
surroundings and finally accommodate itself to the provincial environment. The
elements of the city, which the painter has assimilated, disappear in the provinces,
just as an illness contracted in the city is overcome in a sanitarium in the country.
These considerations can unquestionably cause the general public and the learned
critics to view Cubism, Futurism, and Suprematism as evidences of sickness, of
which the artists can be cured . . . . One has only to remove the artist from the
center of energy of the city, so that he no longer sees machines, motors, and power
lines and can devote himself to the agreeable sight of hills, meadows, cows, farmers
and geese, in order to heal his Cubist or Futurist illness. When a Cubist or Futurist
after a long sojourn in the provinces, returns with a lot of charming landscapes

he is greeted joyfully by friends and critics as one who has found his way back to wholesome art.

This characterizes the attitude not only of the provincial but also of dwellers in the big city, for they—even they!—have not yet become a part of the big city's metallic culture, the culture of the new humanized nature. They are still drawn out of the city into the peace of the countryside and this explains the leaning of many painters toward rural nature. The pictorial culture of the provinces is incensed at the art of the big city (Futurism, etc.) and seeks to combat it, because it is not objective-representational and consequently seems unsound. If the viewpoint that Cubism, Futurism, and Suprematism are abnormal were correct, one would necessarily have to conclude that the city itself, the dynamic center is an unwholesome phenomenon because it is largely responsible for the "morbid alteration" in art and the creators of art.

The new art movements can exist only in a society which has absorbed the tempo of the big city, the metallic quality of industry. No Futurism can exist where society still maintains an idyllic, rural way of life.

Conventional painters fear the metallic city for they find there no truly pictorial element . . . . Futurism reigns in the city.

Futurism is not the art of the provinces but rather, that of industrial labor. The Futurist and the laborer in industry work hand in hand—they create mobile things and mobile forms, both in works of art and in machines. Their consciousness is always active. The form of their works is independent of weather, the seasons, etc . . . . It is the expression of the rhythms of our time. Their work, unlike that of the farmer, is not bound up with any sort of natural laws. The content of the city is dynamism and the provinces always protest against this. The provinces fight for their tranquillity. They sense in metallization the expression of a new way of life in which small, primitive establishments and the comforts of country living will come to an end. The provinces therefore protest against everything which comes from the city, everything which seems new and unfamiliar, even when this happens to be new farm machinery.

It is nevertheless to be expected that the culture of the city will sooner or later embrace all the provinces and subject them to its technology. It is only when this has taken place that Futurist art will be able to develop its full power and thrive in the provinces as well as in the city. Futurism is, to be sure, today still exposed to relentless persecution by the adherents of the idyllic art of the provinces. The followers of this art, incidentally, are provincial only in their attitude toward art, for otherwise they already lean toward "futuromachinology," for life itself, indeed, is already futurist.

The more active the life, the more intensive and consistent is the creation of dynamic form.

The Futurist should by no means portray the machine; he should create new abstract forms.

339

The machine is, so to speak, the "overt" form of utilitarian movement and it produces new form-formulae through multiplication by the creative energy of the Futurist.

In this connection, the difference between the kind of "multiplication" of form brought about by the creative activity of the Futurist and that of the so-called realistic (naturalistic) painters can be seen in the fact that the multiplication occasioned by the Futurist yields an increase while the realist never goes beyond $1 \times 1 = 1$.

The subconscious or superconscious mind plays the leading part in the creative activity of the Futurist, since he transforms the elements of the city, just as it does in the case of every true artist.

The role played by science and theory is completely subordinate. *Futurism will become the art representative of the environment of the working man, whose job it is to build machines (to construct dynamic elements), since his (the worker's) dynamic life forms the substance of this artistic culture.*

*He has no taste for conventional painting (easel painting)—this belongs in the provinces.* Thus painting stands at the crossroads and has the choice of going either in the direction of a metallic organization of materials or in the direction of easel painting—plastic painting.

So some stick to their old principles, whereas others begin to move along a new road, they enter actual space and express the dynamic energy of the city in the new formulae of Cubism and Futurism. A third group degenerates into industrial art (a mistaken course for art which, under the most favorable circumstances, leads to a sensitive choice of materials, out of which at some later date works of art can develop). There is no place for painting and architecture in the utilitarian productions of industry. It is only through a misunderstanding that applied art, the job of which is to create useful forms, could have come into existence.

We note that in practice Futurism is rejected and persecuted while provincial art is supported and cultivated. We can infer from this that even in the big city provincial art has not yet been surmounted.

We observe further that propagandistic art (political art, advertising art), in which currently active social or religious doctrines are presented, is pushed into the foreground. And then one inevitably ends up with, what is most important, a portrayal of the person of the leader, the teacher, or the martyr, so that the masses may see in him both the personification of their ideal and their own likeness. The art which has grown out of the dynamic environment of the city is rejected because every representation of the above-mentioned sort is alien to it.

We can conclude, therefore, that three different courses lie open to art—that of the provinces, that of the city, and that of applied art.

The artists constitute, accordingly, three different camps which fight one another and confront each other with their knowledge, temperaments, and energy.

The adherents of the pictorial culture of the provinces reproach the artists

of the city on the score that their art is incomprehensible to the masses (the general public). A representation of a rustic tilling the soil is doubtless more readily understood by the farmer than a picture of a workman operating a complicated machine . . . .

The Futurist replies that futurist paintings could also be intelligible to the general public if the public would make an effort to relinquish its accustomed, obsolete way of thinking and to acquire the new point of view which, however unfamiliar, is entirely justified.

The workman who constructs a modern motorized plow is quite correct in maintaining that this new plow, once its mechanism has been understood, is just as easy to operate as an outmoded, primitive plow; one has only to recognize that it is an improvement over the old plow to realize that it represents a valuable new advance.

*Kasimir Malevich, "Suprematism"* ★

Under Suprematism I understand the supremacy of pure feeling in creative art.

To the Suprematist the visual phenomena of the objective world are, in themselves, meaningless; the significant thing is feeling, as such, quite apart from the environment in which it is called forth.

The so-called "materialization" of a feeling in the conscious mind really means a materialization of the *reflection* of that feeling through the medium of some realistic conception. Such a realistic conception is without value in Suprematist art . . . . And not only in Suprematist art but in art generally, because the enduring, true value of a work of art (to whatever school it may belong) resides solely in the feeling expressed.

Academic naturalism, the naturalism of the Impressionists, Cézanneism, Cubism, etc.—all these, in a way, are nothing more than dialectic methods which, as such, in no sense determine the true value of an art work.

An objective representation, having objectivity as its aim, is something which, as such, has nothing to do with art, and yet the use of objective forms in an art work does not preclude the possibility of its being of high artistic value.

Hence, to the Suprematist, the appropriate means of representation is always the one which gives fullest possible expression to feeling as such and which ignores the familiar appearance of objects.

Objectivity, in itself, is meaningless to him; the concepts of the conscious mind are worthless.

Feeling is the determining factor . . . and thus art arrives at non-objective representation—at Suprematism.

It reaches a "desert" in which nothing can be perceived but feeling.

★ Malevich, *The Non-Objective World*, pp. 67–100 *passim.*

Everything which determined the objective-ideal structure of life and of "art"—ideas, concepts, and images—all this the artist has cast aside in order to heed pure feeling.

The art of the past which stood, at least ostensibly, in the service of religion and the state, will take on new life in the pure (unapplied) art of *Suprematism*, which will build up a new world—the world of feeling . . . .

When, in the year 1913, in my desperate attempt to free art from the ballast of objectivity, I took refuge in the square form and exhibited a picture which consisted of nothing more than a black square on a white field, the critics and, along with them, the public sighed, "Everything which we loved is lost. We are in a desert . . . . Before us is nothing but a black square on a white background!"

"Withering" words were sought to drive off the symbol of the "desert" so that one might behold on the "dead square" the beloved likeness of "reality" ("true objectivity" and a spiritual feeling).

The square seemed incomprehensible and dangerous to the critics and the public . . . and this, of course, was to be expected.

The ascent to the heights of nonobjective art is arduous and painful . . . but it is nevertheless rewarding. The familiar recedes ever further and further into the background . . . . The contours of the objective world fade more and more and so it goes, step by step, until finally the world—"everything we loved and by which we have lived"—becomes lost to sight.

No more "likenesses of reality," no idealistic images—nothing but a desert!

But this desert is filled with the spirit of nonobjective sensation which pervades everything.

Even I was gripped by a kind of timidity bordering on fear when it came to leaving "the world of will and idea," in which I had lived and worked and in the reality of which I had believed.

But a blissful sense of liberating nonobjectivity drew me forth into the "desert," where nothing is real except feeling . . . and so feeling became the substance of my life.

This was no "empty square" which I had exhibited but rather the feeling of nonobjectivity.

I realized that the "thing" and the "concept" were substituted for feeling and understood the falsity of the world of will and idea.

Is a milk bottle, then, the symbol of milk?

Suprematism is the rediscovery of pure art which, in the course of time, had become obscured by the accumulation of "things."

It appears to me that, for the critics and the public, the painting of Raphael, Rubens, Rembrandt, etc., has become nothing more than a *conglomeration* of countless "things," which conceal its true value—the feeling which gave rise to it. The virtuosity of the objective representation is the only thing admired.

If it were possible to extract from the works of the great masters the feeling

expressed in them—the actual artistic value, that is—and to hide this away, the public, along with the critics and the art scholars, would never even miss it.

So it is not at all strange that my square seemed empty to the public.

If one insists on judging an art work on the basis of the virtuosity of the objective representation—the verisimilitude of the illusion—and thinks he sees in the objective representation itself a symbol of the inducing emotion, he will never partake of the gladdening content of a work of art.

The general public is still convinced today that art is bound to perish if it gives up the imitation of "dearly loved reality" and so it observes with dismay how the hated element of pure feeling—abstraction—makes more and more head-way . . . .

Art no longer cares to serve the state and religion, it no longer wishes to illustrate the history of manners, it wants to have nothing further to do with the object, as such, and believes that it can exist, in and for itself, without "things" (that is, the "time-tested well-spring of life").

But the nature and meaning of artistic creation continue to be misunder-stood, as does the nature of creative work in general, because feeling, after all, is always and everywhere the one and only source of every creation.

The emotions which are kindled in the human being are stronger than the human being himself . . . they must at all costs find an outlet—they must take on overt form—they must be communicated or put to work.

It was nothing other than a yearning for speed . . . for flight . . . which, seeking an outward shape, brought about the birth of the airplane. For the airplane was not contrived in order to carry business letters from Berlin to Moscow, but rather in obedience to the irresistible drive of this yearning for speed to take on external form.

The "hungry stomach" and the intellect which serves this must always have the last word, of course, when it comes to determining the origin and purpose of *existing* values . . . but that is a subject in itself.

And the state of affairs is exactly the same in art as in creative tech-nology . . . . In painting (I mean here, naturally, the accepted "artistic" painting) one can discover behind a technically correct portrait of Mr. Miller or an ingenious representation of the flower girl at Potsdamer Platz not a trace of the true essence of art—no evidence whatever of feeling. Painting is the dictatorship of a method of representation, the purpose of which is to depict Mr. Miller, his environment, and his ideas.

The black square on the white field was the first form in which non-objective feeling came to be expressed. The square = feeling, the white field = the void beyond this feeling.

Yet the general public saw in the nonobjectivity of the representation the demise of art and failed to grasp the evident fact that feeling had here assumed external form.

The Suprematist square and the forms proceeding out of it can be likened to the primitive marks (symbols) of aboriginal man which represented, in their combinations, *not ornament but a feeling of rhythm.*

Suprematism did not bring into being a new world of feeling but, rather, an altogether new and direct form of representation of the world of feeling.

The square changes and creates new forms, the elements of which can be classified in one way or another depending upon the feeling which gave rise to them.

When we examine an antique column, we are no longer interested in the fitness of its construction to perform its technical task in the building but recognize in it the material expression of a pure feeling. We no longer see in it a structural necessity but view it as a work of art in its own right.

"Practical life," like a homeless vagabond, forces its way into every artistic form and believes itself to be the genesis and reason for existence of this form. But the vagabond doesn't tarry long in one place and once he is gone (when to make an art work serve "practical purposes" no longer seems practical) the work recovers its full value.

Antique works of art are kept in museums and carefully guarded, not to preserve them for practical use but in order that their eternal artistry may be enjoyed.

The difference between the new, nonobjective ("useless") art and the art of the past lies in the fact that the full artistic value of the latter comes to light (becomes recognized) only after life, in search of some new expedient, has forsaken it, whereas the unapplied artistic element of the new art outstrips life and shuts the door on "practical utility."

And so there the new nonobjective art stands—the expression of pure feeling, seeking no practical values, no ideas, no "promised land." . . .

The Suprematists have deliberately given up objective representation of their surroundings in order to reach the summit of the true "unmasked" art and from this vantage point to view life through the prism of pure artistic feeling.

Nothing in the objective world is as "secure and unshakeable" as it appears to our conscious minds. We should accept nothing as predetermined—as constituted for eternity. Every "firmly established," familiar thing can be shifted about and brought under a new and, primarily, unfamiliar order. Why then should it not be possible to bring about an artistic order? . . .

Our life is a theater piece, in which nonobjective feeling is portrayed by objective imagery.

A bishop is nothing but an actor who seeks with words and gestures, on an appropriately "dressed" stage, to convey a religious feeling, or rather the reflection of a feeling in religious form. The office clerk, the blacksmith, the soldier, the accountant, the general . . . these are all characters out of one stage play or another, portrayed by various people, who become so carried away that they confuse the play and their parts in it with life itself. We almost never get to see the *actual human face* and if we ask someone who he is, he answers, "an engineer," "a farmer,"

etc., or, in other words, he gives the title of the role played by him in one or another effective drama.

The title of the role is also set down next to his full name, and certified in his passport, thus removing any doubt concerning the surprising fact that the owner of the passport is the engineer Ivan and not the painter Kasimir.

In the last analysis, what each individual knows about himself is precious little, because the "actual human face" cannot be discerned behind the mask, which is mistaken for the "actual face."

The philosophy of Suprematism has every reason to view both the mask and the "actual face" with skepticism, since it disputes the reality of human faces (human forms) altogether.

Artists have always been partial to the use of the human face in their representations, for they have seen in it (the versatile, mobile, expressive mimic) the best vehicle with which to convey their feelings. The Suprematists have nevertheless abandoned the representation of the human face (and of natural objects in general) and have found new symbols with which to render direct feelings (rather than externalized reflections of feelings), for *the Suprematist does not observe and does not touch—he feels*.

We have seen how art, at the turn of the century, divested itself of the ballast of religious and political ideas which had been imposed upon it and came into its own—attained, that is, the form suited to its intrinsic nature and became, along with the two already mentioned, a third independent and equally valid "point of view." The public is still, indeed, as much convinced as ever that the artist creates superfluous, impractical things. It never considers that these superfluous things endure and retain their vitality for thousands of years, whereas necessary, practical things survive only briefly.

It does not dawn on the public that it fails to recognize the real, true value of things. This is also the reason for the chronic failure of everything utilitarian. A true, absolute order in human society could only be achieved if mankind were willing to base this order on lasting values. Obviously, then, the artistic factor would have to be accepted in every respect as the decisive one. As long as this is not the case, the uncertainty of a "provisional order" will obtain, instead of the longed-for tranquillity of an absolute order, because the provisional order is gauged by current utilitarian understanding and this measuring-stick is variable in the highest degree.

In the light of this, all art works which, at present, are a part of "practical life" or to which practical life has laid claim, are in some senses devaluated. Only when they are freed from the encumbrance of practical utility (that is, when they are placed in museums) will their truly artistic, absolute value be recognized.

The sensations of sitting, standing, or running are, first and foremost, plastic sensations and they are responsible for the development of corresponding "objects of use" and largely determine their form.

A chair, bed, and table are not matters of utility but rather, the forms taken

by plastic sensations, so the generally held view that all objects of daily use result from practical considerations is based upon false premises.

We have ample opportunity to become convinced that we are never in a position for recognizing any real utility in things and that we shall never succeed in constructing a really practical object. We can evidently only *feel* the essence of absolute utility but, since a feeling is always nonobjective, any attempt to grasp the utility of the objective is Utopian. The endeavor to confine feeling within concepts of the conscious mind or, indeed, to replace it with conscious concepts and to give it concrete, utilitarian form, has resulted in the development of all those useless, "practical things" which become ridiculous in no time at all.

It cannot be stressed to often that absolute, true values arise only from artistic, subconscious, or superconscious creation.

The new art of Suprematism, which has produced new forms and form relationships by giving external expression to pictorial feeling, will become a new architecture: it will transfer these forms from the surface of canvas to space.

The Suprematist element, whether in painting or in architecture, is free of every tendency which is social or otherwise materialistic.

Every social idea, however great and important it may be, stems from the sensation of hunger; every art work, regardless of how small and insignificant it may seem, originates in pictorial or plastic feeling. It is high time for us to realize that the problems of art lie far apart from those of the stomach or the intellect.

Now that art, thanks to Suprematism, has come into its own—that is, attained its pure, unapplied form—and has recognized the infallibility of nonobjective feeling, it is attempting to set up a genuine world order, a new philosophy of life. It recognizes the nonobjectivity of the world and is no longer concerned with providing illustrations of the history of manners.

Nonobjective feeling has, in fact, always been the only possible source of art, so that in this respect Suprematism is contributing nothing new but nevertheless the art of the past, because of its use of objective subject matter, harbored unintentionally a whole series of feelings which were alien to it.

But a tree remains a tree even when an owl builds a nest in a hollow of it.

Suprematism has opened up new possibilities to creative art, since *by virtue of the abandonment of so-called "practical consideration," a plastic feeling rendered on canvas can be carried over into space.* The artist (the painter) is no longer bound to the canvas (the picture plane) and can transfer his compositions from canvas to space.

*Wassily Kandinsky, "Concrete Art," 1938★*

All the arts derive from the same and unique root.

Consequently, all the arts are identical.

★ From *XXᵉ Sicèle* (Paris), No. 1 (1938), reprinted in No. 13 (Christmas, 1959),

But the mysterious and precious fact is that the "fruits" produced by the same trunk are different.

The difference manifests itself by the means of each particular art—by the means of expression.

It is very simple at first thought. Music expresses itself by sounds, painting by colors, etc., facts that are generally recognized.

But the difference does not end here. Music, for example, organizes its means (sounds) within time, and painting its means (colors) upon a plane. Time and plane must be exactly "measured" and sound and color must be exactly "limited." These "limits" are the preconditions of "balance" and hence of composition.

Since the enigmatic but precise laws of composition are the same in all the arts, they obliterate differences.

I should like in passing to emphasize that the organic difference between time and plane is generally exaggerated. The composer takes the listener by the hand, makes him enter into his musical work, guides him step by step, and abandons him once the "piece" is finished. Exactitude is perfect. It is imperfect in painting. But—the painter does not possess this power to "guide." He can if he wishes force the spectator to commence here, to follow an exact path in the pictorial work, and to "leave" it there. These are questions that are excessively complicated, still very little known, and above all very seldom resolved.

I wish only to say that the affinity between painting and music is evident. But it manifests itself still more profoundly. You are well acquainted with the question of "associations" provoked by means of the different arts? Some scientists (especially physicists), some artists (especially musicians) have noticed long ago that a musical sound, for example, provokes an association of a precise color. (Note for example the correspondences established by Scriabin.) Stated otherwise, you "hear" the color and you "see" the sound.

Almost 30 years ago I published a small book which dealt with this question.[1] YELLOW, for example, possesses the special capacity to "ascend" higher and higher and to attain heights unbearable to the eye and the spirit; the sound of a trumpet played higher and higher becoming more and more "pointed," giving pain to the ear and to the spirit. BLUE, with the completely opposite power to "descend" into infinite depths, develops the sounds of the flute (when it is light blue), of the cello (when it has descended farther), of the double bass with its magnificent deep sounds; and in the depths of the organ you "see" the depths of

---

pp. 9–11. See also Kandinsky's essay "On the Problem of Form" (ch. III, above) *ca.* 1912 which, although written at the moment when he was commencing his first Abstract Expressionist paintings, anticipates in its ideology much abstract art of later years.

[1] See his essay "Wirkung der Farbe" (translated as: "Painting: the Effect of Color"), written in 1910 and published in 1912 in *Über das Geistige in der Kunst*, reprinted in Chapter III (above).

blue. GREEN is well balanced and corresponds to the medium and the attenuated sounds of the violin. When skillfully applied, RED (vermillion) can give the impression of strong drum beats, etc. (*Über das Geistige in der Kunst*[Munich, 1912,] pp. 64–71, English and American editions: *The Art of Spiritual Harmony* —W.K.)[2]

The vibrations of the air (sound) and of light (color) surely form the foundation of this physical affinity.

But it is not the only foundation. There is yet another: the psychological foundation. A problem of "spirit."

Have you heard or have you yourself used the expressions: "Oh, such cold music!" or "Oh, such frigid painting!"? You have the impression of frigid air entering through an open window in winter. And your entire body is uncomfortable.

But a skillful application of warm "tones" and "sounds" gives the painter and the composer an excellent possibility of creating warm works. They burn you directly.

Forgive me, but painting and music are able to make you (rather rarely, however) sick to the stomach.

You are also familiar with the case that, when you have the feeling of running your finger over several combinations of sounds or colors, you feel that your finger has been "pricked." As if by spines. But at other times your "finger" runs over painting or music as if over silk or velvet.

Finally, is not VIOLET less odoriferous than YELLOW, for example? And ORANGE? Light BLUE-GREEN?

And as "taste," are not these colors different? Such savory painting! Even the tongue of the spectator or the auditor commences to participate in the work of art.

These are the five known senses of man.

Do not deceive yourself; do not think that you "receive" painting by the eye alone. No, unknown to you, you receive it by your five senses.

Do you think that it could be otherwise?

What we understand by the word "form" in painting is not color alone. What we call "drawing" is inevitably another part of the means of pictorial expression.

To begin with a "point," which is the origin of all other forms, and of which the number is unlimited, the little point is a living being possessed of many influences upon the spirit of man. If the artist places it properly on his canvas, the little point is satisfied, and it pleases the spectator. He says, "Yes, that's me. Do you understand my little necessary sound in the great 'chorus' of the work?"

And how painful it is to see the little point where it should not be! You

---

[2] Published in a new and better translation by Francis Golffing, Michael Harrison and Ferdinand Ostertag as *Concerning the Spiritual in Art* (New York: Wittenborn, Schultz, 1947).

have the sensation of eating a meringue and tasting pepper on the tongue. A flower with the odor of rot.

Rot—that's the word! Composition transforms itself into decomposition. It is death.

Have you noted that in speaking so long of painting and its means of expression I have said not a single word about the "object"? The explanation of this fact is very simple: I have spoken of the essential pictorial means, that is, of inevitables.

One will never find the possibility to make painting without "colors" and "line," but painting without objects has existed in our time for more than 25 years.

As for the object, it can be *introduced* into a painting, or it can not.

When I think of all the *disputes* about this "not," those disputes which began almost 30 years ago and which today have not yet completely ended, I see the immense force of "habit." At the same time I see the immense force of the painting called "abstract" or "nonfigurative." I prefer to call this painting "concrete."

This art is a "problem" which some wanted to "bury" too often, which they said is definitely resolved (naturally, in the negative sense), but which will not let itself be buried.

It is too much alive.

There no longer exists a problem, neither of Impressionism, nor Expressionism (the Fauves!), nor of Cubism. All these "isms" are distributed into the different compartments of the history of art.

The compartments are numbered and bear labels corresponding to their contents. And, thus, the arguments are concluded.

It is the past.

But the arguments around "concrete art" do not yet allow an anticipation of their end. In good time! "Concrete art" is in full development, above all in the free countries, and the number of young artists participating in the "movement" increases in these countries.

The future!

*Piet Mondrian, "Plastic Art and Pure Plastic Art" ("Figurative Art and Nonfigurative Art"), 1937*★

Although art is fundamentally everywhere and always the same, nevertheless two main human inclinations, diametrically opposed to each other, appear in its many and varied expressions. One aims at the *direct creation of universal beauty*, the other at the *aesthetic expression of oneself*, in other words, of that which one thinks and

★ Originally published in Martin, Nicholson, and Gabo, *Circle* (London: Faber & Faber, 1937), pp. 41–56. Reprinted in Piet Mondrian, *Plastic Art and Pure Plastic Art* (New York: Wittenborn, 1945), pp. 50–63.

349

experiences. The first aims at representing reality objectively, the second subjectively. Thus we see in every work of figurative art the desire, objectively to represent beauty, solely through form and color, in mutually balanced relations, and, at the same time, an attempt to express that which these forms, colors, and relations arouse in us. This latter attempt must of necessity result in an individual expression which veils the pure representation of beauty. Nevertheless, both of the two opposing elements (universal-individual) are indispensable if the work is to arouse emotion. Art had to find the right solution. In spite of the dual nature of the creative inclinations, figurative art has produced a harmony through a certain coordination between objective and subjective expression. For the spectator, however, who demands a pure representation of beauty, the individual expression is too predominant. For the artist the search for a unified expression through the balance of two opposites has been, and always will be, a continual struggle.

Throughout the history of culture, art has demonstrated that universal beauty does not arise from the particular character of the form, but from the dynamic rhythm of its inherent relationships, or—in a composition—from the mutual relations of forms. Art has shown that it is a question of determining the relations. It has revealed that the forms exist only for the creation of relationships; that forms create relations and that relations create forms. In this duality of forms and their relations neither takes precedence.

# PIET MONDRIAN

The only problem in art is to achieve a balance between the subjective and the objective. But it is of the utmost importance that this problem should be solved, in the realm of plastic art—technically, as it were—and not in the realm of thought. The work of art must be "produced," "constructed." One must create as objective as possible a representation of forms and relations. Such work can never be empty because the opposition of its constructive elements and its execution arouse emotion.

If some have failed to take into account the inherent character of the form and have forgotten that this—untransformed—predominates, others have overlooked the fact that an individual expression does not become a universal expression through figurative representation, which is based on our conception of feeling, be it classical, romantic, religious, surrealist. Art has shown that universal expression can only be created by a *real equation of the universal and the individual*.

Gradually art is purifying its plastic means and thus bringing out the relationships between them. Thus, in our day two main tendencies appear: the one maintains the figuration, the other eliminates it. While the former employs more or less complicated and particular forms, the latter uses simple and neutral forms, or, ultimately, the free line and the pure color. It is evident that the latter (non-figurative art) can more easily and thoroughly free itself from the domination of

the subjective than can the figurative tendency; particular forms and colors (figurative art) are more easily exploited than neutral forms. It is, however, necessary to point out that the definitions "figurative" and "nonfigurative" are only approximate and relative. For every form, even every line, represents a figure; no form is absolutely neutral. Clearly, everything must be relative, but, since we need words to make our concepts understandable, we must keep to these terms.

Among the different forms we may consider those as being neutral which have neither the complexity nor the particularities possessed by the natural forms or abstract forms in general. We may call those neutral which do not evoke individual feelings or ideas. Geometrical forms being so profound an abstraction of form may be regarded as neutral; and on account of their tension and the purity of their outlines they may even be preferred to other neutral forms.

If, as a conception, nonfigurative art has been created by the mutual interaction of the human duality, this art has been *realized* by the mutual interaction of *constructive elements and their inherent relations*. This process consists in mutual purification; purified constructive elements set up pure relationships, and these in their turn demand pure constructive elements. Figurative art of today is the outcome of figurative art of the past, and nonfigurative art is the outcome of the figurative art of today. Thus the unity of art is maintained.

If nonfigurative art is born of figurative art, it is obvious that the two factors of human duality have not only changed, but have also approached one another towards a mutual balance, towards unity. One can rightly speak of an *evolution in plastic art*. It is of the greatest importance to note this fact, for it reveals the true way of art; the only path along which we can advance. Moreover, the evolution of the plastic arts shows that the dualism which has manifested itself in art is only relative and temporal. Both science and art are discovering and making us aware of the fact that *time is a process of intensification*, an evolution from the individual towards the universal, of the subjective towards the objective; towards the essence of things and of ourselves.

A careful observation of art since its origin shows that artistic expression seen from the outside is *not a process of prolongment but of intensifying one and the same thing*, universal beauty; and that seen from the inside *it is a growth*. Extension results in a continual repetition of nature; it is not human and art cannot follow it. So many of these repetitions which parade as "art" clearly cannot arouse emotions.

Through intensification one creates successively on more profound planes; extension remains always on the same plane. Intensification, be it noted, is diametrically opposed to extension; they are at right angles to each other as are length and depth. This fact shows clearly the temporal opposition of nonfigurative and figurative art.

But if throughout its history art has meant a *continuous and gradual change in the expression of one and the same thing*, the opposition of the two trends—in our time so clear-cut—is actually an unreal one. It is illogical that the two principal

tendencies in art, figurative and nonfigurative (objective and subjective) should be so hostile. Since art is in essence universal, its expression cannot rest on a subjective view. Our human capacities do not allow of a perfectly objective view, but that does not imply that the plastic expression of art is based on subjective conception. Our subjectivity realizes but does not create the work.

If the two human inclinations already mentioned are apparent in a work of art, they have both collaborated in its realization, but it is evident that the work will clearly show which of the two has predominated. In general, owing to the complexity of forms and the vague expression of relations, the two creative inclinations will appear in the work in a confused manner. Although in general there remains much confusion, today the two inclinations appear more clearly defined as two tendencies: *figurative and nonfigurative art.* So-called nonfigurative art often also creates a particular representation; figurative art, on the other hand, often neutralizes its forms to a considerable extent. The fact that art which is really nonfigurative is rare does not detract from its value; evolution is always the work of pioneers, and their followers are always small in number. This following is not a clique; it is the result of all the existing social forces; it is composed of all those who through innate or acquired capacity are ready to represent the existing degree of human evolution. At a time when so much attention is paid to the collective, to the "mass," it is necessary to note that evolution, ultimately, is never the expression of the mass. The mass remains behind yet urges the pioneers to creation. For the pioneers, the social contact is indispensable, but not in order that they may know that what they are doing is necessary and useful, nor in order that "collective approval may help them to persevere and nourish them with living ideas." This contact is necessary only in an indirect way; it acts especially as an obstacle which increases their determination. The pioneers create through their reaction to external stimuli. They are guided not by the mass but by that which they see and feel. They discover consciously or unconsciously the fundamental laws hidden in reality, and aim at realizing them. In this way they further human development. They know that humanity is not served by making art comprehensible to everybody; to try this is to attempt the impossible. One serves mankind by enlightening it. Those who do not see will rebel, they will try to understand and will end up by "seeing." In art the search for a content which is collectively understandable is false; the content will always be individual. Religion, too, has been debased by that search.

Art is not made for anybody and is, at the same time, for everybody. It is a mistake to try to go too fast. The complexity of art is due to the fact that different degrees of its evolution are present at one and the same time. The present carries with it the past and the future. But we need not try to foresee the future; we need only take our place in the development of human culture, a development which has made nonfigurative art supreme. It has always been only one struggle, of only one real art: to create universal beauty. This points the way for both present and future. We need only continue and develop what already exists. The

essential thing is that *the fixed laws of the plastic arts must be realized*. These have shown themselves clearly in nonfigurative art.

Today one is tired of the dogmas of the past, and of truths once accepted but successively jettisoned. One realizes more and more the relativity of everything, and therefore one tends to reject the idea of fixed laws, of a single truth. This is very understandable, but does not lead to profound vision. For there are "made" laws, "discovered" laws, but also laws—a truth for all time. These are more or less hidden in the reality which surrounds us and do not change. Not only science, but art also, shows us that reality, at first incomprehensible, gradually reveals itself, by the mutual relations that are inherent in things. Pure science and pure art, disinterested and free, can lead the advance in the recognition of the laws which are based on these relationships. A great scholar has recently said that pure science achieves practical results for humanity. Similarly, one can say that pure art, even though it appear abstract, can be of direct utility for life.

Art shows us that there are also constant truths concerning forms. Every form, every line has its own expression. This objective expression can be modified by our subjective view but it is no less true for that. Round is always round and square is always square. Simple though these facts are, they often appear to be forgotten in art. Many try to achieve one and the same end by different means. In plastic art this is an impossibility. In plastic art it is necessary to choose constructive means which are of one piece with that which one wants to express.

Art makes us realize that there are *fixed laws which govern and point to the use of the constructive elements, of the composition and of the inherent interrelationships between them*. These laws may be regarded as subsidiary laws to the *fundamental* law of equivalence which creates *dynamic equilibrium and reveals the true content of reality*.

We live in a difficult but interesting epoch. After a secular culture, a turning point has arrived; this shows itself in all the branches of human activity. Limiting ourselves here to science and art, we notice that, just as in medicine some have discovered the natural laws relating to physical life, in art some have discovered the artistic laws relating to plastics. In spite of all opposition, these facts have become movements. But confusion still reigns in them. Through science we are becoming more and more conscious of the fact that our physical state depends in great measure on what we eat, on the manner in which our food is arranged, and on the physical exercise which we take. Through art we are becoming more and more conscious of the fact that the work depends in large measure on the constructive elements which we use and on the construction which we create. We will gradually realize that we have not hitherto paid sufficient attention to constructive physical elements in their relation to the human body, nor to the constructive plastic elements in their relation to art. That which we eat has deteriorated through a refinement of natural produce. To say this, appears to invoke a return to a primitive natural state and to be in opposition to the exigencies of pure plastic art, which degenerates precisely through figurative trappings. But a

return to pure natural nourishment does not mean a return to the state of primitive man; it means on the contrary that cultured man obeys the laws of nature discovered and applied by science.

Similarly in nonfigurative art, to recognize and apply natural laws is not evidence of a retrograde step; the pure abstract expression of these laws proves that the exponent of nonfigurative art associates himself with the most advanced progress and the most cultured minds, that he is an exponent of denaturalized nature, of civilization.

In life, sometimes the spirit has been overemphasized at the expense of the body, sometimes one has been preoccupied with the body and neglected the spirit; similarly in art content and form have alternately been overemphasized or neglected because *their inseparable unity* has not been clearly realized.

To create this unity in art *balance of the one and the other must be created.*

It is an achievement of our time to have approached towards such balance in a field in which disequilibrium still reigns.

Disequilibrium means conflict, disorder. Conflict is also a part of life and of art, but it is not the whole of life or universal beauty. Real life is the *mutual interaction of two oppositions of the same value but of a different aspect and nature.* Its plastic expression is universal beauty.

In spite of world disorder, instinct and intuition are carrying humanity to a real equilibrium, but how much misery has been and is still being caused by primitive animal instinct. How many errors have been and are being committed through vague and confused intuition? Art certainly shows this clearly. But art shows also that in the course of progress, intuition becomes more and more conscious and instinct more and more purified. Art and life illuminate each other more and more; they reveal more and more their laws according to which a real and living balance is created.

Intuition enlightens and so links up with pure thought. They together become an intelligence which is not simply of the brain, which does not calculate, but which feels and thinks. Which is creative both in art and in life. From this intelligence there must arise nonfigurative art in which instinct no longer plays a dominating part. Those who do not understand this intelligence regard nonfigurative art as a purely intellectual product.

Although all dogma, all preconceived ideas, must be harmful to art, the artist can nevertheless be guided and helped in his intuitive researches by reasoning apart from his work. If such reasoning can be useful to the artist and can accelerate his progress, it is indispensable that such reasoning should accompany the observations of the critics who talk about art and who wish to guide mankind. Such reasoning, however, cannot be individual, which it usually is; it cannot arise out of a body of knowledge outside plastic art. If one is not an artist oneself one must at least know *the laws and culture of plastic art.* If the public is to be well informed and if mankind is to progress it is essential that the confusion which is everywhere present should be removed. For enlightenment, a clear demonstration

of the *succession of artistic tendencies is necessary*. Hitherto, a study of the different styles of plastic art in their progressive succession has been difficult since the expression of the essence of art has been veiled. In our time, which is reproached for not having a style of its own, the content of art has become clear and the different tendencies reveal more clearly the progressive succession of artistic expression. Nonfigurative art brings to an end the ancient culture of art; at present therefore, one can review and judge more surely *the whole culture of art*. We are not at the turning-point of this culture; *the culture of particular form is approaching its end. The culture of determined relations has begun.*

It is not enough to explain the value of a work of art in itself; it is above all necessary to show *the place which a work occupies on the scale of the evolution of plastic art*. Thus in speaking of art, it is not permissible to say "this is how I see it" or "this is my idea." True art like true life takes a *single road*.

The laws which in the culture of art have become more and more determinate are *the great hidden laws of nature which art establishes in its own fashion*. It is necessary to stress the fact that these laws are more or less hidden behind the superficial aspect of nature. Abstract art is therefore opposed to a natural representation of things. But it *is not opposed to nature* as is generally thought. It is opposed to the raw primitive animal nature of man, but it is one with true human nature. It is opposed to the conventional laws created during the culture of the particular form but it is one with the laws of the culture of pure relationships.

First and foremost there is the fundamental law of *dynamic equilibrium* which is opposed to the static equilibrium necessitated by the particular form.

The important task then of all art is to destroy the static equilibrium by establishing a dynamic one. Nonfigurative art demands an attempt of what is a consequence of this task, the *destruction* of particular form and the *construction* of a rhythm of mutual relations, of mutual forms of free lines. We must bear in mind, however, a distinction between these two forms of equilibrium in order to avoid confusion; for when we speak of equilibrium pure and simple we may be for, and at the same time against, a balance in the work of art. It is of the greatest importance to note the destructive-constructive quality of dynamic equilibrium. Then we shall understand that the equilibrium of which we speak in nonfigurative art is not without movement of action but is on the contrary a continual movement. We then understand also the significance of the name "constructive art."

The fundamental law of dynamic equilibrium gives rise to a number of other laws which relate to the constructive elements and their relations. These laws determine the manner in which dynamic equilibrium is achieved. The relations of *position* and those of *dimension* both have their own laws. Since the relation of the rectangular position is constant, it will be applied whenever the work demands the expression of stability; to destroy this stability there is a law that relations of a changeable dimension-expression must be substituted. The fact that all the relations of position except the rectangular one lack that stability, also creates a law which we must take into account if something is to be established in

355

a determinate manner. Too often right and oblique angles are arbitrarily employed. All art expresses the rectangular relationship even though this may not be in a determinate manner; first by the height and width of the work and its constructive forms, then by the mutual relations of these forms. Through the clarity and simplicity of neutral forms, nonfigurative art has made the rectangular relation more and more determinate, until, finally, it has established it through free lines which intersect and appear to form rectangles.

As regards the relations of dimension, they must be varied in order to avoid repetition. Although, as compared with the stable expression of the rectangular relationship, they belong to individual expression, it is precisely they that are most appropriate for the destruction of the static equilibrium of all form. By offering him a freedom of choice the relations of dimension *present the artist with one of the most difficult problems.* And the closer he approaches the ultimate consequence of his art the more difficult is his task.

Since the constructive elements and their mutual relations form an inseparable unity, the laws of the relations govern equally the constructive elements. These, however, have also their own laws. It is obvious that one cannot achieve the same expression through different forms. But it is often forgotten that varied forms or lines *achieve—in form—altogether different degress in the evolution of plastic art.* Beginning with natural forms and ending with the most abstract forms, *their expression becomes more profound.* Gradually form and line gain in tension. For this reason the straight line is a stronger and more profound expression than the curve.

In pure plastic art the significance of different forms and lines is very important; it is precisely this fact which makes it pure.

In order that art may be really abstract, in other words, that it should not represent relations with the natural aspect of things, the law of the *denaturalization of matter* is of fundamental importance. In painting, the primary color that is as pure as possible realizes this abstraction of natural color. But color is, in the present state of technique, also the best means for denaturalizing matter in the realm of abstract constructions in three dimensions; technical means are as a rule insufficient.

All art has achieved a certain measure of abstraction. This abstraction has become more and more accentuated until in pure plastic art not only a transformation of form but also of matter—be it through technical means or through color—a more or less neutral expression is attained.

According to our laws, it is a great mistake to believe that one is practicing nonfigurative art by merely achieving neutral forms or free lines and determinate relations. For in composing these forms one runs the risk of a figurative creation, that is to say, one or more particular forms.

Nonfigurative art is created by establishing *a dynamic rhythm of determinate mutual relations* which *excludes the formation of any particular form.* We note thus, that to destroy particular form is only to do more consistently what all art has done.

The dynamic rhythm which is essential in all art is also the essential element of a nonfigurative work. In figurative art this rhythm is veiled.

Yet we all pay homage to clarity.

The fact that people generally prefer figurative art (which creates and finds its continuation in abstract art) can be explained by the dominating force of the individual inclination in human nature. *From this inclination arises all the opposition to art which is purely abstract.*

In this connection we note first the *naturalistic conception* and the *descriptive or literary orientation:* both a real danger to purely abstract art. From a purely plastic point of view, until nonfigurative art, artistic expression has been naturalistic or descriptive. To have emotion aroused by pure plastic expression one must abstract from figuration and so become "neutral." But with the exception of some artistic expressions (such as Byzantine art)[1] there has not been the desire to employ neutral plastic means, which would have been much more logical than to become neutral oneself in contemplating a work of art. Let us note, however, that the spirit of the past was different from the spirit of our own day, and that it is only tradition which has carried the past into our own time. In past times when one lived in contact with nature and when man himself was more natural than he is today, abstraction from figuration in thought was easy; it was done unconsciously. But in our more or less denaturalized period, such abstraction becomes an effort.

However that may be, the fact that figuration is a factor which is unduly taken into account, and whose abstraction in the mind is only relative, proves that today even great artists regard figuration as indispensable. At the same time these artists are already abstracting from figuration to a much greater extent than has been done before. More and more, not only the uselessness of figuration, but also obstacles which it creates, will become obvious. In this search for clarity, nonfigurative art develops.

There is, however, one tendency which cannot forgo figuration without losing its descriptive character. That is Surrealism. Since the predominance of individual thought is opposed to pure plastics it is also opposed to nonfigurative art. Born of a literary movement, its descriptive character demands figuration. However purified or deformed it may be, figuration veils pure plastics. There are, it is true, Surrealist works whose plastic expression is very strong and of a kind that if the work is observed at a distance, i.e., if the figurative representation is abstracted from, they arouse emotion by form, color and their relations alone. But if the purpose was nothing but plastic expression, why then use figurative representation? Clearly, there must have been the intention to express something outside the realm of pure plastics. This of course is often the case even in abstract art. There, too, there is sometimes added to the abstract forms something particular, even without the use of figuration; through the color or through the

---

[1] As regards these works we must note that, lacking a dynamic rhythm, they remain, in spite of the profound expression of forms, more or less ornamental. [P.M.]

execution, a particular idea or sentiment is expressed. There is generally not the literary inclination but the naturalistic inclination which has been at work. It must be obvious that if one evokes in the spectator the sensation of, say, the sunlight or moonlight, of joy or sadness, or any other determinate sensation, one has not succeeded in establishing universal beauty, one is not purely abstract.

As for Surrealism, we must recognize that it deepens feeling and thought, but since this deepening is limited by individualism it cannot reach the foundation, the universal. So long as it remains in the realm of dreams, which are only a rearrangement of the events of life, jt cannot touch true reality. Through a different composition of the events of life, it may remove their ordinary course but it cannot purify them. Even the intention of freeing life from its conventions and from everything which is harmful to the true life can be found in Surrealist literature. Nonfigurative art is fully in agreement with this intention but it achieves its purpose; it frees its plastic means and its art from all particularity. The names, however, of these tendencies, are only indications of their conceptions; it is the realization which matters. With the exception of nonfigurative art, there seems to have been a lack of realization of the fact that it is possible to express oneself profoundly and humanely by plastics alone, that is, by employing a neutral plastic means without the risk of falling into decoration or ornament. Yet all the world knows that even a single line can arouse emotion. But although one sees— and this is the artist's fault—few nonfigurative works which live by virtue of their dynamic rhythm and their execution, figurative art is no better in this respect. In general, people have not realized that one can express our very essence through neutral constructive elements; that is to say, we can express the essence of art. The essence of art of course is not often sought. As a rule, individualist human nature is so predominant, that the expression of the essence of art through a rhythm of lines, colors, and relationships appears insufficient. Recently, even a great artist has declared that "complete indifference to the subject leads to an incomplete form of art."

But everybody agrees that art is only a problem of plastics. What good then is a subject? It is to be understood that one should need a subject to expound something named "Spiritual riches, human sentiments, and thoughts." Obviously, all this is individual and needs particular forms. But at the root of these sentiments and thoughts there is one thought and one sentiment: these do not easily define themselves and have no need of analogous forms in which to express themselves. It is here that neutral plastic means are demanded.

For pure art then, the subject can never be an additional value; it is the line, the color and their relations which must "bring into play the whole sensual and intelligent register of the inner life . . . ," not the subject. Both in abstract art and in naturalistic art color expresses itself "in accordance with the form by which it is determined," and in all art it is the artist's task to make forms and colors living and capable of arousing emotion. If he makes art into an "algebraic equation," that is no argument against the art, it only proves that he is not an artist.

If all art has demonstrated that to establish the force, tension, and move-ment of the forms, and the intensity of the colors of reality, it is necessary that these should be purified and transformed; if all art has purified and transformed and is still purifying and transforming these forms of reality and their mutual relations, if all art is thus a continually deepening process: why then stop halfway? If all art aims at expressing universal beauty, why establish an individualist expression? Why then not continue the sublime work of the Cubists? That would not be a continuation of the same tendency, but on the contrary, *a complete break-away from it and all that has existed before it.* That would only be going along the same road that we have already traveled.

Since Cubist art is still fundamentally naturalistic, the break which pure plastic art has caused consists in becoming abstract instead of naturalistic in essence. While in Cubism, from a naturalistic foundation, there sprang forcibly the use of plastic means, still half object, half abstract, the abstract basis of pure plastic art must result in the use of purely abstract plastic means.

In removing completely from the work all objects, "the world is not separated from the spirit," but is on the contrary *put into a balanced opposition* with the spirit, since the one and the other are purified. This creates a perfect unity between the two opposites. There are, however, many who imagine that they are too fond of life, particular reality, to be able to suppress figuration, and for that reason they still use in their work the object of figurative fragments which indicate its character. Nevertheless, one is well aware of the fact that in art one cannot hope to represent in the image things as they are, nor even as they manifest themselves in all their living brilliance. The Impressionists, Divisionists, and Pointillists have already recognized that. There are some today who, recognizing the weakness and limitation of the image, attempt to create a work of art through the objects themselves, often by composing them in a more or less transformed manner. This clearly cannot lead to an expression of their content nor of their true character. One can more or less remove the conventional appearance of things (Surrealism), but they continue nevertheless to show their particular character and to arouse in us individual emotions. To love things in reality is to love them profoundly; it is to see them as a microcosmos in the macrocosmos. *Only in this way can one achieve a universal expression of reality.* Precisely on account of its profound love for things, nonfigurative art does not aim at rendering them in their particular appearance.

Precisely by its existence nonfigurative art shows that "art" *continues always on its true road.* It shows that "art" is *not the expression of the appearances of reality such as we see it, nor of the life which we live, but that it is the expression of true reality and true life . . . indefinable but realizable in plastics.*

Thus we must carefully distinguish between two kinds of reality; one which has an individual and one which has a universal appearance. In art the former is the expression of space determined by particular things or forms, the latter establishes expansion and limitation—the creative factors of space—through

neutral forms, free lines, and pure colors. While universal reality arises from determinate relations, particular reality shows only veiled relations. The latter must obviously be confused in just that respect in which universal reality is bound to be clear. The one is free, the other is tied to individual life, be it personal or collective. Subjective reality and relatively objective reality: this is the contrast. Pure abstract art aims at creating the latter, figurative art the former.

It is astonishing, therefore, that one should reproach pure abstract art with not being "real," and that one should envisage it as "arising from particular ideas."

In spite of the existence of nonfigurative art, one is talking about art today as if nothing determinate in relation to the new art existed. Many neglect the real nonfigurative art, and looking only at the fumbling attempts and at the empty nonfigurative works which today are appearing everywhere, ask themselves whether the time has not arrived "to integrate form and content" or "to unify thought and form." But one should not blame nonfigurative art for that which is only due to the ignorance of its very content. If the form is without content, without universal thought, it is the fault of the artist. Ignoring that fact, one imagines that figuration, subject, particular form, could add to the work that which the plastic itself is lacking. As regards the "content" of the work, we must note that our "attitude with regard to things, our organized individuality with its impulses, its actions, its reactions when in contact with reality, the lights and shades of our spirit," etc., certainly do modify the nonfigurative work, but they do not constitute its content. We repeat, that its content cannot be described, and that it is only through pure plastics and through the execution of the work that it can be made apparent. Through this indeterminable content, the nonfigurative work is "fully human." Execution and technique play an important part in the aim of establishing a more or less objective vision which the essence of the non-figurative work demands. The less obvious the artist's hand the more objective will the work be. This fact leads to a preference for a more or less mechanical execution or to the employment of materials produced by industry. Hitherto, of course, these materials have been imperfect from the point of view of art. If these materials and their colors were more perfect and if a technique existed by which the artist could easily cut them up in order to compose his work as he conceives it, an art more real and more objective in relation to life than painting would arise. All these reflections evoke questions which have already been asked many years ago, mainly: is art still necessary and useful for humanity? Is it not even harmful to its progress? Certainly the art of the past is superfluous to the new spirit and harmful to its progress: just because of its beauty it holds many people back from the new conception. The new art is, however, still very necessary to life. In a clear manner it establishes the laws according to which a real balance is reached. Moreover, it must create among us a profoundly human and rich beauty realized not only by the best qualities of the new architecture, but also by all that the constructive art in painting and sculpture makes possible.

But although the new art is necessary, the mass is conservative. Hence these cinemas, these radios, these bad pictures which overwhelm the few works which are really of our era.

It is a great pity that those who are concerned with the social life in general do not realize the utility of pure abstract art. Wrongly influenced by the art of the past, the true essence of which escapes them, and of which they only see that which is superfluous, they make no effort to know pure abstract art. Through another conception of the word "abstract," they have a certain horror of it. They are vehemently opposed to abstract art because they regard it as something ideal and unreal. In general they use art as propaganda for collective or personal ideas, thus as literature. They are both in favor of the progress of the mass and against the progress of the elite, thus against the logical march of human evolution. Is it really to be believed that the evolution of the mass and that of the elite are incompatible? The elite rises from the mass; is it not therefore its highest expression?

To return to the execution of the work of art, let us note that it must contribute to a revelation of the subjective and objective factors in mutual balance. Guided by intuition, it is possible to attain this end. The execution is of the greatest importance in the work of art; it is through this, in large part, that intuition manifests itself and creates the essence of the work.

It is therefore a mistake to suppose that a nonfigurative work comes out of the unconscious, which is a collection of individual and prenatal memories. We repeat that it comes from pure intuition, which is at the basis of the subjective-objective dualism.

It is, however, wrong to think that the nonfigurative artist finds impressions and emotions received from the outside useless, and regards it even as necessary to fight against them. On the contrary, all that the nonfigurative artist received from the outside is not only useful but indispensable, because it arouses in him the desire to create that which he only vaguely feels and which he could *never represent in a true manner without the contact with visible reality and with the life which surrounds him.* It is precisely from this visible reality that he draws the objectivity which he needs in opposition to his personal subjectivity. It is precisely from this visible reality that he draws his means of expression: and, as regards the surrounding life, it is precisely this which has made his art nonfigurative.

That which distinguishes him from the figurative artist is the fact that in his creations he frees himself from individual sentiments and from particular impressions which he receives from outside, and that he breaks loose from the domination of the individual inclination within him.

It is therefore equally wrong to think that the nonfigurative artist creates through "the pure intention of his mechanical process," that he makes "calculated abstractions," and that he wishes to "suppress sentiment not only in himself but also in the spectator." It is a mistake to think that he retires completely into his system. That which is regarded as a system is nothing but constant obedience to the laws of pure plastics, to necessity, which art demands from him. It is thus clear

that he has not become a mechanic, but that the progress of science, of technique, of machinery, of life as a whole, has only made him into a living machine, capable of realizing in a pure manner the essence of art. In this way, he is in his creation sufficiently neutral, that nothing of himself or outside of him can prevent him from establishing that which is universal. Certainly his art is art for art's sake . . . for the sake of the art *which is form and content at one and the same time.*

If all real art is the "sum total of emotions aroused by purely pictorial means" his art is the sum of the emotions aroused by plastic means.

It would be illogical to suppose that nonfigurative art will remain stationary, for this art contains *a culture* of the use of new plastic means and their determinate relations. Because the field is new there is all the more to be done. What is certain is that no escape is possible for the nonfigurative artist; he *must stay within his field and march towards the consequence of his art.*

This consequence brings us, in a future perhaps remote, towards the end of *art as a thing separated from our surrounding environment, which is the actual plastic reality.* But this end is at the same time a new beginning. Art will not only continue but will realize itself more and more. By the unification of architecture, sculpture, and painting, a new plastic reality will be created. Painting and sculpture will not manifest themselves as separate objects, nor as "mural art" which destroys architecture itself, nor as "applied" art, but *being purely constructive* will aid the creation of a surrounding not merely utilitarian or rational but also pure and complete in its beauty.

*Piet Mondrian, statement, ca. 1943*★

The first aim in a painting should be universal expression. What is needed in a picture to realize this is an equivalence of vertical and horizontal expressions. This I feel today I did not accomplish in such early work as my 1911 "Tree" paintings. In those the vertical emphasis predominated. A "gothic" expression was the result.

The second aim should be concrete, universal expression. In my work of 1919 and 1920 (where the surface of the canvas was covered by adjoining rectangles) there was an equivalence of horizontal and vertical expression. Thus the whole was more universal than those in which verticals predominated. But this expression was vague. The verticals and horizontals cancelled each other, the result was confused, the structure was lost.

In my paintings after 1922 I feel that I approached the concrete structure I regard as necessary. And in my latest pictures such as *Broadway Boogie Woogie* [1942–1943, Museum of Modern Art, New York] and *Victory Boogie Woogie* the structure and means of expression are both concrete and in mutual equivalence . . . .

★ From *Eleven Europeans in America, Bulletin of the Museum of Modern Art*, New York, XII, 4 and 5, 1946, and reprinted with its permission.

In my "cubist" paintings such as *Tree* the color was vague. Some of my 1919 rectangle compositions and even many of my earlier works were painted in black and white. This was too far from reality. But in my canvases after 1922 the colors have been primary—concrete.

It is important to discern two sorts of equilibrium in art: 1. static balance; 2. dynamic equilibrium. And it is understandable that some advocate equilibrium, others oppose it.

The great struggle for artists is the annihilation of static equilibrium in their paintings through continuous oppositions (contrasts) among the means of expression. It is always natural for human beings to seek static balance. This balance of course is necessary to existence in time. But vitality in the continual succession of time always destroys this balance. Abstract art is a concrete expression of such a vitality.

Many appreciate in my former work just what I did not want to express, but which was produced by an incapacity to express what I wanted to express—dynamic movement in equilibrium. But a continuous struggle for this statement brought me nearer. This is what I am attempting in *Victory Boogie Woogie*.

Doesburg, in his late work, tried to destroy static expression by a diagonal arrangement of the lines of his compositions. But through such an emphasis the feeling of physical equilibrium which is necessary for the enjoyment of a work of art is lost. The relationship with architecture and its vertical and horizontal dominants is broken.

If a square picture, however, is hung diagonally, as I have frequently planned my pictures to be hung, this effect does not result. Only the borders of the canvas are on 45° angles, not the picture. The advantage of such a procedure is that longer horizontal and vertical lines may be employed in the composition.

So far as I know, I was the first to bring the painting forward from the frame, rather than set it within the frame. I had noted that a picture without a frame works better than a framed one and that the framing causes sensations of three dimensions. It gives an illusion of depth, so I took a frame of plain wood and mounted my picture on it. In this way I brought it to a more real existence.

To move the picture into our surroundings and give it real existence, has been my ideal since I came to abstract painting. I think that the logical outgrowth of painting is the use of pure color and straight lines in rectangular opposition; and I feel that painting can become much more real, much less subjective, much more objective, when its possibilities are realized in architecture in such a way that the painter's capabilities are joined with constructive ones. But then the constructions would become very expensive; they would require a pretty long time for execution. I have studied the problem and practiced the approach with removable color and noncolor planes in several of my studios in Europe, just as I have done here in New York. (See Museum of Modern Art *Bulletin*, XII, 4 [1945], 12.)

The intention of Cubism—in any case in the beginning—was to express volume. Three-dimensional space—natural space—thus remained. Cubism therefore remained basically a naturalistic expression and was only *an abstraction*—not true abstract art.

This attitude of the cubists to the representations of volume in space was contrary to my conception of abstraction which is based on belief that this very space *has to be destroyed*. As a consequence I came to the destruction of volume by the use of the plane. This I accomplished by means of lines cutting the planes. But still the plane remained too intact. So I came to making only lines and brought the color within the lines. Now the only problem was to destroy these lines also through mutual oppositions.

Perhaps I do not express myself clearly in this, but it may give you some idea why I left the Cubist influence. True Boogie-Woogie I conceive as homogeneous in intention with mine in painting: destruction of melody which is the equivalent of destruction of natural appearance; and construction through the continuous opposition of pure means—dynamic rhythm.

I think the destructive element is too much neglected in art.

*Constantin Brancusi, Aphorisms (undated)* ★

Beauty, it is absolute equity.

Things are not difficult to accomplish. What is difficult is to prepare ourselves to do them.

When we are no longer children, we are already dead.

Theories are patterns without value. Only action counts.

Nude men in sculpture are not as beautiful as toads.

To be cunning is something, but to be honest is worthwhile.

*Aphorisms (undated)* †

Direct cutting [of stone] is the true way to sculpture. But it is also the worst for those who do not know how to follow the road. Finally, direct or indirect cutting means nothing at all. It is the finished thing that counts.

Polishing is a necessity which demands the almost absolute forms of certain materials. It is not obligatory, in fact, it is very detrimental to those whose livelihood depends on it.

Simplicity is not an objective in art, but one achieves simplicity despite oneself by entering into the real sense of things.

★ Translated from *This Quarter* (Paris), I, 1 (January 1925), p. 236.
† Translated from *This Quarter*, I, 1 (collected by Irene Codreame), p. 235.

*Aphorisms (undated)* ★

It is pure joy that I give you.

There is a purpose in everything. In order to achieve it, one must detach oneself from an awareness of self.

I am no longer of this world, I am far from myself, I am no longer a part of my own person. I am within the essence of things themselves.

*Aphorisms (ca. 1957)* †

They are imbeciles who call my work abstract; that which they call abstract is the most realist, because what is real is not the exterior form but the idea, the essence of things.

★ Translated from David Lewis, *Constantin Brancusi* (New York: Wittenborn, 1957), p. 43.
† Translated from "Propos de Brancusi" (collected by Claire Gilles Guilbert), *Prisme des Arts* (Paris), No. 12, May 1957, p. 6.

# VII    DADA, SURREALISM
AND *SCUOLA METAFISICA*:
The Irrational and the Dream

## INTRODUCTION: Dada and Surrealism

Surrealism may be described in two quite different ways: in the broadest philosophic sense, as one of the important poles toward which art and thought have always been drawn, and specifically, as the ideology of an organized group of artists and writers who from about 1924 on gathered about André Breton in Paris. It is to this latter group that we owe the term Surrealism itself, and to a large extent the recognition of its earlier manifestations.

The broad meaning represents a significant constituent of human feeling, a love for the world of dreams and of fantasy. In Walter Friedlaender's duality of rational-irrational, this is the realm of the irrational; it depends upon inspiration rather than upon rules, and it values the free play of the individual imagination rather than the codification of the ideals of society or of history. With the artists who tended toward this pole in the historic past, such as Hieronymous Bosch, Salvator Rosa, Goya, etc., the free element of fantasy is only a part of a total concept which is basically traditional. That is, the class of subject matter chosen by the artist and his mode of visualizing it are dependent upon tradition and are similar to those of other contemporary artists. The unconventional element, fantasy, is secondary to the larger conventional framework of the work of art. The twentieth-century Surrealist group, on the contrary, sought to revolutionize art completely so that both the kinds of subjects represented and the stylistic coherence of the painting itself were to be unconventional if not actually fantastic. Furthermore, the group was given support by a large body of Surrealist literature and theory, much of it based upon the methods and the findings of psychoanalysis.

The Surrealist movement was anticipated by an earlier "proto-Surrealist" group called by the nonsense term Dada. Formed in 1916 in Zurich by French and German youths, who had they remained in their own countries would have been drafted into the army, Dada was a movement of negation. The young artists were appalled by the violence of the war be-

366

tween their countries, but at the same time they could not regret the disruption of the conventional society that had ignored the many new art movements of the age.

Their response took the form of an insurrection against all that was pompous, conventional, or even boring in the arts. In general, they admired "nature," in the sense of being natural, and they opposed all formulas imposed by man. Jean Arp wrote in his diary that his aim was "to destroy the rationalist swindle for man and incorporate him again humbly in nature." Hugo Ball attacked with satire the "language devastated and made impossible by journalists." The Dadaists composed and read nonsense poems, sang, and argued in the nihilistic spirit which was their reaction to the holocaust of the war. Unlike the Surrealists, they had neither a leader, nor a theory, nor an organized group. Only in 1918, after nearly three years of activity, was a manifesto written, and even then the author, Tristan Tzara, made no pretense of explaining the movement.

The movement was founded by Hugo Ball (1886–1927), a German actor and playwright, in a music hall, the Cabaret Voltaire, operated by him in Zurich. He was soon joined in the festivities by Jean Arp (1887–1966), an Alsatian artist anxious to avoid serving in the army of the Kaiser; Tristan Tzara (1886–1963), a Rumanian poet; Marcel Janco (b. 1895), a Rumanian artist; and Richard Huelsenbeck (b. 1892), a German poet. At the age of 29, Arp already had an international reputation as an artist. He had shown his work in 1912 with the *Blaue Reiter* in Munich and in 1913 in the first *Herbstsalon* in Berlin; he had lived in Paris in 1904, and also around 1914 where he had been associated with Picasso and Apollinaire; and he was acquainted with Max Ernst, who was to become the initiator of Dada in Cologne. Arp had written poetry since his youth, and he contributed both poetry and illustrations to the many Dada publications. The reviews, *Cabaret Voltaire* and *Dada*, were highly eclectic, including original and revolutionary articles by Apollinaire and Marinetti as well as those by the Dadaists themselves. Their exhibitions showed work by revolutionary painters of many various movements, such as De Chirico, Ernst, Kandinsky, Picabia, Kokoschka, Marc, and Picasso.

But even before Dada was founded, Marcel Duchamp (b. 1887) in Paris had anticipated its light-hearted assaults on traditional ideas. While in New York during World War I, he continued working on a series of "Ready-Mades," which have now become a kind of touchstone for the contemporary admiration for commonplace and junk objects. He was extremely active in America, editing several reviews, making an abstract film, and inventing word games, all of which was done in a spirit of

good-humored irony akin to that of the Zurich group. Duchamp actually produced very little—a few paintings, drawings and fragmentary writings— yet his superior intelligence and his refined sensibility provided a wealth of associated meaning for each of his works, even when, as with the "Ready-Mades," he did nothing to the object except to present it for contemplation. With the decline in the spontaneous creativity that had attended the beginnings of Dada, Duchamp in 1923 abandoned painting for more purely intellectual activities, such as chess, and for experiments in optics and mechanics. But the perceptiveness of his observations on the problem of art versus "non-art" shaped many of the conceptions of contemporary painting and sculpture.

Francis Picabia (1879-1952), was, like Duchamp, a congenital anarchist and Dadaist in the broadest meaning of the term. He seemed to appear, like a political agitator, at whatever place there was any possibility of subverting with his wit any false dignity or conventionality in art, and he was ready to incite any latent Dadaist tendencies. He was several years older than the men of the Zurich Dada group, who were all in their twenties, and had achieved a substantial reputation as a painter of Impressionist pictures, a career which he abruptly rejected before 1912 in order to paint quasi-Dadaist pictures. These paintings with nonsense titles (*Catch as Catch Can* and *Infant Carburetor*) were among the first abstractions ever created. He went to New York in 1913 to witness the great impact created by the Armory Show on American art. He remained there to inject a proto-Dada spirit into Alfred Stieglitz's review, *Camera Work*, and later into *291*, the journal of Stieglitz's gallery. He founded in 1916 in Barcelona a counterpart, *391*, which he published intermittently from wherever he might be working. It was not until 1916 that he joined the official Dada group in Zurich, and in the next year he participated in the first Dada demonstrations in Paris.

Dadaism, which had always been fervently internationalist, spread rapidly throughout Europe at the end of the war. In 1919 Arp assisted his old friend Max Ernst (b. 1891) to launch Dada in his home town of Cologne. Their first exhibition the next year created a perfect Dadaist situation, stirring up such a scandal that it was closed by the police upon the order of a magistrate who was Ernst's own uncle. The Dada spirit broke out in Hanover in 1923 under the leadership of Kurt Schwitters (1887–1948), who was joined by men like El Lissitzky, refugees from the new reactionary artistic policies of the Soviets, and also by the Dutchmen Mondrian and Van Doesberg. Again, Arp was present to fan the flames of artistic anarchy. Schwitter's title for the Hanover movement was *Merz* (literally, something cast-off, like junk),

which he also gave to his collage-paintings and to an extremely lively review that he edited. During the long life of the review from 1923 until 1932, he published articles on a wide variety of *avant-garde* subjects, such as child art and Russian Constructivism. In Berlin Dada sprang from the activities of the galleries and the journal of *Der Sturm*, which before the war had launched the German Expressionists. It was initiated by Huelsenbeck, who in 1918 returned from Zurich to Berlin and there drew George Grosz and Raoul Hausmann into the movement. The Berlin group promoted the huge international Dada exhibition of 1920, the largest yet shown.

The finale of Dada as a group activity came about in 1921, by which time all the initiators had been drawn to Paris. Here in 1920 André Breton (1896–1966) had staged a great Dada soiree at the *Théâtre de l'Oeuvre*, combining an art exhibition with a public reading of Dadaist writings by Picabia. The last issues of *391* appeared in Paris, and Breton's own review *Littérature*, founded in 1919, was no longer the official organ of the movement. The original spontaneous character of Dada degenerated into public demonstrations, violent arguments, and actual riots, while maintaining to the end its character of complete freedom of expression.

The Surrealist movement was composed of a highly organized group of writers and artists, most of them former Dadaists, who in 1924 rallied about Breton in Paris when he issued his Surrealist Manifesto. This group was quite different in structure and attitude from the Dadaists with their spontaneous meetings in the Cabaret Voltaire. It had a strong identity as a closed group obedient to doctrinaire theories; it was dominated by the person and the ideas of Breton; and it was motivated by an avalanche of totally new and stimulating ideas flowing from Breton's interpretation of Freud's experiments. The members of the group were prolific writers, and they issued an enormous body of articles, novels, essays, propaganda brochures, and several manifestoes. The larger part of their theoretical writing was concerned with experiments and studies of methods, some of them drawn from psychology, whereby they could stimulate the subconscious mind to yield some of its limitless store of fantastic and dreamlike images. They had a deep respect for scientific method, especially that of psychology; they fully accepted the reality of the physical world, even though they believed that they had gone so deeply into it that they had transcended it; and they believed in a close interrelationship between their art and revolutionary elements in society.

The result of all these factors—a closed group, a powerful leader, and a doctrine—was the creation of a revolutionary spirit that sought first to

clear the field by the total derangement of all the conventions of art as they were then known. Breton named as the ideological precursors of the movement Lautréamont, Freud, and Trotsky. Each of these men had in his own field—literature, the study of man in his most intimate aspect, and the study of social and political organisms—revolutionized modern life from its very roots. Breton, called the "Pope of Surrealism," proposed an equally dynamic role for Surrealism.

Surrealism had its ideological origins specifically in Freud's methods, which gave the artists a model for their own investigations, and which revealed to them a new world of fantastic images from the subconscious. The authority of Freud's theories also gave support to Breton's statement in the Manifesto: "I believe in the future transmutation of these two seemingly contradictory states, dream and reality, into a sort of absolute reality, of surreality . . . ."

They also found authority for their revolutionary theories in Hippolyte Taine's studies of intelligence, made in the 1860s. Taine had undermined the Realists' faith in the concrete reality of sense impressions by asserting that sensation was not a fact at all but actually a hallucination.[1]

In their eagerness to understand more of the new world of the subconscious mind that they were exploring and also the new concept of man that they were creating, the Surrealists even denied the value of art except as a means to achieve those ends. They were in a sense actually anti-poetry and anti-art, in the usual meaning of these terms. Breton once said about Surrealist painting: "It is not a question of drawing, it is simply a question of tracing," meaning that art was only the means of recording the visible configurations of images that existed in the subconscious.

The direct effect of such influences on the Surrealist poets was seen in the method of "automatic writing." In this exercise, when all controls by the conscious mind were released, the marvelous and boundless world of

---

[1] It is interesting and significant that, although both the Symbolists and Surrealists clearly participated in the irrational mode and shared a taste for fantasy and the images of dreams they held almost diametrically opposite opinions of Taine's theories of art. Taine was convinced that art, as one of the several activities of man, was closely related to and dependent upon the conditions of life of the artist and upon the nature of his society. G.-Albert Aurier, the leading Symbolist art critic, vigorously rejected this point of view as an outdated remnant of mid-nineteenth-century materialism, which because of its dependence upon practical affairs denied the artist his inspiration from spiritual sources. On the contrary, André Breton saw in it scientific justification for the collaboration of psychiatry and art, whereby art, precisely because it was so intimately a part of man and his society, became, like psychiatry, one of the techniques for examining those sources. Thus, while for one generation Taine's theories stultified art, for the next they led it to the very source of its inspiration.

images of the subconscious could flow to the surface. The writer had only by various means to shock himself free from these controls and then automatically to record whatever thoughts and images presented themselves. The same method for the painter produced "automatic drawings." Surrealism as a movement thus was much broader in scope than either literature or painting, and was, in the words of Breton, "pure psychic automatism."

Surrealism, being initially a movement of literary men, looked for its literary antecedents to Baudelaire and Poe among the Romantics, Rimbaud and Mallarmé among the Symbolists, and to Apollinaire as its immediate precursor in the twentieth century. It was indeed Apollinaire who in 1917 had given the movement its name when he chose as a subtitle for his play *Les Mamelles de Tirésias* the term, *drame surréaliste*, in preference to the usual word, *surnaturaliste*. It looked back, in painting, to the great fantasts and painters of imaginary subjects, to the Romantics and Symbolists and, farther afield, to the sculpture of primitive peoples, especially the fantastic figures and masks of Oceania. Surrealism also claimed contemporary artists who, even though having nothing to do with the movement, worked in styles and created images in a spirit similar to those of the group. Such artists as Picasso, Braque, Klee, and Chagall were at different times claimed by them and had their work reproduced in Surrealist publications. Marc Chagall's (b. 1887) work manifests many characteristics of Surrealism, and he had upon many occasions encountered the group. And yet, although he is very articulate and literate, and was at one time a Commissar of Fine Arts under the Bolshevik regime, the naïveté of his mind and work is so natural and unprogrammatic that his own statements on his art have nothing to do with Surrealist theory or with what the Surrealists said about him.

Since both art and literature were considered only means of implementing the Surrealist spirit, theoretical controversies soon arose on the question of whether there can actually be such a thing as Surrealist painting. In reply, Breton wrote a series of articles, published in 1928 as the book *Surréalisme et la Peinture*, in which he spoke only of Surrealism *and* painting, citing as examples the artists of the group, but also such disparate artists as Picasso, Braque, Matisse, and Klee. (He included among the illustrations 15 works each by Picasso and De Chirico, but only 10 by Ernst, 8 each by Masson and Miro, 6 each by Tanguy, Arp, and Man Ray, and 1 by Picabia.)

The attraction of Breton and his circle of literary colleagues, together with their theories of art, was so great that by the time of the first exhibition of Surrealist art in 1925, all the major artists who were to become orthodox Surrealists had joined, with the exception of several younger men who had

not yet come into contact with the group. Even prior to this Breton had laid down the basis for the organization of the group and for the theory. He had studied with Freud, was experienced as a military psychiatrist, and was eager to apply his knowledge to literature and to painting. He had made a study of his own dreams, and he had experimented with automatic writing as early as 1920, the results of which appear in his book, *Les Champs magné-tiques*. He worked with Max Ernst about 1922 on experiments in automatism in both writing and drawing, and his theories on the method for inducing hallucinations by exciting the sensibilities were probably partially responsible for Ernst's method of *frottage*. His manifesto of 1924 had rallied the poets under the new banner of Freud, and the first exhibition of painting in 1925 gathered the Dada painters together with Joan Miro, André Masson, Man Ray, and Pierre Roy. In the next year the Galerie Surréaliste opened, presenting paintings and photographs by the American Man Ray alongside primitive Oceanic sculpture from Breton's collection.[2]

The painters constituting the group came from various backgrounds, but they had already in their earlier experiences shared tendencies toward fantasy in their art. Joan Miro (b. 1893 near Barcelona) had submitted to many influences before his adherence to Surrealism: Fauvism in his youth in Spain, Cubism in 1919 after his acquaintance with Picasso in Paris, and Dada by the time of the last great Dada exhibition in 1922. Nevertheless, his natural innocence and simplicity made him thoroughly and for his entire career a true Surrealist, causing Breton to say that Miro was "possibly the most Surrealist of us all." Although André Masson (b. 1896) had passed through a Cubist period under the influence of Juan Gris just before encoun-tering the Surrealists in 1924, he found an immediate accord with them. At the same time he became interested in the great mystical writers and artists, especially Blake, Nietzsche, and Kafka. Despite the fact that Masson's drawings are in the plastic realm the closest parallel to the automatic writing of the poets, he resisted the literary interpretations given to his work by the poets. He insisted that a painting had a plastic value which lay in the realm of visual art and was independent of the value of the ideas and images brought up from the subconscious. For these heretical beliefs, which recalled the despised Cubist art theory, Breton in the pages of *La Révue Surréaliste* of 1929 repudiated Masson, although the suspension was only temporary. Yves Tanguy (1900–1955), after wandering from one activity to another for

---

[2] It is interesting to compare the admiration felt by Breton and the Surrealists for the fantastic forms and colors of South Pacific art with the Cubists' admiration for the more con-structive and rationally composed African sculpture.

*Max Ernst, Self-Portrait, 1920 photomontage.*

several years during his youth, underwent a conversion that was thoroughly Surrealist in spirit. Upon first seeing an early De Chirico painting in the window of Paul Guillaume's shop, he had a revelation that he should become a painter. Shortly after this experience he made his first visit to Breton and was converted to Surrealism. He participated in all of its activities, being associated particularly with the method of drawing called *Corps exquis*, in which several persons each contributed portions of a common drawing without having seen what the others had done (see example, illustrated). Man Ray (b. 1890) was an American painter who came to Paris and to Dada in 1921 after having been well prepared by his participation with Duchamp in Dadaist activities in New York. Because he was best known for having injected the Dada-Surrealist spirit into photography, he became known as the "machine-poet," and his photographs and paintings appear reproduced in the pages of *La Révue Surréaliste* more often than the work of any other artist.

Even before Breton had founded the movement, he had discovered an artist whom he considered to be the supreme example of a Surrealist painter, Giorgio De Chirico (b. 1888 in Greece). Furthermore, De Chirico had painted the works that interested Breton the most—the dreamy and ominous piazzas and arcades of empty Italian cities—between 1911 and

373

1917, before the existence of either Surrealism or Dada, and apparently with no contact with any of the artists who were so important later for the movement. De Chirico was born of Italian parents in Greece, and spent his youth in Munich, where he was deeply impressed by Nietzsche, Richard Wagner, and where he was influenced by the paintings of Arnold Böcklin and Max Klinger. James T. Soby, in his biography, states that the young Italian encountered the idea of the symbolical dream picture from a study of Nietzsche, an influence that was reinforced by both men's infatuation for north Italian cities, especially Turin. It is easy to understand Breton's interest in De Chirico's paintings, so full of childhood memories and expressing a mood so troubling in its awesome symbols. Breton declared that there were two fixed points for Surrealism: Lautréamont in literature and De Chirico in painting. De Chirico's extensive writings, which include a novel, numerous articles, and an autobiography, are themselves highly valued as literature, and like his painting they belong to the realm of dreams. But as might be expected, this artist, who had had little contact with other artists, scarcely any relationships outside his own family, and who had an obsessive dependence upon his mother, found it extremely difficult to effect any personal relationships with a group as vociferous and inquisitive as the Surrealists. Not only did the association turn into bitter denunciations on both sides, but De Chirico precipitated a complete break in 1933 by renouncing all of his paintings of the early period—the only ones admired by the Surrealists.

The last major artist to join the group was Salvador Dali (b. 1904 near Barcelona). He was extremely precocious as a child, showing decided symptoms of an overexcited state of mind and being given to violent hysterical outbursts. In later life he became obsessed with memories of these early experiences and transcribed them into his paintings. Even his earliest work, produced when he was still in Madrid and Barcelona, was influenced by major *avant-garde* movements, at first by Futurism and *Pittura Metafisica* and later by Surrealism. Before going to Paris and meeting Breton's group, he had already learned about and experimented with the literal transcription of dreams into painting. In 1929 he went to Paris and was at once caught up in Surrealist activity. He studied and was influenced by the early De Chirico, Ernst, and Tanguy, and in 1929 with Luis Buñuel he made the first Surrealist motion picture, *Un Chien Andalou*, today one of the classics of the experimental cinema. He also added to the list of historical precursors of Surrealism by "discovering" *Art Nouveau* and the fantastic architecture of his countryman, Antoni Gaudi. He studied closely the method and discoveries of Freud, and invented his own method of forcing creation by means of what he called

"paranoiac-critical activity," which is described in his book, *La Femme Visible* of 1930.[3] This method went a stage beyond those of even the most radical of the group, for Dali proposed a state of mind that was permanently disoriented from the outside world. Wallace Fowlie describes this method as that of a madman, and no longer that of the somnambulist. Although Dali was later excommunicated from the group by Breton, his extraordinary brilliance as a theoretician and his rich invention injected new energy and ideas into the movement at the moment when it was beginning to lose its initial impetus.

During the 'thirties Surrealism dominated poetry and painting in Europe and exerted an influence upon the work of virtually every major artist everywhere. A second manifesto had been issued in 1929, and numerous large exhibitions were arranged in major cities of the world. Most of the Surrealist group took refuge in New York during World War II, but while they continued to call themselves Surrealists and to stage exhibitions, the disruption of 1940 was the final one. But by this time they had seen Breton's prediction come true. The Surrealist spirit had indeed revolutionized the arts, penetrated social theory, and it continues to dominate the theater and films. Surrealism has thus become a major period in history while its influence continues to be very strongly felt in contemporary art.

[3] See Andre Breton's summary of Dali's method in his essay "What is Surrealism?" (below), and Max Ernst's criticism of it in his "On Frottage" (below).

# DADA

*Dada Slogans, Berlin, 1919*★

DADA
stands on
the side of the revolutionary
Proletariat
Open up at last
your head
Leave it free
for the
demands of our age
Down with art
Down with
bourgeois intellectualism
Art is dead
Long live
the machine art
of Tatlin
DADA
is the
voluntary destruction
of the
bourgeois world of ideas

*Raoul Hausmann and Hannah Höch at the
Dada Manifestation in Berlin, 1920.*

★ From Edouard Roditi, "Interview with Hannah Höch," *Arts* (New York), December 1959, p. 26.

376

*Richard Huelsenbeck, from En Avant Dada: A History of Dadaism, 1920*\*

Dada was founded in Zurich in the spring of 1916 by Hugo Ball, Tristan Tzara, Hans Arp, Marcel Janco, and Richard Huelsenbeck at the Cabaret Voltaire, a little bar where Hugo Ball and his friend Emmy Hennings had set up a miniature variety show, in which all of us were very active.

We had all left our countries as a result of the war. Ball and I came from Germany, Tzara and Janco from Rumania, Hans Arp from France. We were agreed that the war had been contrived by the various governments for the most autocratic, sordid, and materialistic reasons; we Germans were familiar with the book "*J'accuse*," and even without it we would have had little confidence in the decency of the German Kaiser and his generals. Ball was a conscientious objector, and I had escaped by the skin of my teeth from the pursuit of the police myrmidons who, for their so-called patriotic purposes, were massing men in the trenches of Northern France and giving them shells to eat. None of us had much appreciation for the kind of courage it takes to get shot for the idea of a nation which is at best a cartel of pelt merchants and profiteers in leather, at worst a cultural association of psychopaths who, like the Germans, marched off with a volume of Goethe in their knapsacks, to skewer Frenchmen and Russians on their bayonets.

Arp was an Alsatian; he had lived through the beginning of the war and the whole nationalistic frenzy in Paris, and was pretty well disgusted with all the petty chicanery there, and in general with the sickening changes that had taken place in the city and the people on which we had all squandered our love before the war. Politicians are the same everywhere, flat-headed and vile. Soldiers behave everywhere with the same brisk brutality that is the mortal enemy of every intellectual impulse. The energies and ambitions of those who participated in the Cabaret Voltaire in Zurich were from the start purely artistic. We wanted to make the Cabaret Voltaire a focal point of the "newest art," although we did not neglect from time to time to tell the fat and utterly uncomprehending Zurich philistines that we regarded them as pigs and the German Kaiser as the initiator of the war. Then there was always a big fuss, and the students, who in Switzerland as elsewhere are the stupidest and most reactionary rabble—if in view of the compulsory national stultification in that country any group of citizens can claim a right to the superlative in that respect—at any rate the students gave a preview of the public resistance which Dada was later to encounter on its triumphant march through the world.

The word Dada was accidentally discovered by Hugo Ball and myself in a German-French dictionary, as we were looking for a name for Madame le Roy,

\* Originally published as *En Avant Dada: Eine Geschichte des Dadaismus* (Hannover: Steegemann, 1920). This excerpt from the English translation by Ralph Manheim in *The Dada Painters and Poets: An Anthology*, ed. Robert Motherwell (New York: Wittenborn, Schulz, 1951), pp. 23–26.

377

the chanteuse at our cabaret. Dada is French for a wooden horse. It is impressive in its brevity and suggestiveness. Soon Dada became the signboard for all the art that we launched in the Cabaret Voltaire. By "newest art," we then meant by and large, abstract art. Later the idea behind the word Dada was to undergo a considerable change. While the Dadaists of the Allied countries, under the leadership of Tristan Tzara, still make no great distinction between Dadaism and *"l'art abstrait,"* in Germany, where the psychological background of our type of activity is entirely different from that in Switzerland, France, and Italy, Dada assumed a very definite political character, which we shall discuss at length later.

The Cabaret Voltaire group were all artists in the sense that they were keenly sensitive to newly developed artistic possibilities. Ball and I had been extremely active in helping to spread expressionism in Germany; Ball was an intimate friend of Kandinsky, in collaboration with whom he had attempted to found an expressionistic theatre in Munich. Arp in Paris had been in close contact with Picasso and Braque, the leaders of the cubist movement, and was thoroughly convinced of the necessity of combatting naturalist conception in any form. Tristan Tzara, the romantic internationalist whose propagandistic zeal we have to thank for the enormous growth of Dada, brought with him from Rumania an unlimited literary facility. In that period, as we danced, sang, and recited night after night in the Cabaret Voltaire, abstract art was for us tantamount to absolute honor. Naturalism was a psychological penetration of the motives of the bourgeois, in whom we saw our mortal enemy, and psychological penetration, despite all efforts at resistance, brings an identification with the various precepts of bourgeois morality. Archipenko, whom we honored as an unequaled model in the field of plastic art, maintained that art must be neither realistic nor idealistic, it must be true; and by this he meant above all that any imitation of nature, however concealed, is a lie. In this sense, Dada was to give the truth a new impetus. Dada was to be a rallying point for abstract energies and a lasting slingshot for the great international artistic movements.

Through Tzara we were also in relation with the futurist movement and carried on a correspondence with Marinetti. By that time Boccioni had been killed, but all of us knew his thick book, *Pittura e scultura futuriste* [1914]. We regarded Marinetti's position as realistic, and were opposed to it, although we were glad to take over the concept of simultaneity, of which he made so much use. Tzara for the first time had poems recited simultaneously on the stage, and these performances were a great success, although the *poème simultané* had already been introduced in France by Derème and others. From Marinetti we also borrowed "bruitism," or noise music, *le concert bruitiste*, which, of blessed memory, had created such a stir at the first appearance of the futurists in Milan, where they had regaled the audience with *le reveil de la capitale*. I spoke on the significance of bruitism at a number of open Dada gatherings.

"*Le bruit*," noise with imitative effects, was introduced into art (in this connection we can hardly speak of individual arts, music, or literature) by Marin-

etti, who used a chorus of typewriters, kettledrums, rattles, and pot-covers to suggest the "awakening of the capital"; at first it was intended as nothing more than a rather violent reminder of the colorfulness of life. In contrast to the cubists or for that matter the German Expressionists, the futurists regarded themselves as pure activists. While all "abstract artists" maintained the position that a table is not the wood and nails it is made of but the idea of all tables, and forgot that a table could be used to put things on, the futurists wanted to immerse themselves in the "angularity" of things—for them the table signified a utensil for living, and so did everything else. Along with tables there were houses, frying-pans, urinals, women, etc. Consequently Marinetti and his group love war as the highest expression of the conflict of things, as a spontaneous eruption of possibilities, as movement, as a simultaneous poem, as a symphony of cries, shots, commands, embodying an attempted solution of the problem of life in motion. The problem of the soul is volcanic in nature. Every movement naturally produces noise. While number, and consequently melody, are symbols presupposing a faculty for abstraction, noise is a direct call to action. Music of whatever nature is harmonious, artistic, an activity of reason—but bruitism is life itself, it cannot be judged like a book, but rather it is a part of our personality, which attacks us, pursues us, and tears us to pieces. Bruitism is a view of life, which, strange as it may seem at first, compels men to make an ultimate decision. There are only bruitists, and others. While we are speaking of music, Wagner had shown all the hypocrisy inherent in a pathetic faculty for abstraction—the screeching of a brake, on the other hand, could at least give you a toothache. In modern Europe, the same initiative which in America made ragtime a national music, led to the convulsion of bruitism.

Bruitism is a kind of return to nature. It is the music produced by circuits of atoms; death ceases to be an escape of the soul from earthly misery and becomes a vomiting, screaming, and choking. The Dadaists of the Cabaret Voltaire took over bruitism without suspecting its philosophy—basically they desired the opposite: calming of the soul, an endless lullaby, art, abstract art. The Dadaists of the Cabaret Voltaire actually had no idea what they wanted—the wisps of "modern art" that at some time or other had clung to the minds of these individuals were gathered together and called "Dada." Tristan Tzara was devoured by ambition to move in international artistic circles as an equal or even a "leader." He was all ambition and restlessness. For his restlessness he sought a pole and for his ambition a ribbon. And what an extraordinary, never-to-be-repeated opportunity now arose to found an artistic movement and play the part of a literary mime! The passion of an aesthete is absolutely inaccessible to the man of ordinary concepts, who calls a dog a dog and a spoon a spoon. What a source of satisfaction it is to be denounced as a wit in a few cafés in Paris, Berlin, Rome! The history of literature is a grotesque imitation of world events, and a Napoleon among men of letters is the most tragi-comic character conceivable. Tristan Tzara had been one of the first to grasp the suggestive power of the word Dada. From here on he worked indefatigably as the prophet of a word, which only later was to be filled with a concept.

He wrapped, pasted, addressed, he bombarded the French and Italians with letters; slowly he made himself the "focal point." We do not wish to belittle the fame of the *fondateur du Dadaisme* any more than that of *Oberdada* (Chief Dada) Baader, a Swabian pietist, who at the brink of old age, discovered Dadaism and journeyed through the countryside as a Dadaist prophet, to the delight of all fools. In the Cabaret Voltaire period, we wanted to "document"—we brought out the publication *Cabaret Voltaire*, a catch-all for the most diverse directions in art, which at that time seemed to us to constitute "Dada." None of us suspected what Dada might really become, for none of us understood enough about the times to free ourselves from traditional views and form a conception of art as a moral and social phenomenon. Art just was—there was artists and bourgeois. You had to love one and hate the other . . . .

The Galérie Dada capriciously exhibited cubist, expressionist, and futurist pictures; it carried on its little art business at literary teas, lectures, and recitation evenings, while the word Dada conquered the world. It was something touching to behold. Day after day the little group sat in its café, reading aloud the critical comments that poured in from every possible country, and which by their tone of indignation showed that Dada had struck someone to the heart. Stricken dumb with amazement, we basked in our glory. Tristan Tzara could think of nothing else to do but write manifesto after manifesto, speaking of "*l'art nouveau*, which is neither futurism nor cubism," but Dada. But what was Dada? "*Dada*," came the answer, "*ne signifie rien.*" With psychological astuteness, the Dadaists spoke of energy and will and assured the world that they had amazing plans. But concerning the nature of these plans, no information whatever was forthcoming . . . .

In January 1917 I returned to Germany, the face of which had meanwhile undergone a fantastic change. I felt as though I had left a smug fat idyll for a street full of electric signs, shouting hawkers, and auto horns. In Zurich the international profiteers sat in the restaurants with well-filled wallets and rosy cheeks, ate with their knives and smacked their lips in a merry hurrah for the countries that were bashing each other's skulls in. Berlin was the city of tightened stomachers, of mounting, thundering hunger, where hidden rage was transformed into a boundless money lust, and men's minds were concentrating more and more on questions of naked existence. Here we would have to proceed with entirely different methods, if we wanted to say something to the people. Here we would have to discard our patent leather pumps and tie our Byronic cravats to the doorpost. While in Zurich people lived as in a health resort, chasing after the ladies and longing for nightfall that would bring pleasure barges, magic lanterns, and music by Verdi, in Berlin you never knew where the next meal was coming from. Fear was in everybody's bones, everybody had a feeling that the big deal launched by Hindenburg & Co. was going to turn out very badly. The people had an exalted and romantic attitude towards art and all cultural values. A phenonenon familiar in German history was again manifested: Germany always becomes the land of poets and thinkers when it begins to be washed up as the land of judges and butchers.

*Cover design for Richard Huelsenbeck's En Avant Dada: Eine Geschichte des Dadaismus, 1920.*

In 1917 the Germans were beginning to give a great deal of thought to their souls. This was only a natural defense on the part of a society that had been harassed, milked dry, and driven to the breaking point. This was the time when expressionism began to enjoy a vogue, since its whole attitude fell in with the retreat and the weariness of the German spirit. It was only natural that the Germans should have lost their enthusiasm for reality, to which before the war they had sung hymns of praise, through the mouths of innumerable academic thickheads, and which had now cost them over a million dead, while the blockade was strangling their children and grandchildren. Germany was seized with the mood that always precedes a so-called idealistic resurrection, an orgy à la Turnvater-Jahn, a Schenkendorf period . . . .[1]

What is Dadaism and what does it want in Germany?

1. *Dadaism demands:*

    1) The international revolutionary union of all creative and intellectual men and women on the basis of radical Communism;

    2) The introduction of progressive unemployment through compre-

---

[1] "Turnvater"—"gymnastic father," refers to Ludwig Jahn, the founder of the gymnastic societies which played an important part in the liberation of Germany from Napoleon. [R. H.]

hensive mechanization of every field of activity. Only by unemployment does it become possible for the individual to achieve certainty as to the truth of life and finally become accustomed to experience;

    3) The immediate expropriation of property (socialization) and the communal feeding of all; further, the erection of cities of light, and gardens which will belong to society as a whole and prepare man for a state of freedom.

2. *The Central Council demands:*

    a) Daily meals at public expense for all creative and intellectual men and women on the Potsdamer Platz (Berlin);

    b) Compulsory adherence of all clergymen and teachers to the Dadaist articles of faith;

    c) The most brutal struggle against all directions of so-called "workers of the spirit" (Hiller, Adler), against their concealed bourgeoisism, against expressionism and post-classical education as advocated by the Sturm group;

    d) The immediate erection of a state art center, elimination of concepts of property in the new art (expressionism); the concept of property is entirely excluded from the super-individual movement of Dadaism which liberates all mankind;

    e) Introduction of the simultaneist poem as a Communist state prayer;

    f) Requisition of churches for the performance of bruitism, simultaneist and Dadaist poems;

    g) Establishment of a Dadaist advisory council for the remodelling of life in every city of over 50,000 inhabitants;

    h) Immediate organization of a large scale Dadaist propaganda campaign with 150 circuses for the enlightment of the proletariat;

    i) Submission of all laws and decrees to the Dadaist central council for approval;

    j) Immediate regulation of all sexual relations according to the views of international Dadaism through establishment of a Dadaist sexual center.

<div align="right">

The Dadaist revolutionary central council.
German group: Hausmann, Huelsenbeck
Business Office: Charlottenburg, Kantstrasse 118.
Applications for membership taken at business office.

</div>

*Kurt Schwitters, from Merz, 1921*[*]

One might write a catechism of the media of expression if it were not useless, as the desire to achieve expression in a work of art. Every line, color, form has a definite expression. Every combination of lines, colors, forms has a definite expression. Expression can be given only to a particular structure, it cannot be translated.

    [*] Originally published in *Der Ararat* (Munich) 1921. This excerpt from the English translation by Ralph Manheim in *The Dada Painters and Poets*, p. 59.

*Kurt Schwitters, cover design for Merz, Hannover, No. 20, 1927.*

The expression of a picture cannot be put into words, any more than the expression of a word, such as the word "and" for example, can be painted.

Nevertheless, the expression of a picture is so essential that it is worth while to strive for it consistently. Any desire to reproduce natural forms limits one's force and consistency in working out an expression. I abandoned all reproduction of natural elements and painted only with pictorial elements. These are my abstractions. I adjusted the elements of the picture to one another, just as I had formerly done at the academy, yet not for the purpose of reproducing nature but with a view to expression.

Today the striving for expression in a work of art also seems to me injurious to art. Art is a primordial concept, exalted as the godhead, inexplicable as life, indefinable and without purpose. The work of art comes into being through artistic evaluation of its elements. I know only how I make it, I know only my medium, of which I partake, to what end I know not.

The medium is as unimportant as I myself. Essential is only the forming. Because the medium is unimportant, I take any material whatsoever if the picture demands it. When I adjust materials of different kinds to one another, I have taken a step in advance of mere oil painting, for in addition to playing off color against color, line against line, form against form, etc., I play off material against material, for example, wood against sackcloth. I call the *Weltanschauung* [world view] from which this mode of artistic creation arose "Merz."

*Cover design for Kurt Schwitters'
Merz, Hannover, January 1923.*

The word "Merz" had no meaning when I formed it. Now it has the meaning which I gave it. The meaning of the concept "Merz" changes with the change in the insight of those who continue to work with it.

Merz stands for freedom from all fetters, for the sake of artistic creation. Freedom is not lack of restraint, but the product of strict artistic discipline. Merz also means tolerance towards any artistically motivated limitation. Every artist must be allowed to mold a picture out of nothing but blotting paper for example, provided he is capable of molding a picture.

The reproduction of natural elements is not essential to a work of art. But representations of nature, inartistic in themselves, can be elements in a picture, if they are played off against other elements in the picture.

At first I concerned myself with other art forms, poetry for example. Elements of poetry are letters, syllables, words, sentences. Poetry arises from the interaction of these elements. Meaning is important only if it is employed as one such factor.

*Tristan Tzara, "Lecture on Dada," 1924*★

I don't have to tell you that for the general public and for you, the refined public, a Dadaist is the equivalent of a leper. But that is only a manner of speaking. When these same people get close to us, they treat us with that remnant of elegance that comes from their old habit of belief in progress. At ten yards' distance, hatred begins again. If you ask me why, I won't be able to tell you.

Another characteristic of Dada is the continuous breaking off of our friends. They are always breaking off and resigning. The first to tender his resignation from the Dada movement *was myself*. Everybody knows that Dada is nothing. I broke away from Dada and from myself as soon as I understood the implications of *nothing*.

*Francis Picabia, Portrait of Tristan Tzara, 1918, drawing.*

Portrait de **TRISTAN TZARA**
par
**FRANCIS PICABIA**

★ Originally published in *Merz* (Hanover), II, No. 7, January 1924. This English translation from *The Dada Painters and Poets*, pp. 246–251.

385

If I continue to do something, it is because it amuses me, or rather because I have a need for activity which I use up and satisfy wherever I can. Basically, the true Dadas have always been separate from Dada. Those who acted as if Dada were important enough to resign from with a big noise have been motivated by a desire for personal publicity, proving that counterfeiters have always wriggled like unclean worms in and out of the purest and most radiant religions.

I know that you have come here today to hear explanations. Well, don't expect to hear any explanations about Dada. You explain to me why you exist. You haven't the faintest idea. You will say: I exist to make my children happy. But in your hearts you know that isn't so. You will say: I exist to guard my country against barbarian invasions. That's a fine reason. You will say: I exist because God wills. That's a fairy tale for children. You will never be able to tell me why you exist but you will always be ready to maintain a serious attitude about life. You will never understand that life is a pun, for you will never be alone enough to reject hatred, judgments, all these things that require such an effort, in favor of a calm and level state of mind that makes everything equal and without importance.

Dada is not at all modern. It is more in the nature of a return to an almost Buddhist religion of indifference. Dada covers things with an artificial gentleness, a snow of butterflies released from the head of a prestidigitator. Dada is immobility and does not comprehend the passions. You will call this a paradox, since Dada is manifested only in violent acts. Yes, the reactions of individuals contaminated by *destruction* are rather violent, but when these reactions are exhausted, annihilated by the Satanic insistence of a continuous and progressive "What for?" what remains, what dominates is *indifference*. But with the same note of conviction I might maintain the contrary.

. . . . . . . . . . . . . . . . . . .

We have had enough of the intelligent movements that have stretched beyond measure our credulity in the benefits of science. What we want now is spontaneity. Not because it is better or more beautiful than anything else. But because everything that issues freely from ourselves, without the intervention of speculative ideas, represents us. We must intensify this quantity of life that readily spends itself in every quarter. Art is not the most precious manifestation of life. Art has not the celestial and universal value that people like to attribute to it. Life is far more interesting. Dada knows the correct measure that should be given to art: with subtle, perfidious methods, Dada introduces it into daily life. And vice versa. In art, Dada reduces everything to an initial simplicity, growing always more relative. It mingles its caprices with the chaotic wind of creation and the barbaric dances of savage tribes. It wants logic reduced to a personal minimum, while literature in its view should be primarily intended for the individual who makes it. Words have a weight of their own and lend themselves to abstract construction. The absurd has no terrors for me, for from a more exalted point of view everything in life seems absurd to me. Only the elasticity of our conventions creates a bond

*Richard Huelsenbeck, Portrait of Jean Arp,*
*1950, oil on canvas.*

between disparate acts. The Beautiful and the True in art do not exist; what interests me is the intensity of a personality transposed directly, clearly into the work; the man and his vitality; the angle from which he regards the elements and in what manner he knows how to gather sensation, emotion, into a lacework of words and sentiments.

Dada tries to find out what words mean before using them, from the point of view not of grammar but of representation. Objects and colors pass through the same filter. It is not the new technique that interests us, but the spirit. Why do you want us to be preoccupied with a pictorial, moral, poetic, literary, political, or social renewal? We are well aware that these renewals of means are merely the successive cloaks of the various epochs of history, uninteresting ques-

tions of fashion and façade. We are well aware that people in the costumes of the Renaissance were pretty much the same as the people of today, and that Chouang-Dsi was just as Dada as we are. You are mistaken if you take Dada for a modern school, or even for a reaction against the schools of today. Several of my statements have struck you as old and natural; what better proof that you were Dadaists without knowing it, perhaps even before the birth of Dada.

You will often hear that Dada is a state of mind. You may be gay, sad, afflicted, joyous, melancholy, or Dada. Without being literary, you can be romantic, you can be dreamy, weary, eccentric, a businessman, skinny, transfigured, vain, amiable, or Dada. This will happen later on in the course of history when Dada has become a precise, habitual word, when popular repetition has given it the character of a word organic with its necessary content. Today no one thinks of the literature of the Romantic school in representing a lake, a landscape, a character. Slowly but surely, a Dada character is forming.

Dada is here, there, and a little everywhere, such as it is, with its faults, with its personal differences and distinctions which it accepts and views with indifference.

We are often told that we are incoherent, but into the word people try to put an insult that it is rather hard for me to fathom. Everything is incoherent. The gentleman who decides to take a bath but goes to the movies instead. The one who wants to be quiet but says things that haven't even entered his head. Another who has a precise idea on some subject but succeeds only in expressing the opposite in words which for him are a poor translation. There is no logic. Only relative necessities discovered *a posteriori*, valid not in any exact sense but only as explanations.

The acts of life have no beginning or end. Everything happens in a completely idiotic way. That is why everything is alike. Simplicity is called Dada.

Any attempt to conciliate an inexplicable momentary state with logic strikes me as a boring kind of game. The convention of the spoken language is ample and adequate for us, but for our solitude, for our intimate games and our literature we no longer need it.

The beginnings of Dada were not the beginnings of an art, but of a disgust. Disgust with the magnificence of philosophers who for 3000 years have been explaining everything to us (what for?), disgust with the pretensions of these artists-God's-representatives-on-earth, disgust with passion and with real pathological wickedness where it was not worth the bother; disgust with a false form of domination and restriction *en masse*, that accentuates rather than appeases man's instinct of domination, disgust with all the catalogued categories, with the false prophets who are nothing but a front for the interests of money, pride, disease, disgust with the lieutenants of a mercantile art made to order according to a few infantile laws, disgust with the divorce of good and evil, the beautiful and the ugly (for why is it more estimable to be red rather than green, to the left rather than the right, to be large or small?). Disgust finally with the Jesuitical dialectic

*Dada poster for the play,*
*The Bearded Heart*
*1923.*

which can explain everything and fill people's minds with oblique and obtuse ideas without any physiological basis or ethnic roots, all this by means of blinding artifice and ignoble charlatan's promises.

As Dada marches it continuously destroys, not in extension but in itself. From all these disgusts, may I add, it draws no conclusion, no pride, no benefit. It has even stopped combating anything, in the realization that it's no use, that all this doesn't matter. What interests a Dadaist is his own mode of life. But here we approach the great secret.

Dada is a state of mind. That is why it transforms itself according to races and events. Dada applies itself to everything, and yet it is nothing, it is the point where the yes and the no and all the opposites meet, not solemnly in the castles of human philosophies, but very simply at street corners, like dogs and grasshoppers.

Like everything in life, Dada is useless.

Dada is without pretension, as life should be.

Perhaps you will understand me better when I tell you that Dada is a virgin microbe that penetrates with the insistence of air into all the spaces that reason has not been able to fill with words or conventions.

## Jean Arp, "Abstract Art, Concrete Art," ca. 1942[*]

Ever since the cave age, man has been painting still lifes, landscapes, and nudes. Certain artists have found it sickening to feed art eternally with still lifes, landscapes, and nudes. Since the cave age, man has glorified himself, deified himself, and with his monstrous vanity provoked human catastrophies. Art has been the collaborator of man's false development. Certain artists have had their stomach turned by this spurious conception of the world and of art which has buoyed up the vanity of man.

These artists do not wish to copy nature. They do not wish to reproduce but to produce. They wish to produce as a plant which produces a fruit and is unable to reproduce a still life, a landscape, or a nude. They wish to produce directly and not through an interpreter.

But then nothing is less abstract than Abstract art. This is why Van Doesburg and Kandinsky have suggested that Abstract art should be called Concrete art.

The pyramids, the temples, the cathedrals, paintings of men of genius, all these have become beautiful mummies. Man's buzzing will not last very long. Not much longer than the buzzing of those little fallen angels that flutter so gaily around a piece of cheese. All this earthly spectacle: these heads of Adam, articulated commas, gloves with navels, parrots imitating thunder, mountains with ice-shirtfronts, spelling furniture, these as in a dream will be transformed into a beautiful sheaf of fire illuminating the void for an instant. Man needs to be cured of his vanity.

Artists should not sign their works of Concrete art. These paintings, sculptures, objects should remain anonymous and form part·of nature's great workshop as leaves do, and clouds, animals, and men. Yes, man must once again become part of nature. These artists should work communally as did the artists of the Middle Ages. In 1915, O. Van Rees, C. Van Rees, O. Freundlich, S. Taeuber, and myself made several attempts at such a collaboration.

I wrote in 1915 in the preface to an exhibition: "These works are constructed with lines, surfaces, shapes, and colors. They seek to reach beyond human values and attain the infinite and the eternal. They are a denial of man's egoism . . . . The hands of our brothers no longer serve us as our own hands do, but have become the hands of an enemy. Anonymity has been replaced by fame and the masterpiece; wisdom has perished . . . . To reproduce is to imitate play-acting, tight-rope dancing. Art, however, is reality and the reality of all should triumph over the particular . . . ."

The Renaissance taught men how proudly to exalt their reason. The science and technology of modern times has dedicated men to megalomania. That reason has been overvalued, this has caused the confusion of our era.

[*] From *Art of this Century*, ed. Peggy Guggenheim (New York, Art of This Century, n.d. [*ca.* 1942]), pp. 29–31.

The evolution of traditional painting towards Concrete art which began with Cézanne and was carried on by the Cubists has been explained many times but these historical explanations have served but to obscure the problem. Suddenly, in about 1914, "in accordance with the laws of chance," the spirit was transmuted, as though touched by a magic wand, and a cessation occurred the significance of which is still an ethical problem.

Concrete art wishes to transform the world. It wishes to render existence more tolerable. It wishes to save man from the most dangerous of furious madnesses: vanity. It wants to simplify man's life. It urges man to identify himself with nature. Reason has robbed man of his roots. He leads a tragic life. Concrete art is an elementary, natural, and healthy art which causes the stars of peace, love, and poetry to sprout in man's brain. Wherever Concrete art enters, melancholy goes out dragging its gray valises crammed full of black sighs.

Kandinsky, Picabia, Sonja Delaunay, Rossiné, Streminsky, Magnelli, Man Ray, I am unable to enumerate all the artists who painted and sculpted works significant of the period that begins about 1914. Without knowing one another we worked towards the same goal. The greater part of these works was not shown before 1920. Then there was a bursting forth of all the shapes and colors of the world. These paintings and sculptures were stripped of every convention. In every country artists of this new art arose. Concrete art influenced architecture, furniture, the cinema, typography.

In the Breteuil Pavilion at Sèvres we can see at zero degrees centigrade the international meter made of irridium platinum. It is not with this meter that the greatness of geniuses is measured. In order to measure a genius one must employ an appropriate meter. Vanity and commercial imagination have constructed one. At times it must be very short so that you can say: "Look at this genius. See how big he is. He measures a hundred and fifty meters. You'll see no genius in my shop who measures less than a hundred meters." Sometimes the meter must be very long. You can say, then: "Just look at this! It's not even a meter long! Why, it's not a genius, it's a dwarf. This is no man of might. It's a mite."

The man who lives buried in man as a mole in the earth can no longer distinguish black from white. He does not understand the language of shapes and colors. He has never seen the gaze of the stars.

Many of these painters and sculptors, Kandinsky, Picabia, Duchamp, Arp, Hausmann, Van Doesburg, Magnelli, Schwitters, Nebel, have written automatic poems. Automatic poetry comes straight out of the poet's bowels or out of any other of his organs that has accumulated reserves. Neither the Postillon of Longjumeau, nor the Alexandrian, nor grammar, nor aesthetics, nor Buddha, nor the Sixth Commandment are able to constrict him. He crows, swears, moans, stammers, yodels, according to his mood. His poems are like nature: they stink, laugh, and rhyme like nature. Foolishness, or at least what men call foolishness, is as precious to him as a sublime piece of rhetoric. For in nature a broken twig is equal in beauty and importance to the clouds and the stars.

391

*Marcel Duchamp, "Painting . . . at the service of the mind," 1946\**

The basis of my own work during the years just before coming to America in 1915 was a desire to break up forms—to "decompose" them much along the lines the cubists had done. But I wanted to go further—much further—in fact in quite another direction altogether. This was what resulted in *Nude Descending a Staircase*, and eventually led to my large glass, *La Mariée mise à nu par ses célibataires, même* [*The Bride Stripped Bare By Her Bachelors, Even.*]

The idea of the *Nude* came from a drawing which I had made in 1911 to illustrate Jules Laforgue's poem *Encore à cet astre*. I had planned a series of illustrations of Lafourge's poems but I only completed three of them. Rimbaud and Lautréamont seemed too old to me at the time. I wanted something younger. Mallarmé and Laforgue were closer to my taste—Laforgue's *Hamlet*, particularly. But perhaps I was less attracted by Laforgue's poetry than by his titles. *Comice agricole* [Farmers' Union], when written by Laforgue, becomes poetry. "*Le soir, le piano*"—no one else could have written this in his time.

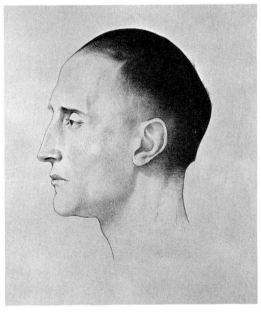

*Joseph Stella, Portrait of Marcel Duchamp, ca. 1922, pencil.*

\* From an interview with James Johnson Sweeney in "Eleven Europeans in America," *Bulletin of the Museum of Modern Art* (New York), XIII No. 4–5, 1946, 19–21. Reprinted with permission.

In the drawing *Encore à cet astre* the figure is, of course, mounting the stairs. But while working on it, the idea of the *Nude*, or the title—I do not recall which—first came to my mind. I eventually gave the sketch to F. C. Torrey of San Francisco who bought the *Nude Descending a Staircase* from the 1913 New York Armory Show.

No, I do not feel there was any connection between the *Nude Descending a Staircase* and futurism. The futurists held their exhibition at the Galerie Bernheim-Jeune in January 1912. I was painting the *Nude* at the same time. The oil sketch for it, however, had already been done in 1911. It is true I knew Severini. But I was working quite by myself at the time—or rather with my brothers.[1] And I was not a café frequenter. Chronophotography was at the time in vogue. Studies of horses in movement and of fencers in different positions as in Muybridge's albums[2] were well known to me. But my interest in painting the *Nude* was closer to the cubists' interest in decomposing forms than to the futurists' interest in suggesting movement, or even to Delaunay's *Simultaneist* suggestions of it. My aim was a static representation of movement—a static composition of indications of various positions taken by a form in movement—with no attempt to give cinema effects through painting.

The reduction of a head in movement to a bare line seemed to me defensible. A form passing through space would traverse a line; and as the form moved the line it traversed would be replaced by another line—and another and another. Therefore I felt justified in reducing a figure in movement to a line rather than to a skeleton. Reduce, reduce, reduce was my thought,—but at the same time my aim was turning inward, rather than toward externals. And later, following this view, I came to feel an artist might use anything—a dot, a line, the most conventional or unconventional symbol—to say what he wanted to *say*. The *Nude* in this way was a direct step to The Large Glass, *La Mariée mise à nu par ses célibataires, même*. And in the *King and Queen* painted shortly after the *Nude* there are no human forms or indications of anatomy. But in it one can see where the forms are placed; and for all this reduction I would never call it an "abstract" painting . . . .

Futurism was an impressionism of the mechanical world. It was strictly a continuation of the Impressionist movement. I was not interested in that. I wanted to get away from the physical aspect of painting. I was much more interested in recreating ideas in painting. For me the title was very important. I was interested in making painting serve my purposes, and in getting away from the physicality of

---

[1] In order to avoid confusion, the other two talented Duchamp brothers assumed variations on the family name, thus Raymond Duchamp-Villon and Jacques Villon.

[2] The photographer Eadweard Muybridge (1830–1904), a student of animal locomotion, invented a device for sequentially tripping a series of cameras so that he could document movement with a series of photographs. The idea of seizing a clear, fixed view from a rapidly moving object had been very stimulating to artists ever since the publication of Muybridge's book *The Horse in Motion* (1878).

painting. For me Courbet had introduced the physical emphasis in the nineteenth century. I was interested in ideas—not merely in visual products. I wanted to put painting once again at the service of the mind. And my painting was, of course, at once regarded as "intellectual," "literary" painting. It was true I was endeavoring to establish myself as far as possible from "pleasing" and "attractive" physical paintings. That extreme was seen as literary. My *King and Queen* was a chess king and queen.

In fact until the last hundred years all painting had been literary or religious: it had all been at the service of the mind. This characteristic was lost little by little during the last century. The more sensual appeal a painting provided—the more animal it became—the more highly it was regarded. It was a good thing to have had Matisse's work for the beauty it provided. Still it created a new wave of physical painting in this century or at least fostered the tradition we inherited from the nineteenth-century masters.

Dada was an extreme protest against the physical side of painting. It was a metaphysical attitude. It was intimately and consciously involved with "literature." It was a sort of nihilism to which I am still very sympathetic. It was a way to get out of a state of mind—to avoid being influenced by one's immediate environment, or by the past: to get away from clichés—to get free. The "blank" force of dada was very salutary. It told you "don't forget you are not quite so 'blank' as you think you are." Usually a painter confesses he has his landmarks. He goes from landmark to landmark. Actually he is a slave to landmarks—even to contemporary ones.

Dada was very serviceable as a purgative. And I think I was thoroughly conscious of this at the time and of a desire to effect a purgation in myself. I recall certain conversations with Picabia along these lines. He had more intelligence than most of our contemporaries. The rest were either for or against Cézanne. There was no thought of anything beyond the physical side of painting. No notion of freedom was taught. No philosophical outlook was introduced. The cubists, of course, were inventing a lot at the time. They had enough on their hands at the time not to be worried about a philosophical outlook; and cubism gave me many ideas for decomposing forms. But I thought of art on a broader scale. There were discussions at the time of the fourth dimension and of non-Euclidean geometry. But most views of it were amateurish. Metzinger was particularly attracted. And for all our misunderstandings, through these new ideas we were helped to get away from the conventional way of speaking—from our café and studio platitudes.

Brisset and Roussel were the two men in those years whom I most admired for their delirium of imagination. Jean-Pierre Brisset was discovered by Jules Romains through a book he picked up from a stall on the quais. Brisset's work was a philological analysis of language—an analysis worked out by means of an incredible network of puns. He was sort of a Douanier Rousseau of Philology. Romains introduced him to his friends. And they, like Apollinaire and his com-

*Marcel Duchamp, Monte Carlo Share, 1924, collage.*

panions, held a formal celebration to honor him in front of Rodin's *Thinker* in front of the Panthéon where he was hailed as *Prince of Thinkers.*

But Brisset was one of the real people who has lived and will be forgotten. Roussel was another great enthusiasm of mine in the early days. The reason I admired him was because he produced something that I had never seen. That is the only thing that brings admiration from my innermost being—something completely independent—nothing to do with the great names or influences. Apollinaire first showed Roussel's work to me. It was poetry. Roussel thought he was a philologist, a philosopher, and a metaphysician. But he remains a great poet.

It was fundamentally Roussel who was responsible for my glass, *La Mariée mise à nu par ses célibataires, même.* From his *Impressions d'Afrique* I got the general approach. This play of his which I saw with Apollinaire helped me greatly on one side of my expression. I saw at once I could use Roussel as an influence. I felt that as a painter it was much better to be influenced by a writer than by another painter. And Roussel showed me the way.

My ideal library would have contained all Roussel's writings—Brisset, perhaps Lautréamont and Mallarmé. Mallarmé was a great figure. This is the direction in which art should turn: to an intellectual expression, rather than to an animal expression. I am sick of the expression *"bête comme un peintre"*—stupid as a painter.

*Hannah Höch, "Dada Photo Montage"* *

Actually, we borrowed the idea from a trick of the official photographer of the Prussian army regiments. They used to have elaborate oleolithographed mounts, representing a group of uniformed men with a barracks or a landscape in the background, but with the faces cut out; in these mounts, the photographers then inserted photographic portraits of the faces of their customers, generally coloring them later by hand. But the aesthetic purpose, if any, of this very primitive kind of photo montage was to idealize reality, whereas the Dada photo monteur set out to give to something entirely unreal all the appearances of something real that had actually been photographed. . . .

Our whole purpose was to integrate objects from the world of machines and industry in the world of art. Our typographical collages or montages set out to achieve this by imposing, on something which could only be produced by hand, the appearances of something that had been entirely composed by a machine; in an imaginative composition, we used to bring together elements borrowed from books, newspapers, posters, or leaflets, in an arrangement that no machine could yet compose.

* Excerpt from Roditi, "Interview with Hannah Höch," p. 26.

# SURREALISM

*Giorgio de Chirico, "Meditations of a Painter," 1912*★

What will the aim of future painting be? The same as that of poetry, music, and philosophy: to create previously unknown sensations; to strip art of everything routine and accepted, and of all subject matter, in favor of an aesthetic synthesis; completely to suppress man as a guide, or as a means to express symbol, sensation, or thought, once and for all to free itself from the anthropomorphism that always shackles sculpture; to see everything, even man, in its quality of *thing*. This is the Nietzschean method. Applied to painting, it might produce extraordinary results. This is what I try to demonstrate in my pictures.

When Nietzsche talks of the pleasure he gets from reading Stendhal, or listening to the music from Carmen, one feels, if one is sensitive, what he means: the one is no longer a book, nor the other a piece of music, each is a *thing* from which one gets a sensation. That sensation is weighed and judged and compared to others more familiar, and the most original is chosen.

A truly immortal work of art can only be born through revelation. Schopenhauer has, perhaps, best defined and also (why not) explained such a moment when in *Parerga und Paralipomena* he says, "To have original, extra-ordinary, and perhaps even immortal ideas, one has but to isolate oneself from the world for a few moments so completely that the most commonplace happenings appear to be new and unfamiliar, and in this way reveal their true essence." If instead of the birth of *original, extraordinary immortal* ideas, you imagine the birth of a work of art (painting or sculpture) in an artist's mind, you will have the principle of revelation in painting.

In connection with these problems let me recount how I had the revelation of a picture that I will show this year at the *Salon d'Automne*, entitled *Enigma of an Autumn Afternoon*. One clear autumnal afternoon I was sitting on a bench in the middle of the Piazza Santa Croce in Florence. It was of course not the first time I had seen this square. I had just come out of a long and painful intestinal illness, and I was in a nearly morbid state of sensitivity. The whole world, down to the marble of the buildings and the fountains, seemed to me to be convalescent. In the middle of the square rises a statue of Dante draped in a long cloak, holding his works

★ Manuscript in the collection of Jean Paulham. This translation from *Georgio de Chirico* by James Thrall Soby, 1955, The Museum of Modern Art, New York, and reprinted with its permission. The above translation is by Louise Bourgeois and Robert Goldwater.

clasped against his body, his laurel-crowned head bent thoughtfully earthward. The statue is in white marble, but time has given it a gray cast, very agreeable to the eye. The autumn sun, warm and unloving, lit the statue and the church façade. Then I had the strange impression that I was looking at all these things for the first time, and the composition of my picture came to my mind's eye. Now each time I look at this painting I again see that moment. Nevertheless the moment is an enigma to me, for it is inexplicable. And I like also to call the work which sprang from it an enigma.

Music cannot express the *non plus ultra* of sensation. After all, one never knows what music is about. After having heard any piece of music the listener has the right to say, and can say, what does this mean? In a profound painting, on the contrary, this is impossible: one must fall silent when one has penetrated it in all its profundity. Then light and shade, lines and angles, and the whole mystery of volume begin to talk.

The revelation of a work of art (painting or sculpture) can be born of a sudden, when one least expects it, and also can be stimulated by the sight of something. In the first instance it belongs to a class of rare and strange sensations that I have observed in only one modern man: Nietzsche. Among the ancients perhaps (I say perhaps because sometimes I doubt it) Phidias, when he conceived the plastic form of Pallas Athena, and Raphael, while painting the temple and the sky of his *Marriage of the Virgin* (in the Brera in Milan), knew this sensation. When Nietzsche talks of how his *Zarathustra* was conceived, and he says, "I was *surprised* by Zarathustra," in this participle—surprised—is contained the whole enigma of sudden revelation.

When on the other hand a revelation grows out of the sight of an arrangement of objects, then the work which appears in our thoughts is closely linked to the circumstance that has provoked its birth. One resembles the other, but in a strange way, like the resemblance there is between two brothers, or rather between the image of someone we know seen in a dream, and that person in reality; it is, and at the same time it is not, that same person; it is as if there had been a slight transfiguration of the features. I believe that as from a certain point of view the sight of someone in a dream is a proof of his metaphysical reality, so, from the same point of view, the revelation of a work of art is the proof of the metaphysical reality of certain chance occurrences that we sometimes experience in the way and manner that *something* appears to us and provokes in us the image of a work of art, an image, which in our souls awakens surprise—sometimes, meditation—often, and always, the joy of creation.

## THE SONG OF THE STATION

Little station, little station, what happiness I owe you. You look all around, to left and right, also behind you. Your flags snap distractedly, why suffer? Let us go in, aren't we already *numerous enough?* With white chalk or black coal let us trace happiness and its enigma, the enigma and its affirmation. Beneath the porticoes are

windows, from each window an eye looks at us, and from the depths voices call to us. *The happiness of the station* comes to us, and goes from us transfigured. Little station, little station, you are a divine toy. What distraught Zeus forgot you on this square—geometric and yellow—near this limpid, disturbing fountain? All your little flags crackle together under the intoxication of the luminous sky. Behind walls life proceeds like a catastrophe. What does it all matter to you?

Little station, little station, what happiness I owe you.

### THE MYSTERIOUS DEATH

The steeple clock marks half past twelve. The sun is high and burning in the sky. It lights houses, palaces, porticoes. Their shadows on the ground describe rectangles, squares, and trapezoids of so soft a black that the burned eye likes to refresh itself in them. What light. How sweet it would be to live down there, near a consoling portico or a foolish tower covered with little multicolored flags, among gentle and intelligent men. Has such an hour ever come? What matter, since we see it go!

What absence of storms, of owl cries, of tempestuous seas. Here Homer would have found no songs. A hearse has been waiting forever. It is black as hope, and this morning someone maintained that during the night it still waits. Somewhere is a corpse one cannot see. The clock marks twelve thirty-two; the sun is setting; it is time to leave.

### A HOLIDAY

They were not many, but joy lent their faces a strange expression. The whole city was decked with flags. There were flags on the big tower which rose at the end of the square, near the statue of the great king-conqueror. Banners crackled on the lighthouse, on the masts of the boats anchored in the harbor, on the porticoes, on the museum of rare paintings.

Towards the middle of the day *they* gathered in the main square, where a banquet had been set out. There was a long table in the center of the square.

The sun had a terrible beauty.

Precise, geometric shadows.

Against the depth of the sky the wind spread out the multicolored flags of the great red tower, which was of such a consoling red. Black specks moved at the top of the tower. They were gunners waiting to fire the noon salute.

At last the twelfth hour came. Solemn. Melancholic. When the sun reached the center of the heavenly arch a new clock was dedicated at the city's railroad station. Everyone wept. A train passed, whistling frantically. Cannon thundered. Alas, it was so beautiful.

Then, seated at the banquet, they ate roast lamb, mushrooms, and bananas, and they drank clear, fresh water.

Throughout the afternoon, in little separate groups, they walked under the arcades, and waited for the evening to take their repose.

That was all.

African sentiment. The arcade is here forever. Shadow from right to left, fresh breeze which causes forgetfulness, it falls like an enormous projected leaf. But its beauty is in its line: enigma of fatality, symbol of the intransigent will.

Ancient times, fitful lights and shadows. All the gods are dead. The knight's horn. The evening call at the edge of the woods: a city, a square, a harbor, arcades, gardens, an evening party; sadness. Nothing.

One can count the lines. The soul follows and grows with them. The statue, the meaningless statue had to be erected. The red wall hides all that is mortal of infinity. A snail; gentle ship with tender flanks; little amorous dog. Trains that pass. Enigma. The happiness of the banana tree: luxuriousness of ripe fruit, golden and sweet.

No battles. The giants have hidden behind the rocks. Horrible swords hang on the walls of dark and silent rooms. Death is there, full of promises. Medusa with eyes that do not see.

Wind behind the wall. Palm trees. Birds that never came.

### THE MAN WITH THE ANGUISHED LOOK

In the noisy street catastrophe goes by. He had come there with his anguished look. Slowly he ate a cake so soft and sweet it seemed he was eating his heart. His eyes were very far apart.

What do I hear? Thunder rumbles in the distance, and everything trembles in the crystal ceiling; it is a battle. Rain has polished the pavement: summer joy.

A curious tenderness invades my heart: oh man, man, I want to make you happy. And if someone attacks you I will defend you with a lion's courage and a tiger's cruelty. Where do you wish to go; speak. Now the thunder no longer rumbles. See how the sky is pure and the trees radiant.

The four walls of the room broke him and blinded him. His icy heart melted slowly: he was perishing of love. Humble slave, you are as tender as a slaughtered lamb. Your blood runs on your tender beard. Man, I will cover you if you are cold. Come up. Happiness will roll at your feet like a crystal ball. And all the *constructions* of your mind will praise you together. On that day, I too will commend you, seated in the center of the sun-filled square, near the stone warrior and the empty pool. And towards evening, when the lighthouse shadow is long on the jetty, when the banners snap, and the white sails are as hard and round as breasts swollen with love and desire, we will fall in each other's arms, and together weep.

### THE STATUE'S DESIRE

"I wish at any cost to be alone," said the statue with the eternal look. Wind, wind that cools my burning cheeks. And the terrible battle began. Broken heads fell, and skulls shone as if they were of ivory.

Flee, flee toward the square and radiant city. Behind, devils whip me with

all their might. My calves bleed horribly. Oh the sadness of the lonely statue down there. Beatitude.

And never any sun. Never the yellow consolation of the lighted earth. It *desires.*

Silence.

It loves its strange soul. It has *conquered.*

And now the sun has stopped, high in the center of the sky. And in ever-lasting happiness the statue immerses its soul in the contemplation of its shadow.

There is a room whose shutters are always closed. In one corner there is a book no one has ever read. And there on the wall is a picture one cannot see without weeping.

There are arcades in the room where he sleeps. When evening comes the crowd gathers there with a hum. When the heat has been torrid at noon, it comes there panting, seeking the cool. But he sleeps, he sleeps, he sleeps.

What happened? The beach was empty, and now I see someone seated there, there on a rock. A *god* is seated there, and he watches the sea in silence. And that is all.

The night is deep. I toss on my burning couch. Morpheus detests me. I hear the sound of a carriage approaching from far off. The hoofs of the horse, a gallop, and the noise bursts, and fades into the night. In the distance a locomotive whistles. The night is deep.

The statue of the conqueror in the square, his head bare and bald. Everywhere the sun rules. Everywhere shadows console.

Friend, with vulture's glance and smiling mouth, a garden gate is making you suffer. Imprisoned leopard, pace within your cage, and now, on your pedestal, in the pose of a conquering king, proclaim your victory.

*Giorgio de Chirico, "Mystery and Creation," 1913\**

To become truly immortal a work of art must escape all human limits: logic and common sense will only interfere. But once these barriers are broken it will enter the regions of childhood vision and dream.

Profound statements must be drawn by the artist from the most secret

---

\* Originally published in André Breton, *Le Surréalisme et la Peinture* (Paris: Gallimard, 1928), pp. 38–39. This English translation from *London Bulletin*, No. 6 (October 1938), p. 14.

recesses of his being; there no murmuring torrent, no birdsong, no rustle of leaves can distract him.

What I hear is valueless; only what I see is living, and when I close my eyes my vision is even more powerful.

It is most important that we should rid art of all that it has contained of *recognizable material* to date, all familiar subject matter, all traditional ideas, all popular symbols must be banished forthwith. More important still, we must hold enormous faith in ourselves: it is essential that the revelation we receive, the conception of an image which embraces a certain thing, which has no sense in itself, which has no subject, which means *absolutely nothing* from the logical point of view, I repeat, it is essential that such a revelation or conception should speak so strongly in us, evoke such agony or joy, that we feel compelled to paint, compelled by an impulse even more urgent than the hungry desperation which drives a man to tearing at a piece of bread like a savage beast.

I remember one vivid winter's day at Versailles. Silence and calm reigned supreme. Everything gazed at me with mysterious, questioning eyes. And then I realized that every corner of the palace, every column, every window possessed a spirit, an impenetrable soul. I looked around at the marble heroes, motionless in the lucid air, beneath the frozen rays of that winter sun which pours down on us *without love*, like perfect song. A bird was warbling in a window cage. At that moment I grew aware of the mystery which urges men to create certain strange forms. And the creation appeared more extraordinary than the creators.

Perhaps the most amazing sensation passed on to us by prehistoric man is that of presentiment. It will always continue. We might consider it as an eternal proof of the irrationality of the universe. Original man must have wandered through a world full of uncanny signs. He must have trembled at each step.

### André Breton, *"Surrealism and Painting," 1928*\*

The eye exists in its primitive state. The marvels of the earth a hundred feet high, the marvels of the sea a hundred feet deep, have for their witness only the wild eye that when in need of colors refers simply to the rainbow. It is present at the conventional exchange of signals that the navigation of the mind would appear to demand. But who is to draw up the scale of vision? There are those things that I have already seen many a time, and that others tell me they have likewise seen, things that I believe I should be able to remember, whether I cared about them or not, such, for instance, as the façade of the Paris Opera House, or a horse, or the horizon; there are those things that I have seen only very seldom, and that I have not always chosen to forget, or not to forget, as the case may be; there are those

---

\* Originally published in Breton, *Le Surréalisme et La Peinture.* Reprinted by Brentano (New York: 1945). This excerpt from the English translation by David Gascoyne in André Breton, *What is Surrealism?* (London: Faber and Faber, 1936), pp. 9–24.

things that having looked at in vain I never dare to see, which are all the things I love (in their presence I no longer see anything else); there are those things that others have seen, and that by means of suggestion they are able or unable to make me see also; there are also those things that I see differently from other people, and those things that I begin to see and that *are not visible*. And that is not all.

To these varying degrees of sensation correspond spiritual realizations sufficiently precise and distinct to allow me to accord to plastic expression a value that on the other hand I shall never cease to refuse to musical expression, the most deeply confusing of all.[1] Auditive images, in fact, are inferior to visual images not only in clearness but also in strictness, and with all due respect to a few melomaniacs, they hardly seem intended to strengthen in any way the idea of human greatness. So may night continue to fall upon the orchestra, and may I, who am still searching for something in this world, may I be left with open or closed eyes, in broad daylight, to my silent contemplation.

The need of fixing visual images, whether these images exist before their fixation or not, stands out from all time and has led to the creation of a veritable language, which does not seem to me more artificial than any other, over the origins of which I do not feel it necessary to linger here. The most I can do is to consider the present state of this language from the same angle as that from which I should consider the present state of poetic language. It seems to me that I can demand a great deal from a faculty which, above almost all others, gives me advantage over the real, over what is vulgarly understood by *the real*. Why is it that I am so much at the mercy of a few lines, a few colored patches? The object, the strange object itself draws from these things the greatest amount of its force of provocation, and God knows whether this is a great provocation, for *I* cannot understand whither it is tending. What does it matter to me whether trees are green, whether a piano is at this moment "nearer" to me than a state-coach, whether a ball is cylindrical or round? That is how things are, nevertheless, if I am to believe my eyes, that is to say up to a certain point. In such a domain I dispose of a power of illusion whose limits, if I am not careful, I cease to perceive. If at this moment I turn to some illustration or other in a book, there is nothing to prevent the world around me from ceasing to exist. In place of what was surrounding me there is now something else, since, for example, I can without difficulty take part in quite another ceremony .... The corner formed by the ceiling and two walls in the picture can easily be substituted for the corner of this ceiling and these two walls. I turn over a few pages, and in spite of the almost uncomfortable heat, I do not in the least refuse to consent to this winter landscape. I can play with these winged children. "He saw before him an illuminated cavern," says a caption, and I can actually see it too. I see it in a way in which I do not at this moment see you for whom I am writing, yet all the same I am writing so as to be able to see you

---

[1] "On his death-bed, Mozart declared that he 'began to see what might be accomplished in music.'" (Poe) [A. B.]

*Tristan Tzara, André Breton, 1921, drawing.*

one day, just as truly as I have lived a second for this Christmas tree, this illuminated cavern, or these angels. It does not matter whether there is a perceptible difference between things thus invoked and real beings, for this difference can at any moment be made light of. So that it is impossible for me to consider a picture as anything but a window, in which my first interest is to know what it *looks out on*, or, in other words, whether, from where I am, there is a "beautiful view," for there is nothing I love so much as that which stretches away before me and *out of sight*. Within the frame of an *unnamed figure, land- or seascape*, I can enjoy an enormous spectacle. What am I doing here, why have I to stare this person in the face for so long, of what enduring temptation am I the object? But apparently it is a man who is making this proposition to me! I do not refuse to follow wherever he would lead me. Only afterwards can I judge whether I was wise to take him as my guide and whether the adventure into which I have been drawn by him was worthy of me.

Now I declare I have passed like a madman through the slippery-floored halls of museums; and I am not the only one. In spite of a few marvelous glances I received from women just like those of today, I have never for an instant been the dupe of the unknown that those subterranean and immovable walls had to offer me. I left adorable suppliants behind without remorse. There were too many scenes all at once; I had not the heart to speculate upon them. As I passed by in front of all those religious compositions and pastoral allegories, I could not help losing the sense of the part I was playing. The enchantments that the street outside had to offer me were a thousand times more real. It is not my fault if I cannot help feeling a profound lassitude when confronted by the interminable march past of the entries for this gigantic *prix de Rome* in which nothing, neither the subjects nor the manner of treating them, has been left optional.

I do not necessarily mean that no emotion can be aroused by a painting of "Leda," or that no heartrending sun can set behind a scene of "Roman palaces," nor even that it would be impossible to give some semblance of eternal morality to the illustration of a fable as ridiculous as *Death and the Woodcutter*. I simply mean that genius has nothing to gain by following these beaten tracks and roundabout paths. There is nothing with which it is so dangerous to take liberties as liberty.

But all question of emotion for emotion's sake apart, let us not forget that in this epoch it is reality itself that is in question. How can anyone expect us to be satisfied with the passing disquiet that such and such a work of art brings us? There is no work of art that can hold its own before our essential *primitivism* in this respect. When I know how the grim struggle between the actual and the possible will end, when I have lost all hope of enlarging the field of the real, until now strictly limited, to truly stupefying proportions, when my imagination, recoiling upon itself, can no longer do more than coincide with my memory, I will willingly accord myself, like the others, a few relative satisfactions. I shall then number myself among the "embroiderers," whom I shall have had to forgive. But not before.

The very narrow conception of *imitation* which art has been given as its aim is at bottom of the serious misunderstanding that we see continuing right up to the present. In the belief that they are only capable of reproducing more or less fortunately the image of that which moves them, painters have been far too easy-going in their choice of models. The mistake lies in thinking that the model can only be taken from the exterior world, or even simply that it can be taken at all. Certainly human sensibility can confer a quite unforeseen distinction upon even the most vulgar-looking object; none the less, to make the magic power of figuration which certain men possess serve the purpose of preserving and reinforcing that which would exist without them anyway, is to make wretched use of it. There lies the inexcusable abdication. It is in any case impossible, under the present conditions of thought, when above all the exterior world appears more and more suspect,

still to consent to such a sacrifice. The plastic work of art, in order to respond to the undisputed necessity of thoroughly revising all real values, will either refer to a *purely interior model* or cease to exist.

It remains to us to determine what is meant by the term *interior model*, and at this point it becomes a question of tackling the great problem raised in recent years by the attitude of those few men who have truly rediscovered a reason to paint—a problem that a miserable system of art-criticism is forced desperately to evade. In the domain of poetry, Lautréamont, Rimbaud, and Mallarmé were the first to endow the human mind with what it lacked so much: I mean a truly *insolent grace*, which has enabled the mind, on finding itself withdrawn from all ideals, to begin to occupy itself with its own life, in which the attained and the desired no longer mutually exclude one another, and thereupon to attempt to submit to a permanent and most rigorous censorship whatever has constrained it heretofore. After their appearance, the idea of what is forbidden and what is allowed adopted its present elasticity, to such a point that the words family, fatherland, society, for instance, seem to us now to be so many macabre jests. It was they who really caused us to make up our minds to rely for our redemption here below upon ourselves alone, so that we have desperately to pursue their footsteps, animated by the feverish desire for conquest, total conquest, that will never leave us; so that our eyes, our precious eyes, have to reflect that which, while not existing, is yet as intense as that which does exist, and which has once more to consist of visual images, fully compensating us for what we have left behind. The mysterious path on which fear dogs our every step and our desire to turn back is only over-come by the fallacious hope of being accompanied, has for the past fifteen years been swept by a powerful searchlight. It is now fifteen years since Picasso began to explore this path, bearing rays of light with him as he went. No one had had the courage to see anything there before he came. Poets used to talk of a country they had discovered, where in the most natural way in the world a drawing-room appeared "at the bottom of a lake," but this image was only a virtual one for us. What miracle has enabled this man, whom it is my astonishment and good fortune to know, to body forth all that remained, up till his appearance, in the highest domain of fantasy? What a revolution must have taken place within him for it to have been possible for this to happen! People will begin to search passionately, later on, for what must have animated Picasso towards the end of the year 1909. Where was he then? How did he live? How could that ridiculous word "cubism" unveil for me the prodigious meaning of the discovery that, to my mind, took place in his work somewhere between *The Horta and Ebro Factory* [this title is customarily given as *L'Usine, Horta de Ebro*—Ed.] and the portrait of M. Kahn-weiler?[2] Neither the non-disinterested testimonies of participants nor the feeble

---

[2] Zervos dates *L'Usine, Horta de Ebro* in Summer 1909, and the portrait of Kahnweiler in Autumn 1910.

explanations of a few scribblers could succeed in reducing such an adventure in my eyes to the proportions of a mere news item or local artistic phenomenon. In order to be able to break suddenly away from sensible things, or with more reason from the *easiness* of their customary appearance, one has to be aware of their treason to such a high degree that one cannot escape recognizing the fact of Picasso's immense responsibility. A single failure of willpower on his part would be sufficient for everything we are concerned with to be at least put back, if not wholly lost. His admirable perseverance is such a valuable guarantee that it dispenses with all need for us to appeal to any other authority. Shall we ever know what awaits us at the end of this agonizing journey? All that matters is that the exploration be continued, and that the objective rallying signs take place without any possibility of equivocation and follow one another uninterruptedly. Of course, our heroic determination systematically to let go our prey in favor of its shadow exposes us far less to the risk of finding that this shadow, this second shadow, this third shadow have cunningly been given all the characteristics of the prey. We leave behind the great grey and beige "scaffoldings" of 1912, the most perfect example of which is undoubtedly the fabulously elegant *Man with a Clarinet*, upon whose "aside" existence we shall never cease to meditate. The supposed material conditions of this existence leave us indifferent today. The *Man with a Clarinet* subsists as a tangible proof that we continue to advance and to be aware that the mind talks obstinately to us of a *future continent*, and that everyone is in a position to accompany an ever more beautiful Alice to Wonderland. As to those who would declare this opinion gratuitous, it is sufficient for me to show them Picasso's pictures as evidence. And to say to them: "Look at this sand that falls so slowly in order to tell the earth's time. It is your whole life, and if you could gather it up you could hold it in the palm of your hand. Here is the fragile glass that you held up so high, and here is the card that just now you missed turning up once and for all. These things are not symbols, my friends: they are just an only too explicable and lingering farewell, and they are likewise the wind-blown echo of an emigrant's song, just as you choose."

One would have to have formed no idea of Picasso's exceptional predestination to dare to fear or hope for a partial renunciation on his part. Nothing seems to me more amusing or more just than that, in order to discourage insupportable followers or to draw a sigh of relief from the beast of reaction, he has only from time to time to offer for their admiration the things he has scrapped. From the laboratory open to the sky there will continue to escape, at nightfall, divinely unwonted beings, dancers dragging fragments of marble mantelpieces behind them, adorably laden tables, beside which yours are mere turning-tables, and all that remains clinging to the immemorial newspaper: *Le Jour* . . . . It has been said that there could be no such thing as surrealist painting. Painting, literature—what are they to us, O Picasso, you who have carried the spirit, no longer of contradiction, but of evasion, to its furtherest point! From each one of your pictures you

have let down a rope-ladder, or rather a ladder made of the sheets of your bed, and we, and probably you with us, desire only to climb up into your sleep and down from it again. And they come and talk to us of painting, they come and remind us of that lamentable expedient which is painting!

When we were children we had toys that would make us weep with pity and anger today. One day, perhaps, we shall see the toys of our whole life, like those of our childhood, once more. It was Picasso who gave me this idea. (*The Woman in a Chemise* [1914] and that still life in which the inscription *Vive La* shines out upon a white vase above two crossed flags.) I never received this impression so strongly as on the occasion of the ballet *Mercury*, a few years ago. We grow up until a certain age, it seems, and our playthings grow up with us. Playing a part in the drama whose only theater is the mind, Picasso, creator of tragic toys for adults, has caused man to grow up and, sometimes under the guise of exasperating him, has put an end to his puerile fidgeting.

On account of these many considerations, we emphatically claim him as one of us, even while it is impossible and would be impudent to subject his methods to the rigorous system of criticism which we propose to institute. If surrealism has assigned to itself a line of conduct, it has only to submit to it in the way that Picasso has submitted to it and will continue to submit; I hope by saying this to prove myself very exacting. I shall always oppose the absurdly restrictive character of that which any kind of discipline[3] would impose on the activity of the man from whom we persist in expecting more than from anyone else. The "cubist" discipline made this mistake long ago. Such restrictions may be suitable for others, but it seems to me urgently desirable that Picasso and Braque should be exempted.

. . . . . . . . . . . . . . . . . . . .

We shall see the Revolution, concerning the definition of which there can today be no more misunderstanding, and it will provide a reason for our scruples. It is only before the Revolution that I consider it to be efficacious to summon the best men that I know. The responsibility of painters, as of all those to whom it falls due in no small measure to prevent, in whatever form of expression is theirs, the survival of the sign for the thing signified, seems to me at present to be both a heavy and an ill-supported one. Yet that is the price of eternity. The mind slips up on this apparently fortuituous circumstance as on a piece of banana-skin. Those who prefer to take no account of the moment when they expect the least to happen seem to me to lack that mysterious aid which to my mind is the only aid of any importance. The revolutionary content of a work, or merely its content, could not depend upon the choice of the elements which this work brings into play. This accounts for the difficulty of obtaining a strict and objective scale of plastic values at a time when a total revision of all values is about to be undertaken, and when

[3] Even were that the "surrealist" discipline. A.B.

clairvoyance obliges us to recognize only those values which are likely to hasten this revision.

Confronted by the utter bankruptcy of art-criticism, a bankruptcy that is really quite comic, it is not for us to complain that the articles of a Raynal, a Vauxcelles, or a Fels surpass the limits of imbecility. The continued scandal of Cézannism, of neo-academism, or of machinism, is incapable of compromising the issue that is our real interest. Whether Utrillo is still or already a good "seller," whether Chagall happens to be considered a surrealist or not, are matters for grocers' assistants. Undoubtedly the study of conventions, to which I will content myself with making a passing allusion, could be profoundly edifying if it were properly conducted, but it would be a waste of time for me to attempt it here, inasmuch as these conventions are in perfect accord with all those things which, in a more general domain, are now being denounced. From an intellectual point of view, it is simply a question of finding out to what causes can be attributed the incontestable failure of certain artists, which, in two or three cases, goes so far as to appear to us as resulting from the loss of a *state of grace*.

Now that Picasso, absolved by his genius from all merely moral obligations, he who unceasingly deceives appearances with reality, going so far as to defy, to a sometimes alarming extent, that which, as we see it, is forever unforgiving— now that Picasso, finally escaping from all compromise, remains master of a situation that except for him we should have considered desperate, it does in fact seem that the majority of his early companions are traveling a road that is the furthest apart from ours and his own. Those who, with such particularly prophetic intuition, called themselves *Les Fauves*, no longer do anything now except pace ridiculously up and down behind the bars of time, and from their final pounces, so little to be feared, the least dealer, or tamer, can defend himself with a chair. These discouraged and discouraging old lions are Matisse and Derain. They do not even retain their nostalgia for the forest and the desert; they have passed into a tiny arena: their gratitude to those who mate them and keep them alive. A *Nude* by Derain, a new *Window* by Matisse—what surer testimony could there be to the truth of the contention that "not all the water in the sea would suffice to wash out one drop of intellectual blood"?[4] So will these men never rise again? Should they now desire to make honorable amends to the mind, they would find themselves forever lost, both they and the others. The air once so limpid, the journey that will not be made, the uncrossed distance that separates the place where one left an object from the place where one finds it again on waking, the inseparable eternities of this hour and of this place, are all at the mercy of our first act of submission. I should like to discuss so total a loss at greater length. But what is to be done? It is too late.

[4] Isidore Ducasse. A.B.

*André Breton, What is Surrealism? 1934*\*

At the beginning of the war of 1870 (he was to die four months later, aged twenty-four), the author of the *Chants de Maldoror* and of *Poésies*, Isidore Ducasse, better known by the name of Comte de Lautréamont, whose thought has been of the very greatest help and encouragement to my friends and myself throughout the fifteen years during which we have succeeded in carrying on a common activity,[1] made the following remark, among many others which were to electrify us fifty years later: "At the hour in which I write, new tremors are running through the intellectual atmosphere; it is only a matter of having the courage to face them." 1868–75: it is impossible, looking back upon the past, to perceive an epoch so *poetically* rich, so victorious, so revolutionary, and so charged with distant meaning as that which stretches from the separate publication of the *Premier Chant de Maldoror* to the insertion in a letter to Ernest Delahaye of Rimbaud's last poem, *Rêve*, which has not so far been included in his *Complete Works*. It is not an idle hope to wish to see the works of Lautréamont and Rimbaud restored to their correct historical background: the coming and the immediate results of the war of 1870. Other and analogous cataclysms could not have failed to rise out of that military and social cataclysm whose final episode was to be the atrocious crushing of the Paris Commune; the last in date caught many of us at the very age when Lautréamont and Rimbaud found themselves thrown into the preceding one, and by way of revenge has had as its consequence—and this is the new and important fact—the triumph of the Bolshevik Revolution.

· · · · · · · · · · · · · · · · · · ·

In an article, "Enter the Mediums," published in *Littérature*, 1922, reprinted in *Les Pas Perdus*, 1924, and subsequently in the Surrealist Manifesto, I explained the circumstance that had originally put us, my friends and myself, on the track of the surrealist activity we still follow and for which we are hopeful of gaining ever more numerous new adherents in order to extend it further than we have so far succeeded in doing. It reads:

It was in 1919, in complete solitude and at the approach of sleep, that my attention was arrested by sentences more or less complete, which became perceptible to my mind without my being able to discover (even by very meticulous analysis) any possible previous volitional effort. One evening in particular, as I was about to fall asleep, I became aware of a sentence articulated clearly to a point excluding all possibility of alteration and stripped of all quality of vocal sound; a

---

\* From a lecture originally published in André Breton, *Qu'est-ce-que le Surréalisme?* (Brussels: R. Henriquez, 1934). This excerpt from the English translation by David Gascoyne in Breton, *What is Surrealism?*, pp. 44–90.

[1] While the Surrealist movement itself did not date back this far, Breton was associated with the Dadaists and he had visited Sigmund Freud in Vienna soon after the end of World War I. His first book, *Les Champs magnétiques* (1921) was an experiment in unconscious writing.

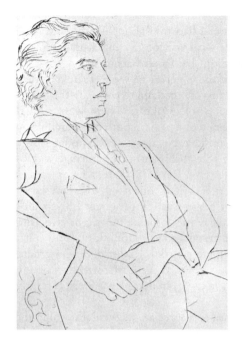

*Pablo Picasso, André Breton, 1923, dry point*

curious sort of sentence which came to me bearing—in sober truth—not a trace of any relation whatever to any incidents I may at that time have been involved in; an insistent sentence, it seemed to me, a sentence I might say, that *knocked at the window.* I was prepared to pay no further attention to it when the organic character of the sentence detained me. I was really bewildered. Unfortunately, I am unable to remember the exact sentence at this distance, but it ran approximately like this: "A man is cut in half by the window." What made it plainer was the fact that it was accompanied by a feeble visual representation of a man in the process of walking, but cloven, at half his height, by a window perpendicular to the axis of his body. Definitely, there was the form, re-erected against space, of a man leaning out of a window. But the window following the man's locomotion, I understood that I was dealing with an image of great rarity. Instantly the idea came to me to use it as material for poetic construction. I had no sooner invested it with that quality, than it had given place to a succession of all but intermittent sentences which left me no less astonished, but in a state, I would say, of extreme detachment.

Preoccupied as I still was at that time with Freud, and familiar with his methods of investigation, which I had practiced occasionally upon the sick during the War, I resolved to obtain from myself what one seeks to obtain from patients, namely a monologue poured out as rapidly as possible, over which the subject's critical faculty has no control—the subject himself throwing reticence to the winds—and which as much as possible represents *spoken thought.* It seemed and still seems to me that the speed of thought is no greater than that of words, and

411

hence does not exceed the flow of either tongue or pen. It was in such circumstances that, together with Philippe Soupault, whom I had told about my first ideas on the subject, I began to cover sheets of paper with writing, feeling a praiseworthy contempt for whatever the literary result might be. Ease of achievement brought about the rest. By the end of the first day of the experiment we were able to read to one another about fifty pages obtained in this manner and to compare the results we had achieved. The likeness was on the whole striking. There were similar faults of construction, the same hesitant manner, and also, in both cases, an illusion of extraordinary verve, much emotion, a considerable assortment of images of a quality such as we should never have been able to obtain in the normal way of writing, a very special sense of the picturesque, and, here and there, a few pieces of out-and-out buffoonery. The only differences which our two texts presented appeared to me to be due essentially to our respective temperaments, Soupault's being less static than mine, and, if he will allow me to make this slight criticism, to his having scattered about at the top of certain pages—doubtlessly in a spirit of mystification—various words under the guise of titles. I must give him credit, on the other hand, for having always forcibly opposed the least correction of any passage that did not seem to me to be quite the thing. In that he was most certainly right.

It is of course difficult in these cases to appreciate at their just value the various elements in the result obtained; one may even say that it is entirely impossible to appreciate them at a first reading. To you who may be writing them, these elements are, in appearance, *as strange as to anyone else*, and you are yourself naturally distrustful of them. Poetically speaking, they are distinguished chiefly by a very high degree of *immediate absurdity*, the peculiar quality of that absurdity being, on close examination, their yielding to whatever is most admissible and legitimate in the world: divulgation of a given number of facts and properties on the whole not less objectionable than the others.

The word "surrealism" having thereupon become descriptive of the *generalizable* undertaking to which we had devoted ourselves, I thought it indispensable, in 1924, to define this word once and for all:

SURREALISM, n. Pure psychic automatism, by which it is intended to express, verbally, in writing, or by other means, the real process of thought. Thought's dictation, in the absence of all control exercised by the reason and outside all aesthetic or moral preoccupations.

ENCYCL. *Philos.* Surrealism rests in the belief in the superior reality of certain forms of association neglected heretofore; in the omnipotence of the dream and in the disinterested play of thought. It tends definitely to do away with all other psychic mechanisms and to substitute itself for them in the solution of the principal problems of life. Have professed *absolute surrealism:* Messrs. Aragon, Baron, Boiffard, Breton, Carrive, Crevel, Delteil, Desnos, Eluard, Gérard, Limbour, Malkine, Morise, Naville, Noll, Péret, Picon, Soupault, Vitrac.

These till now appear to be the only ones, and there would not have been any doubt on that score were it not for the strange case of Isidore Ducasse, of whose extra-literary career I lack all data. Were one to consider their output only superficially, a goodly number of poets might well have passed for surrealists, beginning with Dante and Shakespeare at his best. *In the course of many attempts I have made towards an analysis of what, under false pretences, is called genius, I have found nothing that could in the end be attributed to any other process than this.*

The *Manifesto* also contained a certain number of practical recipes, entitled: "Secrets of the Magic Surrealist Art," such as the following:
*Written Surrealist Composition or First and Last Draft.*

Having settled down in some spot most conductive to the mind's concentration upon itself, order writing material to be brought to you. Let your state of mind be as passive and receptive as possible. Forget your genius, talents, as well as the genius and talents of others. Repeat to yourself that literature is pretty well the sorriest road that leads to everywhere. Write quickly without any previously chosen subject, quickly enough not to dwell on, and not to be tempted to read over, what you have written. The first sentence will come of itself; and this is self-evidently true, because there is never a moment but some sentence alien to our conscious thought clamors for outward expression. It is rather difficult to speak of the sentence to follow, since it doubtless comes in for a share of our conscious activity and so the other sentences, if it is conceded that the writing of the first sentence must have involved even a minimum of consciousness. But that should in the long run matter little, because therein precisely lies the greatest interest in the surrealist exercise. Punctuation of course necessarily hinders the stream of absolute continuity which preoccupies us. But you should particularly distrust the prompting whisper. If through a fault ever so trifling there is a fore-warning of silence to come, a fault, let us say, of inattention, break off unhesitatingly the line that has become too lucid. After the word whose origin seems suspect you should place a letter, any letter, *l* for example, always the letter *l*, and restore the arbitrary flux by making that letter the initial of the word to follow.

We still live under the reign of logic, but the methods of logic are applied nowadays only to the resolution of problems of secondary interest. The absolute rationalism which is still the fashion does not permit consideration of any facts but those strictly relevant to our experience. Logical ends, on the other hand, escape us. Needless to say that even experience has had limits assigned to it. It revolves in a cage from which it becomes more and more difficult to release it. Even experience is dependent on immediate utility, and common sense is its keeper. Under color of civilization, under the pretext of progress, all that rightly or wrongly may be regarded as fantasy or superstition has been banished from the mind, all un-customary searching after truth has been proscribed. It is only by what must seem sheer luck that there has recently been brought to light an aspect of mental life—to

my belief by far the most important—with which it was supposed that we no longer had any concern. All credit for these discoveries must go to Freud. Based on these discoveries a current of opinion is forming that will enable the explorer of the human mind to continue his investigations, justified as he will be in taking into account more than mere summary realities. The imagination is perhaps on the point of reclaiming its rights. If the depths of our minds harbor strange forces capable of increasing those on the surface, or of successfully contending with them, then it is all in our interest to canalize them, to canalize them first in order to submit them later, if necessary, to the control of the reason. The analysts themselves have nothing to lose by such a proceeding. But it should be observed that there are no means designed *a priori* for the bringing about of such an enterprise, that until the coming of the new order it might just as well be considered the affair of poets and scientists, and that its success will not depend on the more or less capricious means that will be employed.

I am resolved to render powerless that *hatred of the marvelous* which is so rampant among certain people, ridicule to which they are so eager to expose it. Briefly: The marvelous is always beautiful, anything that is marvelous is beautiful; indeed, nothing but the marvelous is beautiful.

The admirable thing about the fantastic is that it is no longer fantastic: there is only the real.

As I said in the *Manifesto:*
I believe in the future transmutation of those two seemingly contradictory states, dream and reality, into a sort of absolute reality, of surreality, so to speak. I am looking forward to its consummation, certain that I shall never share in it, but death would matter little to me could I but taste the joy it will yield ultimately.
Aragon expressed himself in very much the same way in *Une Vague de Rêves* (1924):
It should be understood that the real is a relation like any other; the essence of things is by no means linked to their reality, there are other relations beside reality, which the mind is capable of grasping, and which also are primary like chance, illusion, the fantastic, the dream. These various groups are united and brought into harmony in one single order, surreality . . . . This surreality—a relation in which all notions are merged together—is the common horizon of religions, magics, poetry, intoxications, and of all life that is lowly—that trembling honeysuckle you deem sufficient to populate the sky with for us.
And René Crevel, in *L'Esprit contre la Raison:*
The poet does not put the wild animals to sleep in order to play the tamer, but, the cages wide open, the keys thrown to the winds, he journeys forth, a traveler who thinks not of himself, but of the voyage, of dream-beaches, forests of hands, soul-endowed animals, all undeniable surreality.

I was to sum up the idea in these terms in *Surrealism and Painting* (1928):[3]

All that I love, all that I think and feel inclines me towards a particular philosophy of immanence according to which surreality will reside in reality itself, will be neither superior nor exterior to it. And conversely, because the container shall be also the contained. One might say that it will be a communicating vessel placed between the container and the contained. That is to say, I resist with all my strength temptations which, in painting and literature, might have the immediate tendency to withdraw thought from life as well as place life under the aegis of thought.

From 1930 until today the history of surrealism is that of successful efforts to restore to it its proper *becoming* by gradually removing from it every trace both of political opportunism and of artistic opportunism. The review *La Révolution Surréaliste* (12 issues) has been succeeded by another, *Le Surréalisme au Service de la Révolution* (6 issues). Owing particularly to influences brought to bear by new elements, surrealist experimenting, which had for too long been erratic, has been unreservedly resumed; its perspectives and its aims have been made perfectly clear; I may say that it has not ceased to be carried on in a continuous and enthusiastic manner. This experimenting has regained momentum under the master-impulse given to it by Salvador Dali, whose exceptional interior "boiling" has been for surrealism, during the whole of this period, an invaluable ferment. As Guy Mangeot has rightly pointed out in his *History of Surrealism*[4] published recently by René Henriquez, Dali has endowed surrealism with an instrument of primary importance, in particular the paranoiac-critical method, which has immediately shown itself capable of being applied with equal success to painting, poetry, the cinema, to the construction of typical surrealist objects, to fashions, to sculpture, and even, if necessary, to all manner of exegesis.

He first announced his convictions to us in *La Femme Visible* (1930):

I believe the moment is at hand when, by a paranoiac and active advance of the mind, it will be possible (simultaneously with automatism and other passive states) to systematize confusion and thus to help to discredit completely the world of reality.

In order to cut short all possible misunderstandings, it should perhaps be said: "immediate" reality.

Paranoia uses the external world in order to assert its dominating idea and has the disturbing characteristic of making others accept this idea's reality. The reality of the external world is used for illustration and proof, and so comes to serve the reality of our mind.

In the special "Intervention surréaliste" number of *Documents* 34 [Brussels, 15 May 1934] under the title "Philosophic Provocations," Dali undertakes today

---

[3] Not translated until 1936. See *Le Surréalisme et la Peinture* (Paris: Gallimard, 1928); *Surrealism and Painting* (London; Faber and Faber, 1936).

[4] Not translated; see *Histoire du Surréalisme* (Brussels: 1934).

to give his thought a didactic turn. All uncertainty as to his real intentions seems
to be swept away by these definitions:

*Paranoia:* Delirium of interpretation bearing a systematic structure.

*Paranoiac-critical activity:* Spontaneous method of *"irrational knowledge,"* based on
the critical and systematic objectification of delirious associations and inter-
pretations.

*Painting:* Hand-done color "photography" of "concrete irrationality" and of the
imaginative world in general.

*Sculpture:* Modeling by hand of "concrete irrationality" and of the imaginative
world in general. Etc. . . .

In order to form a summary idea of Dali's undertaking, one must take
into account the property of *uninterrupted becoming* of any object of paranoiac
activity, in other words of the ultra-confusing activity rising out of the obsessing
idea. This uninterrupted becoming allows the paranoiac who is their witness
to consider the images of the exterior world as unstable and transitory, or suspect;
and what is so disturbing is that he is able to make other people believe in the
reality of his impressions. One aspect, for instance, of the *multiple* image occupying
our attention being a putrefied donkey, the "cruel" putrefaction of the donkey
can be considered as "the hard and blinding flash of new gems." Here we find
ourselves confronted by a new affirmation, accompanied by formal proofs, of the
*omnipotence of desire*, which has remained, since the beginnings, surrealism's sole
act of faith. At the point where surrealism has taken up the problem, its only
guide has been Rimbaud's sibylline pronouncement: "I say that one must be a
*seer*, one must make oneself a seer." As you know, this was Rimbaud's only means
of reaching "the *unknown*." Surrealism can flatter itself today that it has discovered
and rendered practicable many other ways leading to the unknown. The abandon-
ment to verbal or graphic impulses and the resort to paranoiac-critical activity are
not the only ones, and one may say that, during the last four years of surrealist
activity, the many others that have made their appearance allow us to affirm that
the automatism from which we started and to which we have unceasingly returned
does in fact constitute the *crossroads* where these various paths meet. Among those
we have partly explored and on which we are only just beginning to see ahead,
I should single out the simulation of mental diseases (acute mania, general paralysis,
dementia praecox), which Paul Eluard and I practised in *The Immaculate Con-
ception* (1930), undertaking to prove that the normal man can have access to the
provisorily condemned places of the human mind; the manufacture of objects
functioning symbolically, started in 1931 by the very particular and quite new
emotion aroused by Giacometti's object, *L'Heure des Traces*; the analysis of the
interpenetration of the states of sleep and waking, tending to make them depend
entirely upon one another and even condition one another in certain affective
states, which I undertook in *The Communicating Vessels*; and finally, the taking into
consideration of the recent researches of the Marburg school, to which I drew
attention in an article published in *Minotaure*, "The Automatic Message" [(Paris)

1933, nos. 3–4], whose aim is to cultivate the remarkable sensorial dispositions of children, enabling them to change any object whatever into no matter what, simply by looking at it fixedly.

Nothing could be more coherent, more systematic or more richly yielding of results than this last phase of surrealist activity, which has seen the production of two films by Luis Bunuel and Salvador Dali, *Un Chien Andalou* and *L'Age d'Or*, the poems of René Char, *L'Homme Approximatif*, *Où Boivent les Loups* and *L'Antitête* by Tristan Tzara, *Le Clavecin de Diderot* and *Les Pieds dans le Plat* by René Crevel, *La Vie Immédiate* by Eluard, the very previous *visual* commentaries by Madame Valentine Hugo on the works of Arnim and Rimbaud, the most intense part of the work of Yves Tanguy, the inspired sculpture of Alberto Giacometti, the coming together of Georges Hugnet, Gui Rosey, Pierre Yoyotte, Roger Caillois, Victor Brauner, and Balthus. Never has so precise a common will united us. I think I can most clearly express this will by saying that today it applies itself to *"bring about the state where the distinction between the subjective and the objective loses its necessity and its value."*

*Salvador Dali, "The object as revealed in Surrealist experiment," 1931\**

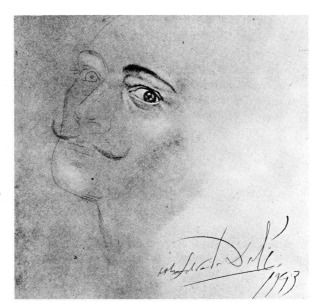

*Salvador Dali, Self-Portrait, 1943, drawing.*

\* Originally published in part as "Objets Surréalistes," *Le Surréalisme au Service de la Révolution* (Paris), No. 3 (1931). This English translation from *This Quarter* (London), V, 1 (September 1932), 197–207. Titles in brackets are the actual titles of books which do not exist in an English translation but which the translator nevertheless has rendered into English.

In my fancies, I like to take as the point of departure for surrealist experiments the title of a Max Ernst picture, *Revolution by Night*. If in addition to how nearly quite dreamlike and almost overwhelming these experiments were originally, one considers the nocturnal, the splendidly blinding, power of the word more or less summing up our future, the word "revolution," nothing could be less subjective than this phrase, "Revolution by Night." After all, that the review which for several years recorded the experiments should have been called *La Révolution Surréaliste* must be significant.

The years have modified the surrealist concept of the object most instructively, showing as it were in image how the surrealist view of the possibilities of action on the external world have been and may still be subject to change. In the early experiments with poetic solicitation, automatic writing, and accounts of dreams, real or imaginary articles appeared to be endowed with a real life of their own. Every object was regarded as a disturbing and arbitrary "being" and was credited with having an existence entirely independent of the experimenters' activity. Thanks to the images obtained at "The Exquisite Corpse,"[1] this anthropomorphic stage confirmed the haunting notion of the metamorphoses—inanimate life, continuous presence of human images, etc.—while also displaying the regressive characters determining infantile stages. According to Feuerbach,[2] "primitively the concept of the object is no other than the concept of a second self; thus in childhood every object is conceived as a being acting freely and arbitrarily." As will be seen in the sequel, the objects come gradually to shed this arbitrary character as the surrealist experiments proceed; when produced in dreams, they grow adapted to the most contradictory forms of our wishes, and finally are subordinated—quite relatively, it is true—to the demands of our own action. But it must be insisted that before the object yields to this necessity, it undergoes a nocturnal and indeed subterranean phase.

The early Surrealist experimenters found themselves plunged into the subterranean passages of *Revolution by Night*, the passages where *The Mysteries of New York* must have just been enacted; in fact, dream passages still identifiable today. They found themselves plunged in the post-mechanical open street, where the most beautiful and hallucinating iron vegetation sprouts those electric blooms

---

[1] The experiment known as "The Exquisite Corpse" was instigated by Breton. Several persons had to write successively words making up a sentence on a given model ("The exquisite/corpse/shall drink/the bubbling/wine"), each person being unaware of what word his neighbor might have had in mind. Or else several persons had to draw successively the lines making up a portrait or a scene, the second person being prevented from knowing what the first and second had drawn, etc. In the realm of imagery, "The Exquisite Corpse" produced remarkably unexpected poetic associations, which could not have been obtained in any other way, associations which still elude analysis and exceed in value as *fits* the rarest documents connected with mental disease. [s. d.]

[2] Ludwig Andreas Feuerbach (1804–1872), German naturalistic philosopher who believed the proper study of philosophy to be man as defined by experience.

*Valentine Hugo, André Breton, Tristan Tzara,*
*Landscape ("The Exquisite Corpse"), ca.*
*1933, chalk on paper.*

still decorating in the "Modern Style" [*Art Nouveau*] the entrances to the Paris Métro. There they were stricken with oblivion and, owing to the threat of unintended cataclysms, became highly developed automatic puppets such as men now risk becoming. All night long a few surrealists would gather round the big table used for experiments, their eyes protected and masked by thin though opaque mechanical slats on which the blinding curve of the convulsive graphs would appear intermittently in fleeting luminous signals, a delicate nickel apparatus like an astrolabe being fixed to their necks and fitted with animal membranes to record by interpenetration the apparition of each fresh poetic streak, their bodies being bound to their chairs by an ingenious system of straps, so that they could only move a hand in a certain way and the sinuous line was allowed to inscribe the appropriate white cylinders. Meanwhile their friends, holding their breath and biting their lower lips in concentrated attention, would lean over the recording apparatus and with dilated pupils await the expected but unknown movement, sentence, or image.

On the table, a few scientific instruments employed in a system of physics now forgotten or still to be elaborated, endowed the night with their different

temperatures and the different smells of their delicate mechanisms, having been made a little feverish by the fresh and cool taste of the electricity. There was also a woman's bronze glove and several other perverted articles such as "that kind of white, irregular, varnished half-cylinder with apparently meaningless bulges and hollows," which is mentioned in *Nadja*, and further the age Breton describes in *Wandering Footsteps* [*Lès Pas perdus*, 1924]: "I have in mind the occasion when Marcel Duchamp got hold of some friends to show them a cage which seemed to have no birds in it, but to be half-full of lumps of sugar. He asked them to lift the cage and they were surprised at its heaviness. What they had taken for lumps of sugar were really small lumps of marble which at great expense Duchamp had had sawn up specially for the purpose. The trick in my opinion is no worse than any other, and I would even say that it is worth nearly all the tricks of art put together."

The semi-darkness of the first phase of surrealist experiment would disclose some headless dummies and a shape wrapped up and tied with string, the latter, being unidentifiable, having seemed very disturbing in one of Man Ray's photographs (already then this suggested other wrapped-up objects which one wanted to identify by touch but finally found could not be identified; their invention, however, came later). But how can one give the feel of the darkness which for us shrouded the whole business? Only by mentioning the way the surrealists were strongly attracted by articles shining with their own light—in short, phosphorescent articles, in the proper or improper meaning of that word. These were a paper-cutter decorated with ears of wheat, casts of naked women hung on the walls, and T-squares and biscuits forming a Chirico "metaphysical interior." It is of no importance that some of these things had been covered with the luminous paint used on watch faces to make the hands and figures shine in the dark. What matters is the way in which the experiments revealed *the desire for the object*, the tangible object. This desire was to get the object at all costs out of the dark and into the light, to bear it all winking and flickering into the full daylight. That is how the *dream objects* Breton called for in his *Introduction to a Speech on the Poverty of Reality* [*Introduction au discours sur le peu de réalité*, 1927] were first met with.

He then said:

It should be realized that only our belief in a certain necessity prevents us from granting to poetic testimony the same credence we give, for example, to an explorer's story. Human fetishism is ready to try on the white toupee or stroke the fur cap, but it displays quite another attitude when *we* come back full of *our* adventures. It absolutely requires to believe that what it is told about has *actually happened*. That is why I recently suggested that as far as is feasible one should manufacture some of the articles one meets only in dreams, articles which are as hard to justify on the ground of utility as on that of pleasure. Thus the other night during sleep, I found myself at an open-air market in the neighborhood of Saint-Malo and came upon a rather unusual book. Its back consisted of a wooden gnome

whose white Assyrian beard reached to his feet. Although the statuette was of a normal thickness, there was no difficulty in turning the book's pages of thick black wool. I hastened to buy it, and when I woke up I was sorry not to find it beside me. It would be comparatively easy to manufacture it. I want to have a few articles of the same kind made, as their effect would be distinctly puzzling and disturbing. Each time I present one of my books to some selected person, I shall add some such object to my gift.

For thereby I may assist in demolishing the thoroughly hateful trophies of the concrete and add to the discredit of "rational" people and things. I might include ingeniously constructed machines of no possible use, and also maps of immense towns such as can never arise while human beings remain as they are, but which nevertheless would put in their place the great capitals now extant and to be. We could also have ridiculous but perfectly articulated automatons, which, though not doing anything in a human way, would yet give us proper ideas of action.

It is at least possible that the poet's creations are destined very soon to assume such tangibility and so most queerly to displace the limits of the so-called real. I certainly think that one must no longer underrate the hallucinatory power of some images or the imaginative gift some men possess independently of their ability to recollect.

In the second phase of surrealist experiment, the experimenters displayed a desire to interfere. This intentional element tended more and more to tangible verification and emphasized the possibilities of a growing relation to everydayness.

It was in the light of this that the inquiry concerning the daydream which love is pre-eminently (*The Surrealist Revolution* [*La Révolution Surréaliste*] No. 12) took place. It is significant that the inquiry was undertaken at the very moment when surrealism was bestowing an ever more concrete meaning on the word "revolution." In the circumstances, it cannot be denied that there is a dialectical potentiality in the fancy whereby the title of Max Ernst's picture, *Revolution by Night*, is converted into *Revolution by Day* (such an apt motto for the second phase of surrealist experiment!), it being understood and emphasized that the day meant must be the exclusive day of dialectical materialism.

The proof of the existence of the desire to interfere and of the (ill-intentioned) intentional element just mentioned is provided in the overwhelming assertions which André Breton makes in the *Second Manifesto* (cf. pages 26 seq. of the present number of *This Quarter*) with the assurance natural to those who have become fully conscious of their mission to corrupt wickedly the foundations of the illegitimate, assertions which have necessarily had their effect on art and literature.

The awareness I was given in *The Visible Woman* [*La Femme Visible*, 1930] that certain fulfillments were iminent led me to write, quite individually and personally, however: "I think the time is rapidly coming when it will be possible

(simultaneously with automatism and other passive states) to systematize confusion thanks to a paranoiac and active process of thought, and so assist in discrediting completely the world of reality." This has led me in the course of things to manufacture quite recently some articles still undefined which, in the realm of action, provide the same conflicting opportunities as the most remote mediumistic messages provide in the realm of receptivity.

But the new phase of surrealist experiment is given a really vital character and as it were defined by the *simulations of mental diseases* which in *The Immaculate Conception* [*L'immaculée conception*, 1931] André Breton and Paul Eluard have contrasted with the various poetic styles. Thanks to simulation in particular and images in general, we have been enabled, not only to establish communication between automatism and the road to the object, but also to regulate the system of interferences between them, automatism being thereby far from diminished but, as it were, liberated. Through the new relation thus established our eyes see the light of things in the external world.

Thereupon, however, we are seized with a new fear. Deprived of the company of our former habitual phantoms, which only too well ensured our peace of mind, we are led to regard the world of objects, the objective world, as the true and manifested content of a new dream.

The poet's drama as expressed by surrealism has been greatly aggravated. Here again as we have an entirely new fear. At the limit of the emerging cultivation of desire, we seem to be attracted by a new body, we perceive the existence of a thousand bodies of objects we feel we have forgotten. That the probable splitting of the personality is due to loss of memory is suggested by Feuerbach's conception of the object as being primitively only the concept of second self, all the more so that Feuerbach adds, "The concept of the object is usually produced with the help of the 'you' which is the 'objective self.'" Accordingly it must be the "you" which acts as "medium of communication," and it may be asked if what at the present moment haunts surrealism is not the possible body which can be incarnated in this communication. The way in which the new surrealist *fear* assumes the shape, the light and the appearance of the terrifying body the "objective self" should be compels us to think so. This view is further supported by the fact that André Breton's next book, amounting to a third surrealist manifesto, will be entitled with the clarity of a magnetized meteor, a talisman-meteor, *The Communicating Vessels* [*Les vases communicants*, 1932].

I have recently invited the surrealists to consider an experimental scheme of which the definite development would have to be undertaken collectively. As it is still individual, unsystematized, and merely suggestive, it is only put forward at present as a starting-point.

1. *The Transcription of Reveries.*

2. *Experiment Regarding the Irrational Acquaintance of Things:* Intuitive and very quick answers have to be given to a single and very complex series of

questions about known and unknown articles such as a rocking-chair, a piece of soap, etc. One must say concerning one of these articles whether it is

Of day or night,

Paternal or maternal,

Incestuous or not incestuous,

Favorable to love,

Subject to transformation,

Where it lies when we shut our eyes (in front or behind us, or on our left or our right, far off or near, &c.),

What happens to it if it is put in urine, vinegar, &c., &c.

3. *Experiment Concerning Objective Perception:* Each of the experimenters is given an alarm-watch which will go off at a time he must not know. Having this watch in his pocket, he carries on as usual and at the very instant the alarm goes off he must note where he is and what most strikingly impinges on his senses (of sight, hearing, smell, and touch). From an analysis of the various notes so made, it can be seen to what extent objective perception depends upon imaginative representation (the causal factor, astrological influence, frequency, the element of coincidence, the possibility of the result's symbolical interpretation in the light of dreams, &c.). One might find, for instance, that at five o'clock elongated shapes and perfumes were frequent, at eight o'clock hard shapes and purely phototypical images.

4. *Collective Study of Phenomenology* in subjects seeming at all times to have the utmost surrealist opportuneness. The method which can be most generally and simply employed is modeled on the method of analysis in Aurel Kolnai's phenomenology of repugnance. By means of this analysis one may discover the objective laws applicable scientifically in fields hitherto regarded as vague, fluctuating, and capricious. It would in my opinion be of special interest to surrealism for such a study to bear on *fancies* and on *caprice*. They could be carried out almost entirely as polemical inquiries, needing merely to be completed by analysis and coordination.

5. *Automatic Sculpture:* At every meeting for polemics or experiment let every person be supplied with a fixed quantity of malleable material to be dealt with automatically. The shapes thus made, together with each maker's notes (of the time and conditions of production), are later collected and analysed. The series of questions regarding the irrational acquaintance of things (cf. Proposal 2 above) might be used.

6. *Oral Description of Articles* perceived only by touch. The subject is blindfolded and described by touching it some ordinary or specially manufactured article, and the record of each description is compared with the photograph of the article in question.

[No number 7 in original.—Ed.]

8. *Making of Articles* on the strength of descriptions obtained according

to the preceding Proposal. Let the articles be photographed and compared with the original articles described.

9. *Examination of Certain Actions* liable owing to their irrationality to produce deep currents of demoralization and cause serious conflicts in interpretation and practice, e.g.:

(a) Causing in some way any little old woman to come along and then pulling out one of her teeth,

(b) Having a colossal loaf (fifteen yards long) baked and left one morning in a public square, the public's reaction and everything of the kind until the exhaustion of the conflict to be noted.

10. *Inscription of Words on Articles*, the exact words to be decided upon. At the time of *Calligrammes* the typographical arrangement was made to suit the form of articles, which was one way of fitting the shapes of articles to the writing. Here I am proposing that the writing should be made to take the shape of the articles and that one should write directly on articles. There is not the slightest doubt that specific novelties would arise through the *direct* contact with the object, from this so very material and novel unifying of thought with the object—the novel and continuous flowering of fetishist "desires to verify" and the novel and constant sense of responsibility. Surely the poetry written on fans, tombs, monuments, &c., has a very particular, a very clearly distinct, style? I don't want to exaggerate the importance of such precedents or of the realist error to which they give rise. Of course I am not thinking of occasional poems, but, on the contrary, of writings devoid of any obvious or intentional relation to the object on which they are read. Thus writing would exceed the limits of "inscription" and entirely cover over the complex, tangible and concrete shapes of things.

Such writing could be on an egg or on a roughly cut slice of bread. I dream of a mysterious manuscript written in white ink and completely covering the strange, firm surfaces of a brand-new Rolls-Royce. Let the privilege of the prophets of old be conferred on every one: let every one be able to read from things.

In my opinion this writing on things, this material devouring of things by writing, is enough in itself to show how far we have travelled since Cubism. No doubt, we became accustomed during the Cubist period to seeing things assume the most abstract intellectual shapes; lutes, pipes, jam-pots, and bottles were seeking to take the form of the Kantian "thing in itself," supposedly invisible behind the quite recent disturbances of appearance and phenomena. In *Calligrammes* (the symptomatic value of which has not yet been realized) it was indeed the shapes of things which were seeking to take the very form of writing. Nevertheless one must insist that although this attitude is a relative step forward towards the concrete, it is still on the contemplative and theoretical plane. The object's action is allowed to influence, but there is no attempt at acting on the object. On the other hand, this principle of action and of practical and concrete taking part is what presides unceasingly over the surrealist experiments and it is our submission

to this principle which leads us to bring into being "objects that operate symbolically," objects which fulfill the necessity of being open to action by our own hands and moved about by our own wishes.[1]

But our need of taking an active part in the existence of these things and our yearning to form *a whole* with them are shown to be emphatically material through our sudden consciousness of a *new hunger* we are suffering from. As we think it over, we find suddenly that it does not seem enough to devour things with

[1] Typical Surrealist Objects Operating Symbolically:

*Article by Giacometti*—A wooden bowl, having a feminine depression is suspended by means of a fine fiddle-string over a crescent, one tip of which just touches the cavity. The spectator finds himself instinctively compelled to slide the bowl up and down over the tip, but the fiddle-string is not long enough for him to do so more than a little. [*Suspended Ball* (1930–1931), private collection.]

*Article by Valentine Hugo*—Two hands, one white-gloved, the other red, and both having ermine cuffs, are placed on a green roulette cloth from which the last four numbers have been removed. The gloved hand is palm upwards and holds between thumb and forefinger (its only movable fingers) a die. All the fingers of the red hand are movable and this hand is made to seize the other, its forefinger being put inside the glove's opening which it raises slightly. The two hands are enmeshed in white threads like gossamer which are fastened to the roulette cloth with red-and white-topped drawing pins in a mixed arrangement.

*Article by André Breton*—An earthenware receptacle filled with tobacco on which are two long pink sugared almonds is placed on a little bicycle saddle. A polished wooden globe which can revolve in the axis of the saddle causes, when it moves, the end of this saddle to come into contact with two orange-colored celluloid antennae. The sphere is connected by means of two arms of the same material with an hour-glass lying horizontally (so that the sand does not move) and with a bicycle bell intended to ring when a green sugared almond is slung into the axis by means of a catapult behind the saddle. The whole affair is mounted on a board covered with woodland vegetation which leaves exposed here and there a paving of percussion caps, and in one corner of the board, more thickly covered with leaves than the rest, there stands a small sculptured alabaster book, the cover of which is ornamented with a glazed photograph of the Tower of Pisa, and near this one finds, by moving the leaves, a cap which is the only one to have gone off: it is under the hoof of a doe.

*Article by Gala Eluard*—There are two oscillating and curved metal antennae.

At each end of them are two sponges, one in metal, the other real, and they are breast-shaped, the dugs being represented by re-painted little bones. When the antennae are given a push, the sponges come just in touch, one with flour in a bowl, the other with the bristle tips of a metal brush.

The bowl is placed in a sloping box containing other things which correspond to additional representations. There is a stretched red elastic membrane, which vibrates for a long time on the slightest touch, and a small flexible black spiral looking like a wedge hangs in a little red cage. A deal paint-brush and a chemist's glass tube divide the box into compartments.

*Article by Salvador Dali*—Inside a woman's shoe is placed a glass of warm milk in the center of a soft paste colored to look like excrement.

A lump of sugar on which there is a drawing of the shoe has to be dipped in the milk, so that the dissolving of the sugar, and consequently of the image of the shoe, may be watched. Several extras (pubic hairs glued to a lump of sugar, an erotic little photograph, &c.) make up the article, which has to be accompanied by a box of spare sugar and a special spoon used for stirring leaden pellets inside the shoe. s. d.

our eyes and our anxiety to join actively and effectively in their existence brings us to want to *eat them*.

The persistent appearance of eatables in the first surrealist things painted by Chirico—crescents, macaroons, and biscuits finding a place among complex constructions of T-squares and other utensils not to be catalogued—is not more striking in this respect than the appearance in the public squares, which his pictures are, of certain pairs of artichokes or clusters of bananas which, thanks to the exceptional cooperation of circumstances, form on their own, and without any apparent modification, actual surrealist articles.

But the predominance of eatables or things that can be ingested is disclosed to analysis in almost all the present surrealist articles (sugared almonds, tobacco, coarse salt in Breton's; medical tablets in Gala's; milk, bread, chocolate, excrement, and fried eggs in mine; sausage in Man Ray's; light lager in Crevel's). The article I find most symptomatic from this point of view—and this precisely because of the complex indirectness—is Paul Eluard's, although in his there is an apparently not very edible element, a taper. Wax, however, is not only one of the most malleable substances, and therefore very strongly invites one to act upon it, but also wax used to be eaten in former times, as we learn from certain eastern tales; and further from reading certain Catalan tales of the Middle Ages, it may be seen that wax was used in magic to bring about metamorphoses and the fulfilment of wishes. As is well-known, wax was almost the only material which was employed in the making of sorcery effigies which were pricked with pins, this allowing us to suppose that they are true precursors of articles operating symbolically. Moreover, the meaning of its consubstantiality with honey has to be seen in the fact that honey is much used in magic for erotic purposes. Here, then, the taper very likely plays the part of an intestinal morphological metaphor. Finally, by extension, the notion of eating wax survives nowadays in a stereotyped process: at séances of theatrical hypnotism and conjuring which display certain magical survivals it is quite common to see candles swallowed. In the same way also, the edible meaning of one of Man Ray's recent articles would be revealed—an article in the middle of which a candle only has to be lit for it to set fire to several elements (a horse's tail, strings, a hoop) and cause the collapse of the whole. If one takes into account that the perception of a smell is equivalent in the phenomenology of repugnance to the perception of the taste the thing which smells may have, so that the intentional element, which is the burning of the article, may be interpreted as a roundabout desire to eat it (and so obtain its smell and even its ingestible smoke), one sees that burning a thing is equivalent, *inter alia*, to making it edible.

To sum up, the surrealist object has undergone four phases so far:

1. The object exists outside us, without our taking part in it (anthropomorphic articles);

2. The object assumes the immovable shape of desire and acts upon our contemplation (dream-state articles);

3. The object is movable and such that it can be acted upon (articles operating symbolically);

4. The object tends to bring about our fusion with it and makes us pursue the formation of a unity with it (hunger for an article and edible articles).

## Max Ernst, *"What is the mechanism of Collage?" 1936*★

A ready-made reality, whose naïve destination has the air of having been fixed, once and for all (a canoe), finding itself in the presence of another and hardly less absurd reality (a vacuum cleaner), in a place where both of them must feel displaced (a forest), will, by this very fact, escape to its naïve destination and to its identity; it will pass from its false absolute, through a series of relative values, into a new absolute value, true and poetic: canoe and vacuum cleaner will make love. The mechanism of collage, it seems to me, is revealed by this very simple example. The complete transmutation, followed by a pure act, as that of love, will make itself known naturally *every time the conditions are rendered favorable by the given facts: the coupling of two realities, irreconcilable in appearance, upon a plane which apparently does not suit them . . . .*

One rainy day in 1919, finding myself in a village on the Rhine, I was struck by the obsession which held under my gaze the pages of an illustrated catalogue showing objects designed for anthropologic, microscopic, psychologic, mineralogic, and paleontologic demonstration. There I found brought together elements of figuration so remote that the sheer absurdity of that collection provoked a sudden intensification of the visionary faculties in me and brought forth an illusive succession of contradictory images, double, triple, and multiple images, piling up on each other with the persistence and rapidity which are peculiar to love memories and visions of half-sleep.

These visions called themselves new planes, because of their meeting in a new unknown (the plane of non-agreement). It was enough at that time to embellish these catalogue pages, in painting or drawing, and thereby in gently reproducing only that which *saw itself in me*, a color, a pencil mark, a landscape foreign to the represented objects, the desert, a tempest, a geological cross-section, a floor, a single straight line signifying the horizon . . . thus I obtained a faithful fixed image of my hallucination and transformed into revealing dramas my most secret desires—from what had been before only some banal pages of advertising.

Under the title *"La Mise sous Whisky-Marin"* I assembled and exhibited in Paris (May 1920) the first results obtained by this procedure, from the *Phallustrade* to *The Wet Nurse of the Stars.*

★ Originally published in "Au delà de la Peinture," *Cahiers d'Art* (Paris), XI, 6–7, 1936 (not paginated). This excerpt from the English translation by Dorthea Tanning in Max Ernst, *Beyond Painting* (New York: Wittenborn, Schultz, 1948), pp. 13–14.

*Max Ernst, "On Frottage," 1936*★

"It is not to be despised, in my opinion, if, after gazing fixedly at the spot on the wall, the coals in the grate, the clouds, the flowing stream, if one remembers some of their aspects; and if you look at them carefully you will discover some quite admirable inventions. Of these the genius of the painter may take full advantage, to compose battles of animals and of men, of landscapes or monsters, of devils and other fantastic things which bring you honor. In these confused things genius becomes aware of new inventions, but it is necessary to know well (how to draw) all the parts that one ignores, such as the parts of animals and the aspects of landscape, rocks, and vegetation."

(from Leonardo's *Treatise on Painting*.)

On the tenth of August, 1925, an insupportable visual obsession caused me to discover the technical means which have brought a clear realization of this lesson of Leonardo. Beginning with a memory of childhood . . . in the course of which a panel of false mahogany, situated in front of my bed, had played the role

*Max Ernst, Forest and Sun,*
*1957, color lithograph.*

★ Originally published in "Au delà de la Peinture," *Cahiers d'Art*. These excerpts from the English translation in Ernst, *Beyond Painting*, pp. 7–11.

of optical *provocateur* of a vision of half-sleep, and finding myself one rainy evening in a seaside inn, I was struck by the obsession that showed to my excited gaze the floor-boards upon. which a thousand scrubbings had deepened the grooves. I decided then to investigate the symbolism of this obsession and, in order to aid my meditative and hallucinatory faculties, I made from the boards a series of drawings by placing on them, at random, sheets of paper which I undertook to rub with black lead. In gazing attentively at the drawings thus obtained, "the dark passages and those of a gently lighted penumbra," I was surprised by the sudden intensification of my visionary capacities and by the hallucinatory succession of contradictory images superimposed, one upon the other, with the persistence and rapidity characteristic of amorous memories.

My curiosity awakened and astonished, I began to experiment indifferently and to question, utilizing the same means, all sorts of materials to be found in my visual field: leaves and their veins, the ragged edges of a bit of linen, the brush-strokes of a "modern" painting, the unwound thread from a spool, etc. There my eyes discovered human heads, animals, a battle that ended with a kiss (*the bride of the wind*), rocks, *the sea and the rain, earthquakes*, the *sphinx in her stable*, the *little tables around the earth*, the *palette of Caesar, false positions*, a *shawl of frost flowers*, the *pampas* . . . .

I insist on the fact that the drawings thus obtained lost more and more, through a series of suggestions and transmutations that offered themselves spontaneously—in the manner of that which passes for hypnagogic visions—the character of the material interrogated (the wood, for example) and took on the aspect of images of an unhoped-for precision, probably of a sort which revealed the first cause of the obsession, or produced a simulacrum of that cause.

### FROM 1925 TO THE PRESENT

The procedure of *frottage*, resting thus upon nothing more than the intensification of the irritability of the mind's faculties by appropriate technical means, excluding all conscious mental guidance (of reason, taste, morals), reducing to the extreme the active part of that one whom we have called, up to now, the "author" of the work, this procedure is revealed by the following to be the real equivalent of that which is already known by the term *automatic writing*. It is as a spectator that the author assists, indifferent or passionate, at the birth of his work and watches the phases of its development. Even as the role of the poet, since the celebrated *lettre de voyant* of Rimbaud, consists in writing according to the dictates of that which articulates itself in him, so the role of the painter is to pick out and *project that which sees itself in him*.[1] In finding myself more and more engrossed in this activity

[1] Vasari relates that Piero di Cosimo sometimes sat plunged in contemplation of a wall upon which certain sick persons had formed the habit of spitting. Out of these stains he formed equestrian battles, fantastic towns, and the most magnificent landscapes. He did the same with the clouds of the sky. [M. E.]

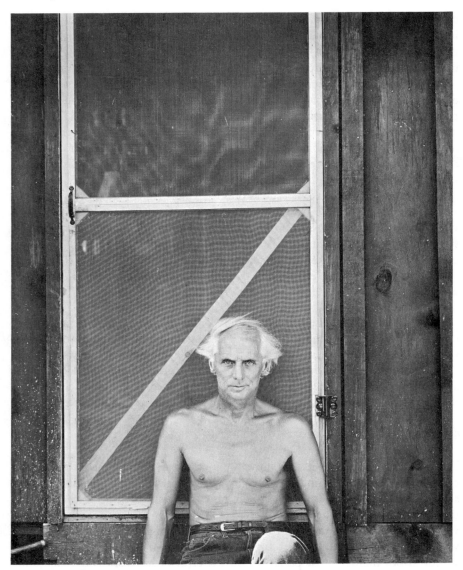

*Max Ernst, Sedona, Arizona, 1946.*
*Photograph by Frederick Sommer.*

(passivity) which later came to be called "critical paranoia,"[1] and in adapting to the technical means of painting (for example: the scraping of pigments upon a ground prepared in colors and placed on an uneven surface) the procedure of *frottage* which seemed applicable at first only to drawing, and in striving more and more to restrain my own active participation in the unfolding of the picture and, finally, by widening in this way the active part of the mind's hallucinatory faculties I came to assist *as spectator* at the birth of all my works, from the tenth of August, 1925,[2] memorable day of the discovery of *frottage*. A man of "ordinary constitution" (I employ here the words of Rimbaud), I have done everything to render my soul monstrous.[3] Blind swimmer, I have made myself see. *I have seen.* And I was surprised and enamoured of what I *saw*, wishing to identify myself with it. . . .

The field of vision and of action opened up by *frottage* is not limited by the capacity of the mind's faculties of irritability. It far surpasses the limits of artistic and poetic activity.

*Joan Miro, from an interview with Georges Duthuit, 1936**

What really counts is to strip the soul naked. Painting or poetry is made as we make love; a total embrace, prudence thrown to the wind, nothing held back. . . . Have you ever heard of greater nonsense than the aims of the Abstractionist group? And they invite me to share their deserted house as if the signs that I transcribe on canvas, at the moment when they correspond to a concrete representation of my mind, were not profoundly real, and did not belong essentially to the world of reality! As a matter of fact, I am attaching more and more importance to the subject matter of my work. To me it seems vital that a rich and robust theme should be present to give the spectator an immediate blow between the eyes before a second thought can interpose. In this way poetry pictorially expressed speaks its own language. . . . For a thousand men of letters, give me one poet.

---

[1] This rather pretty term (and one which will probably have some success because of its paradoxical content) seems to me to be subject to precaution inasmuch as the notion of paranoia is employed there in a sense which doesn't correspond to its medical meaning. I prefer, on the other hand, the proposition of Rimbaud: "The poet becomes a *seer*, by a long, immense, and conscious disorder of all the senses." M. E.

The term "paranoiac—critical activity" was invented by Salvador Dali and first published in *Documents* 34. See André Breton's summary in *What is Surrealism*, above.

[2] With the exception of *The Virgin Spanking the Infant Jesus* (1926), picture-manifesto, painted after an idea of André Breton. M. E.

[3] "Monstrous," in this sense, is meant to convey the idea of nobility, greatness, immensity. [Translator's note.]

* Originally published in Georges Duthuit, "Où allez-vous Miro?" *Cahiers d'Art* (Paris), XI, 8–10 (1936), 261. This excerpt from the English translation in *Joan Miró* by James Johnson Sweeney, copyright 1941 by The Museum of Modern Art, New York, and reprinted with its permission.

*Joan Miro, from an interview with James Johnson Sweeney, 1947*[*]

### ON SYMBOLIC FORMS

For me a form is never something abstract; it is always a sign of something. It is always a man, a bird, or something else. For me painting is never form for form's sake. . . .

I had always admired the primitive Catalan church-paintings and the gothic retables. An essential factor in my work has always been my need of self-discipline. A picture had to be right to a millimeter—had to be in balance to a millimeter. For example in painting *The Farmer's Wife* I found that I had made the cat too large: it threw the picture out of balance. This is the reason for the double circles and the two angular lines in the foreground. They look symbolic, esoteric: but they are no fantasy. They were put in to bring the picture into equilibrium. And it was this same need that had forced me the year before to sacrifice reality to some degree in *The Farm*: the smooth wall had to have the cracks to balance the wire of the chicken coop on the other side of the picture. It was this need for discipline which forced me to simplify in painting things from nature just as the Catalan primitives did.

Then there was the discipline of cubism. I learned the structure of a picture from cubism. . . .

I remember two paintings of Urgell in particular, both characterized by long, straight, twilit horizons which cut the pictures in halves: one a painting of a moon above a cypress tree, another with a crescent moon low in the sky. Three forms which have become obsessions with me represent the imprint of Urgell: a red circle, the moon, and a star. They keep coming back, each time slightly different. But for me it is always a story of recovering: one does not discover in life. . . .

Another recurrent form in my work is the ladder. In the first years it was a plastic form frequently appearing because it was so close to me—a familiar shape in *The Farm*. In later years, particularly during the war, while I was on Majorca, it came to symbolize "escape"; an essentially plastic form at first—it became poetic later. Or plastic, first; then nostalgic at the time of painting *The Farm*; finally symbolic.

### ON SOURCES OF HIS FORMS

At the time I was painting *The Farm*, my first year in Paris, I had Gargallo's studio. Masson was in the studio next door. Masson was always a great reader and full of ideas. Among his friends were practically all the young poets of the day. Through Masson I met them. Through them I heard poetry discussed. The poets Masson

[*] Excerpt from James Johnson Sweeney, "Joan Miro: Comment and Interview," *Partisan Review*, XV, 2 (February 1948), 208–212. (Footnote by J.J.S.: "The following remarks do not pretend to be verbatim, but are based on several formal and informal discussions with the artist.") © 1948 by *Partisan Review*.

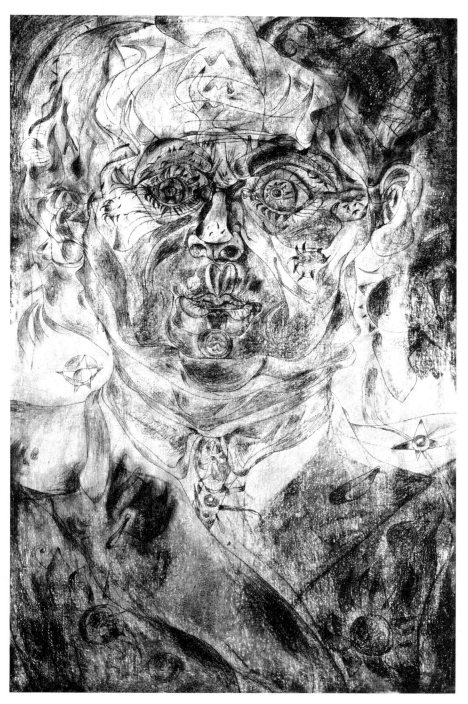

*Joan Miro, Self-Portrait, 1937–38, pencil, crayon and oil on canvas.*

introduced me to interested me more than the painters I had met in Paris. I was carried away by the new ideas they brought and especially the poetry they discussed. I gorged myself on it all night long—poetry principally in the tradition of Jarry's *Surmâle*. . . .

As a result of this reading I began gradually to work away from the realism I had practiced up to *The Farm*, until, in 1925, I was drawing almost entirely from hallucinations. At the time I was living on a few dried figs a day. I was too proud to ask my colleagues for help. Hunger was a great source of these hallucinations. I would sit for long periods looking at the bare walls of my studio trying to capture these shapes on paper or burlap. . . .

Little by little I turned from dependence on hallucinations to forms suggested by physical elements, but still quite apart from realism. In 1933, for example, I used to tear newspapers into rough shapes and paste them on cardboards. Day after day I would accumulate such shapes. After the collages were finished they served me as points of departure for paintings. I did not copy the collages. I merely let them suggest shapes to me. . . .

At Varengeville-sur-Mer [Seine-Maritime], in 1939, began a new stage in my work which had its source in music and nature. It was about the time that the war broke out. I felt a deep desire to escape. I closed myself within myself purposely. The night, music, and the stars began to play a major role in suggesting my paintings. Music had always appealed to me, and now music in this period began to take the role poetry had played in the early 'twenties—especially Bach and Mozart when I went back to Majorca upon the fall of France.

Also the material of my painting began to take a new importance. In watercolors I would roughen the surface of the paper by rubbing it. Painting over this roughened surface produced curious chance shapes. Perhaps my self-imposed isolation from my colleagues led me to turn for suggestions to the materials of my art. First to the rough surfaces of the heavy burlap series of 1939; then to ceramics—

Nowadays I rarely start a picture from an hallucination as I did in the 'twenties, or, as later, from collages. What is most interesting to me today is the material I am working with. It supplies the shock which suggests the form just as cracks in a wall suggested shapes to Leonardo.

For this reason I always work on several canvases at once. I start a canvas without a thought of what it may eventually become. I put it aside after the first fire has abated. I may not look at it again for months. Then I take it out and work at it coldly like an artisan, guided strictly by rules of composition after the first shock of suggestion has cooled. . . .

They [a group of gouaches made beginning in 1940] were based on reflections in water. Not naturalistically—or objectively—to be sure. But forms suggested by such reflections. In them my main aim was to achieve a compositional balance. It was a very long and extremely arduous work. I would set out with no preconceived idea. A few forms suggested here would call for other forms elsewhere to balance them. These in turn demanded others. It seemed interminable.

It took a month at least to produce each water color, as I would take it up day after day to paint in other tiny spots, stars, washes, infinitesimal dots of color in order finally to achieve a full and complex equilibrium.

As I lived on the outskirts of Palma I used to spend hours looking at the sea. Poetry and music both were now all-important to me in my isolation. After lunch each day I would go to the cathedral to listen to the organ rehearsal. I would sit there in that empty gothic interior daydreaming, conjuring up forms. The light poured into the gloom through the stained-glass windows in an orange flame. The cathedral seemed always empty at those hours. The organ music and the light filtering through the stained-glass windows to the interior gloom suggested forms to me. I saw practically no one all those months. But I was enormously enriched during this period of solitude. I read all the time: St. John of the Cross, St. Teresa, and poetry—Mallarmé, Rimbaud. It was an ascetic existence: only work.

After having finished this series of paintings in Palma, I moved to Barcelona. And as these Palma paintings had been so exacting both technically and physically I now felt the need to work more freely, more gaily—to "proliferate."

I produced a great deal at this time, working very quickly. And just as I worked very carefully in the Palma series which had immediately preceded these, "controlling" everything, now I worked with the least control possible—at any rate in the first phase, the drawing. Gouaches: in pastel colors, with very violent contrasts. Even here, however, only the broad outlines were unconsciously done. The rest was carefully calculated. The broad initial drawing, generally in grease crayon, served as a point of departure. I even used some spilled blackberry jam in one case as a beginning; I drew carefully around the stains and made them the center of the composition. The slightest thing served me as a jumping-off place in this period.

And in the various paintings I have done since my return from Palma to Barcelona there have always been these three stages—first, the suggestion, usually from the material; second, the conscious organization of these forms; and third, the compositional enrichment.

Forms take reality for me as I work. In other words, rather than setting out to paint something, I begin painting and as I paint the picture begins to assert itself, or suggest itself under my brush. The form becomes a sign for a woman or a bird as I work.

Even a few casual wipes of my brush in cleaning it may suggest the beginning of a picture. The second stage, however, is carefully calculated. The first stage is free, unconscious; but after that the picture is controlled throughout, in keeping with that desire for disciplined work I have felt from the beginning. The Catalan character is not like that of Malaga or other parts of Spain. It is very much down-to-earth. We Catalans believe you must always plant your feet firmly on the ground if you want to be able to jump in the air. The fact that I come down to earth from time to time makes it possible to jump all the higher.

435

*André Masson, "Painting Is a Wager," 1941*★

For us, young surrealists of 1924, the great prostitute was reason. We judged that Cartesians, Voltaireans, and other officials of the intelligence had only made use of it for the preservation of values which were both established and dead, whilst, at the same time, affecting a façade of dissension. And the supreme accusation was that it has given reason the mercenary job of making fun of love and poetry. This denunciation was made by one group with intense energy. At that time there was a great temptation to try to operate magically on things, and then on ourselves. The impulse was so great that we could not resist it and so, from the end of the winter of 1924, there was a frenzied abandon to automatism. This form of expression has survived until today. Objectively I will add that to this immersion in the night—(into what the German romantics call the night side of things) and to the always desirable appeal of the marvelous was added the game, the serious game. I can see us again. None of us, stunned as we were by our magic, whether vain or effective, asked himself if "the contrary of a fault is not another fault"— thus, a century before, Friedrich Schlegel had asked himself this question which clearly illuminates with a shaft the romantic irony. Certainly, ever since the first surrealist conquests, the question should have been put whether the abandon to the imagination was ever likely to be surpassed.

Some of us have since replied in the affirmative. The danger of automatism is, without any doubt, only the association of inessential connections whose content, Hegel said, does not surpass that which is contained in the images. However it is correct to add that if, in philosophical research, the capital law is to mistrust the association of ideas, the same law does not hold good for artistic creation which is, in essence, sensitive intuition. The process of images, the wonder or the agony of meeting, open a way rich in plastic metaphor: *a fire of snow*. From this springs its attraction and its fragility, and the tendency to become too easily satisfied, and too far removed, from the laws of proportion and from any tactile understanding of the world.

Whatever it may have been, a few of us were in fear of "the other fault": of making of the appeal to the unconscious something as limited as the discredited rationalism, but all to no good. Towards 1930, five years after the foundation of surrealism, a formidable disaster appeared in its midst: the demagogy of the irrational. For a time this was to lead pictorial surrealism to the trite and to universal approbation. The conquest of the irrational for the irrational is a poor conquest, and the imagination is indeed sad which only associates those elements worn out by dismal reason, such as materials tarnished by lazy habit, by memory (I will refer again to this) picked up here and there, from the works of "amusing

★ Originally published as "Peindre est une Gageure" in *Cahiers de Sud*, No. 233 (March 1941); reprinted in André Masson, *Le plaisir de peindre* (Paris: La Diane française, 1950), pp. 11–18. This English translation from *Horizon* (London), VII, 39 (March 1943), 180–183.

436

natural philosophy," from the antique shops and from our grandfathers' magazines.

Thus, in its turn, surrealism shut itself into a duality incomparably more dangerous than cubism;

(a) by liberating the psychic menagerie, or, at any rate, making a pretence of this liberation in order to use it as a theme;

(b) by expressing itself by the methods left over by the academics of the preceding century. The rediscovery of the old horizon, that of Meissonier, set a limit to this reactionary perversion. The retrogression proceeded with perfect insolence. The admirable achievements of Seurat, Matisse, and the cubists, were considered empty and of no significance. Their inspiring conception of space, their discovery of essentially pictorial means were taken for an obstructive inheritance to be left behind.

Should one conform to this new academism? Of course not. It was obviously necessary to assess a strict estimate of the conditions pertaining to the imaginative work. And first of all, to establish the principle that it is vital for the imaginative artist, who is only able to compose his work with elements which are already existing within reality, to keep his eyes open on to the exterior world and not to see things in their perceived generality, but in their revealed individuality. There is a whole world in a drop of water trembling on the edge of a leaf, but it is only there when the artist and the poet have the gift of seeing it in its immediacy. However, to avoid making any mistakes, this revelation or inspired knowledge, and this contact with nature are only profound in so far as they have been prepared by the thought and by the intense consideration of the artist. This is the only way in which sensitive revelation can enrich knowledge. The tendency to allow oneself to be swamped by things, the ego being no more than the vase which they fill, really only represents a very low degree of knowledge. In the same way a casual appeal to subterranean powers, the superficial identification with the cosmos, false "primitivism" are only aspects of an easy pantheism.

Let us repeat the major conditions which the contemporary work of the imagination must fulfill in order to last. We have seen that automatism (the investigation of the powers of the unconscious), dreams, and the association of images only provide the materials. In the same way Nature and the elements provide the subjects. The real power of an imaginative work will derive from the three following conditions: (1) the intensity of the preliminary thought; (2) the freshness of the vision on to the exterior world; (3) the necessity of knowing the pictorial means most suitable for the art of this time. It is also important not to forget that the saying of Delacroix "*une oeuvre figurative doit être surtout une fête pour les yeux*" remains true. This certainly does not mean that instinct must give way to reflection and inspiration to intelligence. The fusion of the different elements brought into play by the painter-poet will take place with the flashing rapidity of light. The unconscious and the conscious, intuition and understanding must operate their transmutation on the subconscious mind in radiant unity.

437

*André Masson, "A Crisis of the Imaginary," 1944*[*]

To look for the unusual at all cost or to shun its appeal, to refer to the *natural* or to protest against it, is not the question. *La grande odalisque*, by Ingres, is no more *natural* than a still-life by Georges Braque. A picture always relates to the Imaginary. Jean-Paul Sartre proves this irrefutably in an important work of this name.

The reality of a picture is only the sum of the elements which compose it: canvas, colored paints, varnish. . . . But what it expresses is necessarily something *unreal*. And we might add that the artist, whatever pretext he may have for his work, always makes his appeal to the imagination of other people.

Once this is understood, all discussion about the pre-eminence of the super-real over the real (or the contrary) falls flat. Since a picture is in essence something unreal, what is the point of giving the advantage to the dream over reality? A victory for the ambiguous.

For instance the surrealist painters implicitly recognize the supremacy of the pictorial imagination over the *imitation of poetry* since they admire Georges Seurat more than Gustave Moreau or Redon. The former, entirely preoccupied by problems relating to his profession, has used only scenes of everyday life for subject matter: Sunday walks (from which neither the nursemaid nor the soldier is omitted), circuses, fair scenes, the pleasures of the most ordinary citizen—a model undressing, a woman powdering herself. Each picture was preceded by numerous studies "from nature." And let us not forget the method: the dot, the most deliberate and considered of techniques: automatic to the least possible degree. But the "subject" is a secondary affair and what does it matter if the artist lets himself be carried away by dreams. The dreams of Goya are the equal of his observations.

The childish mistake has been to believe "that to choose a certain number of precious stones and to write down their names on paper was the same, even if well done, as *making* precious stones. Certainly not. As poetry consists of creating, we must take from the human soul moods and lights of such absolute purity that well sung and well displayed, they really constitute the jewels of man . . . ." This remark of Mallarmé condemning one kind of literature can be applied very well to a certain kind of painting.

In fact, the mistake is to believe that there is anything except the intrinsic value of a work: the personal flavor it gives out, the new emotion it displays and the pleasure it gives.

A work of art is not written information. Read again in the inexhaustible "*Curiosités esthétiques*" [Charles Baudelaire] the passage summing up the failure of Grandville: "He has touched on several important questions but finished by falling between two stools, being neither absolutely a philosopher nor an artist . . . .By

[*] Originally published in *Fontaine* (Algiers), No. 35 (1944). Reprinted in English translation in *Horizon* (London), XII, 67 (July 1945), 42–44 and in *Magazine of Art* (New York), XXXIX, 1 (January 1946), 22.

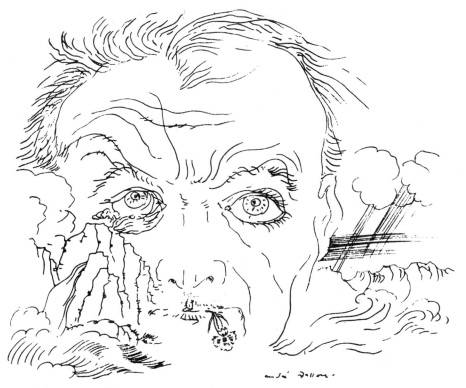

*André Masson, Self-Portrait, ca. 1938, ink.*

means of his drawings he took down the succession of dreams and nightmares with the precision of a stenographer who is writing out the speech of a public speaker . . ." but "as he was an artist by profession and a man of letters by his head" he has not known how to give all that a sufficiently plastic form.

In fact, once the raw materials offered by chance or by experience, by the known or by the unknown are collected together, the only thing left is . . . to begin.

It is far from my aim to present favorable arguments to those who accuse some contemporary artists of representing monsters on their canvases. For these people have done no good who, spurred on by the basest interest or by the blindest grievance, helped to drive the day out of our sky and make it possible for funereal hallucinations and the chilling dreams of a Kafka to become daily reality. Reactionary critics will do this in vain: disturbed periods have their beast-fighters and their apocalypses. Nevertheless, should we not realize that he who is neither a poet, nor a visionary, nor an artist and who sets to work to fabricate the "fantastic" is *dishonoring the profession?* The meeting of the umbrella and the

439

sewing-machine on the operating table happened only *once*. Traced, repeated over and over again, mechanized, the unusual vulgarizes itself. A painful "fantasy" can be seen in the street shop-windows.

People talk a lot about abstraction with reference to contemporary painting. I do not know at what point in a work of art the critics decide that it begins or ends. Perhaps a painter will be allowed to suggest that this term abstract should be reserved for metaphysical discussions: a domain in which this notion— it is at home there—has provoked brilliant controversies from Aristotle to Husserl and Whitehead.

The absence of subject—the picture itself considered as an object—this esthetic is perfectly defensible. However, the fear of painters who lay claim to it— the fear of making reference to the outer world—forms a curious parallel to the fear of those who will not compromise with the irrational: that of not being surprising enough.

Now, it is not enough to draw or to paint a few cylinders or rectangles in a certain assembled order to be out of the world. The demon of analogy, in a sly mood that day, may whisper to us that there is an involuntary allusion here to ordinary, commonplace, recognizable objects.

In the same way it is not enough to introduce a rapturous passage into a mediocre form nor to descend into the frontiers of the invertebrate to escape conformism, nor again to convince oneself that to achieve originality it is sufficient to bow to the Hegelian contradiction.[1]

Extremes cannot enslave genius; on the contrary genius contains and masters them. To place onself on one end of the map of art waving a laughable working drawing, or on the other end offering a soliciting anecdote—mistakenly rivaling the engineer or parodying the psychiatrist—only results in installing oneself comfortably on the lower slopes of the mind.

The columns of the storm, the pure pediment, and the peaks hold sway far above this.

*Marc Chagall, from an interview by James Johnson Sweeney, 1944*\*

Chagall—I am against the terms "fantasy" and "symbolism" in themselves. All our interior world is reality—and that perhaps more so than our apparent world. To call everything that appears illogical, "fantasy," fairy-tale, or chimera—would be practically to admit not understanding nature.

Impressionism and cubism were relatively easy to understand, because

---

[1] "We must not take the word contradiction in the mistaken sense in which Hegel used it and which he made others and contradiction itself believe that it had a creative power." Kierkegaard. [A. M.]

\* Originally published in *Partisan Review* (New York), XI, I (Winter 1944), 88–93. Reprinted from *Eleven Europeans in America, Bulletin of The Museum of Modern Art*, New York. XIII, 4 and 5, 1946, and reprinted with its permission.

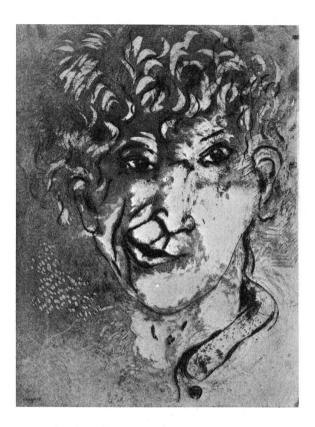

*Marc Chagall, Self-Portrait with Grimace, ca.*
*1924, etching with aquatint.*

they only proposed a single aspect of an object to our consideration—its relations of light and shade, or its geometrical relationships. But one aspect of an object is not enough to constitute the entire subject matter of art. An object's aspects are multifarious.

I am not a reactionary from cubism. I have admired the great cubists and have profited from cubism. But I have argued the limitations of such a view even with my friend Apollinaire, the man who really gave cubism its place. To me cubism seemed to limit pictorial expression unduly. To persist in that I felt was to impoverish one's vocabulary. If the employment of forms not as bare of associations as those the cubists used was to produce "literary painting," I was ready to accept the blame for doing so. I felt painting needed a greater freedom than cubism permitted. I felt somewhat justified, later, when I saw a swing toward expressionism in Germany and still more so when I saw the birth of surrealism in the early 'twenties. But I have always been against the idea of schools and only an admirer

441

of the leaders of schools. Cubism was an emphasis on one aspect only of reality—a single point of view—the architectural point of view of Picasso—and of Braque in his great years. And let me say in passing, Picasso's gray cubist pictures and his *papiers collés* are in my opinion his masterpieces.

But please defend me against people who speak of "anecdote" and "fairy tales" in my work. A cow and woman to me are the same—in a picture both are merely elements of a composition. In painting, the images of a woman or of a cow have different values of plasticity,—but not different poetic values. As far as literature goes, I feel myself more "abstract" than Mondrian or Kandinsky in my use of pictorial elements. "Abstract" not in the sense that my painting does not recall reality. Such abstract painting in my opinion is more ornamental and decorative, and always restricted in its range. What I mean by "abstract" is something which comes to life spontaneously through a gamut of contrasts, plastic at the same time as psychic, and pervades both the picture and the eye of the spectator with conceptions of new and unfamiliar elements. In the case of the decapitated woman with the milk pails, I was first led to separating her head from her body merely because I happened to need an empty space there. In the large cow's head in *Moi et le village* I made a small cow and woman milking visible through its muzzle because I needed that sort of form, there, for my composition. Whatever else may have grown out of these compositional arrangements is secondary.

The fact that I made use of cows, milkmaids, roosters, and provincial Russian architecture as my source forms is because they are part of the environment from which I spring and which undoubtedly left the deepest impression on my visual memory of any experiences I have known. Every painter is born somewhere. And even though he may later respond to the influences of other atmospheres, a certain essence—a certain "aroma" of his birthplace clings to his work. But do not misunderstand me: the important thing here is not "subject" in the sense pictorial "subjects" were painted by the old academicians. The vital mark these early influences leave is, as it were, on the handwritings of the artist. This is clear to us in the character of the trees and card players of a Cézanne, born in France,—in the curled sinuosities of the horizons and figures of a Van Gogh, born in Holland,—in the almost Arab ornamentation of a Picasso, born in Spain,—or in the quattrocento linear feeling of a Modigliani, born in Italy. This is the manner in which I hope I have preserved the influences of my childhood, not merely in subject matter.

*Sweeney.*—On your first visit to Paris Guillaume Apollinaire, the poet-critic from whom the term "surrealism" has been reputedly adopted, already pointed out a *surnaturel* character in your work; do you feel this movement an important factor in recent art development and do you feel your work has had any relation to the surrealist point of view?

*Chagall.*—Surrealism was the latest awakening of a desire to lead art out of the beaten paths of traditional expression. If it had been a little more reliable, a little more profound in its interior and exterior expression, it would have crystallized into an important movement after the example of those of the periods im-

mediately preceding it. You ask me if I make use of the surrealist approach. I began to paint in 1907 and in my work from the beginning one can see these very surrealist elements whose character was definitely underlined in 1912 by Guillaume Apollinaire.

Again in Russia during the First World War, far from the Salons, exhibitions, and cafes of Paris, I began to ask myself: doesn't the outbreak of such a war call for a certain auditing of accounts? The recent forms of the so-called realist schools, which for me embraced both impressionism and cubism, seemed to have lost their vitality. It was then that that characteristic which so many had treated disdainfully and lazily as "literature" began to come to the surface.

On my return to Paris in 1922, I was agreeably surprised to find a new artistic group of young men, the surrealists, rehabilitating to some degree that term of abuse in the period before the war, "literary painting." What had previously been regarded as a weakness was now encouraged. Some did go to the extreme of giving their work a frankly symbolic character, others adopted a baldly literary approach. But the regrettable part was that the art of this period offered so much less evidence of natural talent and technical mastery than the heroic period before 1914.

As I was not yet fully acquainted with surrealist art in 1922, I had the impression of rediscovering in it what I myself had felt at once darkly and concretely between the years 1908 and 1914. But why, thought I, is it necessary to proclaim this would-be automatism? Fantastic or illogical as the construction of my pictures may seem, I would be alarmed to think I had conceived them through an admixture of automatism, if I put Death in the street and the violinist on the roof in my 1908 picture, or if, in another painting of 1911, *Moi et le Village*, I had placed a little cow with a milk-maid in the head of a big cow, I did not do it by "automatism."

Even if by automatism one has succeeded in composing some good pictures or in writing some good poems, that does not justify us in setting it up as a method. Everything in art ought to reply to every movement in our blood, to all our being, even our unconscious. But every one who has painted trees with blue shadows cannot be called an Impressionist. For my part, I have slept well without Freud. I confess I have not read a single one of his books; I surely will not do it now. I am afraid that as conscious method, automatism engenders automatism. And if I am correct in feeling that the technical mastery of the "realist period" is now on the decline, then surely the automatism of surrealism is being stripped rather naked.

*Matta (Matta Echaurren), "On Emotion," 1954*★

Art serves to arouse one's intuition to the emotion latent in everything around one, and to show up the emotional architecture which people need in order to be and to live together.

★ From *Reality* (New York), No. 2 (Spring 1954), p. 12.

443

*Matta (Matta Echaurren), 1941*
*Photograph by Sidney Janis,*
*New York.*

Important emotion is a menace to those who live for their own selfish interest; so they have invented the philanthropic lie, and with that philanthropic lie have reduced the artist to the condition of a hostage. They have instituted an "Art Police," a police which operates against deep-rooted human emotion.

I identified myself with this hostage. The philanthropist-masters' comfort is menaced and they "shoot" the hostage.

This new poet-hostage is always conspiring against their selfishness.

To be this hostage one must put poetry at the center of one's life.

True poetry is deeply human. And the true poet is stubborn about not forgetting that "man" is at the center of everything and that all deviation towards anti-human action should be denounced.

To revive the kind of man that a poet always was. (Byron died for the liberty of the Greeks.)

I know that an artist will only be actual if his work enters the two-way traffic of receiving from his people the consciousness of needs they have detected in themselves, and, as an artist, charges this consciousness with an intuition of important emotion, thus sending it back to widen their picture of reality.

For the conscious painter the "subject" is the same as for Cimabue—to make the man of his time think with sentiment.

# INTRODUCTION: Scuola Metafisica by Joshua C. Taylor\*

In 1915, Giorgio de Chirico (b. 1888) returned to Italy for military service and was assigned to garrison duty in Ferrara. Born in Greece of Italian parents, De Chirico studied in Munich from 1906 to 1908, and then went to Paris where he began his strange, evocative paintings, quite untouched by the new movements in painting around him. In January 1917, Carlo Carrà, who had more than a year before turned his back on Futurism to find a more stable and monumental art based on the early Italian tradition, was assigned to the military convalescent hospital at Ferrara, and quickly saw in De Chirico's painting the expression he himself was working toward. Both Carrà and De Chirico were eager theorists of art, and they, with De Chirico's brother, who worked under the name of Savinio, formulated the principles of a new "school" of painting which they called the *Scuola Metafisica* (Metaphysical School).

Carrà was the first to exhibit paintings of this sort in Italy, exhibiting in Milan in the spring of 1917. De Chicico first exhibited in Italy in Rome in

---

\* All translations in this section are by Joshua C. Taylor.

445

1919, but his work was already known in Paris, having been noted with interest by Apollinaire in 1913 and 1914.

In January 1919 the first issue of *Valori Plastici*, a magazine edited by Mario Broglio in Rome, was published, clearly dominated by the *Metafisica* idea. The double issue, Nos. 4 and 5, for April and May 1919, contains the most complete statement of the *Scuola Metafisica* point of view with articles by Carrà, Savinio, and De Chirico.

As a movement, the *Scuola Metafisica* lasted only a few years and attracted few direct adherents, notably Giorgio Morandi and, briefly, Filippo de Pisis. De Chirico and Carrà soon quarreled over the authorship of the movement, and De Chirico returned to work in France. The general influence of the movement, however, was considerable, especially upon the Paris movement of Surrealism. It had also an effect on some aspects of the Italian *Novecento Italiano* movement.

The *Scuola Metafisica* as formulated in Ferrara between 1917 and 1919 had two main principles: to evoke those disquieting states of mind that prompt one to doubt the detached and impersonal existence of the empirical world, judging each object instead as only the external part of an experience which is chiefly imaginative and enigmatic in meaning; and to do this through solid, clearly defined constructions which, paradoxically, seem entirely objective. The artists spoke often of "classical" compositions, of avoiding spontaneous self-expression. They were not interested in dreams but in the more puzzling phenomenon of associations growing out of everyday observations.

But there is a divergence between De Chirico and Carrà. While De Chirico was fascinated by an awareness of a haunting, threatening force generated by the unknown, Carrà's imagery tended towards a rather sweet melancholy, a passive kind of rumination. In their writings, too, it can be noted that Carrà emphasizes the impersonal perfection of ordered forms, whereas De Chirico speaks always of enigmatic obsessions. Clearly, De Chirico, not Carrà, was most readily allied with the group around Breton, well versed in the new psychological studies.

*Giorgio de Chirico, "Zeus the Explorer," 1918*[*]

Once the gates in the idiotic stockade that enclosed the various bleating or lowing "groups" have been breached, the new Zeuses take off alone to discover the curiosities that nestle like moles throughout the crust of the terrestrial globe.

[*] Originally published as "Zeus l'esploratore," *Valori Plastici* (Rome), I, 1 (January 1919), 10.

446

"The world is full of demons," said Heraclitus of Ephesus,[1] walking in the shade of the porticoes at the mystery-fraught hour of high noon, while within the dry embrace of the Asiatic gulf the salty water swelled under the warm south wind.

*One must find the demon in every thing.*

The ancient people of Crete painted an enormous eye in the middle of the narrow bands that circled their vases, on their household utensils, and on the walls of their houses.

Even the fetus of a man, a fish, a chicken, a snake in its first stage is exactly an eye.

*One must discover the eye in every thing.*

Thus I thought in Paris in the years just before the explosion of the war.

Around me the international set of *modern* painters strove stupidly with over-exploited formulas and sterile systems.

I alone, in my squalid studio in the Rue Campagne-Première, began to glimpse the first shades of a more complete, more profound, more complicated art, or, in a word—at the risk of provoking a liver attack for a French critic—*more metaphysical.*

New land appeared on the horizon.

The great zinc-colored glove with frightening gilded fingernails, swinging over the door of the shop in the woeful currents of the urban afternoon, with its index finger pointing at the slabs of the sidewalk indicated to me the hermetic signs of a new melancholy.

The cardboard head in the barber's window, cut out with the strident heroism of shadowy prehistoric times, burned in my heart and brain like a remembered song.

The demons of the city opened the way to me.

When I returned home, other heralding phantoms came to meet me.

I discovered new zodiacal signs on the ceiling as I watched its desperate flight, only to see it die in the depths of the room in the rectangle of the window which opened onto the mystery of the street.

The door half opened on the night of the hallway had the sepulchral solemnity of the stone rolled away from the empty tomb of the resurrected.

And the new annunciatory paintings took form.

Like autumn fruit we are by now ripe for the new metaphysic.

The powerful breezes come from out there, from troubled seas.

Our cry reaches the populous cities of faraway continents.

We must not grow soft, however, in the pleasure of our new creations.

We are explorers ready for new departures.

Under the sheds echoing with metallic shocks the signals are set at the sign for departure.

---

[1] Heraclitus of Ephesus (ca. 540-ca. 480 B.C.) was a Greek philosopher who detached himself from society and sought to discover an all-pervading spirit as manifest in the continuous conflict of opposites in nature. J. C. T.

In the wall-boxes the bells ring.
It is time . . .
"Gentlemen, all aboard!"

*Giorgio de Chirico, "On Metaphysical Art," 1919*\*

A continuous control is needed of our thoughts and of all those images which come to our minds even when we are awake but which have, none the less, a close relationship to those we encounter in dreams. It is a curious fact that no dream image, strange as it may seem, strikes us with metaphysical force. We therefore refrain from seeking the source of our creation in dreams; Thomas de Quincey's theories do not tempt us.[1] Although the dream is a very strange phenomenon and an inexplicable mystery, far more inexplicable is the mystery and aspect our minds confer on certain objects and aspects of life. Psychologically speaking, to discover something mysterious in objects is a symptom of cerebral abnormality related to certain kinds of insanity. I believe, however, that such abnormal moments can be found in everyone, and it is all the more fortunate when they occur in individuals with creative talent or with clairvoyant powers. Art is the fatal net which catches these strange moments on the wing like mysterious butterflies, fleeing the innocence and distraction of common men.

Happy but unconscious metaphysical moments can be detected both in painters and writers. With regard to writers, I wish to recall an old provincial Frenchman whom we shall call, in order to be understood, the explorer in house slippers. To be precise, I want to speak of Jules Verne who wrote travel and adventure novels and who is considered a writer *ad usum puerum*.[2]

But who knew better than he how to hit upon the metaphysic of a city like London in its houses, its streets, its clubs, its parks and squares? The ghostliness of a London Sunday afternoon, the melancholy of a man—a true walking phantom—like Philéas Fogg in *Around the World in Eighty Days*.

The work of Jules Verne is filled with these felicitous and consoling moments. I still remember the description of the departure of the steamer from Liverpool in *A Floating City*.

---

\* Originally published as "Sull'arte metafisica," *Valori Plastici* (Rome), I, 4–5 (April–May 1919), 15–18. This translation by Joshua C. Taylor.

[1] Thomas de Quincey (1785–1859) published his *Confessions of an English Opium Eater* in 1822. It included lengthy descriptions of dreams experienced under the influence of drugs. J. C. T.

[2] Jules Verne (1828–1905) first published his *Around the World in Eighty Days* in 1872. His many books on imaginary travels were inspired by advances in modern science, but combine a high degree of fantasy with seemingly plausible scientific data. J. C. T.

NEW ART

The uneasy and complicated state of the new art is not owing to the caprice of fate, nor is it a longing for novelty and notoriety on the part of a few artists, as some people innocently believe. It is instead a destined state of the human spirit which, regulated by mathematically fixed rules, has its ebb and flow, its departures and returns and rebirths, like all other elements on our planet. A people, from its very beginnings, loves myth and legend, the surprising and monstrous, the inexplicable, and takes refuge in them. With the passage of time and the maturing of a culture, it refines and reduces the primitive images, molds them to the requirements of its clarified spirit, and writes its history flowing from the original myths. A European epoch like ours, which carries within itself the overwhelming burden of so many civilizations and the maturity of so many spiritual periods, is fated to produce an art that, from a certain viewpoint, seems to be like one of mythical uneasiness. Such an art arises through the works of those few who are gifted with particular clarity of vision and sensitivity. Naturally such a return will bear within it the signs of successive preceding epochs, from which an art is born that is enormously complicated and polimorphous in the various aspects of its spiritual values. The new art, then, is not an error of the times.

It is useless to believe, however, as do some deluded and utopian people, that the new art can redeem and regenerate humanity, that it might give humanity a new *sense* of life, a new *religion*. Humanity is and will continue to be just what it has been in the past. It accepts and will increasingly accept this art. The day will come when people will go to museums to look at it and study it! One day they will talk about it easily and naturally as they talk now about the champions of an art which is more or less remote, artists who are now listed and catalogued and have their fixed places and pedestals in the museums and libraries of the world.

The matter of comprehension bothers us much today; tomorrow it will no longer disturb. To be or not to be understood is a problem for today. Also, one day our work will lose for the public its look of madness, that is, the madness the public sees in it, because the great madness, precisely that which is not apparent to everyone, will always exist and will continue to gesture and show itself behind the inexorable screen of matter.

GEOGRAPHIC DESTINY

From the geographical point of view, it was fated that a first conscious manifestation of great metaphysical painting should be born in Italy. It could not have happened in France. The facile virtuosity and well-cultivated artistic taste, mixed with such a dose of "*esprit*" (not only in the exaggerated punning sense) as powders 99 percent of the inhabitants of Paris, would suffocate and impede a prophetic spirit. Our terrain, on the other hand, is more propitious for the birth and development of such animals. Our inveterate *gaucherie* and the effort we have continually to make to accustom ourselves to a concept of spiritual lightness,

have determined the weight of our chronic sadness. However, it would seem true that only amid such herds do great shepherds arise, and so the most monumental prophets who turn history into new channels arise amongst the tribes and populations with least happy destinies. Hellas, aesthetic in art and nature, could not produce a prophet, and the most profound Greek philosopher I know, Heraclitus, meditated on other shores, less fortunate because of their proximity to the desert infernos.

## MADNESS AND ART

It is an axiomatic truth that madness is an inherent phenomenon in all profound artistic manifestations.

Schopenhauer defines the madman as a person who has lost his memory.[1] It is an apt definition because, in fact, that which constitutes the logic of our normal acts and our normal life is a continuous rosary of recollections of relationships between things and ourselves and vice versa.

We can cite an example: I enter a room, I see a man sitting in an armchair, I note a bird cage with a canary hanging from the ceiling; I notice paintings on the wall and a bookcase with books. None of this startles nor astonishes me because a series of memories which are connected one to the other explains to me the logic of what I see. But let us suppose that for a moment, for reasons that remain unexplainable and quite beyond my will, the thread of this series is broken. Who knows how I might see the seated man, the cage, the paintings, the bookcase! Who knows with what astonishment, what terror and possibly also with what pleasure and consolation I might view the scene.

The scene, however, would not be changed; it is I who would see it from a different angle. Here we meet the metaphysical aspect of things. By deduction we might conclude that everything has two aspects: a normal one that we almost always see and which is seen by other people in general; the other, the spectral or metaphysical which can be seen only by rare individuals in moments of clairvoyance or metaphysical abstraction, just as certain bodies that exist within matter which cannot be penetrated by the sun's rays, appear only under the power of artificial light, under X-ray for example.

For some time, however, I have tended to believe that things might have other aspects than the two we have mentioned (a third, fourth, fifth aspect), all different from the first but closely related to the second or metaphysical.

## THE ETERNAL SIGNS

I remember the strange and profound impression made on me as a child by an illustration in an old book which bore the title, *The Earth before the Flood*.

[1] Arthur Schopenhauer (1788–1860) a German philosopher, published his influential work, *The World as Will and Idea* in 1819. De Chirico was much interested in Schopenhauer's ideas, notably those which gave inner, intuitive knowledge supremacy over the perception of external things. J. C. T.

The illustration represented a landscape of the Tertiary Period. Man did not yet exist. I have often meditated on this strange phenomenon of *human absence* in the metaphysical aspect. Every profound work of art contains two solitudes: one which can be called "plastic solitude," which is that contemplative pleasure derived from the happy construction and combination of forms (dead-live or live-dead elements or materials; the second life of the *nature morte* still-lifes [literally "dead nature" painting, the Italian term for "still-life"] considered not in the sense of a pictorial subject but as the spectral aspect, might apply as well to a supposedly living figure). The second solitude is that of signs,[1] an eminently metaphysical solitude for which all logical possibility of visual or psychological education is automatically excluded.

There are paintings by Böcklin,[2] Claude Lorain, Poussin which although inhabited by human figures, are closely allied to landscapes of the Tertiary Period: man as a human being is absent. Some portraits of Ingres reach this limit. It is worth noting, however, that in the above works (with the possible exception of some paintings by Böcklin) only the first solitude exists, the plastic solitude. Only in the new Italian metaphysical painting does the second solitude appear, the solitude of signs or the metaphysical.

The metaphysical work of art is rather serene in aspect, yet gives the impression that something new must happen in this very serenity and that other signs, beyond those already manifest, must find place within the square of the canvas. This is the revealing symptom of the *inhabited depth*. The flat surface of a perfectly calm ocean, for example, disturbs us not so much by the idea of the miles that extend between us and its end, as by all the unknown that is hidden in the depth. If this were not our idea of space we would experience only a feeling of vertigo as when we are at a great height.

METAPHYSICAL AESTHETIC

In the construction of cities, in the architectural form of houses, squares, gardens and public walks, ports, railroad stations, etc., exist the fundamentals of a great metaphysical aesthetic. The Greeks had a particular scruple in such constructions, guided by their aesthetic-philosophic sense: porticoes, shaded walks, terraces erected like auditoriums before the great spectacles of nature (Homer, Aeschylus); the tragedy of serenity. In Italy we have wonderful modern examples of such structures. So far as Italy is concerned, their psychological origin remains obscure to me. I have thought much about this problem of the Italian architectural metaphysic and all my painting of the years 1910, 1911, 1912, 1913, and 1914 was concerned with it. The day will come, perhaps, in which such an aesthetic, left

---

[1] "Sign" is here used in the general sense of "symbol." J. C. T.

[2] Arnold Böcklin (1827–1901) was a Swiss painter who worked in Germany and Italy. De Chirico was much impressed with his evocative paintings and prints of mythological subjects when he was studying in Munich. J. C. T.

for now to the caprice of chance, will become a law and necessity for the upper classes and the directors of public affairs. Then possibly we shall be able to avoid the repugnance of finding ourselves pushed aside in favor of monstrous apotheoses of bad taste and invading imbecility, such as the white monument to the Great King in Rome, otherwise known as the Altar of the Fatherland,[1] which stands in relation to the architectural sense much as the odes and orations of Tirteo Calvo[2] stand with regard to a sense of poetry.

Schopenhauer, who had a long acquaintance with this kind of thing, counseled his contemporaries not to put the statues of their illustrious men on columns and pedestals that were too high, but to place them instead on low bases "as used in Italy," he said, "where some men of marble seem to be on the level of the passer-by and to walk along with him."

The imbecile, that is, the man without metaphysical sense, is instinctively drawn towards an effect of mass and height, towards a kind of architectural Wagnerism. It is a matter of innocence. They are people who do not know the terror of lines and angles but are drawn towards the infinite. In this they find support for their limited psyche, closed within the same circle as femininity and childishness. But we who understand the signs of the metaphysical alphabet, know what joys and sorrows are hidden within a portico, the angle of a street or even a room, on the surface of a table between the sides of a box.

The limits of these signs constitute for us a kind of moral and aesthetic code of representation; further, in painting with clairvoyance we construct a new metaphysical psychology of things.

The absolute consciousness of space which an object must occupy in a painting and of the space that separates objects from each other, establishes a new astronomy of things which are attached to the planet by the fatal law of gravity. The minutely accurate and carefully determined use of surface and volumes constitutes the canon of the metaphysical aesthetic. It is useful here to consider some of Otto Weininger's profound reflections on the geometrical metaphysic.[3] ". . . The arc of a circle can be beautiful as ornament: this does not mean perfect completion, which no longer lends its support to some critic like the serpent of Midgard that surrounded the world.

"In an arc there is still something incomplete, that needs to be and can be completed—*this makes for a presentiment.* For this reason even a ring is always a symbol of something either amoral or immoral." (This idea clarified for me the

---

[1] The huge monument to Victor Emanuel II in the center of Rome was begun in 1885 and dedicated in 1911. The architect was Giuseppe Sacconi. On the second level is the Altar to the Fatherland with sculpture by Angel Zanelli. J. C. T.

[2] Possibly De Chirico is referring to Tyrtaeus, an early Greek poet famous for his military verses. J. C. T.

[3] Otto Weininger (1880–1903) an Austrian philosopher, published his controversial book, *Geschlecht und Charakter* in 1903 (Italian translation, 1912). J. C. T.

eminently metaphysical impression that porticoes and arches in general have always made on me.) Symbols of a superior reality are often to be seen in geometrical figures. For example, the triangle has served *ab antico*, and still serves today in Theosophical doctrine, as a mystic and magical symbol and certainly often awakens in a person who looks at it, whether he knows the tradition or not, a sense of uneasiness and almost fear. (Draughtmen's triangles have obsessed and continue to obsess my mind in this way; I have always seen them shining out like mysterious stars from behind every one of my pictorial figurations.)

Taking off from such principles, we can look about us at the surrounding world without again falling into the errors of our predecessors.

We can still follow every aesthetic, including that of the human figure, because so long as we work and meditate on such problems, facile and false illusions are no longer possible. Friends of a new understanding, new *philosophers*, we can finally smile with pleasure on the graces of our art.

## Carlo Carrà, "The Quadrant of the Spirit," 1919[*]

I know perfectly well how little importance vain philosophizing is, but people always tend to attribute qualities to us that are quite aside from what we are aiming at.

I know perfectly well that only in happy instants am I lucky enough to lose myself in my work. But this thought produces a feeling in me that is quite the opposite of what others imagine. Since I have now become one with my conscience, the statement that coldness is more necessary in the conquest of art than blind devotion or untrammeled passion seems right to me.

Look how the colors flow in masses up to the exact limits of the new architectural essences that rest upon the surface of the canvas.

The painter-poet feels that his true immutable essence comes from that invisible realm that offers him an image of eternal reality. His infatuation is not a passing state because it does not derive from the physical realm, rather, his sensory faculties are only accessory.

He feels himself to be a plastic microcosm in direct contact with everything.

Matter itself has existence only in the degree to which it provokes a response within him.

Thus, in this somnambulistic voyage, I return to that infinite particle of eternity that is within me, by means of which I feel in contact with my truer self, and I try to penetrate the recondite intimacy of ordinary things, which are the last to be conquered. I feel that I do not exist in time, but that time exists in me. I can also realize that it is not given to me to solve the mystery of art in an absolute

[*] Originally published as "Il Quadrante dello Spiriti," *Valori Plastici* (Rome), I, 4–5 April–May 1919), 1–2.

fashion. Nonetheless, I am almost brought to believe that I am about to get my hands on the divine. Quite aside from seeming a reprovable thing, such an act may make me look unforgivably frivolous.

I feel as if I were the law itself, not a simple rendezvous of elements. How could the advocates of naturalism ever make me believe that all art is reducible to things constructed by manual skill? So it happens that at my every internal quiver I ask for the whole and not a conditioned part. Because I do not work by addition, the distinctive criterion of the real is revealed within me as indivisible and fundamental. I quickly objectify the idea-mother of the form and bestow a value that is other than relative on every external thing.

The question of art, which engages the supreme part of man, is very troublesome.

Now it seems that my spirit is moving in an unknown matter or is lost in the whirlpools of a sacred spasm. It is knowledge! It is a sweet dreaming that dissolves all measure and broadens my individuality in relationship to things. Even the periodicity of times, their principle, their continuity, is broadened. In this moment I feel myself withdrawn from the social order.

I see human society below me.

Ethics is there submerged.

The universe appears to me wholly in terms of symbols, ranged at the same distance, as if I were looking down on a city plan.

But I see the boundary which is far away, very far, and the way to God remains as always long.

Here am I, doubtful of reaching that absolute intensity of expression that a short while ago was sought, not even that imperfect perfection that an organism living for itself can realize.

From two, the one has not yet emerged—that one which is no longer I and yet no longer nature.

Alas! Now I see that I have been the blind man for whom the enchantments of life were destroyed when his sight was restored. My idea runs the risk of being upset if it outstrips certain capacities.

I believed in and swore by the flattering concept of my mind. Fugitive voluptuousness; then enthusiasms inflict heavy loss.

The illusion of being able to fix the immortal part of myself. Still and always there remains my catastrophic being!

Empty forms and empty polished planes, cubed; my denominating segments are in agreement. These images that I supposed were constructed at the spiritual center of the times, and of all time, are abstract and detached manias of a stylist, cold and meager strivings.

Far from wearisome research, I felt so secure in the shadow of my work. I seemed to have arrived at that next point to happiness, which is so dear to us above all else.

Ah, horrifying Beauty which extends a ladder to the arbitrary paradises of the One-God.

In my soul a command is sounded! Look how once more I bring to hand my oppressive nostalgias, miraculously overcome! And I say: Ravished word, give up the ah's, and oh's, the woe is me!

Look how I build fantasies upon the solid geometries of objects! Shall I arrive at the total song if a mere nothing sends me into ecstasies? If a mere nothing causes my heart to throb?

This consideration stands as a parenthesis commenting on my intimate drama.

Natural brevities, intimate and clear in grain and porosity, primordial recallers of iridescent solidity, are brought together by my centralizing instinct.

The sign of the sphere: vision is no longer animal.

The cruiser of the wind, the wheel of extrasensory destinies, has come to rest on the black sea, which possibly sleeps beyond the first level, sooty and streaked like steamboats.

Pushing upward in vertical planes, the metaphysical house of the Milanese proletariat encloses an immense silence.[1]

Because the Marconi Telegraph antenna is erected on the arc of the earth, the syllables of the legend that returns at every spring are murmured.

This is the poetry of this grand and mathematical time.

The vast sky is hidden in slate color.

The lot is about to be cast as in year one.

Electrical man sets forth into the air in the guise of an inverted cone. His bust is in the form of a water-clock surrounded by circular, moving planes of polychrome tin which reflect reality as seen in concave and convex mirrors. His chest and torso are sharp volumes, and attributes with white highlights are nailed to his back.

On the same plane but farther back rises the archaic statue of my infancy (the shy anonymous lover or angel without wings?) It holds in its hand the tennis racquet and ball like its rubber sister on the wall in front of me.

Still farther back on the right side, a tombstone intervenes, possibly bearing an inscription in Latin whose softness is our Provençal.

At the same distance, parallel, stands the immobile spector of the enormous hammered copper fish, resting on two iron bars (that have escaped from a museum?).

The shadows are sharp and black on the gray pavement. It is the drama of apparitions.

---

[1] Carrà here begins a description of his painting, *The Oval Apparitions*, which was reproduced as the frontispiece to *Valori Plastici*, I, 1 (January 1919). J. C. T.

ART AND POLITICS:

The Artist and the Social Order

INTRODUCTION: by Peter Selz

The relationship between art and politics within the total cultural framework is extremely complex and cannot be defined in those simplified Marxist terms which would explain both art and politics as symptoms of a basic economic substructure. The patriotic subject matter and hard heroic form of David's Neoclassicism, for example, was a cause as well as an effect of the French Revolution of which David himself was one of the decisive leaders. Courbet's concern with a tangible and visible reality some fifty years later has its anti-idealist parallel in the contemporary philosophy of Historic Materialism, but is not derived from it. It is worth noting that, in fact, nobody has been more aware of the powerful impact of ideas—including works of art—on the economic-political condition than the leaders of totalitarian states.

At the end of the nineteenth century many artists and writers, among them William Morris, Leo Tolstoy, and Vincent van Gogh, were disappointed with the indifference and rejection of the bourgeoisie or were troubled by the constantly widening gulf between the artist and society. They desired a reintegration in which art was to serve a Utopian brotherhood of man. The Expressionists too dreamed of a renewal of society in which art could take the place once occupied by religion. The Bauhaus set out to train artists and craftsmen to participate in an expanding industrial society. The Constructivists felt that they were forging a weapon for a truly revolutionary art, that "the new world of the masses needs Constructivism because it needs fundamentals that are without deceit."[1]

Moholy-Nagy in Budapest called for a purely abstract art of "visual fundamentals" in his "Constructivism and the Proletariat" before joining the Bauhaus, which had proclaimed at the outset that it would "create a new guild of craftsmen, without class distinctions"[2] and would find a way

[1] Lazlo Moholy-Nagy, "Constructivism and the Proletariat," *MA*, May 1922.

[2] From "The First Bauhaus Proclamation," Weimar, 1919. Quoted in Herbert Bayer, Walter Gropius, and Ise Gropius, *Bauhaus 1919–1928* (New York: Museum of Modern Art, 1938), p. 16.

to reintegrate the artist into a technological society. At the same time artists in revolutionary Mexico turned to the topical subject matter of their Indian ancestors in large mural projects which themselves were an integral part of a tremendous building program. Painters like Orozco, Rivera, and Siqueiros formed the "Revolutionary Syndicate of Technical Workers, Painters, and Sculptors" and issued the Manifesto for a new, monumental art of social purpose, quoted here in its brief entirety.

Meanwhile, a much more conservative attitude toward the creative faculties gained the upper hand in the Soviet Union. After auspicious beginnings in which Constructivists and Suprematists participated together with other progressive artists as diverse as Kandinsky and Chagall, bourgeois taste prevailed and its academic artists regained supremacy. They would paint propagandistic pictures and make statues glorifying socialism or attacking its enemies, and they would work in a realistic style easily understood by the masses. Slowly the doctrine of Socialist Realism evolved in art and literature. In 1924 Leon Trotsky published his important *Literature and Revolution* in which the place of art in the revolutionary society is rather well defined as one of relative freedom under "watchful revolutionary censorship." Trotsky also explains the materialist view of a utilitarian art and has little use for the explorations of form by Tatlin and Lipchitz. Instead he visualizes art and technology in the service of the revolutionary state, and his essay ends with a view toward a gloriously Utopian future in which man will have moved mountains, and when both the earth itself and the human species will have become works of art.

While the narrow and restrictive doctrine of Socialist Realism gained ground in the Soviet Union, Trotsky's attitude toward a continuing revolution and the "complete and radical reconstruction of society" was largely responsible for his expulsion from the U.S.S.R. But it also inspired many intellectuals and artists such as André Breton, the Surrealists' "pope" who embraced the Marxist tenet of a dialectical program leading from thought to action. He published the periodical, *Le Surréalisme au service de la Révolution* (1930–1933), but his belief in the interpenetration of reason and unreason was unacceptable to the more didactic Marxists. Breton and Diego Rivera, largely under the influence of Trotsky,[1] who was now exiled in

[1] André Breton in a letter to me (P.S.), Paris, 12 February 1962: "In reply to your letter of January 21, I gladly authorize you to reproduce in *The Theories of Modern Art* the manifesto: 'Towards a Free Revolutionary Art,' in the translation published in *Partisan Review* in 1938. There is, however, cause to specify (as I have done several times since then for reprints in French) that although this manifesto appeared under the signatures of Diego Rivera and myself, Diego Rivera in fact took no part in its inception. This text, in its entirety, was drawn up by Leon Trotsky and me, and it was for tactical reasons that Trotsky wanted Rivera's

Mexico, signed the *Manifesto: Towards a Free Revolutionary Art* in 1938, demanding that the artist, freely following his own radical spirit, take part in the dynamic transformation of society. The International Federation of Independent Revolutionary Art set out to bring about the freedom of the artist for the sake of a total revolution and, in turn, a revolution which would help achieve the complete liberation of art.

A much more matter-of-fact proposal to resolve the artist's plight had been suggested by the eminent American painter Stuart Davis. As an artist he ignored the doctrines of Socialist Realism, but created Cubist abstractions of the American urban scene in vibrating, brassy colors. But as president of the Artists' Union he sees the artist as a "have-not" and as the natural ally of the worker, who joins in the organized fight for his rights of employment, better wages, and social insurance. The union also helps the artist to "discover his identity with the working class," and standards of quality are not allowed to interfere with his class-conscious function as an "organized artist."

While the Artists' Union and its militant publication, *Art Front* (1934–1937), was a short-lived phenomenon of the Depression, the Federal Art Project was of staggering importance. It was probably the most ambitious public undertaking in support of the artist in recent times. The most remarkable thing about the Federal Art Project of the Works Progress Administration during the Roosevelt era is not only that over 5,000 artists were given public aid, but that they were left free to follow the dictates of their own talents and wishes. The "Project" created for the first time a wide concern with art in this country; it gave artists such as Milton Avery, William Baziotes, Arshile Gorky, Philip Guston, Willem de Koonig, Ibram Lassaw, Jackson Pollock, Theodore Roszak, Mark Rothko, and many others the time to gather their forces, the same forces which were eventually to change the face of world art. It was a manifestation of the possibilities of healthy cooperation between the creative artist and the body politic in a democratic society. We quote extensively from the introduction by Holger Cahill, National Director of the Federal Art Project, to the catalogue of an exhibition of WPA art held at the Museum of Modern Art in 1936.

With the outbreak of World War II the Federal Art Project was abolished. It had been, as the historian of American art, Oliver Larkin, has observed, "the greatest experiment in democratic culture the world had

---

signature substituted for his own. On page 40 of my work, *La Clé des champs* [Paris: Sagittaire, 1953], I have shown a facsimile page of the original manuscript in additional support of this rectification."

ever seen." At the extreme opposite were the dictatorial edicts and prohibitions which Hitler, whose own early ambitions as a painter had been frustrated by his lack of talent, imposed on the artists of the German Reich. Having "cleansed" the German museums of all vital modern art from Van Gogh to Kandinsky, Hitler opened the grossly inhuman *Haus der deutschen Kunst* in 1937 and decreed that the brutally propagandistic art in the exhibition was not to change for the duration of his 1000-year empire. Any artist who demanded the prerogative of free expression was threatened with sterilization or punishment:

> They would be the object of great interest to the Ministry of the Interior of the Reich which would then have to take up the question of whether further inheritance of such gruesome malfunctioning of the eyes cannot at least be checked. If, on the other hand, they themselves do not believe in the reality of such impressions by trying to harass the nation with this humbug for other reasons, then such an attempt falls within the jurisdiction of the penal law.

After World War II (and the defeat of Hitler), it was possible for Picasso, in his admiration for the personal achievements of Communists in the struggle against Fascism and Nazism in Spain, France, and Russia, to join the Communist Party and to issue a statement which suggests a more direct relationship between art and its political effect than is apparent in his own painting. While what may well be the greatest painting of our century, Picasso's *Guernica*, deals with a political and social theme, it was motivated not by political dogma but by the artist's shock at a human situation, when for the first time in the West an undefended population was destroyed by an invisible enemy. Picasso interpreted his purpose—though not the complex formal structure—of the great mural to Jerome Seckler, who interviewed him for the *New Masses* in 1945.

The opening words to the review *Possibilities* by the painter Robert Motherwell and the critic Harold Rosenberg are a great deal more ambiguous and certainly less optimistic. The postwar situation, however, was one of disillusionment with all panaceas: the undogmatic view of complete flexibility seemed the only one possible.

This attitude is certainly justified in view of the aggressive criticism by Professor Vladimir Kemenov, Director of Moscow's Tretjakov Gallery and expert on Socialist Realism, who leaves us as little room for the work of Picasso as for any kind of free expression. Again we find modern art attacked by being called decadent, antihumanist, and pathological. Personal and searching or imaginative statements by the artist are referred to as "subjective anarchy," which cannot be tolerated because the state is too acutely aware

of the possible consequence of the assertion of nonconformity. Since the 1920's, when the doctrine of Socialist Realism was first developed to the detriment of free artistic expression, the attitude has become even more frozen. An even greater control is exercised by the Communist Party. As late as 1963 Nikita Khrushchev, then premier of the U.S.S.R. and chairman of its Communist Party, endorsed this narrow-minded and restrictive position.

In our own country, we find a remarkably similar attitude of violent hostility to modern art by persons in high office. Former Representatives Fred E. Busby of Illinois and George A. Dondero of Michigan, for example, have leveled ruthless and frequent attacks against modern artists. It makes little difference that Dondero smears as subversive Communists the very artists whose work is attacked by Kemenov for being formalistic, decadent, and capitalist. An officialdom that wishes to preserve the *status quo* or use the artist for purposes of indoctrination is anxious to quell artistic freedom. The alternative, of course, is a free society, flourishing on the subjective concepts, ideas, and forms visualized and expressed by its artists.

Fortunately, the arts in the United States have not encountered a great deal of interference from the body politic and have—especially during John F. Kennedy's administration—experienced significant official encouragement.

In countries dominated by Communist parties, the situation is also in a process of change. In Cuba, Fidel Castro let it be understood that the social-political revolution would in no way interfere with the freedom of the artist, but that the arts served the people best by following their own pursuits.

Assembling an exhibition of recent Polish painting for the Museum of Modern Art in New York, I traveled in Poland during 1959 and 1960 and found free artistic expression not only a goal but, indeed, a fact. Having rebelled against Socialist Realism in the mid-fifties, painters were free to explore all manners and styles and media and to exhibit their work in museums and sell it in cooperative galleries in Poland or send it abroad. Their work proved to be of high artistic merit by all international standards. In addition to putting brush to canvas, painters in Poland are actively engaged in cinematic production, stage design, book illustration, and all forms of the "useful arts."

Since the early 1960s artists in Italy, France, Yugoslavia, and Germany have banded together in groups for the purpose of collaborating on visual research in the Constructivist tradition and making use of new and often scientific techniques and media as well as evolving an experimental conceptual art greatly interested in optical phenomena and kinetic processes.

Giulio Carlo Argan, Italy's leading art critic, professor of modern art at the University of Rome and president of the International Association of Art Critics, has caused a great controversy in the European art world by becoming the spokesman of these "research teams" and endowing them with socio-political ideology.

Professor Argan, making use of unnecessarily difficult language, hopes to reintegrate the artist into a modern mechanized society, asserting that technology needs the guidance of aesthetics in order to function ethically as well as effectively. This guidance, he believes, can come from the "Gestalt research groups" and he traces their history back to the Bauhaus and sees parallels in Wright's Taliesin Fellowship and Gropius' Architects' Collaborative. He is less concerned with the aesthetic results than with the sociological ramifications. The individual in his solitude can, according to Argan, no longer exist in the modern technological society and produce significant works of art. He is being swallowed by the masses, which "in their obedient inertia do not know of aesthetic exigencies and cannot produce art." The group, however, consisting of individuals in meaningful relationship to each other, can be a dynamic "community organized for creative goals."

Many of Italy's established artists, however, protested against Argan's team spirit and reaffirmed their faith in the personal statement of the individual.

*Manifesto issued by the Syndicate of Technical Workers, Painters, and Sculptors, Mexico City, 1922\**

Social, Political, and Aesthetic Declaration from the Syndicate of Technical Workers, Painters, and Sculptors to the indigenous races humiliated through centuries; to the soldiers converted into hangmen by their chiefs; to the workers and peasants who are oppressed by the rich; and to the intellectuals who are not servile to the bourgeoisie:

We are with those who seek the overthrow of an old and inhuman system within which you, worker of the soil, produce riches for the overseer and politician, while you starve. Within which you, worker in the city, move the wheels of industries, weave the cloth, and create with your hands the modern comforts enjoyed by the parasites and prostitutes, while your own body is numb with cold. Within which you, Indian soldier, heroically abandon your land and give your life in the eternal hope of liberating your race from the degradations and misery of centuries.

---

\* Published as a broadside. This English translation from Laurence E. Schmeckebier *Modern Mexican Art* (Minneapolis: University of Minnesota, 1939), p. 31. The same translation appears in Bernard S. Myers, *Mexican Painting in Our Time* (New York: Oxford University, 1956), p. 29.

461

Not only the noble labor but even the smallest manifestations of the material or spiritual vitality of our race spring from our native midst. Its admirable, exceptional, and peculiar ability to create beauty—the art of the Mexican people—is the highest and greatest spiritual expression of the world-tradition which constitutes our most valued heritage. It is great because it surges from the people; it is collective, and our own aesthetic aim is to socialize artistic expression, to destroy bourgeois individualism.

We repudiate the so-called easel art and all such art which springs from ultra-intellectual circles, for it is essentially aristocratic.

We hail the monumental expression of art because such art is public property.

We proclaim that this being the moment of social transition from a decrepit to a new order, the makers of beauty must invest their greatest efforts in the aim of materializing an art valuable to the people, and our supreme objective in art, which is today an expression for individual pleasure, is to create beauty for all, beauty that enlightens and stirs to struggle.

## Leon Trotsky, *Literature and Revolution, 1923*★

Our Marxist conception of the objective social dependence and social utility of art, when translated into the language of politics, does not at all mean a desire to dominate art by means of decrees and orders. It is not true that we regard only that art as new and revolutionary which speaks of the worker, and it is nonsense to say that we demand that the poets should describe inevitably a factory chimney, or the uprising against capital! Of course the new art cannot but place the struggle of the proletariat in the center of its attention. But the plough of the new art is not limited to numbered strips. On the contrary, it must plow the entire field in all directions. Personal lyrics of the very smallest scope have an absolute right to exist within the new art. Moreover, the new man cannot be formed without a new lyric poetry. But to create it, the poet himself must feel the world in a new way. If Christ alone or Sabaoth himself bends over the poet's embraces, then this only goes to prove how much behind the times his lyrics are and how socially and aesthetically inadequate they are for the new man. Even where such terminology is not a survival of experience so much as of words, it shows psychologic inertia and therefore stands in contradiction to the consciousness of the new man. No one is going to prescribe themes to a poet or intends to prescribe them. Please write about anything you can think of! But allow the new class which considers itself, and with reason, called upon to build a new world, to say to you in any given case: It does not make new poets of you to translate the philosophy of life of the seventeenth

★ First published in 1923 in a Russian edition. These excerpts from the English translation in Leon Trotsky, *Literature and Revolution* (New York: Russell and Russell, 1957), pp. 170–171, 219, 220–221, 235–236, 247–248, 249–251.

462

century into the language of the Acméists. The form of art is, to a certain and very large degree, independent, but the artist who creates this form, and the spectator who is enjoying it, are not empty machines, one for creating form and the other for appreciating it. They are living people, with a crystallized psychology representing a certain unity, even if not entirely harmonious. This psychology is the result of social conditions. The creation and perception of art forms is one of the functions of this psychology. And no matter how wise the Formalists try to be, their whole conception is simply based upon the fact that they ignore the psychological unity of the social man, who creates and who consumes what has been created . . . .

Does not such a policy mean, however, that the Party is going to have an unprotected flank on the side of art? This is a great exaggeration. The Party will repel the clearly poisonous, disintegrating tendencies of art and will guide itself by its political standards. It is true, however, that it is less protected on the flank of art than on the political front . . . .

But does not the work of culture-bearing, that is, the work of acquiring the A B C of pre-proletarian culture, presuppose criticism, selection, and a class standard? Of course it does. But the standard is a political one and not an abstract cultural one. The political standard coincides with the cultural one only in the broad sense that the Revolution creates conditions for a new culture. But this does not mean that such a coinciding is secured in every given case. If the Revolution has the right to destroy bridges and art monuments whenever necessary, it will stop less from laying its hand on any tendency in art which, no matter how great the achievement in form, threatens to disintegrate the revolutionary environment or to arouse the internal forces of the Revolution, that is, the proletariat, the peasantry, and the intelligentsia, to a hostile opposition to one another. Our standard is, clearly, political, imperative, and intolerant. But for this very reason, it must define the limits of its activity clearly. For a more precise expression of my meaning, I will say: we ought to have a watchful revolutionary censorship, and a broad and flexible policy in the field of art, free from petty partisan maliciousness . . . .

What are we to understand under the term realism? At various periods, and by various methods, realism gave expression to the feelings and needs of different social groups. Each one of these realistic schools is subject to a separate and social literary definition, and a separate formal and literary estimation. What have they in common? A definite and important feeling for the world. It consists in a feeling for life as it is, in an artistic acceptance of reality, and not in a shrinking from it, in an active interest in the concrete stability and mobility of life. It is a striving either to picture life as it is or to idealize it, either to justify or to condemn it, either to photograph it or generalize and symbolize it. But it is always a preoccupation with our life of three dimensions as a sufficient and invaluable theme for art. In this large philosophic sense, and not in the narrow sense of a literary school, one may say with certainty that the new art will be realistic. The Revolution cannot live together with mysticism. Nor can the Revolution live together with romanticism, if that which Pilnyak, the Imagists, and others call romanticism is, as it may

463

be feared, mysticism shyly trying to establish itself under a new name. This is not being doctrinaire, this is an insuperable psychological fact. Our age cannot have a shy and portable mysticism, something like a pet dog that is carried along "with the rest." Our age wields an ax. Our life, cruel, violent, and disturbed to its very bottom, says: "I must have an artist of a single love. Whatever way you take hold of me, whatever tools and instruments created by the development of art you choose, I leave to you, to your temperament and to your genius. But you must understand me as I am, you must take me as I will become, and there must be no one else besides me."

This means a realistic monism, in the sense of a philosophy of life, and not a "realism" in the sense of the traditional arsenal of literary schools. On the contrary, the new artist will need all the methods and processes evolved in the past, as well as a few supplementary ones, in order to grasp the new life. And this is not going to be artistic eclecticism, because the unity of art is created by an active world-attitude and active life-attitude.

De Maupassant hated the Eiffel Tower, in which no one is forced to imitate him. But it is undoubtedly true that the Eiffel Tower makes a dual impression; one is attracted by the technical simplicity of its form, and, at the same time, repelled by its aimlessness. It is an extremely rational utilization of material for the purpose of making a high structure. But what is it for? It is not a building, but an exercise. At present, as everyone knows, the Eiffel Tower serves as a radio station. This gives it a meaning, and makes it aesthetically more unified. But if the tower had been built from the very beginning as a radio station, it probably would have attained a higher rationality of form, and so therefore a higher perfection of art.

From this point of view Tatlin's project for a monument appears much less satisfactory. The purpose of the main building is to make glass headquarters for the meetings of the World Council of People's Commissars, for the Communist International, etc. But the props and the piles which are to support the glass cylinder and the pyramid—and they are there for no other purpose—are so cumbersome and heavy that they look like unremoved scaffolding. One cannot think what they are for. They say: they are there to support the rotating cylinder in which the meetings will take place. But one answers: Meetings are not necessarily held in a cylinder and the cylinder does not necessarily have to rotate. I remember seeing once, when a child, a wooden temple built in a beer bottle. This fired my imagination, but I did not ask myself at that time what it was for. Tatlin proceeds by a reverse method; he wants to construct a beer bottle for the World Council of People's Commissars which would sit in a spiral concrete temple. But for the moment, I cannot refrain from the question: What is it for? To be more exact: we would probably accept the cylinder and its rotating, if it were combined with a simplicity and lightness of construction, that is, if the arrangements for its rotating did not depress the aim . . . . Nor can we agree with the arguments which are given to interpret the artistic significance of the sculpture by Jacob [Jacques] Lipchitz.

464

Sculpture must lose its fictitious independence which only means that it is relegated to the backyards of life or lies vegetating in dead museums, and it must revive in some higher synthesis its connection with architecture. In this broad sense, sculpture has to assume a utilitarian purpose. Very good, then. But it is not at all clear how one is to approach the Lipchitz sculpture from such a point of view. I have a photograph of several intersecting planes, which are supposed to be the outlines of a man sitting with a stringed instrument in his hands. We are told that if today it is not utilitarian, it is "purposeful." In what way? To judge purposefulness, one has to know the purpose. But when one stops to think of the purposefulness and possible utility of those numerous intersecting planes and pointed forms and protrusions, one comes to the conclusion that if, as a last resort, one were to transform such a piece of sculpture into a hatrack, he would have probably found a more purposeful form for it. At any rate, we cannot recommend that a plaster cast be made of it for hatracks . . . .

Take the penknife as an example [of purposefulness]. The combination of art and technique can proceed along two fundamental lines; either art embellishes the knife and pictures an elephant, a prize beauty, or the Eiffel Tower on its handle; or art helps technique to find an "ideal" for for the knife, that is, such a form which will correspond most adequately to the material of a knife and its purpose. To think that this task can be solved by purely technical means is incorrect, because purpose and material allow for innumerable . . . variations. To make an "ideal" knife, one must have, besides the knowledge of the properties the material and the methods of its use, both imagination and taste. In accord with the entire tendency of industrial culture, we think that the artistic imagination in creating material objects will be directed towards working out the ideal form of a thing, as a thing, and not towards the embellishment of the thing as an aesthetic premium to itself. If this is true for penknives, it will be truer still for wearing apparel, furniture, theatres, and cities. This does not mean the doing away with "machine-made" art, not even in the most distant future. But it seems that the direct cooperation between art and all branches of technique will become of paramount importance.

Does this mean that industry will absorb art, or that art will lift industry up to itself on Olympus? This question can be answered either way, depending on whether the problem is approached from the side of industry, or from the side of art. But in the object attained, there is no difference between either answer. Both answers signify a gigantic expansion of the scope and artistic quality of industry, and we understand here, under industry, the entire field without excepting the industrial activity of man; mechanical and electrified agriculture will also become part of industry.

The wall will fall not only between art and industry, but simultaneously between art and nature also. This is not meant in the sense of Jean-Jacques Rousseau, that art will come nearer to a state of nature, but that nature will become more "artificial." The present distribution of mountains and rivers, of fields, of meadows,

of steppes, of forests, and of seashores, cannot be considered final. Man has already made changes in the map of nature that are not few nor insignificant. But they are mere pupils' practice in comparison with what is coming. Faith merely promises to move mountains; but technology, which takes nothing "on faith," is actually able to cut down mountains and move them. Up to now this was done for industrial purposes (mines) or for railways (tunnels); in the future this will be done on an immeasurably larger scale, according to a general industrial and artistic plan. Man will occupy himself with re-registering mountains and rivers, and will earnestly and repeatedly make improvements in nature. In the end, he will have rebuilt the earth, if not in his own image, at least according to his own taste. We have not the slighest fear that this taste will be bad . . . .

It is difficult to predict the extent of self-government which the man of the future may reach or the heights to which he may carry his technique. Social construction and psycho-physical self-education will become two aspects of one and the same process. All the arts—literature, drama, painting, music, and architecture—will lend this process beautiful form. More correctly, the shell in which the cultural construction and self-education of Communist man will be enclosed, will develop all the vital elements of contemporary art to the highest point. Man will become immeasurably stronger, wiser, and subtler; his body will become more harmonized, his movements more rhythmic, his voice more musical. The forms of life will become dynamically dramatic. The average human type will rise to the heights of an Aristotle, a Goethe, or a Marx. And above this ridge new peaks will rise.

*Stuart Davis, "The Artist Today," 1935**

This article deals with the artistic, the social, and the economic situation of the American artist in the field of fine arts, regarding the situation in the broadest possible way, and does not intend to stigmatize individuals except as they are the name-symbols of certain group tendencies.

The most superficial contact with artists makes it clear that the artist today is in a state of confusion, doubt, and struggle. He is not alone in his plight but has the respectable company of business men, chambers of commerce, politicians, congresses, presidents, and supreme courts. In short, the artist participates in the world crisis.

The immediate past of the American fine-artist was briefly as follows—he

* From *American Magazine of Art* (New York), XXVIII (August 1935), 476–478, 506. The article was subtitled, "The Standpoint of the Artists' Union." Davis was very active in artists' organizations, both artistic and political. He was an editor of the left-wing periodical *Art Front* during the middle 'thirties, and was president of the Artists' Congress beginning in 1936. H. B. C.

came in general from families of the lower middle class who could afford to send their children to art school, in many cases to European schools. These schools were, in their nature, schools of the middle class, and it is also generally true that the art taught in these schools was oriented towards the middle class. Consequently the work of the future artists was supposed to be absorbed by that class through the appropriate commercial channels. This does not mean, of course, that the middle class as a whole were art patrons; it means that the upper strata of the class, who were the wealthy art buyers, still retained their lower-middle-class psychology and were qualitatively one with the class as a whole in culture.

Thus the artist exercised his talents within the framework of the middle-class culture. Still-lifes, landscapes, and nudes were the chief categories of subject matter, and the artists competed freely against each other for originality within this framework of subject material. In addition, there were of course the different schools of theory and method such as the impressionists, the post impressionists, the Cézanneists, the Cubists, the *Surrealists*, and always the reactionary Academy in different forms. The commercial contact of the artist was through the art dealer and gallery and the private patron, as well as the museum, which is really a collective of art patrons conditioned by the art dealer.

It follows, then, that the artist of the immediate past was an individualist, progressive or reactionary, in his painting theory, working within the framework of middle-class culture with a subject matter acceptable to that culture and marketing his product through channels set up by the middle class. His economic condition in general was poor and he was badly exploited by art dealer and patron alike.

For those unaware of this exploitation, I will briefly specify. The dealer opened shop with a free choice of the field for his stock in trade. His stock cost him nothing but promises, and these promises were not promises to pay, but promises of a vague future of affluence to the unorganized and wildly competing artists. In many cases the artists were actually forced to pay gallery rent, lighting and catalogues and advertising costs in return for the promises of the dealer. In addition, commissions of from a third to a half and more were charged for sales. In the few cases where certain artists were subsidized by dealers the situation was not different in kind but only in degree. What resulted? In each gallery two or three artists emerged as commercial assets to the dealer, and at that point a certain character was given to the gallery. This character was the result of the planning of the one-man and group exhibitions around the works of the artists that time had shown to be the easy sellers. The body of artists of the gallery were used chiefly for window dressing and quantitative filler. In addition, the dealers carried variously old masters, early American, folk art, etc., which they bought at bargain prices and sold at enormous profit, frequently to the exclusion of the work of the contemporary artists they were supposedly marketing. Art for profit, profit for everybody but the artist. With the art patron and museum the situation

is similar, free choice without responsibility, but there is the additional feature of social snobbery. Artists are subsidized with the hope of financial gain on a statistical basis; a number are picked for low subsidy with the hope that one of them will bring home the bacon, financially speaking. There is also the desire of the patron to be regarded as an outstanding person of culture among his fellow traders, social snobbery, or in cases of extreme wealth, the ability of the patron to add the prestige of charity to the excitement of gambling. For these reasons the term "badly exploited" surely applied directly to the artist.

This is a factual description of the social-economic relation of the artist body to society as a whole in the immediate past, and of course today as well.

Today, however, there are certain developments which are peculiar to the time and which directly affect the artist in his social-economic relations. They are: (1) Federal, State, and Municipal Art Projects; (2) street exhibitions and art marts; (3) the Mayor's Committee of One Hundred in New York City, appointed over the protests of the artists, whose supposed function is the creation of a Municipal Art Center; (4) suppression and destruction of murals, as in the case of Diego Rivera, Alfaro Siqueiros, and Ben Shahn, and the Joe Jones affair in Missouri; (5) gallery rackets, self-help plans, such as the Artists' Aid Committee in New York, artists' and writers' dinner clubs, five- and ten-dollar gallery exhibitions, etc.; (6) a rental policy for all exhibitions as adopted by the American Society of Painters, Sculptors, and Gravers, and the refusal of museums and dealers to accept it; and (7) the organization of the Artists' Union of New York and the "firing" of members for organizational activities on the projects.

These events and others are not isolated phenomena peculiar to the field of art. They are reflections in that field of the chaotic conditions in capitalist world society today. The artist finds himself without the meagre support of his immediate past and he realizes now, if not before, that art is not a practice disassociated from other human activities. He has had the experience of being completely thrown overboard and sold out by art dealer and patron, and his illusions as to their cultural interests are destroyed. He realizes now that the shallowness of cultural interest of his middle-class audience was retroactive on his own creative efforts, resulting in a standard of work qualitatively low from any broad viewpoint. Looking about him, he sees sharp class distinction, those who have, and those (the great majority) who have not. He recognizes his alignment with those who have not—the workers.

With these realizations the artists of New York have taken certain actions. They organized the Artists' Committee of Action and undertook a struggle for a Municipal Art Gallery and Center, administered by artists. Mass meetings and demonstrations were held. The mayor of the city, La Guardia, refused to see their delegations, gave them the runaround and finally appointed a Committee of One Hundred to plan a municipal gallery and center. This committee was appointed without consulting the artists and is composed for the most part of names of socially prominent people who have no conception of the problems involved. Their first

468

act was to hold an exhibit in a department store, their idea of solving the artists' problem. Most of those invited to exhibit withdrew their work from the walls on the opening day in protest, and the whole story with photographs, phoned in to papers by reporters on the spot, was killed in the press because the department store was a big advertiser. After this farcical first step the Committee of One Hundred went into temporary retirement and is now planning some summer festival, another attempt to give the present administration of the city credit for patronizing the arts without doing it.

The formation of the Artists' Union over a year ago is an event of greatest importance to all artists. With a present membership of thirteen hundred artists, the Union invites all artists to membership, and locals in other cities are being formed. The most direct action taken by the Union has been on the Municipal Art Projects. Over three hundred art teachers, painters, and sculptors are employed, a small fraction of those needing employment. Those employed have the necessity of proving themselves paupers before they are eligible and after employment are often badly misplaced in regard to their best abilities. All organization by the artists on these projects is frowned upon by the administration, which subscribes to the ancient adage that paupers cannot be choosers. The administration is wrong; paupers today can choose when they are organized, and through their Artists' Union they have won some rights, have had "fired" members reinstated, and through their picket lines have shown the authorities that they are not to be kicked around at will. They fight steadily for increase in projects, against lay-offs, against time and wage cuts, for genuine social and unemployment insurance, for trade union unity, against the degrading pauper's oath on the projects, and for free expression in art as a civil right. Through their struggles in the Artists' Union the members have discovered their identity with the working class as a whole, and with those organized groups of artist-craftsmen such as woodcarvers and architectural modelers and sculptors in particular. With this realization a morale has developed which grows in spite of the efforts of the administration and its agents to break it. Exhibitions of the work of the members of the Union during the past winter showed a quality comparable in every way with the gallery exhibitions. This quality will change and improve, for reasons I will give later. The Artists' Union has an official organ, *The Art Front*, which has been widely hailed as the most vital art magazine in the country, with critical articles of high quality. The slogan of the Union, "EVERY ARTIST AN ORGANIZED ARTIST" means something which no artist can afford to disregard. Negotiations are now under way for the entrance of the Union into the American Federation of Labor.

The question of the civil right of free expression is a vital one today for the artists. It affects his life as a man and as an artist. Fascism is a powerful trend in the current political world set-up. Fascism is defined by the Methodist Federation for Social Service as "the use of open force (against the workers) by big business." We have seen it at work in Germany and Italy, and one of its first acts is the sup-

pression of freedom in the arts. Schools are closed; artists, scientists, and intellectuals are driven into exile or thrown into concentration camps. Culture in general is degraded and forced to serve mean and reactionary nationalistic ends, and the creative spirit of the artist is crushed ruthlessly. Such trends exist in this country, as any newspaper reader knows, and already individuals and small groups have committed Fascist-like acts of suppression, for ideological and political reasons. The destruction of the Rivera mural, the Siqueiros murals in Los Angeles, the suppression of the Ben Shahn and Lou Block mural for Riker's Island Penitentiary in New York by Jonas Lie of the Municipal Art Commission are examples. No artist can afford to remain complacent in the face of these and a thousand other similar cases, nor can he feel that they do not concern him directly. Organization by the artists and cooperation with the organized workers is the only method to fight these attacks on culture.

The question of quality interests artists. They say, "Yes, we agree with your ideas of organization, but what standards have you? We can't have everybody in a Union who calls himself an artist. We have a standard and we resent the implication that our standard of quality is unimportant in the type of organization you say is necessary for artists." The answer to this point is as follows: A work of art is a public act, or, as John Dewey says, an "experience." By definition, then, it is not an isolated phenomenon, having meaning for the artist and his friends alone. Rather it is the result of the whole life experience of the artist as a social being. From this it follows that there are many "qualities" and no one of these qualities is disassociated from the life experience and environment that produced it. The quality standard of any group of artists, such as the National Academy of Design for example, is valid for the social scheme of that group only. Its "world validity" depends precisely on the degree to which the life-scheme of the group of artists is broad in scope. We have, therefore, little qualities and big qualities. Any artist group which seeks to isolate itself from broad world interests and concentrates on the perpetuation of some subclassifications of qualitative standard is by definition the producer of small quality. For such a group to demand that all artists meet this static qualitative concept is of course absurd. Art comes from life, not life from art. For this reason the question of the quality of the work of the members of the Artists' Union has no meaning at this time. The Artists' Union is initiating artists into a new social and economic relationship, and through this activity a quality will grow. This quality will certainly be different from the quality standard of any member before participation in union activities and will take time to develop. As the social scheme of the Union is broad and realistic, directly connected to life today in all its aspects, so we confidently expect the emergence of an aesthetic quality in the work of the members which has this broad, social, realistic value. Therefore, an artist does not join the Union merely to get a job; he joins it to fight for his right to economic stability on a decent level and to develop as an artist through development as a social human being.

*Holger Cahill, "The Federal Art Project, "1936★*

... The organization of the Project has proceeded on the principle that it is not the solitary genius but a sound general movement which maintains art as a vital, functioning part of any cultural scheme. Art is not a matter of rare, occasional masterpieces. The emphasis upon masterpieces is a nineteenth-century phenomenon. It is primarily a collector's idea and has little relation to an art movement. When one goes through the galleries of Europe which preserve, in spite of war, fire, flood, and other destructive forces, an amazing quantity of works from the past, one is struck by the extraordinary amount of work which was produced in the great periods. During the early part of the twentieth century it is said that some forty thousand artists were at work in Paris. It is doubtful if history will remember more than a dozen or two of these, but is probable that if the great number of artists had not been working, very few of these two dozen would have been stimulated to creative endeavor. In a genuine art movement a great reservoir of art is created in many forms, both major and minor . . . .

### FINE ART AND ART FOR USE

In organizing the Federal Art program the many forces which tend to build up a sound art movement have been considered. An effort has been made to view American art in perspective, both as to the past and as to the future. While the fate of the workers in the fine arts has seemed of paramount importance, it is clear that under the most favorable conditions these artists cannot prosper alone, nor can they by their solitary efforts create a fully developed art movement in America.

The importance of an integration between the fine arts and the practical arts has been recognized from the first by the Federal Art Project, as an objective desirable in itself and as a means of drawing together major aesthetic forces in this country. Our manufacturing system has produced much that may be called good from the aesthetic point of view, but it has also produced a fearful clutter of unlovely things, and this in turn has resulted in a degradation of popular taste, since these objects provide the only art that many individuals know. Direction from the fine arts has been sorely needed for the manufacturer, the craftsman, and the public. It has been impossible to provide a solution for all the ensuing problems under an emergency program, but an attempt has been made by the Federal Art Project to break down the artificial barrier which exists between these forms of art expression. The young commercial artist has received direction, which has often been distinguished, from teachers or workers in the fine arts. In the printshops

★ From *New Horizons in American Art*, with an introduction by Holger Cahill, National Director, Federal Art Project, copyright 1936 by The Museum of Modern Art, New York, and reprinted with its permission.

and workshops set up under the Project, in the making of posters, mural maps, dioramas, lantern slides for schools, of scenic models for natural history museums, young workers in the fine and the practical arts have come together to work out mutual problems. The outcome has been the accomplishment of many useful services for public institutions, and a stimulation toward higher levels in the creation of objects of common use . . . .

### THE YOUNG ARTIST

For the young artist another relationship has seemed of importance. Because of the development of local or regional creative or teaching projects, the young artist has tended for perhaps the first time within the modern period to attack the problems of art at home, in his own setting, among familiar surroundings, in the midst of a social life which he is likely to know well. This situation—part of it enforced by the depression—has meant at least a beginning toward a naturalization of art in all our communities, an outcome which must be achieved if our art is to be anything more than an effervescence along the Atlantic seaboard . . . .

### THE FINE ARTS PROJECTS

Naturally in any program of this kind the position of the creative artist has been considered as of primary importance. If the mainstream of American art is to continue, he must be given a chance to develop and to assume the leadership which belongs to him in a sound general movement. An art tradition may be said to have existence only as it is created anew by each generation. No matter what the museum collections tell us about the past it is in the work of present-day artists that we must look for the living tradition.

That the tradition of American art is still vigorous is amply shown by the response of creative artists to government encouragement and support. This response has been magnificent. Their production has been large and of high quality. They have worked with intelligence, energy, and initiative . . . .

A full and free expression on the part of creative artists may have come about in a measure at this time because of a release from the grueling pressure which most of them suffered during the early part of the depression. It seems to have its origin also in a special set of circumstances determined by the Project. The new and outstanding situation is that these artists have been working with a growing sense of public demand for what they produce. For the first time in American art history a direct and sound relationship has been established between the American public and the artist. Community organizations of all kinds have asked for his work. In the discussions and interchanges between the artist and the public concerning murals, easel paintings, prints, and sculptures for public buildings, through the arrangements for allocations of art in many forms to schools and libraries, an active and often very human relationship has been created. The artist has become aware of every type of community demand for art, and has had the prospect of

increasingly larger audiences, of greatly extended public interest. There has been at least the promise of a broader and socially sounder base for American art with the suggestion that the age-old cleavage between artist and public is not dictated by the very nature of our society. New horizons have come into view.

American artists have discovered that they have work to do in the world. Awareness of society's need and desire for what they can produce has given them a new sense of continuity and assurance. This awareness has served to enhance the already apparent trend toward social content in art. In some instances the search for social content has taken the form of an illustrative approach to certain aspects of the contemporary American scene—a swing back to the point of view of the *genre* painters of the nineteenth century. Evidences of social satire have also appeared. In many phases of American expression this has been no more than a reaction against the genteel tradition or a confession of helplessness. The dominant trend today, as illustrated by the Project work, is more positive. There is a development toward greater vigor, unity, and clarity of statement, a search for an adequate symbolism in the expression of contemporary American experience, less dependence on the easily obvious in subject matter, and a definite relation to local and regional environments . . . .

### ART AND SOCIETY

Surely art is not merely decorative, a sort of unrelated accompaniment to life. In a genuine sense it should have use; it should be interwoven with the very stuff and texture of human experience, intensifying that experience, making it more profound, rich, clear, and coherent. This can be accomplished only if the artist is functioning freely in relation to society, and if society wants what he is able to offer.

The idea which has seemed most fruitful in contemporary art—particularly as shown by the work of artists under the Project—has been that of participation. Though the measure of security provided by the government in these difficult times unquestionably has been important, a sense of an active participation in the life and thought and movement of their own time has undoubtedly been even more significant for a large number of artists, particularly those in the younger groups. A new concept of social loyalty and responsibility, of the artist's union with his fellow men in origin and in destiny, seems to be replacing the romantic concept of nature which for so many years gave to artists and to many others a unifying approach to art. This concept is capable of great development in intellectual range and emotional power. This is what gives meaning to the social content of art in its deepest sense. An end seems to be in sight to the kind of detachment which removed the artist from common experience, and which at its worst gave rise to an art merely for the museum, or a rarified preciousness. This change does not mean any loss in the peculiarly personal expression which any artist of marked gifts will necessarily develop. Rather it means a greater scope and freedom for a more complete personal expression.

*Adolf Hitler, speech inaugurating the "Great Exhibition of German Art 1937," Munich\**

When, four years ago, the solemn ceremony of laying the cornerstone for this building took place, we were all conscious of the fact that not only the stone for a new building must be laid but the foundation for a new and true German art. At stake was our chance to provoke a turning-point in the development of the total German cultural output . . . .

Germany's collapse and general decline had been—as we know—not only economic or political, but probably even to a much greater extent, cultural. Moreover, this process could not be explained exclusively on the grounds of the lost war. Such catastrophes have very often afflicted peoples and states, only to provide an impetus to their purification and give rise to an inner elevation.

---

\* The speech inaugurating the Munich exhibition was published in *"Der Führer eröffnet die Grosse Deutsche Kunstausstellung 1937," Die Kunst im Dritten Reich* (Munich), I, 7–8 (July–August 1937), 47–61. These excerpts in English translation by Ilse Falk.

Hitler had devised a cunning means of demonstrating to the public the superiority of "true German art" over what the Nazis called "degenerate, Bolshevik, and Jewish art." This speech was delivered at the dedication of the *Haus der Deutschen Kunst* (now *Haus der Kunst*) a museum in Munich which conformed in style to the rigid Neoclassicism of the official Nazi architectural style. The opening exhibition was composed of German art approved by the Nazi leaders. It was in a pallid academic style verging on illustration that was concerned with the Nazi themes of heroism, familial duty, and work on the land. (But see how on the contrary Nazi propaganda leaders admitted the force of German Expressionism by utilizing it in their posters, see illus.).

For contrast Hitler had arranged a second art exhibition which opened in Munich that same summer—this one entitled *Entartete Kunst*, the infamous Degenerate Art exhibition that included virtually all the modern German artists who are important in the history of art, as well as many foreigners. This exhibition, in which paintings by the insane were mingled with the others and which was slovenly presented, was the subject of violent ridicule and vicious attack by the controlled press.

The exhibition was but a part of a great stock of nearly 20,000 works of modern art which had been confiscated from German museums by order of Joseph Goebbels with the advice of a minor academic painter of the nude, Adolf Ziegler, part of which two years later was sold abroad to finance the preparations for war and the rest burned.

Hitler's views on modern art in 1937 were not new, for as early as 1931 he had threatened "to release a tornado" against it. In 1933 official Nazi propaganda organs demanded that "all artistic productions with cosmopolitan or bolshevist tendencies must be thrown out of German museums and collections; they should be shown first to the public, the purchase price and the name of the responsible museum officials must be made known, but then all must be burned." In 1935, in a speech at Nuremberg, Hitler had threatened: "One will no longer discuss or deal with these corruptors of art. They are fools, liars, or criminals who belong in insane asylums or prisons."

The Nazi S.S. man who replaced the director of the Folkwang Museum in Essen unwittingly revealed the party's philosophy of culture when he declared that "the most perfect object created in the course of the last epochs did not originate in the studios of our artists. It is the steel helmet." (Quotations from Rudolf Schröder, "Modern Art in the Third Reich," *German Contemporary Art*, special issue of *Documents*, Offenburg, 1952.) [H. B. C.]

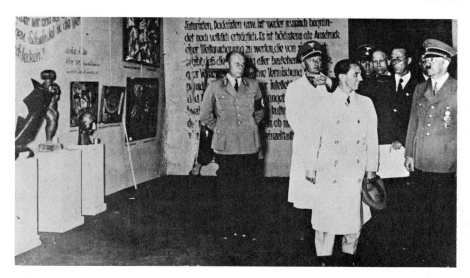

*Hitler and Goebbels viewing the exhibition of
degenerate art, 1937.*

However, that flood of slime and ordure which the year 1918 belched forth into
our lives was not a product of the lost war, but was only freed in its rush to the
surface by that calamity. Through the defeat, an already thoroughly diseased body
experienced the total impact of its inner decomposition. Now, after the collapse
of the social, economic, and cultural patterns which continued to function in
appearance only, the baseness already underlying them for a long time, triumphed,
and indeed this was so in all strata of our life.

It is obvious that, due to its nature, the economic decline was felt most
strongly, since the masses always become most urgently conscious of these condi-
tions. In comparison to this economic decline, the political collapse was either flatly
denied or at least not recognized by a great number of Germans, while the cultural
collapse was neither seen nor understood by the vast majority of our people . . . .

To begin with:

1. The circle of those who are consciously occupied with cultural matters is by
nature not nearly as large as the number of those who have to deal with economic
matters.

2. On these cultural grounds, more than on any others, Judaism had taken
possession of those means and institutions of communication which form, and
thus finally rule over public opinion. Judaism was very clever indeed, especially
in employing its position in the press with the help of so-called art criticism and
succeeding not only in confusing the natural concepts about the nature and scope
of art as well as its goals, but above all in undermining and destroying the general
wholesome feeling in this domain . . . .

475

Art, on the one hand, was defined as nothing but an international communal experience, thus killing altogether any understanding of its integral relationship with an ethnic group. On the other hand its relationship to time was stressed, that is: There was no longer any art of peoples or even of races, but only an art of the times. According to this theory, therefore, Greek art was not formed by the Greeks, but by a certain period which formed it as their expression. The same, naturally, was true of Roman art, which, for the same reasons, coincided only by accident with the rise of the Roman empire. Again in the same way the more recent art epochs of humanity have not been created by the Arabs, Germans, Italians, French, etc., but are only appearances conditioned by time. Therefore today no German or French or Japanese or Chinese art exists, but plainly and simply only a "modern art." Consequently, art as such is not only completely isolated from its ethnic origins, but it is the expression of a certain vintage which is characterized today by the word "modern," and thus, of course, will be un-modern tomorrow, since it will be outdated.

According to such a theory, as a matter of fact, art and art activities are lumped together with the handiwork of our modern tailor shops and fashion industries. And to be sure, following the maxim: Every year something new. One day Impressionism, then Futurism, Cubism, maybe even Dadaism, etc. A further result is that even for the most insane and inane monstrosities thousands of catch-words to label them will have to be found, and have indeed been found. If it weren't so sad in one sense, it would almost be a lot of fun to list all the slogans and clichés with which the so-called "art initiates" have described and explained their wretched products in recent years . . . .

Until the moment when National-Socialism took power, there existed in Germany a so-called "modern art," that is, to be sure, almost every year another one, as the very meaning of this word indicates. National-Socialist Germany, however, wants again a "German Art," and this art shall and will be of eternal value, as are all truly creative values of a people. Should this art, however, again lack this eternal value for our people, then indeed it will mean that it also has no higher value today.

When, therefore, the cornerstone of this building was laid, it was with the intention of constructing a temple, not for a so-called modern art, but for a true and everlasting German art, that is, better still, a House for the art of the German people, and not for any international art of the year 1937, '40, '50 or '60. For art is not founded on time, but only on peoples. It is therefore imperative for the artist to erect a monument, not so much to a period, but to his people. For time is changeable, years come and go. Anything born of and thriving on a certain epoch alone, would perish with it. And not only all which had been created before us would fall victim to this mortality, but also what is being created today or will be created in the future.

*But we National-Socialists know only one mortality, and that is the mortality of the people itself. Its causes are known to us. As long as a people exists, however, it is*

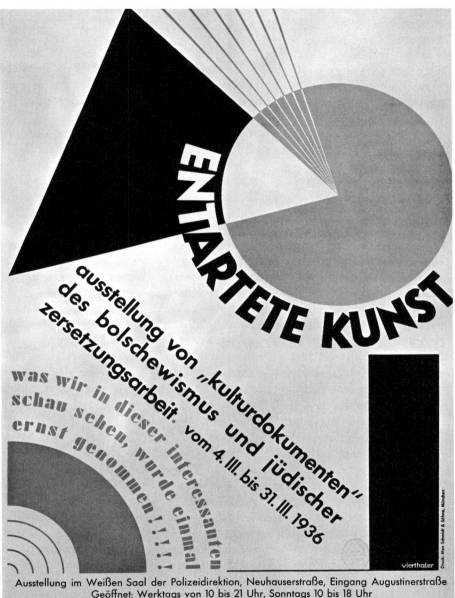

*Vierthaler (unidentified), Degenerate Art,*
*"Exhibition of 'culture documents' of the*
*decadent work of Bolsheviks and Jews," 1936.*

*the fixed pole in the flight of fleeting appearances. It is the being and the lasting per-manence. And, indeed, for this reason, art as an expression of the essence of this being, is an eternal monument—in itself the being and the permanence . . . .*

From the history of the development of our people we know that it is composed of a number of more or less differentiated races, which in the course of millenniums, thanks to the overwhelming formative influence of one outstand-ing racial core, resulted in that particular mixture which we see in our people today.

This power, once capable of forming a people, and thus still today an active one, is contained here again in the same Aryan race which we recognize not only as the carrier of our own culture, but as that of the preceding cultures of antiquity as well.

This particular type of composition of our national heritage conditions the versatility of our own cultural development just as much as it does the resulting natural kinship with those peoples and cultures of the same homogeneous racial core in other European countries of the same family of peoples.

Nevertheless, we who see in the German people the gradually crystallizing end result of this historical process, desire for ourselves an art which takes into account within itself the continually growing unification of this race pattern and, thus, emerges with a unified, well-rounded total character.

The question has often been asked: What does it really mean to be German? Among all those definitions which through the centuries have been suggested by many men, the most valuable one for me seems to be that one which from the start does not even try to give an explanation, but which rather sets up a law. And the most beautiful law which I can envisage for my people as the task set for its life in this world, a great German has already long ago put into words: "To be German is to be clear." This, moreover, implies that to be German means to be logical and also, above all, to be true . . . .

Now, this deep inner longing for such a true German art which carries within it the traits of this law of clarity has always been alive in our people. It occupied our great painters, our sculptors, the formers of our architecture, our thinkers and poets, and probably to the highest degree, our musicians. When on that fateful 6th of June in 1931 the old *Glaspalast*[1] burnt down in that horrible fire, an immortal treasure of such true German art went up in flames. They were called the Romantics, but in essence they were the most glorious representatives of those noble Germans in search of the true intrinsic virtue of our people and the honest and respectable expression of those only inwardly experienced laws of life. Yet it

---

[1] The Glaspalast (built 1854), located in the Botanical Garden in Munich, contained at the time of the destructive fire a comprehensive exhibition of German Romantic painting. This art, which included such masters as Caspar David Friedrich (1774–1840) and Philipp Otto Runge (1777–1810), was almost the only recent tradition of which the Nazis approved, embodying as it did a style and spirit which they took to be Germanic. Thus the destruction of many master works of this tradition presented an opportunity for Hitler to build a new museum devoted to his concept of what the art of the Third Reich should be. [H. B. C.]

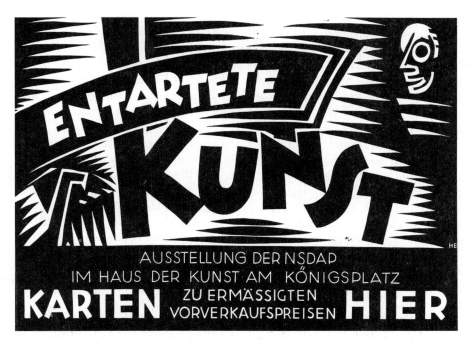

*H. E. (unidentified), Degenerate Art, Nazi
exhibition, ca. 1937.*

was not only the chosen subject matter that was decisive for the characterization
of the German substance, but just as important was the clear and simple manner
in which these feelings were represented . . . .

Art can in no way be a fashion. As little as the character and the blood of
our people will change, so much will art have to lose its mortal character and
replace it with worthy images expressing the life-course of our people in the
steadily unfolding growth of its creations. Cubism, Dadaism, Futurism, Im-
pressionism, etc., have nothing to do with our German people. For these concepts
are neither old nor modern, but are only the artifactitious stammerings of men to
whom God has denied the grace of a truly artistic talent, and in its place has
awarded them the gift of jabbering or deception. I will therefore confess now, in
this very hour, that I have come to the final inalterable decision to clean house,
just as I have done in the domain of political confusion, and from now on rid the
German art life of its phrase-mongering.

"Works of art" which cannot be understood in themselves but, for the
justification of their existence, need those bombastic instructions for their use,
finally reaching that intimidated soul, who is patiently willing to accept such
stupid or impertinent nonsense—these works of art from now on will no longer
find their way to the German people.

All those catchwords: "inner experience," "strong state of mind," "forceful will," "emotions pregnant with the future," "heroic attitude," "meaningful empathy," "experienced order of the times," "original primitivism," etc.—all these dumb, mendacious excuses, this claptrap or jabbering will no longer be accepted as excuses or even recommendations for worthless, integrally unskilled products. *Whether or not anybody has a strong will or an inner experience, he will have to prove through his work, and not through gibberish. And anyhow, we are all much more interested in quality than in the so-called will* . . . .

I have observed among the pictures submitted here, quite a few paintings which make one actually come to the conclusion that the eye shows things differently to certain human beings than the way they really are, that is, that there really are men who see the present population of our nation only as rotten cretins; who, on principle, see meadows blue, skies green, clouds sulphur yellow, and so on, or, as they say, experience them as such. I do not want to enter into an argument here about the question of whether the persons concerned really do or do not see or feel in such a way; but, in the name of the German people, I want to forbid these pitiful misfortunates who quite obviously suffer from an eye disease, to try vehemently to foist these products of their misinterpretation upon the age we live in, or even to wish to present them as "Art."

No, here there are only two possibilities: Either these so-called "artists" really see things this way and therefore believe in what they depict; then we would have to examine their eyesight-deformation to see if it is the product of a mechanical failure or of inheritance. In the first case, these unfortunates can only be pitied; in the second case, they would be the object of great interest to the Ministry of Interior of the Reich which would then have to take up the question of whether further inheritance of such gruesome malfunctioning of the eyes cannot at least be checked. If, on the other hand, they themselves do not believe in the reality of such impressions but try to harass the nation with this humbug for other reasons, then such an attempt falls within the jurisdiction of the penal law.

This House, in any case, has neither been planned, nor was it built for the works of this kind of incompetent or art criminal . . . .

But far more important is the fact that the labor performed here on this spot for four and a half years, the maximum achievements demanded here of thousands of workers, were not intended to serve the purpose of exhibiting the production of men who, to top it off, were lazy enough to dirty a canvas with color droppings in the firm hope that, through the daring advertisement of their products as the lightning birth of genius, they could not fail to produce the needed impression and qualifications for their acceptance. No, I say. The diligence of the builder of this House and the diligence of his collaborators must be equaled by the diligence of those who want to be represented in this House. Beyond this, I am not the least bit interested in whether or not these "also-rans" of the art world will cackle among themselves about the eggs they have laid, thereby giving to each other their expert opinion.

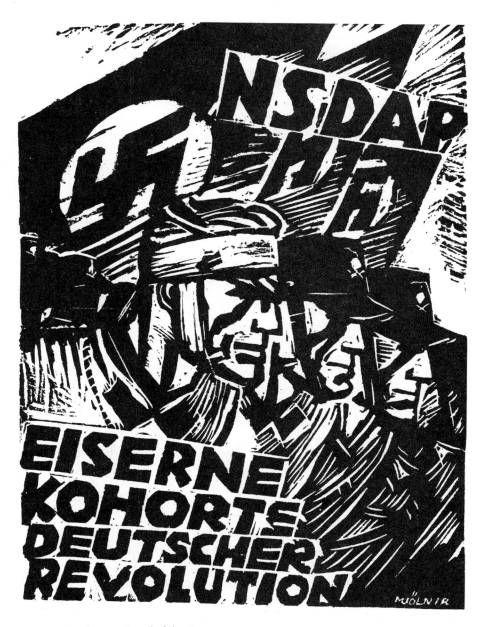

N.S.D.A.P.: *The Iron Guard of the German
Revolution* (*N.S.D.A.P.—National Sozial-
istiche Deutsche Arbeiter Partei-Nazi*), *ca.
1934.*

481

*For the artist does not create for the artist, but just like every one else he creates for the people.*

And we will see to it that from now on the people will once again be called upon to be the judges of their own art . . . .

I do not want anybody to have false illusions: National-Socialism has made it its primary task to rid the German Reich, and thus, the German people and its life of all those influences which are fatal and ruinous to its existence. And although this purge cannot be accomplished in one day, I do not want to leave the shadow of a doubt as to the fact that sooner or later the hour of liquidation will strike for those phenomena which have participated in this corruption.

*But with the opening of this exhibition the end of German art foolishness and the end of the destruction of its culture will have begun.*

From now on we will wage an unrelenting war of purification against the last elements of putrefaction in our culture. However, should there be someone among those elements who still believes that he is destined to higher ranks, then he has had ample time in these four years to prove it. For us, in any case, these four years are long enough to reach a final judgment. From now on—I assure you— all those cliques of babblers, dilettantes and art crooks which lend support to each other and are therefore able to survive, will be eliminated and abolished. For our sake those prehistoric stone-age culture-vultures and art stammerers may just as well retreat to the caves of their ancestors to adorn them with their primitive international scribblings.

But the House for German Art in Munich has been built by the German people for their own German art.

To my great pleasure, I am able to state that now already, besides the many decent older artists, who have until now lived in terror and were suppressed, but, who deep in their souls had always remained German, a number of new youthful masters are presenting themselves. A walk through this exhibition will allow you to find quite a few things that will impress you as beautiful and, above all, as decent, and which you will sense to be good. Particularly the level of the graphic art submitted was on the average from the very beginning extremely high and thus satisfying.

Many of our young artists will now recognize in what is being offered them which road they should take; but perhaps they will also gain a new impetus from the greatness of the times in which we all live, and from which we take courage and, above all, retain the courage to produce a really diligent and, thus, in the final run, competent work.

AND WHEN ONCE AGAIN IN THIS REALM OF ART THE HOLY CONSCIENTIOUSNESS WILL HAVE REGAINED ITS FULL RIGHTS, THEN, I HAVE NO DOUBT, THE ALMIGHTY WILL ELEVATE A FEW FROM THIS MULTITUDE OF DECENT CREATORS OF ART INTO THE STARRY SKIES OF THE IMMORTAL, DIVINELY INSPIRED ARTISTS OF THE GREAT PAST. FOR WE DO NOT BELIEVE THAT WITH THE GREAT MEN OF THE CENTURIES GONE BY, THE TIME FOR THE CREATIVE POWER OF A FEW BLESSED MEN HAS COME TO AN END, NOR THAT

THE CREATIVE POWER OF A COLLECTIVE BROAD MASS WILL TAKE ITS PLACE IN THE FUTURE. NO! WE BELIEVE THAT ESPECIALLY TODAY, WHEN IN SO MANY REALMS THE HIGHEST ACHIEVEMENTS ARE BEING ACCOMPLISHED, THAT ALSO IN THE REALM OF ART THE HIGHEST VALUE OF A PERSONALITY AS AN INDIVIDUAL WILL MAKE A TRIUMPHANT REAPPEARANCE.

I CAN THEREFORE EXPRESS NO OTHER WISH AT THIS MOMENT THAN THAT THE NEW HOUSE BE PRIVILEGED TO REVEAL AGAIN TO THE GERMAN PEOPLE A LARGE NUMBER OF WORKS BY GREAT ARTISTS IN THESE HALLS DURING THE COMING CENTURIES, AND THUS CONTRIBUTE NOT ONLY TO THE GLORY OF THIS TRUE CITY OF ART, BUT ALSO TO THE HONOR AND PRESTIGE OF THE ENTIRE GERMAN NATION.

I HEREWITH DECLARE THE GREAT EXHIBITION OF GERMAN ART 1937 IN MUNICH OPENED!

*André Breton and Leon Trotsky, "Manifesto: Towards a Free Revolutionary Art," 1938\**

We can say without exaggeration that never has civilization been menaced so seriously as today. The Vandals, with instruments which were barbarous, and so comparatively ineffective, blotted out the culture of antiquity in one corner of Europe. But today we see world civilization, united in its historic destiny, reeling under the blows of reactionary forces armed with the entire arsenal of modern technology. We are by no means thinking only of the world war that draws near. Even in times of "peace," the position of art and science has become absolutely intolerable.

Insofar as it originates with an individual, insofar as it brings into play subjective talents to create something which brings about an objective enriching of culture, any philosophical, sociological, scientific, or artistic discovery seems to be the fruit of a precious *chance*, that is to say, the manifestation, more or less spontaneous, of necessity. Such creations cannot be slighted, whether from the standpoint of general knowledge (which interprets the existing world), or of revolutionary knowledge (which, the better to change the world, requires an exact analysis of the laws which govern its movement). Specifically, we cannot remain indifferent to the intellectual conditions under which creative activity take place, nor should we fail to pay all respect to those particular laws which govern intellectual creation.

In the contemporary world we must recognize the ever more widespread destruction of those conditions under which intellectual creation is possible. From this follows of necessity an increasingly manifest degradation not only of the work of art but also of the specifically "artistic" personality. The regime of Hitler, now

---

\* This English translation by Dwight MacDonald from *Partisan Review* (New York), IV, 1 (Fall 1938), 49–53. For tactical reasons, Diego Rivera rather than Trotsky was originally cited as co-author of the manifesto. See footnote, p. 457.

that it has rid Germany of all those artists whose work expressed the slightest sympathy for liberty, however superficial, has reduced those who still consent to take up pen or brush to the status of domestic servants of the regime, whose task it is to glorify it on order, according to the worst possible aesthetic conventions. If reports may be believed, it is the same in the Soviet Union, where Thermidorean reaction is now reaching its climax.

It goes without saying that we do not identify ourselves with the currently fashionable catchword: "Neither fascism nor communism!" a shibboleth which suits the temperament of the Philistine, conservative and frightened, clinging to the tattered remnants of the "democratic" past. True art, which is not content to play variations on ready-made models but rather insists on expressing the inner needs of man and of mankind in its time—true art is unable *not* to be revolutionary, *not* to aspire to a complete and radical reconstruction of society. This it must do, were it only to deliver intellectual creation from the chains which bind it, and to allow all mankind to raise itself to those heights which only isolated geniuses have achieved in the past. We recognize that only the social revolution can sweep clear the path for a new culture. If, however, we reject all solidarity with the bureaucracy now in control of the Soviet Union, it is precisely because, in our eyes, it represents not communism but its most treacherous and dangerous enemy.

The totalitarian regime of the U.S.S.R., working through the so-called "cultural" organizations it controls in other countries, has spread over the entire world a deep twilight hostile to every sort of spiritual value. A twilight of filth and blood in which, disguised as intellectuals and artists, those men steep themselves who have made of servility a career, of lying for pay a custom, and of the palliation of crime a source of pleasure. The official art of Stalinism mirrors with a blatancy unexampled in history their efforts to put a good face on their mercenary profession.

The repugnance which this shameful negation of the principles of art inspires in the artistic world—a negation which even slave states have never dared carry so far—should give rise to an active, uncomprising condemnation. The *opposition* of writers and artists is one of the forces which can usefully contribute to the discrediting and overthrow of regimes which are destroying, along with the right of the proletariat to aspire to a better world, every sentiment of nobility and even of human dignity.

The communist revolution is not afraid of art. It realizes that the role of the artist in a decadent capitalist society is determined by the conflict between the individual and various social forms which are hostile to him. This fact alone, insofar as he is conscious of it, makes the artist the natural ally of revolution. The process of *sublimation*, which here comes into play, and which psychoanalysis has analyzed, tries to restore the broken equilibrium between the integral "ego" and the outside elements it rejects. This restoration works to the advantage of the "ideal of self," which marshals against the unbearable present reality all those powers of the interior world, of the "self," which are *common to all men* and which are constantly

flowering and developing. The need for emancipation felt by the individual spirit has only to follow its natural course to be led to mingle its stream with this primeval necessity: the need for the emancipation of man.

The conception of the writer's function which the young Marx worked out is worth recalling. "The writer," he declared, "naturally must make money in order to live and write, but he should not under any circumstances live and write in order to make money. The writer by no means looks at his work as a *means*. It is *an end in itself* and so little a means in the eyes of himself and of others that if necessary he sacrifices his existence to the existence of his work . . . . *The first condition of the freedom of the press is that it is not a business activity.*" It is more than ever fitting to use this statement against those who would regiment intellectual activity in the direction of ends foreign to itself, and prescribe, in the guise of so-called "reasons of State," the themes of art. The free choice of these themes and the absence of all restrictions on the range of his explorations—these are possessions which the artist has a right to claim as inalienable. In the realm of artistic creation, the imagination must escape from all constraint and must, under no pretext, allow itself to be placed under bonds. To those who would urge us, whether for today or for tomorrow, to consent that art should submit to a discipline which we hold to be radically incompatible with its nature, we give a flat refusal, and we repeat our deliberate intention of standing by the formula: *complete freedom for art.*

We recognize, of course, that the revolutionary State has the right to defend itself against the counterattack of the bourgeoisie, even when this drapes itself in the flag of science or art. But there is an abyss between these enforced and temporary measures of revolutionary self-defense and the pretension to lay commands on intellectual creation. If, for the better development of the forces of material production, the revolution must build a *socialist* regime with centralized control, to develop intellectual creation an *anarchist* regime of individual liberty should from the first be established. No authority, no dictation, not the least trace of orders from above! Only on a base of friendly cooperation, without the constraint from outside, will it be possible for scholars and artists to carry out their tasks, which will be more far-reaching than ever before in history.

It should be clear by now that in defending freedom of thought we have no intention of justifying political indifference, and that it is far from our wish to revive a so-called "pure" art which generally serves the extremely impure ends of reaction. No, our conception of the role of art is too high to refuse it an influence on the fate of society. We believe that the supreme task of art in our epoch is to take part actively and consciously in the preparation of the revolution. But the artist cannot serve the struggle for freedom unless he subjectively assimilates its social content, unless he feels in his very nerves its meaning and drama and freely seeks to give his own inner world incarnation in his art.

In the present period of the death agony of capitalism, democratic as well as fascist, the artist sees himself threatened with the loss of his right to live and

continue working. He sees all avenues of communication choked with the debris of capitalist collapse. Only naturally, he turns to the Stalinist organizations, which hold out the possibility of escaping from his isolation. But if he is to avoid complete demoralization, he cannot remain there, because of the impossibility of delivering his own message and the degrading servility which these organizations exact from him in exchange for certain material advantages. He must understand that his place is elsewhere, not among those who betray the cause of the revolution and of mankind, but among those who with unshaken fidelity bear witness to this revolution, among those who, for this reason, are alone able to bring it to fruition, and along with it the ultimate free expression of all forms of human genius.

The aim of this appeal is to find a common ground on which may be reunited all revolutionary writers and artists, the better to serve the revolution by their art and to defend the liberty of that art itself against the usurpers of the revolution. We believe that aesthetic, philosophical, and political tendencies of the most varied sort can find here a common ground. Marxists can march here hand in hand with anarchists, provided both parties uncompromisingly reject the reactionary police-patrol spirit represented by Joseph Stalin and by his henchman, Garcia Oliver.

We know very well that thousands on thousands of isolated thinkers and artists are today scattered throughout the world, their voices drowned out by the loud choruses of well-disciplined liars. Hundreds of small local magazines are trying to gather youthful forces about them, seeking new paths and not subsidies. Every progressive tendency in art is destroyed by fascism as "degenerate." Every free creation is called "fascist" by the Stalinists. Independent revolutionary art must now gather its forces for the struggle against reactionary persecution. It must proclaim aloud its right to exist. Such a union of forces is the aim of the *International Federation of Independent Revolutionary Art* which we believe it is now necessary to form.

We by no means insist on every idea put forth in this manifesto, which we ourselves consider only a first step in the new direction. We urge every friend and defender of art, who cannot but realize the necessity for this appeal, to make himself heard at once. We address the same appeal to all those publications of the left-wing which are ready to participate in the creation of the International Federation and to consider its task and its methods of action.

When a preliminary international contact has been established through the press and by correspondence, we will proceed to the organization of local and national congresses on a modest scale. The final step will be the assembling of a world congress which will officially mark the foundation of the International Federation.

Our aims:

The independence of art—for the revolution;

The revolution—for the complete liberation of art!

*Pablo Picasso, statement about the artist as a political being, 1945*★

What do you think an artist is? An imbecile who has only his eyes if he's a painter, or ears if he's a musician, or a lyre at every level of his heart if he's a poet, or even, if he's a boxer, just his muscles? On the contrary, he's at the same time a political being, constantly alive to heartrending, fiery, or happy events, to which he responds in every way. How would it be possible to feel no interest in other people and by virtue of an ivory indifference to detach yourself from the life which they so copiously bring you? No, painting is not done to decorate apartments. It is an instrument of war for attack and defense against the enemy.

*Pablo Picasso, conversation on Guernica as recorded by Jerome Seckler, 1945*†

I told Picasso that many people were saying that now, with his new political affiliations, he had become a leader in culture and politics for the people, that his influence for progress could be tremendous. Picasso nodded seriously and said, "Yes, I realize it." I mentioned how we had often discussed him back in New York, especially the *Guernica* mural (now on loan to the Museum of Modern Art in New York) [acquired by the museum soon after—Ed.]. I talked about the significance of the bull, the horse, the hands with the lifelines, etc., and the origin of the symbols in Spanish mythology. Picasso kept nodding his head as I spoke. "Yes,' he said, "the bull there represents brutality, the horse the people. Yes, there I used symbolism, but not in the others."

I explained my interpretation of two of his paintings at the exhibition, one of a bull, a lamp, palette and book. The bull, I said, must represent fascism, the lamp, by its powerful glow, the palette and book all represented culture and freedom—the things we're fighting for—the painting showing the fierce struggle going on between the two.

"No," said Picasso, "the bull is not fascism, but it is brutality and darknesss."

I mentioned that now we look forward to a perhaps changed and more simple and clearly understood symbolism within his very personal idiom.

"My work is not symbolic," he answered. "Only the *Guernica* mural is symbolic. But in the case of the mural, that is allegoric. That's the reason I've used the horse, the bull, and so on. The mural is for the definite expression and solution of a problem and that is why I used symbolism.

★ Excerpt from an interview with Simone Téry, "Picasso n'est pas officier dans l'armée Française," *Lettres Françaises* (Paris), V, 48 (24 March 1945), 6. This English translation from *Picasso: Fifty Years of His Art* by Alfred Barr, Jr., copyright 1946 by The Museum of Modern Art, New York, and reprinted with its permission.

† Excerpt from an interview with Pfc. Jerome Seckler, "Picasso Explains," *New Masses* (New York), LIV, 11 (13 March 1945), 4–7.

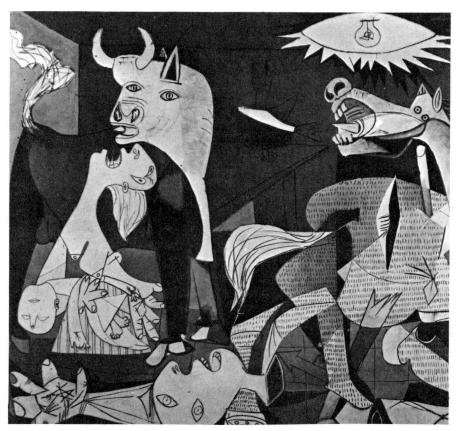

*Pablo Picasso, Guernica (detail), 1937, oil on canvas.*

"Some people," he continued, "call my work for a period 'surrealism.' I am not a surrealist. I have never been out of reality. I have always been in the essence of reality [literally the 'real of reality']. If someone wished to express war it might be more elegant and literary to make a bow and arrow because that is more esthetic, but for me, if I want to express war, I'll use a machine-gun! Now is the time in this period of changes and revolution to use a revolutionary manner of painting and not to paint like before." He then stared straight into my eyes and asked, *"Vous me croirez?"* [Do you believe me?] . . . .

". . . But," I insisted, "you do think about and feel deeply these things that are affecting the world. You recognize that what is in your subconscious is a result of your contact with life, and your thoughts and reactions to it. It couldn't be merely accidental that you used precisely these particular objects and presented them in a particular way. The political significance of these things is there whether you consciously thought of it or not."

"Yes," he answered, "what you say is very true, but I don't know why I

used those particular objects. They don't represent anything in particular. The bull is a bull, the palette a palette, and the lamp is a lamp. That's all. But there is definitely no political connection there for me. Darkness and brutality, yes, but not fascism."

He motioned to the color etching of the glass and lemon. "There," he said, "is a glass and a lemon, its shapes and colors—reds, blues, yellows. Can you see any political significance in that?"

"Simply as objects," I said, "no."

"Well," he continued, "it's the same with the bull, the palette, and lamp." He looked earnestly at me and went on, "If I were a chemist, Communist or fascist—if I obtain in my mixture a red liquid it doesn't mean that I am expressing Communist propaganda, does it? If I paint a hammer and sickle people may think it's a representation of Communism, but for me it's only a hammer and sickle. I just want to reproduce the objects for what they are and not for what they mean. If you give a meaning to certain things in my paintings it may be very true, but it was not my idea to give this meaning. What ideas and conclusions you have got I obtained too, but instinctively, unconsciously. I make a painting for the painting. I paint the objects for what they are. It's in my subconscious. When people look at it each person gets perhaps a different meaning from it, from what each sees in it. I don't think of trying to get any particular meaning across. There is no deliberate sense of propaganda in my painting."

"Except in the *Guernica*," I suggested.

"Yes," he replied, "except in the *Guernica*. In that there is a deliberate appeal to people, a deliberate sense of propaganda . . . ."

"I am a Communist and my painting is Communist painting . . . . But if I were a shoemaker, Royalist or Communist or anything else, I would not necessarily hammer my shoes in a special way to show my politics."

*Robert Motherwell and Harold Rosenberg, "The Question of What Will Emerge is Left Open," 1947*★

This is a magazine of artists and writers who "practice" in their work their own experience without seeking to transcend it in academic, group or political formulas.

Such practice implies the belief that through conversion of energy something valid may come out, whatever the situation one is forced to begin with.

The question of what will emerge is left open. One functions in an attitude of expectancy. As Juan Gris said: "You are lost the instant you know what the result will be."

Naturally the deadly political situation exerts an enormous pressure.

★ Opening statement for *Possibilities*, "An Occasional Review," (New York), No. 1 (Winter 1947/48), p. 1.

The temptation is to conclude that organized social thinking is "more serious" than the act that sets free in contemporary experience forms which that experience has made possible.

One who yields to this temptation makes a choice among various theories of manipulating the known elements of the so-called objective state of affairs. Once the political choice has been made, art and literature ought of course be given up.

Whoever genuinely believes he knows how to save humanity from catastrophe has a job before him which is certainly not a part-time one.

Political commitment in our times means logically—no art, no literature. A great many people, however, find it possible to hang around in the space between art and political action.

If one is to continue to paint or write as the political trap seems to close upon him he must perhaps have the extremest faith in sheer possibility.

In his extremism he shows that he has recognized how drastic the political presence is.

## Vladimir Kemenov, "Aspects of Two Cultures," 1947*

The basic features of decadent bourgeois art are its falseness, its belligerent anti-realism, its hostility to objective knowledge and to the truthful portrayal of life in art. Here, too, the reactionary tendency in contemporary bourgeois art is presented under the banner of "originality," of struggle against "bourgeois" ideology, etc. Those extreme forms represented by the various "-isms" of anti-realistic bourgeois art were led up to by the gradual renunciation by bourgeois artists of the finest traditions of bourgeois realism in the eighteenth and nineteenth centuries as well as of the realistic traditions of the art of Greece and the Renaissance. The decline of bourgeois art became most rapid at the end of the nineteenth and the beginning of the twentieth centuries, with the rise of the epoch of imperialism and the decay of bourgeois culture which it involved. Even in impressionism we have a suggestion of the artist's indifference to subject matter, reflecting an indifference to the message of art. The interests of the artists of this school became greatly limited; the impressionists painted mostly landscapes and portraits, but their landscapes were approached almost exclusively from the point of view of portraying light, while their portraits, strange as it may seem, reflect a "landscape" approach to the portrayal of the human face. The interpretation of the sitter's character, his inner world and psychology are all subordinated to problems of plain air and the object of conveying the vibrations of light on the body and clothes of the sitter. But the impressionists still saw nature whole, perceiving it directly through man's visual channels.

* Excerpts from the article in *VOKS Bulletin* (Moscow), U.S.S.R. Society for Cultural Relations with Foreign Countries, 1947, pp. 20–36.

The post-impressionists, especially Cézanne, criticised the impressionists for making the portrayal of light the exclusive concern of their pictures, sometimes allowing light to diffuse, as it were, the forms of objects. Going to the opposite extreme in their zeal to confirm "material substance," they banned light from painting entirely, and in their portrayals of man and nature began to emphasize properties (volume, weight, form, structure) common to both animate and inanimate objects, gradually turning both landscapes and portraits into still-lifes. In Cézanne's still-lifes the objects become doubly lifeless: his fruits and flowers lack texture and aroma. Particularly lifeless are his portraits, which completely express the artist's profound and even demonstrative indifference to man. This paved the way for the ensuing anti-humanistic trends of bourgeois art. But "in his compositions, Cézanne could not yet dispense with natural objects as a foundation," laments the suprematist K. Malevich.[1] Cubism and futurism finally broke up objects into geometric lines and planes, dissected them into the elements composing their outer forms and attempted to bring some kind of order into the resulting chaos. Realism was done for, as Picasso openly proclaimed. "We now know," wrote Picasso, "that art is not the truth. Art is a lie enabling us to approach the truth . . . . It is up to the artist to find means of convincing the public of the truth of his lie." [2]

The underlying essence of the class ideology of the reactionary bourgeois epoch of imperialism is clearly expressed in this championing of the lie, in this denial of all objective laws and the possibility of fathoming them, in this hatred for realistic art (no less than for the materialistic theory of knowledge in science). It represents a fear of the truth, a fear of rational knowledge of life, an animal fear in the face of the inexorable operation of the laws governing the development of reality, laws presaging the inevitable destruction of monopolistic capitalism as an antiquated social form hindering the further development of humanity, smothering all that is vital and progressive, maiming the lives of millions of people for the sake of maintaining and strengthening power in the hands of a group of parasitic exploiters . . . .

In truth, the principle reasons for the gulf between contemporary art and the people, for the extreme decline and degradation of contemporary bourgeois art, is its reactionary content, that is, its militant hostility to popular ideas, and its decadent form—the result of its having cut itself off from life. Within art this is reflected in the rejection of realism, which is the sole basis of genuine artistic creation, without which an integral work of art is impossible . . . .

As for correcting the basic and all-decisive error of modern art—that is, changing its attitude towards reality, bridging the gap between art and life, returning to realism as the only road leading to progress and the flourishing of the

---

[1] K. Malevich, *Manifest suprematizma.* V. K.
[2] *Arts de France*, No. 5, 1946. V. K.

arts—that was something these experimenters and innovators in art failed to think about, and therefore their attempts to find a solution for the growing artistic crisis were doomed to failure.

Leaders of various schools of contemporary bourgeois art embarked upon a one-sided development of the diverse elements of artistic form which in classical bourgeois realism existed in unity and harmony.

Thus, the impressionists made a fetish of light and visual sensation and developed these one-sidedly to the detriment of other elements of painting. Disputing with the impressionists, Cézanne banned light in favor of geometric volumes modelled in color. The futurists, just as one-sidedly, developed problems of motion, making a fetish of that, and subordinating all else to it. The expressionists, again, one-sidedly emphasized the subjective factor and the element of exaggeration (factors, which, as such and no more, may be said to be intrinsic to the creative process), hypertrophying them, for purposes of greater "expressiveness," to the point of hideously deforming the objects and phenomena depicted. Lesser schools have contented themselves with making a fetish of such components of painting as surface texture, geometric line, and so on (purism, tactilism). Innumerable schools and trends have arisen, each of them making pretentious claims, shouting imprecations at each other, waging a war of "principles."

This seeming activity in the realm of art is, however, by no means evidence of virility. On the contrary, it bears witness to its progressive deterioration . . . .

For all the "freedom" which artists won after they had driven life from the realm of their formalistic art, they nevertheless tried at the beginning of the century to justify this subjective anarchy by pseudo-scientific, technical, and other subterfuges in their work, writings and declarations . . . to prove its analytical character, and so on. However, very soon even this quasi-scientific terminology was discarded, and in contemporary bourgeois formalistic art the most rampant subjectivism, proclaiming the cult of mysticism and of the subconscious, has triumphed openly, and abnormal mental states are held up as examples of the complete creative freedom of the individual.

All these features of decadent bourgeois art were declared aspects of "art for art's sake," which is alleged to be alien to any semblance of ideological content. As a matter of fact, this "pure" art actually disseminated reactionary ideas, ideas that were advantageous or useful to the capitalists. Formalistic artists ceased to be rebels and became the abject slaves of capital, even though from time to time they did assail capitalism, sometimes even sincerely. How are these different factors to be reconciled? Among certain formalistic artists in foreign countries a yawning chasm formed between their political views and public sympathies on the one hand, and their artistic practice on the other. This chasm proved so great that even the events of the world war against fascism, in which many of them participated as members of the allied armies or the resistance movement, could not change their views on art. They continued demonstratively to deny the ideological

content of art and all connection between the aims of art and the interests of the wide masses.

Even those formalists, who, like Picasso, have repeatedly professed sympathy for the struggle of democracy against fascism show a marked unwillingness to apply the progressive aspects of their world outlook to their artistic practice. A yawning chasm still exists in their work to this day, resulting not merely in the failure of these artists to advance the struggle of their peoples against fascism and reaction by their creative efforts, but also, objectively, in their furthering (through their art) the very aims of the bourgeois reaction against which they vehemently protest in their political utterances and declarations.

By proclaiming "art for art's sake," void of all contact with the struggle, aspirations and interests of the wide masses, by cultivating individualism, the formalists are affirming the very thing the reactionaries want them to. They are playing into the hands of the decadent bourgeoisie who in their efforts to preserve their domination look with hatred upon the development of the consciousness of the masses, upon the growth of their sense of human dignity and their feeling of solidarity, upon any rousing of their activity through the means of realistic art rich in ideological content.

It is frequently said that in his pathological work Picasso has deliberately created an ugly and repellant image of contemporary capitalist reality in order to rouse the spectator's hatred for it—that Picasso is the artist of "Spanish democracy."

This, obviously, is not true. Although Picasso's early works of his "blue" period still retain some connection with Spanish painting, when he turned to cubism his art became absolutely abstract. He then renounced all the traditions of realistic art, Spanish included, and followed the line of cosmopolitanism, of empty, ugly, geometric forms, which are as alien to Spanish as to any other democracy. When Picasso wanted to portray the suffering of the Spanish people in the war against Italian and German fascism, he painted his *Guernica*—but here, too, instead of heroic Spanish republicans, he showed us the same wretched, pathological and deformed types as in his other paintings. No, it is not in order to expose the contradictions of reality nor to arouse hatred for the forces of reaction that Picasso creates his morbid, revolting pictures. His is an aesthetic apologetics for capitalism; he is convinced of the artistic value of the nightmares called into being by the disintegration of the social psyche of the capitalist class . . . .

It is naive to imagine that an incongrous distortion of man "upsets" the bourgeoisie. This is a favorite theory (accepted without question by Madelaine Rousseau) by which Picasso's champions attempt to prove the "anti-bourgeois" and "revolutionary" nature of his art. But it is notable that this ugly distortion rouses the indignation of the plain people rather than of the bourgeoisie. This can be observed in France as well as in other countries. It was just these plain people who were most incensed by Picasso's London exhibition. Even the magazine *Studio* wrote that the pictures in this exhibition were severely judged and were defined as degrading, demoralizing, decadent and degenerate. The *Times* received

more letters about this exhibition than it received when the atom bomb was invented, and the overwhelming majority of the letters expressed the indignation of those who had visited Picasso's exhibition. As for his pictures "upsetting" the bourgeoisie, it is just the bourgeoisie who represent his principal admirers and supporters. American magazines are always prompt to report how many thousands of dollars Picasso's latest picture has been sold for.

Certain of Picasso's champions manage to find that his art is "humane," although every one of his pictures refutes this by tearing the body and face of man to pieces and by distorting him beyond recognition. (See, for example, his series of feminine portraits published in Paris in 1943, or his painting of a seated woman included in the post-war New York exhibition of 1947.) They explain his distortions by claiming that Picasso gives a true reflection of his age. Here, for example, is what the French critic Anatole Jakovski says in an article in the *Arts de France:* "Nothing human is alien to Picasso. He sees all that is human just as it is, with all its evils and ugliness, and only as a worthy contemporary of Buchenwald and Ravensbruck must often see it. Can Picasso be blamed for having chosen the wrong epoch?" [1] The same idea is met in an article by another contributor to this magazine.[2] In this article the author shows that Picasso's attitude to reality is one of "tenderness, sometimes turning to harshness. But is the gulf dividing these two attitudes so very great?" Such is reality for Picasso. "Of course it is claimed that he sometimes sees it as monstrous. This is a fine accusation to be made by an epoch which forces the artist to become locked up in himself and is shocked when he, like the trees in a Japanese garden, responds with nothing but thorns and prickly flowers. Picasso is also offered as proof that a genius can do nothing other than reflect the best and the worst aspects of his age, with all of its most striking contradictions." [3]

Thus it follows that the age is entirely to blame. There is, of course, a measure of truth in such a claim, for the epoch of imperialism has indeed crippled and mutilated the talent of many artists, including Picasso. It has led them astray and turned them from realism, the only true path in art, into the hopeless labyrinth of formalistic tendencies and endless "-isms." But it would be wrong to claim that every contemporary artist is fated to become part of the process of disintegration characteristic of decadent bourgeois art. The age (which Picasso cannot indeed be blamed for choosing) has produced not only fascism, Buchenwald, and Ravensbruck. It has also produced the heroic struggle of the peoples against fascism and works by writers and artists inspired with democratic ideas. Why have these aspects of contemporary life not influenced the work of Picasso? ...

The Great Socialist revolution changed reality; in place of the former bourgeois-landlord structure of old tsarist Russia it built up a socialist society. On this new soil art flourished and a way was found out of the impasse presented by

[1] *Arts de France*, No. 5, 1946. V. K.
[2] *Arts de France*, No. 6, 1946. V. K.
[3] *Arts de France*, No. 7, 1946. V. K.

formalism and ideological vacuity. In the U.S.S.R. art received the right to participate in the building up of life not as ordered by the rich patrons of the arts, but in accordance with the nation-wide state socialist plan (the construction of new and the reconstruction of old cities, architecture, sculpture, frescoes, easel painting applied to large public projects—the subway, the Volga Canal, the Palace of Soviets, etc.). Art in the U.S.S.R. again enjoys a mass audience, a wide public comprised of the millions of Soviet peoples of all nationalities and walks of life. Art has again become popular in the fullest, most literal sense of the word.

Soviet art is progressing along the path of socialist realism, a path pointed out by Stalin. It is this path that has led to the creation of a vital Soviet art, ideologically forward-looking and artistically wholesome: socialist in content and national in form; an art worthy of the great Stalin epoch.

As opposed to decadent bourgeois art, hypocritically hiding its reactionary class nature behind phrases such as "pure art" and "art for art's sake," Soviet artists openly espouse the ideas of Bolshevism expressing the advanced ideas of the Soviet people who at present represent the most advanced people of the world, for they have built up Socialism, the most advanced form of contemporary society. As opposed to decadent bourgeois art with its anti-humanism, Soviet artists present the art of socialist humanism, an art imbued with supreme love for man, with pride in the emancipated individual of the socialist land, with profound sympathy for that part of humanity living under the capitalist system, a system which cripples and degrades men. As opposed to decadent bourgeois art with its falseness, its rejection of a realistic, truthful reflection of life as it is, Soviet artists present the wholesome and integral art of socialist realism, expressed in profound artistic images reflecting true life, showing the struggle between the old and the new and the inevitable triumph of the new and progressive, an art mobilizing Soviet people for further victories. As opposed to decadent bourgeois art, divorced from the people, hostile to the interests of the democratic masses, permeated with biological individualism and mysticism, reactionary and anti-popular, Soviet artists present an art created for the people, inspired by the thoughts, feelings and achievements of the people, and which in its turn enriches the people with its lofty ideas and noble images.

Young Soviet art has already created works of world-wide significance. Soviet artists are inspired by great tasks and purposes. Soviet art is advancing along the true path indicated by the genius of Stalin.

Among the many burdens which the young Soviet republic inherited a quarter of a century ago from old landlord-bourgeois Russia, was the decadent, formalistic art of that time. All those "original" tricks which the formalists of Europe and America take such pride in, were ousted by Soviet artists long ago as ridiculous anachronisms.

The road travelled by Soviet art in overcoming formalism is of inestimable importance to the art culture of the whole world. The experience

accumulated by Soviet artists will time and again stand the artists of other countries in good stead when they begin to look for a way out of the impasse of formalism and to create a genuine people's art.

Soviet artists were the daring pioneers who blazed new trails for the further development of contemporary art. This is their great historic contribution. The victory of the socialist revolution in the U.S.S.R. and upbuilding of socialism have radically changed the relationship between countries; it has reassigned the places of different countries on the ladder of general human progress. Much time has passed since Radishchev and the Decembrists had to go to Europe for the progressive ideas that inspired the struggle against the feudal system, ideas which they could rework and adapt to the improvement of the life and culture of tsarist Russia, then still a backward country. Today the position has changed fundamentally. Today forward-looking people all over the world place their hopes in the U.S.S.R. Thanks to the victory of Socialism, a higher social system, the Soviet Union has become the most advanced country in the world. Similarly, Soviet socialist culture is now the most progressive and highest culture. That is why the leading representatives of culture abroad look with eager enquiry, hope, admiration, and gratitude to Soviet socialist culture, to the art of socialist realism.

Soviet painters, sculptors, graphic artists, the artists of the higher social system called Socialism, are creating a real people's art, expressing the greatest ideas of the present day—the ideas of Lenin and Stalin—in the artistic images of socialist realism.

*Congressman George A. Dondero, "Modern Art Shackled to Communism," 1949*\*

Mr. Speaker, quite a few individuals in art, who are sincere in purpose, honest in intent, but with only a superficial knowledge of the complicated influences that surge in the art world of today, have written me—or otherwise expressed their opinions—that so-called modern or contemporary art cannot be Communist because art in Russia today is realistic and objective . . . .

This glib disavowal of any relationship between communism and so-called modern art is so pat and so spontaneous a reply by advocates of the "isms" in art, from deep, Red Stalinist to pale pink publicist, as to identify it readily to the observant as the same old party-line practice. It is the party line of the left-wingers, who are now in the big money, and who want above all to remain in the big money, voiced to confuse the legitimate artist, to disarm the arousing academician, and to fool the public.

As I have previously stated, art is considered a weapon of communism, and the Communist doctrinaire names the artist as a soldier of the revolution. It is a weapon in the hands of a soldier in the revolution against our form of government, and against any government or system other than communism.

\* From a speech given in the United States House of Representatives, 16 August 1949. Published in *Congressional Record*, First Session, 81st Congress, Tuesday, 16 August 1949.

From 1914 to 1920 art was used as a weapon of the Russian Revolution to destroy the Czarist Government, but when this destruction was accomplished, art ceased to be a weapon and became a medium of propaganda, picturing and extolling the imaginary wonders, benefits, and happiness of existence under the socialized state . . . .

What are these isms that are the very foundation of so-called modern art? . . . I call the roll of infamy without claim that my list is all-inclusive: dadaism, futurism, constructionism, suprematism, cubism, expressionism, surrealism, and abstractionism. All these isms are of foreign origin, and truly should have no place in American art. While not all are media of social or political protest, all are instruments and weapons of destruction . . . .

Cubism aims to destroy by designed disorder.

Futurism aims to destroy by the machine myth . . . .

Dadaism aims to destroy by ridicule.

Expressionism aims to destroy by aping the primitive and insane . . . .

Abstractionism aims to destroy by the creation of brainstorms.

Surrealism aims to destroy by the denial of reason . . . .

The artists of the "isms" change their designations as often and as readily as the Communist front organizations. Picasso, who is also a dadaist, an abstractionist, or a surrealist, as unstable fancy dictates, is the hero of all the crackpots in so-called modern art . . . .

Legér and Duchamp are now in the United States to aid in the destruction of our standards and traditions. The former has been a contributor to the Communist cause in America; the latter is now fancied by the neurotics as a surrealist . . . .

It makes little difference where one studies the record, whether of surrealism, dadaism, abstractionism, cubism, expressionism, or futurism. The evidence of evil design is everywhere, only the roll call of the art contortionists is different. The question is, what have we, the plain American people, done to deserve this sore affliction that has been visited upon us so direly; who has brought down this curse upon us; who has let into our homeland this horde of germ-carrying art vermin? . . .

We are now face to face with the intolerable situation, where public schools, colleges, and universities, art and technical schools, invaded by a horde of foreign art manglers, are selling to our young men and women a subversive doctrine of "isms," Communist-inspired and Communist-connected, which have one common, boasted goal—the destruction that awaits if this Marxist trail is not abandoned . . . .

*Giulio Carol Argan, "The Reasons for the Group," 1963*★

What does it signify when there appear in the current artistic situation not only tendencies or trends, but also groups organized for research whose work is often

★ Originally published as "La Ragioni del Gruppo," *Il Messaggero* (Rome), 21 September 1963. This English translation by Renée Neu.

identified only by a number, letter, or sign? Isn't the group method reserved for scientific and technological research? And what will become of personal discovery and that value of aesthetic quality which many believe is the expression of the most perfect individuality?

First answer: Group research has been practised by city planners and architects for a long time. Therefore, either city planners and architects have moved from the aesthetic to the technological field, or aesthetic research, even if limited to that area, is already group research. The schools of Wright at Taliesin and Gropius at Harvard have all the characteristics of the "team," of the research group in operation. Nevertheless, no one thinks that Wright and Gropius belong to the history of science and technology rather than the history of art.

Second answer: "Gestalt" trends seen in today's aesthetic group research were not developed recently but spring from the teachings of Moholy-Nagy and Albers at the Bauhaus some thirty years ago. These currents continue to develop at excellent institutions such as the American schools of design and visual arts and the school "für Gestaltung" of Ulm. (There is no need to repeat that every serious school is a "team" and does the work of a group.) They now emerge saliently as alternatives to movements that are, to say the least, disquieting, and represent products of the reaction to the general crisis of formal languages. Their meaning and historical significance must be valued within the limits of a dialectical relation like a force in a system.

Before one can describe the collectivism of the "gestalt groups," one must study the individualism advocated and practiced by contrasting groups, the so-called "realism of the object," the dubious American "Pop Art" and the equally ambiguous "new Figuration." Without discussing the values or even the intentions of these trends it is possible to group them in the vast category of social reportage .... The situation can be noted with sympathy, acquiesence, irony, nausea, but the personal contribution, when there is one, is limited to a psychological reaction which might even become an opinion but is never pushed to the point of a formed judgment. There is no ideological stimulus; this kind of observation immobilizes, it does not change the situation. Rather, it reduces it to the level of minimum values, of non-values: individuality is identified with sex and its anomalies; collectivity with the passion for comic-strips, television quizzes, and football games. The same phenomena that are the objects of this research (if one can still call it this) are also the objects of scientific psycho-sociological investigation conducted through relevant statistics. In this case, however, motivational research is united with operational research which has a tendency, when positive, to orient and, when negative, to exploit the behavior of individuals and the masses. The art of reportage lags way behind. It does not affirm the right and necessity for individual action but limits itself to insinuating that in taking stock of the situation and therefore objectifying it, one might be able to avoid as a solitary individual the law of the herd. Since one cannot suffer simultaneously from the common ills and from one's own isolation, what is defended is not the

right of the individual to his own freedom but to his own cowardice, his own neurosis, his own liver or cerebral cancer, and finally, suicide.

Aside from theoretical and functional assumptions, the "gestalt research groups" stand out in comparison with technological impersonality on one hand and the solipsistic attitudes often confused with individualism on the other. Gestalt research cannot be reduced to technological research because its goal is to verify: first, if and in what way rigorous, perceptive behavior can be translated into operative procedure; second, whether a rigorous, operative procedure is valid only in its technological aspects or as a type of moral behavior as well; third, whether a rigorous, moral behavior can realize its own ends in technologically perfect and socially useful production or if it demands to take place within a larger field with ideological motivations.

"Gestalt groups" give an affirmative answer to the first two points. As for the third one, it is readily admitted that a rigorous technology neither fulfills all the demands nor exhausts all the possibilities of moral life and that, as a matter of fact, there cannot be a rigorous technology without a largely social goal and, therefore, ideological motivations. A rigorous technology is one which produces both the object and the value; but a consciousness of the value is already a criticism of it, i.e., a condition of its historical supremacy. There cannot be value and consciousness of value without finality and aesthetic judgment. The gestaltic trend does not identify (and never confuses) technology with aesthetics, or aesthetics with ethics, but affirms that only a technology guided by a consciousness of value, or by an aesthetic methodology can be situated in an ethical field and only a technology located in ethics can consider itself a rigorous technology . . . .

There is a third answer relating to the function of the individual within the group. Group consciousness excludes individual research and discovery for the very obvious reason that one does not become part of a group to do what he can or would like to do by himself. But we are not trying to determine here whether or not interest in adventure and individual discovery in the aesthetic or any other field will disappear from the earth. Time will tell us that. Instead, at a moment when the pace of the deplorable process of massification is alarmingly accelerated, it is extremely important to know if nonindividual aesthetic experience and activity is possible. The Gestaltic groups answer in the affirmative and show that these are possible but only as experiences of groups, not of masses. The masses in their obedient inertia do not know of aesthetic exigencies and cannot produce art. Thus, in discussing the dangerous dilemma of the masses and the individual, the term "group" is substituted for "individual." This is not done arbitrarily; the danger of the actual situation lies in the fact that, instead of the sociability, it is the nonsociability, the solitude of the individual that is often advocated and defended. But the individual is desperately alone in the desert, desperately alone in the crowd. The individual, already divested of every social interest and attitude, is disarmed and ready to be swallowed by the masses. That is why artistic trends which search for indications and symptoms and then limit themselves to confirming the

situation with indifference, or perhaps denouncing it angrily, seem to us dangerously resigned and, in fact, already alienated on the moral and political level. Whoever wants to defend the free activity of the individual from the torpid and lethal inertia of the masses must realize, first of all, that the fundamental quality of the human being is the capacity, the will to place himself in relation to and associate himself with others in community; to coordinate his own actions with those of others, to become a group, to build a society which finds in its own internal dynamism the impulse to surpass itself and advance. One should not forget that the masses, or those who lead and exploit them, are always indulgent and even generous with the individual even when he rebels; but they fear the committed, organic group, detest a community organized for creative goals, mortally hate a society in movement. In order to destroy them at their roots, the masses are always capable of generating, from the darkness of their own viscera, a monstrous type of the "solitary," the "unique" individual the dictator Hitler.

# IX

# CONTEMPORARY ART:
## The Autonomy of the Work of Art

## INTRODUCTION: The Americans

The contemporary period, beginning about 1945, has seen changes that are exceptionally drastic even in a century characterized by revolutions in all areas of culture, society, and politics. Most importantly, the scene changes centering first in New York, and then dispersing to several world capitals, such as London, Rome, and Tokyo, which share with Paris and New York the distinction of fostering important new movements. But beginning immediately after the end of World War II, the vigorous New York School emerged as the dominant one, creating influences which gradually flowed back to Europe, thus reversing the traditional westward march of civilization.

The sweeping character of this revolution is all the more evident when it is recalled that the dominant art movements in America at the beginning of the century had resolutely ignored or were unaware of the major advanced European movements. Even those Americans who, many years after the first Impressionist exhibition in New York in 1886 began tentatively to paint with Impressionist brush strokes and colors, were considered radicals. The academic tradition that dominated had little real competition, for the small amount of patronage that went to the arts invariably went to the institutionalized art represented by the National Academy of Design. Although many American artists had studied in Europe, they had dutifully studied at the academies of Paris, Düsseldorf, and Munich, and had almost completely overlooked the vital new ideas that were germinating in the informal café meetings of the Impressionists and Symbolists. That Sargent as well as Whistler and Mary Cassatt had forsaken their heritage for another was, according to Milton Brown, generally explained away as "more a proof that there were no national boundaries in art than that our own culture was too narrow for their comfort." [1]

---

[1] Milton W. Brown, *American Painting from the Armory Show to the Depression* (Princeton: Princeton University, 1955), p. 3.

Thus the "emergence" of modern art in America followed corresponding European movements with a considerable lag, but when it did arrive, it came with great impetus and with reverbations that carried away many of the stagnant conventions and ideals that had restrained it. As Meyer Schapiro has observed, excesses in the response to the first modern art in America are in keeping with excesses in first responses in other aspects of our culture.[1]

The modern point of view in America was anticipated in the first years of the twentieth century by the artists of the Ash Can School, which rejected both the rather effete and derivative work of the academy and also the faint echoes of the Barbizon or Düsseldorf schools which appeared in the painting of those who had studied abroad. Under the vigorous leadership of Robert Henri (1865–1929)—especially through his school, which flourished in New York from 1907 to 1912, and through his sayings and writings—these artists sought their subjects in the everyday world around them. Most of them—Eugene Glackens, George Luks, Everett Shinn, John Sloan, and George Bellows—had been staff artists on Philadelphia newspapers, and they were convinced that the everyday life of the city streets was the stimulus of the most vital art. Henri preached with great conviction that art was dependent upon a social purpose, that truth was more important than beauty, and life more important than art. His idea of the "Real" was not difficult to understand—it surrounded him in the everyday incidents of the great metropolis, and it appeared to him also in the social problems arising from the rapid urbanization of America.

The first consistent program of modern art exhibitions in this country began about 1908 at the Little Galleries of the Photo-Secession (opened in 1905) by the photographer Alfred Stieglitz, and located on Fifth Avenue a little farther uptown than the section made famous by the Ash Can School. The art shown at the gallery (later called "291") was exactly opposite in ideology to that of the painters of the Lower East Side; it included the first exhibitions in America of the works of Rodin, Henri Rousseau, Cézanne, Picasso, Brancusi, Matisse, Picabia, Severini, and Toulouse-Lautrec. Among the Americans whose work appeared were those who had studied abroad with the modern European masters: Alfred Maurer, John Marin, Max Weber, Edward Steichen, Arthur G. Dove, Charles Demuth, Charles Sheeler, and Marsden Hartley.

The most decisive point in the revolution of taste in America was

---

[1] For this and other references see his "Rebellion in Art," pp. 203–242, in *America in Crisis*, ed. Daniel Aaron (New York: Knopf, 1952).

the International Exhibition of Modern Art, or the Armory Show, of 1913.[1] It came about as a result of the combined efforts of about twenty-five artists—principally of the Ash Can and the Stieglitz groups—who, in order to contest the academy's authoritarian dominance of art exhibitions, proposed to organize a large show of the work of younger Americans of progressive ideas. The years around 1913 were a most favorable moment for such a venture, for at home a spirit of reform pervaded political and social activities, and in Paris, Munich, Moscow, and Milan important innovations were shaking the traditional conceptions of art. Under the spell of the excitement of these events, the organizers of the developing Armory exhibition constantly changed the plan; the foreign representation grew larger and larger as Arthur B. Davies, and later Walt Kuhn and Walter Pach, realized how many great accomplishments were being made in European art about which Americans knew virtually nothing. The issue of internationalism versus regionalism that had separated the Stieglitz and Ash Can groups was thrust upon a broader plane, and the decided lag of art movements in this country was revealed. The catalogue of the Armory Show bore a foreword which declared:

> The American artists exhibiting here consider the exhibition as of equal importance for themselves as for the public. The less they find their work showing signs of the developments indicated in the Europeans, the more reason they will have to consider whether or not painters or sculptors here have fallen behind through escaping the incidence through distance, and for other reasons, of the forces that have manifested themselves on the other side of the Atlantic.

Although the Armory Show was a great success as an exhibition, attracting large crowds in New York, Chicago, and Boston, and although nearly one-fifth of the 1,500 entries were sold to American collectors, the influence on American art was somewhat delayed. A disagreement over the scope of the exhibition caused the Ash Can painters to withdraw, and organizational problems caused the artists' association itself to collapse. The overpowering spectacle of so many revolutionary artistic ideas which had

---

[1] For a dissenting opinion of the importance of the Armory Show and modern European art in general, see Clyfford Still's Statement of 1939 (below). For agreement see Stuart Davis' several statements (below).

The National Academy of Design, apparently feeling that its status as the guardian of official art was not seriously threatened, chose not to combat but only to satirize the exhibition. Soon after the Armory Show had closed its members staged a mock show advertised as sponsored by the "Academy of Misapplied Art" with a *vernissage* entitled "First Annual Vanishing Day."

existed in Europe for almost a decade but were largely unknown to American artists, took some time to assimilate. It was the idea of being "modern" itself that took hold before the influence of European advanced painting began to be evident in the art.

The events of World War I, when as soldiers many young Americans first saw France or even the world outside their own community for the first time, confirmed the traditional view that Paris was the center of the art world. Few of the returning soldiers were to live again their isolated cultural lives of the prewar period. As the popular song of the 'twenties put it: "How ya gonna keep 'em down on the farm (after they've seen Paree)?" [copyright Warock Corp.]

The consequent emigration of American artists and intellectuals to Paris in the 'twenties is a rich chapter in cultural history. Virtually all young artists of that generation—painters, poets, novelists, musicians—spent a few months or a year or more in Paris absorbing the atmosphere that had nourished the masters of modern art, and also vicariously reliving their experiences.

But even before 1914 the way had been paved by numerous adventurous Americans of an earlier generation who had gone in search of modern ideas and who were, like the Stein family (Gertrude, Leo, and Sarah), extraordinarily receptive to what was new. Alfred Maurer was in Paris as early as 1900; Charles Demuth, John Marin, and Max Weber around 1905; Morgan Russell, Abraham Walkowitz, Stanton McDonald Wright, Patrick Bruce, Arthur G. Dove, Andrew Dasburg, Thomas Benton, Charles Sheeler, and Joseph Stella all before 1910; and Hartley in 1912. Weber was a close friend of Henri Rousseau, and several of the Americans had worked and exhibited with the Fauves.

The second or postwar wave could now see for itself the results of the triumph of Cubism: Cubist paintings in the galleries—even though not yet in the museums—and the artists who had created the movement walking the streets and revered by the art world like living myths. The rationale of Cubism, so well expressing what the young Americans had been taught to think of as typically a French attitude, had a special appeal to the visitors from another point of view: the clean-cut, workmanlike, mechanical qualities of the paintings seemed to have a special relevance to New World technology and its cult of efficiency.

Among the few exceptions to the general taste for the Cézanne-Cubist tradition were Marsden Hartley and Joseph Stella (1877–1946. Born in Italy; came to U.S. in 1902), who were drawn to Germany and Italy, respectively, where they discovered in the Blaue Reiter and the Futurist

groups ideas more congenial to their own tastes. In the meantime Albert Gleizes had visited New York, where he not only exhibited his paintings but lectured and continued his writing on theories derived from Cubism. And in 1920 Marcel Duchamp became associated with Katherine Dreier, a painter and ardent collector of the new art, in the formation of the *Société Anonyme* (according to Duchamp's Dadaist humor: "*Société Anonyme, Inc.*"). The Society was an active agency for circulating exhibitions from Miss Dreier's collection of Cubist and abstract art, and it was the direct ancestor of the Museum of Modern Art in New York.

The economic distress and the sociological conflicts that marked the decade of the Depression contributed to still another division of attitude between the conservative-regionalist and the modern-internationalist artists that resulted in at least two clearly defined ideologies and their attendant styles. On the one hand, the regionalists of the Midwest, such as Thomas Benton and Grant Wood, tenaciously resisted both European and modernist influences, seeing the true expression of American art in the simple life, close to the earth, of the Midwestern farmer. In this they reflected the sentiment for political isolationism of the country as a whole, and the Midwest in particular, that was so strong during the Depression years. On the other hand, the internationalists, looking to New York if not actually living there, had grown to maturity in the Paris-oriented 1920's. Living in close contact with one another, with European visitors and with ideologies and theories from abroad, they responded to the crisis of the Depression on the broader plane of an intellectual struggle. The American Artists' Congress, organized in 1934 and composed of most of the *avant-garde* artists in New York, was basically a liberal political action group concerned primarily with the economic welfare of the artists. Government agencies for the support of art, the Works Progress Administration, organized in 1933, and the Federal Art Project, organized in 1935, drew the leading American artists even closer together and gave them a strong sense of identity as an artist class.[1] And although the "WPA style," particularly in art for public buildings, was often a kind of uninspired stylized realism, there were also some important monuments, such as Arshile Gorky's murals for the Newark Airport (since lost or destroyed), which combined a socially useful theme with a vigorous modern style based upon Cubism. There was temporarily an influence from Orozco, who had come to New York to paint murals in the New School for

[1] Among those on the "project" were Stuart Davis, Mark Tobey, Arshile Gorky, Willem De Kooning, Jackson Pollock, Mark Rothko, William Baziotes, James Brooks, and Jack Tworkov.

Social Research, and from Diego Rivera, who created a series in Detroit on its industries and another in Rockefeller Center (since destroyed). The urgent domestic social problems, however, seemed much more crucial than the Mexicans' blunt interpretations of Marxist and Mexican revolutionary themes.

Although the transatlantic flow of ideas diminished during the 'thirties because of reduced travel and an increased concern for domestic problems, international modern art was rapidly becoming institutionalized in New York City. In 1927 A. E. Gallatin's collection of contemporary Europeans was placed on permanent exhibition in the library of the Washington Square campus of New York University, probably the first such gallery in New York. In 1929 the Museum of Modern Art was founded. It soon acquired the best representation of modern art movements on both sides of the Atlantic, and it launched a program of exhibitions and publications that were models of interesting and scholarly presentation. In 1937 the Museum of Non-Objective Painting (now the Solomon R. Guggenheim Museum) presented a permanent exhibition which included many works of of the prime periods of Kandinsky and abstract art by other Europeans. And from the close contacts formed among New York artists on the Project and in the Congress, there emerged in 1936 the influential American Abstract Artists Group which, in presenting abstract art through its programs of exhibitions and publications, also gave it firm theoretical support.

The depression came to an end at the close of the 1930's, and the slack in the economy was taken up by the production of war materials. The WPA was disbanded and thousands of the paintings produced under its auspices were stored away in warehouses, but it had drawn together in a comradeship of necessity most of the leading artists of an entire generation. The associations they had developed during the years on the Project had strengthened their identity as artists, but they had been brought together on an economic, and not on an aesthetic or theoretical basis, as was the case with the artistic movements of Europe. So in suffering through the depression together, yet able to earn a livelihood in their profession, these men came out of it with an increased awareness of themselves as artists—American artists— which only a few men in the past, except in the Academy, had been able to attain. Since they had been a close group during the socially conscious 1930's, and especially since the American Artists' Congress drew so many of the WPA artists into its program, there was naturally a strong element of what was then called "social significance" in the artists' thinking, even if not in their work. This strain of thought, which had already been vigorously propagated by Robert Henri before the First World War, reinforced the

American's feeling that art was a serious occupation connected with the realities of life as it was seen and lived and with all its problems. This was a point of view in direct opposition to the one that prevailed in America prior to the Armory Show, namely, as Meyer Schapiro has observed, that art was a rare cultural commodity, usually created in Europe, that existed only in museums or as ornaments in the homes of the rich.

The vast scope of the Second World War and the sudden and total involvement of the United States in it precipitated violent changes in relations with Europe and the rest of the world. The Hitler-Stalin Pact of 1939 put to an end the dream that the Soviet Union was the ideological model for the new society, and the fall of France in the next year fatally weakened the long reign of Paris as the queen of the art world. Artists' groups in Europe were disrupted and many artists fled to America. It became apparent that Old World movements and ideologies could no longer provide to the same extent the initiative of new ideas. And on the opposite side of the world the suprise attack by the Japanese in 1941 precipitated a vast centrifugal reaction that soon extended the American consciousness, along with military and political power, over the entire globe. The new world-consciousness and the consequent cosmopolitanism was the final blow to the political isolationism of the depression years and to the regionalist art that reflected it.

The emergence of a vigorous and independent school of painting in New York followed closely upon the emergence of the United States at the end of the war as an influential cultural as well as political and economic world power. For the first time an artistic movement originating in America was recognized on the international scene as one of the significant epochs in the development of contemporary art. The internationalist strain from that time on has been clearly dominant. But internationalism now had a new meaning, it meant that American art was a force upon the world scene, and no longer merely that artists were looking abroad for ideas.

Even some of the artists most indebted to European styles reflect Robert Henri's vigorous realism and anti-aestheticism. Stuart Davis (1894–1964) is deeply indebted to Cubism and especially to Léger, whose mechano-morphism is often cited as similar in spirit to American mechanical "know how." On the other hand, Davis is entirely in agreement with Henri on the value of the local scene. His long career embraced the entire history of modern art in America: as a child in Philalephia he knew many of the artists who were to become the Ash Can group, then working as illustrators for his father on the Philadelphia *Press*. At the age of sixteen he was a student in Henri's school in New York, where he spent his spare time wandering the streets and absorbing the life which his teacher proclaimed the greatest

reality. He drew cartoons for the leftist journal, *The Masses*, and he was represented in the Armory Show, where he especially admired Gauguin, Van Gogh, and Matisse. In the early 'twenties he discovered Léger and began to assimilate Cubism into his own work, and soon after he went to Paris for an extended stay, where he painted street scenes in the new style. Upon returning to New York in 1929 he stated that he was appalled by its inhuman scale and its commercialism in contrast to Paris, but he also insisted that it was his own city and that he needed its impersonal dynamism. From that time on he lived in New York and Gloucester, Massachusetts, painting—according to Henri's dictum—the American scene, but with the plastic means of international Cubism. His American scenes, however, extend deeper into the national consciousness than those of his predecessors, for he interpreted his city and village streets in jumping rhythms and dissonant contrasts similar to those of Negro jazz, for a long time a special interest of his. He was on the WPA and for a time was an active member of the Artists' Congress, although his mature work as a painter shows no trace of the political ideas of the Congress. Davis is exceptionally clear and matter-of-fact in his many writings on various aspects of his own art and that of others, and has little patience with elaborate aesthetic theories or with stylistic affectations. His friendship with Arshile Gorky was in part ended by his scorn of Gorky's quaint habit of performing Armenian shepherd dances for his friends.

Marsden Hartley (1877–1943) also faced, in his work as in his life, the problem of an American artist who wished to comprehend modern European movements and who yet must retain his American identity. Born in Lewiston, Maine, Hartley began his art training in Cleveland, Ohio, and continued it in New York at the National Academy of Design and at William Merritt Chase's school. Chase was at that time one of the most famous and successful of all of those who wore the aura of extensive study and travel in Europe. Beginning in 1912 Hartley frequently traveled between Europe and America, and experienced in his lifetime periods of high public recognition, alternating with intense and self-inflicted isolation. His first exhibition was in 1909 at Alfred Stieglitz's Photo-Secession Gallery, but he also showed with Kandinsky and the *Blaue Reiter* group in Munich. His paintings were hung in the Armory Show in New York, and he frequented the Paris salon of Gertrude Stein. In an early essay he speaks of Cézanne and Whitman as the founders of modernism. Throughout his career his own art was informed by current European movements, yet he finally came "home," to his native New England, despite his indictment that "art in America is like patent

medicine or a vacuum cleaner. It can hope for no success until ninety million people know what it is."

Critical writings occupied him throughout his lifetime as a painter and a poet; a collection of essays, *Adventures in the Arts*, "*Informal Chapters on Painters, Vaudeville and Poets*," was published in 1921. In his poem "Return of the Native," he expresses a sentiment that his art should return to nature just as he should return to his homeland:

> Rock, juniper, and wind,
> And a seagull sitting still—
> All these of one mind.
> He who finds will
> To come home
> Will surely find old faith made new again,
> And lavish welcome.

John Marin (1870–1953) was already a practicing architect when at the age of 29 he began to study painting, first at the Pennsylvania Academy, and then at the Art Students' League. It was not until 1905 when he was 35 that he went to Europe where he lived in Paris and painted and traveled for several years. He was discovered there by Steichen and Stieglitz, who at once arranged an exhibition for him at their 291 gallery in New York. Two years later he returned to America where he fell into the highly stimulating environment created by the artists and writers of 291. The vigor of Stieglitz's leadership of the gallery can be attested by the fact that it was in New York in the ambience of 291 rather than in Europe itself that Marin was most influenced by contemporary European art.

Marin soon became one of the 291 gallery group, but in 1915 he went to live on the coast of Maine where he could develop his close personal attachment to nature. Uninterested in aesthetic speculations, he wrote of his art as a vibrant living force which owed both its vitality and its structure to the model of nature.

The influx into New York of European artists, chiefly the Surrealists, at the outbreak of war in Europe in 1939 ranks in importance second only to the Armory Show itself in the history of American art. By 1942 the group, including Breton, Ernst, Masson, Tanguy, Dali, Kurt Seligmann, and Matta, together with Léger, Mondrian, Chagall, Feininger, Jacques Lipschitz, and Gabo, as well as many distinguished teachers of art, architects, and art dealers, had come to America. The way for the Surrealists had been well prepared:

De Chirico had exhibited in New York as early as 1927, Miro in 1928, Dali three times beginning in 1933, and all of them were included in the Museum of Modern Art's exhibition, *Fantastic Art, Dada, Surrealism* of 1936. Although the Surrealists took little part in the art life of New York and did relatively little work themselves, the impact of their presence as the chief representatives of the last great European movement exerted a strong influence on New York artists.

They had come, wrote Harold Rosenberg, at a critical moment in American art, when "social significance" and the style that went with it had been definitely abandoned, but when the way ahead into the new world was entirely unclear.[1] Moreover, the Surrealists revealed a strain of fantasy in their art that was rare in the traditions of American painting, although thriving in its literature (Poe was greatly admired in Europe, especially by Baudelaire and Huysmans). Surrealist theories and practices released the Americans from the comparatively moralistic teachings of Henri and his school and the sober dogmatisms of the Artists' Congress, and revealed to them the exhilarating freedom possible in the play of the spontaneous imagination. As Rosenberg put it, they taught that the joining of art with life occurs within the intimate self, and not in wrestling with social themes.

The lesson of the Surrealists was learned by many of the Americans, who then found themselves better equipped to face the challenge of the vast possibilities that were now opened up to them, the leading artists of the new world center of art. Rosenberg observed that they also realized that the Surrealists were now a part of history and not a part of the unknown future. And so for the first time in modern history there was no European model that could show the way ahead. The way had to be created empirically and on the basis of past experience, but created in terms of the vast possibilities resulting from the new knowledge and freedoms enjoyed by mid-twentieth-century man, especially in America.

Arshile Gorky (1905–1948) among all the American painters perhaps profited the most by his association with the Surrealists. His friendship with Matta Echaurren (b. 1912) awakened him to a side of himself which he had ignored—the irrational side of feeling and imagination—and this awareness congealed his art into a personal imagery.[2] Until that time Gorky had

---

[1] For this and other references see his *Arshile Gorky* (New York: Horizon, 1962).

[2] André Breton wrote the introduction to the catalogue of Gorky's first important one-man exhibition in New York at the Julian Levy Gallery in March 1945. Levy had shown Dali and Giacometti for the first time in New York in the early 30's, and in 1946 he wrote a history of the movement (*Surrealism*, Black Sun, 1936). Breton's essay was included in the New York edition (Brentano, 1945) of his *Surréalisme et la Peinture*. He states, "Here is an art entirely

exhaustively studied the modern masters, but his works were more "in the style of" the masters, even though exceptionally strong, than they were original conceptions. Throughout his difficult life he went through all the stages of the struggle which accompanied the advent of modern art in America. And his own life story as an immigrant—the passage from an Armenian peasant village to Greenwich Village, Union Square and, finally, to a Connecticut country home—exemplifies, according to Rosenberg, the American "success story."

Hans Hofmann (1880–1966) brought with him to America a deep understanding of modern European movements which he synthesized in his own theory and in his teaching, which influenced many of the postwar generation of artists. He was born and educated near Munich, but lived during the extremely fertile years of 1904 to 1914 in Paris, where he became associated with the leading artists and readily absorbed the most vital ideas and styles, chiefly Symbolism, Neoimpressionism, Fauvism, and Cubism. He worked with Matisse and was a friend of Picasso and Delaunay during his stay in Paris, which ended when the outbreak of World War I forced him to return to Germany. Back in Munich he established a school where he taught the principles of an art based chiefly upon Cézanne, Cubism, and Kandinsky. This school was probably the first school of modern art anywhere. In 1932 he moved to New York and reopened his school, where many of the artists who were to become the leaders of the postwar generation became his students or were influenced by him, either through his teaching, his painting, or by his powerful personality. By all of these means he injected directly into the stream of art in this country his rich store of twentieth-century European ideas.

His theory is based upon the belief that abstract art has its origin in nature. It reflects his belief in the duality of the world of art and the world of appearances, similar to the theory of the Symbolists; it deals with color as an element in itself which is capable of expressing the most profound moods, similar to, if not derived directly from, ideas stated by Kandinsky and the Expressionists; but it is concerned also with form in the tradition of Cézanne and Cubism. Hofmann's theories remained essentially the same throughout

---

new, at the antipodes of those tendencies of today, fashion aiding confusion which simulate surrealism by a limited and superficial counterfeit of its style. Here is the terminal of a most noble evolution, a most patient and rugged development which has been Gorky's for the past twenty years; the proof that only absolute purity of means in the service of unalterable freshness of impressions and the gift of unlimited effusion can empower a leap beyond the ordinary and the known to indicate, with an impeccable arrow of light, a real feeling of liberty." Translation from Ethel K. Schwabacher, *Arshile Gorky*, (New York: Macmillan, 1957), p. 108.

nearly fifty years of teaching and painting and formed a substantial foundation for much of contemporary theory on abstract art. His principles were unaffected by the social-consciousness interregnum, and they transmitted the major innovations of European modern art of the first years of the century directly to the postwar generation of Americans. His theories acquired additional prestige as a result of his own eminence as a painter, which had a remarkable efflorescence after he abandoned teaching in 1958 at the age of seventy-eight.

The younger generation of artists who were drawn to New York before and immediately after the Second World War tended to be drawn into groups, but unlike earlier European ones, they were unconcerned with common ideologies. Each artist sought in the group, as he sought in New York itself, the fulfillment of a personal need.

Before the war the WPA Project had provided a neutral structure for the formation of groups. Peggy Guggenheim's Art of This Century Gallery, which showed the work of the Surrealists during the war, also showed several of the young Americans who were to become the leaders of the postwar movement: Gorky, Willem de Kooning, Jackson Pollock. Robert Motherwell, Mark Rothko, William Baziotes, and Bradley Walker Tomlin. Through this association they became acquainted with the Surrealists and in particular with Matta Echaurren, the youngest of them, who inspired the Americans, and Gorky in particular, to an interest in Surrealism. In 1948 under the leadership of Motherwell, several of these painters started a school called "Subjects of the Artist," where one of the principal topics of discussion was the role of subject matter in abstract art.[1] The school's greatest influence was, however, in the informal talks and discussions by the leading New York artists which took place every Friday evening. The school existed for only one year, but the weekly meetings continued until the early 'sixties and provided an important forum for the stimulus and exchange of ideas by the artists.

During the 'fifties an influence from an unexpected quarter appeared when many of the leading advanced artists were invited to become guest instructors at art schools and colleges throughout the country. Art schools in the vicinity of New York had for a long time taken advantage of their location to engage important artists to teach on a part-time basis, but for the first time the demand was nationwide, and it was mainly from universities.

[1] The school was in a loft at 35 East 8th Street. The idea of the school was originated by Clyfford Still, but the actual founders were Motherwell, Rothko, Baziotes, and David Hare. Barnett Newman usually led the Friday night discussions.

In addition, the artists were accepted as permanent members of academic faculties, disregarding the fact that many of them had never attended college. The role of the artist as professor gave a certain legitimacy to his statements and his theories on art, just as it imposed upon him the obligation to speak with deliberation and clarity. Finally, the growing practice of museums and galleries of publishing statements by the artists in their increasingly elaborate exhibition catalogues, encouraged artists to make statements of their intentions which were directed toward the public. But all of these opportunities and encouragements, if sometimes resulting in ideas that were forced, produced in general a large body of clear and relevant theory. Some artists temporarily turned art critic with excellent results, and some, under special conditions where their experience as an artist was of particular advantage, achieved distinction as historians of contemporary art. In all of these situations, however, the theories themselves, in accordance with the intellectual climate of postwar America, relate (at least through the 'fifties) to a view of art as a free expression of the individual.

Robert Motherwell (b. 1915), the leader of several of the earliest artists' groups, was well-equipped as a theoretician, having studied philosophy at Stanford, Harvard, and in France before beginning to paint. He grew up on the West Coast, went to New York in 1939, and was closely associated with the Surrealist group, and Gorky, Pollock, and De Kooning. In addition to his own distinguished career as a painter, he is an articulate and thoughtful writer, and he has been a college teacher and an energetic editor concerned especially with artists' statements.

Willem de Kooning (b. 1904) began his career in his native Amsterdam, where as a boy he was apprenticed to a house painter and decorator. When he was twenty-three he emigrated to America and settled in New York, where he continued to work as a house painter, commercial artist, and stage designer. By 1939 he was a member of the New York artists' group, and was especially close to Gorky. Although he has written little on art, his spontaneous remarks in the form of aphorisms are extremely pertinent. He taught for a short period of his career during the early 'fifties at Black Mountain College and at Yale, before his painting was widely recognized and he had achieved financial success.

Jackson Pollock (1912–1956) spent his childhood in Wyoming and his youth in Los Angeles and Arizona. At seventeen, with considerable experience as a painter already behind him, he went to New York, where he studied with Thomas Hart Benton at the Art Students' League and was strongly influenced by him. He was on the WPA and became acquainted

with the New York painters. His work was viewed with especial interest by the Surrealists, who invited him to show with them in the International Surrealist Exhibition of 1942, and in 1943 Peggy Guggenheim gave him his first one-man exhibition in her Art of This Century Gallery. He was acquainted with those New York artists who entered into the Surrealist circle, and it was through them that he got to know Matta, whose work was especially important for him. But however strongly influenced Pollock was by Surrealist ideas or by Benton's hardy expressionist style, he never wholly entered into the discussions and controversies which occupied so many of the other artists. He always retained his love for the vast expanses of the far West, which he liked to traverse in an old automobile as he had done as a youth.

Mark Rothko (b. 1903) emigrated from Russia as a child and spent his youth in Oregon. He was educated at Yale, but began the study of art only later, when in 1926 he entered the Art Students' League in New York.

He has lived there since that time, where he was on the WPA, exhibited at the Art of This Century Gallery, and associated with other artists of the New York group. He was one of the founders in 1948 of the Eighth Street art school, and he has taught college classes for several years.

Alexander Calder (b. 1898, Philadelphia) studied engineering in college. Later while working as an engineer, he began to attend evening classes in drawing, and soon after left for Paris to study art. About 1926 he created his famous circus, a collection of moving animals and performers made of wire, and in 1932 constructed his first mobile. Since then, he had divided his time between his farms, one in Connecticut and another in the Loire valley. His mobile sculpture is admired abroad for what is thought of as a typically American talent for mechanics and a love of motion. Although his mobiles have influenced sculptors and have stimulated the development of theories of kinetic sculpture, Calder speaks little about his own art except with other artists in informal situations.

Ad Reinhardt (1913–1967, b. Buffalo) studied art history at Columbia University with Meyer Schapiro before beginning to study painting at the National Academy of Design. Later he worked as an artist on the WPA project. His first one-man exhibition was at the Art of This Century Gallery in 1944, the same year he became artist-reporter on the newspaper *P.M.* After the war he continued his study of art history at New York University. He taught painting at Brooklyn College, and as guest instructor at Yale and other colleges and art schools. His experience in both art history and painting provided him with unique qualifications as a commentator on contemporary art.

William Baziotes (1912–1963, born Pittsburgh) studied at the National Academy of Design, New York. He first taught on the WPA art project and then worked as a painter in close association with other New York artists. During the war he became acquainted with the French Surrealists and was given his first one-man show at Peggy Guggenheim's Art of the Century Gallery.

Adolph Gottlieb (b. 1903, New York City) is largely self-taught, except for brief period of study with John Sloan at the Art Students' League. In 1921–1922 he traveled and painted in Europe, then returned to New York, where he has lived since. He was deeply impressed by the art of the Indians of the American Southwest which he saw during a visit in 1937, and since then developed a vocabulary of simple, primitivistic forms and signs.

Theodore Roszak (b. 1907, Poland) studied and then taught art in Chicago, where he was strongly influenced by Moholy-Nagy and his Bauhaus-oriented Institute of Design. Roszak was first a lithographer, but turned to sculpture after moving to New York in 1931. He is interested in modern literature, especially Existentialism, and he conceives of his sculpture as an interaction of ideas with materials.

Clyfford Still (b. 1904, North Dakota) has worked independently of most group activities. He was educated in the state of Washington, where he also taught painting, and in 1941 moved to San Francisco, where he taught in the California School of Fine Art (now San Francisco Art Institute) from 1946 to 1949. Still has an extensive background in the academic and intellectual life and he himself taught art history in a Washington college. He was one of the founders of the school on Eighth Street. Although he has lived continuously in New York since 1950, he is remote from the artists' group discussions and activities and maintains a fierce independence in both his art and thought.

Barnett Newman (b. 1905), a native New Yorker, was educated at City College of New York and at Cornell University and studied at the Art Students' League. He was one of the founders of the school on Eighth Street in 1948, and was one of the most important contributors to the discussions there. He has maintained in his writing, as in his painting, an intensely individualistic attitude.

David Smith (b. 1905–1965, Indiana) lived in the Midwest during his youth, where he attended a university before leaving for New York in 1926 to study painting at the Art Students' League. He encountered two important influences in New York: the idea of abstract art chiefly through Stuart Davis, and an interest in sculpture in metal through the work of Julio Gonzales. Smith's experience with metal was intimate and of long standing; as a youth

he worked as a welder on an automobile assembly line, and again during the war in the fabrication of tanks. In 1940 he started working in a studio-metal shop in upstate New York, which he called the Terminal Iron Works. He taught at intervals in several universities, but for the most part remained independent of the art activities of New York.

Herbert Ferber (b. 1906), a native New Yorker, has lived his entire life there. He was educated at City College and Columbia University, where he studied dentistry and oral surgery, and practiced dentistry for many years during the time he was developing as a sculptor. He has written several essays on sculpture.

Richard Stankiewicz (b. 1922, Philadelphia) enlisted in the Navy at the outbreak of the war, when he was nineteen. Upon his discharge in 1948 he gravitated to New York, where he studied at the Hans Hofmann school. Like many other young veterans he went to Paris, where he continued his studies with Léger and Ossip Zadkine. Stankiewicz's studies and his re-orientation were made possible by government subsidy of the re-education of veterans of the recent war, the so-called "G. I. Bill of Rights." An entire generation of young men, including many artists, were launched on new or better careers as a result of this support, and the artists in particular took this opportunity to travel and study in Europe or to study art in universities. In the latter case they were exposed to an intellectual stimulus that made it necessary for them to formulate and express their ideas and beliefs. They were, therefore, like the artist-teachers, often fully at ease in the role of a theoretician of art.

Several important painters and sculptors have also written significant critical comment. John Ferren (b. 1905, Oregon) went to Europe at the age of 24 where he studied painting for the next nine years, thus missing the depression and the associations of the WPA. Returning to New York in 1938 he settled down to paint there and entered into the artists' activities, continuing to teach and write. Elaine de Kooning (b. 1920, New York) has always lived in New York, where she has distinguished herself as a painter, and lectured and written on contemporary art. Upon several occasions she has taught at universities. Louis Finkelstein (b. 1923) is well known as an artist in the trend which he describes as "Abstract-Impressionism" (below). The sculptor Sidney Geist (b. 1914, Paterson, N.J.) has written on art since 1953. His critical writings, especially in his journal *Scrap* (1960–1961) are concerned chiefly with sculpture. Early an apprentice to Paul Feine in Woodstock, he also studied at the Art Students' League and in Paris and Mexico. He participated in the New Jersey WPA, the artists' sessions at the Eighth Street

Club, and in the Tenth Street cooperative gallery, the Tanager. He has taught in universities and art schools, and is presently an instructor at the New York Studio School.

The first of the three critics represented in the text, Clement Greenberg (b. 1909, New York City) studied at the Art Students' League and at Syracuse University, and exhibited his work in the Stable Gallery (New York) annuals. One of the most important observers of contemporary trends in painting and sculpture, he was formerly an editor of *Commentary*, and since the late 'forties his art criticism has appeared in the major reviews (*Partisan Review*, *The Nation*) and art magazines. He was among the early partisans of the New York School of Abstract Expressionism, and recognized and named a development of the 'sixties with his exhibition "Post-Painterly Abstraction."

The critic Harold Rosenberg (b. 1906, Brooklyn, N.Y.) introduced the term "action painting" to a wide art public through the article included in the text (below). For some years a contributor to literary and art reviews in this country and abroad, he has also written on Marxist theory, and has lectured in universities and at government-sponsored symposia on education. He is preparing a book on Hans Hofmann's art theories. During the 'thirties he painted murals for the Federal Art Project, and was also an editor for *Art Front*, the magazine of the Artists' Union.

Hilton Kramer (b. 1928, Gloucester, Mass.) is presently Art News Editor for the *New York Times*. Previously he was editor of *Arts* (New York) and on the editorial staff of the *New Leader* (New York). He earlier contributed a regular column on art to the *Nation* and has published articles in the leading journals on art and literature. He studied at Syracuse, Columbia and Harvard Universities, and at the New School for Social Research in New York. He has regularly reviewed the New York scene since 1955. He brings a wide experience of the art of this century to his writings, and has been a lucid commentator on the work of the sculptor David Smith, to whom he devoted an issue of *Arts* (Special David Smith Issue, February 1960).

Claes Oldenburg (b. 1929, Stockholm) grew up in Chicago as the son of the Swedish consul. He was educated at Yale University and studied art at the Chicago Art Institute. By 1960 he was involved with painted objects, participating in the two exhibitions in New York that brought to public attention the then-new interest in objects and environments, "New Forms, New Media," of 1960, and "Environments, Situations, Spaces" of 1961. He staged his first happening, "Snapshots from the City," in 1960, and has since then continued to translate the common objects and foods of daily

living—a shirt on a hanger, an iron and ironing board, a hamburger—into a monumental scale, first in painted plaster, and, more recently, vinyl. His statements and writings on art are exceptionally acute, perhaps due, in part, to his earlier experience as a newspaper reporter.

George Rickey (b. 1907, South Bend, Indiana) studied history at Oxford before turning to painting. He studied with André Lhote, Léger, and Ozenfant in Paris, and has been a teacher since the early thirties. In the mid 'forties, after service in the Air Force, he studied art history at the Institute of Fine Arts in New York City, and by 1950 he was a sculptor and, as he states, "soon committed to movement as a means." His clear statements of intention in this relatively undeveloped mode have made him the leading theorist of kinetic sculpture, and his work reflects this clarity of intention in what may be termed a "classical" approach to mobile sculpture. His work has been shown in important group exhibitions in Amsterdam, Stockholm, Copenhagen, and Berkeley, California.

The postwar generation of American artists shared with earlier groups of European artists an important environmental condition—they lived in a vital community of fellow artists grouped in a centralized locale, the lower East Side of New York City, from which the new-found force radiated to other parts of the country. In almost every other way they differed. They had no guiding ideology, had few critics or writers close to them who pointed the way and suggested new techniques, and they did not write group manifestoes. Few of this generation had studied in Europe or even visited it, except as members of the Armed Forces or in their maturity as "G.I." students. Their introduction to the art of the past had taken place almost solely in universities or art schools, and later in museums and art galleries, principally in New York City.

The overwhelming majority of them came to the metropolis from elsewhere; many were foreign-born or were the sons of immigrants, and many came from the Midwest or the Pacific Coast. Almost all of them were attracted to New York because of its concentration of everything they needed to fulfill themselves as artists. They explored intensively the vast resources of the city with the passion of those who had been deprived and hence to whom the dream of artistic fulfillment was the more challenging. And New York, although never an American counterpart of Paris, the shining symbol of French culture, offered in an eclectic display an unequaled concentration of art from all countries and all ages. Only in a city as impersonal and competitive as New York could regional, national, and tribal backgrounds be forgotten or religious and social motivations be ignored so

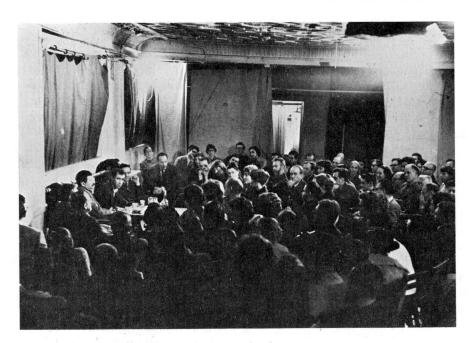

*Panel discussion at "The Club," Second Avenue and 10th Street*
*New York, discussing "Non-critic-artists," 15 January 1960*
*Panel members: Joop Sanders, Herman Cherry, Louis Finkel-*
*stein and Robert Mallary.*

easily. All the art was presented on the common level of something to be studied and enjoyed and as a common reservoir of the world's past traditions and styles.

The city contained the greatest collections of modern art anywhere, discerning and adventurous collectors, ambitious and even scholarly dealers, and the dynamic and free spirit of a new world center of art. It would be difficult to conceive of young artists sensitive to this dynamic environment confining themselves to a parochial theory of art or to regional styles of painting. As some of them have implied, it was inevitable that their painting, while demonstrating the ultimate in individuality of style, should have tended strongly toward abstraction, and furthermore, that it should be deeply expressionist in its general feeling state. Aware of the new world-view that insistently dominated the postwar years, maturing in the most cosmopolitan environment that existed, and aware of their own extremely varied backgrounds, the artists viewed all of the past as in their hands, and the future, although highly uncertain, at least completely open to them.

*Robert Henri, "On Individuality of Ideas and Freedom of Expression," 1909*<sup></sup>*

There has been much discussion within the last year on the question of a national art in America. We have grown to handle the subject lightly, as though it were a negotiable quantity, something to be noted in the daily record of marketable goods. And the more serious have talked much about "subject" and "technique," as though if these were acquired, this desired thing, a national art, would flourish quickly and beautifully; whereas, as a matter of fact, a national art is not limited to a question of subject or of technique, but is a real understanding of the fundamental conditions personal to a country, and then the relation of the individual to these conditions.

And so what is necessary for art in America, as in any land, is first an appreciation of the great ideas native to the country and then the achievement of a masterly freedom in expressing them. Take any American and develop his mind and soul and heart to the fullest by the right work and the right study, and then let him find through this training the utmost freedom of expression, a fluid technique which will respond to every inspiration and enthusiasm which thrills him, and without question his art will be characteristically American, whatever the subject. For through his own temperament, coupled with the right power of utterance, he will, all unconsciously, express his own attitude toward life in whatsoever he creates, and his picture or statue or sonnet will testify to his nationality. For a man ceases to imitate when he has achieved the power to express fully and freely his own ideas; and every man with imagination who has given the best of himself to work, who has learned to think honestly and see clearly, can no more escape the possession of ideas than of ideals, and so the American painter, with brain and brush liberated by the greatest possible self-development, is just as certain to express the quality of his country as he is in himself to present an American type or speak the language of his native land.

Thus it is not possible to create an American art from the outside in. Art does not respond to the whim of the millionaire who would create art galleries as he does libraries. It is quite impossible to start out with a self-conscious purpose of springing a ready-made national art on the public simply because we are grown up enough to realize the value of such an expression. Art is too emotional to respond to coercion or discipline; and it cannot successfully become a whim of the rich, even in America. For successful flowering it demands deep roots, stretching far down into the soil of the nation, gathering sustenance from the conditions in the soil of the nation, and in its growth showing, with whatever variation, inevitably

---

* An excerpt from his "Progress in our National Art Must Spring from the Development of Individuality of Ideas and Freedom of Expression: A Suggestion for a New Art School," *The Craftsman* (New York), January 1909, pp. 387–388. For the ideas that were the basis of his teaching and his enormous influence on students, see his collected writings as compiled by M. Ryerson in *The Art Spirit* (Philadelphia and London: Lippincott, 1923).

For Stuart Davis' opinion of the school, see below.

the result of these conditions. And the most showy artificial achievement, the most elaborate imitation of art grown in France or Germany, are valueless to a nation compared with this product that starts in the soil and blooms over it. But before art is possible to a land, the men who become the artists must feel within themselves the need of expressing the virile ideas of their country; they must demand of themselves the most perfect means of so doing, and then, what they paint or compose or write will belong to their own land. First of all they must possess that patriotism of soul which causes the real genius to lay down his life, if necessary, to vindicate the beauty of his own environment. And thus art will grow as individual men develop, and become great as our own men learn to think fearlessly, express powerfully and put into their work all the strength of body and soul.

For long years we as a nation have felt that all which was required of us in art was novelty and skill. First, novelty in discovering other people's ideas; second, skill in presenting them; later, the novelty of discovering a quality of picturesqueness in our own land with skill in presenting that. And undoubtedly there is a great deal to be said in America that has never been said in any other land, but does the growth of our art so much depend upon skill in saying as upon the weight of the statement? What is truly necessary to our real progress is sufficient skill to present a statement simply and then to use the skill to show forth the great fresh ideas with which our nation is teeming.

## Stuart Davis, *"Is There an American Art?"* *1930*★

Dear Mr. McBride:

I appreciate the good will shown in your review of the watercolors I showed at the Whitney Galleries. There is a point in it, however, on which I think it necessary to take issue with you. In the review you speak of your enthusiasm for my work and call me a "swell American painter." This attitude on your part I heartily approve, but you further state that my style is French and that if Picasso had never lived I would have had to think out a style of my own. Now is that nice, Mr. McBride? And if it is, does it mean anything? My own answer is that it does not, for reasons, some of which are furnished below.

In speaking of French art as opposed to American the assumption is made that there is an American art. Where is it and how does one recognize it? Has any American artist created a style which was unique in painting, completely divorced from European models? To soften this flock of hard questions I will answer the last—no, J. S. Copley was working in the style of the English portrait painters and to my taste doing better work than they did. Whistler's best work was directly inspired by the Japanese while he was housed and fed in England. Ryder's technique derives from Rembrandt by devious ways and Homer's style is no style at all

---

★ A letter of reply to the critic Henry J. McBride, *Creative Art* (New York), VI, 2, Supp. (February 1930), 34–35.

but the natural method of a man who has seen a lot of photographic illustration and likes it. I have never heard the names of the European masters that Eakins particularly admired but from his work I should say that they included Rembrandt and Velasquez. These painters are now regarded as the best that America has produced. Suppose a selected show of the painting of Europe and America for the last four hundred years were held, would the American contribution stand isolated as a distinct point of view, unrelated to the European? Again the answer is, no.

Since this is obviously true, why should an American artist today be expected to be oblivious to European thought when Europe is a hundred times closer to us than it ever was before? If a Scotchman is working on television do similarly interested American inventors avoid all information as to his methods? Not if they can help it. If a Norwegian has the most interesting theory of atomic physics do American scientists make a bonfire of his works on the campus? Hardly. If Darwin says that the species evolved, do American educators try to keep one hundred per cent Americans from hearing it? Yes, they do in Tennessee.

Picasso, I suppose, is not a hundred per cent Spaniard otherwise he wouldn't disregard the home industries and live in Paris. But regardless of that fact he has been incomparably the dominant painter of the world for the last twenty years and there are very few of the young painters of any country who have not been influenced by him. The ones who were not, simply chose some other artist to be influenced by.

*Stuart Davis on Seventh Avenue,*
*New York, 1944.*

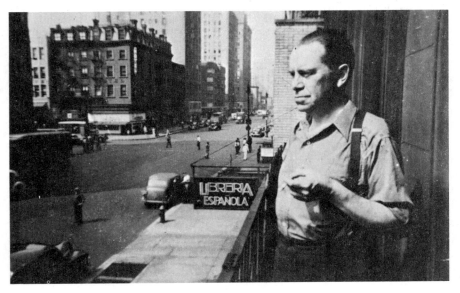

I did not spring into the world fully equipped to paint the kind of pictures I want to paint. It was therefore necessary to ask people for advice. This resulted in my attending the school of Robert Henri where I received encouragement and a vague idea of what it was all about. After leaving the direct influence of Mr. Henri I sought other sources of information and as artists whose work I admired were not personally available I tried to find out what they were thinking about by looking at their pictures. Chief among those consulted were Aubrey Beardsley, Toulouse-Lautrec, Fernand Léger, and Picasso. This process of learning is from my observation identical with that followed by all artists. The only variation lies in the choice of work to be studied. If Picasso had been a practicing artist in Akron, Ohio, I would have admired his work just the same. I admit the study and the influence and regard it as all to the good. But why one should be penalized for a Picasso influence and not for a Rembrandt or a Renoir influence I can't understand.

I can't understand that any more than I can understand how one is supposed to be devoid of influence. I never heard of or saw anyone who was. Picasso himself has as many influences as Carter has pills, as Tad frequently said and I suppose this shows a Tad influence.

In view of all this I insist that I am as American as any other American painter. I was born here as were my parents and their parents before, which fact makes me an American whether I want to be or not. While I admit the foreign influence I strongly deny speaking their language. If my work were an imitation I am sure it couldn't arouse in you that enthusiasm from which, you state in your review, the bridles were almost removed. Over here we are racially English-American, Irish-American, German-American, French, Italian, Russian, or Jewish-American, and artistically we are Rembrandt-American, Renoir-American, and Picasso-American. But since we live here and paint here we are first of all, American.

## Stuart Davis, On the American Scene

1941*

I am an American, born in Philadelphia of American stock. I studied art in America. I paint what I see in America, in other words, I paint the American scene . . . . I don't want people to copy Matisse or Picasso, although it is entirely proper to admit their influence. I don't make paintings like theirs. I make paintings like mine. I want to paint and do paint particular aspects of this country which interest me. But I use, as a great many others do, some of the methods of modern French painting which I consider to have universal validity.

* Excerpt from "Abstract Art in the American Scene," *Parnassus* (New York), XIII (March 1941), 100–103.

## 1943[*]

In my own case I have enjoyed the dynamic American scene for many years, and all my pictures (including the ones I painted in Paris) are referential to it. They all have their originating impulse in the impact of contemporary American environment. Some of the things that have made me want to paint, outside of other paintings, are: American wood and iron work of the past; Civil War and sky-scraper architecture; the brilliant colors on gasoline stations, chain-store fronts, and taxi-cabs; the music of Bach; synthetic chemistry; the poetry of Rimbaud; fast travel by train, auto, and aeroplane which has brought new and multiple perspectives; electric signs; the landscape and boats of Gloucester, Massachusetts; 5 & 10 cent store kitchen utensils; movies and radio; Earl Hines' hot piano and Negro jazz music in general, etc. In one way or another, the quality of these things plays a role in determining the character of my painting; not in the sense of de-scribing them in graphic images, but by pre-determining an analogous dynamics in the design which becomes a new part of the American environment.

### Stuart Davis, Robert Henri's School, 1945[†]

Whatever the Henri School may have lacked in systematic discipline was more than made up for by other positive contributions. It took art off the academic pedestal and, by affirming its origin in the life of the day, developed a critical sense toward social values in the student. If there may have been a tendency toward anarchistic individualism, any preconceived ideas about racial, national, or class superiorities could not thrive in its atmosphere. By developing the student's con-fidence in his own preceptions, it gave his work a freshness and personality that was lacking in the student work of other schools. But the emphasis on "anti-artistic" subject matter, which was implicit in the whole Henri idea, tended to give subject matter, as such, a more important place than it deserves in art. In repudiating academic rules for picture structure, new ones suitable to the new purpose were insufficiently established. The borderline between descriptive and illustrative painting, and art as an autonomous sensate object, was never clarified. Because of this, reliance on the vitality of the subject matter to carry the interest prevented an objective appraisal of the dynamics of the actual color-space relations on the canvas. I became vaguely aware of this on seeing the work at the Armory Show.

[*] Excerpt from "Cube Root," *Art News* (New York), XLI, (1 February 1943), 22–23, 33–34.
[†] Excerpt from the autobiographical monograph, *Stuart Davis* (New York: American Artists Group, 1945), not paginated.

*Stuart Davis, The Armory Show, 1945*\*

[The Armory Show was the greatest shock to me—the greatest single influence I have experienced in my work. All my immediately subsequent efforts went toward incorporating Armory Show ideas into my work.]

It is difficult today to visualize the impact of this gigantic exhibition because at that time only isolated examples of the modern movement had been seen in New York. Here indeed was verification of the anti-Academy position of the Henri School, with developments in undreamed of directions.... I was enormously stimulated by it although appreciation of the more abstract work came later. I responded particularly to Gauguin, Van Gogh, and Matisse, because broad generalization of form and the non-imitative use of color were already practices within my own experience.... [I was interested in Gauguin's arbitrary use of color rather than his exotic subject matter. In the case of Van Gogh the subject matter also interested me because it was fields and things I knew. My interest in Van Gogh was not solely an interest in a work of art, but in a way of expressing something I saw about me. As a result I never had the feeling that Van Gogh's painting was at all alien. Cézanne and the cubists came later. It was probably an intellectual approach: not only the thing you knew but a way of thinking about the things you knew. In Gauguin, Van Gogh and Matisse] ... I also sensed an objective order in these works which I felt was lacking in my own [and which was present here without relation to any particular subject matter]. It gave me the same kind of excitement I got from the numerical precisions of the Negro piano players in the Negro saloons and I resolved that I would quite definitely have to become a "modern" artist.

*Stuart Davis, On Nature and Abstraction, 1945*†

I went to Gloucester every year, with a few exceptions, until 1934, and often stayed late into the fall. I wandered over the rocks, moors, and docks, with a sketching easel, large canvases, and a pack on my back, looking for things to paint. During the war I drew maps for the Army Intelligence. After a number of years the idea began to dawn on me that packing and unpacking all this junk, in addition to toting it all over the Cape, was irrelevant to my purpose. I became convinced that this was definitely doing things the hard way. Following this revelation my daily sorties were unencumbered except by a small sketch book of the lightest design known, and a specially constructed duralumin fountain pen.

---

\* Excerpt from the autobiographical *Stuart Davis*. A similar version is published in James Johnson Sweeney, *Stuart Davis* (New York: Museum of Modern Art, 1945), pp. 9–10. The material in brackets represents quotations that appear in Sweeney only, acknowledged by him as excerpts from conversations with Davis.

† Excerpt from the autobiographical *Stuart Davis*.

The decision was a good one, I felt less tired, and had greater powers of concentration. My standing in the local chess tournaments with Ambrose Gring, and Charley Winter rose a point or two. Further confirmation as to the excellence of this streamlined decision came from the pictures I made following it. It seems that in all this tramping around with full equipment I had actually learned something. All that was required to cash in on some of this information was to stop lifting things up and putting them down for a while. I have scrupulously followed this discipline ever since.

In abandoning the weighty apparatus of the outdoor painter I did not at the same time abandon nature as subject matter. My studio pictures were all from drawings made directly from nature. As I had learned in painting outdoors to use a conceptual instead of an optical perspective, so, in my studio compositions, I brought drawings of different places and things into a single focus. The necessity to select and define the spatial limits of these separate drawings, in relation to the unity of the whole picture, developed an objective attitude toward size and shape relations. Having already achieved this objectivity to a degree in relation to color the two ideas had now to be integrated and thought about simultaneously. The "abstract" kick was on. The culmination of these efforts occurred in 1927–1928, when I nailed an electric fan, a rubber glove and an eggbeater to a table and used it as my exclusive subject matter for a year. The pictures were known as the "Egg Beater" series and aroused some interested comment in the press, even though they retained no recognizable reference to the optical appearance of their subject matter.

*Marsden Hartley, "Art—and the Personal Life," 1928* *

As soon as a real artist finds out what art is, the more is he likely to feel the need of keeping silent about it, and about himself in connection with it. There is almost, these days, a kind of *petit scandale* in the thought of allying oneself with anything of a professional nature. And it is at this point that I shrink a little from asserting myself with regard to professional aspects of art. And here the quality of confession must break through. I have joined, once and for all, the ranks of the intellectual experimentalists. I can hardly bear the sound of the words "expressionism," "emotionalism," "personality," and such, because they imply the wish to express personal life, and I prefer to have no personal life. Personal art is for me a matter of spiritual indelicacy. Persons of refined feeling should keep themselves out of their painting, and this means, of course, that the accusation made in the form of a querulous statement to me recently "that you are a perfectionist" is in the main true.

I am interested then only in the problem of painting, of how to make a better painting according to certain laws that are inherent in the making of a good

* From *Creative Art* (New York) II, 6 (June 1928), xxxi–xxxvii.

picture—and not at all in private extraversions or introversions of specific individuals. That is for me the inherent error in a work of art. I learned this bit of wisdom from a principle of William Blake's which I discovered early and followed far too assiduously the first half of my aesthetic life, and from which I have happily released myself—and this axiom was: "Put off intellect and put on imagination; the imagination is the man." From this doctrinal assertion evolved the theoretical axiom that you don't see a thing until you look away from it—which was an excellent truism as long as the principles of the imaginative life were believed in and followed. I no longer believe in the imagination. I rose one certain day—and the whole thing had become changed. I had changed old clothes for new ones, and I couldn't bear the sight of the old garments. And when a painting is evolved from imaginative principles I am strongly inclined to turn away because I have greater faith that intellectual clarity is better and more entertaining than imaginative wisdom or emotional richness. I believe in the theoretical aspects of painting because I believe it produced better painting, and I think I can say I have been a fair exponent of the imaginative idea.

I have come to the conclusion that it is better to have two colors in right relation to each other than to have a vast confusion of emotional exuberance in the guise of ecstatic fullness or poetical revelation—both of which qualities have, generally speaking, long since become second-rate experience. I had rather be intellectually right than emotionally exuberant, and I could say this of any other aspect of my personal experience.

I have lived the life of the imagination, but at too great an expense. I do not admire the irrationality of the imaginative life. I have, if I may say so, made the intellectual grade. I have made the complete return to nature, and nature is, as we all know, primarily an intellectual idea. I am satisfied that painting also is like nature, an intellectual idea, and that the laws of nature as presented to the mind through the eye—and the eye is the painter's first and last vehicle—are the means of transport to the real mode of thought: the only legitimate source of aesthetic experience for the intelligent painter.

All the "isms," from Impressionism down to the present moment, have had their inestimable value and have clarified the mind and the scene of all superfluous emotionalism; the eye that turns toward nature today receives far finer and more significant reactions than previously when romanticism and the imaginative or poetic principles were the means and ways of expression.

I am not at all sure that the time isn't entirely out of joint for the so-called art of painting, and I am certain that very few persons, comparatively speaking, have achieved the real experience of the eye either as spectator or performer. Modern art must of necessity remain in the state of experimental research if it is to have any significance at all. Painters must paint for their own edification and pleasure, and what they have to say, not what they are impelled to feel, is what will interest those who are interested in them. The thought of the time is the emotion of the time.

I personally am indebted to Segantini the impressionist, not Segantini the symbolist,[1] for what I have learned in times past of the mountain and a given way to express it—just as it was Ryder who accentuated my already tormented imagination. Cubism taught me much and the principle of Pissarro, furthered by Seurat, taught me more. These with Cézanne are the great logicians of color. No one will ever paint like Cézanne, for example,—because no one will ever have his peculiar visual gifts; or to put it less dogmatically, will anyone ever appear again with so peculiar and almost unbelievable a faculty for dividing color sensations and making logical realizations of them? Has anyone ever placed his color more reasonably with more of a sense of time and measure than he? I think not, and he furnished for the enthusiast of today new reasons for research into the realm of color for itself.

It is not the idiosyncrasy of an artist that creates the working formula, it is the rational reasoning in him that furnishes the material to build on. Red, for example, is a color that almost any ordinary eye is familiar with—but in general when an ordinary painter sees it he sees it as isolated experience—with the result that his presentation of red lives its life alone, where it is placed, because it has not been modified to the tones around it—and modification is as good a name as any for the true art of painting color as we think of it today. Even Cézanne was not always sure of pure red, and there are two pictures of his I think of, where something could have been done to put the single hue in its place—the art for which he was otherwise so gifted. Real color is in a condition of neglect at the present time because monochrome has been the fashion for the last fifteen or twenty years—even the superb colorist Matisse was for a time affected by it. Cubism is largely responsible for this because it is primarily derived from sculptural concepts and found little need for color in itself. When a group feeling is revived once again, such as held sway among the Impressionists, color will come into its logical own. And it is timely enough to see that for purposes of outdoor painting, Impressionism is in need of revival.

Yet I cannot but return to the previous theme which represents my conversion from emotional to intellectual notions; and my feeling is: of what use is a painting which does not realize its aesthetical problem? Underlying all sensible works of art, there must be somewhere in evidence the particular problems understood. It was so with those artists of the great past who had the intellectual knowledge of structure upon which to place their emotions. It is this structural beauty that makes the old painting valuable. And so it becomes to me—a problem. I would rather be sure that I had placed two colors in true relationship to each other than to have exposed a wealth of emotionalism gone wrong in the name of richness of personal expression. For this reason I believe that it is more significant to keep

---

[1] Giovanni Segantini (1858–1899), Italian-Austrian whose style was based upon Impressionism but whose themes were of a mystical or Symbolist nature.

one's painting in a condition of severe experimentalism than to become a quick success by means of cheap repetition.

The real artists have always been interested in this problem, and you feel it strongly in the work of Da Vinci, Piero della Francesca, Courbet, Pissarro, Seurat, and Cézanne. Art is not a matter of slavery to the emotion—or even a matter of slavery to nature—or to the aesthetic principles. It is a tempered and happy union of them all.

*Marsden Hartley, Notes, 1919–1936*

### AN AMERICAN ARTIST*

They have talked about de-nationalizing of Americans—I shall talk of their blind and ignorant worship of what no longer exists. But I must do it quietly and carefully. They want Americans to be *American* and yet they offer little or no spiritual sustenance for their growth and welfare. But apart from all that I refuse to accept any status as a Europeanized artist or person, for Europe culturally speaking makes no difference in my life. I am as I always was and will remain to the end. America offers one thing, Europe another, and neither is either more remarkable than the other or preferable. If I had a sure means of support it would be different; I almost feel I would never lift a brush again but go my way living and loving life with a tendency to kill the first human person who ever mentioned art to me. Art is all right when it is left alone; it is a respectable and laudable ambition and occupation but no honest person wants to be driven to do anything, or be driven to doing it in any one given place. I have learned a great deal about art and its meaning since I conceived a kind of contempt for what the idolaters would have the world think it is. I have learned that it is an aristocratic privilege and it is all wrong to be driven to make a mercantile commodity of it. The French are doomed because they have learned how to make a business of art—that's that! I am ready for a lot of things when I get home, and shall only show the necessary tact to express myself, when and where.

### THE ARTIST AND HIS TIME†

Nevertheless there is a hopeful seriousness of interest developing in what is being done this side of the sea, a rediscovery of native art of the sort that is occurring in all countries . . . .

* Excerpt from a letter to Carl Sprinchorn, Aix-en-Provence, 1919. From *Lyonel Feininger/Marsden Hartley* with statements by the artists and foreword by Monroe Wheeler, copyright 1944 by The Museum of Modern Art, New York, and reprinted with its permission.
  † From *Adventures in the Arts: Informal Chapters on Painters, Vaudeville and Poets* New York: Boni & Liveright, 1921), pp. 241–242.

How will this affect the artist? He will learn first of all to be concerned with himself, and what he puts forth of personality and of personal research will receive its character from his strict adherence to this principle, whether he proceeds by means of prevailing theories or by departure from them. The public will thus have no choice but to rely upon what he produces seriously as coming clearly from himself, from his own desire and labor. He will realize that it is not a trick, not a habit, not a trade, this modernity, and that with fashions it has nothing to do; that it is explicitly a part of our modern urge toward expression quite as much as the art of . . . Titian, Giorgione, and Michelangelo were of Italy; that he and his time bear the strictest relationship to one another and that through this relationship he can best build up his own original power.

### SIMPLICITY OF VISION[*]

I am clearing my mind of all art nonsense, trying to accomplish simplicity and purity of vision for Life itself, for that is more important to me than anything else in my life. I am trying to return to the earlier conditions of my inner life, and take out of experience as it has come to me in the intervening years that which has enriched it, and make something of it more than just intellectual diversion. It can be done with proper attention and that is to be my mental and spiritual occupation from now on. In other words, it is the equivalent of what the religious-minded do when they enter a monastery or a convent and give up all the strain and ugliness of Life itself—and if I were younger with the same experience I am not at all sure I wouldn't do something like that now.

### THE QUALITY OF NATIVENESS[†]

Nativeness is built of such primitive things, and whatever is one's nativeness, one holds and never loses no matter how far afield the traveling may be . . . .

Those pictures which are not scenes, are in their way portraits of objects—which relieves them from being still-lifes, objects thrown up with the tides on the shores of the island where I have been living of late, the marine vistas to express the seas of the north, the objects at my feet everywhere which the tides washed representing the visible life of place, such as fragments of rope thrown overboard out on the Grand Banks by the fishermen, or shells and other crustacea driven in from their moorings among the matted seaweed and the rocks, given up even as the lost at sea are sometimes given up.

This quality of nativeness is colored by heritage, birth, and environment, and it is therefore for this reason that I wish to declare myself the painter from Maine.

[*] Excerpt from a letter to Carl Sprinchorn, Gloucester, Massachusetts, September 3, 1931. Reprinted in the Museum of Modern Art, *Feininger, Hartley*, p. 63.

[†] From "On the Subject of Nativeness—A Tribute to Maine" (New York: An American Place exhibition catalogue, 20 April–17 May, 1937).

We are subjects of our nativeness, and are at all times happily subject to it, only the mollusk, the chameleon, or the sponge being able to affect dissolution of this aspect.

When the picture-makers with nature as their subject get closer than they have for some time been, there will naturally be better pictures of nature, and who more than Nature will be surprised, and perhaps more delighted?

And so I say to my native continent of Maine, be patient and forgiving, I will soon put my cheek to your cheek, expecting the welcome of the prodigal, and be glad of it, listening all the while to the slow, rich, solemn music of the Androscoggin as it flows along.

*John Marin, conversation with Dorothy Norman, 1937*\*

I would say to a person who thinks he wants to paint, Go and look at the way a bird flies, a man walks, the sea moves. There are certain laws, certain formulae. You have to know them. They are nature's laws and you have to follow them just as nature follows them. You find the laws and you fill them in in your pictures and you discover that they are the same laws as in the old pictures. You don't create the formulae . . . . You see them.

Do you know why you don't feel satisfied with the top of the Empire State building, we'll say, or any rounded form at a great height? Do you know why? Because nature will not allow rounded forms at great height. Have you looked at the tops of high mountains, at the tops of the great tall trees? Have you ever found rounded forms there?

If the structure you've built isn't enough to hold up what you aim it should, or again, if it is stronger than it needs to be, you feel restless when you stand and look at the picture you are building . . . . Of course, you can address your envelope way over in the corner if you like, but you'll soon feel it out of balance . . . . It is the same with your picture.

The earth revolves around the sun so fast, you think surely it must smash itself to bits. But no. The sun itself keeps the earth from being smashed . . . . You're just going along and not paying any particular attention, and then, you just happen to look up and there is the sun a-shining, and you know it's moving in its course. You feel sure about the way it is going, for you know that it is moving according to some basic law . . . . And that is the way you feel in front of a picture that's made in a workmanlike way, even if you aren't actually thinking about the picture itself at all.

It is the mathematics of the thing you have to care about—not art. Oh yes, you have to care about the message. You don't avoid seeing the story element in anything, I suppose, but the thing you do has to exist by itself. The thing you have

\* *Magazine of Art* (New York), XXX, 3 (March 1937), 151.

to care about is doing a workman's, a builder's, a mathematician's job. You have to be constantly working, building up your weights and balances, so that your picture will stand inevitably, and so that the structure you're building gives you the feeling of solidity, of permanency. And all of the different parts of the picture will have to be working together, and as essential parts of the picture as a whole . . . .

There are things you feel in the back of your head. Your vision is working itself out on an imaginary surface . . . . Then there's your canvas, the focal plane to which you bring all the things in that vision of yours. All the lines and forms of your vision come up to that plane, so that if you make three lines or any number of lines on this canvas you're working on, and consider these lines as centers of movements of what you want to show, you have to keep building in and out from these lines all the time . . . . It is a thing in itself that you are building and you are not copying something outside your vision. But if you make an outline and then try to fill it in, you'll always feel you're only working from out in. You have to work from in out, always working from an axis, holding to that. Then what you are doing will be abstract in the pure sense that what you're doing exists without depending upon copying.

When the structure inside your frame is strong enough to carry itself, then it doesn't so much matter what happens at the edges. If you have a strongly built figure of a woman, we'll say, with fringe around her dress, then that feeling of fringe can't kill the main structure of your picture. But if you have something so violent going on at the edges that it destroys the feeling of solidity in your inside structure, then something is wrong. A picture has to be a thing complete in its frame. You shouldn't feel its strength going off from it. Your picture has got to stop at its four edges through the weights and balances from inside your picture controlling it from the axis . . . . Naturally, no one has ever got it just right, but some do seem to approach it. At times, too, of course, we don't obey the laws. When this happens in a wild state it's all right, but you shouldn't be so wild that you can't counterbalance what you have disobeyed. There is always a certain amount of freedom allowed and I suppose necessary but one is always striving to get at certain laws and to obey them.

*Arshile Gorky, Cubism and Space, 1931**

The twentieth century—what intensity, what activity, what restless, nervous energy! Has there in six centuries been better art than cubism? No. Centuries will go past—artists of gigantic stature will draw positive elements from cubism.

Clumsy painters take a measurable space, a clear definite shape, a rectangle, a vertical or horizontal direction, and they call it blank canvas, while every time

---

* Excerpt from Arshile Gorky, "Stuart Davis," *Creative Art* (New York), IX (September 1931), 217. Reprinted in Ethel K. Schwabacher, *Arshile Gorky* (New York: Macmillan, for the Whitney Museum of American Art, 1957), p. 46.

*Arshile Gorky.*
*Photograph by Gjon Mili.*

one stretches canvas he is drawing a new space. How could they ever have understood cubism or the art of the twentieth century? How could they even conceive of the elements that go into the making of art? How could they accept tranquility and expansion as elements of feeling in painting?

*Arshile Gorky, description of his mural,* Aviation: Evolution of Forms under Aerodynamic Limitations, *ca. 1936*★

The architectonic two-dimensional surface plane of walls must be retained in mural painting. How was I to overcome this plastic problem when the subject of my murals was that of the unbounded space of the sky-world of aviation? How keep the walls from flying away or else crushing together as they would be sure to do in a pictorial narrative? The problem resolved itself when I considered the new vision that flight has given to the eyes of man. The isle of Manhattan with all its skyscrapers from the view of an aeroplane five miles up becomes but a geographical map, a two-dimensional surface plane. This new perception simplifies the forms and shapes of earth objects. The thickness of objects is lost and only the space occupied by the objects remains. Such simplification removes all decorative details and leaves the artist with limitations which become a style, a plastic invention, particular to our time. How was I to utilize this new concept for my murals?

In the popular idea [of] art, an aeroplane is painted as it might look in a photograph. But such a hackneyed concept has no architectural unity in the space that it is to occupy nor does it truthfully represent an aeroplane with all its ramifications. An operation was imperative, and that is why in the first panel of "Activities on the Field" I had to dissect an aeroplane into its constituent parts. An aeroplane is composed of a variety of shapes and forms and I have used such elemental forms as a rudder, a wing, a wheel, a searchlight, etc., to create not only numerical interest, but also to include within a given wall space, plastic symbols of aviation. These plastic symbols are the permanent elements of aeroplanes that will not change with the change of design. These symbols, these forms, I have used in paralyzing disproportions in order to impress upon the spectator the miraculous new vision of our time. To add to the intensity of these shapes, I have used such local colors as are to be seen on the aviation field, red, blue, yellow, black, gray, brown, because these colors were used originally to sharpen the objects against neutral backgrounds so that they could be seen clearly and quickly.

The second panel of the same wall contains objects commonly used around a hangar, such as a ladder, a fire extinguisher, a gasoline truck, scales, etc. These objects I have dissected and reorganized in the same homogeneous arrangement as in the previous panel.

In the panel "Early Aviation," I sought to bring into elemental terms the

★ Originally published as a pamphlet for the WPA. Reprinted in Schwabacher, *Arshile Gorky*, pp. 70–74.

sensation of the passengers in the first balloon to the wonder of the sky around them and the earth beneath. Obviously this conception entails a different problem than those previously cited. In fact each of the walls presents a different problem concerning aviation and to solve each one, I had to use different concepts, different plastic qualities, different colors. Thus, to appreciate my panel of the first balloon, the spectator must seek to imaginatively enter into the miraculous sense of wonder experienced by the first balloonists. In the shock of surprise everything changes. The sky becomes green. The sun is black with astonishment on beholding an invention never before created by the hand of God. And the earth is spotted with such elliptical brown forms as had never been seen before.

This image of wonder I continued in the second panel. From the first balloon of Mongolfier, aviation developed until the wings of the modern aeroplane, figuratively speaking, stretch across the United States. The sky is still green, for the wonders of the sky never cease, and the map of the United States takes on a new geographical outline because of the illusion of change brought about by the change in speed.

The first three panels of "Modern Aviation" contain the anatomical parts of autogyros in the process of soaring into space, and yet with the immobility of suspension. The fourth panel is a modern aeroplane simplified to its essential form and so spaced as to give a sense of flight.

In the last three panels I have used arbitrary colors and shapes; the wing is black, the rudder yellow, so as to convey the sense that these modern gigantic toys of men are decorated with the same fanciful play as children have in coloring their kites. In the same spirit the engine becomes in one place like the wings of a dragon and in another the wheels, propeller, and motor take on the demonic speed of a meteor cleaving the atmosphere.

In "Mechanics of Flying" I have used morphic shapes. The objects portrayed, a thermometer, hygrometer, anemometer, an aeroplane map of the United States, all have a definitely important usage in aviation, and to emphasize this, I have given them importance by detaching them from their environment.

*Arshile Gorky, notes on his painting series, Garden in Sochi, 1942**

I like the heat, the tenderness, the edible, the lusciousness, the song of a single person, the bathtub full of water to bathe myself beneath the water, I like Uccello, Grünewald, Ingres, the drawings and sketches for paintings of Seurat, and that man Pablo Picasso.

* Excerpt from a manuscript in the files of the Museum of Modern Art Library, New York. Printed in Schwabacher, *Arshile Gorky*, p. 66. Written in June 1942, at the request of Dorothy Miller, about the painting, "Garden in Sochi," which The Museum of Modern Art had just acquired. From the Collections Archives, The Museum of Modern Art, New York, and reprinted with its permission.

535

I measure all things by weight.

I love my Mougouch. What about papa Cézanne! I hate things that are not like me and all the things I haven't got are God to me.

Permit me—

I like the wheatfields, the plough, the apricots, the shape of apricots, those flirts of the sun. And bread above all . . . .

About 194 feet away from our house on the road to the spring, my father had a little garden with a few apple trees which had retired from giving fruit. There was a ground constantly in shade where grew incalculable amounts of wild carrots, and porcupines had made their nests. There was a blue rock half-buried in the black earth with a few patches of moss placed here and there like fallen clouds. But from where came all the shadows in constant battle like the lancers of Paolo Uccello's painting? This garden was identified as the Garden of Wish Fulfillment and often I had seen my mother and other village women opening their bosoms and taking their soft and dependent breasts in their hands to rub them on the rock. Above all this stood an enormous tree all bleached under the sun, the rain, the cold, and deprived of leaves. This was the Holy Tree. I myself don't know why this tree was holy but I had witnessed many people, whoever did pass by, that would tear voluntarily a strip of their clothes and attach this to the tree. Thus through many years of the same act, like a veritable parade of banners under the pressure of wind all these personal inscriptions of signatures, very softly to my innocent ear used to give echo to the sh-h-h-sh-h of silver leaves of the poplars.

*Hans Hofmann, excerpts from his teaching*★

TERMS:

| | |
|---|---|
| Nature: | the source of all inspiration. |
| | Whether the *artist* works directly from nature, from memory, or from fantasy, nature is always the source of his creative impulses. |
| The Artist: | an agent in whose mind nature is transformed into a new *creation*. |
| | The artist approaches his problems from a metaphysical standpoint. His intuitive faculty of sensing the inherent qualities of things dominates his creative instinct. |
| Creation: | a synthesis, from the artist's standpoint, of matter, space and color. |
| | Creation is not a reproduction of observed fact. |

★ From *Search for the Real and Other Essays* by Hans Hofmann, eds. S. T. Weeks and B. H. Hayes, Jr., translated by Glenn Wessels (Andover, Mass.: Addison Gallery of American Art, 1948), pp. 65–78, *passim*. The best study of Hofmann's philosophy of painting is in William C. Seitz, *Hans Hofmann* (New York: Museum of Modern Art, 1963).

*Hans Hofmann, ca. 1960.*
*Photograph by Marvin P. Lazarus, New York.*

Positive Space:    the presence of visible matter.

Negative Space:    the configuration, or "constellation," of the voids between and around portions of visible matter.

Color:    in a scientific sense, a particular state of light; in an artistic sense, the perception of plastic and psychological differences in the quality of light.

These differences are conceived as color *intervals* which are similar to *tensions*, the expression of related forces between two or more solid forms.

In nature, light creates the sensation of color; in a picture, color creates light.

Vision:    the stimulus of the optic nerve by light; artistically, the awareness of variations in the nature of this stimulus which enables one to distinguish positive and negative space and color.

Empathy:    the imaginative projection of one's own consciousness into another being, or thing. In visual experience, it is the intuitive

537

# Terms

Hans Hofmann, *diagram of Nature-Artist-Creation, ca. 1948.*

| | |
|---|---|
| | faculty to sense qualities of formal and spatial relations, or tensions, and to discover the plastic and psychological qualities of form and color. |
| Expression Medium: | the material means by which ideas and emotions are given visible form. |
| | Each expression medium has a nature and life of its own according to which creative impulses are visualized. The artist must not only interpret his experience of nature creatively, but he must be able to translate his feeling for nature into a creative interpretation of the *expression medium*. To explore the nature of the medium is part of the understanding of nature, as well as part of the process of creation. |
| Picture Plane: | the plane, or surface, on which the picture exists. |
| | The essence of the picture plane is flatness. Flatness is synonymous with two-dimensionality. |
| Plasticity: | the transference of three-dimensional experience to two dimensions. A work of art is plastic when its pictorial message is integrated with the picture plane and when nature is embodied in terms of the qualities of the *expression medium*. |
| Spirituality: | the emotional and intellectual synthesis of relationships perceived in nature, rationally, or intuitively. |

538

Spirituality in an artistic sense should not be confused with religious meaning.

Reality: artistically, an awareness.

There are two kinds of reality: physical reality, apprehended by the senses, and spiritual reality created emotionally and intellectually by the conscious or subconscious powers of the mind.

## ON THE AIM AND NATURE OF ART

The aim of art, so far as one can speak of an aim at all, has always been the same; the blending of experience gained in life with the natural qualities of the art medium.

Artistic intuition is the basis for confidence of the spirit. Art is a reflection of the spirit, a result of introspection, which finds expression in the nature of the art medium.

When the artist is well equipped with conscious feeling, memory, and balanced sensibilities, he intensifies his concepts by penetrating his subject and by condensing his experience into a reality of the spirit complete in itself. Thus he creates a new reality in terms of the medium.

The medium becomes the work of art, but only when the artist is intuitive and at the same time masters its essential nature and the principles which govern it.

A work of art is a world in itself reflecting senses and emotions of the artist's world.

Just as a flower, by virtue of its existence as a complete organism, is both ornamental and self-sufficient as to color, form, and texture, so art, because of its singular existence, is more than mere ornament.

## ON CREATION

The encompassing, creative mind recognizes no boundaries. The mind has ever brought new spheres under its control.

All our experiences culminate in the perception of the universe as a whole with man as its center.

Visual experience cannot be based on feeling or perception alone. Feelings and perceptions which are not sublimated by the essence of things lose themselves in the sentimental.

Every deep artistic expression is the product of a conscious feeling for reality. This concerns both the reality of nature and the reality of the intrinsic life of the medium of expression.

The difference between art produced by children and great works of art is that one is approached through the purely subconscious and emotional, and the other retains a consciousness of experience as the work develops and is emotionally enlarged through the greater command of the expression-medium.

To experience visually, and to transform our visual experience into plastic terms, requires the faculty of empathy.

Dreams and reality are united in our imagination. The artist possesses the means to create only after he has effective command of his faculty of empathy which he must develop simultaneously with his imaginative capacity.

The process of creation is based upon two metaphysical factors: (1) upon the power to experience through the faculty of empathy, and (2) upon the spiritual interpretation of the expression-medium as a result of such powers. Concept and execution condition each other equally. The greater the concept, the more profound and intensive will the spiritual animation of the expression-medium generally be and, consequently, the greater will be the impressiveness and importance of the work.

We distinguish two technical factors in creative painting: (1) the symphonic animation of the picture plane (as in the so-called art of easel painting or print making, etching, engraving, and other forms of drawing which may suggest color); and (2) the decorative animation of the picture plane, as in so-called mural painting. Truly considered, however, the names "easel picture" and "mural picture" express purely external differences. Philosophically, every work which possesses intrinsic greatness is at once decorative and symphonically focused and integrated.

Every creative act requires elimination and simplification. Simplification results from a realization of what is essential.

The mystery of plastic creation is based upon the dualism of the two dimensional and the three dimensional . . . .

## ON RELATION

Monumentality is an affair of relativity. The truly monumental can only come about by means of the most exact and refined relation between parts. Since each thing carries both a meaning of its own and an associated meaning in relation to something else—its essential value is relative. We speak of the mood we experience when looking at a landscape. This mood results from the relation of certain things rather than from their separate actualities. This is because objects do not in themselves possess the total effect they give when interrelated.

Similarly the representation element (subject matter) and the presentation elements (line, plane, color) do not separately produce the same effects as when related in a finally created work. The effect produced is the quintessence of the relation.

The mind uses subject matter as a vehicle for the creation of a surreal effect. The sum total of such surreal effects forms the emotional substance of a work.

It is a mistake to believe that the representation of objects excludes aesthetic profoundness. In my opinion, the very opposite is true. The greatness of aesthetic form which the artist creates may culminate in a pictorial realization of

objects without any harm to the aesthetic development of the work. The works of the old masters are examples.

The artist who works independently of the chance appearance of nature uses the accumulation of experience gained from nature as the source of his inspiration. He faces the same aesthetic problems in regard to his medium as the artist who works directly from nature. It makes no difference whether his work is naturalistic or abstract; every visual expression follows the same fundamental laws.

Each expression-medium has a life of its own. Regulated by certain laws, it can be mastered only by intuition during the act of creating. It is in the nature of the laws which govern every expression-medium that two separate entities, related through empathy, always produce a higher third of a purely spiritual nature. The spiritual third manifests itself as quality which carries an emotional content. This quality is the opposite of illusion; it is a reality of the spirit. Spiritual qualities influence each other according to the way (creation-direction) in which they become related.

This perception leads necessarily to the concept of an "interval" art. An interval results from relationship. A relation requires at least two material carriers to produce a super-imposed higher "surreal" as the meaning of the relation. A mystic overtone now overshadows the carrier. Its coming into existence is the exact equivalent of the relation. Being of a higher order, only these ultra, dominating relations can give a spiritual character to the work. This spiritual character determines the nature of the final plastic expression.

There is only a very limited relation between scientific laws and the creative process. The first deal with experiences that occur repeatedly in the same manner. Creation occurs through progress from one result to another. A work of art goes through many phases of development, but in each phase it is always a work of art. (Therein lies the importance of sketches.) A work of art is finished, from the point of view of the artist, when feeling and perception have resulted in a spiritual synthesis.

## ON THE MEDIUM OF EXPRESSION

An idea can only be materialized with the help of a medium of expression, the inherent qualities of which must be surely sensed and understood in order to become the carrier of an idea. The idea is transformed, adapted to, and carried by the inner quality of the medium, not by its external aspect. This explains why the same formative idea can be expressed in a number of different mediums.

An idea to be expressed may be based upon naturalistic experience, fantasy, or abstract concepts. All these sources generate impulses in the mind which may be transformed and given expression through corresponding vibrations within the expression-medium.

The intensity of enlivenment which the expression-medium finally reaches depends solely on the artist's faculty to experience emotionally, which, in its turn,

determines the degree of spiritual projection into the nature of the expression-medium. The enlivenment of the expression-medium is the prerequisite of a plastic creation. The question of "What shall be expressed?" is always anticipated by this requirement.

From the very start of his studies an artist who works from nature faces a double problem. He must learn to see (it is amazing what people do not see) and he must learn to interpret his visual experience as a plastic experience. This will not yet enable him to create, for the act of creation is bound to a medium of expression. He must interpret the plastic nature of the medium of expression and translate his experience in accordance with it. This is the meaning of plastic creation.

The artist who disregards plastic creation will be an imitator, not a creator; his work will have no aesthetic foundation.

## ON PICTORIAL LAWS

Painting possesses fundamental laws. These laws are dictated by fundamental perceptions. One of these perceptions is: the essence of the picture is the picture plane. The essence of the picture plane is its two-dimensionality. The first law is then derived: the picture plane must be preserved in its two-dimensionality throughout the whole process of creation until it reaches its final transformation in the completed picture. And this leads to the second law: the picture must achieve a three-dimensional effect, distinct from illusion, by means of the creative process. These two laws apply both to color and to form.

## ON THE PICTURE PLANE

Three-dimensional objects in nature are recorded optically as two-dimensional images. These images are identified with the two-dimensional quality of the picture plane.

The most complete representation of three-dimensionality, in which all the three-dimensional fragments are summarized in an entity, results in pictorial two-dimensionality.

The act of creation agitates the picture plane, but if the two-dimensionality is lost the picture reveals holes and the result is not pictorial, but a naturalistic imitation of nature.

The plane is the creative element of all the plastic arts, painting, sculpture, architecture, and related arts. Colors, commonly color-bearing planes, are creative elements in painting . . . .

## ON MOVEMENT

Life does not exist without movement and movement does not exist without life. Movement is the expression of life. All movements are of a spatial nature. The continuation of movement throughout space is rhythm. Thereby rhythm is the expression of life in space.

Movement develops from depth sensation. There are movements into space and movements forward, out of space, both in form, and in color.

The product of movement and counter-movement is tension. When tension—working strength—is expressed, it endows the work of art with the living effect of coordinated, though opposing, forces.

Movement, as we experience it, can take a two- or a three-dimensional course. Movement on a picture plane can only take a two-dimensional course. Three-dimensional movement can be established upon the picture plane only as two-dimensional, for one cannot produce actual depth on the picture plane but only the sensation of depth.

For the same reason, one cannot produce actual motion on the picture plane but only the sensation of motion. Depth and motion find formal expression in the shifting of planes and lines within the plane of the picture.

The tension of movement and counter-movement, achieved through plastic order and unity, parallels the artist's life experience and his artistic and human discipline. It arouses a sympathetic response in the spirit of the observer. The balance of many contrasting factors produces a many-faceted, yet unified, life.

A plastic presentation which is not dominated by movement and rhythm is a dead form and, therefore, inexpressive. Form is the shell of life. Form discloses itself to us as a living thing in its surface tensions. These tensions are kept under the spell of living forces. Only in the fullness of life does a form present its greatest surface tension. The form shrinks and dissolves when life ends, and cold unanimated space ensues. When all form dissolves, unpresentable nothingness remains.

## ON LIGHT AND COLOR

We recognize visual form only by means of light, and light only by means of form, and we further recognize that color is an effect of light in relation to form and its inherent texture. In nature, light creates color; in painting, color creates light.

In symphonic painting, color is the real building medium. "When color is richest, form is fullest." This declaration of Cézanne's is a guide for painters.

Swinging and pulsating form and its counterpart, resonating space, originate in color intervals. In a color interval, the finest differentiations of color function as powerful contrasts. A color interval is comparable to the tension created by a form relation. What a tension signifies in regard to form, an interval signifies in regard to color; it is a tension between colors that makes color a plastic means.

A painting must have form and light unity. It must light up from the inside through the intrinsic qualities which color relations offer. It must not be illuminated from the outside by superficial effects. When it lights up from the inside, the painted surface breathes, because the interval relations which dominate the whole cause it to oscillate and to vibrate.

A painted surface must retain the transparency of a jewel which stands as a

prototype of exactly ordered form, on the one hand, and as a prototype of the highest light emanation on the other.

The Impressionists led painting back to the two-dimensional in the picture through the creation of a light unity, whereas their attempt to create atmosphere and spatial effectiveness by means of color, resulted in the impregnation of their works with the quality of translucence which became synonymous with the transparency of the picture plane.

Light must not be conceived as illumination—it forces itself into the picture through color development. Illumination is superficial. Light must be created. In this manner alone is the balance of light possible.

The formation of a light unity becomes identified with the two-dimensionality of the picture. Such a formation is based on comprehending light complexities. Color unity, in the same manner, is identified with the two-dimensionality of the picture. It results from color tensions created by color intervals. Thus the end product of all color intervals is two dimensionality.

Spatial and formal unity and light and color unity create the plastic two-dimensionality of the picture.

Since light is best expressed through differences in color quality, color should not be handled as a tonal gradation, to produce the effect of light.

The psychological expression of color lies in unexpected relations and associations.

## ON ENJOYMENT

"Aesthetic enjoyment is caused by the perception of hidden laws ... aesthetic enjoyment is joy in itself, released from subordination to any purpose; therefore, it embraces the enjoyment of nature and the enjoyment of art both." (Walter Rathenau: *Notes on Art Philosophy*.) The aim of art is always to provide such joy for us in every form of expression. The faculty to enjoy rests with the observer.

*Adolph Gottlieb and Mark Rothko, Statement, 1943*★

To the artist the workings of the critical mind is one of life's mysteries. That is why, we suppose, the artist's complaint that he is misunderstood, especially by the critic, has become a noisy commonplace. It is therefore an event when the worm turns and the critic quietly, yet publicly, confesses his "befuddlement," that he is "nonplused" before our pictures at the federation show. We salute this honest, we might say cordial, reaction toward our "obscure" paintings, for in other critical quarters

★ A response to remarks by the art critic Edward Alden Jewell on their paintings in the Federation of Modern Painters and Sculptors exhibition held in New York at Wildenstein Gallery, June 1943. The statement was published in Mr. Jewell's column in the *New York Times*, 13 June 1943.

we seem to have created a bedlam of hysteria. And we appreciate the gracious opportunity that is being offered us to present our views.

We do not intend to defend our pictures. They make their own defense. We consider them clear statements. Your failure to dismiss or disparage them is *prima facie* evidence that they carry some communicative power. We refuse to defend them not because we cannot. It is an easy matter to explain to the befuddled that *The Rape of Persephone* [by Adolph Gottlieb] is a poetic expression of the essence of the myth; the presentation of the concept of seed and its earth with all the brutal implications; the impact of elemental truth. Would you have us present this abstract concept, with all its complicated feelings, by means of a boy and girl lightly tripping?

It is just as easy to explain *The Syrian Bull* [by Mark Rothko] as a new interpretation of an archaic image, involving unprecedented distortions. Since art is timeless, the significant rendition of a symbol, no matter how archaic, has as full validity today as the archaic symbol had then. Or is the one 3,000 years old truer? . . .

No possible set of notes can explain our paintings. Their explanation must come out of a consummated experience between picture and onlooker. The point at issue, it seems to us, is not an "explanation" of the paintings, but whether the intrinsic ideas carried within the frames of these pictures have significance. We feel that our pictures demonstrate our aesthetic beliefs, some of which we, therefore, list:

    1. To us art is an adventure into an unknown world, which can be explored only by those willing to take the risks.

    2. This world of the imagination is fancy-free and violently opposed to common sense.

    3. It is our function as artists to make the spectator see the world our way—not his way.

    4. We favor the simple expression of the complex thought. We are for the large shape because it has the impact of the unequivocal. We wish to reassert the picture plane. We are for flat forms because they destroy illusion and reveal truth.

    5. It is a widely accepted notion among painters that it does not matter what one paints as long as it is well painted. This is the essence of academism. There is no such thing as good painting about nothing. We assert that the subject is crucial and only that subject-matter is valid which is tragic and timeless. That is why we profess spiritual kinship with primitive and archaic art.

Consequently, if our work embodies these beliefs it must insult any one who is spiritually attuned to interior decoration; pictures for the home; pictures for over the mantel; pictures of the American scene; social pictures; purity in art; prize-winning potboilers; the National Academy, the Whitney Academy, the Corn Belt Academy; buckeyes; trite tripe, etc.

*Robert Motherwell, Statement, 1944*\*

As a result of the poverty of modern life, we are confronted with the circumstance that art is more interesting than life.

*Jackson Pollock, Three Statements, 1944–1951*

## 1944†

I accept the fact that the important painting of the last hundred years was done in France. American painters have generally missed the point of modern painting from beginning to end. (The only American master who interests me is Ryder.) Thus the fact that good European moderns are now here is very important, for they bring with them an understanding of the problems of modern painting. I am particularly impressed with their concept of the source of art being the Unconscious.[1] This idea interests me more than these specific painters do, for the two artists I admire most, Picasso and Miro, are still abroad . . . .

The idea of an isolated American painting, so popular in this country during the thirties, seems absurd to me just as the idea of creating a purely American mathematics or physics would seem absurd . . . . And in another sense, the problem doesn't exist at all; or, if it did, would solve itself. An American is an American and his painting would naturally be qualified by that fact, whether he wills it or not. But the basic problems of contemporary painting are independent of any country.

## 1947‡

My painting does not come from the easel. I hardly ever stretch my canvas before painting. I prefer to tack the unstretched canvas to the hard wall or the floor. I need the resistance of a hard surface. On the floor I am more at ease. I feel nearer, more a part of the painting, since this way I can walk around it, work from the four sides and literally be *in* the painting. This is akin to the method of the Indian sand painters of the West.

I continue to get further away from the usual painter's tools such as easel,

---

\* From *Partisan Review* (New York), XI, 1 (Winter 1944), 96.

† Excerpt from the artist's written answer to a questionnaire published in *Arts and Architecture*, LXI (February 1944). Reprinted in Bryan Robertson, *Jackson Pollock* (New York: Abrams, 1961), p. 193.

[1] Pollock was close to the Surrealists at this time. He had been invited to exhibit his work with them at the International Surrealist Exhibition in New York in 1942, and his one-man exhibition at Peggy Guggenheim's Art of this Century Gallery in 1943 received considerable attention from them.

‡ Excerpt from "My Painting," *Possibilities* I (New York), Winter 1947/48, p. 79.

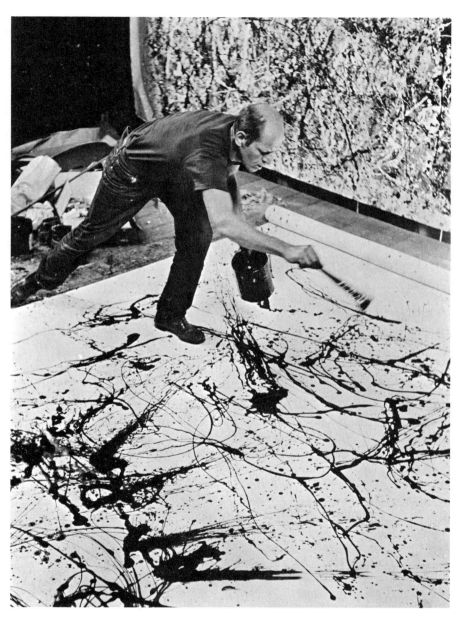

*Jackson Pollock, 1951.*
*Photograph by Hans Namuth,*
*New York.*

palette, brushes, etc. I prefer sticks, trowels, knives, and dripping fluid paint or a heavy impasto with sand, broken glass, and other foreign matter added.

When I am *in* my painting, I'm not aware of what I'm doing. It is only after a sort of "get acquainted" period that I see what I have been about. I have no fears about making changes, destroying the image, etc., because the painting has a life of its own. I try to let it come through. It is only when I lose contact with the painting that the result is a mess. Otherwise there is pure harmony, an easy give and take, and the painting comes out well.

### 1951*

I don't work from drawings or color sketches. My painting is direct . . . . The method of painting is the natural growth out of a need. I want to express my feelings rather than illustrate them. Technique is just a means of arriving at a statement. When I am painting I have a general notion as to what I am about. I *can* control the flow of paint: there is no accident, just as there is no beginning and no end.

*Mark Rothko, "The Romantics Were Prompted," 1947†*

The romantics were prompted to seek exotic subjects and to travel to far off places. They failed to realise that, though the transcendental must involve the strange and unfamiliar, not everything strange or unfamiliar is transcendental.

The unfriendliness of society to his activity is difficult for the artist to accept. Yet this very hostility can act as a lever for true liberation. Freed from a false sense of security and community, the artist can abandon his plastic bank-book, just as he has abandoned other forms of security. Both the sense of community and of security depend on the familiar. Free of them, transcendental experiences become possible.

I think of my pictures as dramas; the shapes in the pictures are the performers. They have been created from the need for a group of actors who are able to move dramatically without embarrassment and execute gestures without shame.

Neither the action nor the actors can be anticipated, or described in advance. They begin as an unknown adventure in an unknown space. It is at the moment of completion that in a flash of recognition, they are seen to have the quantity and function which was intended. Ideas and plans that existed in the mind at the start were simply the doorway through which one left the world in which they occur.[1]

---

* From the narration by the artist for the film *Jackson Pollock* (1951), by Hans Namuth and Paul Falkenberg. Reprinted in Robertson, *Jackson Pollock*, p. 194.

† From *Possibilities* I, p. 84.

[1] Compare Rothko's statement that the shapes are the performers in an action that cannot be anticipated with Harold Rosenberg's "action painting" (below).

The great cubist pictures thus transcend and belie the implications of the cubist program.

The most important tool the artist fashions through constant practice is faith in his ability to produce miracles when they are needed. Pictures must be miraculous: the instant one is completed, the intimacy between the creation and the creator is ended. He is an outsider. The picture must be for him, as for anyone experiencing it later, a revelation, an unexpected and unprecedented resolution of an eternally familiar need.

On shapes:

They are unique elements in a unique situation.

They are organisms with volition and a passion for self-assertion.

They move with internal freedom, and without need to conform with or to violate what is probable in the familiar world.

They have no direct association with any particular visible experience, but in them one recognizes the principle and passion of organisms.

The presentation of this drama in the familiar world was never possible, unless everyday acts belonged to a ritual accepted as referring to a transcendent realm.

Even the archaic artist, who had an uncanny virtuosity, found it necessary to create a group of intermediaries, monsters, hybrids, gods, and demigods. The difference is that, since the archaic artist was living in a more practical society than ours, the urgency for transcendent experience was understood, and given an official status. As a consequence, the human figure and other elements from the familiar world could be combined with, or participate as a whole in the enactment of the excesses which characterize this improbable hierarchy. With us the disguise must be complete. The familiar identity of things has to be pulverized in order to destroy the finite associations with which our society increasingly enshrouds every aspect of our environment.

Without monsters and gods, art cannot enact our drama: art's most profound moments express this frustration. When they were abandoned as untenable superstitions, art sank into melancholy. It became fond of the dark, and enveloped its objects in the nostalgic intimations of a half-lit world. For me the great achievements of the centuries in which the artist accepted the probable and familiar as his subjects were the pictures of the single human figure—alone in a moment of utter immobility.

But the solitary figure could not raise its limbs in a single gesture that might indicate its concern with the fact of mortality and an insatiable appetite for ubiquitous experience in face of this fact. Nor could the solitude be overcome. It could gather on beaches and streets and in parks only through coincidence, and, with its companions, form a *tableau vivant* of human incommunicability.

I do not believe that there was ever a question of being abstract or representational. It is really a matter of ending this silence and solitude, of breathing and stretching one's arms again.

*Barnett Newman, "The Ideographic Picture," 1947*\*

> Ideograph—A character, symbol, or figure which suggests the idea without expressing its name.
>
> Ideographic—Representing ideas directly and not through the medium of their names; applies specifically to that mode of writing which by means of symbols, figures, or hieroglyphics suggests the idea of an object without expressing its name.
>
> —*The Century Dictionary*
>
> Ideograph—A symbol or character painted, written, or inscribed, representing ideas.
>
> —*The Encyclopaedia Britannica*

The Kwakiutl artist painting on a hide did not concern himself with the inconsequentials that made up the opulent social rivalries of the Northwest Coast Indian scene, nor did he, in the name of a higher purity, renounce the living world for the meaningless materialism of design. The abstract shape he used, his entire plastic language, was directed by a ritualistic will towards metaphysical understanding. The everyday realities he left to the toymakers; the pleasant play of non-objective pattern to the women basket weavers. To him a shape was a living thing, a vehicle for an abstract thought-complex, a carrier of the awesome feelings he felt before the terror of the unknowable. The abstract shape was, therefore, real rather than a formal "abstraction" of a visual fact, with its overtone of an already-known nature. Nor was it a purist illusion with its overload of pseudo-scientific truths.

The basis of an aesthetic act is the pure idea. But the pure idea is, of necessity, an aesthetic act. Here then is the epistemological paradox that is the artist's problem. Not space cutting nor space building, not construction nor fauvist destruction; not the pure line, straight and narrow, nor the tortured line, distorted and humiliating; not the accurate eye, all fingers, nor the wild eye of dream, winking; but the idea-complex that makes contact with mystery—of life, of men, of nature, of the hard, black chaos that is death, or the grayer, softer chaos that is tragedy. For it is only the pure idea that has meaning. Everything else has everything else.

Spontaneous, and emerging from several points, there has arisen during the war years a new force in American painting that is the modern counterpart of the primitive art impulse. As early as 1942, Mr. Edward Alden Jewell was the first publicly to report it. Since then, various critics and dealers have tried to label it, to describe it. It is now time for the artist himself, by showing the dictionary, to make clear the community of intention that motivates him and his colleagues. For here is

---

\* From *The Ideographic Picture* (New York: Betty Parsons Gallery exhibition catalogue, January 20–February 8, 1947). The exhibition included work by Hans Hofmann, Pietro Lazzari, Boris Margo, Barnett Newman, Ad Reinhardt, Mark Rothko, Theodoros Stamos, and Clyfford Still.

a group of artists who are not abstract painters, although working in what is known as the abstract style.

Mrs. Betty Parsons has organized a representative showing of this work around the artists in her gallery who are its exponents. That all of them are associated with her gallery is not without significance.

## Barnett Newman, "The First Man Was an Artist," 1947*

Undoubtedly the first man was an artist.

A science of paleontology that sets forth this proposition can be written if it builds on the postulate that the aesthetic act always precedes the social one. The totemic act of wonder in front of the tiger-ancestor came before the act of murder. It is important to keep in mind that the necessity for dream is stronger than any utilitarian need. In the language of science, the necessity for understanding the unknowable comes before any desire to discover the unknown.

Man's first expression, like his first dream, was an aesthetic one. Speech was a poetic outcry rather than a demand for communication. Original man, shouting his consonants, did so in yells of awe and anger at his tragic state, at his own self-awareness, and at his own helplessness before the void. Philologists and semioticians are beginning to accept the concept that, if language is to be defined as the ability to communicate by means of signs, be they sounds or gestures, then language is an animal power. Anyone who has watched the common pigeon circle his female knows that she knows what he wants.

The human in language is literature, not communication. Man's first cry was a song. Man's first address to a neighbor was a cry of power and solemn weakness, not a request for a drink of water. Even the animal makes a futile attempt at poetry. Ornithologists explain the cock's crow as an ecstatic outburst of his power. The loon gliding lonesome over the lake, with whom is he communicating? The dog, alone, howls at the moon. Are we to say that the first man called the sun and the stars *God* as an act of communication and only after he had finished his day's labor? The myth came before the hunt. The purpose of man's first speech was an address to the unknowable. His behavior had its origin in his artistic nature.

Just as man's first speech was poetic before it became utilitarian, so man first built an idol of mud before he fashioned an ax. Man's hand traced the stick through the mud to make a line before he learned to throw the stick as a javelin. Archeologists tell us that the ax-head suggested the ax-head idol. Both are found in the same strata so they must have been contemporaneous. True, perhaps, that the ax-head idol of stone could not have been carved without ax instruments, but this is a division in metier, not in time, since the mud figure anticipated both the stone figure and the ax. (A figure can be made out of mud but an ax cannot.) The God image, not pottery, was the first manual act. It is the materialistic corruption

* Excerpt from *Tiger's Eye* (New York), No. 1 (October 1947), pp. 59–60.

of present-day anthropology that has tried to make men believe that original man fashioned pottery before he made sculpture. Pottery is the product of civilization. The artistic act is man's personal birthright.

The earliest written history of human desires proves that the meaning of the world cannot be found in the social act. An examination of the first chapter of Genesis offers a better key to the human dream. It was inconceivable to the archaic writer that original man, that Adam, was put on earth to be a toiler, to be a social animal. The writer's creative impulses told him that man's origin was that of an artist and he set him up in a Garden of Eden close to the Tree of Knowledge, of right and wrong, in the highest sense of divine revelation. The fall of man was understood by the writer and his audience not as a fall from Utopia to struggle, as the sociologicians would have it, nor, as the religionists would have us believe, as a fall from Grace to Sin, but rather that Adam, by eating from the Tree of Knowledge, sought the creative life to be, like God, "a creator of worlds," to use Rashi's phrase, and was reduced to the life of toil only as a result of a jealous punishment.

In our inability to live the life of a creator can be found the meaning of the fall of man. It was a fall from the good, rather than from the abundant, life. And it is precisely here that the artist today is striving for a closer approach to the truth concerning original man than can be claimed by the paleontologist, for it is the poet and the artist who are concerned with the function of original man and who are trying to arrive at his creative state. What is the *raison d'être*, what is the explanation of the seemingly insane drive of man to be painter and poet if it is not an act of defiance against man's fall and an assertion that he return to the Adam of the Garden of Eden? For the artists are the first men.

## Barnett Newman, "The Sublime Is Now," 1948*

Michelangelo knew that the meaning of the Greek humanities for his time involved making Christ—the man, into Christ—who is God; that his plastic problem was neither the mediaeval one, to make a cathedral, nor the Greek one, to make a man like a god, but to make a cathedral out of man. In doing so he set a standard for sublimity that the painting of his time could not reach. Instead, painting continued on its merry quest for a voluptuous art until in modern times, the Impressionists, disgusted with its inadequacy, began the movement to destroy the established rhetoric of beauty by the Impressionist insistence on a surface of ugly strokes.

The impulse of modern art was this desire to destroy beauty. However, in discarding Renaissance notions of beauty, and without an adequate substitute for a sublime message, the Impressionists were compelled to preoccupy themselves, in their struggle, with the cultural values of their plastic history so that instead of evoking a new way of experiencing life they were able only to make a transfer of

---

* Excerpt from "The Ides of Art, Six Opinions on What is Sublime in Art?", *Tiger's Eye* (New York), No. 6 (15 December 1948), pp. 52–53.

values. By glorifying their own way of living, they were caught in the problem of what is really beautiful and could only make a restatement of their position on the general question of beauty; just as later the Cubists, by their Dada gestures of substituting a sheet of newspaper and sandpaper for both the velvet surfaces of the Renaissance and the Impressionists, made a similar transfer of values instead of creating a new vision, and succeeded only in elevating the sheet of paper. So strong is the grip of the *rhetoric* of exaltation as an attitude in the large context of the European culture pattern that the elements of sublimity in the revolution we know as modern art, exist in its effort and energy to escape the pattern rather than in the realization of a new experience. Picasso's effort may be sublime but there is no doubt that his work is a preoccupation with the question of what is the nature of beauty. Even Mondrian, in his attempt to destroy the Renaissance picture by his insistence on pure subject matter, succeeded only in raising the white plane and the right angle into a realm of sublimity, where the sublime paradoxically becomes an absolute of perfect sensations. The geometry (perfection) swallowed up his metaphysics (his exaltation).

The failure of European art to achieve the sublime is due to this blind desire to exist inside the reality of sensation (the object world, whether distorted or pure) and to build an art within the framework of pure plasticity (the Greek ideal of beauty, whether that plasticity be a romantic active surface, or a classic stable one). In other words, modern art, caught without a sublime content, was incapable of creating a new sublime image, and unable to move away from the Renaissance imagery of figures and objects except by distortion or by denying it completely for an empty world of geometric formalisms—a *pure* rhetoric of abstract mathematical relationships, became enmeshed in a struggle over the nature of beauty; whether beauty was in nature or could be found without nature.

I believe that here in America, some of us, free from the weight of European culture, are finding the answer, by completely denying that art has any concern with the problem of beauty and where to find it. The question that now arises is how, if we are living in a time without a legend or mythos that can be called sublime, if we refuse to admit any exaltation in pure relations, if we refuse to live in the abstract, how can we be creating a sublime art?

We are reasserting man's natural desire for the exalted, for a concern with our relationship to the absolute emotions. We do not need the obsolete props of an outmoded and antiquated legend. We are creating images whose reality is self-evident and which are deviod of the props and crutches that evoke associations with outmoded images, both sublime and beautiful. We are freeing ourselves of the impediments of memory, association, nostalgia, legend, myth, or what have you, that have been the devices of Western European painting. Instead of making *cathedrals* out of Christ, man, or "life," we are making it out of ourselves, out of our own feelings. The image we produce is the self-evident one of revelation, real and concrete, that can be understood by anyone who will look at it without the nostalgic glasses of history.

*Herbert Ferber, "On Sculpture," 1954*★

The contemporary sculptor was brought up on the concept of the monolith. Western tradition from Egypt through Greece and Rome, the Middle Ages and the Renaissance, to the nineteenth century, reached its culminations through the monolith alone. It was a tradition peopled with representations of figures, worldly or divine, and with, on the whole, solid, massive human and animal forms. Different concepts of sculpture, as we now see, were realized in other places and at other times. But they contributed little to the tradition with which the twentieth-century sculptor was confronted. The idea of sculpture he inherited, it seems to me, was a "centripetal" one: sculpture was tied to its own center.

In our time, however, the canon of tradition and taste has been overthrown and sculpture has now become an art of extension. It has become "centrifugal," and, in the work I admire, it shuns the center. This revolution has brought new life to an art which had been mired in tradition. Without this change in concept, in my opinion, it would make only comparatively minor contributions to the art of our time.

Monolithic sculpture has been a representation of the animate world, man and animal, however transformed or transcended. Perhaps the closed forms of biological life were a source for the forms of sculpture even when verisimilitude was not the aim. When the tradition was broken, when the human or divine body was no longer held to be either sacred or inviolable, for whatever reason, a new era dawned in the realm of art. Cubism fragmented the object in creating the work of art from its parts. The Bauhaus and the Constructivists made a fetish of materials and logical structure. Surrealism and Expressionism re-evoked the fantastic and the non-rational. Together they brought new forms and new subjects to an art which need no longer follow physiological channels; it can carry its strength through "lines of force" which are not necessarily enclosed in a biological envelope. In contemporary sculpture this has, I think, opened a new way which marks a radical divergence from the old.

Monolithic sculpture, centripetal sculpture, possessed by the idea of mass, presents a continuous surface, enclosing a volume, which is motivated from the center. Sculpture of extension, centrifugal sculpture, is neither massive nor monolithic, nor does it present a continuous surface. Its elements are not oriented to a center nor are they projections from a central mass. Where sculpture had been solid, closed, it is now an art of open, airy, discontinuous forms, suspended in space.

The very act by which the *sculptor as carver* cut into a mass, freeing from it the mass within, was a movement from outside toward a predictable surface resting upon a solid core. Similarly, the *sculptor as modeler* worked out to the preconceived surface from a core upon which it rested. In either case, the meaning of the surface was a result of the forces lying within the core. When the columns at the portals

★ Excerpts from *Art in America* (New York), XLII, 4 (December 1954), 262–308.

of the Gothic cathedrals came to life or when the monolith was chipped to uncover the enduring calm of the god-king of Egypt, or bronze was cast into the likeness of the warrior-hero, it was, by and large, an opaque solid which carried the measure of either human or transcendent meaning on its surface. In those modeled or carved sculptures the surface is motivated and interpreted in the same way in which the hardened waves of lava reveal the forces which produced them. The continuous surface was the means of exchange, the meeting place where the forces within were made known to the spectator through color and surface variation, outline, and gesture. These he read in the given terms of the culture of his time. Thus, Michelangelo's Moses, with its tense and active surface, reveals in every movement the inner forces of moral and wrathful intelligence. And the smile of the Angel of Reims is the expression of the knowledge of God.

Michelangelo's dictum that a good sculpture would lose nothing of importance if rolled down a mountain could never have retained its authority for so long if it had not been assumed that the unbroken mass of the work contained the essential aesthetic idea. Rather than by this rule, the new sculpture might be tested by its ability to withstand a hurricane because it offers so little surface. It resembles the open summits of Gothic towers more than the statues of Gothic portals. Its aesthetic body is the relationship of solids and spaces which define each other. Space is not displaced, the mark of traditional sculpture; rather is it pierced and held in tension. Spaces and shapes form a complex, of which the parts are, of course, interdependent, but not centered. This sculpture of extension does not begin with the idea of removing the found surface in order to charge the revealed one with meaning. Nor does it work out from a core to a preconceived surface. Rather this sculpture may be said to have abandoned the idea of surface altogether so that instead of enclosing a volume its shape allows the free use of spaces as essential parts of the sculpture. One becomes involved with these spaces, as if there were a kinetic compulsion to move into and about them. The eye no longer plays over a surface. There is no longer the constraint to think of front and back any more than there is in looking at a tree or landscape. Without recourse to illusionism sculpture has become truly spatial.

### Willem de Kooning, "The Renaissance and Order," 1950*

There is a train track in the history of art that goes way back to Mesopotamia. It skips the whole Orient, the Mayas, and American Indians. Duchamp is on it. Cézanne is on it. Picasso and the Cubists are on it; Giacometti, Mondrian, and so many, many more—whole civilizations. Like I say, it goes way in and back to Mesopotamia for maybe 5,000 years, so there is no sense in calling out names . . . .

---

* Excerpt from a lecture given in 1950 at Studio 35, New York. Published in *trans/formation* (New York), I, 2 (1951), 86–87. (See the descriptions of Studio 35 in introductory essay to this chapter and in the footnote to "Artists' Session," below.)

But I have some feeling about all these people—millions of them—on this enormous track, way into history. They had a peculiar way of measuring. They seemed to measure with a length similar to their own height. For that reason they could imagine themselves in almost any proportions. That is why I think Giacometti's figures are like real people. The idea that the thing that the artist is making can come to know for itself, how high it is, how wide and how deep it is, is a historical one—a traditional one I think. It comes from man's own image.

I admit I know little of Oriental art. But that is because I cannot find in it what I am looking for, or what I am talking about. To me the Oriental idea of beauty is that "it isn't here." It is in a state of not being here. It is absent. That is why it is so good. It is the same thing I don't like in Suprematism, Purism, and nonobjectivity.

And, although I, myself, don't care for all the pots and pans in the paintings of the burghers—the genre scenes of goodly living which developed into the kind sun of Impressionism later on—I do like the idea that they—the pots and pans, I mean—are always in relation to man. They have no soul of their own, like they seem to have in the Orient. For us, they have no character; we can do anything we please with them. There is this perpetual irritability. Nature, then, is just nature. I admit I am very impressed with it.

The attitude that nature is chaotic and that the artist puts order into it is a very absurd point of view, I think. All that we can hope for is to put some order into ourselves. When a man ploughs his field at the right time, it means just that.

Insofar as we understand the universe—if it can be understood—our doings must have some desire for order in them; but from the point of view of the universe, they must be very grotesque . . . .

*Symposium: "What Abstract Art Means to Me," 1951* \*

WILLEM DE KOONING

The first man who began to speak, whoever he was, must have intended it. For surely it is talking that has put "Art" into painting. Nothing is positive about art except that it is a word. Right from there to here all art became literary. We are not yet living in a world where everything is self-evident. It is very interesting to notice that a lot of people who want to take the talking out of painting, for instance, do nothing else but talk about it. That is no contradiction, however. The art in it is the forever mute part you can talk about forever.

For me, only one point comes into my field of vision. This narrow, biased

\* Three papers given at a symposium held on 5 February 1951 at the Museum of Modern Art, New York, in conjunction with the exhibition "Abstract Painting and Sculpture in America." From *What Abstract Art Means to Me, Bulletin of The Museum of Modern Art* (New York), XVIII, 3 (Spring 1951), and reprinted with its permission.

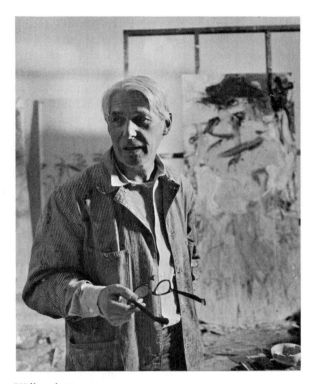

*Willem de Kooning, 1965.*
*Photograph by Hans Namuth, New York.*

point gets very clear sometimes. I didn't invent it. It was already here. Everything that passes me I can see only a little of, but I am always looking. And I see an awful lot sometimes.

The word "abstract" comes from the light-tower of the philosophers, and it seems to be one of their spotlights that they have particularly focused on "Art." So the artist is always lighted up by it. As soon as it—I mean the "abstract"—comes into painting, it ceases to be what it is as it is written. It changes into a feeling which could be explained by some other words, probably. But one day, some painter used "Abstraction" as a title for one of his paintings. It was a still life. And it was a very tricky title. And it wasn't really a very good one. From then on the idea of abstraction became something extra. Immediately it gave some people the idea that they could free art from itself. Until then, Art meant everything that was in it—not what you could take out of it. There was only one thing you could take out of it sometime when you were in the right mood—that abstract and indefinable sensation, the aesthetic part—and still leave it where it was. For the painter to come to the "abstract" or the "nothing" he needed many things. Those things were always things in life—a horse, a flower, a milkmaid, the light in

557

a room through a window made of diamond shapes maybe, tables, chairs, and so forth. The painter, it is true, was not always completely free. The things were not always of his own choice, but because of that he often got some new idea. Some painters liked to paint things already chosen by others, and after being abstract about them, were called Classicists. Others wanted to select the things themselves and, after being abstract about them, were called Romanticists. Of course, they got mixed up with one another a lot too. Anyhow, at that time, they were not abstract about something which was already abstract. They freed the shapes, the light, the color, the space, by putting them into concrete things in a given situation. They *did* think about the possibility that the things—the horse, the chair, the man—were abstractions, but they let that go, because if they kept thinking about it, they would have been led to give up painting altogether, and would probably have ended up in the philosopher's tower. When they got those strange, deep ideas, they got rid of them by painting a particular smile on one of the faces in the picture they were working on.

The aesthetics of painting were always in a state of development parallel to the development of painting itself. They influenced each other and vice versa. But all of a sudden, in that famous turn of the century, a few people thought they could take the bull by the horns and invent an aesthetic beforehand. After immediately disagreeing with each other, they began to form all kinds of groups, each with the idea of freeing art, and each demanding that you should obey them. Most of these theories have finally dwindled away into politics or strange forms of spiritualism. The question, as they saw it, was not so much what you *could* paint but rather what you could *not* paint. You could *not* paint a house or a tree or a mountain. It was then that subject matter came into existence as something you ought *not* to have.

In the old days, when artists were very much wanted, if they got to thinking about their usefulness in the world, it could only lead them to believe that painting was too worldly an occupation and some of them went to church instead or stood in front of it and begged. So what was considered too worldly from a spiritual point of view then, became later—for those who were inventing the new aesthetics—a spiritual smoke-screen and not worldly enough. These latter-day artists were bothered by their apparent uselessness. Nobody really seemed to pay any attention to them. And they did not trust that freedom of indifference. They knew that they were relatively freer than ever before *because* of that indifference, but in spite of all their talking about freeing art, they really didn't mean it that way. Freedom to them meant to be useful in society. And that is really a wonderful idea. To achieve that, they didn't need *things* like tables and chairs or a horse. They needed ideas instead, social ideas, to make their objects with, their constructions—the "pure plastic phenomena"—which were used to illustrate their convictions. Their point was that until they came along with their theories, Man's own form in space— his body—was a private prison; and that it was because of this imprisoning misery— because he was hungry and overworked and went to a horrid place called home late

at night in the rain, and his bones ached and his head was heavy—because of this very consciousness of his own body, this sense of pathos, they suggest, he was overcome by the drama of a crucifixion in a painting or the lyricism of a group of people sitting quietly around a table drinking wine. In other words, these aestheticians proposed that people had up to now understood painting in terms of their own private misery. Their own sentiment of form instead was one of comfort. The beauty of comfort. The great curve of a bridge was beautiful because people could go across the river in comfort. To compose with curves like that, and angles, and make works of art with them could only make people happy, they maintained, for the only association was one of comfort. That millions of people have died in war since then, because of that idea of comfort, is something else.

This pure form of comfort became the comfort of "pure form." The "nothing" part in a painting until then—the part that was not painted but that was there because of the things in the picture which were painted—had a lot of descriptive labels attached to it like "beauty," "lyric," "form," "profound," "space," "expression," "classic," "feeling," "epic," "romantic," "pure," "balance," etc. Anyhow that "nothing" which was always recognized as a particular something— and as something particular—they generalized, with their book-keeping minds, into circles and squares. They had the innocent idea that the "something" existed "in spite of" and not "because of" and that this something was the only thing that truly mattered. They had hold of it, they thought, once and for all. But this idea made them go backward in spite of the fact that they wanted to go forward. That "something" which was not measurable, they lost by trying to make it measurable; and thus all the old words which, according to their ideas, ought to be done away with got into art again: pure, supreme, balance, sensitivity, etc.

Kandinsky understood "Form" as *a* form, like an object in the real world; and an object, he said, was a narrative—and so, of course, he disapproved of it. He wanted his "music without words." He wanted to be "simple as a child." He intended, with his "inner-self," to rid himself of "philosophical barricades" (he sat down and wrote something about all this). But in turn his own writing has become a philosophical barricade, even if it is a barricade full of holes. It offers a kind of Middle-European idea of Buddhism or, anyhow, something too theosophic for me.

The sentiment of the Futurists was simpler. No space. Everything ought to keep on going! That's probably the reason they went themselves. Either a man was a machine or else a sacrifice to make machines with.

The moral attitude of Neo-Plasticism is very much like that of Constructivism, except that the Constructivists wanted to bring things out in the open and the Neo-Plasticists didn't want anything left over.

I have learned a lot from all of them and they have confused me plenty too. One thing is certain, they didn't give me my natural aptitude for drawing. I am completely weary of their ideas now.

The only way I still think of these ideas is in terms of the individual artists

who came from them or invented them. I still think that Boccioni was a great artist and a passionate man. I like Lissitzky, Rodchenko, Tatlin, and Gabo; and I admire some of Kandinsky's painting very much. But Mondrian, that great merciless artist, is the only one who had nothing left over.

The point they all had in common was to be both inside and outside at the same time. A new kind of likeness! The likeness of the group instinct. All that it has produced is more glass and a hysteria for new materials which you can look through. A symptom of love-sickness, I guess. For me, to be inside and outside is to be in an unheated studio with broken windows in the winter, or taking a nap on somebody's porch in the summer.

Spiritually I am wherever my spirit allows me to be, and that is not necessarily in the future. I have no nostalgia, however. If I am confronted with one of those small Mesopotamian figures, I have no nostalgia for it but, instead, I may get into a state of anxiety. Art never seems to make me peaceful or pure. I always seem to be wrapped in the melodrama of vulgarity. I do not think of inside or outside—or of art in general—as a situation of comfort. I know there is a terrific idea there somewhere, but whenever I want to get into it, I get a feeling of apathy and want to lie down and go to sleep. Some painters, including myself, do not care what chair they are sitting on. It does not even have to be a comfortable one. They are too nervous to find out where they ought to sit. They do not want to "sit in style." Rather, they have found that painting—any kind of painting, any style of painting—to be painting at all, in fact—is a way of living today, a style of living, so to speak. That is where the form of it lies. It is exactly in its uselessness that it is free. Those artists do not want to conform. They only want to be inspired.

The group instinct could be a good idea, but there is always some little dictator who wants to make his instinct the group instinct. There *is* no style of painting now. There are as many naturalists among the abstract painters as there are abstract painters in the so-called subject-matter school.

The argument often used that science is really abstract, and that painting could be like music and, for this reason, that you cannot paint a man leaning against a lamp-post, is utterly ridiculous. That space of science—the space of the physicists— I am truly bored with by now. Their lenses are so thick that seen through them, the space gets more and more melancholy. There seems to be no end to the misery of the scientists' space. All that it contains is billions and billions of hunks of matter, hot or cold, floating around in darkness according to a great design of aimlessness. The stars I think about, if I could fly, I could reach in a few old-fashioned days. But physicists' stars I use as buttons, buttoning up curtains of emptiness. If I stretch my arms next to the rest of myself and wonder where my fingers are—that is all the space I need as a painter.

Today, some people think that the light of the atom bomb will change the concept of painting once and for all. The eyes that actually saw the light melted out of sheer ecstasy. For one instant, everybody was the same color. It made angels out of everybody. A truly Christian light, painful but forgiving.

Personally, I do not need a movement. What was given to me, I take for granted. Of all movements, I like Cubism most. It had that wonderful unsure atmosphere of reflection—a poetic frame where something could be possible, where an artist could practice his intuition. It didn't want to get rid of what went before. Instead it added something to it. The parts that I can appreciate in other movements came out of Cubism. Cubism *became* a movement, it didn't set out to be one. It has force in it, but it was no "force-movement." And then there is that one-man movement; Marcel Duchamp—for me a truly modern movement because it implies that each artist can do what he thinks he ought to—a movement for each person and open for everybody.

If I *do* paint abstract art, that's what abstract art means to me. I frankly do not understand the question. About twenty-four years ago, I knew a man in Hoboken, a German who used to visit us in the Dutch Seamen's Home. As far as he could remember, he was always hungry in Europe. He found a place in Hoboken where bread was sold a few days old—all kinds of bread: French bread, German bread, Italian bread, Dutch bread, Greek bread, American bread and particularly Russian black bread. He bought big stacks of it for very little money, and let it get good and hard and then he crumpled it and spread it on the floor in his flat and walked on it as on a soft carpet. I lost sight of him, but found out many years later that one of the other fellows met him again around 86th street. He had become some kind of a Jugend Bund leader and took boys and girls to Bear Mountain on Sundays. He is still alive but quite old and is now a Communist. I could never figure him out, but now when I think of him, all that I can remember is that he had a very abstract look on his face.

### ALEXANDER CALDER

My entrance into the field of abstract art came about as the result of a visit to the studio of Piet Mondrian in Paris in 1930.

I was particularly impressed by some rectangles of color he had tacked on his wall in a pattern after his nature.

I told him I would like to make them oscillate—he objected. I went home and tried to paint abstractly—but in two weeks I was back again among plastic materials.

I think that at that time and practically ever since, the underlying sense of form in my work has been the system of the universe, or part thereof. For that is a rather large model to work from.

What I mean is that the idea of detached bodies floating in space, of different sizes and densities, perhaps of different colors and temperatures, and surrounded and interlarded with wisps of gaseous condition, and some at rest, while others move in peculiar manners, seems to me the ideal source of form.

I would have them deployed, some nearer together and some at immense distances.

And great disparity among all the qualities of these bodies, and their motions as well.

A very exciting moment for me was at the planetarium—when the machine was run fast for the purpose of explaining its operation: a planet moved along a straight line, then suddenly made a complete loop of 360° off to one side, and then went off in a straight line in its original direction.

I have chiefly limited myself to the use of black and white as being the most disparate colors. Red is the color most opposed to both of these—and then, finally, the other primaries. The secondary colors and intermediate shades serve only to confuse and muddle the distinctness and clarity.

When I have used spheres and discs, I have intended that they should represent more than what they just are. More or less as the earth is a sphere, but also has some miles of gas about it, volcanoes upon it, and the moon making circles around it, and as the sun is a sphere—but also is a source of intense heat, the effect of which is felt at great distances. A ball of wood or a disc of metal is rather a dull object without this sense of something emanating from it.

When I use two circles of wire intersecting at right angles, this to me is a sphere—and when I use two or more sheets of metal cut into shapes and mounted at angles to each other, I feel that there is a solid form, perhaps concave, perhaps convex, filling in the dihedral angles between them. I do not have a definite idea of what this would be like, I merely sense it and occupy myself with the shapes one actually sees.

Then there is the idea of an object floating—not supported—the use of a very long thread, or a long arm in cantilever as a means of support seems to best approximate this freedom from the earth.

Thus what I produce is not precisely what I have in mind—but a sort of sketch, a man-made approximation.

That others grasp what I have in mind seems unessential, at least as long as they have something else in theirs.

### ROBERT MOTHERWELL (EXCERPTS)

The emergence of abstract art is one sign that there are still men able to assert feeling in the world. Men who know how to respect and follow their inner feelings, no matter how irrational or absurd they may first appear. From their perspective, it is the social world that tends to appear irrational and absurd. It is sometimes forgotten how much wit there is in certain works of abstract art. There is a certain point in undergoing anguish where one encounters the comic—I think of Miro, of the late Paul Klee, of Charlie Chaplin, of what healthy and human values their wit displays . . . .

I find it sympathetic that Parisian painters have taken over the word "poetry," in speaking of what they value in painting. But in the English-speaking world there is an implication of "literary content," if one speaks of a painting as having "real poetry." Yet the alternative word, "aesthetic," does not satisfy me.

It calls up in my mind those dull classrooms and books when I was a student of philosophy and the nature of the aesthetic was a course given in the philosophy department of every university. I think now that there is no such thing as *the* "aesthetic," no more than there is any such thing as "art," that each period and place has its own art and its aesthetic—which are specific applications of a more general set of human values, with emphases and rejections corresponding to the basic needs and desires of a particular place and time. I think that abstract art is uniquely modern—not in the sense that word is sometimes used, to mean that our art has "progressed" over the art of the past; though abstract art may indeed represent an emergent level of evolution—but in the sense that abstract art represents the particular acceptances and rejections of men living under the conditions of modern times. If I were asked to generalize about this condition as it has been manifest in poets, painters, and composers during the last century and a half, I should say that it is a fundamentally romantic response to modern life—rebellious individualistic, unconventional, sensitive, irritable. I should say that this attitude arose from a feeling of being ill at ease in the universe, so to speak—the collapse of religion, of the old close-knit community and family may have something to do with the origins of the feeling. I do not know.

But whatever the source of this sense of being unwedded to the universe, I think that one's art is just one's effort to wed oneself to the universe, to unify oneself through union. Sometimes I have an imaginary picture in mind of the poet Mallarmé in his study late at night—changing, blotting, transferring, transforming each word and its relations with such care—and I think that the sustained energy for that travail must have come from the secret knowledge that each word was a link in the chain that he was forging to bind himself to the universe; and so with other poets, composers and painters . . . . If this suggestion is true, then modern art has a different face from the art of the past because it has a somewhat different function for the artist in our time. I suppose that the art of far more ancient and "simple" artists expressed something quite different, a feeling of *already* being at one with the world . . . .

One of the most striking of abstract art's appearance is her nakedness, an art stripped bare. How many rejections on the part of her artists! Whole worlds—the world of objects, the world of power and propaganda, the world of anecdotes, the world of fetishes and ancestor worship. One might almost legitimately receive the impression that abstract artists don't like anything but the act of painting . . . .

What new kind of *mystique* is this, one might ask. For make no mistake, abstract art is a form of mysticism.

Still, this is not to describe the situation very subtly. To leave out consideration of what is being put into the painting, I mean. One might truthfully say that abstract art is stripped bare of other things in order to intensify it, its rhythms, spatial intervals, and color structure. Abstraction is a process of emphasis, and emphasis vivifies life, as A. N. Whitehead said.

Nothing as drastic an innovation as abstract art could have come into

existence, save as the consequence of a most profound, relentless, unquenchable need.

The need is for felt experience—intense, immediate, direct, subtle, unified, warm, vivid, rhythmic.

Everything that might dilute the experience is stripped away. The origin of abstraction in art is that of any mode of thought. Abstract art is a true mysticism—I dislike the word—or rather a series of mysticisms that grew up in the historical circumstance that all mysticisms do, from a primary sense of gulf, an abyss, a void between one's lonely self and the world. Abstract art is an effort to close the void that modern men feel. Its abstraction is its emphasis.

*Artists' Session, New York, 1951*★

### CREATIVITY

Hans Hofmann: Everyone should be as different as possible. There is nothing that is common to all of us except our creative urge. It [abstract art] means one thing to me: to discover myself as well as I can. But every one of us has the urge to be creative in relation to our time—the time to which we belong may work out to be our thing in common.

### WHEN IS A PAINTING FINISHED?

Hans Hofmann: To me a work is finished when all parts involved communicate themselves, so that they don't need me.
Barnett Newman: I think the idea of a "finished" picture is a fiction. I think a man spends his whole lifetime painting one picture or working on one piece of sculpture. The question of stopping is really a decision of moral considerations. To what extent are you intoxicated by the actual act, so that you are beguiled by it? To what extent are you charmed by its inner life? And to what extent do you then really approach the intention or desire that is really outside of it? The decision is always made when the piece has something in it that you wanted.
Robert Motherwell: . . . in "finishing" a picture they [young French painters] assume traditional criteria to a much greater degree than we do. They have a real "finish" in that the picture is a real object, a beautifully made object. We are involved in "process" and what is a "finished" object is not so certain.

★ Excerpts from the transcript of an artists' session held at 35 East 8th Street in New York in the quarters formerly occupied by the school established in 1948 by Clyfford Still, Robert Motherwell, Mark Rothko, William Baziotes, and David Hare. Edited version printed in *Modern Artists in America*, eds. Robert Motherwell and Ad Reinhardt (New York: Wittenborn, Schultz, 1951), pp. 9-22. (The various headings are added by the editor to indicate the topics under discussion.)

### FRENCH PAINTERS AND AMERICAN PAINTERS

Hans Hofmann: It would seem that the difference between the young French painters and the young American painters is this: French pictures have a cultural heritage. The American painter of today approaches things without basis. The French approach things on the basis of cultural heritage—that one feels in all their work. It is a working toward new experiences, and painting out these experiences that may finally become tradition. The French have it easier. They have it in the beginning.

Willem de Kooning: I agree that tradition is part of the whole world now. The point that was brought up was that the French artists have some "touch" in making an object. They have a particular something that makes them look like a "finished" painting. They have a touch which I am glad not to have.

### ON TITLES FOR PAINTINGS

William Baziotes: Whereas certain people start with a recollection or an experience and paint that experience, to some of us the act of doing it becomes the experience; so that we are not quite clear why we are engaged on a particular work. And because we are more interested in plastic matters than we are in a matter of words one can begin a picture and carry it through and stop it and do nothing about the title at all.

### HOW IMPORTANT ARE YOUR EMOTIONS?

Willem de Kooning: If you are an artist, the problem is to make a picture work whether you are happy or not.

Ad Reinhardt: I would like to ask a question about the exact involvement of a work of art. What kind of love or grief is there in it? I don't understand, in a painting, the love of anything except the love of painting itself. If there is agony, other than the agony of painting, I don't know exactly what kind of agony that would be. I am sure external agony does not enter very importantly into the agony of our painting.

### ARE SHAPES EXPRESSIVE?

Hans Hofmann: I believe that in an art every expression is relative, not absolutely defined as long as it is not the expression of a relationship. Anything can be changed. We speak here only about means, but the application of the means is the point. You can change one thing into another with the help of the relations of the things. One shape in relation to other shapes makes the "expression"; not one shape or another, but the relationship between the two makes the "meaning." As long as a means is only used for itself, it cannot lead to anything. Construction consists of the use of one thing in relation to another, which then relates to a third, and higher, value.

565

*Artists' session at Studio 35, New York, 1950. (L to R: Seymour Lipton, Norman Lewis, Jimmy Ernst, Peter Grippe, Adolph Gottlieb, Hans Hofmann, Alfred H. Barr, Jr., Robert Motherwell, Richard Lippold, Willem de Kooning, Ibram Lassaw, James Brooks, Ad Reinhardt and Richard Pousette-Dart.) Photographs by Max Yavno*

Herbert Ferber: The means are important, but what we were concerned with is an expression of a relationship to the world. Truth and validity cannot be determined by the shape of the elements of the picture.

Adolph Gottlieb: It is my impression that the most general idea which has kept cropping up is a statement of the nature of a work of art as being an arrangement of shapes or forms of color which, because of the order or ordering of materials, expresses the artist's sense of reality or corresponds with some outer reality. I don't agree that . . . reality can be expressed in a painting purely in terms of line, color, and form, that those are the essential elements in painting, and anything else is irrelevant and can contribute nothing to the painting.

Robert Motherwell: All of the people here move as abstractly or back to the world of nature as freely as they like to, and would fight at any time for that freedom.

566

*Artists' session at Studio 35, New York, 1950. (L to R: James Brooks, Ad Reinhardt, Richard Poussette-Dart, Louise Bourgeois, Herbert Ferber, Bradley Walker Tomlin, Janice Biala, Robert Goodnough, Hedda Sterne, David Hare, Barnett Newman, Seymour Lipton, Norman Lewis and Jimmy Ernst.)*

## SUBJECT MATTER

Hans Hofmann: Every subject matter depends on how to use meaning. You can use it in a lyrical or dramatic manner. It depends on the personality of the artist. Everyone is clear about himself, as to where he belongs, and in which way he can give aesthetic enjoyment. Painting is aesthetic enjoyment. I want to be a "poet." As an artist I must conform to my nature. My nature has a lyrical as well as a dramatic disposition. Not one day is the same. One day I feel wonderful to work and I feel an expression which shows in the work. Only with a very clear mind and on a clear day I can paint without interruptions and without food because my disposition is like that. My work should reflect my moods and the great enjoyment which I had when I did the work.

### THE PERSONAL PRESENT

David Smith: I exist in the best society possible because I exist in this time. I have to take it as the ideal society. It is ideal as far as I am concerned. I cannot go back, I cannot admit that there is any history in my life outside of the times in which I live. Nothing can be more idealistic for work than right now—and there never will be an ideal society.

### ON NAMING THE GROUP

Willem de Kooning: It is disastrous to name ourselves.

*Saul Baizerman, Statement, 1952*\*

How do I know when a piece is finished?
    When it has taken away from me everything I have to give. When it has become stronger than myself. I become the empty one and it becomes the full one. When I am weak and it is strong the work is finished.

*Theodore Roszak, Statement, 1952*†

The work that I am now doing constitutes an almost complete reversal of ideas and feelings from my former work [constructivist sculpture done before 1945]. Instead of looking at densely populated man-made cities, it now begins by contemplating the clearing. Instead of sharp and confident edges, its lines and shapes are now gnarled and knotted, even hesitant. Instead of serving up slick chromium, its surfaces are scorched and coarsely pitted. The only reminder of my earlier experiences that I have retained is the overruling structure and concept of space . . . . No longer buoyant, but unobtrusively concealed, where I now think it properly belongs . . . .
    The forms that I find necessary to assert, are meant to be blunt reminders of primordial strife and struggle, reminiscent of those brute forces that not only produced life, but in turn threatened to destroy it. I feel that, if necessary, one must be ready to summon one's total being with an all-consuming rage against those forces that are blind to the primacy of life-giving values . . . . Perhaps, by this sheer dedication, one may yet merge force with grace.

---

\* From Robert Goodnough, "Baizerman Makes a Sculpture," *Art News* (New York), March 1952, p. 67.
    † Excerpts from a symposium on "The New Sculpture," held at the Museum of Modern Art, New York, 1952. From *Sculpture of the Twentieth Century* by Andrew Carnduff Ritchie, 1952, The Museum of Modern Art, New York, and reprinted with its permission.

*Harold Rosenberg, "The American Action Painters," 1952\**

This new [American] painting does not constitute a School. To form a School in modern times not only is a new painting consciousness needed but a consciousness of that consciousness—and even an insistence on certain formulas. A School is the result of the linkage of practice with terminology—different paintings are affected by the same words. In the American vanguard the words, as we shall see, belong not to the art but to the individual artists. What they think in common is represented only by what they do separately.

### GETTING INSIDE THE CANVAS

At a certain moment the canvas began to appear to one American painter after another as an arena in which to act—rather than as a space in which to reproduce, re-design, analyze, or "express" an object, actual or imagined. What was to go on the canvas was not a picture but an event.

The painter no longer approached his easel with an image in his mind; he went up to it with material in his hand to do something to that other piece of material in front of him. The image would be the result of this encounter.

It is pointless to argue that Rembrandt or Michelangelo worked in the same way. You don't get Lucrece with a dagger out of staining a piece of cloth or spontaneously putting forms into motion upon it. She had to exist some place else before she got on the canvas, and paint was Rembrandt's means for bringing her there, though, of course, a means that would change her by the time she arrived. Now, everything must have been in the tubes, in the painter's muscles, and in the cream-colored sea into which he dives. If Lucrece should come out she

---

\* Excerpts from *Art News* (New York), LI (December 1952), 22–23ff. Reprinted in Harold Rosenberg, *The Tradition of the New* (New York: Horizon, 1959; Grove, 1961).
The term "action painting" was at once taken up and widely used. Parts of it, in particular Rosenberg's reduction of the role of the painting to "an arena in which to act" and his belief that "What was to go on the canvas was not a picture but an event," were vigorously attacked. Hilton Kramer wrote: "... but painting being painting, and not the theatre, what does he mean by the canvas 'as an arena in which to act'?" ("The New American Painting," *Partisan Review* (New York), XX, 4 [July–August 1953], 421–427.) Clement Greenberg objected that for Rosenberg painting "remained as but the record of solipsistic 'gestures' that could have no meaning whatsoever as art—gestures that belonged to the same reality that breathing and thumbprints, love affairs and wars, but not works of art, belonged to." ("How Art Writing Earns its Bad Name," *The Second Coming*, I, 3 [March 1962], 58–62.)

For Rosenberg's reply to the criticism aroused by it, see "Action Painting, A Decade of Distortion," *Art News*, LCI, 8 (December 1962), 42–44ff. In his article on the Pollock exhibition at the Museum of Modern Art he attaches action painting to Pollock (*The New Yorker*, 6 May 1967).

will be among us for the first time—a surprise. To the painter, she *must* be a surprise. In this mood there is no point to an act if you already know what it contains.

"B is not modern," one of the leaders of this mode said to me. "He works from sketches. That makes him Renaissance."

Here the principle, and the difference from the old painting, is made into a formula. A sketch is the preliminary form of an image the *mind* is trying to grasp. To work from sketches arouses the suspicion that the artist still regards the canvas as a place where the mind records its contents—rather than itself the "mind" through which the painter thinks by changing a surface with paint.

If a painting is an action the sketch is one action, the painting that follows it another. The second cannot be "better" or more complete than the first. There is just as much in what one lacks as in what the other has.

Of course, the painter who spoke had no right to assume that his friend had the old mental conception of a sketch. There is no reason why an act cannot be prolonged from a piece of paper to a canvas. Or repeated on another scale and with more control. A sketch can have the function of a skirmish.

Call this painting "abstract" or "Expressionist" or "Abstract-Expressionist," what counts is its special motive for extinguishing the object, which is not the same as in other abstract or Expressionist phases of modern art.

The new American painting is not "pure" art, since the extrusion of the object was not for the sake of the aesthetic. The apples weren't brushed off the table in order to make room for perfect relations of space and color. They had to go so that nothing would get in the way of the act of painting. In this gesturing with materials the aesthetic, too, has been subordinated. Form, color, composition, drawing, are auxiliaries, any one of which—or practically all, as has been attempted logically, with unpainted canvases—can be dispensed with. What matters always is the revelation contained in the act. It is to be taken for granted that in the final effect, the image, whatever be or be not in it, will be a *tension*.

Based on the phenomenon of conversion the new movement is, with the majority of the painters, essentially a religious movement. In almost every case, however the conversion has been experienced in secular terms. The result has been the creation of private myths.

The tension of the private myth is the content of every painting of this vanguard. The act on the canvas springs from an attempt to resurrect the saving moment in his "story" when the painter first felt himself released from Value—myth of past self-recognition. Or it attempts to initiate a new moment in which the painter will realize his total personality—myth of future self-recognition.

Some formulate their myth verbally and connect individual works with its episodes. With others, usually deeper, the painting itself is the exclusive formulation, a Sign.

*Elaine de Kooning, "Subject: What, How, or Who?" 1955*<sup>*</sup>

Most artists today, unlike the Impressionists or the Cubists, feel they are alone with their aspirations. They find company in their antagonisms. Sometimes, oddly, the antagonisms seem to work in opposite directions simultaneously. That is, artists who are in favor of a representation of nature may be opposed to the inclusion of actual bits of nature in abstract painting and collage, or the other way around. In both cases, they feel some sacred canon of art has been violated. The exclusion or inclusion of nature is, however, not a matter of the individual artist's choice. For art, nature is unavoidable. There is no getting away from it, or, as the painter Leland Bell said, "nature is all we have."

Nature might be defined as anything which presents itself as fact—that includes all art other than one's own. And after a while, one's own too, if one begins to be detached from it and influenced by it, which happens to almost every artist. Nature does not imitate art; it devours it. If one does not want to paint a still-life or a landscape or a figure now, one can paint an Albers or a Rothko or a Kline. They are all equally real visual phenomena of the world around us. That is, there is a point where any work stops being a human creation and becomes environment—or nature.

There is also a point, of course, where environment can be turned back into an idea. At the point of exchange between nature and the idea that makes art, the question of *influence* arises. Contemporary artists and audiences alike tend to regard evidences of influence with contempt. "Those guys are a bunch of Boswells," one well-known abstract painter was heard to say irritably of some younger artists. But the fact is that there is a good deal of Boswell in every artist, including the one who made the remark. It is just a question of how obvious the Boswell element is. The life of Johnson is nature for Boswell and what he makes of it is Boswell's art. Western art is built on the biographical passion of one artist for another: Michelangelo for Signorelli; Rubens for Michelangelo; Delacroix for Rubens; Cézanne for Poussin; the Cubists for Cézanne; and Picasso, the philanderer, for anyone he sees going down the street. That something new in art cannot come into existence despite influence is a ridiculous idea, and it goes hand in hand with an even more ridiculous idea: namely that something totally new, not subject to any influence, *can* be created. It is proposed, in this "creation-out-of-nothing" creed, that Boswell, by simply changing his subject and writing a life of Boswell, could have "liberated" himself from nature, society, and previous art, that autobiography can be the road to total independence. Any artist, however, who looks only into his own life for his ideas is still going to find the irresistible ideas of other artists there.

---

<sup>*</sup> Excerpt from *Art News* (New York), LIV, 4 (April 1955), 26–29, *passim*.

*Louis Finkelstein, "New Look: Abstract-Impressionism," 1956*★

It was only a few years ago that Monet was considered pretty much a dead issue among most abstract painters. Yet in the Museum of Modern Art we now have the great delicious expanse of the *Nymphéas* looking for all the world like something hot out of a New York studio. The label comments on how abstract (unreal) it looks, yet it seems also to work in reverse—making a number of abstract paintings look more real, and itself looking real by virtue of the vision created by Abstract Expressionist works. This gives us the opportunity to re-examine our assumptions in this regard, as well as the work of a number of painters who, having grown up in the environment of Abstract Expressionism, have assumed a direction more closely related to the specifically visual character of Impressionism.

There is no clear grouping of these artists, but rather a tendency through varied personal developments to rely more on an optical unity as the dominant expression in their work . . . . By and large these artists are more colorists than draftsmen, and their works evidence more a sensuous response than conceptual control. Subject as such is not the issue; seeing is—a kind of seeing which I feel has grown out of the implications of Abstract Expressionism. This recourse to visual sensibility as the basis of stylistic decision is what links to the *Nymphéas* the artists I have mentioned, and, I have no doubt, many others working along similar lines. When Cézanne said of Monet that he was "only an eye, but my God what an eye," he was, besides defining a part of his own position, expressing a kind of artistic authority which in the course of recent development has revalued itself.

This growing towards rather than receding from reality contradicts that view of modern painting which regards it as dealing with a world "completely incompatible with the world of experience" (Malraux, *Voices of Silence*) and its corollary assumption that the experience of abstract painting is of painting-means existing autonomously on the surface. Alternatively, it has been suggested that the reality served by abstract painting is other than that of the physical world of appearance and more a world of abstract concepts arising from redefinitions of reality given by psychology and contemporary physics. Doubtless the sense of all stylistic change is that the underlying view of the world changes. But the artist does not proceed by gathering up these changes, be they provided by science, theology, or politics and then erecting, in a systematic fashion, a vision tailored to meet their demands. The activity of the artist as distinguished from the theoretician proceeds from a recognition of the world of the senses, and the work is authentic only when these antecedent premises are bound up with rather than imposed upon vision. For the artist perception always challenges concept. To say that an underlying concept is realized by the picture means that the picture introduces some process of verification uniquely the property of painting. This assimilation into sense is, in a way, the authentication of the unity of the concept. This is what we use painting for . . . .

★ Excerpts from *Art News* (New York), LV, 3 (March 1956), 36–68, *passim*.

In general the works of the new Impressionists are landscapes or interiors which permit a generality and continuity of spatial activity which separate objects usually impede. It is this generality and its sense of contemplativeness, as opposed to the athleticism of Expressionism, this openness of the eye so lacking in *hubris*, this relinquishing of theatricality which brings us back to the waters of the *Nymphéas* (or even perhaps to the mists of Mi Fei). For at the end of his life Monet transcends the optical realism of specific objects in a conventional assumption of space for the reality of the space itself as a mystical essence divorced from its specifics, a pervasive flux "linking," as Laurence Binyon put it, "the human heart to the life of the earth, the waters and the air."

## John Ferren, "Epitaph for an Avant-Garde," 1958★

It was not a question of knocking over other gods. It was a question of finding your own reality, your own answers, your own experience . . . . We discovered a simple thing, yet far-reaching in its effects: "The search is the discovery." Picasso had said, "I don't search. I find." We lacked the confidence for such an arrogant remark. We discovered instead that searching was itself a way of art. Not necessarily a final way, but a way. I remember that around the Club in the late 'forties the word "evaluation" was taboo. We looked, and we like it or did not: we did not give it a value. We took it as part of the search. Our feeling was the reverse of the motto, "I don't know anything about art, but I know what I like." We knew something about art, but we didn't know what we liked.

This was indeed the realm of ambiguities. But why did we savor these ambiguities? And why didn't we make the usual evaluations? Because we then conceived of a different arrangement of things new and old. We had judged the old things. Cubism adhered to balanced structure and left out the demonic. Matisse adhered to color but tied it to a woman's skirts. Surrealism seemed like pictures from the Sunday supplement; Klee went to the primitive and tied it to a civilized wit; Kandinsky started out fine and pure, and then went to the Theosophists' heaven. Picasso became a public character—less the "hero" artist.

Our new arrangement was, quite simply, no arrangement. We kept all the elements of painting—those that we knew or felt—suspended, as it were. We faced the canvas with the Self, whatever that was, and we painted. We faced it unarmed, so to speak. The only control was that of truth, intuitively felt. If it wasn't true to our feeling, according to protocol it had to be rubbed out. In fact, painters boasted of their paintings as a tangible record of a series of errors, and invited X-rays so you could see more.

These were "real gone" times, and I do not recommend them without reservations. The valuable element was the questioning search for the basic motives

★ Excerpts from *Arts* (New York), XXXIII, 2 (November 1958), 25.

573

of painting: the insistence that they be real, and a willingness to let the appearance of the picture follow the fact. In this period, if a picture looked like a picture, i.e., something you already knew, it was no good. We tried to make a clean slate, to start painting all over again. Some of us found monsters. Some of us found *a* painting. Some of us found painting.

The painters of this period shared certain ideas about painting and about the process of painting. They did not—and still do not—share a style of painting. Each one of them has a style of his own which is increasingly individual and personal. It is the outsider who has capitalized on a "look" and made it appear a style.

## Clyfford Still, Statement, 1959*

Your suggestion that I write a few notes for the catalog of this collection of paintings raises the same interest and the same qualifications that were present when the exhibition itself was first considered. The paradox manifest by the appearance of this work in an institution whose meaning and function must point in a direction opposite to that implied in the paintings—and my own life—was accepted. I believe it will not be resolved, but instead will be sharpened and clarified. For it was never a problem of aesthetics, or public or private acceptance, that determined my responsibility to the completed work. Rather, it was the hope to make clear its conceptual germination of idea and vision, without which all art becomes but an exercise in conformity with shifting fashions or tribal ethics. Perhaps a brief review is in order—.

In the few directions we were able to look during the 1920's, whether to past cultures or the scientific, aesthetic, and social myths of our own, it was amply evident that in them lay few answers valid for insight or imagination.

The fog had been thickened, not lifted, by those who, out of weakness or for positions of power, looked back to the Old World for means to extend their authority in this newer land. Already mired by moralists and utilitarians in the swamps of folkways and synthetic traditions, we were especially vulnerable to the mechanistic interpretations of motive and meaning. There followed a deluge of total confusion.

Self-appointed spokesmen and self-styled intellectuals with the lust of immaturity for leadership invoked all the gods of Apology and hung them around our necks with compulsive and sadistic fervor. Hegel, Kierkegaard, Cézanne, Freud, Picasso, Kandinsky, Plato, Marx, Aquinas, Spengler, Einstein, Bell, Croce, Monet,—the list grows monotonous. But that ultimate in irony—the Armory Show of 1913—had dumped upon us the combined and sterile conclusions of Western European decadence. For nearly a quarter of a century we groped and

---

* A letter to Gordon Smith, Director, 1 January 1959, published in the exhibition catalog, *Paintings by Clyfford Still*, The Buffalo (New York) Fine Arts Academy, Albright-Knox Art Gallery (5 November–13 December 1959).

stumbled through the nightmare of its labyrinthine evasions. And even yet its banalities and trivia are welcomed and exploited by many who find the aura of death more reassuring than their impotence or fears. No one was permitted to escape its fatalistic rituals—yet I, for one, refused to accept its ultimatums.

To add to the body of reference or "sensibility" which indulges homage or acquiescence to the collectivist rationale of our culture, I must equate with intellectual suicide. The omnivorousness of the totalitarian mind, however, demands a rigor of purpose and subtlety of insight from anyone who would escape incorporation.

Semantically and ethically the corruption is complete. Preoccupation with luminous devices is equated with spiritual enlightenment. The laws of Euclid are publicly damned to promote work illustrating an authoritarian dialectic. Witless parodies are displayed as evidence of social artistic commitment; and qualitative arrangements are presented as evidence of access to supernal mysteries. The rush to betray, in the name of aesthetics or "painting," an imagery born in repudiation of socio-psychological fallacies becomes a popular, but sinister, measure of its power.

Unknown are the crimes not covered by the skirts of that ubiquitous old harridan called Art. Even the whimperings and insolence of the venal are treasured in her name—and for their reassurance—by the arrogant and contemptuous. Indeed, among ambitious aesthetes, artists, architects, and writers, the burden of our heritage is borne lightly but mainly by hatred or cynicism. The impudence and sterility which so hypnotically fascinate the indifferent, perform a sordid substitute for responsibility and truth.

I held it imperative to evolve an instrument of thought which would aid in cutting through all cultural opiates, past and present, so that a direct, immediate, and truly free vision could be achieved, and an idea be revealed with clarity.

To acquire such an instrument, however,—one that would transcend the powers of conventional technics and symbols, yet be as an aid and instant critic of thought—demanded full resolution of the past, and present, through it. No shouting about individualism, no capering before an expanse of canvas, no manipulation of academic conceits or technical fetishes can truly liberate. These only make repetition inevitable and compound deceit.

Thus it was necessary to reject the superficial value of material—its qualities, its tensions, and its concomitant ethic. Especially it became necessary not to remain trapped in the banal concepts of space and time, nor yield to the morbidity of "the objective position"; nor to permit one's courage to be perverted by authoritarian devices for social control.

It was as a journey that one must make, walking straight and alone. No respite or short-cuts were permitted. And one's will had to hold against every challenge of triumph, or failure, or the praise of Vanity Fair. Until one had crossed the darkened and wasted valleys and come at last into clear air and could stand on a high and limitless plain. Imagination, no longer fettered by the laws of fear,

became as one with Vision. And the Act, intrinsic and absolute, was its meaning, and the bearer of its passion.

The work itself, whether thought of as image of idea, as revelation, or as a manifest of meaning, could not have existed without a profound concern to achieve a purpose beyond vanity, ambition, or remembrance, for a man's term of life. Yet, while one looks at this work, a warning should be given, lest one forget, among the multitude of issues, the relation I bear to those with "eyes." Although the reference is in a different context and for another purpose, a metaphor is pertinent as William Blake set it down:

> THE Vision of Christ that thou dost see
> Is my Vision's Greatest Enemy:
> Thine is the friend of All Mankind,
> Mine speaks in parables to the Blind:

Therefore, let no man under-value the implications of this work or its power for life;—or for death, if it is misused.

## Richard Stankiewicz, Statement, 1959*

Things may be objectively present without having the affective power that we call "presence." The extraordinary object, the one with presence, is one which is subjectively and tyrannically there: it can no more be ignored than being stared at can. It seems to me that this charged quality of things is what a work must have to be sculpture and any technical means for achieving it is allowable. It is the ultimate realism, this presence, having nothing to do with resemblances to "nature." The peculiar posture of the convincing being, the stance of being about to move, the enormity of the immovable, the tension between the separate parts of a whole are qualities that pull us to the special object like iron to a magnet. And these beings of presence that we try to make—they are models of a never quite credible existence.

## David Smith, "Notes on My Work," 1960†

I cannot conceive a work and buy material for it. I can find or discover a part. To buy new material—I need a truckload before I can work on one. To look at it every day—to let it soften—to let it break up in segments, planes, lines, etc.—wrap itself in hazy shapes. Nothing is so impersonal, hard and cold as straight rolling-mill stock. If it is standing or kicking around, it becomes personal and fits into visionary use. With possession and acquaintance, a fluidity develops which was not there the day it was unloaded from Ryersons' truck . . . .

* From *Sixteen Americans*, ed. Dorothy C. Miller (New York: Museum of Modern Art, 1959), p. 70. Copyright 1959 by The Museum of Modern Art, New York, and reprinted with its permission.

† Excerpts from *Arts* (New York), XXXIV, 2 (February 1960: Special David Smith Issue), 44.

Rarely the Grand Conception, but a preoccupation with parts. I start with one part, then a unit of parts, until a whole appears. Parts have unities and associations and separate after-images—even when they are no longer parts but a whole. The after-images of parts lie back on the horizon, very distant cousins to the image formed by the finished work.

The order of the whole can be perceived, but not planned. Logic and verbiage and wisdom will get in the way. I believe in perception as being the highest order of recognition. My faith in it comes as close to an ideal as I have. When I work, there is no consciousness of ideals—but intuition and impulse.

## Clement Greenberg, "Abstract, Representational, and so forth," 1961 *

The tendency is to assume that the representational as such is superior to the non-representational as such; that all other things being equal, a work of painting or sculpture that exhibits a recognizable image is always preferable to one that does not. Abstract art is considered to be a symptom of cultural, and even moral, decay, while the hope for a "return to nature" gets taken for granted by those who do the hoping as the hope for a return to health. Even some of the apologists of abstract art, by defending it on the plea that an age of disintegration must produce an art of disintegration, more or less concede the inherent inferiority of the non-representational. And those other apologists who claim, rightly or wrongly, that abstract art is never entirely abstract, are really conceding the same. One fallacy usually gets answered by another; and so there are fanatics of abstract art who turn the argument around and claim for the nonrepresentational that same absolute, inherent, and superior virtue which is otherwise attributed to the representational.

Art is a matter strictly of experience, not of principles, and what counts first and last in art is quality; all other things are secondary. No one has yet been able to demonstrate that the representational as such either adds or takes away from the merit of a picture or statue. The presence or absence of a recognizable image has no more to do with value in painting or sculpture than the presence or absence of a libretto has to do with value in music. Taken by itself, no single one of its parts or aspects decides the quality of a work of art as a whole. In painting and sculpture this holds just as true for the aspect of representation as it does for those of scale, color, paint quality, design, etc., etc.

It is granted that a recognizable image will add conceptual meaning to a picture, but the fusion of conceptual with aesthetic meaning does not affect quality. That a picture gives things to identify, as well as a complex of shapes and colors to behold, does not mean necessarily that it gives us more as *art*. More and less in art do not depend on how many varieties of significance are present, but on the intensity and depth of such significances, be they few or many, as are present. And we cannot tell, before the event—before the experience of it—whether the addition

* From his *Art and Culture* (Boston: Beacon, 1961), pp. 133–138. Originally given, in somewhat different form, as a Ryerson Lecture at the School of Fine Arts, Yale University, 12 May 1954, and published in *Arts Digest* (New York), XXIX, 3 (1 November 1954), 6–8.

577

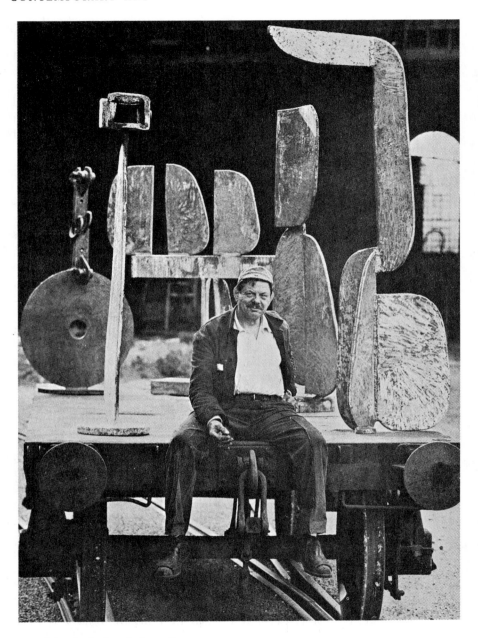

*David Smith, Spoleto, Italy, 1963.*
*Photograph by Ugo Mulas, Milan.*

or subtraction of conceptual meaning, or of any other given factor, will increase or diminish the aesthetic meaning of a work of art. That *The Divine Comedy* has an allegorical and anagogical meaning, as well as a literal one, does not necessarily make it a more effective work of literature than the *Iliad*, in which we really discern no more than a literal meaning. The explicit comment on a historical event offered in Picasso's *Guernica* does not make it necessarily a better or richer work than an utterly "nonobjective" painting by Mondrian.

To hold that one kind of art must invariably be superior or inferior to another kind means to judge before experiencing; and the whole history of art is there to demonstrate the futility of rules of preference laid down beforehand: the impossibility, that is, of anticipating the outcome of aesthetic experience. The critic doubting whether abstract art can ever transcend decoration is on ground as unsure as Sir Joshua Reynolds was when he rejected the likelihood of the pure landscape's ever occasioning works as noble as those of Raphael.

Ambitious, major painting and sculpture continue in our time, as they always did in the past, by breaking with fixed notions about what is possible in art and what is not. If certain works of Picasso as well as Mondrian deserve to be considered *pictures*, and certain works of Gonzalez as well as Pevsner deserve to be considered *sculpture*, it is because actual experience has told us so. And we have no more reason to doubt the validity of our experience than the contemporaries of Titian had to doubt theirs.

At this point I feel free, however, to turn around and say things perilously like those which I have just denied any one the right to say. But I will say what I have to say only about the abstract art I already know, not about abstract art in principle.

Free-standing pictorial and sculptural art, as distinct from decoration, was until a short while ago identified wholly with the representational, the figurative, the descriptive. Now it can be properly asked whether, in view of what painting and sculpture have achieved in the past, they do not risk a certain impoverishment by eliminating the representation, the figurative, the descriptive. As I have said, the nonrepresentational is not necessarily inferior to the representational—but is it not too little provided for, nevertheless, by the inherited, habitual, automatic expectations with which we approach an object that our society agrees to call a picture or statue? For this reason, may not even the best of abstract painting still leave us a little dissatisfied?

Experience, and experience alone, tells me that representational painting and sculpture have rarely achieved more than minor quality in recent years, and that major quality gravitates more and more toward the nonrepresentational. Not that most of recent abstract art is major; on the contrary, most of it is bad; but this still does not prevent the very best of it from being the best art of our time. And if the abstract is indeed impoverishing, then such impoverishment has now become necessary to important art.

But may it not be, on the other hand, that our dissatisfaction with abstract

art—if it is a dissatisfaction—has its source not so much in our nostalgia for the representational, as in the relatively simple fact that we are unable to match the past no matter how we paint or sculpt? May it not be that art in general is in decline? But if this is so, the dogmatic opponents of abstract art would be right only by accident, and on empirical, not principled or theoretical grounds; they would be right, not because the abstract in art is invariably a symptom of decline, but simply because it happens to accompany decline at this moment in the history of art, and they would be right only for this moment.

The answer may be even simpler, however—and at the same time more complicated. It may be that we cannot yet see far enough around the art of our own day; that the real and fundamental source of the dissatisfaction we may feel with abstract painting lies in the not uncommon problems offered by a new "language."

From Giotto to Courbet, the painter's first task had been to hollow out an illusion of three-dimensional space on a flat surface. One looked through this surface as through a proscenium into a stage. Modernism has rendered this stage shallower and shallower until now its backdrop has become the same as its curtain, which has now become all that the painter has left to work on. No matter how richly and variously he inscribes and folds this curtain, and even though he still outlines recognizable images upon it, we may feel a certain sense of loss. It is not so much the distortion or even the absence of images that we may mind in this curtain-painting, but rather the abrogation of those spatial rights which images used to enjoy back when the painter was obliged to create an illusion of the same kind of space as that in which our bodies move. This spatial illusion, or rather the sense of it, is what we may miss even more than we do the images that used to fill it.

The picture has now become an entity belonging to the same order of space as our bodies; it is no longer the vehicle of an imagined equivalent of that order. Pictorial space has lost its "inside" and become all "outside." The spectator can no longer escape into it from the space in which he himself stands. If it deceives his eyes at all, it is by optical rather than pictorial means: by relations of color and shape largely divorced from descriptive connotations, and often by manipulations in which top and bottom, as well as foreground and background, become interchangeable. Not only does the abstract picture seem to offer a narrower, more physical, and less imaginative kind of experience than the illusionist picture, but it appears to do without the nouns and transitive verbs, as it were, of the language of painting. The eye has trouble locating central emphases and is more directly compelled to treat the whole of the surface as a single undifferentiated field of interest, and this in turn, compels us to feel and judge the picture more immediately in terms of its over-all unity. The representational picture, seemingly (though only seemingly), does not require us to squeeze our reactions within such a narrow compass.

If, as I believe, abstract sculpture meets less resistance than abstract painting, it is because it has not had to change its language so radically. Whether

abstract or representational, its language remains three-dimensional—literal. Constructivist or quasi-constructivist sculpture, with its open, linear forms and denial of volume and mass, may puzzle eyes attuned to the monolith, but it does not require them to be refocused.

Shall we continue to regret the three-dimensional illusion in painting? Perhaps not. Connoisseurs of the future may prefer the more literal kind of pictorial space. They may even find the Old Masters wanting in physical presence, in corporeality. There have been such reversals of taste before. The connoisseurs of the future may be more sensitive than we to the imaginative dimensions and overtones of the literal, and find in the concreteness of color and shape relations more "human interest" than in the extra-pictorial references of old-time illusionist art. They may also interpret the latter in ways quite different from ours. They may consider the illusion of depth and volume to have been aesthetically valuable *primarily* because it enabled and encouraged the artist to organize such infinite subtleties of light and dark, of translucence and transparence, into effectively pictorial entities. They may say that nature was worth imitating because it offered, above all, a wealth of colors and shapes, and of intricacies of color and shape, such as no painter, in isolation with his art, could ever have invented. At the same time, these connoisseurs of the future may be able, in their discourse, to distinguish and name more aspects of quality in the Old Masters, as well as in abstract art, than we can. And in doing these things they may find much more common ground between the Old Masters and abstract art than we ourselves can yet recognize.

I do not wish to be understood as saying that a more enlightened connoisseurship will hold that *what*, as distinct from *how*, Rembrandt painted is an indifferent matter. That it was on the noses and foreheads of his portrait subjects, and not on their ears, that he piled the juiciest paint of his last manner has very much to do with the aesthetic results he obtained. But we still cannot say why or how. Actually, my own hope is that a less qualified acceptance of the importance of sheerly abstract or formal factors in pictorial art will open the way to a clearer understanding of the value of illustration as such—a value which I, too, am convinced is indisputable. Only it is not a value that is realized by, or as, *accretion*.

## Sidney Geist, "The Private Myth," 1961 *

Submerged beneath the public styles, schools, and theories of art, independent of isms and unamenable to criticism, is the private mind of the artist. This is the realm of fantasy and desire, of dream and obsession, of secret need and stated program, of Idea and *idée fixe*. It is the part of art that gives resonance to structure and meaning to the marks and shapes the artist makes: it is the part that is "impure." In the vast field of broken idols, worn-out legends, and obscure signposts, it erects its own myth.

* From *The Private Myth* (New York), The Tanager Gallery exhibition catalogue (6–26 October 1961).

*Sidney Geist, "Sculpture and Other Trouble," 1961* ★

In the changing relation between the amount of painting and the amount of sculpture, we are faced with a trend which is not going to be halted for a long time. Paintings as *things* cannot change much and still remain paintings; and this because the notion of flatness, of a surface, is rather absolute and not susceptible to much tampering. Collage provided and still provides a mechanically new way of making pictures, but anyone can see it is not painting except in the sense that it becomes a way of moving areas of color about. Every so often someone whips up a thick impasto, or glues a piece of bread to a canvas, or cuts a slit in it or makes it bulge by some pressure from behind, but always at risk to life and limb. In these cases we are witnessing a performance on a tightrope and are expected to hold our breath.

While any bulky addition to the surface of a painting, or even an unusual format, is likely to throw it into the domain of sculpture, the coloring of sculpture never tips it into the domain of painting—think of Picasso or Trajan or Chamberlain or King or anyone else. (It is never color which tips sculpture toward painting, but an atmospheric quality arrived at by *malerisch* means, as in Rosso or the reliefs of Manzù.) But the most important reason for the increasing proportion of sculpture is an ever increasing ambiguity about what sculpture is. *Any object*, it appears, may be called sculpture now. Duchamp, who exhibited a bottle rack in 1914, can be thanked for this development, but not by me.

I don't think that every object, however ingenious, interesting, or diverting, is sculpture, at the same time that I realize, definition of the term being what it is, that such a statement is an act of arrogation. There is a whole class of three-dimensional things which I can only call objects, not sculpture. These objects are often sculptural, that is, *like* sculpture in one of their aspects, and so are an automobile, a pebble, and the Great Stone Face. In the same sense, a woman may be statuesque and still not be a statue. Sculpture itself is always avoiding the sculptural while always creating a new idea of the sculptural; yet it has a core which is constant.

When we have said that sculpture is not sculptural, not an object, not a game, demonstration, machine, architecture, or theater—what is it? It is a figuration with a presence, a thing of ancient lineage, learned about always from previous sculpture, and the idea so passed on to any one who can get it. The idea is maintained by an act of arrogation, as I have said, but one that is no more exceptional than that by which the makers of objects dub their work sculpture.

*Hilton Kramer, "On Drawing as a Crucible of Style," 1963* †

One has the impression that an immense effort is now taking place among artists in New York—though more among painters than sculptors, probably—to restore

★ Excerpt from *Scrap* (New York), No. 3 (20 January 1961), p. 4.
† Excerpts from "The Possibilities of Mary Frank," *Arts* (New York), XXXVII, 6 (March 1963), 52, 54.

drawing to the position it formerly occupied as a crucible of style. And I mean, specifically, drawing from life—from the model, from objects, from the familiar visual facts of the artist's immediate world. Interest in drawing of this kind has never completely died out, even among abstract painters and sculptors who suppressed all evidences of it in their finished work; in fact, many of these artists have been very accomplished draftsmen. But what did suffer something like total demise was the idea that drawing of this kind had anything to offer in the way of intellectual guidance. So far as the New York School was concerned, drawing from life lost its intellectual prestige. It became a sport. And the predominantly conceptual bias of all modern art made it inevitable that this loss of intellectual prestige would effectively diminish the role that such drawing would play in conceiving new styles. A shift of aesthetic loyalties now seems to be taking place, however, with the result that drawing from the model is once again becoming an abiding interest for many of our most ambitious artists. With a few, indeed, it has become an obsession—and precisely, an *intellectual* obsession, the very crux whereby it is hoped to reunite the conceptual with the preceptual in a manner that has been out of favor (and thus, for many younger artists, out of mind) for many years now.

All this has its relevance to Mrs. Frank's exhibition. The first thing that many artists discover in their efforts to draw from the model is the degree to which they remain dependent upon the precedents of style when attempting to render, as exactly as possible, their own concrete observations. The search for a "neutral," or innocent, style—for a way of drawing that is somehow closer to the pure biological art of vision than to past methods of rendering the data of vision—proves always to be an illusory goal. There seems to be a kind of politics of the imagination that favors, perhaps even demands, a real conflict of aesthetic precedents as the most fecund ground from which to derive new possibilities of style *and* vision. Every fresh departure thus depends as much upon the choice of useful precedents, and the particular equations or clashes that may obtain between them, as it does on the force and thrust of the sensibility that utilizes them. Only an encounter of this sort between countervailing aesthetic precedents seems powerful enough, as an artistic instrument, to open a crack in the wall of art large enough for some new feeling about experience to enter into the conception of a new style.

*Hilton Kramer, "Style and Sensibility: David Smith," 1964*★

Rare are the exhibitions in which one is shown an artist of superior powers consolidating and surpassing an already sizable achievement. Even rarer, perhaps, are the occasions when the artist is an American of middle age. The careers of American artists, particularly those of modernist persuasion, have tended to consist of a series of disavowals and changes of "identity" dictated less by a sense of vocation

★ Excerpt from "David Smith's New Work," *Arts* (New York), XXXVIII, 6 (March 1964), 28–29, 30.

or experience than by sudden shifts in the aesthetic weather. Such shifts ought ideally, to challenge an artist's assumptions, clarify his intentions, and—if his essential vision derives from a source more personal and more profound than fashion—help fructify his original statement and lend it new impetus. But one does not have to be very old to have noticed how few really personal resources American artists have at their disposal in confronting these inevitable shifts of taste, value and idea—shifts which nowadays occur at such a rapid, wasteful, and exhausting rate of speed.

American artists tend to be swamped rather than stimulated by these shifts. That essential equation between an artist's brute experience and his characteristic ways of dealing with it, an equation of the kind one can see at the core of literary *oeuvres* as different as Henry James' and William Carlos Williams', is a rarity in American art. Our painters and sculptors are, typically, victims of a disassociation of existential fact and stylistic method that makes them peculiarly vulnerable to the pressures of change and ultimately robs them of what is most authentic in their own sensibilities. Of how few American artists can one really say, "The style is the man himself"!

Part of the interest that any exhibition of David Smith's work is likely to generate lies precisely in the knowledge that he is one of these rare American artists with a style, a sensibility—a voice—of his own. In approaching his new work, one does not have to suppress half (or more) of what one knows of his past accomplishments. Indeed, his new work is itself likely to invoke and enlarge upon some aspect of that past. In approaching what is new, one is therefore conscious of re-establishing a connection, of having a term of reference at once immediately relevant and yet larger than the fashion of the moment by which to judge what one sees. One is conscious of a personal and aesthetic continuity that, far from preserving itself against crisis and innovation, goes out of its way to confront and enlist them as a source of energy.

For an artistic development on this order to sustain itself—and in Smith's case, it has now been sustained uninterruptedly for more than three decades—two conditions, only one of which pertains to talent, are required. Smith's talents—his great gifts as a draftsman, designer, and constructor, his technical finesse and conceptual fecundity—have been, and remain, large. But of equal importance, perhaps, has been the aesthetic ground from which he has been able to deploy them. In writing about Smith four years ago, I suggested that "as an artist he came into the inheritance of all the modernist impulses of European art simultaneously and without having to commit himself exclusively to one over another." [1] This meant, among other things, that he was able to accommodate and connect, at the very outset of his career, the principal stylistic impulses—Cubism *and* Surrealism, Constructivism *and* Expressionism—which, taken separately as exclusive arbiters of style, trapped so many of his contemporaries into the aesthetic sectarianism that

[1] From "Special David Smith Issue," *Arts* (New York), XXXIV, 2 (February 1960).

was a cause and precondition of their later chameleon-like shifts of identity. Smith was able, very early on, to unify these disparate impulses by clearly discerning where the strength of each of them lay. From Cubism and Constructivism, he drew his formal syntax; from Surrealism, a vein of fantasy that permitted a wide range of symbolic and imagistic invention; from Expressionism, a gestural freedom that allowed an unflagging energy to penetrate and animate these elements of fantasy and construction, and carry them into new expressive arrangements.

Thus, the stylistic basis of Smith's art was broad enough to encompass, and in some cases anticipate, the principal innovations in modernist painting (the art with which his sculpture has carried on the closest dialogue) from the 'thirties down to the present moment. He has been able to avoid the main pitfall of the most recent developments in this painting—its increased narrowness and specialization—even as he has profited from them. Few of these developments have posed problems for which he could not find a precedent or analogue in his own *oeuvre*, with the result that with one exception, none has thrown his work off course. (The exception is the use of color as an integral sculptural component, which continues both to interest and elude Smith—as it does other sculptors.[1]) Each of these developments has sharpened a visual or conceptual "tool," which Smith could put to use in his sculpture without any basic alteration of method or expressive purpose, for its use was an amplification of something already implicit in his own work. His *oeuvre* is thus unique in the American art of the last thirty years not so much for the steadiness of its point of view as for the way this steadiness has been able to thrive on the shocks and reversals of the intervening period. The very shifts of taste and emphasis that shattered first the confidence and then the integrity of so many artists in these years have been, for Smith, a source of strength.

## Claes Oldenburg, Discussion, 1964*

### SUBJECT MATTER

I shouldn't really talk about Pop art in general, but it seems to me that the subject matter is the least important thing. Pop imagery, as I understand it, if I can sever it from what I do, is a way of getting around a dilemma of painting and yet not

---

[1] In a very fine essay for the catalogue of Smith's current exhibition in Philadelphia, Clement Greenberg remarks that "the question of color in Smith's art (as in all recent sculpture along the same lines) remains a vexed one. I don't think he has ever used applied color with real success . . . ." The most ambitious works in which Smith has used color were shown at the Carnegie International in 1961, and were discussed in my article on that exhibition (*Arts*, December, 1961). H.K.

* Excerpts from "Claes Oldenburg, Roy Lichtenstein, Andy Warhol: A Discussion," moderated by Bruce Glaser and broadcast over radio station WBAI in New York in June 1964. Edited and published in *Artforum* (Los Angeles), IV, 6 (February 1966), pp. 22, 23. Headings supplied.

painting. It is a way of bringing in an image that you didn't create. It is a way of being impersonal. At least that is the solution that I see, and I am all for clear definitions . . . .

I think that the reaction to the painting of the last generation, which is generally believed to have been a highly subjective generation, is impersonality. So one tries to get oneself out of the painting. . . .

### IMPERSONALITY AS STYLE

It's true that every artist has a discipline of impersonality to enable him to become an artist in the first place, and these disciplines are traditional and well known—you know how to place yourself outside the work. But we are talking about making impersonality a style, which is what I think characterizes Pop art, as I understand it, in a pure sense.

I know that Roy [Lichtenstein] does certain things to change his comic strips when he enlarges them, and yet it's a matter of the degree. It's something that the artist of the last generation, or for that matter of the past, would not have contemplated. . . .

### "TRANSLATE THE EYE INTO THE FINGERS . . ."

If I didn't think that what I was doing had something to do with enlarging the boundaries of art I wouldn't go on doing it. I think, for example, the reason I have done a soft object is primarily to introduce a new way of pushing space around in a sculpture or painting. And the only reason I have taken up Happenings is because I wanted to experiment with total space or surrounding space. I don't believe that anyone has ever used space before in the way Kaprow and others have been using it in Happenings. There are many ways to interpret a Happening, but one way is to use it as an extension of painting space. I used to paint but I found it too limiting so I gave up the limitations that painting has. Now I go in the other direction and violate the whole idea of painting space.

But the intention behind this is more important. For example, you might ask what is the thing that has made me make cake and pastries and all those other things. Then I would say that one reason has been to give a concrete statement to my fantasy. In other words, instead of painting it, to make it touchable, to translate the eye into the fingers. That has been the main motive in all my work. That's why I make things soft that are hard and why I treat perspective the way I do, such as with the bedroom set, making an object that is a concrete statement of visual perspective. But I am not terribly interested in whether a thing is an ice cream cone or a pie or anything else. What I am interested in is that the equivalent of my fantasy exists outside of me, and that I can, by imitating the subject, make a different work from what has existed before.

MATERIALS

In fact, that is one way to view the history of art, in terms of material. For example, because my material is different from paint and canvas, or marble or bronze, it demands different images and it produces different results. To make my paint more concrete, to make it come out, I used plaster under it. When that didn't satisfy me I translated the plaster into vinyl which enabled me to push it around. The fact that I wanted to see something flying in the wind made me make a piece of clothing, or the fact that I wanted to make something flow made me make an ice cream cone.

FORMAL PARODY

Parody in the classical sense is simply a kind of imitation, something like a paraphrase. It is not necessarily making fun of anything, rather it puts the imitated work into a new context. So if I see an Arp and I put that Arp into the form of some ketchup, does that reduce the Arp or does it enlarge the ketchup, or does it make everything equal? I am talking about the form and not about your opinion of the form. The eye reveals the truth that the ketchup looks like an Arp. That's the form the eye sees. You do not have to reach any conclusions about which is better. It is just a matter of form and material.

*George Rickey, "Observations and Reflections," 1964**

As for myself, I don't know whether I am in or out of step—either would be dangerous—or with what. I have plenty to occupy me without that worry. My concern with "movement itself"—Gabo's phrase—leads me into ever deeper, if narrower, water. I will never explore the whole gamut of it—the possibilities are too wide. I am less and less interested in exploration. I don't want to show, in my work, what can be done; I do that in my teaching. I want to make simple declaratory statements in a visual language I can control.

I was a long time getting over youth, misgivings, inexperience. I was a painter for twenty years. I have been a teacher for thirty-five. In 1930 I was a Cubist. In 1950, aged forty-three, I had become a sculptor, non-objective, and was soon committed to movement as a means . . . .

I have worked for several years with the simple movement of straight lines, as they cut each other, slice the intervening space and divide time, responding to the gentlest air currents. I work also with large complexes of small forms—perhaps a stack of waving lines, or revolving squares in groups too numerous to count, or pivoting eccentric rotors bearing hundreds of light-reflecting strips. Such countless elements together compose simple, monolithic, seething forms, either volumes or surfaces, which oscillate or undulate slowly in a breeze.

* Excerpts from his article published as "The Metier," *Contemporary Sculpture, Arts Yearbook*, 8, ed. James R. Mellow (New York: Arts Digest, 1965), pp. 164–166.

My technology is borrowed from crafts and industry. It has more in common with clocks than with sculpture. The materials are simple: stainless-steel sheet, rods, bars, angles, pipe; silicon bronze, brass, very occasionally a little silver; lead for counterweights. I join by silver brazing, acetylene and heli-arc welding, spot-welding, occasionally riveting or bolting. The tools are shears, sheet-metal bending brake, drill press, band saw, cut-off wheel, bench grinder, disk grinder, vise; pliers, hammers, files, in diverse shapes and sizes; and an anvil. You now find all these in any art school; they were formerly only in "industrial arts" departments. Hardware includes allen-head, phillips-head and binding screws; all kinds of nuts and bolts in stainless steel, bronze, and brass; taps and dies; silicon carbide to weld onto bearing surfaces; and abrasives and solvents for cleaning . . . .

I have been able in the last two years to make larger pieces—the largest is thirty-four feet high. Part of the spectrum of movement is related to size. In sculpture or painting there is a change in thought when the work is bigger than the artist; with movement there is a functional change in performance as well. Two lines twenty-four inches long may swing across each other at three- or four-second intervals. This seems very slow. A big piece can take half a minute to swing from side to side; this is as different as red from purple . . . .

Though I do not imitate nature I am aware of resemblances. If my sculptures sometimes look like plants or clouds or waves of the sea, it is because they respond to the same laws of motion and follow the same mechanical principles. Periodicity produces similar images in sand, water, a skip-rope and an oscilloscope, but none of these is a record of the other. Sometimes I have recognized analogues in titles, after the event, such as *Sedge* and *Windflower*. Recently I have preferred a title which identifies the piece without suggestion, such as *Six Lines Horizontal* or *Ten Pendulums, Ten Cubes, Ten Rotors*.

Even without titles abstract works evoke all kinds of associations. Machinery has always done this, as have ships, plows, and tools. What I have associated with leaves of grass others have seen as weapons; of course "spears," "shoots," and "blades" are ancient botanical terms. I cannot control evocations.

I respect fine workmanship when it furthers a firmly held purpose. I can see the use of exactness to eliminate mystique and confusion. I am interested in the recent trend toward objectification of the work of art and the attempts to eliminate emotive, expressive, subjective, or personalized influences from the object, also in the idea of a spectator who has no conditioning as a connoisseur. Others as well as I have begun to find that movement is more accessible than static relations in form, and certainly more so than the esoteric calligraphy which has been so important in recent painting. I feel lucky to live in an epoch when such interests are allowable in art.

I do not claim to be a Constructivist. Yet I respect the humility, rigor, self-effacement, and regard for object-rather-than-process which characterized early Constructivist work and gave meaning to the "real" in Gabo's Realist Manifesto. I see no reason why analytical thought and rational systems need

endanger an artist's work, nor do I mind temperament, if the show of it is not made the purpose. There is a bloom of temperament in Malevich and Albers just as there is a core of reason in Van Gogh and Klee.

Artists prosper, but it becomes no clearer what art is. To present a Swedish roller bearing as art is at least as plausible as Warhol presenting a commercial container. The ultimate in kinetic art may well have been Galileo's pendulum which swung clear not only of his temperament but of the very rotation of the earth. It was a conscious, bold, imaginative act.

I distrust the idea of art as process or performance, especially when it is a wanton effusion masquerading as "automatic." Art is not somnambulist. I respect a temperament which can endure control.

## INTRODUCTION: The Europeans

The extensive dislocation suffered by Europeans in almost every aspect of life as a result of World War II deeply affected artists and art movements. Perhaps of greatest importance was the flight of many of the masters from their homelands. Not only was their work disrupted, but groups were broken up and the members scattered, some never to be reunited. Most of the Surrealists became refugees in New York, and although nearly all of them returned to Paris at the end of the war, the group never again attained the unity that prevailed in the 'thirties. Only a few of them, such as Tanguy, Ernst, and Dali, established more or less permanent ties in America. The Cubists (with the exception of Léger), being of an older generation, remained in France and continued to work, although suffering deprivation and isolation from their colleagues. The younger generation, artists such as Manessier, Soulages, and Winter, went into the army, and many were interned or impressed into forced labor camps. Many German artists, such as Beckmann, Albers, and Schwitters, had already fled their country after their paintings had been confiscated and sold at auction by the Nazis, and none of them returned. Klee remained in Switzerland, Kandinsky went to Paris, Campendonk remained in Amsterdam, and Feininger returned to America. Mondrian had fled to England from Holland at the outbreak of the war and later made his way to New York.

The postwar generation of European artists was a product of this disruption, and they witnessed the destruction of the old artistic order wherein art movements represented a clear concept of form or content and were supported by an ideology. This destruction was the last stage in what André Malraux calls the "twilight of the absolute," or the end of widely

accepted, clearly defined standards in art and culture. But at the same time, the young artists were exposed to foreign artists and foreign ideas to an extent never before known. Their ideological sources were, therefore, two differing ones: a knowledge of and ingrained respect for traditionally accepted values, even though they had been seriously challenged by the spirit of disillusion and change of the postwar era, and an exposure to foreign ideas which were readily accessible as a result of the new "one-world" point of view.

The art theories of European and especially of French artists tend to translate images into mental concepts, an intellectualization of sensations which is the result of a background of classical education based upon literary values. Thus, they are apt, more than Americans, to express a revolt against tradition in a rational and sophisticated argument. This classical background provides them with categories which, even though outdated, are nevertheless fixed points against which the revolutionary may react with some certainty. Thus, even when in the most destructive mood, the European may operate according to traditional rules of conduct. This may be contrasted with the contemporary Americans, who, lacking not only a clearly defined opponent (such as the Academy or the Salon), but also the habit of theorizing in terms of categories, tended in their primary beliefs to rely upon the supremacy of individual feelings and ideas.

The theories of European artists, originating in a rich cultural field nourished by social and political controversy, are sometimes influenced or even guided by other ideologies. Existentialism, the major philosophic contribution of postwar France, had profound implications for the artists. A philosophic system indebted to Kierkegaard and Heidegger, it found fertile ground in the disillusionment of the fall of France and the weakening of the almost absolute sway which Paris has held as the center of the world of art. As expressed by Jean-Paul Sartre (b. 1905 in Paris), who is himself a critic and close friend of artists, man is a solitary being who is only what he wills himself to be in an absurd world where no valid given patterns of behavior exist. Such a belief gave vigorous support to artists who felt themselves to be a part of a new, free, and different world, but who realized that they must first release themselves both from the shackles of their national traditions and from the prestigious masters of the recent past whose shadows fell across their own careers.

Henry Moore (b. 1898 in Yorkshire) is one of the most perceptive and intelligent commentators on modern sculpture, both on his own and on the problems and aims of present-day artists. He was trained as a teacher, studied, and then taught in major art schools of England. Although he has

written little on art, his few comments are remarkable in their clarity and significance. He has been associated with both the Surrealists and the Constructivists, but his own tastes have led him to an admiration of Pre-Columbian and primitive sculpture and to Brancusi. His theoretical writing is concerned with fundamental sculptural problems such as the interaction of volume and space, which are both universal problems and particular concerns of his own.

Alberto Giacometti (1908-1965, born in Switzerland) frankly expressed his admiration for the masters of Italian Renaissance painting and his adherence to the characteristics of the natural world, yet his sculpture and his thoughts point to a struggle with the problem of what is spiritually real for contemporary man. Sartre has recognized in Giacometti's sculpture a search for a reality similar to his own and consequently has been able to write about him with particularly penetrating insight (included in exhibition catalogue with Giacometti's letter, below.) Giacometti studied sculpture in Switzerland and Italy before going to Paris in 1922, where he studied with Bourdelle and later became associated with the Surrealists.

Constant (Nieuwenhuys, b. 1920) is one of the members of the Cobra group, which was founded in Paris in 1948 and named after the principal members' home cities, Copenhagen, Brussels, and Amsterdam. The founding members were Karel Appel, Corneille, Asger Jorn, Atlan, Alechinsky, and Constant. They believed in direct and spontaneous expression uninhibited by the intellect, and they violently rejected artistic traditions that prevented this freedom. Their vigorous art might be similar to the New York School of "action painting," except that out of the torrent of color there emerge vague images associated with Northern European folklore, which is dominated by mythical animals, demons, and magic cults.

Michel Tapié (b. 1909 in Southern France) has been associated with avant-garde art since the mid-'forties, not only as an author of books, criticism, and catalogue introductions, but also as an organizer of exhibitions of contemporary art in Europe, Latin America, and Japan, and as an adviser to galleries throughout the world. He has lived in Paris since 1929, where he studied art, aesthetics, and philosophy. In 1960 he founded with the architect Luigi Moretti, the International Center of Aesthetic Research at Turin, a publishing and exhibition facility.

Etienne Hajdu (b. 1907 in Rumania) studied briefly in Vienna before going to Paris to study at the *Ecole des Arts Décoratifs* and with Bourdelle. Soon turning away from traditional instruction, he found his own teachers among the masters of sculptural form, both ancient and modern: Classical Greek, Cycladic, and Romanesque, as well as Rodin and Brancusi.

591

Hans Uhlmann (b. 1900 in Berlin) was trained as an engineer and later taught engineering; at the same time he began to work in sculpture. He employs both the materials of engineering—industrially produced sheet metal and wire—and its techniques—geometric forms with perforations. Yet the modes by which these forms are composed have the freedom of painting and sculpture, as in a freehand sketch employing straight lines or in a collage. Uhlmann teaches at the Akademie der Künste in Berlin.

Jean Dubuffet (b. 1901 in Le Havre) attacked both the French painting tradition and art movements in general in clear and convincing terms, and proposed that the act of creation in which chance is a major factor is the supreme experience. Nevertheless, he is deeply involved with the real objects of the physical world, such as stones and plants, and he mistrusts the rare or the fantastic. Dubuffet has written extensively on his art, which he calls *l'art brut*, opposing it to conventional concepts of culture.

Peter Selz notes that "the article 'Empreintes,' published in 1957, gives perhaps the clearest single statement about his thought and his work. One of the essential aspects of his work is the constant contradiction, the contrast between the undefined, almost abstract landscapes and clearly articulated symmetrical figures, between precise drawing and the absence of line, between gaudy color and dull monochromes, between the heaviest application of materials and the thinnest paint . . . .

Other significant aspects of Dubuffet's work are emphasized in this essay, such as his opposition to consciousness, which can only interfere with the fullness of experience, and his stress on the mutability of matter within a great organic whole, as well as his concern with the simplest, the most ordinary and crude, which has generally been overlooked in man's search for a special 'aesthetic' category. 'My art,' he points out, 'is an attempt to bring all disparaged values into the limelight."

Although Dubuffet's formal education ended at the age of seventeen when he began to study painting at the Académie Julian in Paris, he has read and studied extensively, especially in ancient and modern literature and ethnology. For some years he was engaged in the business of selling wine as a livelihood, turning to painting only intermittently, until after the war when his success as a painter was assured.

Eduardo Paolozzi (b. 1924 in Edinburgh) represents an opposing tendency in Britain to the powerful influence toward formal clarity of Henry Moore. His thought as well as his work has dwelt on the evocative possibilities of a metamorphosis of common objects into a complex and mysterious dream world. This imagery suggests therefore totemic signs and symbols that are the archetypes of prehistoric man, even though the individual parts

of the figure may have come from cast-off machine-made objects. Recently he has turned to materials used by contemporary engineers, and seeks to transform these "anonymous materials" as well into works that will evoke a poetic idea.

Francis Bacon (b. 1910 in Dublin) uses the human figure as his principle iconographic device and attempts to emotionalize the objects and scenes of the visible world. Many of these themes are drawn from the masters of the past, such as Velasquez and Van Gogh. His attitude toward these, however, is conditioned by a disillusioned, brutal, and often terrifying sense of man's experience and inner anguish. He expresses the spiritual crisis of contemporary urban life in his comments upon the brutalizing impact of common objects and particularly of popular culture upon man's sensibilities. Bacon is possessed of a wide cultural background, although self-taught both as an intellectual and as an artist. He has studied Nietzsche, in particular, and the paintings of the Mannerists and the Romantics, being impressed chiefly with the northern European fantasists such as Fuseli, Blake, and Hieronymus Bosch.

Davide Boriani (b. 1936 in Milan) studied painting at the Academy of Fine Arts in the Brera, Milan. A founding member of the Milan *Group T*, he has done research in the area of visual communication, relying upon findings in the fields of electronics and cybernetics, and has worked on various kinds of kinetic constructions, using metal filings and moving magnets. Like the American kineticist Len Lye, his experience includes cinematography.

Phillip King (b. 1934 in Tunis) went to England in 1945, studied at Cambridge during 1954–1957, studied sculpture with Anthony Caro in 1957 and worked with Henry Moore during 1958–1959.

*Henry Moore, "The Sculptor Speaks," 1937*★

It is a mistake for a sculptor or a painter to speak or write very often about his job. It releases tension needed for his work. By trying to express his aims with rounded-off logical exactness, he can easily become a theorist whose actual work is only a caged-in exposition of conceptions evolved in terms of logic and words.

But though the nonlogical, instinctive, subconscious part of the mind must play its part in his work, he also has a conscious mind which is not inactive. The artist works with a concentration of his whole personality, and the conscious part

★ From "The Sculptor Speaks," *The Listener* (London), XVIII (18 August 1937), 449.

of it resolves conflicts, organizes memories, and prevents him from trying to walk in two directions at the same time.

It is likely, then, that a sculptor can give, from his own conscious experience, *clues* which will help others in their approach to sculpture, and this article tries to do this, and no more. It is not a general survey of sculpture, or of my own development, but a few notes on some of the problems that have concerned me from time to time.

### THREE DIMENSIONS

Appreciation of sculpture depends upon the ability to respond to form in three dimensions. That is perhaps why sculpture has been described as the most difficult of all arts; certainly it is more difficult than the arts which involve appreciation of flat forms, shape in only two dimensions. Many more people are "form-blind" than color-blind. The child learning to see, first distinguishes only two-dimensional shape; it cannot judge distances, depths. Later, for its personal safety and practical needs, it has to develop (partly by means of touch) the ability to judge roughly three-dimensional distances. But having satisfied the requirements of practical necessity, most people go no farther. Though they may attain considerable accuracy in the perception of flat form, they do not make the further intellectual and emotional effort needed to comprehend form in its full spatial existence.

This is what the sculptor must do. He must strive continually to think of, and use, form in its full spatial completeness. He gets the solid shape, as it were,

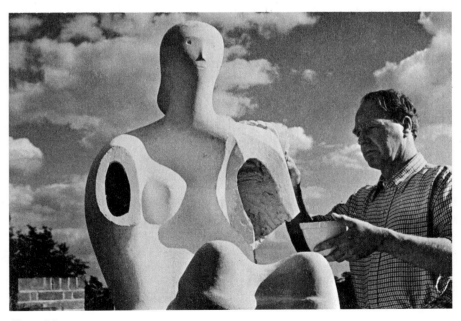

*Henry Moore, ca. 1950.*

inside his head—he thinks of it, whatever its size, as if he were holding it completely enclosed in the hollow of his hand. He mentally visualizes a complex form *from all round itself*; he knows while he looks at one side what the other side is like; he identifies himself with its center of gravity, its mass, its weight; he realizes its volume, as the space that the shape displaces in the air.

And the sensitive observer of sculpture must also learn to feel shape simply as shape, not as description or reminiscence. He must, for example, perceive an egg as a simple single solid shape, quite apart from its significance as food, or from the literary idea that it will become a bird. And so with solids such as a shell, a nut, a plum, a pear, a tadpole, a mushroom, a mountain peak, a kidney, a carrot, a tree-trunk, a bird, a bud, a lark, a lady-bird, a bulrush, a bone. From these he can go on to appreciate more complex forms or combinations of several forms.

### BRANCUSI

Since the Gothic, European sculpture had become overgrown with moss, weeds— all sorts of surface excrescences which completely concealed shape. It has been Brancusi's special mission to get rid of this overgrowth, and to make us once more shape-conscious. To do this he has had to concentrate on very simple direct shapes, to keep his sculpture, as it were, one-cylindered, to refine and polish a single shape to a degree almost too precious. Brancusi's work, apart from its individual value, has been of historical importance in the development of contemporary sculpture. But it may now be no longer necessary to close down and restrict sculpture to the single (static) form unit. We can now begin to open out. To relate and combine together several forms of varied sizes, sections, and directions into one organic whole.

### SHELLS AND PEBBLES; —BEING CONDITIONED TO RESPOND TO SHAPES

Although it is the human figure which interests me most deeply, I have always paid great attention to natural forms, such as bones, shells, and pebbles, etc. Sometimes for several years running I have been to the same part of the seashore—but each year a new shape of pebble has caught my eye, which the year before, though it was there in hundreds, I never saw. Out of the millions of pebbles passed in walking along the shore, I choose out to see with excitement only those which fit in with my existing form-interest at the time. A different thing happens if I sit down and examine a handful one by one. I may then extend my form-experience more, by giving my mind time to become conditioned to a new shape.

There are universal shapes to which everybody is subconsciously conditioned and to which they can respond if their conscious control does not shut them off.

### HOLES IN SCULPTURE

Pebbles show nature's way of working stone. Some of the pebbles I pick up have holes right through them.

When first working direct in a hard and brittle material like stone, the lack of experience and great respect for the material, the fear of ill-treating it, too often result in relief surface carving, with no sculptural power.

But with more experience the completed work in stone can be kept within the limitations of its material, that is, not be weakened beyond its natural constructive build and yet be turned from an inert mass into a composition which has a full form existence, with masses of varied sizes and sections working together in spatial relationship.

A piece of stone can have a hole through it and not be weakened—if the hole is of a studied size, shape, and direction. On the principle of the arch, it can remain just as strong.

The first hole made through a piece of stone is a revelation.

The hole connects one side to the other, making it immediately more three-dimensional.

A hole can itself have as much shape-meaning as a solid mass.

Sculpture in air is possible, where the stone contains only the hole, which is the intended and considered form.

The mystery of the hole—the mysterious fascination of caves in hillsides and cliffs.

## SIZE AND SHAPE

There is a right physical size for every idea.

Pieces of good stone have stood about my studio for long periods, because though I've had ideas which would fit their proportions and materials perfectly, their size was wrong.

There is a size to scale not to do with its actual physical size, its measurement in feet and inches—but connected with vision.

A carving might be several times over life size and yet be petty and small in feeling—and a small carving only a few inches in height can give the feeling of huge size and monumental grandeur, because the vision behind it is big. Example, Michelangelo's drawings or a Massacio madonna—and the Albert Memorial.[1]

Yet actual physical size has an emotional meaning. We relate everything to our own size, and our emotional response to size is controlled by the fact that men on the average are between five and six feet high.

An exact model to one-tenth scale of Stonehenge, where the stones would be less than us, would lose all its impressiveness.

Sculpture is more affected by actual size considerations than painting. A painting is isolated by a frame from its surroundings (unless it serves just a decorative purpose) and so retains more easily its own imaginary scale.

If practical considerations allowed me, cost of material, of transport, etc., I should like to work on large carvings more often than I do. The average

[1] An enormous neo-Gothic spire erected in Kensington Gardens and generally described as "costing £120,000 and requiring 20 years to build."

in-between size does not disconnect an idea enough from prosaic everyday life. The very small or the very big takes on an added size emotion.

Recently I have been working in the country, where, carving in the open air, I find sculpture more natural than in a London studio, but it needs bigger dimensions. A large piece of stone or wood placed almost anywhere at random in a field, orchard, or garden, immediately looks right and inspiring.

### DRAWING AND SCULPTURE

My drawings are done mainly as a help towards making sculpture—as a means of generating ideas for sculpture, tapping oneself for the initial idea; and as a way of sorting out ideas and developing them.

Also, sculpture compared with drawing is a slow means of expression, and I find drawing a useful outlet for ideas which there is not time enough to realize as sculpture. And I use drawing as a method of study and observation of natural forms (drawings from life, drawings of bones, shells, etc.).

And I sometimes draw just for its own enjoyment.

Experience though has taught me that the difference there is between drawing and sculpture should not be forgotten. A sculptural idea which may be satisfactory as a drawing always needs some alteration when translated into sculpture.

At one time whenever I made drawings for sculpture I tried to give them as much the illusion of real sculptures as I could—that is, I drew by the method of illusion, of light falling on a solid object. But I now find that carrying a drawing so far that it becomes a substitute for the sculpture either weakens the desire to do the sculpture, or is likely to make the sculpture only a dead realization of the drawing.

I now leave a wider latitude in the interpretation of the drawings I make for sculpture, and draw often in line and flat tones without the light and shade illusion of three dimensions; but this does not mean that the vision behind the drawing is only two-dimensional.

### ABSTRACTION AND SURREALISM

The violent quarrel between the abstractionists and the surrealists seems to me quite unnecessary. All good art has contained both abstract and surrealist elements, just as it has contained both classical and romantic elements—order and surprise, intellect and imagination, conscious and unconscious. Both sides of the artist's personality must play their part. And I think the first inception of a painting or a sculpture may begin from either end. As far as my own experience is concerned, I sometimes begin a drawing with no preconceived problem to solve, with only the desire to use pencil on paper, and make lines, tones, and shapes with no conscious aim; but as my mind takes in what is so produced, a point arrives where some idea becomes conscious and crystallizes, and then a control and ordering begin to take place.

Or sometimes I start with a set subject; or to solve, in a block of stone of

known dimensions, a sculptural problem I've given myself, and then consciously attempt to build an ordered relationship of forms, which shall express my idea. But if the work is to be more than just a sculptural exercise, unexplainable jumps in the process of thought occur; and the imagination plays its part.

I might seem from what I have said of shape and form that I regard them as ends in themselves. Far from it. I am very much aware that associational, psychological factors play a large part in sculpture. The meaning and significance of form itself probably depends on the countless associations of man's history. For example, rounded forms convey an idea of fruitfulness, maturity, probably because the earth, women's breasts, and most fruits are rounded, and these shapes are important because they have this background in our habits of perception. I think the humanist organic element will always be for me of fundamental importance in sculpture, giving sculpture its vitality. Each particular carving I make takes on in my mind a human, or occasionally animal character and personality, and this personality controls its design and formal qualities, and makes me satisfied or dissatisfied with the work as it develops.

My own aim and direction seems to be consistent with these beliefs, though it does not depend upon them. My sculpture is becoming less representational, less an outward visual copy, and so what some people would call abstract; but only because I believe that in this way I can present the human psychological content of my work with the greatest directness and intensity.

*Alberto Giacometti, Letter to Pierre Matisse, 1947*\*

Impossible to grasp the entire figure (we were much too close to the model, and if one began on a detail, a heel, the nose, there was no hope of ever achieving the whole).

But if, on the other hand, one began by analyzing a detail, the end of the nose, for example, one was lost. One could have spent a lifetime without achieving a result. The form dissolved, it was little more than granules moving over a deep black void, the distance between one wing of the nose and the other is like the Sahara, without end, nothing to fix one's gaze upon, everything escapes.

Since I wanted nevertheless to realize a little of what I saw, I began as a last resort to work at home from memory. I tried to do what I could to avoid this catastrophe. This yielded, after many attempts touching on cubism, one necessarily had to touch on it (it is too long to explain now) objects which were for me the closest I could come to my vision of reality.

This gave me some part of my vision of reality, but I still lacked a sense of the whole, a structure, also a sharpness that I saw, a kind of skeleton in space.

\* Originally published in *Alberto Giacometti* (New York: Pierre Matisse Gallery exhibition catalogue, 1948). Newly translated and published with a facsimile of the original typewritten text in *Alberto Giacometti*, with an introduction by Peter Selz and an autobiographical statement by the artist, copyright 1965 by The Museum of Modern Art, New York, and reprinted with its permission.

Figures were never for me a compact mass but like a transparent construction.

Again, after making all kinds of attempts, I made cages with open construction inside, executed in wood by a carpenter.

There was a third element in reality that concerned me: movement.

Despite all my efforts, it was impossible for me then to endure a sculpture that gave an illusion of movement, a leg advancing, a raised arm, a head looking sideways. I could only create such movement if it was real and actual, I also wanted to give the sensation of motion that could be induced.

Several objects which move in relation to one another.

But all this took me away little by little from external reality, I had a tendency to become absorbed only in the construction of the objects themselves.

There was something in these objects that was too precious, too classical; and I was disturbed by reality, which seemed to me to be different. Everything at that moment seemed a little grotesque, without value, to be thrown away.

This is being said too briefly.

Objects without pedestals and without value, to be thrown away.

It was no longer the exterior forms that interested me but what I really felt. (During all the previous years—the period of the academy—there had been for me a disagreeable contrast between life and work, one got in the way of the other. I could find no solution. The fact of wanting to copy a body at set hours and a body to which otherwise I was indifferent, seemed to me an activity that was basically false, stupid, and which made me waste many hours of my life.)

It was no longer a question of reproducing a lifelike figure but of living, and of executing only what had affected me, or what I really wanted. But all this alternated, contradicted itself, and continued by contrast. There was also a need to find a solution between things that were rounded and calm, and sharp and violent. It is this which led during those years (32–34 approximately) to objects going in directions that were quite different from each other, a kind of landscape—a head lying down; a woman strangled, her jugular vein cut; construction of a palace with a skeleton bird and a spinal column in a cage and a woman at the other end.[1] A model for a large garden sculpture, I wanted people to be able to walk on the sculpture, to sit on it and lean on it. A table for a hall, and very abstract objects which then led me to figures and skull heads.

I saw anew the bodies that attracted me in reality and the abstract forms which seemed to me true in sculpture, but I wanted to create the former without losing the latter, *very briefly put*.

A last figure, a woman called $1 + 1 = 3$, which I could not resolve.

And then the wish to make compositions with figures. For this, I had to make (quickly I thought; in passing), one or two studies from nature, just enough

---

[1] *Woman with Her Throat Cut*, 1932, and *The Palace at 4 a.m.*, 1932–1933, both in The Museum of Modern Art, New York. Giacometti was associated with the Surrealist group in Paris from 1930.

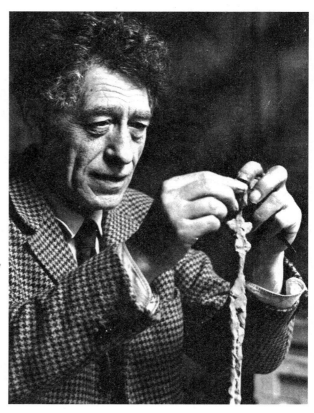

*Alberto Giacometti, 1960.*
*Photograph by Herbert Matter,*
*New York.*

to understand the construction of a head, of a whole figure, and in 1935 I took a model. This study should take (I thought) two weeks, and then I could realize my compositions.

I worked with the model all day from 1935 to 1940.

Nothing was as I had imagined. A head (I quickly abandoned figures, that would have been too much) became for me an object completely unknown and without dimensions. Twice a year I began two heads, always the same ones, never completing them, and I put my studies aside (I still have the casts).

Finally, in order to accomplish at least a little, I began to work from memory, but this mainly to know what I had gotten out of all this work. (During all these years I drew and painted a little, and almost always from life.)

But wanting to create from memory what I had seen, to my terror the sculptures became smaller and smaller, they had a likeness only when they were small, yet their dimensions revolted me, and tirelessly I began again, only to end several months later at the same point.[1]

[1] For perceptive observations on scale in Giacometti's sculpture see Jean-Paul Sartre's "Le Recherche de l'absolu," *Les Temps Modernes* IX, 103, 2221–2232, June 1954.

A large figure seemed to me false and a small one equally unbearable, and then often they became so tiny that with one touch of my knife they disappeared into dust. But head and figures seemed to me to have a bit of truth only when small.

All this changed a little in 1945 through drawing.

This led me to want to make larger figures, but then to my surprise, they achieved a likeness only when tall and slender.

And this is almost where I am today, no, where I still was yesterday, and I realize right now that if I can draw ancient sculptures with ease, I could draw those I made during these last years only with difficulty; perhaps if I could draw them it would no longer be necessary to create them in space, but I am not sure about this.

And now I stop, besides they are closing [the cafe where he was writing the letter], I must pay.

## Constant, "Our Own Desires Build the Revolution" (The Cobra Group), 1949*

For those of us whose artistic, sexual, social, and other desires are farsighted, experiment is a necessary tool for the knowledge of our ambitions—their sources, goals, possibilities, and limitations.

But what can be the purpose of going from one extreme to the other, like man, and of surmounting even those barriers erected by morals, aesthetics, and philosophy? What is the reason for this need to break the bonds which have kept us within the social system for hundreds of years and thanks to which we have been able to think, live, create? Is our culture incapable of prolonging itself and of leading us one day to the satisfaction of our desires?

In fact, this culture has never been capable of satisfying anyone, neither a slave, nor a master who has every reason to believe himself happy in a luxury, a lust, where all the individual's creative potential is centered.

When we say desire in the twentieth century, we mean the unknown, for all we know of the realm of our desires is that it continuously reverts to one immeasurable desire for freedom. As a basic task we propose liberation of social life, which will open the way to the new world—a world where all the cultural aspects and inner relationships of our ordinary lives will take on new meaning.

*It is impossible to know a desire other than by satisfying it, and the satisfaction of our basic desire is revolution.* Therefore, any real creative activity—that is, cultural activity, in the twentieth century—must have its roots in revolution. Revolution alone will enable us to make known our desires, even those of 1949. The revolution submits to no definition! Dialectical materialism has taught us that conscience depends upon social circumstances, and when these prevent us from being satisfied, *our needs impel us to discover our desires.* This results in experiment, or the release of knowledge. Experiment is not only an instrument of knowledge, it is the very

* From *Cobra* (Amsterdam), No. 4 (1949), 304. This translation from the French by Lucy R. Lippard.

condition of knowledge in a period when our needs no longer correspond to the cultural conditions which should provide an outlet for them.

But what has been the basis of experiment until now? Since our desires are for the most part unknown to us, experiment must always take the present state of knowledge as its point of departure. All that we already know is the raw material from which we draw hitherto unacknowledged possibilities. And once the new uses of this experience are found, a still broader range will be opened to us, which will enable us to advance to still unimagined discoveries.

Thus artists have turned to the discovery of creation—extinct since the foundation of our present culture—since creation is above all the medium of knowledge, and therefore of freedom and revolution. Today's individualist culture has replaced creation with *artistic production*, which has produced nothing but signs of a tragic impotence and cries of despair from the individual, enslaved by aesthetic prohibitions: It must not . . .

A creation has always been that which was still unknown, and the unknown frightens those who think they have something to defend. But we who have nothing to lose but our chains, we are perfectly able to tempt adventure. We risk only the sterile virginity of abstractions. Let us fill up *Mondrian's* virgin canvas even if only with our miseries. Isn't misery preferable to death for strong men who know how to struggle? It is the same enemy who obligated us to be partisans, to support the *Maquis*,[1] and if discipline is his advantage, courage is ours, and it is courage, not discipline, that wins wars.

Such is our response to abstractions, whether or not they exploit spontaneity. Their "spontaneity" is that of a spoiled child who doesn't know what he wants; who wants to be free, but cannot do without his parent's protection.

But being free is like being strong; freedom appears only in creation or in strife—and these have the same goal at heart—fulfillment of life.

*Life demands creation and beauty is life!*

So if society turns against us and against our works, reproaching us for being practically "incomprehensible," we reply:

1) That humanity in 1949 is incapable of understanding anything but the necessary struggle for freedom.

2) That we do not want to be "understood" either, but to be freed, and that *we are condemned to experiment by the same causes that drive the world into war.*

3) That we could not be creators in a passive world, and that today's strife sustains our inventiveness.

4) Finally, that humanity, once it has become creative, will have no choice but to discard aesthetic and ethical conceptions whose only goal has been the restraint of creation—those conceptions responsible for man's present lack of understanding for experiment.

[1] The French Resistance during the Second World War.

Therefore, understanding is nothing more than recreating something born of the same desire.

Humanity (us included) is on the verge of discovering its own desires, and by satisfying them we shall make them known.

## Michel Tapié, "A New Beyond," 1952*

Today, art must stupefy to be art. At a time when, for the best reasons and the worst, everything is brought into play to explain art, to popularize and vulgarize it, to get us to swallow it down as a normal complement to our everyday living, the true creators know that the only way for them to express the inevitability of their message is through the extraordinary—paroxysm, magic, total ecstasy. That is why these pages will not discuss aesthetics or works depending on it alone, since today aesthetics is an excuse for nothing but vain pretensions, a shabby alibi for the exercise of talents utterly lacking in necessity.

There can be no question today of art for pleasure, whatever transcendent meaning, including aesthetics, one gives that word, however elaborate, however farfetched it may be. Art is made elsewhere, outside it, on another plane of that Reality which we perceive in a different fashion: art is other . . . .

The way of art, at the present time, confronts us as the way of contemplation confronted St. John of the Cross: steep and rugged, offering no accessory satisfaction whatever. Since Nietzsche and Dada, art appears from beginning to end as the most inhuman of adventures . . . .

It is no longer the movements that interest us, but the authentic—and how much more rare—Individuals . . . .

In collective experiments, the Individual remains himself only insofar as he takes these experiments over, stretching them to the vast dimensions of his own possibilities. This supposes a total confidence in oneself, and at the same time a faith in something as incommensurable as it is indisputable, something both very precise and inexhaustible, that is measured on a scale as humanly superhuman as the NADA of St. John of the Cross[1]—compared to which this swarm of little movements which, with their attendant theologian-critics, make up History, is a negligible force.

The authentic Individual is not imprisoned by his past, but rather by his becoming. He is not afraid of being confronted with those apparent contradictions thought up by impotent imbeciles—people who never have taken a step because they are afraid of making one of the magisterial Faux-Pas that, for those who work in the aura of high adventure, serve rather as springboards for the leap. The key to

---

* From his *Un Art Autre* (Paris: Giraud, 1952). This English translation by Jerrold Lanes from *Arts Yearbook 3*, ed. Hilton Kramer (New York: Art Digest, 1959), 165–167.

[1] Literally "nothingness," but here meaning a spiritual level so elevated that it is above all physical limitations or even description.

the work of men such as *these* becomes, then, if not the finished painting, at least the ultimate painting: the alchemist wins that name only when he has found his philosopher's stone, and not from the decay of life that had to precede it—which the idiots will certainly pounce on, thinking they have finally found the weak spot they need to blackmail into conformity someone whose very existence is a challenge to the apparent presence and not less apparent necessity of their vast herd. Art and universal suffrage are at opposite poles....

When form, transcended, is heavy with the possibilities of becoming, it will be fully elaborated between the terms of the risk this ambiguity sets up, offering itself as marvelously contained in what will always be, for man, the most intoxicating mystery of all: the Imperishable with nothing but its total becoming, the human condition with all the fantastic marvels it can claim—marvelous trials of strength in which an ecstatic dynamism can reach the heights of a transfinite that wholly resolves the concepts of Beauty, Mysticism, Mystery, Eroticism—even of aesthetics. And art, at that point, can be only a kind of sorcery, of the greatest consequence, inducing us to accept, with full knowledge of what we are doing, the dizzying grandeur of a test of violence beyond considerations of "art criticism."

It was just after the last war that a few Individuals began to appear, suited to face the precipice that Actuality uncompromisingly presents to the few imperious souls who, little by little, irresistibly, are emerging from the greatest confusion possible in art (which is hardly surprising, given that art careerists are rather reluctant to face the implacable risks of an inhuman adventure that allows no latitude and offers no supplementary compensation).... Two staggering exhibitions marked the advent, in 1945, of this other thing in which we have finally begun to find our way about, discovering there is no end of invitations to inexhaustible exploration: I mean the OTAGES of Jean Fautrier and the HAUTES PÂTES of Jean Dubuffet....[1]

The work of an Individual, where one can speak of work—that is to say, when this work, charged with the ineluctable necessity of a message adapted to our time, has been created in the epic climate of inspired power, so that it could not not be—this work is, in the human scale of things, something so extraordinary, endowed with a magic so stupefying, so useless in the dreary framework of the everyday, and at the same time so irreducibly necessary to those who, from day to day, seek to live the parabola of our age, that man, coming into contact with it, must feel—to borrow Nietzsche's image—the fabulous dizziness of the flying fish, which, after the tremendous struggle to change its atmosphere, discovers the outerness of the crests of the waves. The discovery of this outerness, in circumstances of such tension and such utter strangeness, has, after all, very little to do with the

---

[1] The extremely heavy impasto of both painters, and the graffiti of Dubuffet in particular that convey an expressive content.

OTAGES: a series of abstract paintings composed of thickly trowelled masses of paint.

HAUTES PÂTES; thick, pasty layers of paint.

preferences-by-protocol of those who claim to like art, or with their insufferable congresses of cultural juries whose second nature it is to follow the prudent skepticism that has traditionally characterized a "sensible" way of life. Beyond the reactionaries of all shades, a new magic is being shaped, which will stand only if it is of a piece with the most advanced achievements in the other human activities of today. It is in the realm of the logic of contraditions, of the transfinite, of relations of uncertainty, of stupefying topologies, of all the explorations of these hithers and beyonds that, precisely, constitute the Reality whose partial and restrictive appearance was all we knew for so long—it is in this realm that we shall be able to bring back into play rhythm and the other pictorial concepts—as the Individuals mature whose work makes us see that a new world, an other world exists, or perhaps is only made clearer by the passage from one potentiality to another, from a finite to an intuitive infinite and thence to a transfinite, a reality in whose realm man can at last risk everything. For some time now we have been hearing the so-called right-thinking people say that *this* time we have gone so far beyond the limits that at last no one could possibly be fooled . . . , that *until now* one might just, strictly speaking, have agreed . . . , but that now . . . and all the rest. Unfortunately for them, *now* a new era *is* beginning, with sensibilities both free and pure enough to walk into it confidently, and heedless of any way out. There are men who, from this new potentiality, are *molding* what they have to say, with passion and without fuss, beyond all agonizing—*this* is forgotten at last in the exhilaration of crossing over to that other register where remorse and regrets for what perhaps was lost hold no place, compared to the fantastic prospect of a total Adventure into what we know is our becoming.

### Etienne Hajdu, On Bas-Relief, 1953*

The traditional task of the sculptor has always been to re-create from earth, stone, or metal the vehicle of his reality. The reality of today, or more precisely my reality, is to be neither "elsewhere" nor "another person" but to open my eyes to the here and now.

This, then, is why I have abandoned the sculpture-object, which by its form and content is incapable of expressing the manifold aspects of life.

I have turned to bas-relief, which allows one to reunite technically many contrary elements and to assure their interaction.

The undulation of the relief can unite form and background. It also gives a spatial sensation without perspective; light makes its way across the surface little by little.

* Excerpt from his statement in *The New Decade: 22 European Painters and Sculptors,* ed. Andrew C. Ritchie (New York: The Museum of Modern Art, 1955), p. 22, copyright 1953 by The Museum of Modern Art, New York, and reprinted with its permission.

*Hans Uhlmann, Statement, 1953*★

The meaning of constructing and forming—the act of creation—this special way of life—is to me the greatest possible freedom. It also means freedom from private feelings (but not without strong feelings) and this also means to be free from dulling tendencies of a didactic or moralizing nature. This is the condition of a man who creates something and is nevertheless astonished when he makes hoped-for discoveries. Many incidents may have prepared this condition, experiences of all kinds, as well as a process of change and purification difficult to demonstrate—a process to which emotion, both conscious and subconscious, contributes. Important to me are the entirely spontaneous drawings which have to be jotted down, mostly without any thought of translation into sculptural terms. I want to create sculpture in a similarly spontaneous way. In sculpture one has to cope with the resistance of the material and of time; and the sense of order, artistic taste, and sculptural thinking must be alert. Sometimes it is important to prepare the right moment for the "spontaneous" and the life-giving element, even in the course of the work itself. My work in metal (since about 1935) has been done directly in the material. I make "spatial" sculpture, which is more than merely three-dimensional sculpture, in which matter seems to have been overcome in much the same way that a dancer, flying across the stage, appears to deny the laws of gravity, and by his apparently effortless performance makes one forget his years of training. The kind of sculpture I wish to make has led to the use of entirely immaterial forms, including mirrored images and fragments of mirrored images. I am concerned with a sculpture which aims at all the senses and does not give tactile satisfaction only.

*Jean Dubuffet, "Empreintes," 1957*†

It is like a hunt. The equipment is very simple, consisting of three or four tables—two of which hold a piece of glass, or, better still, a sheet of thick *rhodoid*[1]—a liter of India ink, several hundred sheets of the good offset paper used by printers. This is quite a glossy paper, made without much glue, and thus well prepared to receive the print: to print, to impregnate—it is the same rule.

On a third table, a pile of sheets of this paper. Sometimes I use them dry, more often I moisten them. For that a thick brush and a pail of water must be within reach. Everything must be ready in advance, so as to be able to act fast once the work is under way. It is useful, as you will see, to operate very quickly.

★ Excerpt from *The New Decade: 22 European Painters and Sculptors* edited by Andrew Carnduff Ritchie, copyright 1953 by The Museum of Modern Art, New York, and reprinted with its permission.

† From *Les Lettres Nouvelles* (Paris), V, 48, April, 1957, pp. 507–527. The English translation of this excerpt is by Lucy R. Lippard. The French word "*empreintes*" has been used throughout the translation for the products of this process to avoid confusion with the technical term "impression" or the ambiguous "print" or "imprint."

[1] A celluloid, less combustible than is usual.

I spread the ink uniformly on my sheet of *rhoidoid* with a fine, soft brush—Siberian squirrel, I think—four fingers long. I can drop a few little things on the surface, just to see. In the first series of these works, at the end of 1953 (the second was done in Venice at the beginning of 1955, and the third is taking place now, motivating these reminiscences), I first used sweepings from my wife's sewing room, rich in bits of thread and minute debris mixed with dust, then various kitchen ingredients also—such as fine salt, sugar, semolina, or tapioca. Sometimes I put to good use the leafy elements of certain vegetables, which I went to look for early in the morning on the refuse piles at *Les Halles*. Later I also did all kinds of experiments with dead leaves, handfuls of grass blades, and a thousand other things, after which I realized that the simplest and poorest means are the most fertile in surprise elements, and I worked without all this assistance. At the most I sometimes sprinkle my ink with a few grains of dust or sand. I have always (it is a kind of vice) liked to use only the most ordinary materials in my work, those which are never considered at first because they are so common, so close to us, and therefore, so apparently unfit for anything. I like to proclaim that my art is an attempt to bring all disparaged values into the limelight. Also, I am more curious about these elements than about all the others, because they are so prevalent as to be always in sight. The voices of dust, the soul of dust, interest me a great deal more than the flower, the tree, or the horse, for I have a feeling that they are more *extraordinary*. Dust is a being so different from us. Just that absence of defined form . . . one might want to change into a tree, but to change into dust—into such a continuous existence—would be so much more tempting. What an experience! What information!

Excuse the digression. Meanwhile the display has been drying. A little air in the ink, the slightest drying, will make things easier. There is nothing against fanning it. I should have said that I almost always mix a little water with the ink, which I don't want too thick. Now the time has come to lay down one sheet, press it lightly with the flats of both hands, withdraw it quickly, put it on the floor.

The image is sumptuous, overwhelming. Completely unforeseen. A multitude of forms has inscribed itself in an instant, a vast secret message appears in the black sauce, to be deciphered later. Time presses. Now the drying will accelerate. Quick, another sheet, pressed again with the hands, perhaps more insistently this time, a second message, very different from the other, falls near it on the floor. To the pile of paper, with the greatest haste! A third, which scarcely resembles the others. Quick, another one! Not dry, but moistened this time—thus more sensitive—and here is a grey image, delicately adorned; then another, also wet, pressed hard with both hands, this time a subtle and tender image, ready to flee, but this is not the time to stop and look at them, it is more urgent to proceed.

Again the ink-filled brush sweeps the *rhodoid* panel, drowning the fine debris which had been sprinkled on the display the last time. First one sheet, to take away the excess ink and stir up the black cover; it would be better to wait longer, but we are impatient, another immediately, and quick, another; some wet, some dry, the images strewn on the floor, some with violent contrasts, bearers of

capricious white forms enveloped in halos (the half tones are somehow imposed with inexplicable success), these very authoritatively drawn forms evoke fast-moving beings, or meteors, with a most fantastic effect; others, on the contrary, exempt from anything which might evoke beings, depopulated, but creating richly adorned surfaces like the depths of the sea or great sandy deserts, skins, soils, milky ways, flashes, cloudy tumults, explosive forms, oscillations, fantasies, dormitions or murmurs, strange dances, expansions of unknown places. There is great excitement. The littered studio no longer offers footroom.

Stupefyingly truthful, these widely varied phenomena which appear on my paper, despite the fact that it is always in the same position, on the same shapeless bed of ink. Games of chance? No. What the paper attracts exists, only it has never been seen before. Wet or not, especially wet, the paper captures in an instant a whole teeming world of facts and accidents which really exists, although the human eye is incapable of seeing it. Why? Because it is too changeable, its states are too brief. It concerns a fluid, a liquid layer, spread out very thin, whose work is incessant; a whole life is being constructed there around the tiny particles of dust which had been sprinkled in the ink; evaporation acts in thirds; the resulting aspects change a hundred times a second; and what are these aspects? The same ones which, in faster or slower tempo, are assumed by the entire natural world, everywhere, the world of mountains and shores, rocks or skins, of the depths of the sea or sandy deserts; the same causes, the same effects. There too the fluids have surrounded the obstacles which torment them, desiccations have acted, imprints have been formed which resemble ours. What then are my methods—my ink, liquid vehicle of a fine pigment, my scattered dust, the pressure of my hands on the paper—but methods borrowed from nature, those she repeats everywhere, always the same? For there is a key to natural mechanisms, just as what happens in a grain of sand or a drop of water exactly reproduces that which happens in a mountain, or an ocean—aside from scale, aside from the rate of speed which vary. As a painter, I am an explorer of the natural world and a fervent seeker of this key. Eager, like all painters, I think, perhaps like all men, to dance the same dance that all of nature dances, and knowing no richer spectacle than to take part in that dance. I declare that every phase of the natural world (and the intellectual world is of course included), every part of every fact—mountains or faces, movements of water or forms of beings—are links in the same chain, and all proceed from the same key, and for this reason I declare that the forms of screaming birds which appear on my ink-spotted page have the same source as real birds, have at least some common origins, *are* in some ways real birds, just as the gestures I reveal in those same spotted pages, the glance which shines from one place, the laughing face which appears in another, are the result of mechanisms which produce these same gestures, glances, laughs, elsewhere, and are *almost* real gestures, real glances, are in any case their cousins, or, if homologues are preferred—abortions, unsuccessful aspirations. This being I perceive, which looks like a disconcerted man, holding a rearing horse which stands somewhat whimsically on one leg, and whose nose is deformed into

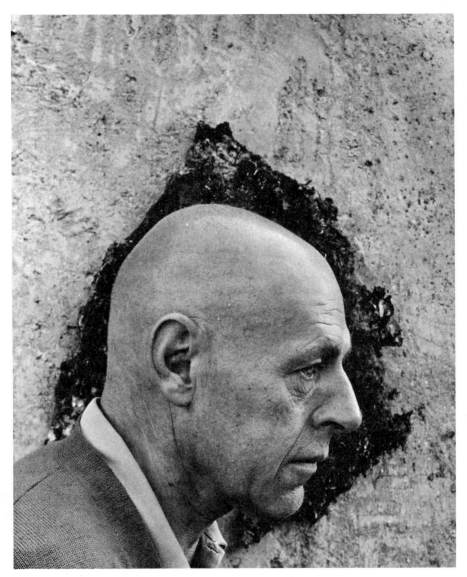

*Jean Dubuffet, 1956.*
*Photograph copyright by Arnold Newman,*
*New York.*

something shapeless and absurd, I declare that the mechanisms which determined its formation included some elements which, differently combined, have in other times, on other levels, produced the figure of a man or horse, or disconcerted the man, or made the horse rear. How can one believe in chance? There is a cause for everything . . . .

Let us re-ink. This time with the newspaper crumpled into a ball and then unfolded again on the plate. Oh! Like elephant skin! What a surprise! Quick, begin again! Another skin! More and more indisputable! A quivering skin! It changes from one proof to another! Foetus's skin, frog's skin, woman's skin, old man's skin, all the skins getting off the train. What luck, what a good group! Now here are skins of slugs, skins of tortoises! Then how they crackle, as though they wanted to revolt. Skin of trees! I apply them crosswise. Now they are skins of dry clay, then delicately veined leaves, then enigmatic textures, skins of what? Stellar materials? Skins beyond life, formations unknown to us? False skins, attempted skins, projects for delirious skins? Where do such creatures live, where are such tales written? Yet I recognize them as facts which I have already seen, or felt, or failed to see. Are these aspects of things which are everywhere and we do not know how to see, which we only suspect, and in such a way that with their revelation by means of a medium more sensitive than our own organs, an anxious hunger to see the things which surround us with our own eyes is satisfied? We who are as eager to impregnate ourselves with them as the sheet of damp, drinking, paper, when it is pressed? Does it serve us as a missing organ? As a beacon miraculously lighting our night for an instant? Or have I, with my apparently simple spread of ink and damp paper, loosed a mechanism of production which bewitches its actions, have I touched off some force which would drive it mad, confuse its course, and give birth to hybrid monsters, encroaching upon kingdoms? The spectacle exceeds all expectation. Later all these mysterious messages must be pinned up on the walls and studied at leisure. For the time being, with no intermission, I must continue to draw this precious black milk as long as it lasts. How eager my sheet is to receive its *empreinte*! It is in a feverish haste, which overcomes me too. As soon as the sheet is applied to the inked plate, which moreover, seems worn out, bloodless, after so many proofs, the image appears immediately, as if summoned under threat. I feel like the blank page myself, and am equally thirsty for impregnation. It is my entire being upon which this one has just been placed. Yes, seeing is like being impregnated. I re-ink . . . .

Now strange aspects of forests emerge, teeming carpets of undergrowth, sprinklings of grassblades and needles, inextricable tangles and swarms of roots. Next the intersecting fluids appear, the darts of effluvia. Do they belong to the natural world? Are acts of this kind happening in the natural world, of which we are all ignorant, and which my apparatus has surprised in action, like a screen, intercepting them head on? Are our surroundings the permanent theater of unsuspected tumults of which we perceive nothing by either sight or hearing—which we can only guess at? Or are we now transported by these ambiguous images

to a bizarre point of reception where the corporal universe and the world of intellectual facts are inscribed at the same time; or which would even take by subterfuge the states of things and their *movements* at the same time, and on which the objects and their deeds, places mingled with times, strike violently—like hail whipping at a windowpane—still intimately mingled, like milk before the creamer has been able to separate the cream from the whey?

I said that it was like a hunt. In fact, when I set my little machine in motion to turn out places and beings I do not know how the session will come out this time, over what unknown terrain it will undertake to sweep me, what encounters will occur and what kind of game will be spread out on my floor at the end of the day. Exciting, then, like a hunt. There too one traps, tracks, while the prey takes unexpected turns. Think, reader, of the vain, illusive side of the searches and disturbances that go on from one end of the world to the other. All that the world in its most distant places can supply, all that life in its rarest conjectures can produce, you can obtain without budging, at your own discretion, at your own doorstep, by the assiduous exertion of any occupation. Our universe is continuous, at a uniform tempo, it is like a homogenous sea; you can plunge your spoon into it the first place you come to. Would you rather, reader, friend, that I traveled, that I took you to absurd countries, led you before mosques, pagodas, Persian markets, tropical rivers, coral reefs? Kindly think seriously about the inanity of dimension. It is a mad prejudice, a vulgar trap, which makes you marvel at your snowcapped peaks, high cliffs, your gardens of rare species, or your elegant islands. Burn scale! Look at what lies at your feet! A crack in the ground, sparkling gravel, a tuft of grass, some crushed debris, offer equally worthy subjects for your applause and admiration. Better! For what is more important is not reaching objects of reputed beauty after long days of travel, but learning that, without having to move an inch, no matter where you are, all that first seemed most sterile and mute is swarming with facts which can entrance you even more. The world does not extend over one single plane, all on the surface. The world is made in layers, it is a layer cake. Probe its depths, without going any further than where you stand, you will see! I am speaking figuratively, you understand.

What did the greatest lovers in history do most? Went to bed, always to bed! What do you do, banker? Always banking! Is that more varied? What do you do, monk? Legs crossed and always at your rosary! The world and the facts of the world are deferred to your rosary. No need to even cite them. The functions are reversed. The world, like a tidal wave, rushes over those who do not seek it out . . . .

Did I say that not long ago (last year), moved by curiosity to interrogate every object I met by means of my processes, I ran all around the house with my bowls of ink and reams of paper, taking impressions of everything that presented itself, ground, walls, stones. For this I employed a pressure vaporizer, used to spray trees, which I loaded with ink. I brought back from my walks in the country all kinds of things to put on my plates—mainly botanical elements. Once I even had a

great heavy stable door, old, in the bad pine of the country, beaten by sun and rain, brought back to print from. Then I abandoned these enterprises which were too demanding and caused many an annoyance—the wind carrying off my pages, and dogs relieving themselves on them. Above all, I decided that without leaving my printing room, with no other aid than my inked plate, I could obtain rocks, plants, soils, walls, in my *empreintes*, more easily than by applying the paper to the objects themselves. Strange! If you think of rocks, it is rocks which immediately appear in your rubbings. Do the subtle ways of your desire guide your hands without your knowledge, or, little by little, superexcited by the particular nature of the task, and too involved in *seeing* through ambiguous supports, do you see a rock in the image today where yesterday you would have seen the sky or a sandy beach? Or then again, is it not more of a revelation, made for us by our machine for recreating the elements, which informs us that these are very similar to each other, made up of the same materials, regulated by the same rhythms, ready—if not eager—to commune with each other? Don't physicists teach that all the matter in the world is almost identical in its composition? Here, I believe, is the key to our affair—which lights the emotion to which we are conveyed by making *empreintes* . . . .

But here comes Dereux, the expert botanist from Lyon, with a precious gift in his bag—an ample collection of plants, usefully displayed, lightly attached to sheets of paper, then dried and pressed—the product of months of painstaking work to which he has devoted himself so that I could use this herbarium in my *empreinte* exercises.

Now these vegetal forms are accordingly dropped on my carpet of ink. I had asked my friend not to gather anything but the most common plants, for unlike most people, I distrust rare things, and, in fact, am always excited by banality. The seekers of the Philosopher's Stone undoubtedly had the same predilection for the most prevalent objects, when, by preference, they concentrated their research upon very common elements, such as blood or urine. I can not get over the feeling that the things closest to us, most constantly in sight, have also always been the least noticed, that they remain the least known, and, that if one is searching for the keys to things, one has the best chance of finding them in those things which are most copiously repeated. Where was the necklace hidden to protect it from thieves? In plain sight, right in the middle of the main thoroughfare. Thus Dereux's collection contained above all, crude tufts of grasses and unimportant, very ordinary plants. One could object that if the *empreintes* I take are so uncertain and disguise the form so much that no one can recognize them, I might just as well use other plants, less dear to me. But take care, this is a venture in which a certain spiritual position in the operator is more necessary than anything else; this is an operation whose success is dependent above all upon a certain *forcing* of the thoughts, a certain over-excitement which augments conduction, facilitates the transformation of one order of ideas into another, makes all parts of the mind permeable, so that currents can pass without restriction. Therefore, please allow me my grasses and tufts of weeds, allow me my common plants which, by their very commonness,

exercise a stimulating effect on my spirit. Heat, a high spiritual temperature, is needed in my business.

At first, in thoughtless haste, my little plants write their story much too docilely on the pages offered them. I obtain images which hardly reveal more than the eye can easily see without my whole system as interpreter, and this is not what I am looking for. Did I say too docilely? Did I say their story? That was very badly put. It is not at all with their story, definitely not anything of their real story, that my plants replied to my evidently too-formulated invitation, but with a delivery which I was very wrong to call docile, when it was only fallacious and derisive. They saw me coming. Plants or people, or everything existing, each has a mask all ready with which to reply to tiresome inquiries, and it is only by this mask that we usually know them. The truth is that no one wants to be looked at; nothing in the world wants to be looked at; each one, the instant he senses a stare, and before having been touched by it, pulls the painted curtain. The indiscreet always get caught! Return with their painted curtains thinking that they have something—having seen nothing, suspected nothing of the real creatures behind them. You must have *savoir faire* to unveil the creature and have it dance in your presence, forgetting that it is watched. For everyone dances and does nothing but dance; living and dancing are one and the same thing; indeed each thing is finally no more than a specific dance; the dance is the thing. Dancing is the subtle word for living, and it is only by dancing too that one can discover anything. One must approach dancing. He who has not understood that will never know anything about anything. All the faults dance badly–dance stiffly, too laboriously, *watch themselves* dance, do not forget that they are dancing. He who dances will not endure a stare, especially his own. Socrates, the point is not to know, but to forget, oneself . . . .

The most varied things are taken in my net, and here I must explain. For example, I will capture here a cavalry, there some theatrically animated cortege of clouds . . . . But very often—and it is then that the game takes on its full significance—the facts are more ambiguous, susceptible to belonging to any one of these different registers, explicitly demonstrating, in a very troubling manner, what these registers have in common, how accidental their specificity, how fragile and ready to change. Such an image seems equally eager to transcribe a ravine or a complex, tormenting sky, or a storm, or the reverie of someone contemplating it, as if suspended between one and the other. Worse than that, between a thing with a strongly marked physical character, such as, if you wish, a shadowy embankment, and another which would be much less so, such as the movement of a gust of wind, indeed still less so, the course of a dream, of an emotion. It is these troubling suspensions which constitute the essential force of my exercise, these hesitations between ideas supposedly foreign to each other, whose close relationship, thus suddenly revealed (and so formally consigned to a concrete image), would not otherwise have even seemed possible. It concerns, let us say, a philosophical, or poetic, manipulation (the same thing: philosophy has never been anything but

clumsy poetry), which consists of bringing together the most distant facts, provoking each one to slide back and forth from one plane to another, one realm to another, to render everything capable at any moment of becoming any one of the others. My apparatus functions as a machine for abolishing the names of things, for felling the partitions raised by the mind between diverse objects, between diverse systems of objects, between different registers of facts or of things, and the different levels of thought; a machine for burning every order in the wall of phenomena established by the mind, and for erasing in one blow every road traced there; a machine for checking all reason and replacing everything in ambiguity and confusion. My bit of grass drowned in ink becomes a tree, becomes a play of light on the ground, becomes a fantastic cloud in the sky, becomes a whirlpool, becomes breath, becomes cry, becomes glance. Everything combines and interferes. Such are the marvels of my game, which so excited me.

Among the well-founded ideas of this game the most seriously open to question is what we currently mean by a *being*, and what differentiates it from a *fact*. That a bird, a tree, a tuft of grass, strictly speaking a cloud—all objects with a little continuance, and a more or less changing character—are beings, no one, I believe, will deny. That fractional elements—a blade from the tuft of grass, a leaf from the tree—can be considered beings, nothing to say to that. A pebble, a mountain, a grain of sand, pass too. No one contests the breath of life is found in minerals as well as plants or animals, and whoever hesitates at that has only to think of the polyhedric crystal, which aspires with all its will to form, and finally does form, the rock. At this point, we are quite easily led to expand our idea of what is embraced by the term *being*—although not without a slight hesitation—to certain elements, no longer isolated and with well-defined contours, like the leaf of a tree or the crystal, but *continuous* and having neither form nor limited quality, such as coal, metal, water. But what of the momentary and moving, of the wave which forms for an instant in the great open sea; is it a being? If a will—no matter how obscure, how vacillating—appears in any part of the inert mass, even for a very short time, does this not suffice to make a *being?* Is the shadow of a walker a being like the walker himself? And the step of the walker, his walk, are they beings? Where does one begin, where does one end, in the use of the term being?

If we accept this train of thought, it will soon appear—and then the images born of our *empreintes* will gain more significance—that the wave in the ocean, the whirlpool in the river, beings of rapid evolution, rapid transformation and disappearance—certainly more rapid than those of the tuft of grass or the human being, must be the object of attention not only at the moment when their development assumes the most amplitude (this is the instant at which their own will most grievously collides with adverse forces, since all beings are the product of opposing aspirations), but again and above all, at their birth, even before they take on any discernable form, when they are no more than a point where volition is beginning to concentrate. It is at this dawn of their career that they move me the most, even if it happens that their growth is immediately impeded, and they vanish before

having been able to be visibly born. That the land, the sky, every existing element, is swarming with these cores of volition, appearing incessantly in innumerable multitudes at all points, only to be immediately extinguished and lit again later, just as flashes of light can be seen crackling without end in rippling water where the sun is reflected; that the being—more or less whimsical or spectral—populates materials we believe to be inert, in immense numbers; that supposedly deserted places are as rich in events as the heart of a great city, is incessantly repeated during our exercise.

Oh! But what a detour from the technical relationships to the spectral routes of metaphysics! Perhaps it would have been more valuable not to have expressed these ideas—at least not here—but how? Is it not the blood of metaphysics which irrigates this whole work in ink, down to its least important technical processes, and besides, imagine an artistic undertaking—or what is expected of art these days—which would not raise the metaphysical views of the operator from their very foundations? What would a work of art be worth, in which each of the smallest parts—the least stroke—did not describe, in one sweep, its author's entire philosophy? Painting, such a rich language, with so many more nuances than that of words, a concentrated language which allows everything to be expressed so quickly, a language crammed with the making of so many different ideas which can be said at once (even when they are opposed to each other), is surely the mode of expression most suitable to the transcription of philosophy without impoverishing or falsifying it too much, provided that one has a slight knowledge of how to approach it, and that is why I am wrong—I will now stop—to penetrate its lands shod in such improper boots as my verbose discourses. Let us return to our printing . . . .

I confess that actually the very special aspect of *empreintes*—of the images coming to inscribe themselves on my pages—I mean the impressive aspect of direct printing on the spot, acts very strongly on me. It is the aspect of an image produced by the elements themselves, inscribing themselves directly, without the intervention of any other medium; that of a primordially immediate, pure image, with no alteration in transcription, no beginning of interpretation, impeccably raw, invested with all the fascination of the portraits children make of themselves in the snow, of marks left on the sand by the bare feet of unknown men, or wild animals, and in a general fashion, all that which belongs to the order of *traces*, a prime example of which are fossils. I will permit myself to add, parenthetically, that I am perhaps more sensitive than just anyone to phenomena from which the intervention of the human hand has been totally eliminated, because of a certain temperamental disposition peculiar to me, which leads me to attribute, contrary to popular opinion, less intelligence, less knowledge, less power, to the human being than to other beings of the natural world, and indeed to those which are rather more often considered out of the question in this sphere, such as plants or stones. I can not rid myself of the constant impression that consciousness—that endowment of which man is so proud—dilutes, adulterates, impoverishes, as soon as it

615

intervenes; and I feel most confident when it does not seem to be present. I am, in all spheres, smitten with savagery.

This fascination with untouched traces will certainly be compromised if I undertake, as I am often tempted to do, to embellish the image no matter how slightly, by intervening with a brush, or especially by relating pieces borrowed from other *empreintes*, which I did so copiously not long ago, and which it is time to mention. Also I increasingly prefer to leave these first *empreintes* in their virgin state, abstaining from any retouching, no matter how vague and summary they are. I even believe that the more vague and summary they are the more they lend themselves to my reverie.

### Eduardo Paolozzi, *The Metamorphosis of Ordinary Things*, 1959*

I suppose I am interested, above all, in investigating the golden ability of the artist to achieve a metamorphosis of quite ordinary things into something wonderful and extraordinary that is neither nonsensical nor morally edifying . . . .

I seek to stress all that is wonderful or ambiguous in the most ordinary objects, in fact often objects that nobody stops to look at or to admire. Besides, I try to subject these objects, which are the basic materials of my sculptures, to more than one metamorphosis. Generally I am conscious, as I work, of seeking to achieve two or at most three such changes in my materials, but sometimes I then discover that I have unconsciously achieved a fourth or even a fifth metamorphosis too. That is why I believe that an artist who works with *objets trouvés* must avoid being dominated by his materials. Wonderful as these may be, they are not endowed with a mind and cannot, as the artist often does, change their mind as they are being transformed. On the contrary, the artist must dominate his materials completely, so as to transform or transmute them fully. You have probably seen, in New York and in Paris, a lot of work by younger sculptors who, like Stankiewicz, César, and me, work mainly with *objets trouvés*. Well, I often feel that if one of us chances to find a particularly nice and spooky-looking piece of junk like an old discarded boiler, he can scarcely avoid using it as the trunk or body of a figure, if only because its shape suggests a body to anyone who sets out to do this kind of assembly work. Then one only needs to weld something smaller onto the top to suggest a head, and four limblike bits and pieces onto the sides and the bottom to suggest arms and legs, and there you have the whole figure, which has come to life like a traditional golem or robot . . . .

I find such an art in a way too simple and already obsolete. It can too easily involve a sculptor in a kind of Walt Disney fantasy that simply makes materials salvaged from the junk yard live as in an animated cartoon, or as if cast for parts in a kind of dramatic *tableau vivant* rather than endowed with motion and life. Of course, these materials undergo a metamorphosis of sorts, but the life that they are

* Excerpts from Edouard Roditi, "Interview with Eduardo Paolozzi," *Arts* (New York), May 1959, p. 44. Also published in Roditi, *Dialogues on Art* (London: Secker & Warburg; New York: Horizon, 1960).

made to assume is too often one that has been suggested to the artist by a kind of obvious analogy which would strike a non-artist too. I really set out in my sculpture to transform the *objets trouvés* that I use to such an extent that they are no longer immediately recognizable, having become thoroughly assimilated to my own particular dream world rather than to an ambiguous world of common optical illusion.

*Eduardo Paolozzi, Interview, 1965*\*

Richard Hamilton: At some point you changed from an interest in things that had an archaic quality, in things that looked as though they had been dug up out of the ground, to things which looked fresh, new—like twentieth-century technology. E. P. The "archaic" earlier bronzes you probably have in mind were done by pressing objects into a clay bed and using these actual embossed sheets to make into figures or heads. I was trying to use a process which was sort of mechanical— which is, that one wasn't actually using a handmade look. The archaeological look you refer to was rather accidental. There was a deliberate attempt to make these images with actual real things. I've been trying to get away from the idea, in

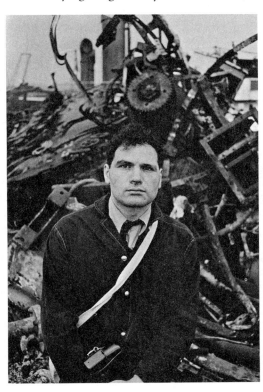

*Eduardo Paolozzi.*
*Photograph by Ulrich Mack, Munich.*

\* Excerpts from Richard Hamilton, "Interview with Eduardo Paolozzi," *Contemporary Sculpture*, Arts Yearbook 8 (New York: Art Digest, 1965), pp. 160–163.

sculpture, of trying to make a Thing—in a way, going beyond the Thing, and trying to make some kind of presence. But usually when one is up to one's neck in one way of working, one is thinking of another possibility. I was led to the new possibility, which is using engineers' materials and engineering techniques, through the other method.

R. H.: I imagine that you don't spend as much time in the Natural History Museum looking at fossils and old bones as you now spend in the science museums.

E. P.: When I went from the Slade [School, in London] directly to Paris, there was all the Surrealist investigation I engaged myself in, and there seems to have been in Surrealism there an engagement with natural history—Max Ernst's *Histoire Naturelle*, for example. But while I was actually at the Slade I used to dismiss the life room and go to the Science Museum and draw some of the machines there. I did this more or less instinctively—there didn't seem to be any reference to it; one was unacquainted really with the modern art reference to the machine. Then there seemed to be something like a lack of knowledge, and certainly the kind of people that one was at school with didn't quite realize why one went to draw machines. It was a sort of instinctive idea. But I still have an interest in natural history. It has its own ortho-natural laws. To try and make what might be called an abstract sculpture with forms which referred to shells and things like that, I still think that one could make a significant sculpture using orthodox techniques which refer to natural history. One could easily have the right ideas but the wrong approach and vice versa.

R. H.: How much do you think you owe to the technique of collage? It strikes me that all of your work comes out of the techniques of collage, the idea of collage, that you put things together . . . .

E. P.: Yes, that's true. But the ship, the airplane, the motor car are all made from components, component parts really. They all have to be constructed, and one uses this same means. But there is also the other idea in collage, like using colored paper, etc.; it is a very direct way of working—cutting out sheets of colored paper, for example. One is able to manipulate, to move, and use certain laws which are in a way blocked off if you try to do a pencil drawing, say, and then fill in the colored areas. It's the same too if you use a direct analogy. If you want to make a metal box in sculpture, there is a traditional way. You can supply a plaster block to the foundry, and going through the lost-wax techniques you will eventually get it back in bronze. But there is another approach, in sheer engineering terms: you cut an aluminum sheet into six parts and weld them together, and you have the metal box. Rather like using a Land camera to take an instantaneous photograph. The emphasis really is on the idea of directness, the way I see collage.

R. H.: In a way you are as much involved in painting as with sculpture. You are concerned with color, drawing techniques, drawing not as sculptors' drawings but also drawings for their own sake. How do you feel about this "universal man" aspect of the artist?

E. P.: Well, I think one might perhaps be able to reach an ultimate, which is the

drawing even closer of painting and sculpture by actually painting the sculpture itself. There is another possibility, with a silk screen, which is something I am involved with and have been for a long time. After the screen is made up, certain geometrical ingredients, such as variations on the square or the curve, the stripe the circle, could be applied by the transfer process to the geometric solids of the sculpture, so that you have geometry on two levels. This I think would be an ultimate of a kind. I think that modern sculpture of the best kind has been in and out of the idea of the painted sculpture, approaching the point where you can't distinguish between painting and sculpture, where they cross over in an original way. This would be a goal for me.

R. H.: Your present source material is very much in the world of science. Your favorite magazine is probably the *Scientific American*. You are concerned with mathematical ideas at the purely visual level—your education doesn't permit you even to know very much about the mathematical structures of these ideas—your concern is simply with liking the way one set of ideas is translated into a model or one set of ideas is translated into a graph. It's the visual side of all this material that interests you, I suppose, more than anything else. Or do you want to go more deeply into the thing?

E. P.: It is debatable whether one can have a totally emotional attitude toward science in the same way one can have a totally emotional attitude toward nature in general. Tied in with the visual interest is the desire to try and find some kind of clues outside of the orthodox art channels, including outside modern art, outside contemporary zones, some kind of means of constructing something without necessarily resorting to programmatic art—to try and use geometry toward an original art, a personal angle.

R. H.: Besides the change in your materials and in your general technical attitudes, there has been a change in subject matter. The earlier sculptures, and a lot of your earlier drawings, took humanity as subject matter. They were men or some indefinable but manlike organism. The recent things have tended toward mechanical subject matter. There is an airplane, or buildings and that kind of thing, a table, the engineer's table—was this a decision that you made or something that happened?

E. P.: There is also a difference of environment, in the sense that even previous to what I call the waxwork period each piece was more or less a studio-bound object. The entire fabrication was done in the studio. The new work is done in a proper engineer's place, principally in the welding workshop. Part of the situation now is that one is trying to go for personality—which in a paradoxical sense may become anonymity. Anonymity in a sense considering all other works done under similar conditions. One has a reversal which is interesting—by risking anonymity, one may find a personality. I am using anonymity in the sense that the actual raw materials, when they arrive and lie around on the floor of the workshop, are things that nobody would give a second glance. I don't think people would actually identify them directly with art. Even in the old days a wax sheet always seemed to look like art—I mean the actual minute details looked like art. But now one is

using flat strip angle channel, and part of the battle now is to try and resolve these anonymous materials into—one doesn't necessarily want to make something which is totally deadpan—but to try and resolve them into a poetic idea really, such as the mechanic's bench. The mechanic's bench or the airplane—I really try to identify these materials with a thing seen.

*Francis Bacon, Statements, 1952–1955*<sup>★</sup>

## 1952

[Art is a] method of opening up areas of feeling rather than merely an illustration of an object.

The object is necessary to provide the problem and the discipline in the search for the problem's solution.

A picture should be a re-creation of an event rather than an illustration of an object; but there is no tension in the picture unless there is the struggle with the object.

Real imagination is technical imagination. It is in the ways you think up to bring an event to life again. It is in the search for the technique to trap the object at a given moment. Then the technique and the object become inseparable. The object is the technique and the technique is the object. Art lies in the continual struggle to come near to the sensory side of objects.

## 1953

He [Matthew Smith] seems to me to be one of the very few English painters since Constable and Turner to be concerned with painting—that is, with attempting to make idea and technique inseparable. Painting in this sense tends towards a complete interlocking of image and paint, so that the image is the paint and vice versa. Here the brushstroke creates the form and does not merely fill it in. Consequently, every movement of the brush on the canvas alters the shape and implications of the image. That is why real painting is a mysterious and continuous struggle with chance—mysterious because the very substance of the paint, when used in this way, can make such a direct assault upon the nervous system; continuous because the medium is so fluid and subtle that every change that is made loses what is already there in the hope of making a fresh gain. I think that painting today is pure intuition and luck and taking advantage of what happens when you splash the stuff down.

★ 1952 statement from an interview published in *Time* (New York) 1952; 1953, from a tribute to the painter Matthew Smith, published in retrospective exhibition catalogue (London: Tate Gallery, 1953); 1955, from *The New Decade: 22 European Painters and Sculptors* edited by Andrew Carnduff Ritchie, copyright 1955 by The Museum of Modern Art, New York, and reprinted with its permission.

1955

I would like my pictures to look as if a human being had passed between them, like a snail, leaving a trail of the human presence and memory trace of past events, as the snail leaves its slime. I think the whole process of this sort of elliptical form is dependent on the execution of detail and how shapes are remade or put slightly out of focus to bring in their memory traces.

*Francis Bacon, Interview, 1963*★

Bacon: One thing which has never been really worked out is how photography has completely altered figurative painting. I think Velasquez believed that he was *recording* the court at that time and certain people at that time. But a really good artist today would be forced to make a game of the same situation. He knows that particular thing could be recorded on film; so this side of his activity has been taken over by something else.

    Also, man now realizes that he is an accident, that he is a completely futile being, that he has to play out the game without reason. I think that even when Velasquez was painting, even when Rembrandt was painting, they were still, whatever their attitude to life, slightly conditioned by certain types of religious possibilities, which man now, you could say, has had cancelled out for him. Man now can only attempt to beguile himself, for a time, by prolonging his life—by buying a kind of immortality through the doctors. You see, painting has become, all art has become, a game by which man distracts himself. And you may say it has always been like that, but now it's entirely a game. What is fascinating is that's going to become much more difficult for the artist, because he must really deepen the game to be any good at all, so that he can make life a bit more exciting . . . .
David Sylvester: You often find, don't you, that existing images start something off for you? There are these few things—the Velasquez *Innocent X*, the famous still from Eisenstein's *Potemkin*, one or two things like that. Does most of your imagery begin from existing images?
Bacon: Very often. They breed other images for me.
Sylvester: The transformations of these existing images which happen by the time the paintings are completed—do you foresee them, before you begin a painting, or do they tend to occur while you're painting?
Bacon: You know in my case all painting—and the older I get, the more it becomes so—is an accident. I foresee it and yet I hardly ever carry it out as I foresee it. It transforms itself by the actual paint. I don't in fact know very often what the paint will do, and it does many things which are very much better than I could make it do. Perhaps one could say it's not an accident, because it becomes a selective process what part of the accident one chooses to preserve . . . .

    ★ Excerpts from an interview with David Sylvester, *Sunday Times Magazine* (London), 14 July 1963, pp. 13–18.

The way I work, now, is accidental, and becomes more and more acciden-tal. How can I re-create an accident? [Another accident] would never be quite the same. This is the thing that can only probably happen in oil paint, because it is so subtle that one tone, one piece of paint, that moves one thing into another com-pletely changes the implications of the image.

Sylvester: If you were to go on, you wouldn't get back what you'd lost, but you might get something else. Now why do you tend to destroy rather than to work on? Why do you prefer to begin on another canvas than to work on?

Bacon: Because sometimes then it disappears completely and the canvas becomes clogged, there's too much paint on it; just a technical thing and one can't go on.

Sylvester: Is it because of the particular texture of your paint?

Bacon: I work between thick and thin paint. Parts of it are very thin, and parts of it are very thick. And it just becomes clogged, and then you start to put on illus-trational paint.

Sylvester: What do you mean by that?

Bacon: Can you analyze the difference, in fact, between paint which conveys directly, and paint which conveys through illustration? It's a very close and difficult thing to know why some paint comes across directly on to the nervous system and other paint tells you the story in a long diatribe through the brain.

Sylvester: Most of your paintings have been of single figures or single heads. But in the *Crucifixion* triptych you did a complicated composition of several figures. Would you like to do that more often?

Bacon: I find it so difficult to do one; that generally seems enough. And, of course, I've got an obsession with doing the one perfect image.

Sylvester: Which would have to be a single figure?

Bacon: In the complicated stage in which painting is now, the moment there are several figures on the same canvas the story begins to be elaborated. And the mo-ment the story is elaborated, the boredom sets in. The story talks louder than the paint. This is because we are in very primitive times once again, and we haven't been able to cancel out this story-telling between one image and another.

Sylvester: Why do you like to glaze your paintings [put them behind glass]?

Bacon: There are two reasons. By glass you cut them away from their surrounding. And another thing is, I work on the reverse side of the canvas and a great deal of the canvas is only stained and it's impossible to give it a texture with varnish or anything, which might bring up the life of it. By glazing them, I feel that it gives an added depth and texture to the quality of the paint that I use. I couldn't do the particular kind of thing I'm trying to do, which is to make a chaos in an isolated area, with other types of paint. I need this absolutely thin stained background, against which I can do this image that I'm trying to do and have never really achieved.

Sylvester: Is it because you want to get a chaos in an isolated area that you often use this rectangular frame around the figures?

Bacon: I use a rectangular frame to see the image . . . . I cut down the scale of the canvas by drawing in these rectangles which concentrate the image down.

*Davide Boriani, Statement, 1966*★

There is a need to overcome the limitations imposed by the traditional requirements of painting and sculpture. This need exists for those artistic trends (not only contemporary) which conceive of reality as a process of becoming and not as an absolute and unchanging system.

A programmed kinetic work is not simply a sculpture set into motion. Motion is a means of obtaining the multiplicity through which the image is transformed, and that multiplicity consists in a variation of the relationships which define the structure in both time and space.

A programmed kinetic work is not then a fixed structure upon which movement is superimposed, but a structualization of changing temporal and spatial conditions which makes use of visual information, irreversible and of unlimited duration.

The traditional work tends to be unchangeable, varying only through the free exploration of the observer. The programmed kinetic work, on the other hand, establishes a relationship between two dynamic poles: between the inherent development and variation of the work, and the consciously and unconsciously perceived processes of the spectator.

Consequently, the artist's problem is not the traditional one of composition in space, but the organization of a sequence in time-space, that is to say, of the programming of the visual message.

The theory of information, the Gestalt theory, experimental psychology, semiology, experimental aesthetics, as well as cybernetics, mathematics, the combination of geometry, technology and industrial techniques, all now constitute a vast repertory of working possibilities and demonstrative rules.

From this rational basis will come the aesthetic potentialities of the work.

*Phillip King, Statement on his Sculpture, 1966*†

Around the end of the fifties, the international style of "wounded art" made me sick. But then around 1958 came the big invasion of American painting. We began to see Pollock, Still, De Kooning. The American work seemed so free and vital. But I think it was the seriousness of American painting that was the real influence—the *attitude* . . . .

I'm . . . interested in abstract problems—with fighting the tradition of the monolith in sculpture. Sculpture probably started with the idea of defying gravity—like heaving a great big rock up on end and deciding it looked like a man. The idea of the man-monolith didn't change until Brancusi. My problem is how to make sculpture open, without definite centers, whose surfaces don't necessarily describe a possible core. I want to create an experience by positioning, not shaping. The industrial materials? They're non-associative, without memory or history. So they illuminate more clearly aesthetic and sculptural concerns.

★ From Peter Selz, *Directions in Kinetic Sculpture*, University of California Art Museum exhibition catalogue (Berkeley, 1966), p. 21.

† Excerpt from an interview with Grace Glueck, the *New York Times*, 10 April 1966.

# APPENDIX

*Thomas Munro,   The Criticism of Criticism*
*An outline for analysis applicable to criticism of any art*[*]

NOTE: This questionnaire is intended as a checklist of considerations which are often relevant in the analysis and appraisal of a piece of critical writing. It is adapted for use in the preparation of books and courses on aesthetics, the history and theory of criticism, and related fields. While the questions are given in a systematic order, it is not implied that this is necessarily the best order for use in any given case. The nature of the critical work being studied, or of the problem in hand, may suggest a different order as preferable. Nor is it implied that all the questions should be asked in every case, or answered with equal fullness. In each case, certain ones will appear as especially important, while others may be answered briefly or omitted. It is not implied that answers to all these questions will provide the basis for a complete understanding or final evaluation of the critical work. Such a final judgment may never be possible. Many other questions, not here included, may be more important in particular cases. But a careful application of those listed may assist the student in working out a balanced, comprehensive, preliminary study.

    I. The *piece of criticism* to be analyzed: title or other identification of the text. (E.g., a complete essay or excerpt from longer work; journalistic criticism, general theory, history, biography, advertising, propaganda. Date and place published; conditions and occasions for writing and publishing it.)

    II. Its *author*; the *critic* or evaluator. (Significant facts about him and his predispositions; personality, education, special interests, and attitudes as elsewhere shown. Social, cultural, intellectual, religious, philosophic background.)

    III. *Artist* or artists whose work is criticized. Significant facts: e.g., their date, place, school or style of work; nature of their other works.

    IV. *Work or works of art* criticized or evaluated: particular objects or performance; general types or styles of art discussed; periods, traits, specific details.

    V. *Main evaluative or affective terms* applied to the text; to what or whom; in what specific ways. (What verdicts, judgments, attitudes, conclusions expressed? Mostly favorable or unfavorable? Extremely or moderately so? Uniformly or with some exceptions? Calmly and objectively or with emotion such as contempt, anger, sarcasm, rapturous or sentimental adulation?)

    VI. *Standards* used by the critic or implied in his evaluation; principles, theories of artistic or moral value. His tastes in art and in related matters. Explicitly

    [*] From *College Art Journal* XVII, 2 (Winter 1958), 197–198. Reprinted with the kind permission of Professor Munro.

stated or tacitly assumed? How defended? Criteria of excellence or improvement; reasons for praising or denouncing; concepts of desired or desirable qualities, effects, functions, purposes of this type of art. Rules for good art accepted by the critic. Cultural and ideological background of these standards (social, historical, religious, philosophical, political, etc.).

VII. *Arguments and evidences* given by the critic to show how these standards apply to the present case. Defense of judgments expressed. Authorities invoked. Sources of evidence. References to the work of art itself, indicating how it exemplifies certain qualities regarded as especially good or bad, strong or weak, beautiful or ugly, great or trivial, original or imitative, etc.

VIII. *Alleged effects and consequences* of the work of art or some parts or aspects of it, on those who observe it. What kinds of *immediate experience* or psychological effect does it tend to produce, according to the critic? (E.g., pleasant or unpleasant, interesting or boring, exciting, soothing, amusing, sad, terrifying, stimulating, elevating, depressing.) Does it tend (according to the critic) to arouse anger and resentment, religious devotion, pity and sympathy, or some emotional attitude? Some disposition to a certain kind of action or attitude? What *deferred or indirect* effects, as on character, education, morality, religious faith, elevation or debasement of mind, mental health, citizenship, success in life? Are these effects considered important enough to determine the total value or disvalue of the work of art?

IX. On *whom or what kinds of person* is the work of art said to have these effects? (E.g., adults, children, men, women, soldiers, foreigners, invalids?) On people in general, without restriction? Under what *circumstances?* (E.g., in school, church, evening entertainment? In foreign exhibition, performance, or translation?)

X. Does the *critic himself* claim to have *experienced* such effects or *observed* them in others? When and how? What evidence does he give for believing them sure or probable in future? How conclusive is this evidence?

XI. General modes of *thinking, feeling, and verbal expression* exemplified in the criticism as a whole. How manifested; in what proportion and degree? (E.g., polemic, interpretive, factual, explanatory, judicial, personal, impressionistic, autobiographical, scientific, hedonistic, art-for-art's-sake, moralistic, mystical, propangandistic.)

XII. Special personal *motivations* and *influences* which may have affected the critic's attitude and judgment. (E.g., friendship or enmity toward the artist; extreme prejudices; connection with political, religious, socio-economic, or other groups which might tend to bias judgment; fear of or desire to please powerful authorities.) What evidence exists for this? To what extent, if at all, does it seem to invalidate the criticism?

XIII. *Strong and weak points of the criticism as an evaluation* of the artist or work of art. Do you find it convincing or not? Why? Is it enlightening, informative, helpful in perceiving, understanding, appreciating, or sympathizing with the

work of art? Fair or unfair? Logical and adequately documented? Based on adequate personal experience and verifiable knowledge? Vague or clear? Thorough, profound, superficial, trivial, or perfunctory? Strongly individual and subjective or the opposite?

XIV. *Literary or other merits or demerits of the criticism.* (Aside from the question of its correctness as evaluation, or its factual truth as description and interpretation.) Does it read well as a literary composition in its own right? For what qualities? (E.g., of style, imagery, colorful personality, etc.) What faults does it have as literature? Is it poetic, humorous, informative, enlightening? The expression of an attitude one can respect even though disagreeing?

XV. Summary estimate of its nature and value. Which of the above questions and answers have been given most weight in reaching this estimate of the critical writing? Why?

# A SELECTED BIBLIOGRAPHY
## of Artists' Writings and
## Theoretical Documents

A number of useful collections of theoretical documents on art by artists already exist. Their plans vary widely, however, so that some of them include only artists' letters, others tend toward anecdotes and biographical details, while in others the selection is made solely on the basis of interest, whether the texts are contemporary documents or recent critical essays.

The value of these collections to the art historian and student in their research varies, therefore, depending upon the basis of choice and the length of the particular quotation, the completeness with which the passages have been documented or annotated, and, of course, the accuracy of the translation.

The most valuable of these have become standard reference works for serious research.[1] Based upon a study of the original texts and completely documented, they are:

Gauss, Charles E. *The Aesthetic Theories of French Artists*. Baltimore: Johns Hopkins, 1949.
> Chapters: "Symbolism and Fauvism," "Early Cubism," and "Surrealism," where the most important statements by artists are briefly analyzed in terms of aesthetic principles.

Goldwater, Robert, and Marco Treves (eds.). *Artists on Art*. New York: Pantheon, 1945.
> Short but well selected quotations by artists on their art from the early Renaissance to the early 1940's. Reliable and useful.

Herbert, Robert L. (ed.). *Modern Artists on Art*. New York: Prentice-Hall, 1964.
> Ten well-selected articles by artists on their art dating from 1912 to 1941, with a brief note on each selection.

Hess, Walter. *Dokumente zum Verständnis der Modernen Malerei*. Hamburg: Rowohlt, 1956.
> An excellent source book composed of selected passages of theories and ideas on art by artists, classified by subjects and accompanied by introductory essays. Beginning with Cézanne, it concludes with Surrealism and an essay by Jean Bazaine.

Holt, Elizabeth J. (ed.). *The Literary Sources of Art History*. Princeton: Princeton University Press, 1947. Expanded and revised as *A Documentary History of Art*. 3 vols. New York: Anchor, 1957, 1966.
> Lengthy documents relating to various aspects of art, including contracts and iconographical programs, from medieval times to Postimpressionism.

---

[1] For a recent evaluation of artists' writings, dealing chiefly with Delacroix, Gauguin, and Van Gogh, see Alfred Werner, "Artists Who Write," *Art Journal*, XXIV, 4 (Summer 1965), 342–347.

A series of paperbound volumes published by Prentice-Hall, Inc. (H. W. Janson, General Editor) entitled "Sources and Documents in the History of Art" is expected to include the Twentieth Century. *Impressionism and Post-Impressionism, 1874–1904*, edited by Linda Nochlin, has appeared and *Abstract Expressionism*, edited by Irving J. Sandler, is forthcoming.

ANTHOLOGIES OF ARTISTS' WRITINGS IN ENGLISH:

Friedenthal, Richard (ed.). *Letters of the Great Artists*. vol. 2, *From Blake to Pollock*. London: Thames and Hudson, 1963.
> Letters dealing chiefly with personal matters and, except for Van Gogh, Cézanne, and Gauguin, seldom concerned with theory or ideas on art.

Gassner, John, and Sidner Thomas (eds.). *The Nature of Art*. New York: Crown, 1964.
> Articles on the general subject of art from a variety of sources including artists, writers of the past, and present-day critics.

Protter, Eric (ed.). *Painters on Painting*. New York: Grosset & Dunlap, 1963.
> Large collection of brief passages from letters, statements, etc. by artists on the subject of painting. About half the book is devoted to Cézanne and later artists. Texts not annotated. Includes bibliography.

Seghers, Pierre, and Jacques Charpier (eds.). *The Art of Painting*. New York and London: Hawthorn, 1965. English translation by Sally T. Abeles from original French edition by Seghers: *L'art de la peinture*. Paris: Seghers, 1957.
> Statements on modern painting from Signac to the present by artists, critics, art historians, and poets. Not annotated. Sources and dates of selections not given.

FIRST-HAND INTERVIEWS AND PERSONAL RECOLLECTIONS:

Alvard, Julien. *Témoignages pour l'art abstrait*. Boulogne: Art d'aujourd'hui, 1952.

Fels, Florent. *Propos d'artistes!* Paris: Renaissance du livre, 1925.
> Statements by the major artists in Paris made to the author during informal interviews in the early 'twenties.

INTERVIEWS WITH CONTEMPORARY ARTISTS:

Kuh, Katherine. *The Artist's Voice*. New York: Harper & Row, 1963.
> Interviews with contemporary American artists.

Roditi, Edouard. *Dialogues on Art*. London: Secker & Warburg, 1960; New York: Horizon, 1960.
> Discussions with contemporary European artists.

ANTHOLOGIES IN GERMAN AND FRENCH:

Charbonnier, Georges (ed.). *Le Monologue du peintre, entretiens . . .* 2 vols. Paris: Julliard, 1959, 1960.
> Transcripts of lively interviews for the French television with both young artists and modern masters. Includes other subjects besides art, but most of them are relevant to the art of the speaker.

Eckstein, Hans (ed.). *Künstler über Kunst*. Darmstadt: Stichnote, 1954.
> Letters and notes by nineteenth- and twentieth-century artists and architects. Useful introductory essays.

Edschmid, Kasimir (ed.). *Schöpferische Konfession: Tribüne der Kunst und Zeit.* Berlin: Reiss, 1920.

Grohman, Will (ed.). *Bildende Kunst und Architektur.* Berlin: Suhrkamp, 1953.

Hess, Walter. *Das Problem der Farbe in den Selbstzeugnissen moderner Malerei.* Munich: Prestel, 1953.

> A thoughtful study of color theory based upon the writings of artists from Signac and Seurat to Mondrian, accompanied by theoretical essays on the differing aspects of color and on attitudes toward it.

*Künstlerbriefe aus dem 19. Jahrhundert.* Berlin: Cassirer, 1914.

> Extensive collection of artists' letters on various subjects, many from the turn of the century.

Schneditz, Wolfgang (ed.). *Begegnung mit Zeitgenossen.* Munich: Prestel, 1959.

Thorn, Eduard (ed.). *Künstler über Kunst.* Baden-Baden: Woldemar Klein, 1951.

Uhde-Bernays, Hermann (ed.). *Künstlerbriefe über Kunst.* Dresden: Jess, 1926. New edition, *Menzel bis zur Moderne,* vol. 2. Frankfurt: Fischer Bücherei, 1963.

> Letters by artists on many subjects. Includes Cézanne, Signac, Gauguin, Rodin, Hodler, Marc, and Beckmann.

Westheim, Paul (ed.). *Künstlerbekenntnisse: Briefe, Tagebuchblätter, Betrachtungen heutiger Künstler.* Berlin: Propylaen, n.d. [before 1940].

> Although not systematically organized, includes interesting works by Jugendstil, Postimpressionist, Fauvist, and Cubist artists, and the German artists of the *Café du Dome* during the 1920's.

Wingler, H. M. (ed.). *Wie sie Einander sahen: moderne Maler im Urteil ihrer Gefährten.* Munich: Langen-Müller, 1957.

AN ANTHOLOGY OF LITERARY TEXTS OF VALUE IN THE STUDY OF ART MOVEMENTS:

Weber, Eugen (ed.). *Paths to the Present: Aspects of European Thought from Romanticism to Existentialism.* New York: Dodd, Mead, 1960.

> Includes interesting essays on literature, history, and culture relevant to art movements.

PERIODICALS ESPECIALLY IMPORTANT FOR THEORETICAL DOCUMENTS:

*Cahiers d'art* (Christian Zervos, ed.). Paris: Cahiers d'art, 1926–.

*Art-documents* (Pierre Cailler, ed.). Geneva: Cailler, October 1950–.

*L'Art d'aujourd'hui* (Albert Morance, ed.). Paris, 1924–1925.

Many important theoretical and documentary books and essays have been collected by George Wittenborn, Inc. (formerly Wittenborn, Schultz, Inc.), New York, and published in English translation under the general title, *The Documents of Modern Art* (Robert Motherwell, ed.). Many of these have been written by artists, and others include artists' statements and other very valuable documentary material. Although the original editions of the most important of these are listed under the appropriate chapter headings, a complete list of titles and dates of republication follows:

1. Apollinaire, Guillaume. *The Cubist Painters.* 1962.
2. Mondrian, Piet. *Plastic Art and Pure Plastic Art.* 1945.

3. Moholy-Nagy, Laszlo. *The New Vision*, 1947.
4. Sullivan, Louis. *Kindergarten Chats*. 1947.
5. Kandinsky, Wassily. *Concerning the Spiritual in Art and Painting in Particular*. 1955.
6. Arp, Jean (Hans). *On My Way, Poetry and Essays*. 1948.
7. Ernst, Max. *Beyond Painting*. 1948.
8. *The Dada Painters and Poets*. 1951.
9. Kahnweiler, Daniel-Henry. *The Rise of Cubism*. 1949.
10. Raymond, Marcel. *From Baudelaire to Surrealism*. 1949.
11. Duthuit, Georges. *The Fauvist Painters*. 1950.
12. Giedion-Welcker, Carola. *Contemporary Sculpture, an Evolution in Volume and Space*. 1961.
13. Karpel, Bernard. *Arts of the Twentieth Century. A Bibliography* (in preparation).
14. Duchamp, Marcel. *The Bride Stripped Bare by Her Bachelors, Even*. 1960.
15. Klee, Paul. *The Thinking Eye*. 1964.
16. *Circle: International Survey of Constructive Art*, 1966.

*Problems of Contemporary Art*
Two of this series are of documentary value:
4. *Possibilities No. 1*. 1947/48.
5. Vantongerloo, Georges. *Paintings, Sculptures, Reflections*. 1948.

A new series, which is actually detailed histories of modern art movements, includes much valuable documentary and theoretical material. It is published in German by Du Mont Schauberg, Cologne, and in English translation by Thames & Hudson, London, and McGraw-Hill, New York. The series as projected will include:

Richter, Hans. *Dada: Art and Anti-Art*. 1965.
Waldberg, Patrick. *Surrealism*. 1964.
Jaffe, H. L. C. *De Stijl*.
Leymarie, Jacques. *Fauvism*.
Fry, Edward F. *Cubism*. 1966.
Apollonio, Vittorio. *Futurism*.

The excellent monographs published since 1930 by the Museum of Modern Art are not only models of scholarship, but include comprehensive bibliographies, often with a complete list of artists' writings and statements. Reference to individual works is made under the appropriate chapter headings. See especially chapter ix, "Contemporary Art."

For additional references to artists' statements and original documents, see also the bibliographies in the principal books on art movements and artists.

A comprehensive bibliography of modern art, a compilation for which scholars have been hoping for a long time, is in preparation by Dr. Bernard Karpel, Librarian of the Museum of Modern Art (see No. 13 of the Wittenborn series above). The eventual appearance of this important work will bring much-needed order into the field, and will surely reveal material which heretofore has been virtually unknown.

# CHAPTER I. Postimpressionism

*Cézanne*

Virtually all of Cézanne's ideas on art are incorporated in letters included in the English edition of *Paul Cézanne: Letters*, London: Cassirer, 1941, a translation by Marguerite Kay of John Rewald's original French edition, *Paul Cézanne, Correspondence*, Paris: Grasset, 1937.

 Several of the authors of books on Cézanne include quotations or paraphrases of his ideas and statements. Chief among the chroniclers of Cézanne's thoughts is Emile Bernard, who queried him on many aspects of his art as well as upon general aesthetic questions. Bernard's two articles of 1905 (later combined to form his book *Souvenirs sur Paul Cézanne*) add a new dimension to Cézanne's statements on art, as they provide us with both his questions and Cézanne's answers. Since Cézanne did not save letters to him, we do not know except by analogy with these articles just what the questions were that he was attempting to answer in his own letters.

Bernard, Emile. *Souvenirs sur Paul Cézanne*. Paris: Société des Trente, 1912.
 Essays concerning his talks with Cézanne, usually on subjects of Bernard's choice and somewhat directed toward Bernard's own ideas. The author, a painter and gifted critic, had written perceptive articles on Cézanne and Van Gogh as early as 1890, and he had carried on correspondence with most of the major figures of the time.

————. "Une Conversation avec Cézanne," *Mercure de France*, CXLVIII, 551 (1 June 1921), 372–397.
 An account from memory of a conversation, Bernard directing the conversation and questioning Cézanne.

Gasquet, Joachim. *Cézanne*. Paris: Bernheim-Jeune, 1921.
 A biography by a close friend, but sometimes inaccurate in facts and unreliable in remembrances.

Larguier, L. *Le dimanche avec Paul Cézanne*. Paris: L'Edition, 1925.
 An apparently unprejudiced account of the author's visits with Cézanne during 1901 and 1902.

*Van Gogh*

*The Complete Letters of Vincent van Gogh*. 3 vols. Greenwich, Connecticut: The New York Graphic Society, 1958.
 Assembled by Dr. Ir. Vincent Van Gogh, it includes all of Van Gogh's known letters, the only source for his ideas on art. Fully documented, including sketches from the letters.

Rewald, John. *Post-impressionism From Van Gogh to Gauguin.* 2nd. ed. New York: Museum of Modern Art, 1962.

> An extensive and detailed documentation of the lives and the work of Van Gogh, Gauguin, Seurat, and Redon between 1886 and 1893. Extensive classified bibliography. Invaluable for reference.

# CHAPTER II. Symbolism and other Subjectivist Tendencies

## General studies of theory

Lövgren, Sven. *The Genesis of Modernism.* Stockholm: Almquist and Wiksell, 1959.

> An important study of the major ideas central to the development of modern painting.

Martin, Elizabeth P. *The Symbolist Criticism of Painting: France, 1880–1895* (microfilm). Ann Arbor, Michigan: University Microfilms, 1948.

> A doctoral dissertation surveying the ideas and viewpoints of the movement, and including an extensive bibliography.

Rookmaaker, H. R. *Synthetist Art Theories.* Amsterdam: Swets and Zeitlinger, 1959.

> An extensive study and analysis of the ideology of Gauguin and the Synthetist movement, including numerous important texts of the period, many of which are annotated.

## Gauguin's letters

A complete edition of Gauguin's correspondence, with numerous new documents, is being prepared by John Rewald. Until this very important work is completed, the student of his letters must rely upon the following volumes:

Joly-Ségalen, Annie (ed.). *Lettres de Gauguin à Daniel de Monfried.* Paris: Falaize, 1950.

Malingue, Maurice (ed.). *Lettres de Gauguin à sa femme et à ses amis.* New ed. Paris: Grasset, 1949.

> Nearly all of Gauguin's letters except those to Daniel de Monfried (see above).

Rewald, John (ed.). *Paul Gauguin, Letters to Ambroise Vollard and André Fontainas.* San Francisco: Grabhorn, 1943.

> A selection of letters including Fontainas's review of Gauguin's exhibition of 1898 and Gauguin's reply.

## Gauguin's writings

"Notes Synthétiques" (Brittany [?], *ca.* 1888).

> Originally published in *Vers et Prose,* XXII (Paris: July–August–September, 1910). Facsimile of the manuscript and a printed text in French and English is in Raymond Cogniat, *Paul Gauguin, A Sketchbook.* 3 vols. Foreword by John Rewald. New York: Hammer Galleries, 1962.

*Cahier pour Aline* (Tahiti, 1893).
> Facsimile edition. Paris: Société des amis de le Bibliotèque d'art et d'archéologie de l'Université de Paris, 1962.

*Noa-Noa* (Tahiti, *ca.* 1893).
> Edited and rewritten by Charles Morice from a manuscript given to him by Gauguin. First published in parts in *La Révue Blanche* beginning 15 October 1897 and in book form: Paris, La Plume, 1901. Morice's version cannot be taken as accurately representing the views of Gauguin.

*Noa-Noa* (Tahiti, *ca.* 1893).
> Facsimile text edition without illustrations of Gauguin's original first manuscript as given to Morice. Paris: Sagot-Le Garrec, 1954. Text edition with a study by Jean Loize of the two manuscripts: Paris: Balland, 1966.

*Noa-Noa* (Tahiti, *ca.* 1893).
> A second manuscript by Gauguin, apparently copied by him from the first one before he had given it to Morice and with Gauguin's later additions of text, clippings of photographs and drawings. Text edition, Paris: Crès, 1924. Facsimile edition, Berlin: Marées Gesellschaft, 1926; Stockholm: Jan Förlag, 1947.

*Ancien Culte Mahorie* (Tahiti, *ca.* 1893).
> Facsimile edition of Gauguin's second manuscript of *Noa-Noa* with essay by René Huyghe. Paris: Pierre Bérès, 1951.
> An important study of the problem of the relationship between the two manuscripts of *Noa-Noa*.

"Diverses choses, 1896–1897," (Tahiti) unpublished. Parts of this appear in Jean de Rotonchamp, *Paul Gauguin, 1848–1903*. Paris: Crès, 1925.

*Avant et Après* (Marquesas, 1903).
> Facsimile edition, Leipzig: Kurt Wolff, 1918. Reprinted, Copenhagen, *ca.* 1948. Printed edition of text, Paris: Crès, 1923.

## Documentation

Rewald, John, *Post-impressionism from Van Gogh to Gauguin.* 2nd. ed. New York: Museum of Modern Art, 1962.
> An extensive and detailed documentation of the lives and the work of Van Gogh, Gauguin, Seurat, and Redon between 1886 and 1893 Extensive bibliography classified by subjects. Invaluable for reference.

Wildenstein, Daniel (ed.). *Gauguin, sa vie, son ouevre.* Paris: Gazette des Beaux-Arts, 1958.
> An important collection of documents relating to the dates and subjects of the paintings, essays of interpretation, and table of translations of Polynesian titles.

## Other Subjectivist tendencies

Aurier, G.-Albert. *Oeuvres posthumes de G.-Albert Aurier.* Paris: Mercure de France, 1893.
> Contains nearly all of this important critic's writings on the Symbolist painters.

Bernard, Emile. *Souvenirs inédits sur l'artiste peintre Paul Gauguin et ses compagnons lors de leurs séjour à Pont-Aven et au Pouldu.* Lorient: privately published, 1939.

Denis, Maurice. *Theories: 1890–1910.* 4th ed. Paris: Rouart et Watelin, 1920. First published in 1912.

Maurice Denis's most important essays written between 1890 and 1910. A valuable collection by a highly articulate and influential artist and theoretician.

————. *Journal*. 3 vols. Paris: La Colombe, 1957–1959.
An account of his life and ideas from 1884 to 1943.

Ensor, James. *Les écrits de James Ensor*. Brussels: Lumière, 1944.
Ensor's principal essays and satires on art and contemporary culture. This edition is a revision with additional material of an earlier publication under the same title.

Hodler, Ferdinand, see Loosli, C. A. *Ferdinand Hodler: Leben, Werk und Nachlass*. 4 vols. Bern: Sluter, 1924.
Includes important essays and writings.

Munch, Edvard, see Langaard, Johan H., and Reidar Revold. *Edvard Munch*. Oslo: Chr. Belser, 1963.
Includes Munch's brief statements on art. For his letters see *Edvard Munch's Brev; Familien*. Oslo: Johann Grundt Tanum, 1949.

Redon, Odilon. *A soi-même, Journal (1867–1915)*. Paris: Floury, 1922. New edition, Paris: J. Corti, 1961.
Expressive and elegantly written essays concerning his thoughts on art and his views of his contemporaries.

————. *Lettres d'Odilon Redon*. Paris and Brussels: Van Oest, 1923.

————. *Lettres à E. Bernard*. Brussels: n.p., 1942.

Sérusier, Paul. *L'ABC de la Peinture*. Paris: Floury, 1921.

# CHAPTER III. Fauvism and Expressionism

*Henri Rousseau*

The most important contemporary document on Henri Rousseau is the special issue of *Les Soirées de Paris*, *"consacré au peintre Henri Rousseau Le Douanier,"* No. 20 (15 January 1914 [misdated 1913]), which consists of essays by Guillaume Apollinaire and Maurice Raynal, and letters and poems by Rousseau.

These recent monographs include bibliographies and a certain amount of source material.

Bouret, Jean. *Henri Rousseau*. Neuchâtel: Ides et Calandes, 1961.

Rich, Daniel D. *Henri Rousseau*. New York: Museum of Modern Art, 1942.

Vallier, Dora. *Henri Rousseau*. Cologne: DuMont Schauberg, 1961.

*Fauvism*

Fauvism has still not been extensively studied, and substantial source material is rare.

Courthion, Pierre. *Georges Rouault*. New York: Abrams, 1961.
Includes selections from Rouault's writings.

*Chatou*. Paris: Galerie Bing, March 1947. Short texts on the Chatou epoch by Derain and Vlaminck.

Derain, André. *Lettres à Vlaminck*. Paris: Flammarion, 1955.
> Letters from 1901 to 1922 with an introductory note and an epilogue by Vlaminck.

Duthuit, Georges. *Les Fauves*. Geneva: Editions des trois collines, *ca.* 1949. English edition, *The Fauvist Painters*. New York: Wittenborn, Schultz, 1950.
> Includes an extensive bibliography by Bernard Karpel. An informative general work, which includes a reproduction of the 1905 *Salon d'Automne* review from *L'Illustration*.

Gauss, Charles E. *The Aesthetic Theories of French Artists: 1855 to the Present*. Baltimore: Johns Hopkins, 1959, pp. 53–68.
> Includes chapter on Fauvist aesthetics.

Sauvage, Marcel. *Vlaminck: Sa vie et son message*. Geneva: Cailler, 1956.
> Includes selections from Vlaminck's writings.

Vlaminck, Maurice. *Tournant dangéreux*. Paris: Stock, 1929. English translation by Michael Ross, *Dangerous Corner*. London: Elek, 1961. Also see Ross's *Désobéir* (Paris: Correa, 1936).
> Includes some important reminiscences of the Fauvist years.

## Henri Matisse

Barr, Alfred H., Jr. *Matisse, His Art and His Public*. New York: Museum of Modern Art, 1951.
> A comprehensive study of Matisse which has become a standard reference work. Includes a complete bibliography by Bernard Karpel.

## Expressionism

*Der Blaue Reiter*. Kandinsky, Wassily and Franz Marc, (eds). Munich: Piper, 1912. New edition, 1965.
> Edited by Kandinsky and Marc, this important book contains theoretical essays by the Blaue Reiter artists and by the composers Schoenberg and Scriabin. It is richly illustrated with their own paintings and with a significant selection from other art they most admired: Medieval, Japanese, Child, Folk, and Primitive of many cultures, as well as the modern masters Cézanne, Van Gogh, Rousseau, Delaunay, and Kokoschka.

Beckmann, Max. *Tagebücher 1940–50*. Edited by Erhard Göpel. Munich: Langen-Müller, 1955.

———. *Briefe im Kriege*. Berlin: Bruno Cassirer, 1916.

———. "Meine Theorie in der Malerei." Lecture delivered in London, 1938. English translation, *On My Painting*. New York: Buchholz Gallery, 1941.

———. "Letters to a Woman Painter." Lecture delivered at Stephens College, Columbia, Missouri, 1948. Translated by Mathilde Q. Beckmann and Perry T. Rathbone in Peter Selz, *Max Beckmann*. New York: The Museum of Modern Art, 1964.

Kandinsky, Wassily. *Punkt und Linie zur Fläche*. Bauhausbuch No. 9. Munich: Langen, 1926. English translation, *Point and Line to Plane*. New York: Solomon R. Guggenheim Foundation, 1947.
> Kandinsky's teaching methods at the Bauhaus.

————. *Rückblicke, 1901–1913*. Berlin: Sturm-Verlag, 1913. A translation of the revised Russian edition appears in *Wassily Kandinsky Memorial*. New York: Solomon R. Guggenheim Foundation, 1945.

> Autobiographical account of his early years in Munich.

————. *Über das Geistige in der Kunst*. Munich: Piper, 1912. English translation by Francis Golffing, Michael Harrison, and Ferdinand Ostertag, *Concerning the Spiritual in Art*. New York. Wittenborn, Schulz, 1947.

> Important essays on the nature of art and on form and color.

Klee, Paul. *Das Bildnerische Denken*. Edited by Jürg Spiller. Basel/Stuttgart: Schwabe, 1956.

> English translation by Ralph Mannheim, *The Thinking Eye*. New York: Wittenborn, 1961.

————. *Pädagogisches Skizzenbuch*. Bauhausbuch No. 2. Munich: Langen, 1925. English translation by Sibyl Moholy-Nagy, *Pedagogical Sketch Book*. New York: Praeger, 1953.

> Klee's teaching methods at the Bauhaus.

————. *Schöpferische Konfession*. Berlin: Erich Reiss, 1920. Edited by Kasimir Edschmidt.

> English translation by Norbert Guterman, "Creative Credo," in *The Inward Vision*. New York: Abrams, 1959.

————. *Tagebücher 1898–1918*. Cologne: DuMont Schauberg, 1957. (English translation forthcoming.)

Kokoschka, Oscar. *Schriften: 1907–1955*. Edited by H. M. Wingler. Munich: Langen-Muller, 1956.

> Extensive collection of poetry, dramas, letters, etc. including his principal essays on art and artists. Detailed documentation.

Marc, Franz. *Briefe, Aufzeichnungen und Aphorismen*. 2 vols. Berlin: Cassirer, 1920.

> Includes his principal statements on his art and his artistic beliefs.

————. *Briefe aus dem Feld*. Berlin: Mann, 1956. War-time letters.

Nolde, Emil. *Das Eigen Leben*. Berlin: Bard, 1931. Revised edition, Flensburg: Wolff, 1949.

> The first volume of an autobiography which includes many important statements on art.

————. *Jahre der Kämpfe*. Berlin: Bard, 1934. Revised edition, Flensburg: Wolff, 1958.

> Second volume of above.

————. *Welt und Heimat*. Flensburg: Wolff, 1965.

> Third volume of above.

### General studies of the artists and the movements

Selz, Peter. *German Expressionist Painting*. Berkeley and Los Angeles: University of California Press, 1957.

> The most extensive scholarly study, which also includes a comprehensive bibliography.

Buchheim, Lothar G. *Der Blaue Reiter*. Feldafing: Buchheim, 1959.

————. *Die Künstlergemeinschaft Brücke*, Feldafing: Buchheim, 1956.

Grohmann, Will. *Wassily Kandinsky*. Cologne: DuMont Schauberg, 1958. English edition, *Kandinsky, Life and Work*. New York: Abrams, 1958.

————. *Paul Klee*. Stuttgart: Kohlhammer, 1954. English edition, New York: Abrams, 1954.

Lindsay, Kenneth. "The Genesis and Meaning of the Cover Design of the First *Blaue Reiter* Exhibition Catalogue," *Art Bulletin*, XXXV, 1 (March 1953), 47–50.

Selz, Peter, "The Aesthetic Theories of Wassily Kandinsky and Their Relationship to the Origin of Non-Objective Painting," *Art Bulletin*, XXXIX, 2 (June 1957), 127–136.

Worringer, Wilhelm. *Abstraktion und Einfühlung.* Munich: Piper, 1948. First published in 1908. English translation, *Abstraction and Empathy.* London: Routledge and Kegan Paul, 1953.

> An influential contemporary statement of some of the philosophical principles underlying German Expressionism.

### Periodicals

*Der Sturm*, Berlin (1910–1932)
*Der Cicerone*, Leipzig (1909–1930)
*Jahrbuch der jungen kunst*, Leipzig (1920–1924)
*Kunst und Künstler*, Berlin (1903–1933)
*Das Kunstblatt*, Weimar, Potsdam, Berlin (1913–1932).

# CHAPTER IV. Cubism

The literature of the Cubist movement is enormous in scope, partly because the central artists of the group are such powerful and influential personalities, but more importantly because the innovations of the movement are so revolutionary and so germane to later art that they readily lend themselves to theorization. The larger part of the literature is critical and historical in nature, and it appeared after the time of the initial impulse of the movement. Several writings on Cubist theory, however, appeared before the First World War.

The most important documents of the formative years of Cubism are by the artists themselves and by their friends, the poets. The first book to appear is by two painters who were intimately involved in the Cubist manifestations in the *Salon des Indépendants* and who were the best-known Cubists in the eyes of the public and the press. Their book attempts to explain the ideology and the aims of the Cubist painters.

Gleizes, Albert, and Jean Metzinger. *Du Cubisme.* Paris: Figuière, 1912. English edition, *Cubism.* London: Unwin, 1913. Also translated into Russian in 1913.

Gleizes later wrote several books and articles deriving from his earlier theories, but no longer specifically relevant to Cubism itself.

Gleizes, Albert, *Du Cubisme et des moyens de la comprendre.* Paris: J. Povolozsky, 1920.

———. *La peinture et ses lois: ce qui devrait sortir du cubisme.* Paris: Povolozsky, 1924.

———. *Tradition et cubisme: vers une conscience plastique.* Paris: Povolozsky, 1927.

———. *Souvenirs: le Cubisme 1908–1914.* Cahiers Albert Gleizes I. Lyon: L'Association des Amis d'Albert Gleizes, 1957. Same edition, New York: Wittenborn, 1957.

Soon after 1905 when Picasso met Guillaume Apollinaire his studio in the Bateau Lavoir became the center of a large group of painters, poets, and collectors. A great many articles in the avant-garde journals and two books were the result.

Salmon, André. *La jeune peinture française*. Paris: Société des Trente, 1912.
> Includes a chapter on Cubism devoted chiefly to the development of Picasso's *Demoiselles d'Avignon*.

Apollinaire, Guillaume. *Les peintres cubistes: méditations esthétiques*. Paris: Figuière, 1913. English translation by Lionel Abel, *The Cubist Painters: Aesthetic Meditations*. New York: Wittenborn, 1944.
> Notwithstanding the fact that Apollinaire first conceived the book as a collection of essays on various directions of contemporary art, it is the most perceptive account of the ideology of the Cubist movement. This important poet and critic was very closely associated with the painters.

There is an important critical study of this text, which includes annotations and additional contemporary documents. This is the first time that a document of twentieth-century art has been subjected to the philological study customary for literary texts, and scholarly study of Cubism has been immeasurably aided by it.

*Méditations esthétiques: les peintres cubistes*. With critical essay and annotations by L.-C. Breunig and J. A. Chevalier. Paris: Hermann, 1965.

All of Apollinaire's writings on art have been collected and published with a brief but careful and illuminating commentary.

Breunig, L.-C. (ed.). *Guillaume Apollinaire: Chroniques d'Art* (1902–1918). Paris: Gallimard, 1960.

## Artists' statements

Barr, Alfred H., Jr. *Picasso: Fifty Years of his Art*. New York: Museum of Modern Art, 1946.
> All of Picasso's writings and statements on art to date.

Penrose, Roland. *Portrait of Picasso*. New York: Museum of Modern Art, 1957.
> Includes photographs and biographical material of documentary value.

Kahnweiler, D.-H. *Juan Gris: sa vie, son oeuvre, ses écrits*. Paris: Gallimard, 1946. English translation by Douglas Cooper, *Juan Gris, His Life and Work*. London: Lund Humphries, 1947; New York: Valentin, 1947.
> The author, who was a close friend and the dealer for Picasso, Braque, Gris, and Leger, was a close observer of the scene since 1907. His historical and critical sense gives weight to his accounts of the movement.

## Theories of Cubism

Fry, Edward F. *Cubism*. New York: McGraw-Hill, 1966.
> A valuable collection of 48 documents, some well-known and others rare, dealing with Cubism. Most of them date before 1914. Brief annotations.

Gray, Christopher. *Cubist Aesthetic Theories*. Baltimore: Johns Hopkins, 1953.

Theories of the Cubist painters and poets seen in relation to general literary and philosophic concepts.

Janneau, Guillaume. *L'Art cubiste*. Paris: Charles Moreau, 1929.

Based largely on statements made by the artists to the author when he was an editor of *Bulletin de la Vie Artistique*, this book is chiefly a history of ideas. The author also had associated with the Bateau Lavoir and the Puteaux groups of artists from the earliest years.

## *Literary Histories*

Lemaitre, Georges. *From Cubism to Surrealism in French Literature*. Cambridge: Harvard University Press, 1941.

A literary history of the period with references to similar concepts in painting.

Raymond, Marcel. *From Baudelaire to Surrealism*. New York: Wittenborn, Schultz, 1950.

An excellent literary history useful for a study of the painting of the period.

## *First-hand Accounts*

Several close friends of the artists have in later years written their reminiscences. The reader must make due allowance for the tendency of the authors to elaborate upon fact and to see the past in terms of their own interests, but he can gain from these works unique, if highly personal views of the period.

Brassai, Gyula H. *Conversations avec Picasso*. Paris: Gallimard, 1964. English translation, *Picasso and Company*, New York: Doubleday, 1966.

Conversations since 1943 with the photographer, an old friend.

Gilot, Francoise, and Carlton Lake. *Life with Picasso*. New York: McGraw-Hill, 1964. Original text in English, subsequently translated into French.

A remarkably perceptive account of Picasso's life, mostly personal, from about 1943 to 1953. Although ghost-written this book is an unusually rich and apparently accurate source for Picasso's attitudes and ideas on art, even those of earlier years.

Kahnweiler, D.-H. *Mes Galleries et mes peintres: Entretiens*. Paris: Gallimard, 1961.

———. *Confessions Esthétiques*. Paris: Gallimard, 1963.

Originally presented as the author's memoirs through the medium of a series of television interviews, this book includes important historical material and perceptive observations on his artists and on his own life as an art dealer.

Olivier, Fernande. *Picasso et ses amies*. Paris: Stock, 1933. English translation by Jane Miller, *Picasso and his Friends*. London: Heinemann, 1964.

The author, Picasso's companion from 1904 to 1909, wrote this book twenty years later, and although her dating is sometimes inaccurate, the events themselves are described in sufficient detail to provide interesting and important material.

Sabartés, Jaime. *Retratos y recuerdos*. Madrid: n.p., 1953, original text. English translation by Angel Flores, *Picasso, An Intimate Portrait*. New York: Prentice-Hall, 1948; London: Allen, 1949.

The author, a close friend of Picasso in his youth in Barcelona and his secretary since 1935, describes in detail their everyday life and their activities since that time.

Stein, Gertrude. *Picasso*. Paris: Floury, 1938. English editions, London: Batsford, 1938 and later; Boston: Beacon, 1959.

Perceptive observations intermingled with reminiscences and anecdotes.

──────. *The Autobiography of Alice B. Toklas*. New York: Harcourt, Brace, 1933.

A rich and vivid account of Gertrude Stein's life, thoughts and many friends, including much important historical information.

## General studies of artists and movements

Bibliographies of writings and other documents of theoretical value may be found in the principal reference books on the movement and in the more scholarly monographs.

Barr, Alfred H., Jr. *Cubism and Abstract Art*. New York: Museum of Modern Art, 1936.

Although only a survey it is still one of the soundest comprehensive studies of the movement. Recently reprinted.

Cooper, Douglas. *Fernand Léger et le nouvel espace*. Geneva: Trois Collines, 1949.

Golding, John. *Cubism: A History and an Analysis, 1907–1914*. New York: Wittenborn, 1959.

An intensive stylistic study of the paintings during the formation of Cubism. Good bibliography.

Hope, Henry R. *Georges Braque*. New York: Museum of Modern Art, 1949.

A basic study of Braque. Good bibliography.

Kahnweiler, D.-H. *Der Weg zum Kubismus*. Munich: Delphin, 1920. English translation by Henry Aronson, *The Rise of Cubism*. New York: Wittenborn, 1949.

An important history of the ideas of Cubism by the dealer and friend of the artists since 1907.

Kuh, Katherine. *Léger*. Exhibition catalogue. Chicago Art Institute, 1953.

*Fernand Léger, Five Themes and Variations*. Exhibition catalogue. New York: Guggenheim Museum, 1962.

Robbins, Daniel. *Albert Gleizes: 1881–1953*. Exhibition catalogue. New York: Guggenheim Museum, 1964.

Extensive study of paintings and theory. Excellent bibliography.

Sabartés, Jaime and Wilhelm Boeck. *Picasso*. Paris: Flammarion, 1955.

Includes an up-to-date bibliography listing Picasso's statements on art.

## Periodicals

*Bulletin de la Vie Artistique* (Paris), 1919–1925 (Félix Fénéon, Guillaume Janneau, P. Fortuny, A. Tabarant, eds.)

*Bulletin de l'Effort Moderne* (Paris), 1924–1935 (Leonce Rosenberg, ed.)

*L'Esprit Nouveau* (Paris), 1920–1925 (Amadée Ozenfant, Ch.-Ed. Jeanneret [Le Corbusier] eds.)

*Montjoie!* (Paris), 1913–1914 (Canudo, ed.)

*Les Soirées de Paris* (Paris), 1912–1914 (Guillaume Apollinaire, André Billy, René Dalize, André Salmon, André Tudesq, founders and editors. Later, Apollinaire and Jean Cerusse were to be editors and directors).

# CHAPTER V. Futurism

Banham, Raynor. *Theory and Design in the First Machine Age*. New York: Praeger, 1960.
> An imaginative treatment of the Futurist impact on architecture.

Boccioni, Umberto. *Pittura, Scultura Futuriste*. Milan: Poesia, 1914.
> A rich source for contemporary material.

Carrà, Carlo. *La mia vita*. Rome: Longanesi, 1943.
> Valuable autobiography.

Carrieri, Raffaele. *Il Futurismo*. Milan: Edizioni del Milione, 1961.
> A history with documentary photographs.

Crispolti, Enrico. *Il secondo Futurismo, Torino 1923–1938*. Turin: Pozzo, 1961.
> Important information on the second generation of Futurists.

Falqui, Enrico. *Bibliografia e iconografia del Futurismo*. Florence: Sansoni, 1959.
> Important supplement to the *Archivi del Futurismo*.

Gambillo, Maria Drudi, and Teresa Fiori (eds.). *Archivi del Futurismo*. 2 vols. Rome: De Luca, 1958, 1962.
> Includes the major writings on art by the Futurists, an extensive but rough catalogue of their works, and a comprehensive bibliography.

Gambillo, Maria Drudi, and Claudio Bruni. *After Boccioni, Futurist Paintings and Documents from 1915 to 1919*. Rome: La Medusa, 1961.
> Includes important documentary and theoretical material.

*Lacerba*, edited by F. T. Marinetti (Florence), 1913–1915.
> A periodical containing invaluable contemporary material beyond that found in the *Archivi* (above).

Severini, Gino. *Tutta la vita di un pittore*. Milan: Garzanti, 1946.
> Valuable autobiography.

Taylor, Joshua C. *Futurism*. New York: Museum of Modern Art, 1961.
> A succinct presentation of the movement including four of the major manifestoes and letters by Boccioni translated into English.

Venturi, Lionello. *Gino Severini*. Rome: De Luca, 1961.
> Important biography.

# CHAPTER VI. Neo-Plasticism and Constructivism

A great amount of theory resulted from the widespread tendency toward non-objective and wholly abstract art. The artists realized how revolutionary was the ideal of an art which had no direct connection with nature, and many of them conceived of a new society which would be as rational in the human sphere as their painting and sculpture was in the visual. They felt the need, furthermore, to proselytize other artists for the new art and to explain it to laymen. Hence they were drawn readily into groups which often published substantial and well-written theoretical documents. Chief among these was *De Stijl* in Holland. An excellent historical, critical, and theoretical account of the movement which includes a

complete bibliography of writings is Jaffé, H. C., *De Stijl: 1917–1931*. Amsterdam: Meulendorf, 1956.

*De Stijl*, edited by Théo van Doesburg (Leiden), 1917–1932.
> The journal of the movement is rich in theoretical documents.

Under the editorship of Walter Gropius, the director, and Moholy-Nagy, one of the faculty, the highly influential Bauhaus published fourteen significant books in the *Bauhausbücher* series. See especially Paul Klee, *Pädagogische Skizzenbuch*, 1925; Piet Mondrian, *Neue Gestaltung, Neoplastizismus, nieuwe beelding*, 1925; Theo van Doesburg, *Grundbegriffe der neuen gestaltenden Kunst*, 1925; Wassily Kandinsky, *Punkt und Linie zu Fläche*, 1926; Kasimir Malevich, *Die Gegendstandslose Welt*, 1927; Albert Gleizes, *Kubismus*, 1928. The movement is described in an important book, Herbert Bayer *et al. Bauhaus: 1918–1928*. New York: Museum of Modern Art, 1938.

*Documents*

*Abstraction-Création: art non-figuratif*. Paris: 1932–1936.
> The organ of the nonobjective movement in Paris which comprised artists of many diverse tendencies such as Gabo, Pevsner, Kandinsky, Mondrian and Arp.

Berckelaers, Ferdinand L. [Michel Seuphor, pseud.] *L'art abstrait*. Paris: Maeght, 1949. English translation by Haakon Chevalier, *Abstract Painting from Kandinsky to the Present*. New York: Abrams, 1962.
> A comprehensive account of the movement which includes many statements by artists.

*Circle: International Survey of Constructive Art*. Edited by V. L. Martin, Ben Nicholson, and Naum Gabo. London: Faber & Faber, 1937. Also, New York: Wittenborn, 1966.
> Includes valuable essays by the artists on important aspects of the theory of Constructive and abstract art.

Itten, Johannes. *Meine Vorkurs am Bauhaus*. Ravensburg: Maier, 1963. English translation by John Maass, *Design and Form. The Basic Course at the Bauhaus*. New York: Reinhold, 1964.
> An account of the influential basic course and its theoretical justification by its founder.

*Artists' writings*

Delaunay, Robert. *Du Cubisme à l'art abstrait*. Edited by Pierre Francastel. Paris: S.E.V.P.E.N., 1957.
> Extensive collection of the writings of Delaunay including letters to other artists and fragmentary notes. Introductory notes by the editor.

Doesburg, Théo van. *Grundbegrippen der nieuwe beeldende kunst*. Amsterdam: n.p., 1917. German edition, *Grundbegriffe der neuen gestaltenden Kunst*. Munich: Langen, 1924.
> Important early document on the ideology of *De Stijl*.

Gabo, Naum. *Gabo*. Introductory essays by Sir Herbert Read and Leslie Martin. London: Lund Humphries, 1957.
> Includes important writings on art by Gabo.

Itten, Johannes. *Kunst der Farbe*. Ravensburg: Maier, 1961. English translation by Ernst von Haagen, *The Art of Color*. New York: Reinhold, 1961.

Kandinsky, Wassily. *Punkt und Linie zur Fläche*. Bauhausbuch No. 9. Munich: Langen, 1926. English translation, *Point and Line to Plane*. New York: Solomon R. Guggenheim Foundation, 1947.

    Kandinsky's teaching methods at the Bauhaus.

Lissitzky, El and (Hans) Jean Arp. *Die Kunstismen, 1914–1924*. Zurich: Reutsch, 1925.

Malevich, Kasimir. *Die Gegenstandslose Welt*. Bauhausbuch No. 11. Munich: Langen, 1927 (translated from the Russian). English translation from the German by Howard Dearstyne, *The Non-Objective World*. Chicago: Theobold, 1959.

    Includes the fundamental theoretical statements on Suprematism.

Moholy-Nagy, Lazlo. *Von Material zu Architektur*. Munich: Langen, 1929. Third English edition, translated by Daphne M. Hoffman, *The New Vision*. New York: Wittenborn, 1947.

    An account of the theory and experiments of this important Bauhaus professor.

Mondrian, Piet. *Le néo-plasticisme*. Paris: l'Effort Moderne, 1920.

————. *Plastic Art and Pure Plastic Art*. New York: Wittenborn, 1945. Originally published in *Circle* (text reprinted, Ch. VI).

    Mondrian's most comprehensive and important statement of his ideas.

Ozenfant, Amadée, and C. E. Jeanneret. *Après le Cubisme*. Paris: Ed. des Commentaires, 1918.

    The basic ideas of Purism as stated by the founders of the movement.

Severini, Gino. *Du cubisme au classicisme*. Paris: Povolozky, 1921.

    A theory of a new, pure, post-Cubist classical art based upon mathematical proportions.

Vantongerloo, Georges. *Paintings, Sculptures, Reflections* (Translated from the French by Dollie Pierre Chareau and Ralph Mannheim). New York: Wittenborn, 1948. Ideas and theories of a *De Stijl* artist.

*General books that include artists' statements and bibliographies*

Alvard, Julien. *Témoignages pour l'art abstrait*. Boulogne: Art d'Aujourd'hui, 1952.

Berckelaers, Ferdinand L. [Michel Seuphor, pseud.] *Piet Mondrian: Life and Work*. New York: Abrams, 1956.

Giedion-Welcker, Carola. *Constantin Brancusi, 1876–1957*. Basel: B. Schwabe, 1959. French edition, translated by André Tanner (Neuchâtel: Griffon, 1958); English translation by Maria Jolas and Anne Leroy (New York: Braziller, 1959).

Read, Sir Herbert. *Naum Gabo and Antoine Pevsner*. New York: Museum of Modern Art, 1948.

Sweeney, James J. *Piet Mondrian*. New York: Museum of Modern Art, 1948.

# CHAPTER VII. Dada, Surrealism, and *Scuola Metafisica*

The literature of Dada and Surrealism is vast and extremely varied. Most of it, like the movements themselves, is literary, and is not directly related to the art. Little of the writing may be considered art theory, although most of it deals, even

643

if in indirect and varied ways, with the basic concepts of the Surrealist view of man and modern life. Since Surrealist belief was grounded in the power of the irrational self, the artists did not often attempt, even in their prolific writings, to rationalize their art or to formulate aesthetic theories about it. Their writings, therefore, must be taken as reflecting their experiences and intimate thoughts more than as summarizing their aims and judgments.

Of primary importance for Dada is the comprehensive anthology of Dada documents, a book which also includes an extensive bibliography of writings by the poets and artists: *The Dada Painters and Poets*. Motherwell, Robert (ed.). New York: Wittenborn, Schultz, 1951.

Hugnet, Georges. *L'Aventure Dada*. Paris: Galerie de l'Institut, 1957.
> An adaptation in book form of a series of four articles appearing in *Cahiers d'Art*, 1932 and 1934. Includes theoretical material and statements by the artists.

Richter, Hans. *Dada: Art and Anti-Art*. London: Thames and Hudson; New York: McGraw. Hill, 1965. Original German edition, Cologne: DuMont Schauberg, 1964.
> Historical study with valuable documentary material including texts by the artists and poets.

Verkauf, Willy. *Dada, Monograph of a Movement*. New York: Wittenborn, 1957.
> Includes an extensive bibliography.

*Artists' writings: Dada*

Duchamp, Marcel. *The Bride Stripped Bare by Her Bachelors, Even*. New York: Wittenborn, 1960.

Ernst, Max. *Beyond Painting*. English translation by Dorothea Tanning. New York: Wittenborn, Schultz, 1948.

Dada periodicals are extremely rare, as they were printed in very small editions and have now become of interest to collectors. They may, however, be studied in part in the Wittenborn anthology and in the several monographs cited above. The principal ones are:

*Dada* (Zurich, Paris) 1917–1920 (Tristan Tzara, ed.).
*Merz* (Hanover) 1923–1932 (Kurt Schwitters, ed.).
*291* (New York) 1915–1916 (Alfred Stieglitz, ed.).
*391* (Barcelona, New York, Zurich, Paris) 1917–1924 (Francis Picabia, ed.).

The Surrealist movement is well documented in several histories and in the extensive writings of the leading figures. A bibliography is included in volume 1 and a collection of writings and other documents is included in volume 2 of Maurice Nadeau, *Histoire du Surréalisme*. 2 vols. Paris: Ed. du Seuil, 1948. English translation by Richard Howard, *The History of Surrealism* (one volume). New York: Wittenborn, 1965. The largest body of literature is the manifestoes and numerous other theoretical writings by the founder of the Surrealist movement, the poet and writer André Breton:

*Manifeste du Surréalisme: Poisson soluble.* Paris: Simon Kra, 1924. English translation by Eugen Weber in *Paths to the Present: Aspects of European Thought from Romanticism to Existentialism.* New York: Dodd, Mead, 1960.

*Les pas perdus.* Paris: Gallimard, 1924.

*Le Surréalisme et la Peinture.* Paris: Gallimard, 1928. English translation by David Gascoyne of about half of this essay appears in André Breton, *What is Surrealism?* (London: Faber & Faber, 1936).

*Qu'est-ce que le Surréalisme?* Brussels: Henriquez, 1934. Transcript of a lecture delivered that year in Brussels. English translation by David Gascoyne in Breton, *What is Surrealism?* (see above).

       Breton's clearest and most explicit statement on the theories of Surrealism as they apply to art.

*Manifestes du Surréalisme.* Paris: Pauvert, 1962.

       The collected manifestoes.

*Artists' writings: Surrealism*

Chirico, Giorgio de. *Hebdomeros.* Paris: Carrefour, 1929.

Dali, Salvador. *La Femme Visible.* Paris: Ed. Surréalistes, 1930.

————. *La Conquête de l'irrational.* Paris: Ed. Surréalistes, 1935. English translation, *Conquest of the Irrational.* New York: Julien Levy, 1935.

Masson, André. *Le plaisir de peindre.* Paris: La Diane française, 1950.

       A collection of highly literate and intelligent essays on his art.

————. *Metamorphose de l'artiste.* Geneva: Cailler, 1956.

————. *Entretiens avec Georges Charbonnier.* Paris: Juillard, 1958.

       Interviews on art and related subjects transcribed from a series on the French television.

*General studies which include theoretical writings*

Barr, Alfred H., Jr. *Fantastic Art, Dada, Surrealism.* New York: Museum of Modern Art, 1936.

       An excellent brief survey of the movement, including a chronology and a comprehensive bibliography.

Giedion-Welcker, Carola. *Arp.* New York: Abrams, 1957.

Guggenheim, Peggy (ed.). *Art of This Century.* New York: Art of This Century, n.d. [1942].

       Includes brief statements by Surrealist artists and an essay by André Breton.

Jean, Marcel. *Histoire de la peinture surréaliste.* Paris: Ed. du Seuil, 1959. English translation by Simon Watson Taylor, *The History of Surrealist Painting.* New York: Grove, 1960.

Lebel, Robert, *Sur Marcel Duchamp.* Paris: privately printed, 1959. English translation by George H. Hamilton, *Marcel Duchamp.* London: Trianon, 1959.

Levy, Julien. *Surrealism,* New York: Black Sun, 1936.

Rubin, William. *Dada and Surrealist Art.* New York: Abrams, 1968.

       This forthcoming book is expected to become the standard work on the subject.

Soby, James T. *Arp.* New York: Museum of Modern Art, 1958.

————. *Giorgio de Chirico*. New York: Museum of Modern Art, 1955.

————. *René Magritte*. New York: Museum of Modern Art, 1965.

————. *Salvador Dali*. New York: Museum of Modern Art, 1941.

————. *The Early Chirico*. New York: Museum of Modern Art, 1941.

Sweeney, James J. *Joan Miro*. New York: Museum of Modern Art, 1941.

*The Bulletin of the Museum of Modern Art*. (New York), Nos. 4–5, 1946.
>    Includes series of interviews with Surrealist artists by James J. Sweeney.

Waldberg, Patrick. *Max Ernst*. Paris: Pauvert, 1958.

————. *Surrealism*. London: Thames and Hudson; New York: McGraw-Hill; Cologne: DuMont Schauberg, 1965.
>    Includes valuable texts by the artists and poets, and other documentary material.

Surrealist periodicals are especially rich in documentary material, much of it by Breton and the leading literary figures of the movement who were also among the most important writers of the time.

*La Révolution Surréaliste* (Paris), 1924–1929 (Pierre Naville, Benjamin Peret, first editors; later André Breton).

*Le Surréalisme au service de la Révolution* (Paris), 1930–1933 (André Breton, ed.).

*The London Bulletin* [formerly *London Gallery Bulletin*] (London), 1938–1940 (E. L. T. Mesens, ed.).

*Minotaure* (Paris), 1933–1939 (E. Tériade, ed.).

*View* (New York), 1941–1946 (Charles Henri Ford, ed.).

*VVV* (New York), 1942–1944 (André Breton, Marcel Duchamp, Max Ernst, eds.).

*Artforum* (Los Angeles) Surrealist number V, 1 (September 1966). (Philip Leider, ed.).
>    A contemporary re-evaluation of the movement.

### Scuola Metafisica

*Valori Plastici* (15 November 1918–October 1921). Important document for theories and for illustrations.

Soby, James T. *Giorgio de Chirico*. New York: Museum of Modern Art, 1955.
>    Excellent account of the movement. Good bibliography.

Carrà, Carlo. *Pittura Metafisica*. Florence: Vallecchi, 1919.
>    A series of essays on the movement.

# CHAPTER VIII. Art and Politics

This is a broad and varied subject, not well documented, parts of which will be extensively covered in a forthcoming anthology and bibliography of Marxist writings on the arts and literature compiled by Lee Baxandall, with Stefan Morawski.

## General studies relating to politics and art

Harap, Louis. *Social Roots of the Arts*. New York: International Publishers, 1949.
Lehmann-Haupt, Helmut. *Art Under a Dictatorship*. New York: Oxford University Press, 1954.
    Two main sections: "The Nazi Experiment" and "Soviet Insistence and Western Dilemma."
Read, Sir Herbert. *The Politics of the Unpolitical*. London: Routledge, 1946. First published in 1943.

## Nazi Germany

Roh, Franz. *"Entartete" Kunst: Kunstbarbarei im Dritten Reich*. Hanover: Fackelträger, 1962.
    Includes theoretical and documentary sections, lists of works removed from museums and a bibliography, as well as complete facsimile reproduction of the original *Entartete Kunst* catalogue and guide.
Wulf, Joseph. *Die Bildenden Künste im Dritten Reich: eine Dokumentation*. Gutersloh: Sigbert Mohn Verlag, 1963.
    Primarily an anthology of documents.

## Berlin Dada

Grosz, George. *A Little Yes and a Big No*. New York: Dial, 1946.
    An autobiography including the political motivations of the Berlin Dadaists.
Herzfelde, Wieland. *John Heartfield, Leben und Werk*. Dresden: VEB Verlag der Kunst, 1962.
    Reviewed by Peter Selz as "John Heartfield's Photomontages," in *The Massachusetts Review*, IV, 2 (Winter 1963). A later political employment of Dada techniques in John Heartfield's montages, posters, and cartoons.

## Marxism

The brief but passionate Surrealist involvement with Communism is most richly documented in the periodical *Le Surréalisme au service de la Révolution* (1930–1933), which includes numerous essays, revolutionary manifestoes, articles by Breton, Aragon, Eluard, and Communists from other countries, as well as reports of conferences and lectures. (Sample of titles: "Belgrade 23 Dec. 1930," "Athéisme et Révolution," "Le Surréalisme et le devenir révolutionnaire," and "En Lisant Hegel" by Lenin.)

Chen, Jack. *Soviet Art and Artists*. London: Pilot, 1944.
    Includes chapters on "Soviet Art Policy," and "In the Battle Against Fascism." A general discussion of Russian contemporary art.
Rivera, Diego. "Lo que opina Rivera sobre la pintura revolucionaria." *Octubre: La Revista del Marxismo revolucionario*, I, 1 (October 1935), 49–59.

647

————. *Raices politicas y motivos personales de la controversia Siqueiros-Rivera: Stalinismo vs. Bolshevismo Leninista.* Mexico: Imprenta mundial, 1935.

Severini, Gino. *Arte Indipendente, arte borghese, arte sociale.* Rome: Danesi, 1944. English translation by Bernard Wall, *The Artist and Society.* New York: Grove, 1952.
> Most important chapters: "The Position of Art in Russia," "Picasso and Bourgeois Art," and "Non-Political Collaboration."
> Specialized treatment of the aesthetic aspects of Marxism and art.

Siqueiros, David Alfaro. *No hay mas ruta que la nuestra: importancia nacional e internacional de la pintura mexicana moderna.* Mexico: n.p., 1945.

Trotsky, Leon. "Art and Politics," *Partisan Review*, V, 3 (August–September 1938), 3–10. Translated by Nancy and Dwight Macdonald.
> Important statement revising his views of the early 1920's.

Viazzi, Glauco. "Picasso e la pittura comunista di fronte al marxismo," *Domus*, No. 208 (April 1946), 39–42.
> Includes Grosz, Surrealism, and Rivera in discussion.

## The United States

For an extremely rich coverage of the varied manifestations of the politically oriented or "socially conscious" American painters and critics grouped around the W.P.A. projects, the Artists Union, and the Artists Committee of Action, among other "revolutionary" artists' groups, see the journal *Art Front* (New York), November 1934–December 1937.

Barr, Alfred H., Jr. "Is Modern Art Communistic?" *The New York Times Magazine*, 14 December 1952, pp. 22–23, 28–30.
> A cogent defense of modern art against political opponents.

Berger, John. "Problems of Socialist Art," *Labour Monthly* (London), March 1961, pp. 135–143 and April 1961, pp. 178–186.
> A recent treatment of abstract and nonobjective art, which reconsiders concepts of realism and formalism from the Marxist standpoint.

# CHAPTER IX. Contemporary Art

The theoretical literature on contemporary art is vast, but it is also extremely diverse and it appears in many different literary forms. Wide public interest in art today has stimulated extensive discussion and explanation by artists and critics, which have been transmitted through all the media of mass communication. The presently frequent position of artists as teachers provides additional stimulus for theorization as well as avenues for its dissemination. And the strong individualism which is so basic to artists' attitudes has diversified contemporary theories to a point where the idea of a group manifesto, which had been so important in the past, is almost totally foreign to contemporary artists.

*Statements by artists*

The admirable books published by the Museum of Modern Art often contain statements by the artists, and the bibliographies usually include a section listing their writings. The exhibition catalogues for group shows listed below usually contain statements by the artists made expressly for the occasion.

*Fourteen Americans*, 1946.
*Contemporary Painters*, 1948.
*Fifteen Americans*, 1952.
*The New Decade: 35 American Painters and Sculptors*, 1955.
*The New Decade: 22 European Painters and Sculptors*, 1955.
*Twelve Americans*, 1956.
*Sixteen Americans*, 1959.
*The New American Painting*, 1958–1959.
*Americans*, 1963.

Similar exhibition catalogues of the Whitney Museum of American Art are:

*Young America*, 1957.
*Nature in Abstraction*, 1958.
*Young America*, 1960.
*Forty Artists Under Forty*, 1962.

Further statements by artists are contained in:

*American Abstract Artists*. New York: American Abstract Artists, 1938.
      Includes several excellent essays by artists of the New York School.
*Art News* (New York) (Thomas B. Hess, ed.) published beginning in 1950 a long series of articles on leading American artists under the general title, "——— Paints a Picture." Most of them include statements by the artists.
*40 American Painters*. University of Minnesota Gallery, Minneapolis: 1951.
      Chiefly artists of the New York School. Brief statements.
Motherwell, Robert, and Ad Reinhardt. *Modern Artists in America*. New York: Wittenborn, Schultz, 1951.
      An account of the New York School in its formative years, including transcripts of important panel discussions.
*Arts* (New York) (Hilton Kramer, ed.) published intermittently several symposia by artists and critics on crucial issues.
Tuchman, Maurice (ed.). *The New York School*. Exhibition catalogue. Los Angeles: Los Angeles County Museum of Art, 1965.
      A valuable survey which includes statements by Baziotes, De Kooning, Gorky, Gottlieb, Guston, Hofmann, Kline, Motherwell, Newman, Pollock, Pousette-Dart, Reinhardt, Rothko, Still and Tomlin, and an extensive classified bibliography of additional statements by them and comments by critics. Also includes an extensive bibliography of articles and books on the New York School.

A SELECTED BIBLIOGRAPHY

*Interviews with artists*

Kuh, Katherine. *The Artist's Voice.* New York: Harper and Row, 1963.
        Interviews with seventeen leading American artists.
Roditi, Edouard. *Dialogues on Art.* London: Secker and Warburg; New York: Horizon, 1960.
        Discussions with major European artists.

*Books by artists*

Baumeister, Willi. *Das Unbekannte in der Kunst.* Stuttgart: 1947.
Bazaine, Jean. *Notes sur la peinture.* Paris: Ed. du Seuil, 1960.
        Thoughtful and interesting observations.
Davis, Stuart. *Stuart Davis.* New York: American Artists Group, 1945.
        Davis's own account of his career and his ideas.
Hassenpflug, Gustav. *Abstrakte Maler Lehren.* Munich and Hamburg: Ellermann, 1959.
Henri, Robert. *The Art Spirit.* Philadelphia: Lippincott, 1923.
        A lively account of his ideas on art and life that were so influential on young artists just before the Armory Show.
*Henry Moore on Sculpture.* Introduction by Philip James. London: Macdonald, 1966.
        A collection of extraordinarily intelligent and perceptive statements on various aspects of sculpture including technique.
Nay, Ernst W. *Vom Gestaltwert der Farbe.* Munich: 1955.
Weeks, S. T., and B. H. Hayes (eds.). *Search for the Real and Other Essays by Hans Hofmann.* Andover: Addison Gallery, 1948.
        A collection of Hofmann's writings to date including those concerned with teaching. (Also see Harold Rosenberg's forthcoming book on Hofmann's theories and his teaching.)

*Collected essays by critics closely involved in artists' circles*

Ashton, Dore. *The Unknown Shore.* Boston: Little, Brown, 1962.
Greenberg, Clement. *Art and Culture.* Boston: Beacon, 1961.
Rosenberg, Harold. *The Tradition of the New.* New York: Horizon, 1959; New York: Grove, 1961.
———. *The Anxious Object; Art Today and Its Audience.* New York: Horizon, 1964.
Tapié, Michel. *Un Art Autre.* Paris: Gabriel Giraud, 1952.
        An important and stimulating essay by the critic and aesthetician on the most advanced nonobjective art.

*General studies of the artists and the movements*

Barr, Alfred H., Jr. *Lyonel Feininger, Marsden Hartley.* New York: Museum of Modern Art, 1944.
        Includes statements and bibliographies of other of the artists' writings.
Brown, Milton W. *American Painting from the Armory Show to the Depression.* Princeton: Princeton University Press, 1955.

A history of American painting with references to social and political history, a fruitful method for this period. No statements but extensive bibliography.

Grohmann, Will. *The Art of Henry Moore*. New York: Abrams, 1960.

*Henry Moore*. Introduction by Sir Herbert Read. Vol. I: *Sculpture and Drawings 1921–1948*. Edited by David Sylvester. 4th ed., 1957. Vol. II: *Sculpture and Drawings since 1948*. 1st ed., 1955. London: Lund, Humphries.

*Robert Motherwell*. With selections from the artist's writings by Frank O'Hara. New York: Museum of Modern Art, 1965.

Includes the principal writings of this important artist and theoretician. Bibliography.

Robertson, Bryan. *Jackson Pollock*. New York: Abrams, 1961.

Includes most of Pollock's few statements on art.

Rosenberg, Harold. *Arshile Gorky, The Man, The Time, The Idea*. New York: Horizon, 1962.

Schwabacker, Ethel K. *Arshile Gorky*. New York: Macmillan, 1957.

A comprehensive monograph which includes most of Gorky's writings.

Seitz, William C. *Hans Hofmann*. New York: Museum of Modern Art, 1963.

Includes a valuable study of Hofmann's philosophy of painting.

Selz, Peter (ed.). *The Work of Jean Dubuffet*. New York: Museum of Modern Art, 1962.

———. *Alberto Giacometti*, New York: Museum of Modern Art, 1965.

Includes a letter by the artist on his method of working.

Sweeney, James J. *Alexander Calder*. New York: Museum of Modern Art, 1951.

———. *Stuart Davis*. New York: Museum of Modern Art, 1945.

Includes bibliography of Davis' extensive writings.

*Periodicals which often include interviews or statements by artists*

*Artforum* (Los Angeles), 1962–. (Philip Leider, ed.).

*Art in America* (New York), 1913–. (Jean Lipman, ed.).

*Art News* (New York), 1902–; also *Art News Annual*, later *Portfolio* (Thomas B. Hess, ed.).

*Arts* (New York), 1926– (formerly *Art Digest, Arts Digest*); also *Arts Yearbook*, 1957–. (The period ca. 1958–1966 is of especial interest; Hilton Kramer, James B. Mellow, eds.).

*It Is* (New York), 1958– (published intermittently) (P. G. Pavia, ed.).

*Magazine of Art* (New York), 1909–1953 (Robert J. Goldwater, last ed.).

*Scrap* (New York), 1960–1961 (Sidney Geist and Anita Ventura, eds.).

*Tiger's Eye* (New York), 1947–1949 (Ruth Stephan, ed.).

*trans/formation* (New York), 1950 (Harry Holtzman, ed.).

*L'Art d'Aujourd'hui* (Paris), 1924–1925 (Albert Morance, ed.).

*Art-documents* (Geneva), 1950– (Pierre Cailler, ed.).

*Art International* (Lugano), 1956– (James Fitzsimmons, ed.).

*Cahiers d'Art* (Paris), 1926– (Christian Zervos, ed.).

*Cimaise* (Paris), 1953– (J. R. Arnaud, ed.).

*Quadrum* (Brussels), 1956– (Pierre Jaulet, Robert Giron and regional editors).

*XX<sup>e</sup> siècle* (Paris), new series, 1951– (Gaultieri di San Lazzaro, ed.).

# LIST OF ILLUSTRATIONS
# AND CREDITS

Unless otherwise noted, the photographs of oil paintings, drawings and prints were obtained from the owners; the prints of photographs from the photographers.

## POST-IMPRESSIONISM

Paul Cézanne, *Self-Portrait*, ca. 1898, transfer lithograph.
Museum of Modern Art, New York, gift of Abby Aldrich Rockefeller.

Paul Cézanne, signature from *Portrait of Victor Choquet*, 1876–77, oil on canvas.
Gallery of Fine Arts, Columbus, Ohio.

Vincent van Gogh, self-portraits from a letter of March 1886. From *The Complete Letters of Vincent van Gogh*, Vol. II, Greenwich, Connecticut, The New York Graphic Society, 1958, p. 510.
Photographs courtesy The New York Graphic Society and Dr. Ir. Vincent W. van Gogh, Laren, The Netherlands.

Vincent van Gogh, signature on a letter (553b), undated (ca. September 1888).
From *The Complete Letters*, Vol. III, p. 85.

Vincent van Gogh, sketch for *The Sower* in a letter (558a) to Theo, end of October 1888.
From *The Complete Letters*, Vol. III, p. 96.

Vincent van Gogh, sketch for *The Bedroom at Arles* in a letter (B22) to Gauguin, undated (ca. October 1888).
From *The Complete Letters*, Vol. III, p. 526.

Table of sizes of canvases (in centimeters).

Vincent van Gogh, *The Night Cafe*, 1888, oil on canvas.
Yale University Art Gallery, New Haven, Conn., bequest of Stephen C. Clark.

Vincent van Gogh, *Self-Portrait Before the Easel*, 1888, oil on canvas.
Collection, Dr. Ir. Vincent W. van Gogh, Laren, The Netherlands. Photograph Gemeente Museum, Amsterdam.

## SYMBOLISM

Paul Gauguin, 1888.
Photograph courtesy of Mme. Annie Joly-Ségalen, Bourg-la-Reine, France.

Residents of Pension Gloanec, Pont-Aven, Brittany, ca. 1888.
Photograph collection of the author.
Courtesy Michel Thersiquel, Pont-Aven, France.

Paul Gauguin, sketch of a Marquesan sculpture, 1891–1893. Collection, Victor Segalen, Paris.
From John Rewald, *Gauguin Drawings*, New York, Yoseloff, 1958, No. 42.

Paul Gauguin, *Self Portrait*, 1891–1892, drawing.
From *Carnet de Tahiti* (facsimile edition), Paris, Quatre Chemins, 1964, p. 4.

Paul Gauguin, cover design of *Cahier pour Aline*, Tahiti, 1893.
From *Cahier pour Aline*, presented by Suzanne Damiron, Paris, Société des amis de la Bibliothèque d'art et d'archéologie de l'Université de Paris, 1962.

Paul Gauguin, page from *Cahier pour Aline*, Tahiti, 1893, with a sketch of *The Spirit of the Dead Watching (Manao Tupapau)*.

Paul Gauguin, cover design of *Avant et Après*, Marquesas, 1904.
From facsimile edition by Scripta with Paul Carit Andersen, Copenhagen.

Paul Gauguin, letter to Daniel de Monfried describing *Whence Do We Come? What Are We? Where Are We Going?* February 1898.
From *Art et Style*, Paris, Vol. 55, 1960.

Paul Gauguin or Emile Bernard, *A Nightmare*, ca. 1888, crayon.
Cabinet des Dessins, Musée du Louvre.
Photograph Service de Documentation Photographique de la Réunion des Musées Nationaux.

Paul Gauguin, *Whence Do We Come?* . . . , 1898, oil on canvas.
Museum of Fine Arts, Boston.

G.-Albert Aurier, ca. 1892.
Photograph from Jacques Lethève, *Impressionnistes et Symbolistes Devant la Presse*, Paris, Colin, 1959, p. 229. Photograph Bibliothèque Nationale.

Maurice Denis, *Hommage à Cézanne*, 1900, oil on canvas.
Musée du Louvre. Photograph Archives Photographiques.

Edvard Munch, *Self-Portrait*, 1895, lithograph.
Oslo Kommunes Kunstsamlinger, Munch-Museum, Oslo. Photograph J. Thurmann Moe, Oslo.

James Ensor, *Myself Surrounded by Demons*, 1898, color lithograph.
Museum of Modern Art, New York.

Picture postcard of the beach at Ostende with a drawing by Ensor.
From Paul Haesaerts, *James Ensor*, New York, Abrams, 1959, p. 351. Courtesy of Harry N. Abrams.

Ensor's visiting card.
From Paul Haesaerts, *James Ensor*, New York, Abrams, 1959, p. 354.
Courtesy of Harry N. Abrams.

Ferdinand Hodler, Poster for his exhibition at the Vienna Secession, 1904.
Photo Kaiser Wilhelm Museum, Krefeld.

Odilon Redon, *Self-Portrait*, ca. 1895, crayon.
Collection, J. E. van der Meulen, Gelderland, The Netherlands.

Ernst Ludwig Kirchner, *Henry van de Velde*, 1917, woodcut.
Copyright Roman Norbert Ketterer, Campione d'Italia.

Henri van de Velde, Poster for the journal *Dekorative Kunst*, 1897.
Photo Kunsthalle, Bremen.

## FAUVISM AND EXPRESSIONISM

Henri Rousseau, *The Dream*, 1910, oil on canvas.
Museum of Modern Art, New York, gift of Nelson A. Rockefeller.

Henri Matisse, *Self-Portrait*, ca. 1900, brush and ink.
Collection, John Rewald, New York. Photograph Museum of Modern Art, New York.

Henri Matisse, four *Self-Portraits*, October 1939, crayon drawings.
Collection, Mme. Marguerite Duthuit, Paris. Photographs Philadelphia Museum of Art.

Maurice Vlaminck, *Self-Portrait*, ca. 1908, etching.
Museum of Modern Art, New York, gift of Leon Mnuchin.

Emil Nolde, *Self-Portrait with Pipe*, 1908, lithograph.
Museum of Modern Art, New York, gift of Mr. and Mrs. Carroll Cartwright.

Wassily Kandinsky, ca. 1903.
Photograph from Will Grohmann, *Kandinsky, Life and Work*, New York, Abrams, 1958, p. 23. Courtesy of Harry N. Abrams.

Wassily Kandinsky, *Der Blaue Reiter*, title page of the first exhibition catalogue, Munich, 1911, woodcut.
Photograph Museum of Modern Art, New York.

Oskar Kokoschka, self-portrait on poster for his lecture at the Academic Society for Literature and Music, 1912, color lithograph.
Museum of Modern Art, New York, Larry Aldrich Fund.

Oskar Kokoschka, *Mörder, Hoffnung der Frauen*, 1909. Poster for his own somewhat autobiographical play.
Photo Museum für Kunst and Gewerbe, Hamburg.

Ernst Ludwig Kirchner, program for *Die Brücke*, 1905, woodcut.
From Bernard S. Myers, *The German Expressionists*, New York, Praeger, 1957, p. 108. Copyright Roman Norbert Ketterer, Campione d'Italia.

Ernst Ludwig Kirchner, *Chronik der Brücke*, title page, 1913, woodcut.
Photograph Museum of Modern Art, New York. Copyright Roman Norbert Ketterer, Campione d'Italia.

Ernst Ludwig Kirchner, *Self-Portrait with a Pipe*, 1908, drypoint.
Photograph Museum of Modern Art, New York. Copyright Roman Norbert Ketterer, Campione d'Italia.

Ernst Ludwig Kirchner, *The Painters of Die Brücke*, 1925, oil on canvas.
Wallraf-Richartz Museum, Cologne. Photograph Rheinisches Bildarchiv. Copyright Roman Norbert Ketterer, Campione d'Italia.

Franz Marc, *Deer Resting*, woodcut.
Photograph Museum of Modern Art, New York.

Franz Marc.
Photograph Archiv Günther Franke, Munich. From Werner, Haftmann, *Painting in the Twentieth Century*, Vol. I, New York, Praeger, 1960, p. 16.

Paul Klee, *An Artist* (self-portrait), 1919, pen and wash.
Present location unknown. (Formerly collection Galka Scheyer.)
Photograph Museum of Modern Art, New York.

Max Beckmann, *Self-Portrait*, 1922, woodcut.
Museum of Modern Art, New York.

## CUBISM

André Lhote, Sketch demonstrating how he combined various elements of a glass into a single Cubist image, 1952.

André Salmon in Picasso's studio, the Bateau Lavoir, with *Les Demoiselles d'Avignon* (covered), 1908.
Photo from Edward F. Fry, *Cubism*, New York, McGraw-Hill, 1966, Pl. VII.

Marie Laurencin, *Group of Artists*, 1908, oil on canvas.
Cone Collection, Baltimore Museum of Art.

Pablo Picasso, *Self-Portrait*, 1907, oil on canvas.
Narodni Galerie, Prague.

Picasso in the Bateau Lavoir with New Caledonia (Melanesia) sculptures, 1908.
Photo by Gelett Burgess, from his article in *The Architectural Record*, New York May, 1910.

Pablo Picasso, *Les Demoiselles d'Avignon*, 1907, oil on canvas.
Museum of Modern Art, New York.

Pablo Picasso. Photograph by Arnold Newman.
Fernande Olivier, *Portrait of Picasso*, drawing.
From Fernande Olivier, *Picasso et ses Amis*, Paris, Stock, 1933.

Braque in his studio, ca. 1911.
Photo from *Arts primitifs dans les ateliers d'artistes*, Paris, 1967.

Jean Metzinger, *Self-Portrait*, drawing.
From Guillaume Apollinaire, *Les Peintres Cubistes*, Geneva, Cailler, 1950, p. 9.

André Billy, *Portrait of André Salmon*, drawing.
From André Billy, *André Salmon*, Paris, Seghers.

Max Jacob, *Portrait of Guillaume Apollinaire*, 1905, drawing.
From Pierre Seghers, *Guillaume Apollinaire*, Paris, Seghers, 1947.

Pablo Picasso, *Guillaume Apollinaire*, 1916, drawing.
From Roland Penrose, *Portrait of Picasso*, London, Lund Humphries, 1960, fig. 109.

Guillaume Apollinaire, *The Mandolin, The Violet and the Bamboo*, ca. 1913, calligram.
From *Calligrammes*, Paris, Gallimard, 1925, p. 71.

Pablo Picasso, *Daniel-Henry Kahnweiler*, 1910, oil on canvas.
The Art Institute of Chicago, Gift of Mrs. Gilbert W. Chapman.

Juan Gris, *Hommage à Pablo Picasso*, 1911–12, oil on canvas.
Collection, Mr. and Mrs. Leigh Block, Chicago.

Juan Gris, *Portrait of D. H. Kahnweiler*, 1921, drawing.
Collection, D. H. Kahnweiler, Paris.
Photograph Galerie Louise Leiris, Paris.

Juan Gris, *Self-Portrait*, 1921, drawing.
Collection, Mme. Josette Gris, Paris.
Photograph Galerie Louise Leiris, Paris.

Fernand Léger, *Self-Portrait*, 1922, drawing.
From *Art News*, New York, October 1955, p. 31.

## FUTURISM

Umberto Boccioni, *A Futurist Evening in Milan*, 1911, drawing.
From Carrieri, *Il Futurismo*, Milan, Edizioni del Milioni, 1961, fig. 7 following p. 29.

The Futurist in Paris, February 1912.
Photograph from Carrieri, *Il Futurismo* fig. 7 following p. 20.

Alberto Grandi, *Portrait of F. T. Marinetti*, 1908, ink.
From Tullio Panteo, *Il Poeta Marinetti*, Milan, Societa Editoriale Milanese, 1908.

Umberto Boccioni, *Self-Portrait*, 1910, etching.
From Joshua C. Taylor, *The Graphic Work of Umberto Boccioni*, New York, Museum of Modern Art, 1961.

F. T. Marinetti, cover of *Parole in libertà*, 1919.
From Carrieri, *Il Futurismo*, p. 88.

## NEO-PLASTICISM

Cover of *De Stijl*, Amsterdam, November 1921.
From Hans Richter, *Dada, Kunst und Antikunst*, Cologne, DuMont Schauberg, 1964, p. 205.

Naum Gabo, 1941.
Photograph Museum of Modern Art, New York.

Salvador Dali, *Self-Portrait*, 1943, drawing.
From Antonio Oriol-Anguera, *Mentira y Verdad de Salvador Dali*, Barcelona, Co-balto, 1948. Reproduced by the kind permission of Sr. Dali.

Max Ernst, *Self-Portrait*, 1920, photomontage.
From Hans Richter, *Dada, Kunst und Antikunst*, Cologne, DuMont Schauberg, 1964, fig. 76 opposite p. 145.

Max Ernst, Sedona, Arizona, 1946.
Photograph by Frederick Sommer, courtesy Museum of Modern Art, New York.

Max Ernst, *Forest and Sun*, 1957, color lithograph.
From Patrick Waldberg, *Max Ernst*, Paris, Pauvert, 1958.

Joan Miro, *Self-Portrait*, 1937–38, pencil, crayon and oil on canvas.
Collection, James Thrall Soby. Photograph Museum of Modern Art, New York.

André Masson, *Self-Portrait*, ca. 1938, ink.
From *André Masson*, Rouen, Wolf, 1940, p. 7.

Marc Chagall, *Self-Portrait with Grimace*, ca. 1924, etching with aquatint.
Museum of Modern Art, New York, gift of the artist.

Matta (Matta Echaurren), 1941.
Photograph by Sidney Janis, New York.

## ART AND POLITICS

Vierthaler (unidentified), *Degenerate Art*, "Exhibition of 'culture documents' of the decadent work of Bolsheviks and Jews," 1936.
Library of Congress.

H. E. (unidentified), *Degenerate Art*, Nazi exhibition, ca. 1937.
Library of Congress.

*N. S. D. A. P.: The Iron Guard of the German Revolution* (N. S. D. A. P.—National Sozialistische Deutsche Arbeiter Partei-Nazi), ca. 1934.
Library of Congress.

Hitler and Goebbels viewing the exhibition of degenerate art, 1937.
Photograph Ullstein Bilderdienst, Berlin.

Pablo Picasso, *Guernica* (detail), 1937, oil on canvas.
Museum of Modern Art, New York. On loan from the artist.

## CONTEMPORARY ART

Stuart Davis on Seventh Avenue, New York, 1944.
Photograph courtesy of Mrs. Stuart Davis.

Arshile Gorky.
Photograph by Gjon Mili, courtesy Museum of Modern Art, New York.

Hans Hofmann, ca. 1960.
Photograph by Marvin P. Lazarus, New York. Photograph University Art Museum, University of California, Berkeley.

Hans Hofmann, diagram of Nature-Artist-Creation, ca. 1948.
From S. T. Weeks and B. H. Hayes, *Search for the Real and Other Essays by Hans Hofmann*, Andover, Addision Gallery, 1948.

Artists' session at Studio 35, New York, 1950.
From *Modern Artists in America*, R. Motherwell, A. Reinhardt, B. Karpel (eds.), New York, Wittenborn, Schultz, 1950, p. 8.

Artists' session at Studio 35, New York, 1950.
From *Modern Artists in America*, R. Motherwell, A. Reinhardt, B. Karpel (eds.), New York, Wittenborn, Schultz, 1950, p. 8.

Jackson Pollock, 1951.
Photograph by Hans Namuth, New York.

Panel discussion at "The Club," Second Avenue and 10th Street, New York, discussing "Non-critic-artists," 15 January 1960.
Photograph by Fred W. McDarrah. From Fred W. McDarrah, *The Artist's World*, New York, E. P. Dutton, 1961, p. 72.

Willem de Kooning, 1965.
Photograph by Hans Namuth, New York.

David Smith, Spoleto, Italy, 1963.
Photograph by Ugo Mulas, Milan. From *Art News Annual*, New York, XXIX, 1963. Copyright 1963 Newsweek, Inc.

Henry Moore, ca. 1950.
Photograph courtesy of Mr. Moore.

Alberto Giacometti, 1960.
Photograph by Herbert Matter, New York.

Jean Dubuffet, 1956.
Photograph copyright by Arnold Newman, New York.

Eduardo Paolozzi.
Photograph by Ulrich Mack, Munich.

# INDEX

Page numbers in italic type list primary documents or mentions of some importance. Those works of art discussed in some detail are included under the name of the artist.

# INDEX